# Lecture Notes in Computer Science 10045

Commenced Publication in 1973
Founding and Former Series Editors:
Gerhard Goos, Juris Hartmanis, and Jan van Leeuwen

More information about this series at http://www.springer.com/series/7409

Frank Nack · Andrew S. Gordon (Eds.)

# Interactive Storytelling

9th International Conference
on Interactive Digital Storytelling, ICIDS 2016
Los Angeles, CA, USA, November 15–18, 2016
Proceedings

 Springer

*Editors*
Frank Nack
University of Amsterdam
Amsterdam
The Netherlands

Andrew S. Gordon
The Institute for Creative Technologies
University of Southern California
Los Angeles, CA
USA

ISSN 0302-9743        ISSN 1611-3349   (electronic)
Lecture Notes in Computer Science
ISBN 978-3-319-48278-1        ISBN 978-3-319-48279-8   (eBook)
DOI 10.1007/978-3-319-48279-8

Library of Congress Control Number: 2016954939

LNCS Sublibrary: SL3 – Information Systems and Applications, incl. Internet/Web, and HCI

Printed on acid-free paper

This Springer imprint is published by Springer Nature
The registered company is Springer International Publishing AG
The registered company address is: Gewerbestrasse 11, 6330 Cham, Switzerland

# Preface

This volume contains the proceedings of ICIDS 2016: the 9th International Conference on Interactive Digital Storytelling. ICIDS took place at the Institute for Creative Technologies, University of Southern California, Los Angeles, USA. This year also featured a collaboration with the ninth edition of Intelligent Narrative Technologies (INT9), a related series of gatherings that holds artificial intelligence as its focus. INT9 was featured at ICIDS 2016 as its own track, organized by co-chairs Chris Martens and Rogelio E. Cardona-Rivera.

ICIDS is the premier annual venue that gathers researchers, developers, practitioners, and theorists to present and share the latest innovations, insights, and techniques in the expanding field of interactive storytelling and the technologies that support it. The field regroups a highly dynamic and interdisciplinary community, in which narrative studies, computer science, interactive and immersive technologies, the arts, and creativity converge to develop new expressive forms in a myriad of domains that include artistic projects, interactive documentaries, cinematic games, serious games, assistive technologies, edutainment, pedagogy, museum science, advertising, and entertainment, to mention a few. The conference has a long-standing tradition of bringing together academia, industry, designers, developers, and artists into an interdisciplinary dialogue through a mix of keynote lectures, long and short article presentations, posters, workshops, and very lively demo sessions. Additionally, since 2010, ICIDS has been hosting an international art exhibition open to the general public. For this edition we also introduced a new track, namely, "Brave New Ideas." This track addresses works that explore highly innovative ideas and/or paradigm shifts in conventional theory and practice of interactive storytelling. It seeks to draw attention to methods that differ from the state of the art in practice or theory and demonstrate potential for changed ways of thinking. The aim is to establish a clearer roadmap as a community guideline for the development of the field.

The review process was extremely selective and many good papers could not be accepted for the final program. Altogether, we received 88 submissions in all the categories. Out of the 66 submitted full papers, the Program Committee selected only 26 submissions for presentation and publication as full papers, which corresponds to an acceptance rate of 39 % for full papers. In addition, we accepted eight submissions as short papers, nine submissions as posters, and three submissions as demonstrations, including some long papers that were offered the opportunity to participate within another category. The ICIDS 2016 program featured contributions from 41 different institutions in 16 different countries worldwide.

The conference program also hosted three invited speakers:

Kevin Bruner co-founded Telltale, Inc., in 2004 to blend technology, creativity, and production processes to create a new entertainment experience and define a new business model. Since its inception, Telltale has pioneered episodic gaming, becoming the first company to release games as monthly episodes. Since 1990, Kevin has been creating

entertainment technology for video games, television game shows, museum installations, and more. Prior to founding Telltale, Kevin applied his talents at LucasArts, working on cutting-edge projects such as the classic Grim Fandango noir adventure, and epic Star Wars titles, as well as crafting core company technology strategies.

Tracy Fullerton is a game designer, professor and director of the USC Games program. Her research center, the Game Innovation Lab, has produced several influential independent games, including Cloud, flOw, Darfur is Dying, The Misadventures of P.B. Winterbottom, The Night Journey, with artist Bill Viola, and Walden, a game. Tracy is the author of – a design textbook used at game programs worldwide, and holder of the Electronic Arts Endowed Chair in Interactive Entertainment. Prior to USC, she designed games for Microsoft, Sony, MTV, among others. Tracy's work has received honors including an Emmy nomination, Indiecade's "Sublime Experience," "Impact," and "Trailblazer" awards, the Games for Change "Game Changer" award, and the Game Developers Choice "Ambassador" Award.

Janet Leahy, a graduate of UCLA's school of film and television, spent 18 years as a comedy writer – producing, writing, and executive producing "Cheers," "The Cosby Show," "Roseanne," "Grace Under Fire," among many others. Her work continued in the one-hour arena as writer/producer for "Gilmore Girls," followed by Executive Producer of "Boston Legal," "Life Unexpected," and "Mad Men." Janet has received six Emmy nominations, as well as Writers' Guild Awards and the Peabody Award for best drama. She is currently developing a half-hour comedy and one-hour drama pilot.

In addition to paper and poster presentations, ICIDS 2016 featured a pre-conference workshop day with four workshops:

WS1: The First Workshop on Tutorials in Intelligent Narrative Technologies, organized by Chris Martens and Rogelio E. Cardona-Rivera

WS2: How to Rapid Prototype Your Very Own Vr Journalism Experience, organized by Marcus Bösch, Linda Rath-Wiggins, and Trey Bundy.

WS3: In-Depth Analysis of Interactive Digital Narrative, organized by Hartmut Koenitz, Mads Haahr, Gabriele Ferri, Tonguc Ibrahim Sezen, and Digdem Sezen.

WS4: Exploring New Approaches to Narrative Modeling and Authoring, organized by Fanfan Chen, Antonia Kampa, Alex Mitchell, Ulrike Spierling, Nicolas Szilas, and Steven Wingate.

In conjunction with the academic conference, the Art Exhibition of the 9th International Conference on Interactive Digital Storytelling was held at the USC Institute for Creative Technologies on November 15, 2016. The art exhibition featured a selection of nine artworks selected from 19 submissions by an international jury.

We would like to express our gratitude and sincere appreciation to all the authors included in this volume for their effort in preparing their submissions and for their participation in the conference. Equally we want to heartily thank our Program Committee and our eight meta-reviewers: Marc Cavazza, Gabriele Ferri, Ben Kybartas, Vincenzo Lombardo, Paolo Petta, Charly Hargood, Jichen Zhu, and Peter A. Mawhorter. Thanks as well to our art exhibition jurors for their accurateness and diligence in the review process, our invited speakers for their insightful and inspirational talks, and the workshops organizers for the dynamism and creativity that they

brought into the conference. A special thank goes to the ICIDS Steering Committee for granting us the opportunity to host ICIDS 2016 in Los Angeles. Thanks to you all!

November 2016                                                                                 Frank Nack
Andrew S. Gordon

# Organization

## General Chair

Andrew S. Gordon       University of Southern California, USA

## Program Chair

Frank Nack       University of Amsterdam, The Netherlands

## INT9 Track Co-chairs

Rogelio E. Cardona-Rivera       North Carolina State University, USA
Chris Martens       North Carolina State University, USA

## Local Chair

Rob Fuchs       University of Southern California, USA

## Workshops Chair

Reid Swanson       University of Southern California, USA

## Communications Chair

Melissa Roemmele       University of Southern California, USA

## Art Exhibition Jury

Valentina Nisi       University of Madeira, Portugal
Jing Ying Chiang       Independent artist
Kristy H.A. Kang       Nanyang Technological University, Singapore
Mez Breeze       mezbreezedesign.com
Linda Kronman       kairus.org
Andreas Zingerie       kairus.org

## Steering Committee

Luis Bruni       Aalborg University, Denmark
Gabriele Ferri       Amsterdam University of Applied Sciences,
            The Netherlands
Hartmut Koenitz       Hogeschool voor de Kunsten Utrecht, The Netherlands

| | |
|---|---|
| Ido Iurgel | Rhine-Waal University of Applied Sciences, Germany |
| Alex Mitchell | National University of Singapore, Singapore |
| Paolo Petta | Austrian Research Institute for Artificial Intelligence, Austria |
| Ulrike Spierling | RheinMain University of Applied Sciences, Germany |
| Nicolas Szilas | University of Geneva, Switzerland |
| David Thue | Reykjavik University, Iceland |

## Program Committee

| | |
|---|---|
| Nahum Alvarez | Shinshu University, Japan |
| Elisabeth Andre | Augsburg University, Germany |
| Ruth Aylett | Heriot-Watt University, UK |
| Julio Bahamon | North Carolina State University, USA |
| Alok Baikadi | University of Pittsburgh, USA |
| Udi Ben-Arie | Tel Aviv University, Israel |
| Rafael Bidarra | Delft University of Technology, The Netherlands |
| Anne-Gwenn Bosser | Ecole Nationale d'Ingénieurs de Brest, France |
| Luis Bruni | Aalborg University, Denmark |
| Daniel Buzzo | University of the West of England, UK |
| Beth Cardier | Sirius-Beta.com |
| Rogelio Cardona-Rivera | North Carolina State University, USA |
| Marc Cavazza | University of Teesside, UK |
| Pablo Cesar | Centrum Wiskunde & Informatica, The Netherlands |
| Fred Charles | Teesside University, UK |
| Fanfan Chen | National Dong Hwa University, Taiwan |
| Teun Dubbelman | Hogeschool voor de Kunsten Utrecht, The Netherlands |
| Micha Elsner | The Ohio State University, USA |
| Clara Fernandez Vara | New York University, USA |
| Gabriele Ferri | Amsterdam University of Applied Sciences, The Netherlands |
| Mark Finlayson | Florida International University, USA |
| Henrik Fog | Aalborg University, Denmark |
| Pablo Gervás | Universidad Complutense de Madrid, Spain |
| Stefan Goebel | Technische Universität Darmstadt, Germany |
| Andrew Gordon | University of Southern California, USA |
| Dave Green | Newcastle University, UK |
| April Grow | University of California, Santa Cruz, USA |
| Charlie Hargood | University of Southampton, UK |
| Sarah Harmon | University of California, Santa Cruz, USA |
| Ian Horswill | Northwestern University, USA |
| Nienke Huitenga | Avans University of Applied Sciences, The Netherlands |
| Ichiro Ide | Nagoya University, Japan |
| Noam Knoller | Utrecht University, The Netherlands |
| Hartmut Koenitz | Hogeschool voor de Kunsten Utrecht, The Netherlands |

| Ben Kybartas | Kitfox Games, Canada |
| James Lester | North Carolina State University, USA |
| Boyang Li | Disney Research, USA |
| Vincenzo Lombardo | Università di Torino, Italy |
| Sandy Louchart | Glasgow School of Art, UK |
| Domitile Lourdeaux | University of Technology of Compiegne, France |
| Stephanie Lukin | University of California, Santa Cruz |
| Simon Lumb | BBC Research & Development, UK |
| Brian Magerko | Georgia Institute of Technology, USA |
| Chris Martens | North Carolina State University, USA |
| Peter A. Mawhorter | University of California, Santa Cruz, USA |
| David Millard | University of Southampton, UK |
| Alex Mitchell | National University of Singapore, Singapore |
| Paul Mulholland | The Open University, UK |
| John Murray | University of California, Santa Cruz, USA |
| Gonzalo Méndez | Universidad Complutense de Madrid, Spain |
| Frank Nack | University of Amsterdam, The Netherlands |
| Michael Nitsche | Georgia Institute of Technology, USA |
| Eefje Op den Buijsch | Fontys, The Netherlands |
| Federico Peinado | Universidad Complutense de Madrid, Spain |
| Paolo Petta | Austrian Research Institute for Artificial Intelligence, Austria |
| Julie Porteous | Teesside University, UK |
| Rikki Prince | Southampton University, UK |
| Justus Robertson | North Carolina State University, USA |
| Remi Ronfard | Inria, France |
| Christian Roth | Hogeschool voor de Kunsten Utrecht, The Netherlands |
| Jonathan Rowe | North Carolina State University, USA |
| James Ryan | University of California, Santa Cruz, USA |
| Magy Seif El-Nasr | Northeastern University, USA |
| Emily Short | Independent writer |
| Mei Si | Rensselaer Polytechnic Institute, USA |
| Marcin Skowron | Austrian Research Institute for Artificial Intelligence, Austria |
| Anne Sullivan | American University, USA |
| Kaoru Sumi | Future University Hakodate, Japan |
| Nicolas Szilas | University of Geneva, Switzerland |
| Theresa Jean Tanenbaum | University of California, Irvine, USA |
| Mariet Theune | University of Twente, The Netherlands |
| David Thue | Reykjavik University, Iceland |
| Emmett Tomai | University of Texas, Rio Grande Valley, USA |
| Martin Trapp | Austrian Institute for Artificial Intelligence, Austria |
| Mirjam Vosmeer | Hogeschool van Amsterdam, The Netherlands |
| Stephen Ware | University of New Orleans, USA |
| Nelson Zagalo | University of Minho, Portugal |
| Jichen Zhu | Drexel University, USA |

# Contents

**Intelligent Narrative Technologies**

**Posters**

**Demonstrations**

**Workshops**

# Analyses and Evaluation of Systems

# IVRUX: A Tool for Analyzing Immersive Narratives in Virtual Reality

Paulo Bala[✉], Mara Dionisio, Valentina Nisi, and Nuno Nunes

Madeira-ITI, University of Madeira, Campus Da Penteada, 9020-105 Funchal, Portugal
{paulo.bala,mara.dionisio}@m-iti.org, {valentina,njn}@uma.pt

**Abstract.** This paper describes IVRUX, a tool for the analysis of 360° Immersive Virtual Reality (IVR) story-driven experiences. Traditional cinema offers an immersive experience through surround sound technology and high definition screens. However, in 360° IVR the audience is in the middle of the action, everything is happening around them. The immersiveness and freedom of choice brings new challenges into narrative creation, hence the need for a tool to help the process of evaluating user experience. Starting from "The Old Pharmacy", a 360° Virtual Reality scene, we developed IVRUX, a tool that records users' experience while visualizing the narrative. In this way, we are able to reconstruct the user's experience and understand where their attention is focused. In this paper, we present results from a study done using 32 participants and, through analyzing the results, provide insights that help creators to understand how to enhance 360° Immersive Virtual Reality story driven experiences.

**Keywords:** Virtual reality · Digital storytelling · 360° immersive narratives

## 1   Introduction

The continuous emergence of new and more powerful media systems is allowing today's users to experience stories in 360° immersive environments away from their desktops. Head-Mounted Displays (HMD) such as the Oculus Rift[1] and Google Cardboard[2], are becoming mainstream and offer a different way of experiencing narratives. In Immersive Virtual Reality (IVR), the audience is in the middle of the action, and everything is happening all around them. Traditional filmmakers are now tasked with adapting tightly controlled narratives to this new media that defies a single view point, strengthens immersion in the viewing experience by offering the freedom to look around but also presents challenges, such as the loss of control over the narrative viewing sequence and the risk of having the audience miss important exciting steps in the story. For this reason in 360° IVR, it is important to understand what attracts their attention to or distracts them from the story.

In this paper, we describe the development of IVRUX, a 360° VR analytics tool and its application in the analysis of a VR narrative scene. Our aim is to further advance the

---

[1] https://www.oculus.com/en-us/.
[2] https://vr.google.com/cardboard/index.html.

© Springer International Publishing AG 2016
F. Nack and A.S. Gordon (Eds.): ICIDS 2016, LNCS 10045, pp. 3–11, 2016.
DOI: 10.1007/978-3-319-48279-8_1

studies of user experience in 360° IVR by trying to understand how we can enhance the story design by analyzing the user's perception of their experience in conjunction with their intentions during the visualization of the story.

## 2    Related Work

In their summary on future Entertainment Media, Klimmt et al. [6] defend the argument that the field of interactive narrative is still in flux and its research is varied. IVR is currently being explored in several technologies and formats [3, 10, 13] One of the common links between these experiences is the freedom in the field of view. Directing a user's gaze is essential if they're to follow a scripted experience, trigger an event in a virtual environment, or maintain focus during a narrative. Currently, developers are compensating for the free movement of the user's gaze by utilizing automatic reorientations and audio cues as in Vosmeer et al.'s work [13], at the risk of affecting user's presence and immersion in the narrative. Such experiments demonstrate the need for a better understanding of user experience in VR, which can be advanced by capturing qualitative information about the user's experience that can be easily visualized and communicated. Nowadays, eye-tracking is used to analyze visual attention in several fields of research. Blascheck et al. [1] highlighted several methods for the visualization of gaze data for traditional video such as attention maps [4, 8] and scan path [9]. However, this is not the case for 360° IVR as the participants have the freedom to look around. Efforts into developing data visualizations that allow users to inspect static 3D scenes in an interactive virtual environment are currently being made [11, 12] but results are incompatible with dynamic content (video, 3D animation). Lowe et al. [7] research the storytelling capability of immersive video, by mapping visual attention on stimuli from a 3D virtual environment, recording gaze direction, and head orientation of participants watching immersive videos. Moreover, several companies are engaged in investigating this topic, such as Retinad[3], CognitiveVR[4], Ghostline[5], by providing analytical platforms for VR experiences. However, little information is available about them as they are all in the early stages of development.

## 3    "The Old Pharmacy"

"The Old Pharmacy" is an 360° Immersive narrative scene, part of a wider transmedia story called "Fragments of Laura", designed with the intention of informing users about the local natural capital of Madeira island and the medicinal properties of its unique plants. The storyline of the overall experience revolves around Laura, an orphan girl who learns the medicinal powers of the local endemic forest. In the "The Old Pharmacy" scene, Laura is working on a healing infusion when a local gentleman, Adam, interrupts

---

[3] http://retinad.io/.
[4] http://cognitivevr.co/.
[5] http://ghostline.xyz/.

her with an urgent request. The experience ends in a cliffhanger as a landslide falls upon our characters. For a summary of the story see Fig. 1.

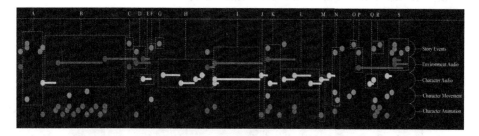

**Fig. 1.** IVRUX data mapping the plot points of the scene, coded alphabetically from A to S. Story Timeline (A) Laura enters the scene, opens and closes door 1; (B) Laura looks for ingredients; (C) Door 2 opens; (D) Thunder sound; (E) Laura reacts to Adam's presence; (F) Adam enters the room; (G) Door 2 closes; (H) Dialogue between Laura and Adam; (I) Laura preparing medicine; (J) Laura points at table; (K) Adam moves to table; (L) Dialogue between Laura and Adam; (M) Laura points at door 3; (N) Adam leaves the room, opens door 3; (O) Door 3 closes; (P) Landslide; (Q) Characters screaming for help; (R) Laura leaves the room; (S) End of scene.

The implementation of the IVR mobile application used was programmed using the Unity 5 game engine[6]. In this scene, we are presented with a 360° virtual environment of a pharmacy from the 19th century. The 360° Camera Rotation in the virtual environment is provided by the Google VR plugin[7]. All multimedia content is stored in the device and no data connection is needed. Information needed for analysis of the VR behavior is stored locally in an Extensible Markup Language (XML) file.

## 4   IVRUX - VR Analytics Tool

In order to supply authors with useful insight and help them design more engaging 360° narratives, we developed a VR analytics prototype (IVRUX) to visualize the user experience during 360° IVR narratives. The implementation of IVRUX was also developed using Unity 5. The prototype, using the XML files extracted from the mobile device, organizes the analytics information into a scrubbable timeline, where we are able to monitor key events of five types: story events, character animation, character position (according to predefined waypoints in the scene), character dialogue and environment audio. The prototype allows the researcher to switch between three observation modes; the single camera mode, a mode for 360° panorama (see C in Fig. 2) and a mode for simulation of HMD VR. The prototype replicates the story's 3D environment and the visual representation of the user's head tracking (field of view) by a semi-transparent circle with the identification number of the participant. Moreover a line connecting past and present head-tracking data from each participant allows us to understand the

---

[6] https://unity3d.com/.
[7] https://developers.google.com/vr/unity/.

participant's head motion over time. Semi-transparent colored spheres are also shown, one represents the points of interest (PI) in the story, simulating the "Director's cut" and the others represent the location of the two characters.

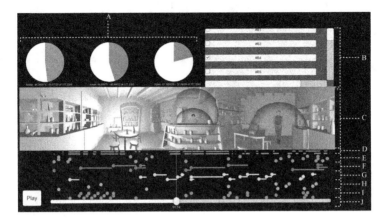

**Fig. 2.** IVRUX interface. (A) Pie charts representing intervals of time where a participant is looking at target spheres; (B) User selection scrollview; (C) 360° panorama; (D) Intervals of time where a participant is looking at target spheres; E) Story Events; F) Environment Audio; (G) Character Audio; (H) Character Movement; (I) Character Animation; (J) Scrubbable Timeline.

The scrubbable story timeline (see J in Fig. 2), presents the logged events and audio events. A scrollable panel (see B in Fig. 2) allows the user to choose which participant session to analyze and by selecting it, three pie charts (see A in Fig. 2) are shown indicating the ratio of time that the participant spent looking at one of the target spheres. Additionally, the timeline is also updated to represent the intervals of time where a participant is looking at each target (see D in Fig. 2).

## 5    Methodology

To test IVRUX, we conducted a study with a total of 32 users (16 females), non-native English speakers, of which 31.3 % were under the age of 25, 62.5 % were within the 25–34 age range and 6.2 % were over the age of 35. To assess participant homogeneity in terms of the tendency to get caught up in fictional stories, we employed the fantasy scale [2], with a satisfactory internal reliability ($\alpha = 0.53$). Two researchers dispensed the equipment (Google Cardboard with a Samsung Galaxy S4) with the narrative and took notes while supervising the evaluation. Participants were asked to view the 3 min IVR narrative. Subsequently, the participants were asked to complete a post-experience questionnaire and were interviewed by the researcher (for questions see Table 1.); this process took, on average, 15 to 20 min. After collecting all the interview data, two researchers analyzed questions IQ1-4, 7, 9 and open coded the answers. In IQ1, 3, answers were classified into three levels of knowledge (low, medium and high). In IQ2,

7, answers were classified positively and negatively. Finally, in IQ9, answers were classified according to the engagement with story plot, environment exploration or both. We used the Narrative Transportation Scale (NTS) [5] to assess participant ability to be transported into the application's narrative ($\alpha = 0.603$).

**Table 1.** Semi-structured interview table

| ID | Question |
|----|----------|
| IQ1 | Please tell us what the story was about? Please re-tell in a few words the story that you have just seen. |
| IQ2 | Was it difficult to follow the story? If yes, what made it difficult? |
| IQ3 | Please draw the room you were in. (On the back of the sheet) |
| IQ4 | What was the trajectory of Laura and Adam in the pharmacy? Please trace it in the drawing. |
| IQ5 | What would you say was the most interesting element of this experience? |
| IQ6 | Did you have the need to stop exploring/moving in the environment, to listen to the dialogue between the characters? If yes can you elaborate why? |
| IQ7 | Were you following the characters and the story plot or were you expressly looking away from the characters? |
| IQ8 | What part of the room did you look at more and why? Did you look at the shelves with the jars, opposite the counter? If so, why? |
| IQ9 | Were you more engaged with the story plot or with exploring the environment? |

## 6 Findings

### 6.1 Findings from Questionnaires and Interviews

The results from the NTS, which evaluates immersion aspects such as emotional involvement, cognitive attention, feelings of suspense, lack of awareness of surroundings and mental imagery, presented a mean value of 4.45 (SD = 0.76).

From the analysis of the semi-structured interviews (see Fig. 3), most participants understood the story at the medium level (IQ1), while with regard to knowledge about the virtual environment (IQ3) participants generally demonstrated medium to high levels of reminiscence of the virtual environment. More than half of the participants had a high

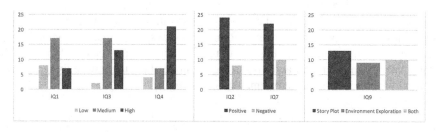

**Fig. 3.** Clustered column charts for participants scores in relation to the semi-structured interviews questions: IQ1, IQ2, IQ3, IQ4, IQ7 and IQ9

awareness of character movement (IQ4) and most participants did not have difficulties following the story (IQ2) and were not averse to the story (IQ7).

For example, participant A26 said "I took the opportunity to explore while the characters weren't doing anything". According to participants the most interesting elements of the experience (IQ5) were factors such as the 360° environment, the surprise effect (doors opening, character entry, thunder, etc.) and the immersiveness of the environment. For example, participant A3 stated "the thunder seemed very real (…)- I liked the freedom of choosing where to look.", participant A6 mentioned"I was surprised when the door opened and I had to look for Adam.". When asked if they would prefer to explore around the environment or focus on the story, the answers were inconclusive; a portion of users believe that the combination made the experience engaging. For example, participant B9 said "I enjoyed both and the story complements the environment and vice-versa."; moreover, participant B1 stated "At the beginning I was more engaged with the environment but afterwards with the story."

## 6.2   Findings from the IVRUX

Through the analysis of the data captured through the IVRUX, we noted that 48 % of the time, participants were looking at the "Director's cut" (M = 85.31 s, SD = 14.82 s). Participants spent 51.16 % of the time (M = 90.93 s, SD = 21.25 s) looking at the female character and 15.37 % (M = 27.32 s, SD = 8.98 s) looking at the male character. All users started by looking at the "Director's cut" but after a couple of seconds, around 10 users drifted into exploring the environment. Of those 10 users, 8 chose to explore the left side rather that the right side of the pharmacy, where the table with the lit candle was situated. Once Laura, the protagonist started talking (B in Fig. 1), the 10 who were exploring shifted their focus back to her and the story ("Director's cut"). Around 9 users looked around the pharmacy as if they were looking for something (mimicking the protagonist's action of looking for ingredients). When Laura stopped talking and started preparing the infusion (end of B in Fig. 1), around 12 users started exploring the pharmacy, while the rest kept their focus on Laura. At the sound and action of the door opening, (C, D in Fig. 1) 13 of the users shifted their attention immediately to the door. When Adam walked in (F in Fig. 1) we observed the remaining users redirecting their attention to the door. As Laura started talking to Adam, 22 users refocused on Laura, however we noticed some delay between the beginning of the dialog and the refocusing. When the characters were in conversation, 20 users shifted focus between Adam and Laura. During the preparation of the medicine (I in Fig. 1), 25 users kept their focus on Laura, while around 7 users started exploring. While all users followed the characters and trajectories, they did not follow indications to look at specific places (J, M in Fig. 1). When Adam left the scene (N in Fig. 1), all users re-directed the focus to Laura. After the landslide, when Adam screamed (Q in Fig. 1), none of the users were looking at the door from where the action sounds emanated.

# 7   Discussion

As we were developing IVRUX, through continuous user testing we understood that at the beginning, orientation of the virtual camera was influential in the user following the "Director's cut", therefore the placement and orientation of the camera should be carefully considered. When characters are performing the same actions for long periods of time or are silent, users tend to explore the environment. These "empty moments", when users are exploring and plot is not developing, are best suited to directing the user's attention to branched narratives or advertising. During the character's dialogue some participants were shifting focus between the two as they would in a real life conversation. A subset of our sample explored the environment during the dialogue; in the interview, users explained that once they knew where the characters were, it was enough for them to fall back on audio to understand the story. This is a clear illustration of freedom of choice in IVR that filmmakers have to embrace.

Lighting design emerged as crucial in drawing the attention of participants to specific elements in the narrative or environment. Users directed themselves towards areas that were better illuminated. Similarly, audio can also be used to attract attention – for example when a doors opens (C, G in Fig. 1) or when characters speak, as participants were seen to focus their attention on the area where the noise originated. From the interviews, participants recalled the characters' movements easily (IQ4); this was also observed in IVRUX as the participant's head tracking accompanies the character's movement. However, participants did not pay attention to where characters were pointing (J, M in Fig. 1.). When concurrent events are happening (S in Fig. 1), it is difficult for participants to be aware of all elements, accentuating a need for a buffer time for awareness and reaction to the events. In VR, we need to adjust the pacing of the story, as has been suggested by the Oculus Story Studio [14].

"The Old Pharmacy" NTS's values are average, this could be explained by two conditions: the average fantasy scale scores of participants and the short duration of the experience as mentioned by participants in IQ9 (e.g. participant B8 "If the story was longer, I would have been more focused on it."). Contrary to what we expected, we did not find significant correlations between NTS and the amount of time spent looking at the "Director's cut". This could be justified by participants who defy the "Director's cut" intentionally (IQ7) or unintentionally (participants who rely on the audio rather than looking at the characters). Authors must account for defiance in participants when designing the story narrative in 360° environments. In the interviews, participants highlighted as interesting (IQ5) the technology and the nature of the medium: "It really felt like I was there" (Participant B8).

# 8   Conclusions and Future Work

In this paper, we have described the development, testing and results of IVRUX, a 360° VR analytics tool and its application in the analysis of IVR "The Old Pharmacy". Results from our study highlight the potential of using VR analytics as a tool to support the iteration and improvement of 360° IVR narratives, by relaying information as to where

the users are looking and how their focus shifts. Creators can now take informed decisions on how to improve their work. We were able to identify shortcomings of "The Old Pharmacy" narrative, such as the camera orientation, story pacing issues and lighting design. We hope that this encourages the further development of 360° IVR analytics tools to empower creators to test narrative design assumptions and create experiences that are immersive and engaging. Furthermore, we envisage the integration of biometric sensing feedback into IVRUX to enable visualization of the user's body reaction to the narrative, superimposed on the IVRUX visualization already discussed. From the point of view of interactive storytellers, testing the tool with further IVR narratives, such as IVR narrative with multiple story threads or a non-linear story is crucial to gathering guidelines to understanding user preference.

**Acknowledgments.** We wish to acknowledge our fellow researchers Rui Trindade, Sandra Câmara, Dina Dionisio and the support of LARSyS (PEstLA9-UID/EEA/50009/2013). The project has been developed as part of the MITIExcell (M1420-01-0145-FEDER-000002). The author Mara Dionisio wishes to acknowledge Fundação para a Ciência e a Tecnologia for supporting her research through the Ph.D. Grant PD/BD/114142/2015.

# References

1. Blascheck, T. et al.: State-of-the-Art of Visualization for Eye Tracking Data (2014)
2. Davis, M.H.: Measuring individual differences in empathy: evidence for a multidimensional approach. J. Pers. Soc. Psychol. **44**(1), 113–126 (1983)
3. Dionisio, M., Barreto, M., Nisi, V., Nunes, N., Hanna, J., Herlo, B., Schubert, J.: Evaluation of yasmine's adventures: exploring the socio-cultural potential of location aware multimedia stories. In: Schoenau-Fog, H., Bruni, L.E., Louchart, S., Baceviciute, S. (eds.) ICIDS 2015. LNCS, vol. 9445, pp. 251–258. Springer, Heidelberg (2015). doi:10.1007/978-3-319-27036-4_24
4. Duchowski, A.T., et al.: Aggregate gaze visualization with real-time heatmaps. In: Proceedings of the Symposium on Eye Tracking Research and Applications, pp. 13–20. ACM, New York (2012)
5. Green, M.C., Brock, T.C.: The role of transportation in the persuasiveness of public narratives. J. Pers. Soc. Psychol. **79**(5), 701–721 (2000)
6. Klimmt, C., et al.: Forecasting the experience of future entertainment technology "interactive storytelling" and media enjoyment. Games Cult. **7**(3), 187–208 (2012)
7. Löwe, T., Stengel, M., Förster, E.-C., Grogorick, S., Magnor, M.: Visualization and analysis of head movement and gaze data for immersive video in head-mounted displays. In: Proceedings of the Workshop on Eye Tracking and Visualization (ETVIS), vol. 1, October 2015 (2015)
8. Mackworth, J.F., Mackworth, N.H.: Eye fixations recorded on changing visual scenes by the television eye-marker. J. Opt. Soc. Am. **48**(7), 439–445 (1958)
9. Noton, D., Stark, L.: Scanpaths in eye movements during pattern perception. Science **171**(3968), 308–311 (1971)
10. de la Peña, N., et al.: Immersive journalism: immersive virtual reality for the first-person experience of news. Presence **19**(4), 291–301 (2010)

11. Pfeiffer, T.: Measuring and visualizing attention in space with 3D attention volumes. In: Proceedings of the Symposium on Eye Tracking Research and Applications, pp. 29–36. ACM, New York (2012)
12. Ramloll, R., et al.: Gaze data visualization tools: opportunities and challenges. In: 2004 Proceedings of the 8th International Conference on Information Visualisation IV, pp. 173–180 (2004)
13. Vosmeer, M., Roth, C., Schouten, B.: Interaction in surround video: the effect of auditory feedback on enjoyment. In: Schoenau-Fog, H., Bruni, L.E., Louchart, S., Baceviciute, S. (eds.) Interactive Storytelling. LNCS, vol. 9445, pp. 202–210. Springer, Heidelberg (2015). doi: 10.1007/978-3-319-27036-4_19
14. Lessons Learned While Making Lost. https://storystudio.oculus.com/en-us/blog/5-lessons-learned-while-making-lost/

# M2D: Monolog to Dialog Generation for Conversational Story Telling

Kevin K. Bowden$^{(\boxtimes)}$, Grace I. Lin, Lena I. Reed, Jean E. Fox Tree, and Marilyn A. Walker

Natural Language and Dialog Systems Lab, University of California, Santa Cruz, USA
{kkbowden,glin5,lireed,foxtree,mawwalker}@ucsc.edu

**Abstract.** Storytelling serves many different social functions, e.g. stories are used to persuade, share troubles, establish shared values, learn social behaviors, and entertain. Moreover, stories are often told conversationally through dialog, and previous work suggests that information provided dialogically is more engaging than when provided in monolog. In this paper, we present algorithms for converting a deep representation of a story into a dialogic storytelling, that can vary aspects of the telling, including the personality of the storytellers. We conduct several experiments to test whether dialogic storytellings are more engaging, and whether automatically generated variants in linguistic form that correspond to personality differences can be recognized in an extended storytelling dialog.

**Keywords:** Analysis and evaluation of systems · ICIDS · Dialog · Natural language generation · Personality · Conversational storytelling

## 1 Introduction

Storytelling serves many different social functions, e.g. stories are used to persuade, share troubles, establish shared values, learn social behaviors, and entertain [24,33]. Moreover, stories are often told conversationally through dialog [38,39] where the telling of a story is shaped by the personality of both the teller and the listener. For example, extraverted friends actively engage one another in constructing the action of the story by peppering the storyteller with questions, and by asking the listener to guess what happened [38,39]. Thus the same story can be told in many different ways, often achieving different effects [22,40].

A system capable of telling a story and then retelling it in different settings to different audiences requires two components: (1) a deep representation of the STORY and (2) algorithms that render the story content as different DISCOURSE instantiations. A deep representation of the story's content, often called the STORY or FABULA, must specifies the events, characters, and props of the story, as well as relations among them, including reactions of characters to story events. This is accomplished through EST [31], a framework that bridges the story annotation tool SCHEHERAZADE and a natural language generator (NLG).

© Springer International Publishing AG 2016
F. Nack and A.S. Gordon (Eds.): ICIDS 2016, LNCS 10045, pp. 12–24, 2016.
DOI: 10.1007/978-3-319-48279-8_2

The DISCOURSE representation is the surface rendering of the FABULA, an instantiated expressive telling of a story as a stream of words, gestures or expressions [3,8,28,29]. This paper presents M2D, a framework with algorithms that manipulate the story content to retell the story as a conversational dialog between two people. An example of the original, monologic, and dialogic telling of the Garden Story is shown in Fig. 1. Note that highlighted areas indicate the same information being presented differently at different stages.

| Garden Story: Original |
|---|
| Today when I arrived at my community garden plot, it actually looked like a garden. Not a weedy mess with maybe some stuff growing in it if you know where to look. We had hit the typical mid-summer mess of fast-growing weeds and no time to do anything about it. Plus all the rain had made a huge swamp and it was hard to get a moment to work when it wasn't actively pouring. I put in a bunch of time this past week, and it's paying off. Along with free-standing non-weed-choked plants, I have now re-planted three of the beds with salad greens, spinach, and chard. And while the viability of the seeds was questionable, I accidentally unearthed some from the bed I planted 2 days ago and they had already started to sprout! ... etc. |

| Garden Story: Monolog generated by EST | Garden Story: Dialog generated by M2D |
|---|---|
| The radishes charmed the butterflies. The communal garden was weedy. It rained. The communal garden was swampy. It rained. The productive gardener planted the plants. The gardener planted the chards the lettuces and the spinach. The pleased gardener did not expect for the chards the lettuces and the spinach to grow. The chards the lettuces and the spinach sprouted. The gardener mistakenly dug the chards the lettuces and the spinach. The surprised gardener saw for the chards the lettuces and the spinach to sprout. The communal garden was not weedy. The communal garden was not swampy. The communal garden was productive. The gardener was proud. The eager gardener wanted to reap the lettuces. The radishes were droopy. The gardener planned to remove the radishes. The thoughtful gardener thought the flowers charmed the butterflies. | S1: The radishes charmed the butterflies. Technically, the damn communal garden was not weedless. Err ... it rained. Great right, it was really swampy. <br> S2: Yeah, it rained. The productive gardener planted the plants. I mean, she planted the chards the lettuces and the spinach. <br> S1: She did not expect for them to grow. The chards the lettuces and the spinach sprouted, didn't they? <br> S2: Unfortunately, the gardener mistakenly dug them. She saw for the chards the lettuces and the spinach to sprout. <br> S1: The communal garden was not weedy. It was pretty productive and not swampy. <br> S2: Mmhm ... the gardener was proud and wanted to reap the lettuces. I thought everybody knew that they were quite droopy? The radishes were droopy. <br> S1: I see, well, she planned to remove them. The thoughtful gardener thought the flowers charmed the butterflies. |

**Fig. 1.** Garden story: original version and monologue/dialog generation. Highlighted areas indicate examples of the same information.

We build on the publicly available PersonaBank corpus[1], which provides us with the deep story representation and a lexico-syntactic representation of its monologic retelling [14]. PersonaBank consists of a corpus of monologic personal narratives from the ICWSM Spinn3r Corpus [6] that are annotated with a deep story representation called a STORY INTENTION GRAPH [13]. After annotation, the stories are run through the EST system to generate corresponding deep linguistic structure representations. M2D then takes these representations as input and creates **dialog with different character voices**. We identify several stories by hand as good candidates for dialogic tellings because they describe events or experiences that two people could have experienced together.

---

[1] Available from nlds.soe.ucsc.edu/personabank.

Our primary hypothesis is **H1**: Dialogic tellings of stories are more engaging than monologic tellings. We also hypothesize that good dialog requires the use of narratological variations such as direct speech, first person, and focalization [14]. Moreover, once utterances are rendered as first-person with direct speech, then character voice becomes relevant, because it does not make sense for all the characters and the narrator to talk in the same voice. Thus our primary hypothesis **H1** entails two additional hypotheses **H2** and **H3**:

**H2:** Narratological variations such as direct speech, first person, and focalization will affect a readers engagement with a story.

**H3:** Personality-based variation is a key aspect of expressive variation in storytelling, both for narrators and story characters. Changes in narrator or character voice may affect empathy for particular characters, as well as engagement and memory for a story.

Our approach to creating different character voices is based on the **Big Five** theory of personality [1,9]. It provides a useful level of abstraction (e.g., extraverted vs. introverted characters) that helps to generate language and to guide the integration of verbal and nonverbal behaviors [11,16,21].

To the best of our knowledge, our work is the first to develop and evaluate algorithms for automatically generating different dialogic tellings of a story from a deep story representation, and the first to evaluate the utility and effect of parameterizing the style of speaker voices (personality) while telling the story.

## 2  Background and Motivation

Stories can be told in either dialog or as a monolog, and in many natural settings storytelling is conversational [4]. Hypothesis **H1** posits that dialogic tellings of stories will be more engaging than monologic tellings. In storytelling and at least some educational settings, dialogs have cognitive advantages over monologs for learning and memory. Students learn better from a verbally interactive agent than from reading text, and they also learned better when they interacted with the agent with a personalized dialog (whether spoken or written) than a non-personalized monolog [20]. Our experiments compare different instances of the dialog, e.g. to test whether more realistic conversational exchanges affects whether people become immersed in the story and affected by it.

Previous work supports **H2**, claiming that direct, first-person speech increases stories' drama and memorability [34,37]. Even when a story is told as a monolog or with third person narration, dialog is an essential part of stortelling: in one study of 7 books, between 40% and 60% of the sentences were dialog [7]. In general narratives are mentally simulated by readers [35], but readers also enact a protagonist's speech according to her speech style, reading more slowly for a slow-speaking protagonist and more quickly for a fast-speaking protagonist, both out-loud and silently [43]. However, the speech simulation only occurred for direct quotation (e.g. *She said "Yeah, it rained"*), not indirect quotation (e.g. *She said that it had rained*). Only direct quotations activate voice-related parts

of the brain [43], as they create a more vivid experience, because they express enactments of previous events, whereas indirect quotations describe events [42].

Several previous studies also suggest **H3**, that personality-based variation is a key aspect of storytelling, both for narrators and story characters. Personality traits have been shown to affect how people tell stories as well as their choices of stories to tell [17]. And people also spontaneously encode trait inferences from everyday life when experiencing narratives, and they derive trait-based explanations of character's behavior [30,32]. Readers use these trait inferences to make predictions about story outcomes and prefer outcomes that are congruent with trait-based models [30]. The finding that the behavior of the story-teller is affected by the personality of both the teller and the listener also motivates our algorithms for monolog to dialog generation [38,39]. Content allocation should be controlled by the personality of the storyteller (e.g. enabling extraverted agents to be more verbose than introverted agents).

Previous work on generation for fictional domains has typically combined STORY and DISCOURSE, focusing on the generation of STORY events and then using a direct text realization strategy to report those events [18]. This approach cannot support generation of different tellings of a story [23]. Previous work on generating textual dialog from monolog suggests the utility of adding extra interactive elements (dialog interaction) to storytelling and some strategies for doing so [2,25,36]. In addition, expository or persuasive content rendered as dialog is more persuasive and memorable [26,27,41]. None of this previous work attempts to generate dialogic storytelling from original monologic content.

## 3   M2D: Monolog-to-Dialog Generation

Figure 2 illustrates the architecture of M2D. The EST framework produces a story annotated by SCHEHERAZADE as a list of Deep Syntactic Structures (**DsyntS**). DsyntS, the input format for the surface realizer RealPro [12,19], is a dependency-tree structure where each node contains the lexical information for the important words in a sentence. Each sentence in the story is represented as a DsyntS.

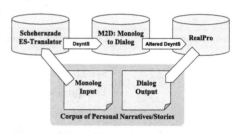

**Fig. 2.** M2D pipeline architecture.

M2D converts a story (as a list of DsyntS) into different versions of a two-speaker dialog using a parameterizable framework. The input parameters control, for each speaker, the allocation of content, the usage of questions of different forms, and the usage of various pragmatic markers (Table 1). We describe the M2D parameters in more details below.

**Content Allocation:** We allocate the content of the original story between the two speakers using a content-allocation parameter that ranges from 0 to 1. A value of .5 means that the content is equally split between 2 speakers. This is

**Table 1.** Dialog conversion parameters

| Parameter | Example |
|---|---|
| Aggregation | |
| Merge short sents | The garden was swampy, and not productive. |
| Split long sents | The garden was very swampy because it rained. The garden is very large, and has lots of plants |
| Coreference | |
| Pronominalize | The gardener likes to eat apples from his orchard. They are red |
| Pragmatic Markers | |
| Emphasizer_great | Great, the garden was swampy. |
| Downer_kind_of | The garden was kind of swampy. |
| Acknowledgment_yeah | Yeah, the garden was swampy. |
| Repetition | $S_1$: The garden was swampy |
| | $S_2$: Yeah, the garden was swampy. |
| Paraphrase | $S_2'$: Right, the garden was boggy |
| Interactions | |
| Affirm Adjective | $S_1$: The red apples were tasty and $-\,-\,-$ |
| | $S_2$: Just delicious, really. |
| | $S_1$: Yeah, and the gardener ate them. |
| Correct Inaccuracies | $S_2$: The garden was not productive and $-\,-\,-$. |
| | $S_1$: I don't think that's quite right, actually. I think the garden was productive |
| Questions | |
| Provoking | I don't really remember this part, can you tell it? |
| With_Answer | $S_1$: How was the garden? |
| | $S_2$: The garden was swampy. |
| Tag | The garden was swampy, wasn't it? |

motivated by the fact that, for example, extraverted speakers typically provide more content than intraverted speakers [16,38].

**Character and Property Database:** We use the original source material for the story to infer information about actors, items, groups, and other properties of the story, using the information specified in the DsyntS. We create actor objects for each character and track changes in the actor states as the story proceeds, as well as changes in basic properties such as their body parts and possessions.

**Aggregation and Deaggregation:** We break apart long DsyntS into smaller DsyntS, and then check where we can merge small and/or repetitious DsyntS. We believe that deaggregation will improve our dialogs overall clarity while aggregation will make our content feel more connected [15].

**Content Elaboration:** In natural dialog, speakers often repeat or partially paraphrase each other, repeating the same content in multiple ways. This can be a key part of entrainment. Speakers may also ask each other questions thereby setting up frames for interaction [38]. In our framework, this involves duplicating content in a single DsyntS by either (1) generating a question/answer pair from it and allocating the content across speakers, or

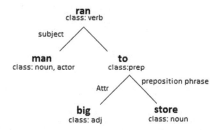

**Fig. 3.** The DsyntS tree for *The man ran to the big store.*

(2) duplicating it and then generating paraphrases or repetitions across speakers. Questions are generated by performing a series of pruning operations based on the class of the selected node and the relationship with its parent and siblings. For example, if STORE in Fig. 3 is selected, we identify this node as our question. The class of a node indicates the rules our system must follow when making deletions. Since STORE is a noun we prune away all of the ATTR siblings that modify it. By noticing that it is part of a prepositional phrase, we are able to delete STORE and use TO as our question, generating *The man ran where?*.

**Content Extrapolation:** We make use of the deep underlying story representation and the actor database to make inferences explicit that are not actually part of the original discourse. For example, the actor database tracks aspects of a character's state. By using known antonyms of the adjective defining the current state, we can insert content for state changes, i.e. the alteration from *the fox is happy* to *now, the fox is sad*, where the fox is the actor and happiness is one of his states. This also allows us to introduce new dialogic interactions by having one speaker ask the other about the state of an actor, or make one speaker say something incorrect which allows the second speaker to contradict them: *The fox was hungry* followed by *No, he wasn't hungry, he was just greedy*.

**Pragmatic Markers:** We can also insert pragmatic markers and tag questions as described in Table 1. Particular syntactic constraints are specified for each pragmatic marker that controls whether the marker can be inserted at all [16]. The frequency and type of insertions are controlled by values in the input parameter file. Some parameters are grouped by default into sets that allow them to be used interchangeably, such as downtoners or emphasizers. To provide us more control over the variability of generated variants, specific markers which are by default unrelated can be packaged together and share a distributed frequency limit. Due to their simplistic nature and low number of constraints, pragmatic markers prove to be a reliable source of variation in the systems output.

**Lexical Choice:** We can also replace a word with one of its synonyms. This can be driven simply by a desire for variability, or by lexical choice parameters such as word frequency or word length.

**Morphosyntactic Postprocessing:** The final postprocessing phase forms contractions and possessives and corrects known grammatical errors.

The results of the M2D processor are then given as input to RealPro [12], an off-the-shelf surface text realizer. RealPro is responsible for enforcing English grammar rules, morphology, correct punctuation, and inserting functional words in order to produce natural and grammatical utterances.

## 4    Evaluation Experiments

We assume H1 on the basis of previous experimental work, and test H2 and H3. Our experiments aim to: (1) establish whether and to what degree the M2D engine produces natural dialogs; (2) determine how the use of different parameters affect the user's engagement with the story and the user's perceptions of the naturalness of the dialog; and (3) test whether users perceive personality differences that are generated using personality models inspired by previous work. All experimental participants are pre-qualified Amazon Mechanical Turkers to guarantee that they provide detailed and thoughtful comments.

We test users' perceptions of naturalness and engagement using two stories: the Garden story (Fig. 1) and the Squirrel story (Fig. 4). For each story, we generate **three** different dialogic versions with varying features:

M2D-EST renders the output from EST as a dialog by allocating the content equally to the two speakers. **No variations** of sentences are introduced.

M2D-BASIC consists of transformations required to produce a minimally natural dialog. First we apply **pronominalization** to replace nouns with their pronominal forms when telling the story in the third person. We then manipulate **sentence length** by breaking very long sentences into shorter ones, or by combining repetitious short sentences into one sentence. This is motivated by the fact that utterances in dialog tend to be less formal and use less complex syntactic structures [5]. The last transformation is **morphosyntactic postprocessing** as described in Sect. 3.

M2D-CHATTY adds interactive features to M2D-BASIC such as the insertion of **pragmatic markers** (acknowledgements, disfluencies, hedges) and question-answer generation (Table 1).

Each pairwise comparison is a Human Intelligence Task (HIT; a question that needs an answer), yielding 6 different HITs. We used 5 annotators (Turkers) per HIT to rate the levels of engagement/naturalness on a scale of 1–5, followed by detailed comments justifying their ratings.

We create several subsets of features that work well together and recursively apply random feature insertion to create many different output generations. These subsets include the types of questions that can be asked, different speaker interactions, content polarity with repetition options, pragmatic markers, and lexical choice options. A restriction is imposed on each of the subgroups, indicating the maximum number of parameters that can be enabled from the associated subgroup. This results in different styles of speaker depending on which subset of features is chosen. A speaker who has a high number of questions along with hedge pragmatic markers will seem more inquisitive, while a speaker who just

**Squirrel Story: Monolog generated by EST**

I placed the steely bowl on the deck in order for Benjamin to drink the bowl's water. The steely bowl was popular. The birds drank the bowl's water. The birds bathed themselves in the steely bowl. The birds organized themselves on the deck's railing in order for the birds to wait. The squirrels drank the bowl's water. The squirrel approached the steely bowl. The crazy squirrel was startled because the squirrel saw the squirrel's reflection. The crazy squirrel leaped because the squirrel was startled. The crazy squirrel fell over the deck's railing because the squirrel leaped because the squirrel was startled. The crazy squirrel held the deck's railing with the squirrel's paw. The squirrel's paw slipped off the deck's railing. The crazy squirrel fell.

**Squirrel Story: Dialog generated by M2D**

**S1:** I placed the steely bowl on the deck. Benjamin drinks its water.
**S2:** The steely bowl was very popular, technically. Typical. The birds drank its water. They bathed themselves in the steely bowl! The birds organized themselves on the deck's railing in order for them to wait.
**S1:** Yeah, the birds organized themselves on the deck's railing in order for them to wait. The squirrels drank it's water. The squirrel approached the steely bowl.
**S2:** Technically, it was startled. I am delighted to say that the squirrel saw its reflection. It jumped, actually and was startled. Basically, the squirrel was literally startled and fell over the deck's railing. It leaped because it was startled.
**S1:** The crazy squirrel held the deck's railing with its paw.
**S2:** Its paw slipped off its railing pal. The particularly crazy squirrel fell mate.

**Fig. 4.** Squirrel story: monolog/dialog generation.

repeats what the other speaker says may appear to have less credibility than the other speaker. We plan to explore particular feature groupings in future work to identify specific dialogic features that create a strong perception of personality.

### 4.1 M2D-EST vs. -Basic vs. -Chatty

The perceptions of engagement given different versions of the dialogic story is shown in Fig. 5. A paired t-test comparing M2D-CHATTY to M2D-EST shows that increasing the number of appropriate features makes the dialog more engaging (p = .04, df = 9). However there are no statistically significant differences between M2D-BASIC and M2D-EST, or between M2D-BASIC and M2D-CHATTY. Comments by Turkers suggest that the M2D-CHATTY speakers have more personality because they use many different pragmatic markers, such as questions and other dialogically oriented features.

The perception of naturalness across the same set of dialogic stories is shown in Fig. 6. It shows that M2D-BASIC was rated higher than M2D-EST, and their paired t-test shows that M2D-BASIC (inclusion of pronouns and agg- and deaggrega-

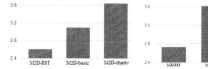

**Fig. 5.** Mean scores for engagement.

**Fig. 6.** Mean scores for naturalness.

tion) has a positive impact on the naturalness of a dialog (p = .0016, df = 8). On the other hand, M2D-BASIC is preferred over M2D-CHATTY, where the use of pragmatic markers in M2D-CHATTY was often noted as unnatural.

## 4.2   Personality Models

A second experiment creates a version of M2D called M2D-PERSONALITY which tests whether users perceive the personality that M2D-PERSONALITY intends to manifest. We use 4 different stories from the PersonaBank corpus [13] and create introverted and extroverted personality models, partly by drawing on features from previous work on generating personality [16].

We use a number of new dialogic features in our personality models that increase the level of interactivity and entrainment, such as asking the other speaker questions or entraining on their vocabulary by repeating things that they have said. Content allocation is also controlled by the personality of the speaker, so that extraverted agents get to tell more of the content than introverted agents.

We generate two different versions of each dialog, an extroverted and an introverted speaker (Table 2). Each dialog also has one speaker who uses a default personality model, neither strongly introverted or extraverted. This allows us to test whether the perception of the default personality model changes depending on the personality of the other speaker.

**Table 2.** Feature frequency for Extra. vs. Intro. Not all lexical instantiations of a feature are listed.

| Parameter | Extra. | Intro. |
|---|---|---|
| Content allocation | | |
| Content density | high | low |
| Pragmatic markers | | |
| Adjective softeners | low | high |
| Exclamation | high | low |
| Tag Questions | high | low |
| Acknowledgments: *Yeah, oh God* | high | low |
| Acknowledgments: *I see, well, right* | low | high |
| Downtoners: *Sort of, rather, quite, pretty* | low | high |
| Uncertainty: *I guess, I think, I suppose* | low | high |
| Filled pauses: *Err..., Mmhm...* | low | high |
| Emphasizers: *Really, basically, technically* | high | low |
| In-group Markers: *Buddy, pal* | high | low |
| Content elaboration | | |
| Questions: Ask &let other spkr answer | high | low |
| Questions: Rhetorical, request confirmation | low | high |
| Paraphrase | high | low |
| Repetition | low | high |
| Interactions: Affirm adjective | high | low |
| Interactions: Corrections | high | low |
| Lexical choice | | |
| Vocabulary size | high | low |
| Word length | high | low |

We again created HITs for Mechanical Turk for each variation. The Turkers are asked to indicate which personality best describes the speaker from among extroverted, introverted, or none, and then explain their choices with detailed comments. The results are shown in Table 3, where Turkers correctly identified the personality that M2D-PERSONALITY aimed to manifest 88 % of the time.

Turkers' comments noted the differential use of pragmatic markers, content allocation, asking questions, and vocabulary and punctuation. The **extroverted** character was viewed as more dominant, engaging, excited, and confident. These traits were tied to the features used: exclamation marks,

**Table 3.** Personality Judgments

|       | Extro | Intro | None |
|-------|-------|-------|------|
| Extro | 16    | 0     | 0    |
| Intro | 3     | 12    | 1    |

**Table 4.** Default Personality Judgments

|                | Extro | Intro | None |
|----------------|-------|-------|------|
| Other is Extro | 1     | 7     | 8    |
| Other is Intro | 8     | 1     | 7    |

questions asked, exchanges between speakers, and pragmatic markers (e.g., *basically, actually*).

The **introverted** character was generally timid, hesitant, and keeps their thoughts to themselves. Turkers noticed that the introverted speaker was allocated less content, the tendency to repeat what has already been said, and the use of different pragmatic markers (e.g. *kind of, I guess, Mhmm, Err...*).

Table 4 shows Turker judgements for the speaker in each dialog who had a default personality model. In 53 % of the trials, our participants picked a personality other than "none" for the speaker that had the default personality. Moreover, in 88 % of these incorrect assignments, the personality assigned to the speaker was the opposite of the personality model assigned to the other speaker. These results imply that when multiple speakers are in a conversation, judgements of personality are **relative** to the other speaker. For example, an introvert seems more introverted in the presence of an extravert, or a default personality may seem introverted in the presence of an extravert.

## 5 Discussion and Future Work

We hypothesize that dialogic storytelling may produce more engagement in the listener, and that the capability to render a story as dialog will have many practical applications (e.g. with gestures [10]. We also hypothesize that expressing personality in storytelling will be useful and show how it is possible to do this in the experiments presented here. We described an initial system that can translate a monologic deep syntactic structure into many different dialogic renderings.

We evaluated different versions of our M2D system. The results indicate that the perceived levels of engagement for a dialogic storytelling increase proportionally with the density of interactive features. Turkers commented that the use of pragmatic markers, proper pronominalization, questions, and other interactions between speakers added personality to the dialog, making it more engaging. In a second experiment, we directly test whether Turkers perceive that different speaker's personalities in dialog. We compared introvert, extrovert, and a speaker with a default personality model. The results show that in 88 % of cases the reader correctly identified the personality model assigned to the speaker. The results show that the content density assigned to each speaker as well as the choice of pragmatic markers are strong indicators of the personality. Pragmatic markers that most emphasize speech, or attempt to engage the other

speaker are associated with extroverts, while softeners and disfluencies are associated with introverts. Other interactions such as correcting false statements and asking questions also contribute to the perception of the extroverted personality.

In addition, the perceived personality of the default personality speaker was affected by the personality of the other speaker. The default personality speaker was classified as having a personality 53 % of the time. In 88 % of these misclassifications, the personality assigned to the speaker was the opposite of the other speaker, suggesting that personality perception is relative in context.

While this experiment focused only on extrovert and introvert, our framework contains other Big-Five personality models that can be explored in the future. We plan to investigate: (1) the effect of varying feature density on the perception of a personality model, (2) how personality perception is relative in context, and (3) the interaction of particular types of content or dialog acts with perceptions of a storyteller's character or personality. The pragmatic markers are seen as unnatural in some cases. We note that our system currently inserts them probabilistically but do not make intelligent decisions about using them in pragmatically appropriate situations. We plan to add this capability in the future. In addition we will explore new parameters that improves the naturalness and flow of the story.

**Acknowledgments.** We would like to thank Chung-Ning Chang and Diego Pedro for their roles as collaborators in the early inception of our system. This research was supported by NSF IIS CHS #1115742 and award #SC-14-74 from the Nuance Foundation.

# References

1. Allport, G.W., Odbert, H.S.: Trait names: a psycho-lexical study. Psychol. Monogr. **47**(1, Whole No. 211), 171–220 (1936)
2. André, E., Rist, T., van Mulken, S., Klesen, M., Baldes, S.: The automated design of believable dialogues for animated presentation teams. In: Embodied Conversational Agents, pp. 220–255 (2000)
3. Bal, M., Tavor, E.: Notes on narrative embedding. Poetics Today **2**, 41–59 (1981)
4. Bavelas, J.B., Coates, L., Johnson, T.: Listeners as co-narrators. J. Pers. Soc. Psychol. **79**(6), 941 (2000)
5. Biber, D.: Variation Across Speech and Writing. Cambridge University Press, Cambridge (1991)
6. Burton, K., Java, A., Soboroff, I.: The icwsm 2009 spinn3r dataset. In: Proceedings of the Annual Conference on Weblogs and Social Media (ICWSM) (2009)
7. De Haan, P.: More on the language of dialogue in fiction. ICAME J. **20**, 23–40 (1996)
8. Genette, G.: Nouveau discours du récit. Éd. du Seuil (1983)
9. Goldberg, L.R.: An alternative "description of personality": the big-five factor structure. J. Pers. Soc. Psychol. **59**, 1216–1229 (1990)
10. Zhichao, H., Dick, M., Chang, C.-N., Bowden, K., Neff, M., Tree, J.F., Walker, M.: A corpus of gesture-annotated dialogues for monologue-to-dialogue generation from personal narratives. In: Proceedings of the Tenth International Conference on Language Resources and Evaluation (LREC 2016) (2016)

11. Zhichao, H., Walker, M., Neff, M., Jean, E.: Fox tree: storytelling agents with personality and adaptivity. Intell. Virtual Agents, p. 30 (2015)
12. Lavoie, B., Rambow, O.: A fast and portable realizer for text generation systems. In: Proceedings of the Third Conference on Applied Natural Language Processing, ANLP 1997, pp. 265–268 (1997)
13. Lukin, S., Bowden, K., Barackman, C., Walker, M.: Personabank: a corpus of personal narratives and their story intention graphs
14. Lukin, S.M., Walker, M.A.: Narrative variations in a virtual storyteller. In: Brinkman, W.-P., Broekens, J., Heylen, D. (eds.) IVA 2015. LNCS (LNAI), vol. 9238, pp. 320–331. Springer, Heidelberg (2015). doi:10.1007/978-3-319-21996-7_34
15. Lukin, S.M., Reed, L.I., Walker, M.: Generating sentence planning variations for story telling. In: 16th Annual Meeting of the Special Interest Group on Discourse and Dialogue, p. 188 (2015)
16. Mairesse, F., Walker, M.A.: Towards personality-based user adaptation: psychologically informed stylistic language generation. User Model. User-Adap. Inter. **20**, 1–52 (2010)
17. McAdams, D.P., Anyidoho, N.A., Brown, C., Huang, Y.T., Kaplan, B., Machado, M.A.: Traits and stories: links between dispositional and narrative features of personality. J. Person. **72**(4), 761–784 (2004)
18. Meehan, J.: The metanovel: writing stories by computer, pp. 197–258 (1976)
19. Mel'čuk, I.A.: Dependency Syntax: Theory and Practice. SUNY, Albany (1988)
20. Moreno, R., Mayer, R., Lester, J.: Life-like pedagogical agents in constructivist multimedia environments: cognitive consequences of their interaction. In: World Conference on Educational Media and Technology, vol. 1, pp. 776–781 (2000)
21. Neff, M., Wang, Y., Abbott, R., Walker, M.: Evaluating the effect of gesture and language on personality perception in conversational agents. In: Allbeck, J., Badler, N., Bickmore, T., Pelachaud, C., Safonova, A. (eds.) IVA 2010. LNCS (LNAI), vol. 6356, pp. 222–235. Springer, Heidelberg (2010). doi:10.1007/978-3-642-15892-6_24
22. Pasupathi, M., Hoyt, T.: The development of narrative identity in late adolescence and emergent adulthood: the continued importance of listeners. Dev. Psychol. **45**(2), 558–574 (2009)
23. Peinado, F., Gervás, P.: Evaluation of automatic generation of basic stories. New Gener. Comput. Spec. Issue Comput. Creat. **24**(3), 289–302 (2006)
24. Pennebaker, J.W., Seagal, J.D.: Forming a story: the health benefits of narrative. J. Clin. Psychol. **55**(10), 1243–1254 (1999)
25. Piwek, P., Stoyanchev, S.: Generating expository dialogue from monologue: motivation, corpus and preliminary rules. In: Human Language Technologies: The 2010 Annual Conference of the North American Chapter of the Association for Computational Linguistics, pp. 333–336. Association for Computational Linguistics (2010)
26. Piwek, P., Hernault, H., Prendinger, H., Ishizuka, M.: T2D: generating dialogues between virtual agents automatically from text. In: Pelachaud, C., Martin, J.-C., André, E., Chollet, G., Karpouzis, K., Pelé, D. (eds.) IVA 2007. LNCS (LNAI), vol. 4722, pp. 161–174. Springer, Heidelberg (2007). doi:10.1007/978-3-540-74997-4_16
27. Piwek, P., Stoyanchev, S.: Data-oriented monologue-to-dialogue generation. In: Proceedings of the 49th Annual Meeting of the Association for Computational Linguistics: Human Language Technologies: Short Papers-Vol. 2, pp. 242–247. Association for Computational Linguistics (2011)
28. Prince, G.: A Grammar of Stories: An Introduction, vol. 13. Walter de Gruyter, Berlin (1973)
29. Propp, V.: Morphology of the Folk Tale, 2nd edn. University of Texas Press, Austin (1969). Trans. Originally published, Laurence Scott 1928

30. Rapp, D.N., Gerrig, R.J., Prentice, D.A.: Readers' trait-based models of characters in narrative comprehension. J. Memory Lang. **45**(4), 737–750 (2001)
31. Rishes, E., Lukin, S.M., Elson, D.K., Walker, M.A.: Generating different story tellings from semantic representations of narrative. In: Koenitz, H., Sezen, T.I., Ferri, G., Haahr, M., Sezen, D., Çatak, G. (eds.) ICIDS 2013. LNCS, vol. 8230, pp. 192–204. Springer, Heidelberg (2013). doi:10.1007/978-3-319-02756-2_24
32. Ross, L.: The intuitive psychologist and his shortcomings: distortions in the attribution process. Adv. Exp. Soc. Psychol. **10**, 173–220 (1977)
33. Ryokai, K., Vaucelle, C., Cassell, J.: Virtual peers as partners in storytelling and literacy learning. J. Comput. Assist. Learn. **19**(2), 195–208 (2003)
34. Schiffrin, D.: Tense variation in narrative. Language **57**, 45–62 (1981)
35. Speer, N.K., Reynolds, J.R., Swallow, K.M., Zacks, J.M.: Reading stories activates neural representations of visual and motor experiences. Psychol. Sci. **20**(8), 989–999 (2009)
36. Stoyanchev, S., Piwek, P.: Harvesting re-usable high-level rules for expository dialogue generation. In: Proceedings of the 6th International Natural Language Generation Conference, pp. 145–154. Association for Computational Linguistics (2010)
37. Tannen, D.: Talking Voices: Repetition, Dialogue, and Imagery in Conversational Discourse. Cambridge University Press, Cambridge (1989)
38. Thorne, A.: The press of personality: a study of conversations between introverts and extraverts. J. Person. Soc. Psychol. **53**(4), 718 (1987)
39. Thorne, A., Korobov, N., Morgan, E.M.: Channeling identity: a study of storytelling in conversations between introverted and extraverted friends. J. Res. Person. **41**(5), 1008–1031 (2007)
40. Thorne, A., McLean, K.C., Lawrence, A.M.: When remembering is not enough: reflecting on self-defining memories in late adolescence. J. Person. **72**(3), 513–542 (2004)
41. Van Deemter, K., Krenn, B., Piwek, P., Klesen, M., Schröder, M., Baumann, S.: Fully generated scripted dialogue for embodied agents. Artif. Intell. **172**(10), 1219–1244 (2008)
42. Wade, E., Clark, H.H.: Reproduction and demonstration in quotations. J. Memory Lang. **32**(6), 805–819 (1993)
43. Yao, B., Scheepers, C.: Contextual modulation of reading rate for direct versus indirect speech quotations. Cognition **121**(3), 447–453 (2011)

# Exit 53: Physiological Data for Improving Non-player Character Interaction

Joseph Jalbert and Stefan Rank$^{(\boxtimes)}$

Drexel University, Philadelphia, PA 19104, USA
stefan.rank@drexel.edu

**Abstract.** Non-player characters (NPCs) in video games have very little information about the player's current state. The usage of physiological data in games has been very limited, mainly to adjustments in difficulty based on stress levels. We assess the usefulness of physiological signals for rapport in interactions with story characters in a small role-playing game, Exit53. Measurements of electrodermal activity and facial muscle tension serves as estimate of player affect which is used to adjust the behavior of NPCs in so far as their dialogue acknowledges the player's emotion. An experimental evaluation of the developed system demonstrates the viability of the approach and qualitative data shows a clear difference in the perception of the system's use of physiological information.

**Keywords:** Analyses and evaluation of systems · Non-player character · Physiological data · Emotion

## 1 Introduction

As the sophistication of interactive stories and video games increases, flaws in certain aspects, such as communicating with non-player characters (NPCs), become more apparent. NPCs have limited information about players, but they should ideally react to the players' emotional states. Previous research in AI resulted in advances towards more convincing agents in terms of behavior [8] or used natural language processing as a means of creating more believable exchanges as seen in Façade [13]. We report on the development of a system and an experiment that tests the feasibility of using physiological data, read using an Arduino device, as an estimate of emotional states [11] to improve this aspect of interaction between players and NPCs. Leveraging advances in systems using physiological signals, such as biofeedback applications, our setup uses electrodermal activity and electromyography for emotion estimation in terms of arousal and valence in an action role-playing game built in Unity. Players navigate through a post-apocalyptic setting as their physiological data is recorded during significant, in-game, events and used to alter conversations with NPCs. A between-subjects experimental design utilized this data to influence the dialogue behaviors of NPCs in the game in order to test the resulting effect on rapport with the characters.

© Springer International Publishing AG 2016
F. Nack and A.S. Gordon (Eds.): ICIDS 2016, LNCS 10045, pp. 25–36, 2016.
DOI: 10.1007/978-3-319-48279-8_3

## 2  Related Work

In virtual agent research, efforts are usually directed at more intelligent human-like behavior [6] or visual fidelity [15]. Experiments in establishing rapport, i.e. a sense of understanding between humans in interaction, with virtual agents have demonstrated that it is possible to share a connection with an avatar that comes close to human-human communication [8]. In the case of [16], the participants were asked questions of increasing intimacy as a means of invoking a reaction in a social situation. For non-player characters (NPCs) in interactive stories, as a special case of virtual agents, authors use such strategies routinely. Notably in genres such as visual novels and role-playing games, non-player character interaction is a central game mechanic. These NPCs are embodied agents with unique traits to create the impression of a specific personality.

Some effort has been placed on improving NPCs with one solution being dynamic quest generators [12]. However, this does not take the user's emotional state into account. GAMYGDALA was a system created to simulate emotions in virtual agents. The system was used to create an adaptive narrative based on these simulated artificial emotions [10]. Another method used, described in [9], assigns emotions to non-player characters through neural networks. In [2], a procedure is setup to create more realistic psychosocial behavior for a group of NPCs interacting with one another. Again, this study only acknowledges the emotions of the artificial intelligence character, as opposed to the user controlling the game. However, while neither of these projects incorporated biofeedback, they show the effectiveness in utilizing emotion in the creation of NPCs in video games.

An aspect of the potential use of physiological data is biofeedback, i.e. the direct feedback of the measured values, in some form, to the human user. Biofeedback devices have been used in various applications, usually within the field of medical research. However, they have also been employed in analyzing game data and determining human emotion [1,11]. In terms of game interaction, the usage of such devices has been fairly limited, with the majority monitoring heart rate as the player's level of exertion. Recently, live streamers on the website Twitch.tv have begun to monitor their heart rate during game-play, as a sort of gimmick to allow viewers to observe at what points they are getting nervous.

Estimating the emotional state of a user based on physiological signals can be done with biofeedback devices in a controlled setting [11]. For this emotion recognition system, the four target "emotions" were sadness, anger, stress, and surprise. Similarly, a music video recommendation system was built to measure arousal levels in participants in order to determine what genre of music they would likely enjoy [14] implying a more satisfying experience. In [7], scenes for a digital animation were selected based on the user's facial electromyography (EMG) and electrodermal activity (EDA) without direct interaction from the user. This combination of both EMG and EDA allows for an estimation of affect in terms of valence and arousal [3,4].

Within the realm of gaming, there are few examples of biofeedback as a means to improve gameplay. For all of those examples, the signals are only

being utilized as a means to alter the difficulty. Nevermind is a biofeedback-driven horror adventure game which shifts the difficulty based on player stress levels [18]. The game was originally intended as a method for users to cope with their stress levels. Similarly, an experiment was conducted to adjust the difficulty of Tetris based on the participant's stress value [5].

While these works have shown the feasibility and effectiveness of the use of physiological signals in gaming, no work has been targeted at improve the interactions and conversations with Non-Player Characters (NPCs) with these same techniques. Our research is addressing this by testing the effect of using physiological data in NPC dialogue behavior on the sense of rapport with the characters. In order to address this question, a small game was designed and developed that allowed for experimental assessment of the impact of physiological data.

## 3    Development and Experimental Approach

Two versions of a game, *Exit 53*, were used in order to test the viability of NPC adjustment with physiological signals. Here, we report on game design decisions, the used hardware, and the experimental approach for collecting data in-game and using questionnaires.

**Fig. 1.** Introducing the player to the game.

Exit53 was created in the Unity game engine, as an isometric action role-playing game set in a post-apocalyptic environment. The player is introduced to the world through a textual description at the start of the game, see Fig. 1. The decision for the game to take place in a post-apocalyptic setting was made in order to present the player with difficult choices, with the intention of eliciting

an emotional response. In addition, a post-apocalyptic setting is a common trope in games and should feel familiar to the player. Further, role-playing games are often associated with story-focused conversations with non-player characters.

During the game, players are wearing electrodermal activity sensors on their non-dominant hand. Because of this, the game had to be designed to work with a single hand. This limitation led to the simple control scheme present in the game, which is completely playable with just the mouse. The left mouse button moves the player around while the right mouse button is used to attack using projectiles. In addition, interaction with NPCs happens automatically as the player moves near them. This simple scheme allowed for the game to be accessible to all participants.

The in-game environment was setup with long stretches of path with no objects of interest. These paths serve to reset the player to return to a baseline level of physiological measurements. Furthermore, the following visual and auditive design elements are used to present events and interactions. As the player approaches a key event, the screen will frame the scene so that the player is able to better understand what it is they should be focused on. In addition, an identifying sound will play to let them know that they are heading in the right direction. Similarly, a textual message will display if they are headed in the wrong direction, and it will lead them towards the correct path. This combination of visual and auditory emphasis is used to increase the likelihood of a strong affective response during decision points.

**Fig. 2.** The player chooses how to deal with a thief.

As the player makes their way through the game world, they are presented with a choice at two points, see Fig. 2 for one of the choices. During both of these decisions, their physiological state is measured, as detailed below, and the resulting estimate of their emotional state is used in the non-player character responses that refer to these choices. These decisions were implemented in order

**Fig. 3.** Rats, Andy, and Clara: the three non-player characters.

to allow the player to feel as if the three non-player characters, see Fig. 3, were directly responding to both their actions and their emotional state in subsequent dialogue. This design is necessary for the impact on the players to be dependent on their choice, however, it is problematic for comparing data across participants with a small sample size as in the reported experiment. Different choices lead to different responses from non-player characters, which makes it difficult to compare post-test results directly per-choice across participants.

When player's are presented with a decision, they are first presented with a framed shot of the scene and a brief description of the situation. Text then presents the player with 3 choices depending on the scene. After choosing an option, the player must make their way towards the NPC, which then triggers the appropriate dialogue with that character. For choices in scenes that are considered relevant for NPC behavior later on, the player's state during that event is recorded in the different phases of the event, to adjust the baseline and record the event reaction, as described below. Table 1 shows the sequence of scenes with a short description of the narrative as well as what previous recorded stat the dialogue is based on. Bold-faced scene names indicate alternative paths after decision points.

### 3.1 Physiological Signals to Emotional States

In order to track physiological signals, two Arduinos were used in combination with the eHealth sensor platform[1] to measure facial EMG (Electromyography) and EDA (Electrodermal activity). In order to measure muscle tension, six electrodes were placed on the face of each participants. The grounds were placed at the top of the forehead. Two more electrodes, measuring the muscle movement of the brow, were placed directly above the participant's eyebrow. The final two electrodes, measuring the movement of the mouth, were placed along the cheek of the participant. These areas correspond to two specific muscle groups, the corrugator supercilii group which is associated with frowning and the zygomaticus major muscle group which is associated with smiling. Electrodermal activity, also known as galvanic skin response, or skin conductance/resistance, is measured between the tips of the participant's fingers of the non-dominant hand. The result from this sensor returns a regularly sampled value for the skin conductance level (SCL).

---

[1] https://www.cooking-hacks.com/ehealth-sensors-complete-kit-biometric-medical-arduino-raspberry-pi.

**Table 1.** Scenes in-game refer to a specific event to determine dialogue.

| Scene name | Description | NPC | Based on |
|---|---|---|---|
| Baby | Discovering a baby arranged in a ritual | - | - |
| Ambush | Being ambushed by a zombie | - | - |
| Rats1 | Meeting Rats for the first time | Rats | Ambush |
| Andy1 | **Choice options** at Andy's camp | - | - |
| **Andy2** | Deciding to kill Andy | Andy | Andy1 decision |
| **Andy3** | Deciding to reason with Andy | Andy | Andy1 decision |
| **Andy4** | Deciding to return to their camp | - | - |
| Rats2 | Speaking to Rats after dealing with Andy | Rats | Andy1 decision |
| Clara1 | Clara arrives at camp and takes the baby | Clara | Baby |
| Clara2 | **Choice options** at Clara's camp | - | - |
| **Clara3** | Deciding to kill Clara | Clara | Clara2 decision |
| **Clara4** | Deciding to reason with Clara | Clara | Clara2 decision |
| **Clara5** | Deciding to sacrifice the baby | Clara | Clara2 decision |
| Rats3 | Speaking to Rats after dealing with Clara | Rats | Clara2 decision |

Combining these two pieces of data, EDA and facial EMG, allows for the estimation of a participant's current emotional state as a correlate of the dimensions of arousal and valence. We assign data gathered from EDA as the y-axis (arousal) while the information from EMG is placed on the x-axis (valence). Raw data from the eHealth devices is gathered using PhySigTK, a toolkit that enables reading time-stamped and cleaned up values from a variety of physiological signal devices [17]. Using the toolkit, raw values were sampled at 100 Hz for both skin conductance level and the muscle tension at both of the muscle groups mentioned above. The toolkit integrates tools for smoothing and normalizing the SCL values, as well as a mechanism for detecting peaks, so called Skin Conductance Responses (SCR). Smoothing was performed by averaging with a sample-window of 9 values, i.e. 4 before and after the sample value of interest. Normalization to the range of 0–1 was performed using a one-second window of recent values, in order to enable efficient real-time peak detection. Peak detection was based on a threshold of 0.6 in the resultant normalized range, and an expected minimum distance between peaks of 0.3 s.

The resulting signal indicated the detected peaks in the skin conductance signal read as a frequency. A higher frequency would correspond to more recent SCRs being detected. Once the frequency is calculated, it is compared to the most recent baseline estimate (as explained below) in order to be placed on the y-axis as an estimate of arousal.

The EMG setup returns two values for the brow and cheek muscles, normalized to the range of 0–1 based on the most recent baseline and initially established maximum values, and then used directly in the calculation of the

estimate of valence. The normalized value of the brow measurements, associated with frowning as an indicator of negative valence, is subtracted from the cheek measurements, associated with smiling.

Initially, a base-line measurement needs to be established for each subject. The base-line is recorded during the initial sequence over a period of sixty seconds. The participants were asked to keep still and relax for the duration without any distraction, in order to record their neutral measurements. The baseline is determined by measuring all activity over the course of 60 s and then averaging those values. After the initial baseline recording, participants were then asked to smile and then to furrow their brow. The values recorded from this were set as the participant's maximum EMG values, which were then used to normalize the data from 0 to 1.

However, this baseline is adjusted throughout, in order to account for any lasting changes in physiological response. Before the start of each scene, the baseline is adjusted during "empty" sections in the game world. In order to adjust the baseline, we take the average of the newly recorded baseline and the previous one.

*Event Measurement:* The measurements are tracked in two different ways throughout the game depending on the type of scene. For most scenes, three points are established in which data is recorded. The first point occurs before the event begins. This point exists to begin the process to adjust the player's baseline measurements. The second point is when the player initiates the event. The data collected during this segment is averaged to establish the estimated emotion for the scene. The final point was recorded as a means to observe how the player's data falls off after the event has ended. This third point was not used in the emotion estimation process in-game.

For scenes that include a decision, the baseline is still adjusted before any action occurs. However, the difference lies in the second data collection point. The player's signals are recorded for the duration of the time that they remain in the decision window, as well as for 3 s after the choice has been made, a time-window based on usual stimulus response times for electrodermal activity. Each NPC can respond to each instance of conversations with one of nine dialogue options, based on the categorization of the estimated emotional state based on arousal and valence. We label these nine emotion categories as follows, referring to labels used in the circumplex model [19]: Neutral, Happy, Alarmed, Miserable, Angry, Depressed, Bored, Tired, Content (as seen in Fig. 4).

## 3.2  Experimental Approach

In addition to the physiological data collected, the experimental design included questionnaires before and after testing. A between subjects approach was used, i.e. every participant was randomly assigned to one of the two versions of the game, either the control condition or the condition that used the physiological signals. The control condition utilized dialogue choices based on the neutral responses. In both versions of the game, all the devices were used and data was

**Fig. 4.** Nine emotion categories on our simplified arousal-valence axis, based on [19].

collected irrespective of its use in-game, and the participants were not told how their data was being used in the game. A pretest questionnaire established the level of familiarity the user had with video games and biofeedback devices. After playing through the short, about 15-min game, a post-test questionnaire was used in order to analyze the rapport established with each non-player character in-game. A three-item Likert scale was based on questions asked by [8] to establish rapport, dropping question that were not applicable to the current setup. The resulting set of questions asked for a connection with the NPC, and understanding with the NPC and if he NPC felt likeable. All three questions were asked separately for each NPC, with answers on a 9-point range from Disagree Strongly to Agree Strongly. Furthermore, the questionnaire included qualitative feedback items on what the player thought the effect of the physiological data was, as well as open-ended feedback.

## 4   Results

The recruited subjects were university students with some experience of video games. The sample size was 16 participants, with 8 in the testing group and 8 in the control group. The participants were all between the ages of 18 and 34, with 11 of the participants being between the ages of 18 and 24. The remaining 5 participants were between the ages of 24 and 34. In the testing group 5 were between the ages of 18 and 24, with 3 being between the ages of 24 and 34. The control group included 6 participants between the ages of 18 through 24 and 2 participants between the ages of 24 and 34. A majority of the people tested identified as male, with the rest identifying as female. A total of 6 participant's

identified as female while 10 identified as male. In both the testing and control group, 5 of the participants were male while 3 of the participants were female.

All participants play video games, with most estimating that they spend between 6 to 20 h a week gaming. Of the 16 participants, 11 expressed that they spent 6 to 20 h a week playing video games. 2 users spent 1 to 5 h per week playing video games with the last 3 split between 0 to 1 h, 21 to 40 h, and 41 to 80 h. This information shows that nearly all, excluding 1, of the participants spend time gaming each week. All of the participants expressed interest in role-playing games, with the second most popular genre being action-adventure indicated by 12 participants. The indicated interest in role-playing games ensures that each participant has spent some time interacting with non-player characters. Out of all of the participants, only 1 had played a game which used physiological data, namely heart-rate.

Measurements of electrodermal activity were not reliable for two members of the testing group and one in the control group despite the use of hand lotion to alleviate the problem, a common issue with EDA measurements related to dry skin.

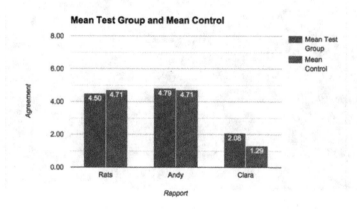

**Fig. 5.** The calculated rapport for each NPC in each group.

**Table 2.** Rapport and standard error for each NPC.

|       | Mean testing | Mean control | SE testing | SE control | p-value |
|-------|--------------|--------------|------------|------------|---------|
| Rats  | 4.50         | 4.71         | 0.37       | 0.78       | 0.41    |
| Andy  | 4.79         | 4.71         | 0.68       | 0.23       | 0.45    |
| Clara | 2.08         | 1.29         | 0.80       | 0.45       | 0.20    |

The results for the rapport scale are shown in Fig. 5 and Table 2. No significant change in rapport between the testing and control groups was observed. However, it is worth noting a trend regarding the least likeable character, Clara, with lower levels of rapport without the access to the player's emotional state.

While the quantitative analysis of the rapport measure indicated a trend, but did not lead to a clear conclusion, the qualitative feedback and comments received show a much clearer picture. Observing the answers given to the question "What effect did you think the biofeedback have on the game?" showed that the members of the testing group were aware that NPCs had access to their physiological data. Neither of the two groups were informed before playing the game that their data would have any effect on the game. In the testing group, 7 out of the 8 responses indicated awareness with answers such as "to capture my emotions" and "gave the game emotional information." On the other end, responses from the control group showed that 7 out of 8 participants were unaware that there was any effect on the game.

**Fig. 6.** Affect estimates for a player that decided to kill an NPC.

This shows that the users were able to recognize that the NPCs had access their estimated emotional state. One participant was noticeably happy while deciding to kill the thief in the game. When another NPC was upset with them for enjoying the event, the participant noticed this and exclaimed their excitement. As another example, shown in Fig. 6, we see the sequence of estimated emotional states during the same scene (Andy2) for which another user decided to kill an NPC, showing a clear change when the effects of the decision are reflected in dialogue.

Further, participants in the testing group had a much more positive response to the game as a whole than those in the control group. However, this could also stem from the difference between the neutral NPC dialogue and the more

emotive responses that users received in the testing group, a notable limitation of the study that will be addressed in future work. A larger scale evaluation can use more varied approaches for control conditions such as the use of randomly selected emotional responses or the selection of counter-indicated or "opposite" responses. In addition, future tests may consider altering aspects of the game other than dialogue. For instance, gestural animations and adaptive music could be added to the NPC models in order to express their emotion.

## 5  Conclusion

We reported on an experimental evaluation of a game and system developed to show that using a combination of facial electromyography and electrodermal activity to estimate human emotion affords non-player characters with more and useful information about the player. The evaluation demonstrated the viability of the approach. In the small sample of the evaluation, there was no significant difference for a questionnaire measure of rapport with the NPCs. However, the qualitative feedback in the questionnaires showed a clear difference in the perception of the system's use of physiological information, providing a useful data point on the feasibility of using physiological data in driving NPC behavior.

As indicated by some participants, the game was seen as very short for establish meaningful connections with the non-player characters. Possible future work could apply the same setup in a modification of an existing games such as Fallout 4 or Skyrim with established story-rich character interaction. Alternatively, as suggested above, a similarly small-scale interaction could be improved by altering more aspects of the gameplay in response to the player's state in order to elicit stronger emotional responses.

## References

1. Ambinder, M.: Biofeedback in gameplay: how valve measures physiology to enhance gaming experience. In: Game Developers Conference: Game Design Track, San Francisco, California (2011). http://www.valvesoftware.com/publications/2011/ValveBiofeedback-Ambinder.pdf
2. Bailey, C., Katchabaw, M.: An emergent framework for realistic psychosocial behavior in non-player characters. In: Future Play 2008 Proceedings of the 2008 Conference on Future Play: Research, Play, Share, Toronto, Ontario, Canada, pp. 17–24. ACM, New York (2008)
3. Bustamante, P.A., Celani, N.M.L., Perez, M.E., Montoya, O.L.Q.: Recognition and regionalization of emotions in the arousal-valence plane. In: International Conference of the IEEE Engineering in Medicine and Biology Society, pp. 6042–6045. IEEE (2015)
4. Calvo, R.A., D'Mello, S.: Frontiers of affect-aware learning technologies. Intell. Syst. **27**, 86–89 (2012)
5. Chanel, G., Rebetez, C., Trancourt, M., Pun, T.: Emotion assessment from physiological signals for adaptation of game difficulty (2011)

6. Donikian, S., Petta, P.: A survey of research work in computer science and cognitive science dedicated to the modeling of reactive human behaviors. Comput. Animat. Virtual Worlds **22**(5), 445–455 (2011). http://dx.doi.org/10.1002/cav.375

7. Gilroy, S., Porteous, J., Charles, F., Cavazza, M.: Exploring passive user interaction for adaptive narrative. In: IUI 2012 ACM International Conference on Intelligent User Interfaces, Lisbon, Portugal, pp. 119–128 (2012)

8. Gratch, J., Wang, N., Gerten, J., Fast, E., Duffy, R.: Creating rapport with virtual agents. In: Pelachaud, C., Martin, J.-C., André, E., Chollet, G., Karpouzis, K., Pelé, D. (eds.) IVA 2007. LNCS (LNAI), vol. 4722, pp. 125–138. Springer, Heidelberg (2007). doi:10.1007/978-3-540-74997-4_12

9. Ingebretsen, M.: Toward more human video game characters. IEEE Intell. Syst. **23**(4), 4–6 (2008)

10. Kaptein, F., Broekens, J.: The affective storyteller: using character emotion to influence narrative generation. In: Brinkman, W.-P., Broekens, J., Heylen, D. (eds.) IVA 2015. LNCS (LNAI), vol. 9238, pp. 352–355. Springer, Heidelberg (2015). doi:10.1007/978-3-319-21996-7_38

11. Kim, K.H., Bang, S.W., Kim, S.R.: Emotion recognition system using short-term monitoring of physiological signals. Med. Biol. Eng. Comput. **42**, 419–427 (2004)

12. Lee, Y.S., Cho, S.B.: Dynamic quest plot generation using petri net planning. In: WASA 2012, Proceedings of the Workshop at SIGGRAPH Asia, Singapore, pp. 47–52. ACM, New York (2012)

13. Mateas, M., Stern, A.: Natural language understanding in façade: surface-text processing. In: Göbel, S., Spierling, U., Hoffmann, A., Iurgel, I., Schneider, O., Dechau, J., Feix, A. (eds.) TIDSE 2004. LNCS, vol. 3105, pp. 3–13. Springer, Heidelberg (2004). doi:10.1007/978-3-540-27797-2_2

14. Matthes, D., Frenzel, P., Fuchs, M.: Synchronized measurement of peripheral physiological signals. Biomed. Eng. **57**(SI–1 Track–F), 663 (2012)

15. Perry, T.S.: Leaving the uncanny valley behind. IEEE Spectr. **51**(6), 48–53 (2014)

16. Putten, A.M.V.D., Kramer, N., Gratch, J., Kang, S.H.: It doesn't matter what you are! explaining social effects of agents and avatars. Comput. Hum. Behav. **26**, 1641–1650 (2010)

17. Rank, S., Lu, C.: PhysSigTK: enabling engagement experiments with physiological signals for game design. In: 2015 International Conference on Affective Computing and Intelligent Interaction (ACII), First International Workshop on ENgagement in HumAN Computer IntEraction (ENHANCE 2015), 21–24 September 2015, Xian, China, pp. 968–969. IEEE (2015)

18. Reynolds, E.: Nevermind: creating an entertaining biofeedback-enhanced game experience to train users in stress management. In: Proceedings of ACM SIGGRAPH 2013 Posters, Anaheim, California, article no. 77 (2013)

19. Russell, J.: A circumplex model of affect. J. Pers. Soc. Psychol. **39**(6), 1161–1178 (1980)

# Brave New Ideas

# Narrative Game Mechanics

Teun Dubbelman[(✉)]

HKU University of the Arts Utrecht, Utrecht, The Netherlands
`teun.dubbelman@hku.nl`

**Abstract.** This paper explores the notion of narrative game mechanics by apposing theories from the field of cognitive narratology with design theories on game mechanics. The paper aims to disclose how narrative game mechanics invite game agents, including the player, to perform actions that support the construction of engaging stories and fictional worlds in the embodied mind of the player. The theoretical argument is supported by three case studies. The paper discusses examples of games that employ mechanics and rules to create engaging story events, focusing on: building tension through spatial conflict, evoking empathy through characterization and creating moral dilemmas through player choices.

**Keywords:** Interactive narrative design · Narrative game design · Environmental storytelling · Game analysis · Design research · Design education

## 1  Introduction

In my experience with educating narrative game designers, I have noticed that not all designers are aware that game mechanics are one of the most powerful narrative devices they have at their disposal. Rather than exploring what kind of mechanics might suit the narrative experience they want to build, they often start a project with a preset of mechanics, borrowed from popular genres. They tend to build the narrative around these "proven" mechanics, using other narrative devices, like environmental storytelling, cutscenes or dialogues for their storytelling. By choosing these familiar mechanics at the start of a project, designers deprive themselves of fully exploring what kind of narratives experiences they can create with games, simply because these existing mechanics only allow for particular kind of story events to unfold. This paper aims to explore the notion of narrative game mechanics and tries to explain how narrative game mechanics can be effectively employed in narrative game design.

## 2  Narrative Game Mechanics

What are narrative game mechanics? For those familiar with the so-called ludology versus narratology debate in game studies [1, 2], the notion of narrative game mechanics brings to mind some fiercely debated questions. Could games tell stories, and could the phenomena of narrative and games coexist in one medium? Without delving too deep into the debate, one insightful remark came from Marie-Laure Ryan, who proposed to

© Springer International Publishing AG 2016
F. Nack and A.S. Gordon (Eds.): ICIDS 2016, LNCS 10045, pp. 39–50, 2016.
DOI: 10.1007/978-3-319-48279-8_4

be clear about what kind of definitions underlie certain viewpoints. Understanding games in terms of narrative becomes problematic only when holding on to a traditional definition of narrative, grounded in classical narratology [3: p. 184]. According to Ryan, classical narratology understands narrative essentially as an act of recounting, that is, 'telling somebody else that something happened' [4: p. 13]. From a classical viewpoint, narrative presupposes a narrator (or narrating instance) telling a story–a fixed sequence of past events–to a narratee. Narrative is the semantic structure within a media text that represents–that encodes–this particular sequence of events [3: p. 184, 5: p. 25–26]. Since games, by virtue of their procedural affordances, are able to produce dynamic sequences of events, real-time, using the input of the narratee, the classical definition of narrative as recounting (i.e. story-telling) becomes problematic or even inapplicable. In short, games do not seem to recount past events in the present [6, 7].

Even though the classical definition of narrative does not seem applicable to the analysis of games, it would be false to conclude that certain games cannot be understood in terms of narrative. Rather than using the classical definition of narrative, Ryan proposes another understanding of narrative; one that stems from the cognitive sciences. According to Ryan, following cognitive narratologists like Herman [8] and Bordwell [9], stories do not essentially reside within the narrative text, but reside within the human mind as a mental construct: 'narrative is a mental image–a cognitive construct–built by the interpreter as a response to the text [...] But it does not take a representation proposed as narrative to trigger the cognitive construct that constitutes narrativity' [4: p. 9–10]. Even when a media text does not represent a story, one can still create stories mentally in response to this text. Similarly, even when the text does not represent a fixed sequence of events, communicated by a narrator (or narrating instance), our mind is still able to construct such a sequence, connecting events meaningfully to each other. In short, stories can be constructed in the mind of the user in response to a media text even when the text does not intent to tell a (predefined) story.

Moreover, these mental stories are not created in retrospect after the experience; they are not constructed in a moment of retelling, but are created real-time in the experiential moment itself [10]. While the player engages real-time with a game, (s)he is continuously constructing stories mentally, as cognitive frames, necessary for understanding past and present actions and plotting future actions. Also, these stories are not simply cognitive constructs in the sense of stored rational information, but are also affective constructs of visceral information [11]. The mental story includes both our intellectual understanding of a situation, for example understanding that John loves Marie, as well as our affective sensation of such a situation, for example seeing how John looks in devotion at Marie. In short, mental stories are created when our embodied minds (or mindful bodies), in an effort to make sense of the surrounding world, process rational and visceral information, deriving from an interaction with this surrounding world.

By understanding stories as mental constructs, it becomes possible to expand the applicability of the term narrative. Narrative does no longer only refer to the expressive act of retelling events of the past, but also to the expressive act of creating events in the present. In both instances, a story is "instantiated", since the narratee is able to construct a mental story in response to the depicted events. It does no longer matter to what extent

these events, and their causal relations, are predefined in the narrative text, nor does it matter if these events experientially belong to a here-and-now or a there-and-then [6].

The cognitive approach to narrative suits the analysis of games and other forms of interactive digital narrative particularly well [12]. One of the merits of games is their ability to create events real-time, in response to the input of the player. Games featuring fictional worlds, inhabited by characters, can now be described in terms of narrative, even though their storylines are not or only partly predefined.[1] Moreover, not only the devices that are commonly associated with narrative expression in games, such as cutscenes, scripts and dialogues, can be theorized as narrative devices, but also the procedural devices that are responsible for creating events real-time, like game mechanics and rules, since the player's engagement with these devices can also trigger the construction of stories in the embodied mind of the player.

## 2.1 Mechanics as Narrative Device

Even though game mechanics can be understood as a narrative device, the notion of narrative game mechanics has not been explored thoroughly by industry or academia. There does not exist a broad awareness that the practice of narrative game design includes the design of game mechanics. Some preliminary work on the topic can be found on leading industry platforms, e.g. Gamasutra [15]. Likewise, in academia, the narrative function of game mechanics is acknowledged [16], but not yet fully theorized. When the dust of the ludology versus narratology debate settled, another notion emerged to the front: environmental storytelling, or alternatively, narrative architecture [17, 18]. Environmental storytelling is indeed one of the most important narrative devices for games, particularly those games that rely heavily on the player's traversal of space. Recent years have seen many games with strong environmental storytelling (e.g. *The Stanley Parable* [19], *Gone Home* [20], *Everybody's Gone to the Rapture* [21] and *Firewatch* [22]). In contrast to cutscenes or scripts, environmental storytelling abides player interaction. For example, when a player moves through a world, the environment can be used to inform the player about setting, characters and conflict. However, game mechanics, more than any other device, determine what the player can and cannot do within the environment, and this, more than anything else, determines what kind of stories the player will experience. Thus, it can be worthwhile to further delve into the notion of narrative game mechanics, as game mechanics can be an important addition to the designer's creative palette for making engaging narrative experiences. To grasp a better understanding of narrative game mechanics, this paper will delve into theories on game mechanics first.

---

[1] This paper understands "narrative games" as games with characters that inhabit a world and that undertake actions to reach certain goals, following established definitions of story from traditional narratology [13: p. 91] and cognitive narratology [14: p. 347].

## 2.2  Game Mechanics

There does not exist one generally accepted definition of game mechanics. In the industry as well as in academia, different ideas and approaches coexist. This paper will construct the notion of narrative game mechanics from the ideas of Sicart [23] and Järvinen [24]. Their contributions are helpful for the purpose of this paper, since they focus on the formal analysis of game design. They also focus on the user, including the notion of player agency in their definitions. Järvinen defines mechanics as: 'means to guide the player into particular behaviour by constraining the space of possible plans to attain goals' [24: p. 254]. Sicart proposes a similar definition: 'game mechanics are methods [behaviors] invoked by agents, designed for interaction with the game state' [23]. Both definitions emphasize the interrelationship between mechanics and player behavior. Mechanics influence (but not determine) the actions of the player. Unlike Järvinen, Sicart emphasizes that mechanics not only describe the actions available to players: 'Game mechanics can be invoked by any agent, be that human or part of the computer system. For instance, AI agents also have a number of methods available to interact with the gameworld' [23]. Both Järvinen and Sicart distinguish mechanics from rules. Following Järvinen, Sicart writes: 'Game mechanics are concerned with the actual interaction with the game state, while rules provide the possibility space where that interaction is possible, regulating as well the transition between states' [23]. In short, mechanics are 'actions the player [and other agents] can take within the space of possibility created by the rules' [23]. Not only the mechanics, but also the rules that constrain the player's handling of these mechanics, structure the behavior of the player.

Following the approach of Järvinen and Sicart, game mechanics are best described by verbs, since they refer to the possible actions available to agents, such as players or NPC's. A move-mechanic, then, could describe the possibility of the player-character to move through the game space. A shoot-mechanic, alternatively, could describe the possibility of the player to aim and fire a weapon.

Since rules provide the possibility space where actions can or cannot be performed, a compressed and somewhat simplified way to formulate the interrelationship between mechanics, rules and states is: The [name agent] can [action] by [instrument of input] and/but will [state change] if [condition of activation]. For example, in a board game, the relation between a shoot-mechanic and the rules related to it, might be formulated as follows: the player can aim and fire by rolling a die and will hit a target if the player rolls a six on a die. Similarly, in a digital 3D game it might be something like: the player-character can aim and fire a weapon by moving the right thumbstick and pushing the right shoulder button of the controller and will hit the target if the player presses the right shoulder button when the crosshair hovers over the target. Even though this simplified way of formulating the connection between mechanics, rules and states, does not do justice to the complexity of their dynamic interrelationship, it does help in gaining a first and basic insight in the workings of mechanics and rules in many games.

## 2.3  Agent Actions

As we have seen in the previous section, game mechanics and rules influence (but not determine) the behavior of agents. By establishing how agents can achieve a desired game state, they invite agents to undertake certain actions. The potential of game mechanics to influence the behavior of agents, like players or NPC's, is also central to the notion of narrative game mechanics. Like any narrative device, narrative game mechanics have the end purpose of creating engaging stories for players. By inviting players and NPC's to undertake certain actions, narrative game mechanics increase the chance that particular stories will unfold, since the nature and direction of a story depends (mainly) on the actions of its characters [5, 14].

With the cognitive understanding of narrative in mind, the following statement about narrative game mechanics can be made at this point: *Narrative game mechanics invite agents, including the player, to perform actions that support the construction of engaging stories and fictional worlds in the embodied mind of the player.*

As the statement indicates, narrative game mechanics support the instantiation of engaging mental stories. In practice, narrative game mechanics always work in tandem with other narrative devices, such as environmental storytelling, scripts, cutscenes, dialogues, monologues, voice-overs, character designs, audio and music designs, etcetera. Also, I am careful not to make a general assumption about what makes a story engaging for a user. This depends on many things, such as cultural background and culturally ingrained expectations. Still, many (Western) stories share some basic elements, such as an immersive world, believable characters and suspense building [25]. In the case studies below, attention will be given to some of the many elements that make stories engaging.

# 3  Case Studies

For the purpose of analytical focus, this section explores how mechanics express story events, rather than stories. Story events can be understood as the constituent, spatio-temporal units of a story, since stories, in a common definition, consist of sequences of story events [26: p. 16]. By choosing to focus on story events, this paper does not explore how separate story events relate to each other in the overall experience of the player. This question goes beyond the purpose of this paper, and could be a next step in theo-rizing the notion of narrative game mechanics. Such an investigation would have to delve into existing ideas concerning the development of storylines, and the ideology of emplotment, often witnessed in traditional theories and practices.

Firstly, I shall discuss *Left 4 Dead 2* [27] as an example of a game with a typical "game story", that is, a story that can be encountered in many popular games, and focuses on the player's traversal of contested spaces [28]. The player enters an area where various obstacles, such as opponents, have to be overcome. Suspense is built through the protag-onist's engagement with the surrounding, hostile environment. Stories like these have a strong presence in contemporary culture and stand in a long tradition of narratives dealing with human's primitive instinct for survival. Even though these stories are not profound in terms of their content, with regards to their form, they are worth our

analytical attention. As I will show, the designers of *Left 4 Dead 2* have found creative solutions for the challenge of expressing these popular stories through player interaction.

Secondly, I shall discuss *The Last of Us: Left Behind* [29] as an example of a game that not only focuses on the player's traversal of contested spaces, but invests in character building as well. I will explain how mechanics and rules are used for the purpose of characterization and the evocation of player empathy.

Finally, I shall discuss *Papers, Please* [30] as an example of a game that employs mechanics and rules to express complex moral dilemmas through player choices.

At this point, I would like to shortly address how I have analyzed the games, and how the object analysis relates to the theoretical inquiry. I have used the theoretical inquiry as a conceptual "lens", necessary for bringing into focus the most constituent elements of narrative game mechanics, namely: sets of available actions (to players and NPC's), usage contexts and restrictions, and state changes. By repeatedly playing the games, and structurally mapping patterns of input and output, I have been able to identify how their mechanics and rules create engaging story events.

However, this approach has its limitations. Game systems can instantiate a great number of stories, depending on the choices and preferences of specific players; a potential referred to as possible stories or protostories [12]. My analysis is based (mainly) on the stories that I have created, possibly decreasing the validity of my claims. The systems under scrutiny can instantiate more stories than the ones I have experienced. Also, game mechanics and rules are programmed into the game system, and cannot be directly perceived. Because game systems are "black boxes", concealing their internal structure and processes, it becomes uncertain if the object analysis has not overlooked essential mechanics and rules. To counter some of these concerns, I have used online comments of developers and other players to confirm my findings and support my analysis. I have also experimented with different play styles and strategies in an effort to avoid unidirectional playthroughs. Still, my claims in the upcoming sections could be further strengthened by additional object analyses, interviews with developers and quantitative or qualitative user tests.

## 3.1    Left 4 Dead 2

The theme of the game *Left 4 Dead 2* could be described best as survival by teamwork. The game centers on a group of four survivors in a post-apocalyptic world, infested by zombies. The player controls one of four survivors; the other survivors are either controlled by other players or by the computer's AI. When playing a level, the survivors enter an area with zombies of various types. The survivors need to move to a safe house at the other end of the level. Chances of survival lower drastically, when survivors do not stay together.

The theme of this game is well established in popular culture. Since George Romero's classic movie *Night of the Living Dead* (1968), we have seen many other movies, comics, books and games that revolve around a small group of individuals that struggle for survival in a zombie-infested world: from movies like *Return of the Living Dead* (Dan O'Bannon, 1985) and *Braindead* (Peter Jackson, 1992) to media franchises like The Walking Dead and Resident Evil. Stories in these media formats differ in detail.

Still, we do see many similarities when looking at the story events they portray. They often feature events such as: survivors being overwhelmed by increasing amounts of zombies, survivors getting separated from each other, survivors being picked off by zombies one at a time, survivors getting low on resources, etcetera. The developers of *Left 4 Dead 2* have tried to make the player experience similar story events. These events manifest themselves not by narrative devices such as cutscenes or scripted sequences, but mainly by the mechanics and rules. To disclose how the developers have succeeded in this, let us discuss one story event in detail, for example, an event where one survivor gets separated from the rest of the group. In line with the theme of the game, tension often heightens when one survivor becomes separated from the others, since being alone makes you vulnerable. As we will see, to increase the chance that a thrilling event like this will unfold, the game has to employ not one, but a broad set of mechanics and rules.

The core mechanics of the player are moving, picking-up items and attacking. One can move slow or fast, one can pick-up items, such as bandages, ammo and weapons and one can attack with melee or fire weapons of various shapes and sizes. These mechanics are constrained by familiar rules, such as: if you are attacked then you lose health points, or, if you fire a weapon then ammo is consumed. The dynamic interaction between these core mechanics and rules make some players decide to move away from the other survivors in certain situations. Items are scarce, and players will often find themselves in need of them. In order to get ammo, bandages, weapons or other items, a survivor could decide to leave the group. The level design is also important here. Items have been scattered around the area, not always in close vicinity to the main roads. Additionally, certain areas have low visibility, making it difficult for players to stay close to each other. Maze-like structures, such as hotels, cornfields, but also highways scattered with car wrecks, make it hard for the player to see further than a few feet ahead. Scarcely lit areas, or areas plagued by storm and rain, have a similar effect on the player's visibility. When players lose direct sight of each other, chances increase that (several) survivors get isolated from the rest of the group.

Another essential mechanic in the game is what I refer to as the incapacitate-mechanic. When a survivor has no health left, (s)he cannot move, and is forced to stay put. If the incapacitated survivor does not get help from another survivor within a certain duration of time, (s)he will die. This incapacitate-mechanic supports the instantiation of story events where survivors get isolated. When a survivor is incapacitated, the other survivors could leave him or her behind, and the survivor has no chance of catching up with the other survivors. Should another survivor decide to rescue the incapacitated survivor, (s)he will have to leave the rest of the group.

Besides the basic incapacitate-mechanic, the designers have devised some additional incapacitate-mechanics, related to so-called special infected. Special infected are dangerously mutated zombies with special abilities. Special infected incapacitate survivors in various ways, for example, they can instantly pin survivors down when coming into contact with them, or they can blind survivors. The special infected called The Smoker and The Charger are particular relevant here. The Smoker has an extremely long tongue. He uses his tongue to snatch and entangle one survivor from a large distance, dragging the survivor towards him. Similarly, The Charger runs into a survivor with great speed, grabbing and taking the survivor with him, until he comes to a halt by hitting

an object, like a solid wall, or until he has traversed a certain distance. The mechanics of The Smoker and The Charger seem to have been designed for the specific purpose of creating story events where one survivor gets separated from the group. Both mechanics make the agents perform actions that instantiate these events.

In the next section, I will discuss how mechanics can be used for the purpose of characterization and empathy building.

## 3.2    The Last of Us: Left Behind

Thematically, *The Last of Us: Left Behind* is similar to *Left 4 Dead 2*, since both games revolve around players having to survive in a zombie-infested environment. However, *Left Behind* also explores how the characters suffer emotionally from their post-apoca-lyptic surroundings. To be more precise, the player follows two adolescent girls who struggle to save their friendship in a hostile and unforgiving world. While some of the story events are quite similar to those in *Left 4 Dead 2*, namely those concerned with the traversal of occupied space, other story events are more focused on characterization and the player's empathic engagement with the two girls. These events seem to serve the purpose of portraying the characters in a believable fashion, and making the player care for the close friendship of the two girls.

The games also differ in terms of narrative structure. *Left 4 Dead 2* is an example of a game with an (primarily) emergent structure; what kind of story events occur (and when and where) is generally the result of the player's engagement with the mechanics. *Left Behind* is an example of a game with a (primarily) planned structure; the designers have largely determined in advance what kind of story events will occur (and when and where). The mechanics are used to make the player enact these pre-established story events, at specific moments in the game.

The core mechanics of *Left Behind* are similar to those of *Left 4 Dead 2*. The game has, amongst others, a move-mechanic, a pick-up-mechanic, a throw-mechanic and an attack-mechanic. In most cases, the player uses these core mechanics for survival in the various zombie-invested areas of the game. The player can move slow or fast, can pick-up items such as ammo, bandages and weapons, can throw objects to distract or stun opponents, and can eliminate opponents with fire arms or melee weapons. Like *Left 4 Dead 2*, these mechanics create story events with a focus on tension building through spatial conflict. For example, there are situations where the player has to carefully and silently navigate through rooms where zombies lumber. However, the designers of *Left Behind* have, rather resourcefully, used the same core mechanics to create another type of story event, namely, an event concerned with characterization.

The designers have managed to repurpose the existing mechanics for creating story events that portray the personalities of the two girls and their interrelationship. At some point in the game, the girls enter an abandoned mall. When stumbling upon two rusty cars, they think of a small challenge: each girl chooses a car and the first one to throw in all the windows wins. The loser needs to answer a question given by the winner. The player controls one of the girls, the protagonist Ellie. Commonly, the player uses items such as bricks or bottles to distract or stun opponents. Now, the player picks up the bricks to throw in the car windows and win this juvenile, playful

competition. By changing the context, the designers have succeeded in using the same set of core mechanics to make the player enact another type of story event. In this particular situation, the mechanics make the characters act in a believable and identifiable fashion; one could expect this behavior from two adolescent girls, hanging out together. In another level, we can witness a comparable re-contextualization of the core mechanics. The girls start a fight with water pistols. Instead of engaging with opponents, the shoot-mechanic, with minor adjustments, is used to create a story event where the two girls frantically chase each other through a shop, spraying water around, as if the world has ceased to be hostile and unforgiving.

In both examples, the mechanics showcase the personalities of the girls, and their close friendship. By cleverly re-using the core mechanics, the game makes the player perform actions in support of characterization and empathy building. The game uses other narrative devices in these story events, like cutscenes and scripted sequences, but only sparsely, because the essential actions do not change (throwing, shooting, etcetera). The designers only need to change the context in order to create the desired narrative effects.

### 3.3 Papers, Please

In the beginning of this paper, I stated that the practice of narrative design should not solely stick to the same, familiar mechanics we know from popular genres such as shooters or platformers, since this would deprive the practice of fully exploring what kind of narrative experiences designers can create with games, simply because these existing, proven mechanics only allow for particular kind of story events to unfold. Certain story events can simply not be created by mechanics when these mechanics are only concerned with the traversal of hostile spaces. I believe that *Left 4 Dead 2* and *Left Behind* are examples of games that, despite their familiar mechanics, have succeeded in creating compelling stories, mainly because the games cleverly refine the mechanics we know from other shooters and action-adventures. I would like to discuss *Papers, Please* as an example of a game that uses unconventional mechanics to create story events that are uncommon in games.

In *Papers, Please*, the player takes on the role of an immigration officer, working at a border checkpoint. The game takes place in the communist country of Arstotzka. After many years of conflict with a neighboring country, peace is restored, and the border is reopened. The player has to check if the people who desire to enter Arstotzka carry the right papers and do not break any of the immigration laws. There exists a constant tread of "unwanted" individuals entering the country, like revolutionaries who want to bring the government down, but also smugglers and spies.

The core-mechanics of *Papers, Please* revolve around inspecting papers and people. At the checkpoint, the player has to scan them for law violations. Amongst others, the player needs to check: name, appearance, height, weight, sex, issuing city, expire date and the presence of contraband. After the inquiry, the player has to apply a "denied" or "approved" stamp to the papers, either allowing or denying access to the country. There is an income-rule associated with these mechanics: for every legit individual entering the country, the player receives a fee, and for every illegal individual entering the

country, the player receives a fine. There is also an important time-rule: income is generated per day, and each day only lasts a couple of minutes, so the player needs to process enough individuals to earn enough income, but also needs to be careful not to make too many mistakes, since this would result in a loss of income. The player needs this income to sustain his family. Arstotzka is an oppressed and poor country. Her citizens suffer from undernourishment, sickness, hyperthermia, homelessness or imprisonment. At the end of each day, the player can choose to safe his income or spend it to housing, medicine, food and heating. If the family is deprived of these essentials for too long, they will eventually die, ending the game.

As previously stated, the innovative mechanics of *Papers, Please* create original stories, about a man with a mindless job, who, sitting in his booth, determines the faith of many: of himself, of his family, of the people at his checkpoint and of Arstotzka. These stories develop with each day, because each day, the status of the player-character, the status of the player's family and the status of Arstotzka change. These changes of status happen first and foremost through the engagement of the player with the mechanics and rules, and only secondly, by other narrative devices such as scripts. To be more precise, changes in states happen depending on whom the player allows to enter the country, and how many immigrants the player can process within a day. For example, if the player repetitively fails to grand access to enough individuals per day, or if the player allows too much unauthorized persons to enter, the player's income (because of the time and income rules) will not be enough to support his family, and their status will rapidly deteriorate. In turn, this could make the player more susceptible to other ways of making a living, like taking bribes from smugglers, human traffickers or revolutionaries. Allowing these individuals to enter the country, affects the future of Arstotzka, and also endangers the player-character, since he can be arrested for treachery. Because the immigration regulations for entering Arstotzka become more complex each turn, that is, the player has to take more restrictions into account when checking people and papers, it becomes increasingly harder to earn a legitimate income. The game will confront the player with other moral dilemmas as well. For example, will you allow access to father and child, but not to the mother, because she has not got the right papers, or will you allow access to a women trafficker with the right papers, even if one of his victims begs you not to.

In short, the driving force behind the development of the story in *Papers, Please* are the mechanics and rules. Depending on the dynamic relation between the mechanics, the rules and the choices of the player, the storyline moves into a certain direction. At heart, these choices come down to allowing or denying access to the people at the checkpoint. Depending on whom the player allows to enter, the player can experience a story of a modal citizen, blindly following the laws of his country; of a Good Samaritan, helping people in need, even though the law does not always allow it; of a corrupt immigration officer, seeking nothing but self-enrichment; of a desperate husband and father, struggling to save his family; and so on. Depending on how the player chooses to engage with the mechanics and rules, any of these stories could unfold.

# 4 Conclusion

This paper has examined the notion of narrative game mechanics, and has offered an insight in how existing games employ these mechanics. As argued, mechanics and rules influence (but not determine) the actions of players, and this, in turn, influences what kind of story events can unfold. The paper has discussed examples of games that employ mechanics and rules to create engaging story events, focusing on: building tension through spatial conflict, evoking empathy through characterization and creating moral dilemmas through player choices. In summation, narrative game mechanics invite game agents, including the player, to perform actions that support the construction of engaging stories and fictional worlds in the embodied mind of the player.

For a deeper understanding of narrative game mechanics, the relationship between player interaction and character behavior should be studied in more depth. In traditional narratives, the author has direct control over the behavior of characters by simply stating (in words, images or sounds) how characters act. In interactive narratives, the designer does not have the same level of direct control over the characters, since their behavior is (partly) the result of the player's interaction with the system. By designing the interactive system, the narrative designer can only influence, but not determine, how characters act. This paper proposes that further research should look into the design patterns of game systems, such as repetition, progression, player mastery and meaningful choices. Studying these patterns in relation to narrative theory and practices will help in getting an extensive understanding of the notion of narrative game mechanics.

To conclude, by examining the notion of narrative game mechanics, and proposing directions for further research, this paper has aimed to give prominence to an under-discussed topic, laying another piece of the complex, but intriguing puzzle that is narrative game design.

# References

1. Frasca, G.: Ludologists love stories, too: notes from a debate that never took place. In: Copier, M., Raessens, J. (eds.) Level-up: Digital Games Research Conference, pp. 92–99. Utrecht University, Utrecht (2003)
2. Simons, J.: Narrative, games, and theory. Game Stud. Int. J. Comput. Game Res. **7** (2007). http://gamestudies.org/0701/articles/simons. Accessed 11 Apr 2016
3. Ryan, M.-L.: Avatars of Story. University of Minnesota Press, Minneapolis (2006)
4. Ryan, M.-L.: Narrative Across Media: The Languages of Storytelling. University of Nebraska Press, Lincoln (2004)
5. Chatman, S.: Story and Discourse: Narrative Structure in Fiction and Film. Cornell University Press, Ithaca, London (1978)
6. Dubbelman, T.: Playing the hero: how games take the concept of storytelling from representation to presentation. J. Media Pract. **12**, 157–172 (2011)
7. Dubbelman, T.: Narratives of being there: computer games, presence and fictional worlds. Ph.D. thesis (2013)
8. Herman, D.: Story Logic: Problems and Possibilities of Narrative. University of Nebraska Press, Lincoln (2002)
9. Bordwell, D.: Narration in the Fiction Film. University of Wisconsin Press, Madison (1985)

10. Arthur, C., Graesser, A.C., Olde, B., Klettke, B.: How does the mind construct and represent stories? In: Green, M.C., Strange, J.J., Brock, T.C. (eds.) Narrative Impact: Social and Cognitive Foundations, pp. 229–262. Lawrence Erlbaum Associates, Mahwah (2002)
11. Herman, D.: Basic Elements of Narrative. Wiley-Blackwell, Chichester (2009)
12. Koenitz, H.: Towards a specific theory of interactive digital narrative. In: Koenitz, H., Ferri, G., Haahr, M., Sezen, D., Sezen, T.I. (eds.) Interactive Digital Narrative: History, Theory and Practice, pp. 91–105. Routledge, New York, London (2015)
13. Prince, G.: A Dictionary of Narratology. University of Nebraska Press, Lincoln (1987)
14. Ryan, M.-L.: Narrative. In: Herman, D., Jahn, M., Ryan, M.-L. (eds.) Routledge Encyclopedia of Narrative Theory, pp. 344–348. Routledge, London (2005)
15. Bycer, J.: Extreme storytelling: the use of narrative mechanics. Gamasutra. http://www.gamasutra.com/blogs/JoshBycer/20120611/172156/Extreme_Storytelling_The_Use_of_Narrative_Mechanics.php. Accessed 11 Apr 2016
16. Sezen, T.I.: Remaking as revision of narrative design in digital games. In: Koenitz, H., Ferri, G., Haahr, M., Sezen, D., Sezen, T.I. (eds.) Interactive Digital Narrative: History, Theory and Practice, pp. 258–271. Routledge, London, New York (2015)
17. Jenkins, H.: Game design as narrative architecture. In: Wardrip-Fruin, N., Harrigan, P. (eds.) First Person: New Media as Story, Performance, and Game, pp. 118–130. MIT Press, Cambridge (2004)
18. Nitsche, M.: Video Game Spaces: Image, Play, and Structure in 3D Game Worlds. MIT Press, Cambridge (2008)
19. Galactic Cafe. The Stanley Parable. Windows, 17 October 2013
20. The Fullbright Company. Gone Home. Windows, 15 August 2013
21. The Chinese Room. Everybody's Gone to the Rapture. PlayStation 4, 11 August 2015
22. Campo Santo. Firewatch. PlayStation 4, 9 February 2016
23. Sicart, M.: Defining game mechanics. Game Stud. Int. J. Comput. Game Res. **8** (2008). http://gamestudies.org/0802/articles/sicart. Accessed 11 Apr 2016
24. Järvinen, A.: Games without frontiers: theories and methods for game studies and design. Ph.D. thesis (2008). http://ocw.metu.edu.tr/pluginfile.php/4468/mod_resource/content/0/ceit706/week3_new/AkiJarvinen_Dissertation.pdf. Accessed 11 Apr 2016
25. Roth, C., Klimmt, C., Vermeulen, I.E., Vorderer, P.: The experience of interactive storytelling: comparing "Fahrenheit" with "Façade". In: Anacleto, J.C., Fels, S., Graham, N., Kapralos, B., Saif El-Nasr, M., Stanley, K. (eds.) ICEC 2011. LNCS, vol. 6972, pp. 13–21. Springer, Heidelberg (2011). doi:10.1007/978-3-642-24500-8_2
26. Rimmon-Kenan, S.: Narrative Fiction: Contemporary Poetics, 2nd edn. Routledge, London, New York (2002)
27. Valve Corporation. Left 4 Dead 2. Xbox 360, 17 November 2009
28. Jenkins, H., Squire, K.: The art of contested spaces. In: King, L. (ed.) Game on: The History and Culture of Videogames, pp. 64–75. Laurence King Publishing, London (2002)
29. Naughty Dog. The Last of Us: Left Behind. PlayStation 3, 14 February 2014
30. 3909. Papers, Please. iOS, 12 December 2014

# An Integrated and Iterative Research Direction for Interactive Digital Narrative

Hartmut Koenitz[✉], Teun Dubbelman[✉], Noam Knoller[✉], and Christian Roth[✉]

Professorship Interactive Narrative Design, HKU University of the Arts Utrecht,
Lange Viestraat 2b, Postbox 1520, 3500 BM, Utrecht, Netherlands
{Hartmut.koenitz,teun.dubbelman,noam.knoller,
christian.roth}@hku.nl

**Abstract.** This paper outlines a roadmap for interactive narrative research that integrates disparate parts while focusing on identifying and experimentally verifying IDN design conventions and on developing a pedagogy to further the development of a professional discipline of IDN creators. This effort connects several key areas, in which the authors have worked before and which are now brought together. These include a specific theory, an approach towards interactive narrative design and its evaluation, an expanded understanding of the manifestations constituting the field, the pedagogy of educating creators of IDN artifacts and a perspective on the cultural significance of these creative expressions as tools to represent complexity.

**Keywords:** Interactive narrative models · Interactive narrative design · Interactive narrative art · Interactive narrative pedagogy · Narrative representations of complexity · Protostory · Protoprocess

## 1   Introduction

So far, approaches to interactive digital narrative (IDN)/interactive digital storytelling have focused on particular aspects like drama management [1], autonomous actors [2], emergent narrative [3], analytical aspects [4], user engagement [5], and authoring tools [6, 7]. More recently, generalizable design conventions have been identified as an area needing attention [8]. At the same time, concerns have been raised about the necessity to educate IDN authors [9, 10], which indicate a need for a specific pedagogy. Since IDN artifacts exist within a societal context [11], we should also attempt to understand this relationship and IDN's cultural significance.

Our reaction to these challenges is an integrated perspective that connects Theory, Practice, Pedagogy and Culture (Fig. 1). We will apply this interconnected perspective in our on work, but also offer it to the community for discussion and collaboration. Our specific approach integrates the authors' prior work in the field while focusing on identifying IDN design conventions and on developing a pedagogy to educate IDN "cyberbards" [12]. Grounded in Koenitz' specific theory of IDN [13], we introduce practice-based research into design conventions based on Roth's empirical methods [14, 15], and apply Knoller's artistic/critical view [16, 17] to further enhance our analytical

© Springer International Publishing AG 2016
F. Nack and A.S. Gordon (Eds.): ICIDS 2016, LNCS 10045, pp. 51–60, 2016.
DOI: 10.1007/978-3-319-48279-8_5

understanding and ability to communicate the form's potential while using Dubbelman's pragmatic approach [18, 19] to develop an IDN pedagogy. Finally, we extend Murray's perspective on the societal impact of configurative, procedural digital artifacts [20] and cast IDN artifacts as tools to represent and make sense of complexity in our postmodern society.

**Fig. 1.** An integrated perspective on IDN

## 2   Establishing Design Conventions

While we argue for a holistic approach, we are fully aware that the direct influence of scholarly work is on the analytical understanding and pedagogy of next generation creators. Thus the impact on practice and cultural significance is more indirect, which explains our two research foci in identifying design conventions and developing a specific pedagogy. Simultaneously, our basis in Koenitz' model of IDN [21] means that we understand theory and practice as connected in a feedback loop. Developments on either side influence the other, which means that novel phenomena in the field of practice demand advancements in critical reflection, while conceptual advances influence practice. This necessitates an iterative approach towards the development of theory.

The same model also takes IDN as a specific expressive form in the digital medium that is fundamentally interactive in contrast to attempts at "interactivizing" [21] traditional narrative structures. This means IDN as a practice is developing novel and distinct formats and genres of narrative, not merely new versions of established formats such as the novel, the movie, or the stage drama. Accordingly, Janet Murray has identified the "invention and refinement" of design conventions as a focus area for practical research in expressive digital media, so as to avoid the danger of "unproductive attempts to apply legacy conventions to new digital frameworks," [22] that fail to exploit the expressive potential of interactive media.

As Murray herself has pointed out [20], the question of novel procedural formats of representation is culturally highly significant. Narratives are a crucial way of organizing knowledge into meaningful structures and thus help individuals and societies make sense of the world [23]. However, the more complex phenomena become, the less effective traditional linear narratives seem to be at performing this organizing function. The societal impact of this observation should not be underestimated at a time when complex interrelated global phenomena such as climate change, mass immigration, or the

functioning of organizations such as the EU are not properly understood. The available majority narratives are incapable of reflecting the complexity of these phenomena and this deficiency can be exposed as "lies" by extremist agitators. Linear narratives can thus be said to provide an opportunity and seemingly a justification for a populist agenda. To an extent, this is a media effect. According to Habermas [24], the public sphere functions when citizens have the opportunity to consider sufficient viewpoints on an issue of public concern in sufficient depth. This (admittedly simplified) picture requires a citizenry of engaged and critical consumers of media. However, traditional media are no longer fit for the purpose while current digital media forms are not yet a solution: long reads on the web engage very few people. The representation of complex issues requires a medium that affords both a comprehensive representation of vast amounts of information and the sustained engagement of contemporary audiences. IDN has this potential thanks to its procedural, participatory, spatial and encyclopedic affordances.

IDN storyworlds can help interactors experience the dynamics of a complex situation or event, for example the continuous struggle for survival in a developing country [25] or the multitude of issues the discovery of a major oil reserve brings to a rural community [26]. The latter example is especially illustrative for the presentation of complex societal topics, as it connects representation with a discussion forum where participants can exchange their views on the matter. Yet, as the problematic aesthetic disconnect between cinematic representation and a non-diegetic discussion forum in Fort McMoney demonstrates, more research into design conventions is necessary to improve our ability to represent complexity.

The critical appreciation of current and future IDN systems and their commercial success will be related to the purposeful application of design conventions to create satisfying and fulfilling experiences. This means to evoke satisfaction or frustration by meeting, manipulating and subverting target audience expectations. User expectations do not merely precede such systems but are co-created in an iterative process of system design, experience, evaluation and feedback. Already, a few emerging conventions for interactive digital narrative have been identified, for example "scripting the interactor" [12] and "delayed consequences" [27]. However, we still lack a broad effort to establish design conventions through identification and experimental verification. This aspect is an integral part of our roadmap, based on methods in evaluating user experience we have developed earlier [14].

## 2.1 Experimental Validation

Qualitative research offers an in-depth look at subjective experiences and phenomena. Content analysis can be used to identify and compare patterns by using structured interviews, investigating transcripts of IDN system interactions, or by analyzing the artifacts directly. The initial basis for identifying design conventions is a content analysis undertaken on a canon of works created with the Advanced Stories Authoring and Presentation System (ASAPS), a lightweight 2D game engine featuring narrative building blocks, procedural elements, and state memory [28]. Currently, there are over 120 projects realized with the platform. In the exploratory study, four researchers independently analyzed and rated the content of 110 works for structural elements, player perspective, visual

styles, replay variety, and subjective appraisal of the experience based on pre-defined coding categories. The results of the study will be used to identify potential design patterns for experimental validation.

To verify the effectiveness of particular design strategies we devise a quantitative approach that connects prototypes with the evaluation of user experience (UX). Specifically, we plan to create prototype pairs – one applying a specific design strategy and another omitting it – to enable a direct A/B comparison. A/B testing (using posttest-only randomized experiments) is one of the best research designs for assessing cause-effect relationships. We will test the effectiveness of design strategies by comparing prototypes that differ only in one specific characteristic. Ideally, a concrete design fosters the experiential qualities of agency, immersion and transformation. [12]. The design of our experimental setups will be based on our earlier experience with IDN user experience evaluation [14], for example, with prototype-based user studies [29] and the A/B testing approach [30]. Our measurement toolbox [31] can evaluate IDN user experiences, covering a broad range of dimensions that can be related to Murray's concepts: agency (effectance, autonomy, usability), immersion (suspense, curiosity, presence, identification, believability, flow), and transformation (eudaimonic appreciation, enjoyment, positive and negative affect).

The identification and verification of potential design conventions is an important step in advancing IDN as an expressive practice. The accumulation of such knowledge means to move beyond derivative practices that interactivize legacy narrative conventions. In that sense, this work feeds into the development of a specific pedagogy, as we will discuss in the next section.

## 3   IDN Pedagogy – Educating IDN Designers

So far, interactive narrative design is still mostly a *Geheimkunst*, a secret art, practiced by a few initiated practitioners and academic researchers. In contrast, training in rule-based aspects of game design is well developed. The current situation produces a vicious circle of the "catch 22" variety: narrative aspects in video games are often given "second class" treatment, which makes IDN appear unattractive and in turn reduces the interest in potential authors to engage with this subject. Simultaneously, IDN has gained a reputation for being overly difficult - a prejudice, which is made even stronger by the lack of trained professionals. The development of an IDN pedagogy is an essential step towards breaking this vicious circle. Our approach is based both on analytical perspectives and personal experiences by the authors in teaching and creating IDN artifacts.

IDN provides a space for playful exploration [16] in which artists experiment with the forms of the medium [32], to create formal systems. The term Interactive Digital Narrative thus describes the overall expressive form, rather than any particular formats or manifestations. IDN manifestations include both existing works such as interactive fiction, narrative-focused computer games, interactive documentaries, interactive installations, AR applications, and interactive VR experiences, as well as formats and genres that are yet to emerge. In that sense, in the post-PC present, the Holodeck (as an

expressive virtual space) is already here, all around us [17], rather than in a contained futuristic entertainment location. However, we have only just begun to explore the expressive potential of IDN.

Therefore, it is of utmost importance to provide an accessible model of IDN that communicates the expressive potential of IDN, the seemingly unwieldy array of formal possibilities, to future cyberbards. This constitutes a fundamental theoretical challenge: to identify and describe these forms, in order to make them available for creative experimentation. To properly reflect the unstable and constantly evolving nature of the medium, any description will remain tentative and thus requires an iterative approach [21]. This means shifting between two perspectives: bottom-up pattern recognition derived from existing manifestations, as we've discussed in the previous section; and top-down theoretical analysis. In the next section, we extend Koenitz analytical model [33] by integrating Knoller's artistic perspective [16], focusing on the process of interaction.

### 3.1  Protostory and Protoprocess

The progression of System – Process – Product [33] (digital artifact, user interaction and resulting output) marks the difference to traditional narrative media forms and solves the disconnect between artifact and instantiated narrative observed by other scholars (e.g. [34]). Additionally, this model includes an understanding of the content of the system as a "protostory," the prototypical space of "potential narratives" [34]. We now extend this notion by integrating Knoller's perspective of the "userly text" [16] which entails a focus on the process. The significance of this enhanced description is in better communicating the expressive potential of IDN.

There are two broad constructs that the user of any work of IDN engages with: the first is the Protostory (Koenitz)/Encoded Storyworld (Knoller) and the second is the Interaction Model (or Protoprocess, extending Koenitz' terminology). Both Protostory and Encoded Storyworld refer to the hardware, software assets and algorithms that together encode a diegesis - the facts of the storyworld, including places, characters, events, things (Aarseth's ontic categories [35]), and the possible relations between these various elements. The relations between the components used in the discursive representation (code objects, bits of video, audio or animation, spatial representation etc.), constitute a higher level of organization of diegetic materials, which we call a discursive strategy. One of the specific expressive opportunities of IDN is in non-traditional discursive strategies.

The second construct as far as the interactor is concerned is the Interaction Model, or Protoprocess. The cyberbard makes a fundamental choice about which aspects of the digital medium to use and which parts of the users' bodies to address. The Protoprocess thus begins to script the interactor by structuring the embodied activity of the interactor, her userly performance. After deciding on the hardware platform, the author needs to structure the internal logic of this performance. This is a matter of interface design: what patterns of embodied performance does the software consider as input, and how does the software model the interactor's emotional or cognitive states? What is the vocabulary of interaction, and how do these patterns of userly performance translate into the storyworld? Do they affect the diegesis, or the discourse? Or perhaps both? What does it

mean, in storyworld terms, to click a button at a certain point, or to perform specific gestures? Does the system make inferences about the user's state, and map these states into the logic of the interaction model in a way that alters the way userly performance affects the storyworld's layers? From a pedagogical point of view, the challenge for authors here is tantamount to having to invent the book format, as well as reading, for every new work.

By emphasizing the importance of Protoprocess, we put a focus on the need for a cyberbard (and analytical perspectives) to consider the logic of the interaction model and its (possibly dynamic) relation to the meaning of the Protostory. Together, they constitute the global meaning of the work and the experience it affords. This expanded perspective is a key step forward in communicating the potential of IDN to practitioners and thus in the development of a pedagogy.

## 3.2 The IDN Designer: Skills, Attitudes, Knowledge

In order to develop a comprehensive IDN pedagogy, we have to establish desired skills, attitudes and knowledge of IDN practitioners, but also specific teaching methods. Essentially, the practice of IDN requires practitioners to be able to design and develop interactive systems. This requirement is fundamentally different from the approaches in well-established narrative practices, like filmmaking or creative writing. In many respects, the practice is akin to interaction design. Provisionally, we might therefore refer to the IDN practitioner as a narrative interaction designer. Like the interaction designer, the IDN practitioner needs to have a thorough understanding of interactive systems and user interaction. The IDN skill set includes abilities such as systems thinking, design thinking, interface design, iterative design, (paper) prototyping, programming and the ability to test and validate user experiences.

However, knowledge of the aesthetic qualities of the interactive medium as well as artistic application of its expressive potential is essential. The cyberbard creates engaging and satisfying narrative user experiences, full of opportunities for interaction. The authorial role in IDN is therefore more akin to a narrative architect, the creator of an aesthetic narrative structure for the interactor to explore and manipulate. We understand this experience as evoking the mental frame of narrative in the sense of the 'cognitive turn' in narratology [36, 37].

IDN benefits from an extensive understanding of narrative beyond dominant western models and insights from the fields of psychology, cognitive sciences and behavioral sciences. Specifically, practitioners need to master the elements that make interactive narratives engaging, including expertise in the areas of user mechanics, exposition techniques [19], character and world building, audio and sound design, and environmental narrative [38]. Intuitively, existing conventions and practices from established narrative formats like cinema, theatre and creative writing should be helpful in developing this expertise. In practice, however, techniques developed for non-interactive forms in legacy media can often be a hindrance to the development of design patterns for interactive, procedural media, as Murray has observed [22], which also reflects our own experiences [8]. Specifically, the procedural and participatory nature of IDN artifacts challenges traditional notions of authorship and authorial control [18]. Therefore,

learning to be a cyberbard means unlearning many deeply held convictions originating in dominant literary and filmic forms of narrative. A further obstacle to this educational effort is our limited knowledge of media-agnostic properties of narrative, something we try to address in related research [39].

Thus, IDN practitioners are not storytellers in the traditional sense. Rather than "telling a story," the IDN practitioner designs and develops an interactive system that enables users to instantiate stories, maybe even of their own [4]. Even though these user stories can be controlled by the system to various degrees (e.g. scripted narratives) [40], IDN has the ability to empower the user within the experience. In comparison to the filmmaker, the interactive narrative designer has less direct control over the user's experience. The IDN practitioner determines (elements of) the interactive system, which structures the behavior and experience of the user. Therefore, the interactive narrative designer must be willing to hand over some authorial control to the interactor. This does not mean that IDN cannot be used for making a clear statement. Rather, the process of expressing meaning in IDN must consider the diversity of userly performances.

In general, the practice of IDN can be situated within the field of creative technologies, located at the intersection of art, design and technology. IDN is an artistic practice; it offers new possibilities for human expression. IDN is also a design practice; its artifacts can be understood as applying comprehensive design conventions and serve a purpose beyond the artist's intended expression. IDN is a technological practice as well; it embraces new technologies as essential narrative tools. In terms of skills, attitudes and knowledge, then, interactive narrative designers might be approached as "creative technologists" [41]. They should be keen to explore the potential of new technologies but also have a deep interest in the user and her experience. In addition, practitioners should be willing and able to work in interdisciplinary teams. The IDN skillset might not commonly be found in one person alone, but in a team of audiovisual artists, designers and developers.

With regard to teaching methods, the pedagogy of IDN could benefit from existing ideas and practices in the educational domains of creative technology and 21st century skills learning. Teaching methods in these domains are often project-based and process-oriented [42]. Pedagogical concepts such as learning by doing [43], participation and play [41], blended learning [44], and flipping the classroom [45], could also be valuable for developing IDN teaching methods, especially when contextualized and rendered useful for the specificity of IDN theory and practice.

On a final note, creative technologists are required to (and should be equipped for) finding technology-driven solutions to complex problems in contemporary society [41]. This means that IDN practitioners need training in comprehending the role and significance of narrative in everyday life, for example with respect to communication [46] or identity construction [23].

## 4   Conclusion

In this paper, we have outlined an integrated approach as a roadmap for future IDN research. After a period in which research has focused on particular aspects, we emphasize connectedness and even interdependency of different aspects. Specifically, we draw

connections between Theory, Practice, Pedagogy and Culture, while focusing on analytical research through practice-based empirical methods, and the development of a specific pedagogy. Unlike more conventional research roadmaps, and given the work we have already done in the respective areas, our approach means to connect parallel efforts.

This interconnected perspective opens up exciting avenues for future research. For example, a qualitative research approach could analyze existing IDN design approaches through their cultural impact and critical validation in cultural channels such as curatorial essays, blogging, and user reviews on gaming platforms. Finally, our concern is decidedly focused on fostering an expanded artistic and professional practice. It is high time for IDN to make more inroads into the fabric of contemporary culture. We position our work as a move in this direction and extend an invitation for collaboration to other researchers in the IDN space.

# References

1. Szilas, N., Richle, U.M.: Towards a computational model of dramatic tension. In: Workshop on Computational Models of Narrative (2013)
2. Riedl, M.O.: A comparison of interactive narrative system approaches using human improvisational actors. In: Presented at the Intelligent Narrative Technologies III Workshop. ACM, New York (2010)
3. Louchart, S., Truesdale, J., Suttie, N., Aylett, R.: Emergent narrative: past, present and future of an interactive storytelling approach. In: Koenitz, H., Ferri, G., Haahr, M., Sezen, D., Sezen, T.I. (eds.) Interactive Digital Narrative, pp. 185–199. Routledge, New York (2015)
4. Bruni, L.E., Baceviciute, S.: Narrative intelligibility and closure in interactive systems. In: Koenitz, H., Sezen, T.I., Ferri, G., Haahr, M., Sezen, D., Çatak, G. (eds.) ICIDS 2013. LNCS, vol. 8230, pp. 13–24. Springer, Heidelberg (2013). doi:10.1007/978-3-319-02756-2_2
5. Mitchell, A., McGee, K.: Reading again for the first time: a model of rereading in interactive stories. In: Oyarzun, D., Peinado, F., Young, R.M., Elizalde, A., Méndez, G. (eds.) ICIDS 2012. LNCS, vol. 7648, pp. 202–213. Springer, Heidelberg (2012). doi:10.1007/978-3-642-34851-8_20
6. Szilas, N.: IDtension-highly interactive drama. In: AIIDE (2008)
7. Mitchell, A.: The HypeDyn Procedural Hypertext Fiction Authoring Tool, p. 1 (2016)
8. Koenitz, H.: Design approaches for interactive digital narrative. In: Schoenau-Fog, H., Bruni, L.E., Louchart, S., Baceviciute, S. (eds.) ICIDS 2015. LNCS, vol. 9445, pp. 50–57. Springer, Heidelberg (2015). doi:10.1007/978-3-319-27036-4_5
9. Spierling, U., Szilas, N.: Authoring issues beyond tools. In: Iurgel, I.A., Zagalo, N., Petta, P. (eds.) ICIDS 2009. LNCS, vol. 5915, pp. 50–61. Springer, Heidelberg (2009). doi: 10.1007/978-3-642-10643-9_9
10. Koenitz, H., Louchart, S.: Practicalities and ideologies, (re)-considering the interactive digital narrative authoring paradigm. In: Li, B., Nelson, M. (eds.) Proceedings of the 10th International Conference on the Foundations of Digital Games (2015)
11. Ferri, G.: Satire, propaganda, play, storytelling. notes on critical interactive digital narratives. In: Koenitz, H., Sezen, T.I., Ferri, G., Haahr, M., Sezen, D., Çatak, G. (eds.) ICIDS 2013. LNCS, vol. 8230, pp. 174–179. Springer, Heidelberg (2013). doi:10.1007/978-3-319-02756-2_21
12. Murray, J.H.: Hamlet on the Holodeck: The Future of Narrative in Cyberspace. Free Press, New York (1997)

13. Koenitz, H.: Towards a specific theory of interactive digital narrative. In: Koenitz, H., Ferri, G., Haahr, M., Sezen, D., Sezen, T.I. (eds.) Interactive Digital Narrative, pp. 91–105. Routledge, New York (2015)
14. Roth, C., Vermeulen, I.: Breaching interactive storytelling's implicit agreement: a content analysis of façade user behaviors. In: Koenitz, H., Sezen, T.I., Ferri, G., Haahr, M., Sezen, D., Çatak, G. (eds.) ICIDS 2013. LNCS, vol. 8230, pp. 168–173. Springer, Heidelberg (2013). doi:10.1007/978-3-319-02756-2_20
15. Roth, C.: Experiencing Interactive Storytelling (2016)
16. Knoller, N.: The expressive space of IDS-as-art. In: Oyarzun, D., Peinado, F., Young, R.M., Elizalde, A., Méndez, G. (eds.) ICIDS 2012. LNCS, vol. 7648, pp. 30–41. Springer, Heidelberg (2012). doi:10.1007/978-3-642-34851-8_3
17. Knoller, N., Ben-Arie, U.: The holodeck is all around us. In: Koenitz, H., Ferri, G., Haahr, M., Sezen, D., Sezen, T.I. (eds.) Interactive Digital Narrative, pp. 51–66. Routledge, New York (2015)
18. Dubbelman, T.: Playing the hero: how games take the concept of storytelling from representation to presentation. J. Media Pract. **12**, 157–172 (2011)
19. Dubbelman, T.: Narratives of Being There (2013)
20. Murray, J.H.: Inventing the medium. In: The New Media Reader, pp. 3–11. MIT Press, Cambridge (2003)
21. Koenitz, H.: Reframing Interactive Digital Narrative. Proquest, UMI Dissertation Publishing (2010)
22. Murray, J.H.: Inventing the Medium: Principles of Interaction Design as a Cultural Practice. MIT Press, Cambridge (2012)
23. Ricoeur, P.: Narrative identity. Philos. Today **35**, 73–81 (1991)
24. Habermas, J.: The Structural Transformation of the Public Sphere. Polity Press/MIT Press, Cambridge (1989)
25. Gamelab: Ayiti: The Cost of Life. http://ayiti.globalkids.org
26. Dufresne, D.: Fort McMoney (2013). http://www.fortmcmoney.com
27. Koenitz, H.: An iterative approach towards interactive digital narrative – early results with the advanced stories authoring and presentation system. In: Chiu, D.K., Wang, M., Popescu, E., Li, Q., Lau, R. (eds.) ICWL 2011 and ICWL 2012. LNCS, vol. 7697, pp. 59–68. Springer, Heidelberg (2014)
28. Koenitz, H., Chen, K.-J.: Genres, structures and strategies in interactive digital narratives – analyzing a body of works created in ASAPS. In: Oyarzun, D., Peinado, F., Young, R.M., Elizalde, A., Méndez, G. (eds.) ICIDS 2012. LNCS, vol. 7648, pp. 84–95. Springer, Heidelberg (2012). doi:10.1007/978-3-642-34851-8_8
29. Endrass, B., Klimmt, C., Mehlmann, G., André, E., Roth, C.: Exploration of user reactions to different dialog-based interaction styles. In: Si, M., Thue, D., André, E., Lester, J., Tanenbaum, T.J., Zammitto, V. (eds.) ICIDS 2011. LNCS, vol. 7069, pp. 243–248. Springer, Heidelberg (2011)
30. Roth, C., Vermeulen, I., Vorderer, P., Klimmt, C., Pizzi, D., Lugrin, J.-L., Cavazza, M.: Playing in or out of character: user role differences in the experience of interactive storytelling. CyberPsychol. Behav. Soc. Netw. **15**, 630–633 (2012)
31. Roth, C., Vorderer, P., Klimmt, C., Vermeulen, I.: Measuring the user experience in narrative-rich games: towards a concept-based assessment for interactive stories. In: Entertainment Interfaces (2010)
32. Cassirer, E.: An essay on man. Theol. Today **3**, 121–124 (1946)
33. Koenitz, H.: Towards a theoretical framework for interactive digital narrative. In: Aylett, R., Lim, M.Y., Louchart, S., Petta, P., Riedl, M. (eds.) ICIDS 2010. LNCS, vol. 6432, pp. 176–185. Springer, Heidelberg (2010)

34. Montfort, N.: Twisty Little Passages. MIT Press, Cambridge (2005)
35. Aarseth, E.J.: A narrative theory of games. In: Presented at the Foundations of Digital Games 2015 (2012)
36. Herman, D.: Story Logic. U of Nebraska Press, Lincoln, NE (2002)
37. Herman, D.: Storytelling and the Sciences of Mind. MIT Press, Cambridge (2013)
38. Jenkins, H.: Game design as narrative architecture. In: Wardrip-Fruin, N., Harrigan, P. (eds.) First Person: New Media as Story, Performance, and Game. MIT Press, Cambridge (2004)
39. Daiute, C., Koenitz, H.: What is shared? - A pedagogical perspective on interactive digital narrative and literary narrative. In: 9th International Conference on Interactive Storytelling ICIDS 2016 (2016)
40. Calleja, G.: In-Game. MIT Press, Cambridge (2011)
41. Connor, A.M., Marks, S., Walker, C.: Creating creative technologists: playing with(in) education. In: Zagalo, N., Branco, P. (eds.) Creativity in the Digital Age. Springer Series on Cultural Computing, pp. 35–56. Springer, London (2015)
42. Ravenscroft, A., Lindstaedt, S., Kloos, C.D., Hernández-Leo, D.: 21st Century Learning for 21st Century Skills. Lecture Notes in Computer Science. Springer, Berlin, Heidelberg (2012)
43. Dufour, R., DuFour, R., Dufour, R.: 21st Century Skills. In: 21st Century Skills (2010)
44. Zurita, H., Baloian, J.: A blended learning environment for enhancing meaningful learning using 21st century skills. In: Chen, G., Kumar, V., Huang, R., Kong, S.C. (eds.) Emerging Issues in Smart Learning. Lecture Notes in Educational Technology, pp. 1–8. Springer, Heidelberg (2014)
45. Scheg, A.G.: Implementation and Critical Assessment of the Flipped Classroom Experience. IGI Global, Hershey (2015)
46. Georgakopoulou, A., Goutsos, D.: Discourse Analysis. Edinburgh University Press, Edinburgh (2004)

# The Narrative Quality of Game Mechanics

Bjarke Alexander Larsen$^{(\boxtimes)}$ and Henrik Schoenau-Fog

Department of Architecture, Design and Media Technology, Section of Medialogy,
Aalborg University, Copenhagen, A.C. Meyers Vænge 15,
2450 Copenhagen, Denmark
bala12@student.aau.dk, hsf@create.aau.dk

**Abstract.** This paper will introduce and discuss a new model for under-standing the relation between narrative and games, by looking at the narrative quality of game mechanics. First, a review of the terms "Narrative" and "Game Mechanics" is made, and defined in this context, before a literature review, based on both narratological and ludological sources. From this, a model is presented and described, which encompasses the previous research as well as defining a clear relation between mechanics, context, story, and narratives of games. This model is intended for both design and analysis of games, and has been developed to cover a lack of definition of how game mechanics create narrative through their own definitions and their relation to the context and storytelling of the game. This model, still in an infant stage, shows potential, but still requires rigorous testing in several areas.

**Keywords:** Brave new ideas · Game mechanics · Narrative · Story · Interactive storytelling · Narrative quality · Aesthetics

## 1 Introduction

The power and possibilities of games is a topic under a lot of evaluation currently. With an increase in games for both personal expression [5,32,37] or games that differ from typical idea of "fun" [26,30], and concepts like "Empathy Games" [7] or "Games for Change" [18], it is becoming increasingly clear that game developers can and want to do more with games than keep them as fleeting entertainment.

The true power of these types of games, however, is not just that they convey difficult topics, but that they do so through their ludic elements: The mechanics and interaction the player is participating in. There is already a lot of research into game mechanics, play, and interaction with systems [3,17,25,36], but there is a distinct lack of definition of what mechanics can do when looking at the thematic or narrative qualities of these mechanics. This paper will attempt to define the power of game mechanics in a narrative sense–looking at what message mechanics convey inherently, and what narrative *playing* gives the player.

The paper will first define the terms "Narrative" and "Game Mechanics" through a literature review, before showing the relation of game mechanics and narrative through a model, which will be exemplified using the game "Papers, Please" [30].

© Springer International Publishing AG 2016
F. Nack and A.S. Gordon (Eds.): ICIDS 2016, LNCS 10045, pp. 61–72, 2016.
DOI: 10.1007/978-3-319-48279-8_6

## 2   Narrative

Narrative, in the traditional Aristotelian sense, has been defined as a series of connected events [12,39], and as Astrid Ensslin [12] says, a game is not a narrative in this sense, a sentiment most would agree with [2,16,23]. However, if we take a different approach to narrative, we get different results. To get there, first we understand that narrative has, in traditional narratology, been divided into "Story" (being the series-of-connected-events), and "Discourse". [39]. The discourse is *the version of the core story that is realized in an actual cinematic or dance or literary creation* [39], thus focusing on the way the story is told. This highlights that stories are not media-specific but instead the medium is part of the discourse itself. Barthes took that a step further, and already in 1977, proposed that games could fit into a schema similar to Greimas' actantial model [31] (a classical narratologist schema), where two opponents are fighting over an object, with the phrase *"a game is too a sentence."* [6] (cited from [31]).

The crucial difference is that the *telling* cannot be understood as a typical "narrating" process when looking at games. There is not a narrator providing an authored series of events. Instead, there are mechanics and gameplay. In traditional media, the discourse is the way the story is told, the point of view, the language used, the techniques we have known for thousands of years. A game's discourse comes through ludological techniques, the mechanics and the interaction itself. Mattie Brice [9] shows how the mechanics of a game can give similar emotional reactions as a linear narrative, and thus mechanics can be narrative elements. Larrimer [25] also (partly) succeeded in designing a game where the story was told through mechanics, which shows how this approach is possible.

But what then, is the narrative in a game? In the ludic sense, narrative is the aesthetics of the ludic elements themselves. Our view on game aesthetics stems from the MDA Framework [20], which state that Aesthetics are *"the desirable emotional responses evoked in the player, when she interacts with the game system."* [20] This is elegant both because it does not care what the desired emotion is, and because it focuses on the player's response. This inherently makes it possible to understand the narrative aspects of a game in a very direct sense.[1]

However, in an attempt to separate narrative and discourse, the following definition is used: Narrative is the story told. The story is the story itself (without the telling), and the discourse is then *how* it is told. But when a story is told and thus experienced, it becomes a narrative in the narratee's mind.

It should be stated, as will be clear once the model is described, that the narrative of the game is not necessarily *only* the ludic aesthetics, but can also come from the traditional storytelling—and more importantly, the relation between these two.

---

[1] As one of the parts of aesthetics is "Narrative" in the MDA framework, that obviously clashes with the idea that aesthetics are ludic narratives, and thus our understanding of aesthetics is slightly adjusted from MDA. This will be explained in Sect. 5.

## 3    Game Mechanics

The MDA Framework [20] puts game mechanics at the other end of the spectrum from aesthetics: Mechanics lead to dynamics, which lead to aesthetics. However, in order to understand this connection, we need to understand what game mechanics are. MDA defines them as the *"particular components of the game, at the level of data representation and algorithms."* Ernest Adams et al. [3] defines them as *"rules, processes, and data at the heart of a game."* [3]. Jesse Schell defines them as *"the interactions and relationships that remain when all of the aesthetics, technology, and story are stripped away."* [35] All these definitions show that game mechanics exist at the core of games, below the surface and as a general structure necessary for something to even be a game: No mechanics, no interaction, no game. And most argue that games with only mechanics—without context, "story", etc—are still very much games. The last definition, however, seems to contradict the idea of "narrative mechanics"—if the mechanics can still be there when the story is *"stripped away"*, how does it make sense that the mechanics convey a narrative?

To answer that, let us look at Frasca's "Simulation vs Narrative" [16]. In this paper, he argues for the separation and of "simulation" (which is an inherent property of games, as they can all simulate behavior) and "representation" (which is a trait of a traditional story, since all stories represent something). With this, Frasca describes three (plus one) ideological levels within simulations:

- **The Narrative Representation and events.**
- **Manipulation rules:** What the player is able to do.
- **Goal rules:** What the player must do to win.
- **(Fourth secret level) Meta-rules:** Adjusting the three other levels.

Setting the first level aside for now, the last three are mechanics, as we have already established that rules are mechanics. By looking at these alone, we can establish a narrative. Let us take the formal, iconic example: Tetris [28]. Tetris was already looked upon narratively by Jack Post [31], who placed it within Greimas' narrative models, using Barthes' definition of narrative. He argues that *"gameplay can be analyzed in narrative terms."* [31]. So the question becomes how to perform such an analysis. Here, we will suggest starting with the mechanical overview Frasca has given us.

Tetris is a game about stacking blocks. Every full line of blocks clears it, leaving more space. The goal is to keep playing as long as possible before the stack reaches the top. You have few options available when you play the game (manipulation rules): Rotating and moving a block sideways. It will fall down by itself. The goal rule defines the ideal scenario: Having no blocks. The way to do this is to organize the blocks and keep a structure so your "wall" stays intact. By setting this goal, the game makes a statement about what it values: Structure and order. You are given a random assortment of blocks, and only by ordering them efficiently can you stay alive.[2] If the goal had been to make the tallest tower,

---

[2] All narratives can have a thousand interpretations. This is just one of them.

Tetris would be played quite differently, and players would make some really sloppy towers. Here, the values are different: The game would value height and rapid construction, which is quite a different narrative. Nothing is mentioned about the representation here, nothing about the traditional storytelling: What you're stacking could be any number of things, but purely through the mechanics a meaning of the game is seen. The content of Tetris is that structure is valuable, and the discourse is the game mechanics, which gives us a narrative.

The narrative representation is worth a note, though. Frasca uses representation in simulation to get a certain result without affecting the simulation itself. And this is true, the narrative of Tetris is colored greatly if what you are stacking is e.g. not boxes, but people. This would not change the mechanics but alter the narrative. However, the shortcoming in this argument comes when thinking that the game does not have a narrative without representation. The mechanics still show what is being valued and what is possible—which in turn becomes a narrative about what is represented.

The choice of game mechanics is similar to the choice of framing in movies: By allowing the player to do certain things and value others, we imply a message, inherently through the mechanics themselves.

## 4    Related Models and Research

Espen Aarseth [2], presented in 2012 the "Variable Model", which showed what games and narrative have in common: Worlds, Objects, Agents, and Events [2]. These, he presents on an Ontic level, with a narrative pole and a ludic pole at each end. However, as is evident from the above breakdown of narrative and game mechanics, this schism of narrative and game, as two opposite poles on an axis, is troublesome. This is a common approach, also seen in, for example the PING model [8], but as is argued above, narrative is possible to have in a "pure game", as Aarseth calls it.[3] Yet, Aarseth's breakdown of the similar elements of games and (traditional) narratives is useful to keep in mind, though, and it will be incorporated into the model as it is a valid way of showing what elements a game has that can contribute to story [2].

Toh [38], using Ryan [34], analyzes the relationship between the narrative and the game, which includes ludonarrative dissonance, resonance and alienation. This concept of relations helps to describe a crucial point about how the representation aligns with what the game mechanics are trying to convey.

Ryan's definition of a narrative [34] presents a narrative as a scalar property, comprising of a spatial, a temporal, a mental, and a formal & pragmatic dimension, all seen as increasing the "scale" of the narrative, if present in the work. Interestingly, most of these map easily to the previously established definition of a narrative, with the only caveat being that the temporal changes of the world is not an authored part, but instead something that happens during play. Thus, we will say that the temporal dimension is only present when looking at

---

[3] It is important to note that in many cases the major difference is the definition of narrative, which is often the root cause of most of the ludonarrative debate.

the "afterstory" (explained in the next paragraph), and not the whole narrative. This touches upon something Koenitz [24] also brings up in his framework for IDN[4], where the separation is "System, Process, and Product". His claim is that the narrative is only present as a product of the interaction and thus not part of the system itself (Similar points are made with Ferri's "narrating machines" model [14]). This is mostly true, however, with one caveat: There are still visible narrative aspects to the mechanics, before they are ever instantiated. We can still analyse and predict the meaning of a game without playing. You do not have to play Tetris to understand the narrative we described above, but you do have to play it to *experience* it. Therefore, we do want to point out a distinction between the narrative (experienced, but also seen/analysed through discourse) and the "afterstory".

This is a concept inferred from Juul [23] who points out how it is possible to tell stories from the events of a video game, but that this does not mean that games were narratives. This phenomenon, which Jenkins [21] and others call "emergent storytelling", is the idea that from the dynamic interactions in games, emerges "narratives" that can later be told as a linear narrative. These "afterstories", as we will call them, does not show that games are narrative, but as argued above, that is not the focus of this paper. However, their existence will be used in the model as well.[5]

The last issue to touch upon is the player's role. That is a topic that can be written many volumes about, but here, it will briefly be touched upon in terms of narrative. Some [15,29] do not acknowledge that there are any characters in e.g. Chess, however, many others [12,31,33] argue that the players are characters in the world of the game. As this contextualises the player within the narrative, we will use this definition. It also has the profound consequence that games "without characters", such as Tetris, or Chess, still have characters.

## 5    The Narrative Quality of Game Mechanics Model

The model, seen in Fig. 1, consists of three parts, further split into sub-categories. It is meant to be seen as going from left to right. The left part is split into three categories. First is the content or story the author or designer wants to tell. This can be told in any medium or any format. This is, for the Tetris example, wanting to show the value of structure. This content is therefore in a sense the theme or intended feeling the author wants to impart, but it can also include elements of a traditional story, such as characters, plot etc. For an abstract game like Tetris, though, only the abstract content exists. Then, the designer begins to look at how this content is portrayed. This is done in two parts: *Mechanics* and *Context*. The game mechanics, as defined above, are the smallest units of the

---

[4] Interactive Digital Narratives. These are not quite games, necessarily, but there are many overlaps.

[5] The experienced narrative is closely related to the "postclassical" sense of narrative as a mental construct as defined by Herman [19], and while that cannot be disregarded here, we will focus more on the mechanical, discoursal parts of games.

**Fig. 1.** The Model, showing the relation of narrative, game mechanics and context of a game.

game, which implies messages through what is allowed and valued as winning and losing conditions. Added on top of Frasca's levels is a "System Rules" category, which describe all the rules that the player does not interact directly with—the AI, for example. The trick here is that the mechanics should all reinforce the story. Every mechanical decision made by the designer should be a reflection of what the game is trying to tell–otherwise it will tell something else.

The other aspect of the game is the context[6]. This is e.g. the presentation, the graphics, audio, effects, etc. designers introduce to make their game presentable to players, as well as to convey a certain style. This is also closely related to the mechanics as this, through elements like feedback, is the closest way the player is to understanding what happens in the game, and thus can follow and appreciate the mechanics, since mechanics by themselves are often hidden from the player. The other part of the context is what we have called *"Static Storytelling"*, which is what, in a traditional view, would be called the "narrative" or "story". This is the direct storytelling mechanisms, such as character interactions, dialogue, plot archs, world building, etc. This is called "Static" storytelling not because it is necessarily perceived the same for each playthrough, but instead, it is authored to follow a predicted (perhaps branching) sequence of events, whereas the other parts of games are (usually) more dynamic.

However, the truly interesting part of games, and what makes them unique, is the fact that these two elements begin to combine when the player begins to play. This is shown in the right part of the model. Here, mechanics and context is shown on a continuum, where they begin to relate and inform each other, as the player interacts with and perceives both. At the top, a mechanic will relate to another mechanic, which MDA would call *"dynamics"* and this word is used here as well. This is what causes mechanics to lead to unpredictable outcomes, because even just a few simple mechanics can quickly have an exponential variety of results when combined. Context relating to context, at the opposite end, is similar to a traditional storytelling medium. The middle, then, is the core of this model: When context relates to mechanics. Here is where the meaning of the game begins to form something unique. This relation is one of understanding the ways a mechanical interaction works within the context: Knowing that nothing exists in a vacuum, it is about analyzing if these interactions fit within the context or not. A successful example of this can be seen in the game "Brothers: A Tale of Two Sons" [1], where the control mechanic is a direct simulation of the two brothers and their need to cooperate with each other in order to fulfill their fairytale quest.

For all of these relations is a third dimension of Quality. A relation can have varying degrees of quality, which is determined by looking at two things: How well the relation works by itself, and how well it relates to the story. A relation can, in theory, work perfectly by its own, but if it tells something completely different

---

[6] Context can also be understood as the outside context, e.g. the players previous experiences, location, etc. but here we focus purely on the context within the game. Not to say that the outside context is not important but it is outside the control of the author and thus not part of the game specifically.

than the story intends, it has failed to support the game's story. However, if the relation perfectly describes the story, but fails as a relation by itself (mechanically, contextually, or both)—making it uninteresting, boring, or confusing—it has also failed the game. The mechanics and context are interrelational: They shape and influence each other, and when the relation is a strong one, it can make the game much more powerful in its narrative, since these will now inform and reinforce the same one instead of conflict with each other. These three relations combine into a narrative. Which, by extension, means that if we analyze how these three relations work, we can understand how a game's narrative works. The final part of the model is this narrative, which can be understood in three different ways. First of all, it exists as itself, which is the complete understanding created by all previous elements. However, we can also understand the narrative in a purely ludic sense, which we here call "Aesthetics", as in the MDA framework, although these aesthetics are understood purely as the aesthetic qualities of the ludic elements (the mechanics), and disbarring any of the context. The narrative in a "contextual" sense is the experienced (or emergent) story, which leads to the "Afterstory", which the player walks away with and can tell, as a traditional, linear story after having played the game. Finally, the arrows of the model are important, since they show a crucial part of this three-part narrative: First, a general narrative is formed from all three relations, then these spread out into aesthetics and the afterstory. This highlights how context and mechanics are *always* important in relation to each other, and cannot be experienced on their own. Tetris' barebones blocks are still a form of context and representation, and it would be impossible to play Tetris without.

Even if the initial story of a game can be seen as quite weak, as in for example "Minecraft" [27], where there is little story outside themes of "survival" and "creation", a game can still instill a powerful narrative, since it is the final product of the mechanics, context, and the relations between these that govern the whole narrative. Of course, a narrative can be different than the intended story, and it might be that Minecraft did not intend for any narrative to be interpreted from it. However, a story and narrative can be read into it nonetheless—just as many interpretations can be read into traditional media.

A final note is the vertical spectrum, which is taken from Bruni et al. [10], defining narrative system on a scale from abstract to didascalic (meaning clear, easy to understand), which fit with this model in an overall sense since mechanics tend to be abstracted compared to the more clear context. This can be used to see how a game may position itself on this spectrum.

## 5.1   Example: "Papers, Please."

The game chosen as an example of using this model for analysis is the game "Papers, Please", made by Lucas Pope in 2013 [30].

Papers, Please is a game about being a border control guard in the fictional country Arstotzka, inspired by Pope's experience with heightened immigration controls. Your job as the player is to check people's passports and let them

through if the papers are in order or reject them if they are not. Correct assessments earn you money, which you will use to keep your family healthy and fed. However, quickly you will be facing difficult moral choices where the people try to convince you to let them in, even though their papers are wrong. The genius of this game has already been commented by several game critics [4, 22], but has yet to be studied further in academic circles. The story of Papers, Please is the following: It wants to show how bureaucracy and the systematization of people begins to dehumanize them. How it does this is twofold, shown both through the mechanics and the context.

The *mechanics* of Papers, Please are (initially) very simple: A person comes to the border control, and you either reject or accept them. A player has free choice, but is punished for wrong judgment. To discover if the immigrants' papers are genuine, the player must compare the data on the papers with either facts known from elsewhere or other papers. The act of doing this becomes a series of number-checks wherein the player needs to compare numbers or texts with each other. "Is the gender of the passport the same as the person? Is the passport expired? Is the stated issued city actually a city in the country they come from?" are all examples of frequent questions the player will ask themselves for every visitor at the booth. More advanced mechanics get added during the playthrough, but the core always stays the same. The values are also clear throughout: Make the correct choice according to the rules of the country, regardless of personal preference. How that is shown is primarily through a punishment of the player character's family: Make too many incorrect choices—or be too slow at the evaluation process—and you will not have enough money to provide for your family, leading to an eventual losing condition.

The *context* of the game is in many ways, also simple. It follows a crude "pixelart" aesthetic, with simple, stylized characters and sparse dialogue. The "world" is one screen that never changes, and the objects at the player's disposal are mostly static—except the papers and stamps used to execute the mechanics. The characters themselves are often simplistic, and most of the interpersonal interaction is through the analysis of their passport, with height, issue date, country of origin etc. being common information given. The world reflects the bureaucratic country, with hard edges and a very militaristic (and corrupt) hierarchy of officials above you, pulling you in various directions. When losing or winning the game, a short sequence shows the consequences of your choices, many times it being a loss because of a mistake or several mistakes (from the country's perspective). The "winning condition" is also bleak: Survive for 30 days without too many errors, and your character is rewarded by being allowed to stay in the same position. Only by breaking the narrative rules of the world and forge passports (a wonderful touch of self-irony) can you escape the country.

Moving to the middle of the model, these mechanical and contextual elements lead to a very minimalistic traditional storytelling, with few, and often short, direct plot threads. The dynamics of the game lies primarily in resource management and stressful decisionmaking. The constant number-checking and time pressure forces the player to regard the world very coldly, and consider nothing

else than the rules of the system in order to succeed—regardless of how the representation tries to strike empathy through emotional—albeit simplistic—means. Even so, the little side-plots that happen underway can be quite effective at showing various sides of the conflict, be it a quirky character who persistently comes with obviously fake papers or the cult-like revolutionary power you can choose to help or counteract.

Because the decisions—systematically—are very simple, the complexity of the gameplay comes through in the interplay with the context. The constant decisions are colored by a bunch of factors the player has to keep in their head: "Can I let this woman through so she can see her husband after four years? Or will I not I have enough money to feed my family if I do that?" These decisions are always conveyed and made mechanically, but the context colors them and makes them more interesting. Furthermore, the willingness the player has to play within the rules of the system *and* the context decides how well they do. In a memorable playthrough, a superior officer ordered a player to accept a specific person, regardless of their papers. When this person came, they forgot her importance, and accidentally rejected her. This led to the player being fired and losing the game, because they did not play by the rules of the world—even though they did play by the rules of the ludic system.

This game shows how small, constant decisions creep up and you slowly lose empathy and willingness to trust in people. As you play, you are less and less willing to let people through with false passports, making you experience first hand how this systematization of humans can lead to dehumanization. Through the mechanics, the player themselves get to "feel" the narrative, and experience their own version of the narrative that shines through the gameplay and the context. And that is, beyond many other aspects, the true power of using games to tell stories: The player experiences the narrative firsthand.

## 6   Conclusions

This paper argues that game mechanics inherently convey a narrative through the possibilities and valorization of actions given to the player. Game mechanics are defined as the core of the interactive part of a game, and narrative is defined as the story told through a medium, and it is shown how any game inherently tells a narrative through its mechanics.

The "Narrative Quality of Game Mechanics" model is a suggestion for how to understand the interplay between narrative and game mechanics, seen through the way mechanics and context of a game relate. This was exemplified by showing how the game "Papers, Please" could be analyzed with the model.

The model, while still needing a lot of rigorous testing, both in terms of applying it to the analysis and design of games, seems to be a viable way to show how the narrative of a game works and how the mechanics are used, in correlation with the context, to tell a narrative. Further work with this model would include a detailed analysis to test its rigidity by applying it to more games, and investigate if it can be used to design a game or interactive digital storytelling experience as well.

As a final comment, during the writing of this paper, we found several cases of game critics or developers already talking about narrative implications of game mechanics [11,13,40], which shows how this kind of approach is already starting to become evident within the game industry, and thus it would be beneficial to unify and define these theories within academia and the interactive storytelling community.

# References

1. 505 Games: Brothers: A tale of two sons (2013)
2. Aarseth, E.: A narrative theory of games. In: Proceedings of the International Conference on the Foundations of Digital Games, FDG 2012, pp. 129–133. ACM, New York (2012). http://doi.acm.org/10.1145/2282338.2282365
3. Adams, E., Dormans, J.: Game Mechanics: Advanced Game Design. New Riders, Thousand Oaks (2012)
4. Alexander, L.: Designing the bleak genius of papers, please, September 2013. http://www.gamasutra.com/view/news/199383/Designing_the_bleak_genius_of_Papers_Please.php
5. Anthropy, A.: Dys4ia (2012). https://w.itch.io/dys4ia
6. Barthes, R.: Introduction to the structural analysis of narratives. In: Image, Music, Text. Fontana Press (1977)
7. Bartleson, E.: Empathy games: birth of a genre (2015). http://ctrl500.com/developers-corner/empathy-games-fighting-tears/
8. Bevensee, S.H., Dahlsgaard Boisen, K.A., Olsen, M.P., Schoenau-Fog, H., Bruni, L.E.: Project aporia – an exploration of narrative understanding of environmental storytelling in an open world scenario. In: Oyarzun, D., Peinado, F., Young, R.M., Elizalde, A., Méndez, G. (eds.) ICIDS 2012. LNCS, vol. 7648, pp. 96–101. Springer, Heidelberg (2012). doi:10.1007/978-3-642-34851-8_9
9. Brice, M.: Narrative is a game mechanic (2012). http://www.popmatters.com/post/153895-narrative-is-a-game-mechanic/
10. Bruni, L.E., Baceviciute, S.: Narrative intelligibility and closure in interactive systems. In: Koenitz, H., Sezen, T.I., Ferri, G., Haahr, M., Sezen, D., Ç atak, G. (eds.) ICIDS 2013. LNCS, vol. 8230, pp. 13–24. Springer, Heidelberg (2013). doi:10.1007/978-3-319-02756-2_2
11. Campbell, C.: Below is a stark and dangerous fairy tale (2016). http://www.polygon.com/2016/3/1/11135996/below-is-a-stark-and-dangerous-fairy-tale
12. Ensslin, A.: Video games as unnatural narratives. In: Ensslin, A., Fuchs, M. (eds.) Diversity of Play, p. 41. Meson Press, Luneburg (2015)
13. Extra credits: the division - problematic meaning in mechanics (2016). https://www.youtube.com/watch?v=4jKsj345Jjw
14. Ferri, G.: Narrating machines and interactive matrices: a semiotic common ground for game studies. In: Situated Play, pp. 466–473 (2007)
15. Frasca, G.: Ludologists love stories, too: notes from a debate that never took place. In: DIGRA Conference (2003)
16. Frasca, G.: Simulation versus narrative. In: Wolf, M.J.P., Perron, B. (eds.) The Video Game Theory Reader, pp. 221–235. Routledge, New York (2003)
17. Frasca, G.: Play the message: play, game and videogame rhetoric. Unpublished Ph.D. dissertation. IT University of Copenhagen, Denmark (2007)
18. Games For Change: Games for change (2016). http://www.gamesforchange.org

19. Herman, D.: Story Logic: Problems and Possibilities of Narrative. University of Nebraska Press, Lincoln (2004)
20. Hunicke, R., LeBlanc, M., Zubek, R.: Mda: a formal approach to game design and game research. In: Proceedings of the AAAI Workshop on Challenges in Game AI, vol. 4 (2004)
21. Jenkins, H.: Game design as narrative architecture. In: Salen, K., Zimmerman, E. (eds.) The Game Design Reader: A Rules of Play Anthology, Chap. 4, pp. 118–130. MIT Press, Cambridge (2004)
22. Juster, S.: Experiencing the banality of evil in 'papers, please', May 2013. http://www.popmatters.com/post/171036-papers-please/
23. Juul, J.: Games telling stories. Game Stud. **1**(1), 45 (2001)
24. Koenitz, H.: Towards a theoretical framework for interactive digital narrative. In: Aylett, R., Lim, M.Y., Louchart, S., Petta, P., Riedl, M. (eds.) ICIDS 2010. LNCS, vol. 6432, pp. 176–185. Springer, Heidelberg (2010). doi:10.1007/978-3-642-16638-9_22
25. Larrimer, S.: Where storytelling and interactivity meet: designing game mechanics that tell a story. Ph.D. thesis, The Ohio State University (2014)
26. Minority: Papo y yo (2012)
27. Mojang: Minecraft (2011)
28. Pajitnov, A., Pokhilko, V.: Tetris (1984)
29. Pearce, C.: Towards a game theory of game. In: Wardrip-Fruin, N., Harrigan, P. (eds.) First Person: New Media as Story, Performance, and Game, vol. 1, pp. 143–153. The MIT Press, Cambridge (2004)
30. Pope, L.: Papers, Please. PC, Downloadable (2013)
31. Post, J.: Bridging the narratology - ludology divide. The tetris case. In: Compagno, D., Coppock, P. (eds.) Computer Games Between Text and Practice, Chap. 2. E—C Rivista online di Studi Semiotici (2009). http://www.ec-aiss.it/monografici/5_computer_games/3_post.pdf. Accessed Aug 2016
32. Quinn, Z., Lindsey, P., Schankler, I.: Depression quest (2013)
33. Ryan, M.L.: Narrative as Virtual Reality. The John Hopkins University Press, Baltimore (2001)
34. Ryan, M.L.: Avatars of Story. University of Minnesota Press, Minneapolis (2006)
35. Schell, J.: The Art of Game Design: A Book of Lenses. CRC Press, Boca Raton (2014)
36. Sicart, M.: Defining game mechanics. Game Stud. **8**(2), 1–14 (2008)
37. Stuart, K.: Meet nina freeman, the punk poet of gaming (2015)
38. Toh, W.: A multimodal discourse analysis of video games: a ludonarrative model. In: Proceedings of DiGRA 2015: Diversity of Play: Games - Cultures - Identities (2015)
39. Toolan, M.: Narrative: linguistic and structural theories. In: Brown, K. (ed.) Encyclopedia of Language & Linguistics, 2nd edn., pp. 459–473. Elsevier, Oxford (2006). http://www.sciencedirect.com/science/article/pii/B0080448542005289
40. Walker, A.: Homefront: the revolution review (2016). http://www.giantbomb.com/reviews/homefront-the-revolution-review/1900-746/

# Improvisational Computational Storytelling in Open Worlds

Lara J. Martin[⊠], Brent Harrison, and Mark O. Riedl

School of Interactive Computing,
Georgia Institute of Technology, Atlanta, GA, USA
{lara.martin, brent.harrison, riedl}@cc.gatech.edu

**Abstract.** Improvisational storytelling involves one or more people interacting in real-time to create a story without advanced notice of topic or theme. Human improvisation occurs in an open-world that can be in any state and characters can perform any behaviors expressible through natural language. We propose the grand challenge of computational improvisational storytelling in open-world domains. The goal is to develop an intelligent agent that can sensibly co-create a story with one or more humans through natural language. We lay out some of the research challenges and propose two agent architectures that can provide the basis for exploring the research issues surrounding open-world human-agent interactions.

**Keywords:** Brave new ideas · Intelligent narrative technologies · Computational improvisation · Interactive narrative

## 1 Introducing Computational Improvisation

Storytelling has been of interest to artificial intelligence researchers since the earliest days of the field. Artificial intelligence research has addressed story understanding, automated story generation, and the creation of real-time interactive narrative experiences. Specifically, *interactive narrative* is a form of digital interactive experience in which users create or influence a dramatic storyline through actions by assuming the role of a character in a fictional virtual world, issuing commands to computer-controlled characters, or directly manipulating the fictional world state [1]. Interactive narrative requires an artificial agent to respond in real time to the actions of a human user in a way that preserves the context of the story and also affords the user to exert his or her intentions and desires on the fictional world. Prior work on interactive narrative has focused on *closed-world domains*—a virtual world, game, or simulation environment constrained by the set of characters, objects, places, and the actions that can be legally performed. Such a world can be modeled by finite AI representations, often based on logical formalizations. In this paper, we propose a grand challenge of creating artificial agents capable of engaging with humans in improvisational, real-time storytelling in *open worlds*.

Improvisational storytelling involves one or more people constructing a story in real time without advanced notice of topic or theme. Improvisational storytelling is often found in improv theatre, where two or more performers receive suggestions of

© Springer International Publishing AG 2016
F. Nack and A.S. Gordon (Eds.): ICIDS 2016, LNCS 10045, pp. 73–84, 2016.
DOI: 10.1007/978-3-319-48279-8_7

theme from the audience. Improvisational storytelling can also happen in informal settings such as between a parent and a child or in table-top role-playing games. While improvisational storytelling is related to interactive narrative, it differs in three significant ways. First, improvisational storytelling occurs in open worlds. That is, the set of possible actions that a character can perform is the space of all possible thoughts that a human can conceptualize and express through natural language. Second, improvisational storytelling relaxes the requirement that actions are strictly logical. Since there is no underlying environment other than human imagination, characters' actions can violate the laws of causality and physics, or simply skip over boring parts. However, no action proposed by human or agent should be a complete non sequitur. Third, character actions are conveyed through language and gesture.

In this paper we explore the challenges from and potential solutions to creating computational systems that can engage with humans in improvisational storytelling. We envision a system in which humans control some characters in an open world, while some are controlled by artificial intelligence. Beyond entertainment, computational improvisational storytelling unlocks the potential for a number of serious applications. Computational improvisational storytelling systems could engage with forensic investigators, intelligence analysts, or military strategists to hypothesize about crimes or engage in creative war-gaming activities. Virtual agents and conversational chatbots can also create a greater sense of rapport with human users by engaging in playful activities or gossip. Successful development of an artificial agent capable of engaging with humans in open-world improvisational storytelling will demonstrate a human-level ability to understand context in communication. It will also provide an existence proof that artificial intelligence can achieve human-like creativity.

## 2 Background

### 2.1 Interactive Narrative

Riedl and Bulitko [1] give an overview of AI approaches to interactive narrative. The most common form of interactive narrative involves the user taking on the role of the protagonist in an unfolding storyline. The user can also be a disembodied observer—as if watching a movie—but capable of making changes to the world or talking to the characters. A common solution, first proposed by Bates [2] is to implement a *drama manager*. A drama manager is an intelligent, omniscient, and disembodied agent that monitors the virtual world and intervenes to drive the narrative forward according to some model of quality of experience. An *experience manager* [3] is a generalization of this concept, recognizing the fact that not all narratives need to be dramatic, such as in the case of education or training applications.

There are many AI approaches to experience management. One way is to treat the problem of story generation as a form of search such as planning [3–5], adversarial search [6, 7], reinforcement learning [8], or case-based reasoning [9, 10], although planning is still appropriate for games since they are closed systems [11]. All of the above systems assume an *a priori*-known domain model that defines what actions are available to a character at any given time.

Closed-world systems can sometimes appear open. *Façade* [12] allows users to interact with virtual characters by freely inputting text. This gives the *appearance* of open communication between the human player and the virtual world; however, the system limits interactions by assigning the natural language input to dramatic beats that are part of the domain model. Open-world story generation attempts to break the assumption of an *a priori*-known domain model. *Scheherazade-IF* [13] attempts to learn a domain model in order to create new stories and interactive experiences in previously unknown domains. However, once the domain is learned, it limits what actions the human can perform to those within the domain model. *Say Anything* [14] is a textual case-based-reasoning story generator, meaning that it operates in the space of possible natural language sentences. It responds to the human user by finding sentences in blogs that share a similarity to human-provided sentences, but consequently tends to fail to maintain story coherence without human intervention.

## 2.2 Improv Theatre

Humans have the ability to connect seemingly unrelated ideas together. If a computer is working together with a user to create a new story, the AI must be prepared to handle anything the human can think of. Even when given a scenario that appears constrained, people can—and will—produce the unexpected. Magerko et al. [15] conducted a systematic study of human improv theatre performers to ascertain how they are able to create scenes in real time without advanced notice of topic or theme. The primary conclusion of this research is that improv actors work off of a huge set of basic scripts that compile the expectations of what people do in a variety of scenarios. These scripts are derived from common everyday experiences (e.g., going to a restaurant) or familiar popular media tropes (e.g., Old West shoot out). Magerko and colleagues further investigated possible computational representations of scripts used in improv [16], and how improv actors create and resolve violations in scripts [17].

## 3 Open-World Improvisational Storytelling

In order to push the boundaries of AI and computational creativity we argue that it is essential to explore open-world environments because (a) we know that humans are capable of doing so, especially with training (actors, comedians, etc.), and (b) natural language interaction is an intuitive mode of human-computer interaction for humans that is not constrained to finite sets of well-defined actions. Once the mode of inter-action between a human and an artificial agent is opened up to natural language, it would be unnatural and ultimately frustrating for the human to restrict their vocabulary to what the agent can understand and respond sensibly to. An intelligent agent trained to work from within a closed world will struggle to come up with appropriate responses to un-modeled actions. On the other hand, limiting the user's actions and vocabulary also limits the user's creativity.

There are two general problems that must be addressed to achieve open-world improvisational storytelling. First, an intelligent improvisational agent must have a set

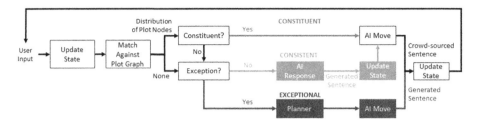

**Fig. 1.** The proposed plot graph system's architecture. (Color figure online)

of scripts comparable in scope to that held by a human user. This is in part addressed by systems, such as *Scheherazade* [18] which learns scripts from crowdsourced example stories, or various projects learning scripts from internet corpora [19, 20]. We loosely define a *script* as some expectation over actions. To date, no system has demonstrated that it has learned a comprehensive set of scripts; however, once a comprehensive set of scripts exists, these scripts can be used to anticipate human actions that are consistent with the scripts and generate appropriate responses.

Second, an intelligent improvisational agent must be able to recognize and respond to *off-script* actions. This means that the agent will need to generate new, possibly off-script actions of its own in order to respond to the player in a seemingly non-random way. The reasons why a human goes off script can be technical—the human's script does not exactly match the agent's script for the same scenario—or because the human wishes to express creative impulses or test the boundaries of the system.

Since humans normally tend to work off of some sort of script while improvising, whether it is explicit or not, the AI also needs to relate user utterances to a script through natural language understanding (NLU). Keeping track of a script is a matter of comparing the meanings of human utterances—or *semantics*—which is an open research question. Given language's nearly infinite possibilities, it is very unlikely that two people would use the exact same words or syntax to express the same idea. It is just as unlikely that a user would create a similar sentence as the creators of the agent would. Beyond understanding the meaning of individual sentences, there is still the matter of what the semantics of the sentence mean within the context of the entire story—also known as the *pragmatics*—since context is important to maintaining coherence in a conversation.

In the remaining sections, we will introduce two potential approaches. The first uses script representations closely aligned with observations of improv actors. The second uses neural networks trained on a corpus of stories.

## 4   Plot Graph Approach

We present a first attempt at creating a computational architecture for maintaining a coherent story context when co-creating with a human user. We acknowledge that open-world improvisation will not be solved until we address many open research

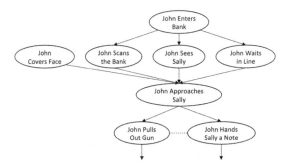

**Fig. 2.** A section of the robbery plot graph used in our system, where solid arrows represent temporal precedence and dotted lines represent mutual exclusion between plot event nodes.

challenges. Our goal is to offer an initial conjecture about how an improvisational agent might be built, which can be expanded upon as research challenges become solved.

The proposed system architecture is shown above in Fig. 1. First, the user enters in a line of text to narrate the action that they want the main character to take. This text is compared against the script, in this case represented as a *plot graph* (Sect. 4.1). Natural language processing happens in two stages: interpreting the semantic content in order to track the world state (Sect. 4.2) and determining the constituency of the user's action (Sect. 4.3). The agent employs different strategies for responding to sentences based on whether they describe actions that are constituent, consistent, or exceptional. Once the AI produces a sentence, the entire process repeats.

## 4.1   Introduction to Plot Graphs

For our work, we assume a script representation; in particular, one called a *plot graph*. Plot graphs have been found to be effective for interactive narrative and story generation [6–8, 13, 18]. We use the representation developed by Li et al. [18], which facilitates script learning from crowdsourced narrative examples. A plot graph is a script representation that compactly describes a space of possible stories (and thus expectations about stories) that can be told about a specific scenario such as going to a restaurant or robbing a bank. A plot graph is a directed acyclic graph where the nodes in the plot graph are events. One type of edge represents temporal precedence relationships between events. For example, consider the plot graph in Fig. 2, which shows a fragment of a plot graph for robbing a bank. The plot graph node <*John Enters the Bank*> is connected to <*John Scans the Bank*>, which means that the former event must be completed before the latter would be expected to begin. These relationships, however, are not strict causal relationships. The node <*John Covers Face*>, for example, is also connected to <*John Approaches Sally*> but has no parent node. This means that it can be executed at any time as long as it occurs before John approaches Sally. A second type of link between nodes represents mutual exclusivity of events, where the occurrence of one event predicts the absence of the other. Mutual exclusions encode branches in the plot where a choice leads to different variations of the scenario.

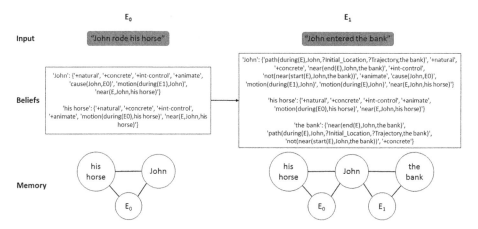

**Fig. 3.** An example of the two parts of the state where the first event is "John rode his horse" (E₀), followed by the second event: "John entered the bank" (E₁). On the top half of the figure are the beliefs of the AI shown after E₀ and E₁, respectively. The bottom half of the figure shows the AI's memory during these events.

Each plot graph node contains a set of semantically-similar sentences, describing the same event in different ways. A plot graph can be used to generate different legal sequences of events. The plot graph in Fig. 2 was learned from data and algorithms from Li et al. [18].

## 4.2   Maintaining World State

One of the challenges of open-world improvisational storytelling is representing and maintaining a world state without making too many constraining assumptions about the entities and relations between entities that can occur in the world. Furthermore, new entities, objects, and places can be created at any time. We propose that the AI's internal world state contains two aspects: the AI's current knowledge about the world's usable items (beliefs), and the AI's memory of the story.

The AI's belief system about world state must ground each user or AI turn in terms of the semantics of the action expressed in natural language. One solution is to ground all sentences using *VerbNet* [21], an ontology of verbs and their syntax-dependent semantics created by linguists to serve as a domain-independent verb lexicon. *VerbNet* consists of *frames* for sets of verbs that are semantically and generally syntactically equivalent. Frames contain rules for how to label entities playing roles in the sentences (e.g., "John rode his horse to the bank" infers that "John" and "his horse" are now at "the bank"), predicate-like facts about those roles (e.g., "John rode his horse" means that "John" and "his horse" moved), and limiting factors for which entities can fill roles (e.g., the verb "ride" requires an animate object).

We are augmenting *VerbNet* to include predicates about *accessibility* and *proximity*. Entities that are accessible exist in the world and entities that are proximate to the AI agent can be directly manipulated. When the user or the agent takes a turn, grounded

predicates are added to the agent's belief state, which continues to grow at every turn unless something becomes inaccessible (i.e., it dies, it disappears, it is eaten, etc.). See the top portion of Fig. 3 for an example of beliefs.

The AI's memory allows the agent to organize concepts based on recency and spatiality. We propose to use the *event-indexing model* [22], a psychology framework that is meant to explain how people comprehend new information and store it in their long-term memory. Event indexing has been modified previously for artificial intelligence and story comprehension to model a readers' memory [23, 24]. The AI maintains a memory graph of what nouns (entities) were mentioned during which turns and what is spatially proximate. Entities are connected to a special node representing the event, $E_n$, as well as to any other entity referenced by the event's sentence. The salience of objects can be computed as the distance in the memory graph between two objects. See the bottom portion of Fig. 3 for an example of an event-indexing memory structure that corresponds to the world state beliefs.

### 4.3  Responding to the User

Recall that improvisational storytelling involves identifying the script for a situation and then breaking that script. Therefore, one of the first things a computational improvisational agent must do is to identify whether the user is attempting to follow a script or break it. Riedl et al. [4] established a classification for how user actions relate to the sense of continuity and coherence in interactive narratives:

- *Constituent*: User actions that meet the expectation of the AI. In the case of improvisational storytelling, a constituent action is one predicted by the AI's script.
- *Consistent*: User actions that do not meet the expectation of the AI but do not prevent the AI from continuing to execute according to its script.
- *Exceptional*: User actions that do not meet the expectation of the AI and exclude the possibility of the AI continuing to execute according to its script.

An improvisational agent must determine if a user action is constituent, consistent, or exceptional. Consistent actions should be responded to before continuing with actions recommended by a script. Exceptions have been the subject of prior research [3, 4, 25]. Once an exceptional user action is identified, we need to have a system that can respond in a sensible matter via planning. We need a way to turn the action that was decided as an appropriate next step into a set of semantic units, and then translate the semantics into some sort of grammatical sentence. Natural language generation is not yet a solved problem, let alone generating creative sentences.

**Constituent Branch.** A constituent action indicates that the user is likely to be following the script. The constituent response strategy is shown in orange in Fig. 1. Our check for constituency is straightforward: The agent checks to see if the user's sentence matches against one of the plot events that can directly succeed the most recently-executed plot event. If the user's action is constituent, the agent can follow up by selecting a successor plot event from the plot graph (if the plot event belongs to an

AI-controlled character). To respond to the user, the agent can choose any existing sentence in the cluster of sentences associated with the selected plot graph node.

**Consistent Branch.** Consistent actions are those that do not move the script forward but also do not prevent it from moving forward. The agent's strategy for consistent actions is shown in purple in Fig. 1. If the agent fails to match the user's sentence to the plot graph and the action is not deemed an exception, the agent continues the story by generating an off-script response. While there are many techniques that can be used to select off-script responses, our proposal is to generate a response by identifying objects with high-salience from its "memory", selecting one that is accessible, and then determining which actions can be performed with said object. One way to determine which verbs can be performed on an entity is to query ConceptNet 5 [26], a commonsense knowledgebase that has a large number of facts about objects commonly found in the real world and what they are used for. The actions that can be performed on the object are looked up in VerbNet, and all possible sentences are generated from the verb frame's syntax templates by filling roles. Any sentence generated in this way can be selected randomly or ranked according to likelihood. The likelihood of a sentence can be computed by constructing a language model over a large corpus such as Wikipedia or Google's Project Gutenberg that estimates the how likely combinations of verbs and nouns are to co-occur in the English language.

**Exceptional Branch.** Exceptions occur when the user's action causes the world to enter a state in which no successor in the plot graph can be executed because one or more preconditions of each successor plot point is contradicted. Exceptions can also occur when future plot events that must occur likewise have their preconditions contradicted. For example, a character expected to contribute to the script is absent, a necessary object is missing, or the user is in the wrong place. The agent's strategy for handling exceptions is shown in red in Fig. 1. The improvisational agent must still act, and one strategy is to "repair" the script by finding another action, or sequence of actions, that is not part of the plot graph but restores the world state such that a subsequent plot point can execute. This repair process can be modeled as a planning problem: the task of searching for a sequence of actions that transforms the world state into one in which a goal situation holds. Planning has been applied to repairing stories represented as partial-order plans [3, 4] and stories represented as petri nets [25].

Planning can be used to repair plot graphs as well. The goal situation is any state in which the preconditions of a successor plot point or descendant of a successor holds. By finding a sequence of actions to be performed by the user and AI-controlled entities, the plot graph is restored and able to continue as normal; the planned sequence becomes a branch of the plot graph. However, there is at least one remaining open challenge. The space of possible actions, being all actions that can be expressed in language, is very large, and the complexity of search is proportional to the branching factor. Therefore, despite work on planning with language in closed worlds [27], the complexity of search through language in an open-world would have a very large, if not infinite, branching factor. Even abstracting actions into *VerbNet* frames results in a branching factor in the thousands (number of frames in the ontology times the number

of ways roles can be instantiated with known characters and objects).[1] Fortunately, most repairs are likely to require a sequence of one or two actions. Sampling-based planning algorithms such as Monte Carlo Tree Search may be adapted to story repair.

It is possible that no repair is possible, meaning the planner fails to find a sequence of actions that transforms the world into a state where the plot graph can continue executing. This may be due to non-reversible actions (e.g., an object is destroyed) performed by the user or due to the search failing because of the size of the search space and the need to respond within a small, fixed amount of time. In this case, new strategies will be required, such as switching to an emergent, reactionary storytelling mode such as that used to generate the response in the consistent branch.

## 4.4 Limitations

The proposed architecture addresses the challenges that we put forth earlier in this paper; however, there are several limitations that must be mentioned. One limitation is that this technique assumes the presence of a plot graph to act as a script. While *Scheherazade* has the ability to learn plot graphs from crowdsourced stories, it will be problematic to assume that the system will have access to all possible stories that a user may want to tell. Furthermore, the learned plot graphs may not match the scripts held in human users' heads, so the user may perform actions not in the AI's plot graph or skip over events deemed irrelevant or uninteresting. To handle greater stochasticity of human behavior, it will be advantageous to convert the plot graph into a dynamic probabilistic graph with skip-transitions, allowing the AI to jump to the most appropriate event in the plot graph. Often in improvisational storytelling, one would move seamlessly from one script to another or blend elements of several scripts. A more complete system would require the ability to recognize if the user has changed topics—a common yet not fully solved problem shared with other conversational AI systems—or to merge plot graphs to better explain what the user is trying to do.

Additionally, the performance of the agent is heavily reliant on the performance of the natural language processing (NLP) techniques used. NLP, especially in the areas of semantic reasoning and pragmatics are still open research problems. Further, *VerbNet* may not be the best technique for tracking semantics, and *ConceptNet* is known to be incomplete. These limitations are enumerated here to recommend research areas likely necessary to move the state of the art in interactive narrative systems toward those fully capable of open-world story improvisation with humans.

## 5 Neural Network Approach

We previously proposed the use of plot graphs to model expectation in a story and explicitly build up state information using external ontologies and corpora. One alternative way that this could be done is to model expectation using a recurrent neural network (RNN) with long short-term memory (LSTM) nodes to preserve story context.

---

[1] This analysis excludes the possibility of creating new objects.

These types of networks can take in a sequence of past events and generate a possibly infinite sequence of new events. During training, RNNs learn a representation of state that is embedded in the network's hidden LSTM layers. As a result, this technique is not as reliant on external ontologies to learn state information. In addition, expectation is innate in an RNN. Each time a new event is presented to the RNN, it will calculate a probability distribution over the expected next events. Thus, script information can be extracted by choosing the most expected event to occur at a given time step [20].

In terms of our initial proposed architecture, this means that an RNN is well suited to handle constituent actions that the user may take, where constituent would mean the user performed an event that the RNN was expecting to see with high probability. However, consistent and exceptional events—events performed by the user that are not high-probability transitions and may also create logical inconsistencies later—may present challenges to RNNs. As with the prior approach, consistent and exceptional events can be handled by turning improvisation into a planning problem.

There has been promising work done using deep reinforcement learning (Deep-RL) to dynamically generate dialogues [28]. Reinforcement learning is a technique for solving planning problems in stochastic and uncertain domains. A reward function provides a measure for how much value the algorithm receives for performing certain actions in certain states; reinforcement learning attempts to maximize expected reward over time. Deep-RL involves the use of a deep neural net to estimate the probability of transitioning from one state to another or the value that will be received in states it has not previously seen. Here, the RNN learns an internal representation of state and uses that in conjunction with an author-supplied reward function to determine the value of generating an event at the current time. Using this framework, these deep neural approaches can handle consistent and exceptional actions. If the user takes *off-script* actions, then the system will still generate events that will maximize its long-term reward. Thus, the system's behavior is largely dependent on how this reward function is defined. For example, if the reward function prioritized staying *on-script* then it would strive to return to a state where future events are predicted with high probability.

There are many advantages to this type of approach. First, it does not rely on external ontologies to build up a representation of state. These neural models can be trained on corpora of natural language, such as stories or news articles, including non-English corpora. In addition, this allows the system to easily learn different types of behavior based on the corpus used for training. The previously proposed architecture uses plot graphs to encode commonsense procedures and then provides strategies for handling unexpected user behavior. What a neural net *expects* would depend on the data it is trained upon; for example, training it on plot synopses of movies would naturally lead to expectations of dramatic behavior from the user and more commonsense behavior would be considered exceptional. One disadvantage of a neural network approach is that the state representation used by the RNN is obfuscated in the hidden LSTM layers. Thus, it is not clear as to why the system will make certain choices (beyond the goal of maximizing future reward). This loss in system transparency can make it difficult to evaluate the effectiveness of such a system. Since state cannot be directly observed, this leads to a greater likelihood of non-sequiturs due to mistaken beliefs about the state of the fictional improv world.

# 6   Conclusions

In this paper, we introduce *improvisational storytelling,* one or more people constructing a story in real time without advanced notice of topic or theme. We discuss some of the challenges that need to be addressed in order to create a computational, improvisational storytelling system and propose two architectures that address some of these challenges as a starting point.

As human-AI interaction becomes more common, it becomes more important for AIs to be able to engage in open-world improvisational storytelling. This is because it enables AIs to communicate with humans in a natural way without sacrificing the human's perception of agency. We hope that formalizing the problem and examining the challenges associated with improvisational storytelling will encourage researchers to explore this important area of work to help enable a future where AI systems and humans can seamlessly communicate with one another.

**Acknowledgements.** This work was supported by the Defense Advanced Research Projects Agency (DARPA) under Contract No. W911NF-15-C-0246. The authors would also like to thank Will Hancock for his work on our initial plot graph system.

# References

1. Riedl, M.O., Bulitko, V.: Interactive narrative: an intelligent systems approach. AI Mag. **34**, 67–77 (2013)
2. Bates, J.: Virtual reality, art, and entertainment. Presence Teleoperators Virtual Environ. **1**, 133–138 (1992)
3. Riedl, M.O., Stern, A., Dini, D.M., Alderman, J.M.: Dynamic experience management in virtual worlds for entertainment, education, and training. ITSSA Spec. Issue Agent Based Syst. Hum. Learn. **4**, 23–42 (2008)
4. Riedl, M., Saretto, C.J., Young, R.M.: Managing interaction between users and agents in a multi-agent storytelling environment. In: 2nd International Joint Conference on Autonomous Agents and Multiagent Systems, pp. 741–748. ACM (2003)
5. Porteous, J., Cavazza, M.: Controlling narrative generation with planning trajectories: the role of constraints. In: Iurgel, I.A., Zagalo, N., Petta, P. (eds.) ICIDS 2009. LNCS, vol. 5915, pp. 234–245. Springer, Heidelberg (2009)
6. Nelson, M.J., Mateas, M.: Search-based drama management in the interactive fiction anchorhead. In: 1st Annual Conference on Artificial Intelligence and Interactive Digital Entertainment, pp. 99–104 (2005)
7. Weyhrauch, P.W.: Guiding interactive drama (1997)
8. Nelson, M.J., Roberts, D.L., Isbell, C.L., Mateas, M.: Reinforcement learning for declarative optimization-based drama management. In: 5th International Joint Conference on Autonomous Agents and Multiagent Systems, pp. 775–782. ACM (2006)
9. Díaz-Agudo, B., Gervás, P., Peinado, F.: A case based reasoning approach to story plot generation. In: Funk, P., González Calero, P.A. (eds.) ECCBR 2004. LNCS (LNAI), vol. 3155, pp. 142–156. Springer, Heidelberg (2004)
10. Zhu, J., Ontañón, S.: Shall I compare thee to another story?—an empirical study of analogy-based story generation. IEEE Trans. Comput. Intell. AI Games **6**, 216–227 (2014)

11. Ware, S.G., Young, R.M.: Rethinking traditional planning assumptions to facilitate narrative generation. In: 2nd Workshop on Computational Models of Narrative (CMN 2010), pp. 71–72 (2010)
12. Mateas, M., Stern, A.: Integrating plot, character and natural language processing in the interactive drama Façade. In: Technologies for Interactive Digital Storytelling and Entertainment Conference, pp. 139–151 (2003)
13. Guzdial, M., Harrison, B., Li, B., Riedl, M.O.: Crowdsourcing open interactive narrative. In: 10th International Conference on the Foundations of Digital Games, Pacific Grove, CA (2015)
14. Swanson, R., Gordon, A.S.: Say anything: a massively collaborative open domain story writing companion. In: Spierling, U., Szilas, N. (eds.) ICIDS 2008. LNCS, vol. 5334, pp. 32–40. Springer, Heidelberg (2008)
15. Magerko, B., Manzoul, W., Riedl, M., Baumer, A., Fuller, D., Luther, K., Pearce, C.: An empirical study of cognition and theatrical improvisation. In: 7th ACM Conference on Creativity and Cognition, pp. 117–126. ACM (2009)
16. Magerko, B., O'Neill, B.: Formal models of western films for interactive narrative technologies. In: 2nd Workshop on Computational Models of Narrative, Istanbul, Turkey, pp. 83–90 (2012)
17. Brisson, A., Magerko, B., Paiva, A.: Tilt riders: improvisational agents who know what the scene is about. In: Vilhjálmsson, H.H., Kopp, S., Marsella, S., Thórisson, K.R. (eds.) IVA 2011. LNCS, vol. 6895, pp. 35–41. Springer, Heidelberg (2011)
18. Li, B., Lee-Urban, S., Johnston, G., Riedl, M.O.: Story generation with crowdsourced plot graphs. In: 27th AAAI Conference on Artificial Intelligence, pp. 598–604 (2013)
19. Chambers, N., Jurafsky, D.: Unsupervised learning of narrative event chains. In: Association of Computational Linguistics, pp. 789–797. Citeseer (2008)
20. Pichotta, K., Mooney, R.J.: Learning statistical scripts with LSTM recurrent neural networks. In: 30th AAAI Conference on Artificial Intelligence (AAAI-16), Phoenix, Arizona (2016)
21. Kipper-Schuler, K.: VerbNet: a broad-coverage, comprehensive verb lexicon (2005). http://repository.upenn.edu/dissertations/AAI3179808/
22. Zwaan, R.A., Langston, M.C., Graesser, A.C.: The construction of situation models in narrative comprehension: an event-indexing model. Psychol. Sci. **6**, 292–297 (1995)
23. Niehaus, J., Young, R.M.: Cognitive models of discourse comprehension for narrative generation. Lit. Linguist. Comput. **29**, 561–582 (2014)
24. O'Neill, B., Riedl, M.: Dramatis: a computational model of suspense. In: AAAI, vol. 2, pp. 944–950 (2014)
25. Riedl, M., Li, B., Ai, H., Ram, A.: Robust and authorable multiplayer storytelling experiences. In: 7th AAAI Conference on Artificial Intelligence and Interactive Digital Entertainment, pp. 189–194 (2011)
26. Speer, R., Havasi, C.: Representing general relational knowledge in ConceptNet 5. In: LREC, pp. 3679–3686 (2012)
27. Branavan, S.R.K., Kushman, N., Lei, T., Barzilay, R.: Learning high-level planning from text. In: 50th Annual Meeting of the Association for Computational Linguistics, pp. 126–135 (2012)
28. Li, J., Monroe, W., Ritter, A., Jurafsky, D.: Deep reinforcement learning for dialogue generation. arXiv Prepr. arXiv:1606.01541 (2016)

# GeoPoetry: Designing Location-Based Combinatorial Electronic Literature Soundtracks for Roadtrips

Jordan Rickman and Theresa Jean Tanenbaum[✉]

Department of Informatics, University of California, Irvine, Irvine, CA, USA
jrickman@uci.edu, tess.tanen@gmail.com

**Abstract.** In this paper we present GeoPoetry, a location-based work of electronic literature that generates poetic language and dynamic soundtracks for roadtrips that reflect the mood of people in the surrounding area. GeoPoetry takes recent nearby geotagged Twitter data and generates strings of combinatorial poetry from them using simple Markov-chain text generation. It also performs a sentiment analysis on the local Twitter traffic, which it uses to seed a playlist on Spotify, using a simple model of affect. The result is a sonic reflection of the social geography traversed by the user that responds to its situatedness in both space and time. GeoPoetry participates in a long tradition of public and locative artwork which has the potential to inspire exciting new works of interactive narrative.

**Keywords:** Locative media · Electronic literature · Combinatorial narrative · Sonification · Emergent narrative · Markov chains · Sentiment analysis

## 1 Introduction

As mobile computing grows more pervasive and ubiquitous a small (but growing) collection of artists, researchers, and designers have started to create playful digital experiences that are meant to be experienced away from the stationary desktop or gaming console. The conceptual roots of these traditions lie in a number of interconnected 20th century artistic movements that sought to liberate art from authoritarian systems and contexts including Dadaism [1], Fluxus [2, 3], Situationism [4, 5], and Happenings [3, 6], as well as avant garde and political theater practices such as Boal's *Theater of the Oppressed* [7] and Brecht's *Epic Theater* [8]. These movements subverted existing orthodoxies around art, power, and the notion of the audience or spectator, often proposing and executing performances and artworks that undermined any critical or conceptual distance between artist, viewer, and context. They form a conceptual foundation for contemporary location-based digital entertainment systems, which can trace their immediate technological and theoretical roots to a number of parallel academic traditions including Ubiquitous Computing [9, 10], Pervasive Gaming [11], and Context-Aware Computing [12–14].

Connecting all of these areas is a broad concern with location awareness, mobility, and sensing technology to attends to the *situatedness* of the user in time and space. Within the Interactive Digital Narrative (IDN) community, there has been an increased interest in these kinds of pervasive and locative technologies as a platform

© Springer International Publishing AG 2016
F. Nack and A.S. Gordon (Eds.): ICIDS 2016, LNCS 10045, pp. 85–96, 2016.
DOI: 10.1007/978-3-319-48279-8_8

for adaptive storytelling technology, but the design space for these experiences remains underdeveloped when compared to the design space of more traditional, non-pervasive, digital narratives. In this paper we present GeoPoetry: a new combinatorial location-based work of electronic literature that expands the design poetics of pervasive storytelling into new territory. We describe our vision for GeoPoetry – currently a work-in-progress – and then describe the design and implementation of the current system. We reflect upon our design process which has illuminated a set of challenges and design considerations that we consider instructive of other more fundamental poetics for locative narrative technologies.

## 2    Key Concepts and Previous Work

In their book on Pervasive Games, Montola et al. argue that one of the defining characteristics of the medium is an expansion of the bounds of Huizinga's "Magic Circle" [15, 16] along three dimensions: spatial, temporal, and social [11]. Pervasive games don't take place in a fixed location or playing field, they are not bounded by traditional play-times or crisply delimited play sessions, and they take place in public spaces, often with-and-around spectators and other people who are not explicitly playing the game. For this work we attend specifically to the notion of "spatial expansion", which Montola et al. further break down into three different categories: location-free games, site-adaptable games, and site-specific games [11].

- **Location-Free Games** are games that use space and distance to expand gameplay, but which are indifferent to the specifics of the spaces where they take place. Thus, a location-free game might require a player to deviate from a normal route, or to seek a high-vantage point, but these activities could be transplanted to another setting without meaningfully altering the game.
- **Site-Adaptable Games** incorporate some semantic awareness of their location into their gameplay, often at the level of generic categories that can be found in a variety of locations (such as banks, parks, schools, etc.) A site adaptable game can be shifted from one region to another so long as the new location has a similar complement of these generic settings.
- **Site-Specific Games** draw on the specific historical, aesthetic, and architectural details and affordances of the location where they are designed and deployed. Because they incorporate specific local details into their design they cannot be relocated without significant cost.

In our review of existing locative digital storytelling systems, we found that the line between "location-free" and "site-adaptable" designs was blurry, with most designs being either site-adaptable or site-specific. For this reason, we choose to focus on these two categories.

## 2.1  Site Specific Storytelling Systems

The vast majority of current locative storytelling systems are designed to explore a specific site. A common strategy is to create an adaptive "guide" for a museum or other cultural heritage site. Lombardo & Damiano created a location aware animated character who supported visitors exploring the historical Palazzo Chiablese in Turin, Italy [17]. Wakkary et al. developed *Kurio:* an interactive museum guide that tracked the locations of family groups as they explored a local history museum in Surrey, Canada [18]. Lu and Arikawa created a map-based storytelling tool that arranged events along a walking tour path through Tokyo, Japan [19]. In *Riot!* the lines between interactive heritage guide and interactive drama are blurred through the use of site-specific mobile technology to recreate important moments from a series of 19th century riots in Britain [20, 21]. Other site specific systems are closer to distributed theater, like Hansen et al.'s *Mobile Urban Drama* where groups of live actors are staged around a large environment that the spectator/user navigates using a mobile phone. Paay et al.'s *Who Killed Hanne Holmgaard?* is a similar, but more technologically mediated experience, where pairs of players navigate the city center of Aalborg, Denmark, uncovering pieces of the fictional world on their PDA devices [22]. This fits into a paradigm of locative storytelling where the environment becomes the site of a mediated scavenger hunt. There have been several other designs where media is distributed through space including Nisi et al.'s *HopStory* [23] and *Location-Aware Multimedia Stories* [24] and Crow et al.'s *M-Views* [25].

## 2.2  Site-Adaptable Storytelling Systems

There are fewer site-adaptable systems to be found, but they are more directly relevant to the design of GeoPoetry. One direct precedent for our work is *Backseat Playground* [26, 27] which is designed to be played by passengers in the backseat of a moving vehicle. Backseat Playground incorporates local GIS information about nearby landmarks and common geographical objects into a sequential narrative that is experienced over the course of a journey. Another inspiration for GeoPoetry is Schoning et al.'s *WikiEar* system, that draws on crowdsourced text to generate narratives about specific locations [28, 29]. Similarly, the GEMS system allows users to upload personal narratives about particular locations, relying more heavily on crowdsourced data [30]. GeoPoetry is site-adaptable, but it is unique in that it mines real-time data from its surroundings. In the following sections we describe it in greater detail.

# 3   System Design

The current prototype of GeoPoetry is still very much a work-in-progress, but we believe that in its current state it still serves as an interesting exploration of the design-space of location based narrative systems Our current implementation comprises two components: a web frontend and a server backend. The frontend is written in HTML, CSS, and Javascript using the popular AngularJS framework. The backend is written in Python. It

depends on several open-source Python projects, namely: Flask, a web microframework[1]; Flask-CORS[2], a Flask extension adding support for Cross-Origin Resource Sharing; Twython, a wrapper for the Twitter API[3]; Spotipy, a wrapper for the Spotify API[4]; pytest, a unit testing framework[5]; fudge, a framework for mocks and stubs[6]; markov-text, a Markov-chain text generator[7]; and VADER, a rule-based sentiment analysis library[8]. The backend and fronted communicate over HTTPS using the JSON data serialization format.

Each request to generate location-linked poetry requires 5 parameters: latitude, longitude, radius (specified as either miles or kilometers), genre, and energy. First, the Twitter API is queried for tweets that are geotagged within the radius of the specified latitude and longitude. Some simple filtering is applied in an attempt to exclude marketing and promotional tweets – see the discussion section below. The tweet text is cleaned of URLs, hashtags, and "@mentions." The resulting corpus of text is fed into a Markov-chain text generator, which generates a few lines of "poetry" that are, statistically speaking, similar to what people in the area are saying on Twitter – albeit largely nonsensical.

Next, this same corpus of text is fed into VADER's sentiment analysis algorithm. Sentiment analysis yields a parameter called the valence, which ranges from $-1$ (extremely negative affect) to 1 (extremely positive affect), and can be any number in between. Spotify's music recommendation API requires at least one seed, which can be a genre, track, or artist. We use a seed genre, which may be selected by the user but defaults to "ambient." In addition to the genre, we specify three parameters for Spotify's API: valence, given by our sentiment analysis; energy, a measure of activity and intensity; and instrumentalness, which we always set to its maximum value. This is to prevent lyrical content from the soundtrack to interfere with the poetic output of the text generator. The Spotify API returns a track ID, which the web frontend uses to display a playable Spotify widget alongside the generated lines of poetry.

We employ Russel's "cicumplex" model of affect as a simple model for the conceptual "mood space" for this work [31]. Russel divides affect into two axes: valence and arousal, where valence is positive vs. negative affect, and arousal is high vs. low energy. This model lends itself well to describing music, in particular, and maps well to parameters within Spotify's API. Valence and arousal together describe the mood that the music track seeks to capture and convey. However, as we discuss in more detail in the next section, VADER's sentiment analysis only yields one dimension of affect: valence. To determine arousal, we draw on GPS information about the speed of the vehicle: faster speeds yield higher arousal, while slower speeds yield lower arousal.

A key feature of the system remains in development: speech synthesis. In order to properly experience the poetry generated by the system while driving, the poetry needs

---

[1]	http://flask.pocoo.org/.

[2]	https://github.com/corydolphin/flask-cors.

[3]	https://github.com/ryanmcgrath/twython.

[4]	https://github.com/plamere/spotipy.

[5]	http://pytest.org/.

[6]	http://farmdev.com/projects/fudge/.

[7]	https://github.com/codebox/markov-text.

[8]	https://github.com/cjhutto/vaderSentiment.

to be read aloud. This feature is currently being implemented, and there are several design considerations that have already become evident through the process. First, the design needs to consider the two different time scales at work within the system. Song lengths can vary significantly but are often between 3 and 8 min in duration. The reading aloud of a fragment of GeoPoetry takes significantly less time, with most of the poems generated by the system lasting less than 30 s. Second, there is a probability of textual confusion if the song queued by the system includes lyrical content which could render the text of the poetry incoherent. Finally, there is the aesthetic question of how to best juxtapose the reading of the poetry alongside the playing of the music, and the technical question of how to manage the volume level of both of these such that both are audible and intelligible. To solve the first problem, we propose that GeoPoetry only generate and read new poems when a new music track is triggered. We believe this will strike a balance between textual content, and musical content, and will also allow the system to re-sample the current location, yielding poetry that moves with the listener through both space and time. We have already addressed the second issue, by using Spotify's API to only search for *instrumental* (non-lyrical) music. This serves our aesthetic goals for this work by creating playlists that reproduce some of the poetics of film scoring. The third challenge for this design remains unresolved, and will require significant trial and error in order to produce aesthetically pleasing and intelligible combinations of words and music.

**System Architecture.** Figure 1 illustrates the architecture of Geo-Poetry, and the flow of information between components of the system. Dashed lines indicate information passed in an HTTP request, and dotted lines indicate information returned from an HTTP request. As described earlier, "cleaned" tweets have all hashtags, @mentions, and URLs removed.

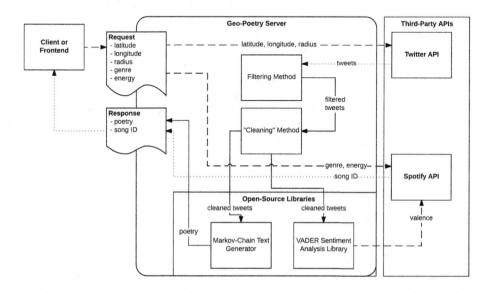

**Fig. 1.** Architecture diagram illustrating data flow when generating poetry

**Sample Output.** For the purposes of testing the geographical situatedness of the output, we ran the system with a variety of GPS coordinates. Table 1 shows some of the generated "poetry", and the valence used to choose a song. All requests included in the table used a radius of ten kilometers, and were performed on the evening of Friday, August 18th (Pacific Time). Note that all valences range from 0.0 (extremely negative) to 1.0 (extremely positive).

During this testing process, we were struck by the preponderance of material that scored negatively on the affect scale. This confirms for us the common sense that twitter is an overwhelmingly negative place[9] and raises some important questions for us for future work.

**Table 1.** Sample output at multiple locations

| Location | Poetry | Valence |
|---|---|---|
| UC Irvine, California | I love is Friday and I'm kinda tired but for a message - mr robot tho - at Library on the beginning again is gorgeous | 0.091233 |
| Kuhio Beach, Honolulu | Yes stop - I instantly think they live in Mexico and Insta - Designed by marine cops | 0.100336 |
| The Capitol Building, Washington, D.C. | Body hurt chest hurt I'm probably just my one name and us raise funds for helping import cholera epidemic to 658 of cartoons*Whacks*shoves at - They Luck When Sh_t Get Real on my profile - Gotta get more on television by and retweeting on this African Mechanic out | 0.098348 |
| Taksim Square, Istanbul | Alma Mazlumun Ah n g n ergenekon - Iktidar g nayd n Anadolu Hisar in stanbul - Bu ehir yaln zca beni de il passe cr me about burkinis tho U can get | 0.021440 |
| The Vatican, Vatican City | Pure io oggi non meno di R diger e quando pensiamo che prenda decisioni stupide - Car By B - There are ten of 69F | 0.078147 |
| Dome of the Rock, Jerusalem | Menpar Arief Yahya Berencana Hadiri Toba Grand Fondo 2016 Thirsty Check out with a true Sigh - Least of the time - Whats love I guess | 0.041793 |
| King's Cross Station, London | ChooseLoveAlbum OutNow That's why not on arrival crews assisted a quiz on showing this year then Olympics mixed with my - ah…you're like blood donation - I just finished running 6.36 km in the palm trees | 0.147892 |

---

[9] This sentiment is common within the popular media: https://www.buzzfeed.com/charlie-warzel/a-honeypot-for-assholes-inside-twitters-10-year-failure-to-s?utm_term=.wmwA54Lx B#.jjBj5KP6o.

# 4   Discussion and Design Considerations

In designing and developing GeoPoetry we have encountered a number of challenges that we think are of relevance to others developing location-based storytelling systems, especially once real-time data becomes involved. In this section we consider these difficulties and discuss how we've addressed them in our design.

## 4.1   Neutral Valence

A key element of our vision for GeoPoetry is that the system should capture the overall mood of the crowd in the area. In our current implementation, this feature is provided by the sentiment analysis component. The sentiment analysis library that we use, VADER, is specifically tailored for analyzing social media content [32]. However, gauging the overall sentiment of the crowd proves to be a more challenging problem, thanks to dynamics of scale.

In order to properly seed the Markov-chain text generator, our system consumes a large number of tweets – the current implementation reads 500 tweets, although that number is a configuration constant and can be easily changed. Sentiment analysis is applied to each tweet individually, and the resulting valence measure is averaged across all tweets read. At such a large scale, the valence falls prey to the law of averages – average valence tends towards neutral (zero). Aesthetically, this is a problem: it yields uninteresting and uniform results when plugged into our system. In an attempt to mitigate this problem, we experimented with excluding relatively neutral tweets from the average. We considered tweets to be "relatively neutral" if their valence fell within a certain interval centered around zero – for instance, plus or minus 0.2.

However, with so many data points, positive and negative tweets tended to cancel each other out, and the problem persisted. We never saw the average sentiment deviate more than 0.35 away from neutral (on a scale from $-1$ to $1$). These results may indeed reflect the overall sentiment of the crowd – it is intuitive that given a large number of people not necessarily discussing the same topic, their average sentiment will tend toward neutral. Nonetheless, we desire a system that will provide more variety in valence, and we want assurance that significant spikes in overall sentiment – for example, in the event of a breaking news story – will be noticeable by the listener.

We will explore this challenge further in future iterations of the project. A couple possible approaches stand out. A simple solution might be to process fewer tweets. More variability in average valence can then be expected. However, experimentation would be needed to find an ideal corpus size that balances the need for fewer tweets in order to gauge sentiment with the need for a large corpus in order for the Markov generator to recombine the text into a sufficiently original composition (given too small of a corpus, such a generator will often regurgitate its input verbatim). Alternatively, we may be able to apply more sophisticated statistical techniques to detect interesting trends or outliers.

## 4.2   One-Dimensional Sentiment Analysis

Most implementations of automatic sentiment analysis are one-dimensional. That is, they return a single measure of valence: from negative, through neutral, to positive [32]. While this is useful information, emotion is clearly a far more complex and nuanced thing. Moreover, in GeoPoetry we are specifically interested in mapping affective information to musical accompaniment, and the affective qualities of a piece of music are also multi-dimensional.

We have already described how we are specifying both "valence" and "arousal" for a song selection, and how the one-dimensionality of sentiment analysis forces us to specify song arousal independently of the set of tweets the system reads. Spotify's recommendation API accepts several more parameters that might relate to the perceived affect of a track, including "acousticness," "danceability," "loudness," and "tempo." Other recommendation engines may accept more or different parameters. One-dimensional analysis and mapping of "valence" only scratches the surface of the general challenge of selecting music that matches the affective content of a textual corpus.

Fortunately, there is some research in the direction of multi-dimensional sentiment analysis. SenticNet [33] is a project aimed at developing sentiment analysis based on semantic concepts, as opposed to individual words. The project provides a database of 30,000 (English-language) concepts, accessible via a REST API. Each concept is described by four dimensions: "pleasantness," "attention," "sensitivity," and "aptitude," as well as a "polarity" measure intended to be closer to the typical one-dimensional valence. The authors describe a new model of affect, the hourglass model, using the four dimensions [34].

Although we discovered SenticNet while developing our current implementation of GeoPoetry, we did not have the resources to integrate it. The API provides only a database of concepts, so we would need to implement an algorithm to recognize the concepts contained within a text, as well as an algorithm to combine those concepts into some representation of overall sentiment. We did not have the time to tackle such a nuanced affective computing problem, so we resorted to one-dimensional sentiment analysis, for which we found open-source implementations that could be readily integrated into our codebase. In future iterations of the work, we may explore the use of SenticNet, or other multi-dimensional sentiment analysis frameworks. Sentiment analysis is an active area of research in affective computing, so the future holds the promise of a more sophisticated mapping from source text to affectively relevant music.

## 4.3   Filtering for "Everyday Human" Tweets

Our vision for GeoPoetry is that it should reflect the sentiment and conversation of the nearby crowd, by which we mean everyday human beings living or traveling in the geographic area. Twitter is an ideal source corpus for this, because of its sheer popularity, its widespread integration of geotagging capability, and its microblogging format (which encourages frequent updates, giving us a constant stream of new material). However, Twitter's status as the dominant microblogging platform also creates a challenge to our vision: the proliferation of tweets that do not contain the remarks of an actual human

being. In particular, Twitter is a popular platform for marketing and branding. Therefore, we apply several filters to the set of tweets our system reads, in order to limit our corpus as best we can to the remarks of everyday people.

First, we excluded "retweets." Retweets are often a vehicle for sharing third-party content, not one's own remarks. Even if the tweet being retweeted is the remark of an everyday person (say, the retweeter's friend or acquaintance), including retweets will create duplication in the corpus.

Second, we exclude tweets from "verified" accounts. Verified accounts are given that special status by the Twitter corporation, in a process that is opaque to outsiders. According to the Twitter FAQ, "Verification is currently used to establish authenticity of identities of key individuals and brands on Twitter."[10] Verified accounts are often celebrities or other public figures, or marketing accounts belonging to corporations. Therefore, their content does not reflect the thoughts of everyday human beings. Following a similar logic, we exclude tweets from accounts with more than 10,000 followers, reasoning that someone with such a large following is unlikely to be an "everyday human being" - or at least, is likely to tailor their content to their large following and personal brand, reducing the authenticity of their remarks.

Although we have no quantitative measure of the success of these filters, they seem to be effective enough for our purposes. The most important measure of success was that our system did not produce poetry that sounded like it was recombined from an advertisement. With Markov-chain generation on a large corpus, a few not-regular-human tweets can slip through without significantly affecting the results. Nonetheless, there may be room for improvement in future work. For example, one could argue that the duplication provided by retweets is desirable, provided the original tweet is the remarks of an everyday human. The resulting "signal boost" would make the retweeted content more likely to come out of the Markov text generator, reflecting the fact that multiple people saw it as a remark worth sharing. The selection of which tweets to exclude or include is a matter of authorial discretion, and we will continue to experiment with it.

## 5    Conclusions and Future Work

In this paper we've presented GeoPoetry – a new approach to location-based storytelling, drawing on real-time social media data to create combinatorial soundtracks to road trips. While the system itself is still clearly a work-in-progress, we believe that the design and development process have already uncovered some interesting and useful design poetics that have not be discussed within the electronic literature and digital storytelling communities.

There is much work still to be done on this project at both the technical and artistic levels. Technically, we have identified a number of features that need to be implemented in order to consider the system complete, the most important of which is the inclusion of a speech synthesis capability. However, the more interesting questions surrounding

---

[10] https://support.twitter.com/articles/119135.

this work have to do with the experience that it creates, and the ways in which it reflects its datasets back into the lives of its users. Unlike many systems within the digital story-telling research space, GeoPoetry lacks the clear metrics of "narrative coherence" or "believable agents" to help assess whether it has successfully achieved its aesthetic goals. In this sense it is more like a work of digital media art, or electronic literature, where the criteria for success are more subjective and ephemeral. The kinds of questions we would like to ask of this system in any user study come down to its aesthetic and affective *legibility:* Do participants correctly perceive the sentiment expressed by the system? Does GeoPoetry have an impact on the experience of a participant, and how does that impact manifest itself? Does the system respond to events and changes in the geo-social landscape and is this response legible to listeners? There is also the bigger question about the suitability of Twitter as a dataset for this kind of location-based poetry. While it lends itself readily to a markov-chain text generation process, the data requires significant cleaning and filtering, and the underlying sentiments expressed on the platform tend to be predominantly negative. Future versions of GeoPoetry will explore other datasets, which will yield new challenges and insights into the design of locative media.

We argue that GeoPoetry represents a new genre of generative storytelling systems that are situated in both time and space. While the aesthetic goals of our current system are oriented towards the production of a poetic abstraction of a geo-social context, there are many other approaches that could be taken using the same underlying infrastructure. GeoPoetry begins to open up the design space for real-time sonification of the invisible flows of data that surround travelers, and as more and more traces of our physical world are digitized and made available online the possibility space for authoring new forms of digital media art continues to expand.

# References

1. Richter, H.: Dada: Art and Anti-Art. Thames & Hudson, New York (1997)
2. Friedman, K.: The Fluxus Reader. Wiley, Chicester (1998)
3. Sell, M.: Avant-garde Performance & the Limits of Criticism: Approaching the Living Theatre, Happenings/Fluxus, and the Black Arts Movement. University of Michigan Press, Ann Arbor (2008)
4. Knabb, K. (ed.): Situationist International Anthology. Bureau Of Public Secrets, Berkeley (2006)
5. Plant, S.: The Most Radical Gesture: The Situationist International in a Postmodern Age. Routledge, London (2002)
6. Sandford, M.: Happenings and Other Acts. Routledge, London (2003)
7. Boal, A.: Theater of the Oppressed. Pluto Press, London (2000)
8. Brecht, B.: Brecht on Theatre: The Development of an Aesthetic. Hill and Wang, London (1977)
9. Weiser, M.: The computer for the 21st century. Sci. Am. **265**, 94–104 (1991)
10. Dourish, P., Bell, G.: Divining a Digital Future: Mess and Mythology in Ubiquitous Computing. The MIT Press, Cambridge (2011)
11. Montola, M., Stenros, J., Waern, A.: Pervasive Games: Theory and Design. Morgan Kaufmann Publishers Inc., San Francisco (2009)

12. Dey, A.K.: Understanding and Using Context. Pers. Ubiquit. Comput. **5**, 4–7 (2001)
13. Schilit, B., Adams, N., Want, R.: Context-aware computing applications. In: First Workshop on Mobile Computing Systems and Applications, WMCSA 1994, pp. 85–90 (1994)
14. Dourish, P.: What we talk about when we talk about context. Pers. Ubiquit. Comput. **8**, 19–30 (2004)
15. Huizinga, J.: Homo Ludens. Taylor & Francis, New York (1949)
16. Salen, K., Zimmerman, E.: Rules of Play: Game Design Fundamentals. MIT Press, Cambridge, London (2004)
17. Lombardo, V., Damiano, R.: Storytelling on mobile devices for cultural heritage. New Rev. Hypermedia Multimed. **18**, 11–35 (2012)
18. Wakkary, R., Hatala, M., Muise, K., Tanenbaum, K., Corness, G., Mohabbati, B., Budd, J.: Kurio: a museum guide for families. In: Proceedings of the 3rd International Conference on Tangible and Embedded Interaction, pp. 215–222. ACM, New York (2009)
19. Lu, M., Arikawa, M.: Map-Based Storytelling Tool for Real-World Walking Tour. In: Krisp, J.M. (ed.) Progress in Location-Based Services. LNGC, pp. 435–451. Springer, Heidelberg (2013)
20. Blythe, M., Reid, J., Wright, P., Geelhoed, E.: Interdisciplinary criticism: analysing the experience of riot! A location-sensitive digital narrative. Behav. Inf. Technol. **25**, 127–139 (2006)
21. Reid, J., Geelhoed, E., Hull, R., Cater, K., Clayton, B.: Parallel worlds: immersion in location-based experiences. In: CHI 2005, Extended Abstracts on Human Factors in Computing Systems, pp. 1733–1736. ACM, New York (2005)
22. Paay, J., Kjeldskov, J., Christensen, A., Ibsen, A., Jensen, D., Nielsen, G., Vutborg, R.: Location-based storytelling in the urban environment. In: Proceedings of the 20th Australasian Conference on Computer-Human Interaction: Designing for Habitus and Habitat, pp. 122–129. ACM, New York (2008)
23. Nisi, V., Wood, A., Davenport, G., Oakley, I.: Hopstory: an interactive, location-based narrative distributed in space and time. In: Göbel, S., Spierling, U., Hoffmann, A., Iurgel, I., Schneider, O., Dechau, J., Feix, A. (eds.) TIDSE 2004. LNCS, vol. 3105, pp. 132–141. Springer, Heidelberg (2004)
24. Nisi, V., Oakley, I., Haahr, M.: Location-aware multimedia stories: turning spaces into places. In: Proceedings of the 4th International Conference on Digital Arts, pp. 72–82, Porto, Portugal (2008)
25. Crow, D., Pan, P., Kam, L., Davenport, G.: M-Views: a system for location-based storytelling. In: Proceedings of the 5th International Conference on Ubiquitous Computing. Association for Computing Machinery, Seattle, WA (2003)
26. Bichard, J., Brunnberg, L., Combetto, M., Gustafsson, A., Juhlin, O.: Backseat playgrounds: pervasive storytelling in vast location based games. In: Harper, R., Rauterberg, M., Combetto, M. (eds.) ICEC 2006. LNCS, vol. 4161, pp. 117–122. Springer, Heidelberg (2006). doi: 10.1007/11872320_14
27. Gustafsson, A., Bichard, J., Brunnberg, L., Juhlin, O., Combetto, M.: Believable environments: generating interactive storytelling in vast location-based pervasive games. In: Proceedings of the 2006 ACM SIGCHI International Conference on Advances in Computer Entertainment Technology. ACM, New York (2006)
28. Schöning, J., Hecht, B., Starosielski, N.: Evaluating automatically generated location-based stories for tourists. In: CHI 2008, Extended Abstracts on Human Factors in Computing Systems, pp. 2937–2942. ACM, New York (2008)

29. Schöning, J., Hecht, B., Rohs, M., Starosielski, N., et al.: WikEar–Automatically generated location-based audio stories between public city maps. In: Adjun. Proceedings of Ubicomp 2007, pp. 128–131 (2007)
30. Procyk, J., Neustaedter, C.: GEMS: the design and evaluation of a location-based storytelling game. In: Proceedings of the 17th ACM Conference on Computer Supported Cooperative Work & Social Computing, pp. 1156–1166. ACM, New York (2014)
31. Russell, J.A.: A circumplex model of affect. J. Pers. Soc. Psychol. **39**, 1161–1178 (1980)
32. Hutto, C.J., Gilbert, E.: Vader: a parsimonious rule-based model for sentiment analysis of social media text. In: Eighth International AAAI Conference on Weblogs and Social Media (2014)
33. Cambria, E., Olsher, D., Rajagopal, D.: SenticNet 3: a common and common-sense knowledge base for cognition-driven sentiment analysis. In: Proceedings of the Twenty-Eighth AAAI Conference on Artificial Intelligence, pp. 1515–1521. AAAI Press (2014)
34. Cambria, E., Livingstone, A., Hussain, A.: The hourglass of emotions. In: Esposito, A., Esposito, A.M., Vinciarelli, A., Hoffmann, R., Müller, V.C. (eds.) Cognitive Behavioural Systems. LNCS, vol. 7403, pp. 144–157. Springer, Berlin, Heidelberg (2012)

# Media of Attraction: A Media Archeology Approach to Panoramas, Kinematography, Mixed Reality and Beyond

Rebecca Rouse[✉]

Department of Communication + Media, Rensselaer Polytechnic Institute, 110 8th Street, Troy, NY 12180, USA
rouser@rpi.edu

**Abstract.** This paper presents a new concept for understanding contemporary interactive works created with emerging or new media, such as virtual and augmented reality, as part of a larger historically informed category called *media of attraction*. Inspired by scholarship in film history and media archaeology, the media of attraction concept connects contemporary digital experiments to earlier forms including cabinets of curiosity, 18th century panoramas, pre-filmic moving image technologies, vaudeville, early film or kinematography, and others. Foundational elements defining media of attraction are laid out and discussed. This new approach has profound implications for how work created today is valued and understood, how central debates in the field can be re-contextualized, and how notions of progress can be radically reframed.

## 1 Introduction

The concept *media of attraction* builds on scholarship in early cinema by Tom Gunning [1, 2], André Gaudreault [3], Charles Musser [4, 5], Richard Abel [6], and colleagues who led a major shift in the approach to film history following the landmark Brighton conference in 1978 sponsored by the Federation Internationale des Archives du Film. In the decades following this influential meeting, these film historians have developed compelling arguments to support their position that so-called early cinema cannot be understood as an embryonic, primitive or naive version of the cinema we know today. These historians eschew a perspective of medium-centricity and reject the idea that media develop by a process of the discovery of essential characteristics that then become exploited by the most adept practitioners, the final result of which becomes recognized as 'serious art.' Instead, this group of scholars contends that from the earliest period of film history, the 1890s to 1908, moving images produced on film were developed in complex, interconnected, and improvisatory ways. Thus, they argue that these experiments need to be understood in their own right, as proper expressive works, not through the lens of what later became the institutionalized cinema form. These early works are referred to as *cinema of attraction*.

By broadening the cinema of attraction concept across more time periods and technologies, we can include mixed reality (MR) works in this larger category of *media of attraction*. MR includes a group of platforms and techniques, such as augmented reality,

© Springer International Publishing AG 2016
F. Nack and A.S. Gordon (Eds.): ICIDS 2016, LNCS 10045, pp. 97–107, 2016.
DOI: 10.1007/978-3-319-48279-8_9

virtual reality, and other immersive or spectacular displays that combine the physical and digital. By understanding MR as a part of the larger, cross-historical media of attraction category, new ways of interpreting MR work may become possible, as well as new directions for the field moving forward. To explore this proposed media of attraction concept, this paper will first discuss the new concept's roots in film scholarship on cinema of attraction, then lay out central characteristics of media of attraction, and conclude with a discussion of implications for future research.

## 1.1   Cinema of Attraction

The *cinema of attraction* concept is so named to emphasize connections with other forms of attraction, such as cabinets of curiosity, vaudeville shows, dioramas, panoramas, fairground attractions, and displays at World's Fairs. Gunning has described cinema of attraction as an "exhibitionist cinema" that both calls attention to its own technical capabilities, as a source of wonder and astonishment for spectators, and simultaneously reaches out to the spectator directly through meta-theatrical techniques [1]. In addition to the aesthetic connections between this period in film and other types of attraction, historical connections are present too. For example, some of the earliest exhibitions of kinetoscopes and projected films were at World's Fairs. In this early period, film was often presented as exhibit or act, including appearances on vaudeville stages such as Winsor McCay's *Gertie the Dinosaur*, which was not only the short film we may be familiar with today, but an animated projection used in McCay's live vaudeville act in 1914 [7]. Many of the same performers who populated World's Fairs amusement areas (Jim Corbett, Eugen Sandow, Annie Oakley, Buffalo Bill, and others) were also performers for early film. As for connections between dioramas, panoramas, and cinema of attraction, the skills and techniques used in creating those earlier attractions were also utilized for film. For example, in a 1907 essay French filmmaker Georges Méliès discusses the need for absolute precision in backdrop and set painting for film, explicitly referencing the techniques of panorama making that combined detailed, perspectively correct painting on flat surfaces with three-dimensional objects [8].

In addition to the relevant scholarship on cinema of attraction, media archeology and media history scholarship also play into the larger media of attraction concept I propose here. For example, several scholars have offered excellent recent studies focused on the history of technologies of immersion, illusion, and illusions in motion; most notably Oliver Grau [9], Alison Griffiths [10], and Errki Huhtamo [11]. These studies explore historical and aesthetic connections between immersive rooms and spaces from the ancient and classical world, painted panoramas, dioramas, magic lantern shows, panorama "rides" exhibited at World's Fairs, the history of immersive museum spaces, large immersive cinema formats such as Cinerama and IMAX, and contemporary interactive installations and virtual spaces. These works approach the artifacts discussed through a variety of valuable lenses (art history, film history, and media archeology, respectively). Here, I propose these studies might be thought of collectively as historical explorations of media of attraction.

By broadening the cinema of attraction concept to encompass more technologies across more time periods, we can develop a larger *media of attraction* concept, that can

include our own experimental media work today. I am convinced by Gunning, Gaudreault, Musser and others that early film, or kinematography, is indeed its own form, and not an infant version of the later, standardized cinema form we recognize today. So if we accept there is not much of a connection between cinema of attraction and cinema, could there be an interesting relationship between cinema of attraction and *other* media in 'attraction' phases? What about early radio, or television? This presents an interesting possibility for future historical research. But more importantly, if mixed reality (MR) works today could be understood as media of attraction, and not naive or embryonic forms of some forthcoming standardized form, we might open new ways of understanding this type of work and how it should be valued. This larger, cross-historical perspective could also offer new ways to reframe central debates surrounding MR (not to mention other contemporary experimental media, and future media yet to come) as well as suggest a new understanding of what constitutes progress in the field. To begin an exploration of these possibilities, I will suggest a set of characteristics or qualities that can define media of attraction, based on my understanding of cinema of attraction scholarship and media archeology, interpretation of historical primary source materials, as well as reflections on my own design experiences with MR over the past decade.

## 2  Media of Attraction

Stepping back from cinema of attraction to consider media of attraction as a larger category, it will be helpful to outline a set of central qualities that define the category. The aim is to develop media of attraction as a meta-category that spans time periods, technologies and techniques, to help illuminate design approaches and artifacts in early phases. A first attempt at diagramming a timeline of past and present examples of media of attraction appears in Fig. 1, bringing together examples of hypermedia spaces, forms from theatre history, screen history, and spectators in motion.

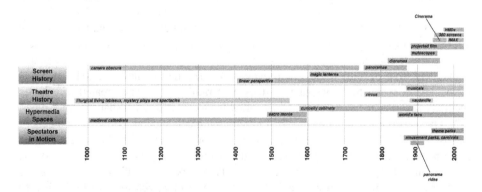

**Fig. 1.** Towards a timeline of media of attraction, past and present. Further research and contribution from the larger community will be needed to map these histories with more nuance, and more completely. A next iteration should include delineation, where applicable, between media in an attraction phase and media in assimilated, institutionalized forms.

Figure 2 presents a suggestion for diagramming media of attraction genealogies for specific artifacts; in this case, *Gertie the Dinosaur*. Reflecting on the variety displayed in both Figs. 1 and 2, what can be said to draw these forms (and others not yet mapped) together? They all revolve around attraction, to be sure, but this can be unpacked in more detail. If we understand attraction at its core as the inciting of wonder or astonishment in the spectator, we can dig into what particular qualities create the necessary conditions for attraction. I propose the following four characteristics as common threads across media of attraction:

1. Unassimilated
2. Interdisciplinary
3. Seamed
4. Participatory

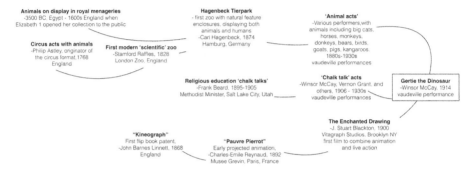

**Fig. 2.** Towards a graphical representation for the genealogy of media of attraction artifacts, highlighting historical and aesthetic connections, with *Gertie the Dinosaur* as an example.

**Unassimilated.** By unassimilated, I refer to media that are not yet institutionalized, meaning they are not part of the fabric of everyday life, retain some novelty, and often have no formal, codified training for associated practitioners. Unassimilated media are not restricted to new technologies; assimilated technologies may be combined in new ways to create convergent media artifacts that also lack assimilation. An example of this convergent strategy is the Radio Photologue phenomenon from the Chicago Daily News in the 1920s, when the newspaper had its own radio station and created broadcasts specially designed to be listened to while following along with a newspaper photo spread [12]. Other examples may be entirely non-technological, such as European cabinets of curiosity from the sixteenth and seventieth centuries [13]. While these collections contained no technology per se, they brought together in new combinations wondrous artifacts in immersive space, and were certainly set apart from the experience of the everyday. In addition, unassimilated media have no formalized means of criticism to evaluate works produced. For example, as of yet there are no professional critics who focus exclusively on augmented reality.

Other consequences of the unassimilated phase in which media of attraction operate is that these media often lack efficient or far-reaching distribution systems, and are also often not archived, or archived poorly. For example, while early film was fairly well

distributed (at least compared to MR works today), a vast amount of early films have been lost or destroyed because the value of the work simply was not understood at the time. To cite a well-known instance of this, hundreds of Georges Méliès' films were seized by the French government and melted down to make boot heels for soldiers during the First World War. A lesser known, but equally important example, is the unexplained loss of all of Alice Guy-Blaché's feature length works made in America [14].

**Interdisciplinary.** Media of attraction draw on multiple art forms and techniques, necessitating complex teams in most cases, or occasionally one-man-band type of creators. This is partly due to the unassimilated phase in which media of attraction operate; practitioners cannot be trained in a media-specific program, so by necessity, practitioners come from other disciplines and bring existing models and concepts from that medium to bear. Méliès claimed that early film or kinematography was "the most engaging and worthy of the arts" because of this intense interdisciplinarity: "It [kinematography] makes use of almost all of [the arts]: The stage, drawing, painting, sculpture, architecture, mechanical skills, manual labor of all kinds—are all employed in equal measure in this extraordinary profession" [8]. While the management of these complex teams can be daunting, the synergy of this variety of perspectives, approaches, and skills leads to a rich multiplicity in media of attraction, that is not dampened by the institutionalizing forces which more assimilated media are routinely subjected to.

**Seamed.** Because of this rich multiplicity of design approaches and structures exhibited by media of attraction, these media are not "seamless" as technology industry rhetoric might have us believe. Instead, media of attraction are decidedly seamed. Edges show between parts of a media of attraction experience, and the patchwork of ways in which multiple forms of representation come together are not hidden from spectators. For example, Gaudreault discusses the previously overlooked role of the film narrator, a live performer who accompanied early films (which were of course silent) by adding spoken narration. Some exhibitors even added spoken dialogue and sound effects, performed behind the projection screen [3]. The role of the film narrator highlights early film's lack of "narrative self-sufficiency" by emphasizing the seam between physical and mediated modes of performance. Many of today's MR works are similarly seamed, and likewise not narratively self-sufficient. They require ancillary materials, explanations, and even live performers or guides. But it is through this exposure of seams that the audience to media of attraction is made explicitly aware of the technology itself. If leveraged well, this awareness can operate to allow audiences to take meta-pleasure in the mediation presented, in addition to the feeling of immersion. This double sense of wonder at both the mastery of the designer, as well as the wonder or astonishment at the effect of the illusion itself, is at the core of media of attraction.

This seamed quality is similar to Bolter and Grusin's concept of hypermediacy, which does not erase mediation, but rather highlights it [15]. This roughness or layering is not only a byproduct of the ways in which media of attraction are developed, on another level the seams are actually necessary for audience members to truly enjoy the illusions presented— you must realize the VR game is a construction to fully appreciate it.

**Participatory.** Media of attraction all reach out to the spectator with some form of invitation to engage in an active and direct way. In some cases, such as vaudeville and other staged entertainments, this invitation comes in the form of a meta-theatrical address to audience members. The Italian Futurist, Filippo Marinetti, described the variety theatre of 1913 as "[...] seeking the audience's collaboration," who do not "remain static like a stupid voyeur" [16]. This invitation to participate impacts several aspects of media of attraction, including experience framing, interface design (if applicable), and narrative structures. Tensions between narrative and interactivity have been a key topic of discussion in relation to digital media in particular with notable contributions from many scholars including Marie-Laure Ryan, George Landow, Janet Murray, Henry Jenkins, and others [17–20]. Despite these many valuable perspectives, the topic of the integration of narrative and interactivity is still somewhat of an open question in the field, with recent papers highlighting the need for the development of new strategies, such as this call by Hartmut Koenitz for more generalized approaches to the issue [21].

Media of attraction always have a push and pull between attraction, narrative, participation, immersion, and seamed-ness. This larger category of media of attraction helps us to see that these tensions should not be understood as negative. Recontextualizing artifacts that may have previously been understood as a part of smaller, siloed categories (database cinema, interactive narrative, augmented reality, etc.) as media of attraction removes some of the negative concepts associated with a mix of interactivity and narrative that may stem from literary theories of narrative, which have been imposed on these more focused disciplines. Moving away from literary approaches into the media of attraction concept also shifts ideas of what constitutes progress in the field, away from calls for 'the Citizen Kane' of VR for example. Instead, we are encouraged to move towards embracing multiple narrative structures and strategies, and anti-narrative or non-narrative experiences, as all representing valid forms of experimentation, and valuable contributions to the multiplicity expected of media of attraction.

In the case of early film or kinematography, it is particularly clear to see this non-exclusive focus on narrative at work, balanced by the necessary focus on the attraction of film's new and exciting capabilities. However the narrative-attraction opposition posed by Gunning [1] has, as noted by Musser, likely been overstated [5]. Among early films, even within the work on a single filmmaker, we can see variety in the ways in which narrative and attraction are balanced, all with valid results. For example, two films from Georges Méliès, made within a year of each other, exhibit a wide range of strategies: *The Man with the Rubber Head* and *A Trip to the Moon*. The 1901 3-minute film *The Man with the Rubber Head* doesn't have much of a story, and is mostly intended to entertain us with film's abilities for superimposition and zooming in. Nevertheless, a story frames the film. This framing shouldn't be discounted, because without the frame and context provided by the story, the film would be much less enjoyable for audiences.

The *Man with the Rubber Head* shows a scientist in a laboratory, with a double of his own head, disembodied. The scientist places the disembodied head on a lab bench, and sets to work inflating it to huge proportions with a bellows. His assistant enters, and is handed the bellows so that he may also see the peculiar effect. The assistant is over-excited, and inflates the head too far, which explodes. The exasperated scientist kicks

his assistant out of the lab. The result is an enigmatic, engaging piece with what could be understood as a sly commentary on scientists' egos. The core of the film is, however, the display of the technology. Interestingly, another film from the following year from Méliès shows a different balance between narrative and attraction: the 1902 film *A Trip to the Moon*. This film is concerned with a space voyage of a group of scientists and officials who visit the moon, and their encounters with the fantastical creatures there. This 9-minute piece includes a showcase of all manner of film capabilities - superimpositions, disappearing characters, explosions, and more. However, the story is much more involved, so much so it is beyond the scope of this paper to relate in detail. What is remarkable across these two examples is the variety of ways in which just one filmmaker has experimented with narrative structures in a short period of time, and this type of energetic experimentation may in fact be a hallmark of media of attraction.

While these early films are not participatory in the same way that today's interactive digital works solicit audience participation, these early films do reach out to the spectator with meta-theatrical techniques (i.e., the magician bowing to the camera before doing his tricks) in a way that invites an interaction. So because there is an inherent connection between media of attraction and interactivity, we might shift our thinking to see a push and pull between story and attraction (which implies participation) as simply a central characteristic of this meta-category, and not a conflict that needs to be solved. The variety of aesthetic choices and narrative structures on display in media of attraction are nonetheless all inextricably bound up with the particular challenges, limits, and affordances of the technology at hand - all of which the creators are (at times quite painfully) aware of.

## 2.1   The Voice of the Media of Attraction Practitioner

There are at least three ways to understand a media artifact of any kind. First, there is a critical perspective, meaning the critique or interpretation of the scholar, critic, or reviewer. Second, there is the audience perspective, either as a personal narrative or testimonial, or audience reception study. Third, there is the voice of the artifact's designer or creator. The unstable and explorative nature of media of attraction means that the need is pressing for these works to be engaged from the design perspective, although this has rarely been done in any systematic way, as we will see.

In drawing this larger category of media of attraction together, one new possibility that is opened up to media of attraction practitioners today is to look back to earlier practitioners and see what can be learned. In terms of cinema of attraction, very few primary sources are available, and even fewer in English, that present the filmmakers' own discussion of their creative process [6]. Part of the difficulty in researching this is that during these very early years, there was no single term for the person with the primary responsibility for making the film - operator, moving photographer, kinematographer, presenter of views - all of these phrases and terms were used, and others besides. (This conundrum must sound familiar to those working in media of attraction today, and has been discussed with respect to interactive narrative in particular [22]).

The earliest sources of writing by makers of films focus on the technical details of the film camera and the various ways in which the filmed image may be displayed. Largely centered on descriptions of the history of the invention of the camera device,

these early sources contain little or no information about how to create meaningful experiences using the new technology. Writings from the Dickson siblings and Edison, Hopwood, and others, while fascinating in their own right, fall into this category [23, 24].

One of the few sources available does include a 1907 essay from French filmmaker Georges Méliès, who was one of the pioneers of the "story film" or film that presented a fictional story enacted by costumed performers in fabricated settings. Méliès' work stands apart from many of the earliest films, which were often referred to as "views," and did just that—they presented the viewer with something of interest to look at, such as a dramatic natural view like a waterfall, an anatomic performance like a sneeze or a body builder's poses, cats fighting, a person throwing a lasso, etc. Méliès brought his experience working at the Theatre Robert-Houdin to bear on his filmmaking, and developed a remarkable number of story films that had great influence on other major early filmmakers, like Edwin S. Porter.

In Méliès' 1907 essay, he describes in brief every aspect of filmmaking, with his advice on how to handle the challenges in each case. The discussion ranges from a rough taxonomy of different types of films, to the particular needs for a studio building, lighting, costumes, the difficulties of teamwork, and so forth [8]. Of particular interest is Méliès' perspective on "composing and preparing scenes," or narrative. He advises one to begin with "[…] a scenario drawn from the imagination." Then, he counsels, "[…] you must seek effects that will have an impact on the audience, create sketches and models of the sets and costumes, and come up with the view's star attraction, without which it has no chance of success." Notably there is no mention of Aristotle, or Freytag, but rather a balance between the "scenario" you imagine, and the "effects" that will draw in the audience. The balance between narrative and attraction appears to be the guiding principle; the rest is left open to the designer's ingenuity and imagination. Just four years after Méliès' essay, in 1911, Bennett's *Handbook of Kinematography* was published including a chapter laying out a standardized format and structure for narrative screenplay writing, that is very close to what persists in Hollywood today [25].

Aside from the Méliès' essay, another interesting source with an early filmmaker's own voice is a New York Times interview with American filmmaker Edwin S. Porter from 1940, a year before his death, looking back at his career. Porter is likely best remembered as the creator of *The Great Train Robbery* (1903), but he made a large number of films both working for Edison and later on his own, and engineered countless influential approaches and effects for film. Like Méliès, Porter came to film with a background in staged entertainment, along with a knack for new technologies, having been one of the country's youngest telegraph operators at age 14 [26]. Porter lost interest in film after standardization, and after debuting the first anaglyph 3D film in 1915, made no more films. In the Times 1940 interview, Porter is said to feel that "though pictures have indubitably made tremendous strides forward since [my] time, much of the initiative and excitement has gone out of movie-making" and confessed "I rarely see pictures any more" [27]. In Porter's estimation, standardization narrowed and perfected the medium to a point of tedium, a sentiment recently echoed at a 2016 games conference by keynote speaker Richard Bartle, originator of the MUD (multi-user dungeon). Speaking about current methods for virtual world design, and the often unanticipated

cost of developing a medium, Bartle put it succinctly: "It's a lot easier to make things nowadays but it's a lot less creative" [28].

Here we find a cautionary tale to those of us working in media of attraction today. By 1912, just a few years after Méliès' exuberant essay, he no longer made films at all. Dissatisfied with the Motion Picture Patents Company that Thomas Edison had created as a conglomerate to oversee, standardize and control the film industry, Méliès was quoted in a trade publication declaring "I am not a corporation; I am an independent producer" [29]. Méliès ended his life in poverty, working in a shop in the Paris Montparnasse train station, hawking toys and candy.

So perhaps as contemporary media of attraction practitioners we might not want to fight quite so stridently for standards, best practices, and institutionalization of our media, because even though it is nearly always possible to work creatively to resist norms to some degree, surely any forces of institutionalization will have vast and far reaching consequences for today's experimental media practitioners.

# 3 The Future of Media of Attraction

While many of us working in contemporary media of attraction may bemoan the considerable technical challenges we face, and the many difficulties of working in a media in which conventions, best practices, and audience expectations are largely undefined, we might glean from Porter and Méliès a wariness of wishing institutionalization upon ourselves just yet. We should value the multiplicity we are in, as a medium of attraction, and work to better catalogue and archive this rich, vast variety ourselves — not only the media artifacts, but also the first-hand reflections and theories of the designers, to inspire the media of attraction makers yet to come, working in technologies of the future.

To this end, I propose the beginning of a prescriptive set of principles for media of attraction practitioners, based on the central qualities of media of attraction as *unassimilated*, *interdisciplinary*, *seamed*, and *participatory*:

- *Unassimilated media must be carefully archived.* We need an archive of attraction, that values the rich multiplicity found in these types of artifacts. We need a way of representing genealogical relationships between related forms, and must pay careful attention to the voice of the designer.
- *Interdisciplinary media require interdisciplinary teams*, and therefore careful attention to the process of team building. There is a wealth of literature of the topic of teamwork, but research on performing arts teams may be most relevant for other expressive domains [30, 31].
- *Seamed media are best approached through seamful design tactics* that seek to exploit these rough edges [32]. Seams in media of attraction may be caused by technical limitations, but also by issues related to these media's lack of assimilation, such as lack of conventions or audience expectations. A seamful design approach identifies the areas of dissonance, and incorporates them into the design as affordances or opportunities for creative interaction.
- *As participatory media, media of attraction need to be designed to support emergent interpretations* [33]. Media of attraction user behavior is often highly unpredictable,

given the unassimilated nature of the technologies and techniques in play. To accommodate this, and develop the naive user's creativity as an asset, designers should work to strike a balance between providing opportunities for emergent interactions to develop, and careful consideration of how to provide proper constraints to ensure a meaningful experience.

This set of four principles for media of attraction design should be developed into a more nuanced framework, created in collaboration with the larger community, and based on continuing historical research in the area. The aim is to produce a design vocabulary that is generative and specific, but also values the multiplicity inherent in media of attraction. In conclusion, instead of thinking of progress in our field as the narrowing toward best practices that exploit unique affordances, and the eventual canonization of a standardized medium as great art, let's think of progress as the continued great exploration of the widest variety of approaches, and let's think of progress as finding a way to record and share these artifacts, along with the thoughts of their creators.

# References

1. Gunning, T.: The cinema of attraction: early film, its spectator and the avant-garde. Wide Angle **8**(3–4), 63–70 (1986)
2. Gunning, T.: Re-newing old technologies: astonishment, second nature, and the uncanny in technology from the previous turn-of-the-century. In: Thorburn, D., Jenkins, H. (eds.) Rethinking Media Change: The Aesthetics of Transition, pp. 39–60. MIT Press, Cambridge (2003)
3. Gaudreault, A.: Film and Attraction: From Kinematography to Cinema. University of Illinois Press, Champaign (2011)
4. Musser, C.: The Emergence of Cinema: The American Screen to 1907. Scribners, New York (1990)
5. Musser, C.: Rethinking early cinema: cinema of attractions and narrativity. Yale J. Criticism **7**(2), 203–232 (1994)
6. Abel, R.: French Film Theory and Criticism: A History/Anthology, 1907-1929, vol. 1. Princeton University Press, Princeton (1993)
7. Canemaker, J.: Winsor McCay: His Life and Art. Harry Abrams, New York (2005)
8. Méliès, G.: Kinematographic views, (1907). In: Gaudreaut, A. Film and Attraction: From Kinematography to Cinema, pp. 133–152. University of Illinois Press, Berkeley (2011)
9. Grau, O.: Virtual Art: From Illusion to Immersion. MIT Press, Cambridge (2003)
10. Griffiths, A.: Shivers Down Your Spine: Cinema, Museums, & the Immersive View. Columbia University Press, New York (2008)
11. Huhtamo, E.: Illusions in Motion: Media Archeology of the Moving Panorama and Related Spectacles. MIT Press, Cambridge (2013)
12. Day Good, K.: Listening to pictures: converging media histories and the multimedia newspaper. Journalism Stud. (2015). doi:10.1080/1461670X.2015.1087813
13. Kenneth, J. (ed.): The Age of the Marvelous. Hood Museum of Art, Hanover (1992)
14. Slide, A. (ed.) Blaché R., Blaché S. (trans.): The Memoirs of Alice Guy-Blaché. Scarecrow Press, Lanham (1986)
15. Bolter, J.D., Grusin, R.: Remediation: Understanding New Media. MIT Press, Cambridge (1999)
16. Marinetti, F.T.: Critical Writings: New Edition. Farrar, Straus and Giroux, New York (2006)

17. Ryan, M.L.: Narrative as Virtual Reality: Immersion and Interactivity in Literature and Electronic Media. Johns Hopkins University Press, Baltimore (2003)
18. Landow, G.: Hypertext 3.0: Critical Theory and New Media in an Era of Globalization. Johns Hopkins University Press, Baltimore (2006)
19. Murray, J.: Hamlet on the Holodeck: The Future of Narrative in Cyberspace. MIT Press, Cambridge (1998)
20. Jenkins, H.: Game design as narrative architecture. In: Salen, K., Zimmerman, E. (eds.) The Game Design Reader: a Rules of Play Anthology, pp. 670–689. MIT Press, Cambridge (2004)
21. Koenitz, H.: Design approaches for interactive digital narrative. In: Schoenau-Fog, H., Bruni, L.E., Louchard, S., Baceviciute, S. (eds.) Interactive Storytelling. LNCS, vol. 9445, pp. 50–57. Springer, Heidelberg (2015)
22. Stern, A.: Embracing the combinatorial explosion: a brief prescription for interactive story R&D. In: Spierling, U., Szilas, N. (eds.) Interactive Storytelling. LNCS, vol. 5334, pp. 1–5. Springer, Heidelberg (2008)
23. Dickson, W.K.L., Dickson, A., Edison, T.: History of the Kinetograph, Kinetoscope, and Kinetophonograph. Museum of Modern Art, New York (1894)
24. Hopwood, H.V.: Living Pictures: Their History, Photo-Production, and Practical Working. Optician & Photographic Trades Review, London (1899)
25. Bennett, C.N.: The Handbook of Kinematography: The History, Theory and Practice of Motion Photography and Projection. The Kinematography Weekly, London (1911)
26. Blaisdell, G.: Edwin S. Porter: A sketch of the Treasurer and Director of the Famous Players —His New Studio. In: Moving Picture World, December 1912, pp. 961–962 (1912)
27. Goodman, E.: Turn Back the Clock: Reminiscences of Edwin S. Porter, or the History of the Motion Picture. In: The New York Times, June 2, 1940, p. 124 (1940)
28. Bartle, R.: Bidirectional Research (Illustrated Using an Unconventional Example). In: First Joint International Conference with Digital Games Research Association (DiGRA) and Foundations of Digital Games (FDG), DiGRA/FDG 2016, Dundee, Scotland, August 1–5. Keynote address (2016)
29. Rosen, M.: Méliès, georges. In: Wakeman, J. (ed.) World Film Directors, 1890-1945, vol. 1, pp. 747–765. H.W. Wilson Company, New York (1987)
30. Barret, F.J.: Creativity and improvisation in jazz and organizations: implications for organizational learning. Organ. Sci. **9**(5), 605–622 (1998)
31. Rouse, W.B., Rouse, R.K.: Teamwork in the performing arts. Proc. IEEE **92**(4), 606–615 (2004)
32. Broll, G., Benford, S.: Seamful design for location-based mobile games. In: Kishino, F., Kitamura, Y., Kato, H., Nagata, N. (eds.) ICEC 2005. LNCS, vol. 3711, pp. 155–166. Springer, Heidelberg (2005). doi:10.1007/11558651_16
33. Barba, E., Rouse, R., MacIntyre, B., Bolter, J.D.: Thinking inside the box: meaning making in a handheld AR experience. In: IEEE International Symposium on Mixed and Augmented Reality 2010. Arts, Media & Humanities Proceedings. Seoul, Korea, October 13–16, pp. 19–26 (2010)

# *Bad News*: An Experiment in Computationally Assisted Performance

Ben Samuel[(✉)], James Ryan, Adam J. Summerville, Michael Mateas,
and Noah Wardrip-Fruin

Expressive Intelligence Studio, University of California, Santa Cruz, USA
{bsamuel,jor,michaelm,nwf}@soe.ucsc.edu, asummerv@ucsc.edu

**Abstract.** Dreams of the prospect of computational narrative suggest a future of deeply interactive and personalized fictional experiences that engage our empathy. But the gulf between our current moment and that future is vast. How do we begin to bridge that divide now, both for learning more specifics of these potentials and to create experiences today that can have some of their impact on audiences? We present *Bad News*, a combination of theatrical performance practices, computational support, and Wizard-of-Oz interaction techniques. These allow for rich, real-time interaction with a procedurally generated world. We believe our approach could enable other research groups to explore similar territory—and the resulting experience is engaging and affecting in ways that help strengthen the case for our envisioned futures and also makes the case for trying to field such experiences today (e.g., in experimental theater or location-based entertainment contexts). *Bad News* is a realized game enjoyed by players with varying degrees of performance experience, and won the Innovative Game Design track of the 2016 ACM Conference on Human Factors in Computing Systems (CHI) Student Game Competition.

**Keywords:** Deep simulation · Live performance · Emergent narrative

## 1 Introduction

*Bad News* (*BN*) is an award-winning experimental game that combines social simulation and live performance. Players are placed in a procedurally generated town with over a century of simulated history, and the bulk of gameplay consists of players engaging in actual conversation with NPCs performed by an improvisational actor. As the player moves about the town, the underlying simulation is updated via live-coding by a wizard, hidden out of the player's sight. Generating a fresh town for every playthrough ensures novelty for the player, actor, and wizard. Players explore these towns with the goal of informing one specific resident of a recent death of a family member.

What results is an experience in which players interact with a deeply simulated virtual world that is capable of adapting to the actions of the player,

© Springer International Publishing AG 2016
F. Nack and A.S. Gordon (Eds.): ICIDS 2016, LNCS 10045, pp. 108–120, 2016.
DOI: 10.1007/978-3-319-48279-8_10

a major goal for interactive drama [14,18], albeit here with ample human process-
ing power. We believe that the combination of a simulation, a live actor, and
Wizard-of-Oz interaction techniques employed by *BN* is a useful one for devel-
oping and testing technologies that will enable future fictional experiences that
are deeply interactive, generative, and personalized [15]. This is a design space
that has only been preliminarily explored [4]. Moreover, we believe that work
created by this research mode can be effective works of interactive storytelling
themselves; *BN* began its life as a means to prototype integrating generative sys-
tems into a purely digital experience [23], but we discovered through playtests
that players found the experience of *BN* to be engaging in and of itself.

*BN* has been officially performed at two venues: the 2015 EXAG workshop,
and the 2016 ACM Conference on Human Factors in Computing Systems (CHI),
where it won the Innovative Game Design track in the Student Game Compe-
tition. Our design, particularly the framing and premise, evolved between these
performances. Unless otherwise noted, descriptions refer to the game as it was
presented at CHI. In this paper we describe the project with a particular focus
on the player experience and the considerations of being an actor in this space.

## 2   Related Work

As an exploration of interactive drama utilizing live performance with director-
ial intervention, we connect this work to *The Bus Station*, an early Oz Project
experiment that placed players among improvisational actors in a tense scenario
managed by a hidden director [9]. This piece was intended in part to prototype a
computational experience, and *BN* was born from similar motivations [23]. More
recently, a gallery installation deployed *Façade* in an *augmented reality* environ-
ment, with human operators intervening to guide its reactive-planning ecosystem
[4]. *BN* carries its torch in exploring the potential of mixing human and machine
control in amateur live performance. More recently, *Coffee: A Misunderstand-
ing* is a computationally assisted interactive play in which participants from the
audience act out characters by performing dialogue and choreography selected
by other human players [3]. Though *BN* is not performed in front of an audience,
we still situate it in the emerging area of computationally assisted experimen-
tal theatre [13,25]. Broadly, the interplay of embodied conversation and deep
simulation makes *BN* an example of a mixed-reality game [1], and its melding
of computation and improv situates it alongside the work of Magerko [12] and
Hayes-Roth [6], though *BN* inverts the puppet-player relationship by having
human-performed improv informed by the actions of virtual agents.

At the 2012 Dagstuhl gathering on Artificial and Computational Intelligence
in Games, the Computational Narrative working group named "systems that
generate tailored story-based support for face-to-face role playing used in cor-
porate training and simulation" as a valuable short-term research direction [10].
We believe that *BN* is a major step along this trajectory. Though the worlds
that it generates are player-agnostic, one could imagine *personalizing* towns for
the needs of a player [15]. Similarly, *BN* is not intended for corporate training

**Fig. 1.** A player and the actor during gameplay.

(besides, perhaps, for a very specific profession, see Sect. 5.2), but the underlying technology could be used as such with a different diegetic framing (Fig. 1).

## 3  The Game

*BN* is a game about death, death notification, and everyday life, combining deep social simulation and live performance.

### 3.1  The Premise

The player is cast in the role of a county mortician's assistant, brought to a small American town in 1979 to investigate and identify an unidentified dead body, hereafter referred to as 'the deceased'. The player's character has never been to this town before; the only person they know is their mentor, the county mortician himself. However, before the investigation can begin, the mortician reveals that a crisis the next town over requires his attention, and that the player will need to handle this job on her own. Namely, the player will need to identify the deceased, ascertain the name and location of the deceased's next of kin, and then deliver the eponymous bad news. Before leaving, the mortician assists the player in brainstorming a cover story for herself, one that will enable her to easily gather information from townsfolk without raising suspicions.

The game ends as soon as the player divulges the death: victory if the notified is the next of kin or loss if not. This encourages the player to seriously investigate the town; revealing the death indiscriminately lessens the dramatic build up to the final reveal, which we want to be a meaningful experience. In descending order of legal familial closeness, a character's next of kin in this town is their spouse, parent, child, sibling, and then any member of their extended family.

### 3.2  The Physical Setup

We now discuss the physical setup as it pertains to the live performance. The player and actor sit at opposite ends of a table, though a *model theatre* with

closed curtains obstructs their view of each other. When the player interacts with an NPC portrayed by the actor, the actor draws the curtain to reveal himself; when the conversation concludes, the actor closes the curtain to reinforce that either the actor's or player's characters left the scene.

The player is given a notebook and pen, as well as an electronic tablet that displays game state information, such as her current location and the physical descriptions of people nearby, as well as custom messages written by the wizard. The actor has a laptop that has an interface (see Sect. 6.2) providing insight into the characters that he will be portraying. The design of the model theatre prevents the player from seeing the actor's laptop.

This physical arrangement has a few advantages over a stage. Both actor and player require easy access to their devices; having them rest on a table frees hands for gesticulation. The piece is meant to be personal; the lack of audience seating precludes spectators. It also enhances the accessibility and mobility of the piece: one might not always have a theatre at hand; one nearly always has a table. One limitation of this arrangement is that the player may only speak with one character at a time. Three party conversations are rare, only occurring when the actor engages in a one-way conversation with "offstage" characters.

Ideally, *BN* is played in a quiet, darkened room, in which the player's attention is focused solely on playing. The tone of any given run of *BN* can vary greatly, and the atmosphere in which it is played seems to greatly influence this variance; well-lit spaces tend to yield less emotional weight behind the actions of the player, antithetical to our goals.

## 4 The Simulation

Before gameplay begins, a town is generated using the *Talk of the Town* AI framework. Due to space limitations, we will only outline the system here, but the reader may consult existing publications on it for more information [21,24].

Each *BN* setting is created by simulating the development of a fictional small American town from its founding in 1839 to 1979, which takes roughly five minutes. This amount of simulated history was selected because it produces towns with around fifty businesses and several hundred residents, which we found to provide a rich player experience without being overwhelming. Character appearances and personalities (using the famous five-factor model [2]) are modeled. At each time step, characters make decisions about where to go based on their personalities, their social and family networks, and their daily routines (which may take them to work, on errands, or to places of leisure). If multiple characters are in the same location, there is a chance that they will talk.

This communication between characters facilitates the passing of knowledge from one character to another. Characters discuss about themselves and others in their lives by sharing specific details. These details might pertain to occupations, addresses, physical descriptions, or familial connections. However, as time advances in the simulation, characters' confidence in their knowledge begins to wane if it isn't continually reinforced; thus, e.g., friends who have had a falling

**Fig. 2.** The wizard sits behind the scenes, live-coding modifications to the simulation and sending information to the actor.

out will slowly begin to forget the details of the other's life. As this happens, characters may unknowingly spread false information. Moreover, characters may lie to one another by intentionally spreading information that they believe to be incorrect. After nearly a century and a half of this simulation, characters build up a comprehensive—though occasionally factually inaccurate—view of the town that they live in and the people that populate it.

Additionally, characters get married, have kids, leave jobs or start new ones, found businesses, move out of town, and pass away. Birth, death, and marriage rates, as well as baby names and the types of businesses that are founded and folded, come from historical U.S. census data; actual historical events such as world wars and natural disasters are not modeled beyond their reflections in this data. A child's personality is informed by those of their parents. Each business type has a set of occupations to be filled (e.g., retail establishments have cashiers, managers, janitors, etc.), and hire for these positions based on the applicant's personality, age, work history, and familial and social connections; family businesses in the *Talk of the Town* framework are a frequent occurrence.

Though the town may be fictional, an important design goal of *BN* was to make it *a game about real life*. The player interacts with run-of-the-mill people living in a small American town. They have jobs, families, and friends. They run errands. They have leisure time at neighbors' houses, or they unwind at the bar. There is no explicit model of narrative in the simulation, but, as others have articulated [15,26], narrative-like meaning can still emerge bottom-up through empathic social interaction with rich characters. By simulating over a century of history, *BN* characters embed in rich social contexts that are brought to light through player interaction (see Sect. 5) and actor performance (see Sect. 6). This does mean that it is the responsibility of the actor and wizard to discover "interesting" elements of the simulation, and for the actor to gently steer conversations to points where these elements can be brought up naturally—this requires a combination of *story recognition* [22], *experience management* [20], and improvisation, skills that less experienced actors and wizards may need to develop. When done well, much of the joy of playing *BN*—for player, actor, and wizard

alike—lies in discovering the inherent wonder in the seemingly mundane lives of these simulated characters (Fig. 2).

## 4.1  The Wizard

Though the bulk of simulation occurs before play begins, there is one important figure of the town whose actions must be executed in the live simulation through-out gameplay: the player. To this end, the game employs a wizard sitting out of the sight of the player who listens to the vocal commands of the player and updates the simulation accordingly. Thus, every time the user travels to a new location, the wizard relocates the player's avatar from one part of town to another via live-coding. Similarly, other actions afforded to the player (see Sect. 5.1) are enabled by the wizard making live updates. Additionally, the wizard queries the simulation to search for narrative intrigue and potential dramatic nuggets that may be nestled in all its accumulated data. These nuggets can then be delivered to the actor over a direct line of communication (an instant-messaging service). This relationship is explored in more detail in Sect. 6.3.

# 5  The Player

The ideal player of *BN* is open to improvisational roleplay. It has been well recognized that not everyone views themselves as, or wants to be, an improvisa-tional actor [5]. However, the trappings of performance and narrative reside in the very fabric of our being [8,16]. Roleplaying has the ability to be profoundly transformational [19], but accessing personal memories around the sensitive sub-ject of death can place players in a vulnerable, uncomfortable state of being [27]. Our goal in creating *BN* is to give players the capacity to tailor the emotional depths to their own comfort levels; the actor will read the cues established by the player—including their use of language and tone of voice, their body posture, and the backstory they fabricate for the character they choose to assume—and attempt to match that energy. See Sect. 5.2 for more on establishing this contract of care; see Sect. 6 for more information on the actor's process.

## 5.1  The Priming Process: The Guide

*BN* begins with an extra-diegetic guide who leads the player to their seat. The guide eases the player into the world of the game, explains the premise and their role as a mortician's assistant, hands them a journal and pen to take notes, and describes what actions the player can take. These actions include beginning a conversation with an NPC in the same room as the player, looking at the city residential directory (which displays each residential address and the last name of the family that lives there), looking at the city business directory (which displays the address and name of every place of business, including restaurants, schools, hospitals, etc.), traveling to a specific address or business name directly, or, in traditional IF fashion, moving in the cardinal directions relative to their

current position. Players can also knock on doors, buzz apartments through an intercom system, and enter and exit buildings. Finally, players can advance the game's simple day–night cycle. These actions are taken by voicing them aloud (e.g., "I go to the quarry."), allowing the wizard to hear and then update the simulation—and thus the content on the player's tablet—accordingly.

## 5.2    The Priming Process: The Mortician

Once the player sits down, the guide instructs her to say that she will now speak to the mortician. Next, the actor opens the curtain as the mortician, greets the player as his assistant, quickly explains that he will have to leave soon, and directs the player to notify the deceased's next of kin on her own. Before he leaves, the mortician asks the player to only reveal the death to the next of kin, so as not to cause undue shock to the town and to respectfully allow the family to choose how to share the news of their loss. The player and mortician collaborate to weave a convincing cover story to justify the player approaching strangers and asking them questions. This is the approach $BN$ takes to establish a contract of care, or simply contract, with the player. In an immersive theatre context [11], these contracts are design strategies that work to make the unraveling experience safe and delivered with care for the audience members. By diegetically framing the player as a mortician's assistant, but giving her the opportunity to develop an additional role on top of this, we found that players had enough narrative scaffolding to feel comfortable exploring the town, while still retaining enough creative freedom that their characters truly belonged to them.

## 5.3    The Moment of Truth

Once the player has discerned the identity and location of the next of kin, she must let that character know of the deceased's passing. Our hope is that by exploring the town and meeting its residents, players will have a mental picture of the deceased's life, and will develop empathy for those the deceased left behind. Consequently, we aim for the reveal of this passing to be the emotional peak of the experience; though there has been a range in how players treat this significant moment, all have been respectful and civil. One observed behavior is the inclination to make the next of kin as comfortable as possible before the reveal. This can be as simple as asking the next of kin to take a seat; sometimes it involves asking them to go somewhere private. Some players have had noticeable hitches in their voices as they deliver the news, stumbling over the words as they struggle with how to break the news of the death of a loved one.

# 6    The Actor

As previously mentioned, all of the non-player characters in the town are played by a single actor. All performances of $BN$ to date have used the same actor—an author of this paper who has a professional performance background, including

more than ten years of improvisation experience. As discussed in Sect. 3.2, the actor remains out of sight until the player engages an NPC. Also hidden is a laptop that displays an actor interface (see Sect. 6.2). Since the actor does not know the qualities of the characters he will be playing until moments before assuming that character, the actor must learn to parse the interface quickly.

## 6.1 An Actor Prepares

Though the characteristics of the characters performed are determined by the simulation, the performance of the actor in *BN* is improvised. Thus, improvisational theory for quickly determining and ascertaining character relationships is incredibly useful for the actor to know and employ, such as status dynamics [8], or recognizing the "heat and weight" of a relationship [7]. It is also important for the actor to familiarize themselves with the Big Five personality traits (extroversion, agreeableness, neuroticism, conscientiousness, and openness to experience) [2]. These serve as a convenient brush to broadly paint the shape of a character and provide a useful hook for an "outside-in" approach to informing a character [17]. Although real values $[-1, 1]$, these are split into five partitions for ease of access for the actor. Other key characteristics, e.g., age, gender, occupation, and beliefs, also contribute heavily to the actor's physical and vocal choices.

Though the actor remains seated the entire time, characters still express themselves through physicality. A low-extroversion or high-neuroticism character might hunch over in their chair, cross their arms, or otherwise posture themselves as small and guarded as possible. Highly agreeable characters might stick out their chest or lean in toward the player to demonstrate that they are a friend. A low-neuroticism, low-agreeableness character might comfortably lean back in the chair, conveying disinterest in the player and their search.

Similarly, strong vocal choices convey character. Volume is an easy vocal quality to modulate based on personality—for example, low-extroversion characters tend to be more soft-spoken. Openness to experience can impact the nature of words used; characters with low openness employ a simpler vocabulary. The location of the conversation impacts the character's demeanor as well. A highly conscientious character at work is likely to be professional and guide the conversation, assuming the player is a patron needing to be assisted, even if the character happens to have unsocial traits such as low extroversion or low agreeableness; elsewhere that same character might act differently.

Though these personality traits assist the actor in quickly assuming a character, the actor must still fill in the details that lead to a memorable, believable, distinct character during performance. These details are determined through character-specific decisions made during conversation, through observed attitudes toward others characters in the town, and through insights provided via chat with the wizard. These details make the character feel more alive; the actor is allowed to invent these details as they see fit, so long as they build upon facts established by the simulation and do not contradict it in any way. For instance, during one playthrough, the player encountered a painter at a construction company eating lunch at a diner. During this conversation, the character revealed his

aspirations for moving to New York and striking up a career as an independent artist, dreams not present in the simulation.

## 6.2   The Actor Interface

Displayed via a hidden laptop, the interface is divided into three parts: information about the character the actor is currently playing, information pertaining to another character that is the topic of conversation, and "match" information (see below). The currently played role fills in once the player initiates conversation. It has information regrading the character's personality, profession, age, gender, marital status, physical appearance, and their reason for being at the current location (work, errands, leisure, etc.)

The second section, regarding the subject of conversation, is populated with data whenever the conversation veers toward a specific character. It consists of everything the character currently being performed knows about this other character, as well as how they feel about them. Since characters can get facts wrong about each other (see Sect. 4), next to every belief is a confidence rating. Characters can have accurate information but not be confident about it, and conversely can be supremely confident in information that is wrong. There can also be gaps; e.g., a character might have no idea where another character works. The actor can choose how upfront they are about their uncertainty.

The final section contains a list of "matches;" after the player asks a broad question (e.g., "do you know anyone who is blond with a scar?"), it is populated with every person the character knows that matches. This section of the actor interface is also maintained as part of the wizard's responsibilities.

## 6.3   Peeking Behind the Curtain

When not updating the simulation, the wizard has time to explore the history of the town and the interweaving relationships of its denizens. When he unearths narratively interesting tidbits, he communicates them to the actor via a chat window. This relates to the *story recognition* challenge of emergent narrative [22]. Sometimes even small things, such as a date, can deeply inform character behavior. For example, if the wizard sees that the character has a child whose birthday is coming up, it can inform both the demeanor of the character (happy, harried, etc.), and provide justifications to their simulated behaviors.

Often the information is more complex, involving love triangles and other rich emergent phenomena (enumerated in [21]). In one playthrough the player was visiting the store where the deceased worked. The wizard was able to discover that the deceased had very high mutual attraction for the store's manager. Moreover, this manager was a man who was significantly older than the deceased and already married, but his spouse was harboring romantic feelings for a coworker of her own. This manifested when the player spoke to a mutual acquaintance of the manager and the deceased: a gossipy teenager who insinuated that the manager, unhappy in his home life, had been flirting with the deceased. This

scandalous behavior provided a bit of drama in these characters' lives, but also cued the player that she might discover information by speaking to the manager.

Just as the actor can "invent" justifications and motivations as long as they build off of information established by the simulation, the wizard may do so as well, and communicate that to the actor. Thus, though the actor has the unique responsibility of determining how information about the world is revealed to the player via performance, the information itself is unearthed and developed by the actor and the wizard working in tandem as both story recognizers [22] and experience managers [20].

## 7  Sample Playthrough Summary

To give the reader a sense of the general progression of a game of *BN*, we include a summary of a thirty-minute playthrough. The player was a male in his mid-20 s with two years of improvisation experience. To elucidate creative sources, we'll append parenthetical attributions specifying the sources (player, actor, or simulation) of details and actions. Though these attributions detail the diegetic decisions and actions of the actor, player, and simulation, the wizard is secretly communicating with the actor (through an interface and chat) about the simulation and updating the player's tablet with information about their physical location, nearby residents, and directory information, thus influencing the behavior of both player and actor. We remind the reader that every run involves a uniquely generated world; the characters, relationships, and histories in this playthrough were never seen before, nor will they ever be seen again.

After speaking with the mortician in the game's introduction, the player left the deceased's apartment and checked the residential directory to quickly ascertain the last name of the deceased (*player, simulation*). From there, he found a janitor in the apartment complex, and asked the janitor if he knew the deceased by name or anyone matching the deceased's description (*player*). The janitor confessed that he did not know any of the tenants (*simulation*), but suggested that the player go to a nearby delicatessen, which was a popular hot spot in town (*simulation, actor*).

The player went and found it to be crowded (*simulation*). Observing the characters in the deli, he sought out someone with similar features to the deceased (*player, simulation*). Doing so, he managed to find the deceased's aunt—the sister of the deceased's father—who in fact had inherited the same physical features of the deceased by virtue of their common ancestry (*simulation*). The aunt was open-minded enough to not mind sharing her table with a stranger (*simulation, actor*), and after the two exchanged introductions and the player learned the aunt's surname (which was the same as the deceased's; *simulation*), he knew he was on the right track. He explained he was a historian chronicling the history of the town (*player*), hoping she would tell him more about her family, and ultimately the next of kin. The aunt obliged, telling familial history that reinforced the game's theme of loss: her father had been a town blacksmith for forty years of life, but as the march of progress advanced and demand for blacksmiths all

but disappeared, her father lost his smithy and—after decades of being a skilled artisan—had to find work as a stocker at a grocery store, until he passed away (*simulation, actor*).[1] The player sympathized with the aunt, and asked if there were other members of her family he could speak to (*player*).

Feeling connected with the player after sharing her family history (*actor*), the aunt told the player that her brother is a janitor at a nearby department store, whose shift was ending soon (*simulation, actor*). The player thanked the aunt for her time, and rushed to the department store (*player*). The player entered the store after hours (*player, simulation*), and a manager irately approached him (*actor*). Before being ushered out, the player spotted the janitor (on the tablet's listing of nearby characters; *player*), who was best friends with the manager (*simulation*). The player struck up a conversation with him (*player*), which the manager begrudgingly allowed (*actor*). It became clear that the janitor was the deceased's father (*actor*), and therefore his next of kin (*simulation*). Out of respect for the father's privacy, the player did not want to reveal the death with the boss glaring at him (*player*). The player offered to meet the father at a bar when he was done with his shift (*player*), which he agreed to (*actor*).

At the bar, the player quickly got into an altercation with the bartender (*player*), who viewed the player as childish (*actor*). The player managed to calm the bartender down without a fight breaking out by asking him to mix a drink (*player, actor*), just as the father arrived (*actor*). The player then asked him to take a seat, somberly revealed his true profession as a mortician's assistant, and respectfully informed the father of his son's passing (*player*).

## 8   Preliminary Results and Critical Reception

Our results are derived from brief 5–10 minute postmortems (immediately after playing) with the approximately thirty players we've had, and through our own observations of players during play. The postmortems involved describing the underlying system to the players (e.g., the simulation process, the actor's interface, etc.), and asking players how they felt about the town they explored (e.g., whether it felt "hand-crafted" or generic, whether the characters were believable) and the decisions they made (e.g., did the player feel like they were the driving force of the narrative).

The most striking observation is how quickly players eased themselves into the roleplaying aspect of the experience. Many players expressed discomfort, most often about lacking training in improvisation, before playing—and sometimes during play at the beginning. However, as play progressed, players stopped verbalizing these discomforts, and began showing investment in the role (thinking aloud about the town and who to talk to next).

Perhaps the most assuring piece of feedback from the postmortems was that many players expressed that the experience felt very unique—both by virtue of

---

[1] This was an artifact of the underlying simulation's modeling of industrial progress, which makes smithies likely to shut down in the period after World War II. The daughter's emotional opinion on these affairs was a choice of the actor.

the fact that this is a gameplay experience unlike most others, but also because the player has free reign to explore a town with hundreds of characters in any way that they choose. Thus players report feeling high senses of agency over the shape of their gameplay session. Players have said that they felt *transported* to the world, and were able to readily visualize the people that they spoke with and the places that they visited. Many players found their towns so vibrant that they were shocked to learn during the postmortem that the towns were not designed by hand. This suggests a promising use of this framework—and the technology that powers it—in future applications of games and stories to enable high senses of player ownership over their narratives.

In summary, *BN*'s unique combination of live performance and simulation appears to have the potential to be a powerful new form of storytelling. The ability to generate towns with hundreds of NPCs with interconnected histories and relationships in a matter of minutes is fertile ground for rich emergent narrative. The open-ended framing of the game enables players to carve their own path, determining which locations and characters in the town become narratively significant—this meets the call for future directions in interactive storytelling articulated in [10,15,22,26]. The casting of the player as a specific character that must develop a cover story simultaneously provides the player with firm scaffolding to build on with the flexibility to diegetically shift their identity lessening some of the vulnerability inherent in roleplaying. We sincerely hope that *BN* is the first of many pieces of its kind.

# References

1. Bonsignore, E.M., Hansen, D.L., Toups, Z.O., Nacke, L.E., Salter, A., Lutters, W.: Mixed reality games. In: Proceedings of Computer Supported Cooperative Work (2012)
2. Costa, P.T., MacCrae, R.R.: Revised NEO personality inventory and NEO five-factor inventory: Professional manual (1992)
3. Squinkifer, D.: Coffee: A Misunderstanding. Deirdra Kiai, Santa Cruz (2014)
4. Dow, S.P., Mehta, M., MacIntyre, B., Mateas, M.: Eliza meets the wizard-of-oz: blending machine and human control of embodied characters. In: Proceedings of CHI (2010)
5. Glassner, A.: Interactive storytelling: people, stories, and games. In: Balet, O., Subsol, G., Torguet, P. (eds.) ICVS 2001. LNCS, vol. 2197, pp. 51–60. Springer, Heidelberg (2001). doi:10.1007/3-540-45420-9_7
6. Hayes-Roth, B., Van Gent, R.: Story-marking with improvisational puppets. In: Proceedings of Autonomous Agents (1997)
7. Jagodowski, T., Pasquesi, D., Victor, P.: Improvisation at the Speed of Life. Sola Roma Books, Inc., Rome (2015)
8. Johnstone, K.: Impro: Improvisation and the Theatre. Routledge, New York (1987)
9. Kelso, M.T., Weyhrauch, P., Bates, J.: Dramatic presence. Presence: Teleoper. Virtual Environ. **2**, 1–15 (1993)
10. Lucas, S.M., Mateas, M., Preuss, M., Spronck, P., Togelius, J.: Dagstuhl seminar 12191. Dagstuhl Rep. **5**, 43–70 (2012)
11. Machon, J.: Immersive Theatres: Intimacy and Immediacy in Contemporary Performance. Palgrave macmillan, Basingstoke (2013)

12. Magerko, B., Riedl, M.: What happens next? toward an empirical investigation of improvisational theatre. In: Proceedings of Computational Creativity (2008)
13. Martens, C.: Towards computational support for experimental theater (2016)
14. Mateas, M., Stern, A.: Build it to understand it: ludology meets narratology in game design space. In: Proceedings of DiGRA (2005)
15. Mateas, M., Wardrip-Fruin, N.: Personalized and interactive literature. In: Bainbridge, W.S., Roco, M.C. (eds.) Handbook of Science and Technology Convergence, pp. 501–515. Springer, Heidelberg (2016)
16. McDonald, B., Armstrong, M.: Invisible Ink: A Practical Guide to Building Stories that Resonate. Libertary Company, New York (2013)
17. Meisner, S., Longwell, D.: Sanford Meisner on Acting. Vintage, New York (2012)
18. Murray, J.H.: Hamlet on the Holodeck: The Future of Narrative in Cyberspace. Free Press, New York (1997)
19. Pettersson, J.: States of play. Nordic larp around the world (2012)
20. Riedl, M.O., Bulitko, V.: Interactive narrative: an intelligent systems approach. AI Mag. **34**(1), 67 (2012)
21. Ryan, J., Mateas, M., Wardrip-Fruin, N.: A simple method for evolving large character social networks. In: Proceedings of Social Believability in Games (2016)
22. Ryan, J.O., Mateas, M., Wardrip-Fruin, N.: Open design challenges for interactive emergent narrative. In: Schoenau-Fog, H., Bruni, L.E., Louchart, S., Baceviciute, S. (eds.) ICIDS 2015. LNCS, vol. 9445, pp. 14–26. Springer, Heidelberg (2015). doi:10.1007/978-3-319-27036-4_2
23. Ryan, J.O., Samuel, B., Summerville, A.J., Lessard, J.: Bad News: a computationally assisted live-action prototype to guide content creation. In: Proceedings of EXAG (2015)
24. Ryan, J.O., Summerville, A., Mateas, M., Wardrip-Fruin, N.: Toward characters who observe, tell, misremember, and lie. In: Proceedings of EXAG (2015)
25. Samuel, B., Ryan, J., Summerville, A., Mateas, M., Wardrip-Fruin, N.: Computatrum personae: toward a role-based taxonomy of (computationally assisted) performance. In: Proceedings of EXAG (2016)
26. Sellers, M., Lograsso, A., Reinhart, A.: Creating emergent narratives using motivated, social NPCs. In: Proceedings of Social Believability in Games (2016)
27. Stanislavsky, K.: An Actor Prepares. Taylor & Francis, London (1989)

# Intelligent Narrative Technologies

# A Formative Study Evaluating the Perception of Personality Traits for Planning-Based Narrative Generation

Julio César Bahamón[1]([✉]) and R. Michael Young[2]

[1] Liquid Narrative Research Group, The University of North Carolina at Charlotte,
9201 University City Blvd., Charlotte, NC 28223-0001, USA
jbahamon@uncc.edu
[2] Liquid Narrative Research Group, University of Utah,
50 S., Central Campus Drive, Salt Lake City, UT 84112, USA
young@cs.utah.edu

**Abstract.** The presence of interesting and compelling characters is an essential component of effective narrative. Well-developed characters have features that enable them to significantly enhance the believability and quality of a story. We present an experiment designed to gauge an audience's perception of specific aspects of character personality traits expressed through the characters' choices for action. The experiment served as a formative evaluation for work on the development of the *Mask* system for the automatic generation of narratives that express character traits through choice. Results from our study evaluate the hypothesis that the relationship between choices and the actions they lead to can be used in narrative to produce the perception of specific personality traits in an audience.

**Keywords:** Intelligent narrative technologies track · Artificial intelligence · Planning · Narrative generation · Character personality

## 1 Introduction

The automatic generation of character behavior in planning-based narrative generation is an area where much work is still possible. This is particularly true if we consider that incorporating character behavior can greatly increase the burden placed on the human author. As narrative delivery mechanisms, such as digital games and virtual training environments become more complex and detailed, the effort needed to create characters with distinguishable features increases in its difficulty. Moreover, well-defined characters add to the complexity of a story, enhance its discourse, and are vital for the realization of crucial story elements, such as events and dialog [8,17]. Several factors contribute to the effective definition of a character. Among these, the depiction of a distinguishable personality is one of the key features that can make a character interesting and compelling.

© Springer International Publishing AG 2016
F. Nack and A.S. Gordon (Eds.): ICIDS 2016, LNCS 10045, pp. 123–135, 2016.
DOI: 10.1007/978-3-319-48279-8_11

Finally, the presence of interesting and compelling characters enables the audience to form a clear mental model of their beliefs, desires, intentions, and morality. This understanding of the characters can lead to a better understanding of the entire story and to a more effective delivery of its content.

The selection of actions is one of the main techniques used by creative writers to define and describe fictional characters [7,17]. Further consideration of narrative structure, specifically plot points where a story could branch into alternate versions [5], indicates that a character's act of considering multiple courses of action before choosing to pursue one in particular has a direct impact on the role that she plays in a story. Additionally, the choices that characters make may be linked to specific personality traits, an idea supported by research in behavioral psychology that has found correlation between actions and personality [10,23].

Building on our earlier work [4], we posit that the link between choice and personality can be used in narrative generation to enable the perception of specific personality traits. An audience that is made aware of the existence of multiple choices available to a character will form an opinion of such character's personality based on the available choices, the choice selection, and the events that provide a context to the choice. We have incorporated this idea into a system named *Mask*, which is briefly described in Sect. 3. *Mask* utilizes plan-based story representations to construct plot lines that afford character-specific choices for action, treating choice as a first-class object. However, the efficacy of this method relies on the reader's ability to perceive personality traits from the choices made by a character over multiple alternatives available for her to achieve her goals.

In order to determine whether readers are able to make inferences about personality traits from the choices made by characters in the course of a story, we conducted a formative study that evaluated the personality traits selected by the audience in relation to the personality factor assigned to story characters. In the experiment, participants read a series of hand-crafted short stories designed to include events representative of a plan-based story structure where the main character is faced with having to choose a specific course of action from a set of applicable alternatives. The chosen action and its alternatives were devised to contrast with each other, ensuring the portrayal of behavior that was either typical of a specific personality factor or its opposite. A control group read story versions where the character's choice is resolved through the intervention of a third party. A treatment group read story versions where the character makes a choice that portrays behavior typical of a specific personality factor. The participants were then asked to rate the personality of the character. We used a standardized questionnaire where observable personality traits are rated on a Likert scale [14,15]. We then compared the personality ratings with the personality factor that the stories were designed to portray. In the case of the control version of the stories, we anticipated a neutral rating of the character's personality. In the case of the treatment versions, we anticipated a rating indicative of a highly agreeable personality or of its direct opposite, depending on the story version read. As we describe in Sect. 4.2, the study results support the claim that *an audience presented with a set of alternate action sequences for a story*

*character will select personality trait ratings that have significant correlation with the choices made by such character.* Furthermore, other results provided evidence of the reader's ability to infer when story characters behave in a manner that is not consistent with personality traits exhibited earlier in the story. The experimental evaluation provides key insight into aspects of readers' construction of mental models about characters from plot-based cues. We used these results to inform the design and implementation of a planning-based narrative generation algorithm and to fine-tune the heuristic it utilizes.

## 2    Related Work

A considerable body of research has been dedicated to the development of narrative generation systems and intelligent virtual agents. Among these, several approaches have focused on the portrayal of personality traits. However, these and similar efforts tend to deal primarily with characters as individual agents who are able to react to their immediate environment or to the actions of other agents. Although existing methods have proven successful at specific aspects of narrative generation [26], drama management [24], portrayal of emotions in virtual agents [1], and natural language generation [20], they typically handle very specific and localized elements of narrative without reasoning about the story in its entirety. In contrast, the research presented in this paper aims at considering characters in the context of an entire story.

The computational model of *narrative* used in this research is based on a modification of the Glaive state-space planning algorithm developed by Ware and Young [30]. Additionally, our work has its foundation on previous research conducted by Young and his colleagues on the use of planning algorithms for narrative generation (e.g., [13,26]).

The use of AI planners to automatically generate stories was first introduced in systems such as Tale-Spin [22]. Considerable effort has been dedicated since then by AI researchers to the development and improvement of techniques, algorithms, and architectures to enable the application of the problem solving capabilities of AI planners to the automatic generation of narrative that is both interesting and coherent [25]. These include the work of Lebowitz on the UNIVERSE system [19], which uses a plan-based story approach combined with predefined character models to promote story extensibility while maintaining consistency and coherence. More recently, the IPOCL planning algorithm by Riedl and Young [26] focused on character intentionality by identifying goals that explain a character's actions. It is important to note that our approach is distinct from that used in IPOCL. The focus of IPOCL is on character intentionality without considering character personality. In contrast, our work focuses on the selection by a character of specific actions to achieve her goals as the means for the system to portray the character's distinct personality traits. We envision that both approaches can be complementary.

Some of the approaches for the automatic generation of narrative have focused on systems that direct the interaction among characters. Work by

Assanie on the extension of synthetic characters based on the Soar QuakeBot environment [16] dealt primarily with providing agents with the ability to adjust to changing goals provided by an external narrative manager [3]. Work by Riedl and Stern on drama managers focused on semi-autonomous agents able to *fail believably* [24]. The system ensures that agents avoid situations that are in conflict with the goals set by the drama manager and also behave in a way that justifies agent failure due to conflict with a goal. This preserves the narrative plot line while still accommodating user actions and agent autonomy.

Our computational model of *character personality* is based on the Five Factor Model (FFM), or Big Five, defined by Goldberg [11]. The FFM provides a taxonomy for the classification of personality using the following factors: Openness, Conscientiousness, Extroversion, Agreeableness, and Neuroticism. Each classification contains distinct bi-polar personality traits, e.g. generosity vs. selfishness. Each factor is linked to specific personality traits that can be mapped to a group of behavioral manifestations [10, 23]. We focus on Agreeableness because this factor is commonly used to describe *good* vs. *evil* personalities [21]. Furthermore, it represents character types and themes frequently used in narrative.

A number of research efforts have been aimed at the operationalization of the FFM to create richer and more expressive characters. The work of Doce *et al.* [9] applied the FFM to create distinguishable personalities in virtual agents by using personality traits to affect specific cognitive and behavioral processes (e.g. coping mechanisms, bodily expressions). Work by Bouchet and Sansonnet [6] applied the FFM and a model of cognition to implement a system in which rational agents make decisions after reasoning about goals that are modulated by pre-assigned personality traits.

Recent work in the area of virtual agents has focused on a specific subset of character actions: utterances in dialog [20]. Of particular interest to our research is the work of Mairesse and Walker on PERSONAGE [20], a natural language generator that can be configured to generate dialog to meet predefined personality requirements. PERSONAGE is built on an architecture that uses the FFM to create a mapping between personality traits and dialog utterances. Experimental results showed that the system could generate dialog correctly perceived as extroverted. Although this system incorporates robust psychological models, it does not consider story generation as a whole and instead focuses on the immediate reactions of virtual agents. It does not fully address the ability to generate a full range of character behavior that adjusts to changing story conditions.

## 3    Context: Developing a Plan-Based Model of Choice-Based Character Personality

The approach evaluated in the study we describe was later implemented in a system named *Mask*, which uses a state-space planning algorithm to generate story lines, modified to ensure that characters behave intentionally, i.e., their actions in the course of the story are justified by a frame of goal adoption and action sequences that are performed in pursuit of such goals. *Mask* utilizes a model of

the intentional behavior of characters and a micro-theory of human behavior to produce stories where characters not only act intentionally but also behave in a manner that is consistent with preassigned personality traits. Construction of stories that meet this criteria is achieved through the use of a sub-module—a micro-planner—that serves as a proxy for a character's own reasoning about different possible courses of action and the impact that their enactment would have on other story participants.

We focus on the creation of an intelligent process that enables the automatic generation of behavior that matches personality traits assigned to story characters. In this model, personality is expressed in the form of actions linked to choices. Actions are determined by individual elements such as goals, beliefs, moral traits, and personality. Characters are further shaped by their reaction to external events or the effect that these have on them. For example, let us consider a character's reaction to a stranger's act of aggression against a friend; an agreeable character may respond by helping the victim in a non-confrontational manner whereas a non-agreeable character may respond with assistance that also punishes the stranger. Rather than hard-coding trait labels on relevant action definitions, our approach uses a declarative representation of action in which a character's traits are used to dynamically determine the set of personality-consistent actions that she should perform.

The narrative generation mechanism used by *Mask* has its foundation on a character-centric model of action selection. Within this model, we work under the assumption that story characters act intentionally and consider multiple courses of action as they pursue their goals. Consequently, we use an operationalization of character intentionality based on the one defined by Riedl and Young for the IPOCL algorithm [26] and later expanded by Ware and Young for the CPOCL algorithm [29]. In these approaches, sub-plans called *intention frames* explicitly mark the adoption of a new goal by a character, the action in the story that gives rise to the new goal, the steps that the character takes in pursuit of that goal and the point in the story where the sub-plan to achieve the goal ends execution.

In contrast to a traditional narrative planner where a uniform planning process handles the construction of a story, in choice-based narrative generation, planning is interleaved between a macro-planner and a micro-planner. The macro-planner is responsible for constructing the authorial view of the global story and its causal coherence. The micro-planner is a restricted version of a planning system, designed to simulate the character's decision-making process as she works toward accomplishing a goal. To represent the character's process of considering multiple plausible courses of action to achieve her goal, the micro-planner generates the set of possible intention frames that allow the character to achieve such goal and then evaluates them utilizing a simplified model of affect appraisal theory. This facilitates the implementation of a process where character choice is treated as a first class object, and as such it guides the construction of the story.

The determination of a character's choice for action is triggered when a character forms an intention to achieve a new goal. When this occurs, the

micro-planner generates, evaluates, and ranks the set of intention frames that can be constructed to achieve the character's intention. It is important to note that in our model not all new intentions will result in a choice. For example, even though multiple possible intention frames for achieving a character's new goal may exist, their effects on the affective response of other story characters may not have measurable differences relative to one another. When this condition occurs, one of the intention frames is chosen non-deterministically.

We say that a choice occurs just when a character adopts a new intention whose achievement requires her to choose between at least two contrasting intention frames. The process of choosing between the alternate intention frames is done by using a simplified version of the appraisal theory proposed by Lazarus [18] to characterize each alternate. Of particular relevance to our research is his study of human emotions and in particular the assessment of the personal significance assigned to events. Our model represents the impact that a character's choice for action has on the emotions of other characters in terms of the beneficial or harmful appraisal of its effects. When a choice is identified, i.e., when two or more contrasting courses of action to achieve the same goal exist, two distinct intention frames are selected: the *choice*, which is the intention frame that the character will execute, and the *contrast*, which is the intention frame that is used to highlight what the character could have done but chose not to do. Steps in the *choice* intention frame are returned to the macro-planner to specify the course of action it then constructs for the given character, merging these actions into the global story structure it generates. Steps in the *contrast* intention frame are not added to the plan, but are recorded to support discourse devices that communicate the deliberation process that the character went through. *Mask* uses a simple discourse generator to present the story events, using language as close as possible to a simple enumeration of events and facts. In the case of choices, the contrasting alternatives are listed, followed by the option that was chosen by the character. The stories used in the study were hand-crafted to follow the same approach.

The heuristic used by the macro-planner to guide plan construction takes into account the existence of alternative choices for action. When a choice and a corresponding contrasting intention frame are identified by the micro-planner, the heuristic favors the steps in the *choice* intention frame to guarantee that these are included in the final plan. Steps in the *contrast* intention frame do not require any special handling by the heuristic because these do not become part of the story.

An essential consideration during the design of *Mask* was whether the approach would be effective. This provided the motivation for the formative study that is described in Sect. 4 (below).

## 4   Experimental Design and Results

In this section we report on the results of a study designed to collect formative data for the design of a choice-based computational model of character

personality. Data collected from the study aimed at testing the validity of a computational model of character behavior that is informed by psychological research. The model is used in the implementation of a narrative generation mechanism in which characters are portrayed making choices for action and action sequences in accordance with a personality factor that has been assigned to them. In this study we focused on the Agreeableness factor as defined by Goldberg in the Big Five Factor Model [11]. Our motivation was to evaluate the feasibility of the approach while the model was still being designed and before its implementation.

The main objective of the study was to evaluate the following thesis: **An audience presented with a set of alternate action sequences for a story character will select personality trait ratings that have significant correlation with the choices made by the character.** Additionally, the experiment was also designed to test whether an audience can recognize when a character's behavior over the course of a story is inconsistent with her assigned personality factor.

## 4.1    Experimental Design

In order to determine whether readers are able to make inferences about personality traits of characters by observing them make choices corresponding to those we describe in Sect. 3, we conducted a study where participants read a series of hand-crafted short stories designed to include events representative of a plan-based story structure where the main character is faced with having to choose a specific course of action from a set of applicable alternatives. The chosen action and its alternatives were devised to contrast with each other, ensuring the portrayal of behavior that was either typical of a specific personality factor or its opposite.

Subjects were assigned in a round-robin manner in to one of six groups. Each participant read three stories, but the ordering of the stories was counterbalanced across the six groups to control for potential learning effects. Three of the groups, called the experimental condition groups, read three stories characterized as follows: (a) a story that includes actions where the main character makes choices to act in a manner that is consistent with an agreeable personality, (b) a story that includes actions where the main character makes choices to act in a manner that is not consistent with an agreeable personality, and (c) a story that includes actions where the main character makes choices to act in in a manner that is not consistent with an agreeable personality, except for the last action in the story. The last action is designed to be inconsistent with the character's non-agreeable personality, i.e., it demonstrates traits from an agreeable personality.

Participants in the other three groups, called the control condition groups, were presented with two stories where the choices for action of the character are designed to be neutral and a version of the story where the character's last action is consistent with the character's non-agreeable personality, i.e., it demonstrates traits from an non-agreeable personality.

The stories used were based on passages from *The Hobbit: Chap. 5 - Rid-dles in The Dark* [27], *The Adventures of Tom Sawyer: Chap. 20* [28], and *The Life of Lazarillo of Tormes; his fortunes and misfortunes as told by himself, Chap. 1* [2]. The names of characters, places, and other story content were mod-ified to obscure the actual narrative sources in order to prevent the introduction of bias due to prior knowledge of the story content. Significant portions of the story content were the same in all versions of each story. Specific portions toward the end of each story were customized depending on the personality factor that was being portrayed. The stories all involved characters with personality traits either typical (e.g. altruism, unselfishness) or atypical (e.g. belligerent, selfish) of the agreeableness personality factor. Each of the stories required the main character to choose between one of several courses of action. There were three versions of each story, depending on the choice made by the character. In the treatment versions, the choice portrays behavior that is either typical of high agreeableness or typical of low agreeableness. The control versions eliminated the need for the character to make a choice through the intervention of a neutral third party or event.

The study included a total of 137 participants who were students recruited from North Carolina State University. Only participants who completed the experiment in its entirety are included in the results. Subjects accessed the sys-tem via a web browser, and were presented with textual narratives followed by a series of questions with Likert-scale responses.

Participants completed an initial demographic information survey, then read each story, completing an additional survey before moving on to read the next story. The story survey focused on collecting information regarding the par-ticipants' perception of the main character's personality in the story they had just read. Subjects provided Likert scale responses to questions about the sto-ries' main character that were drawn from the Big Five Inventory (BFI) instru-ment [14,15] developed at the Berkeley Personality Lab. Post-processing of the data was done following the instructions provided by the instrument's authors. The post-processed results of the survey provided a score of the story protag-onist's personality factors. Even though the raw experiment data was discrete, the score data was a continuous value between 1 and 5.

## 4.2   Results and Analysis

We applied two statistical tests to analyze the results of the experiment. For the first test we ran an Analysis of Variance (ANOVA) on the agreeableness score with respect to the story version that participants read. Results from the test are shown in Table 1. The test indicates statistical significance such that the null hypothesis can be rejected in the case of the agreeableness personality factor.

In addition to ANOVA, we also analyzed the personality scores using the *Chi-square test of independence*. To use this test it was necessary to obtain a discretized version of the personality scores, which was done using bins iden-tified applying the *Ameva autonomous discretization algorithm* developed by Gonzalez-Abril et al. [12]. For this part of the analysis we focused on the

**Table 1.** Agreeableness - S1

Agreeableness score - First story

|  | DF | Sum Sq | Mean Sq | F value | PR(>F) |
|---|---|---|---|---|---|
| Story-ID | 2 | 9.12 | 4.562 | 14.85 | 1.483-06 |
| Residuals | 134 | 14.13 | 0.307 | | |

Agreeableness score - Second story

|  | DF | Sum Sq | Mean Sq | F value | PR(>F) |
|---|---|---|---|---|---|
| Story-ID | 2 | 20.31 | 10.153 | 21.03 | 1.14e-08 |
| Residuals | 134 | 64.71 | 0.483 | | |

Agreeableness score - Combined dataset (S1 and S2)

|  | DF | Sum Sq | Mean Sq | F value | PR(>F) |
|---|---|---|---|---|---|
| Factor-Portrayed | 2 | 24.41 | 12.203 | 22.29 | 1.09e-09 |
| Residuals | 271 | 148.34 | 0.547 | | |

**Table 2.** Frequency tables for agreeableness

|  | Agreeableness score - First story | | |
|---|---|---|---|
| Story ID | Low | Mid | High |
| S1-1 | 4 | 25 | 15 |
| S1-2 | 22 | 21 | 4 |
| S1-3 | 4 | 35 | 7 |
|  | Agreeableness score - Second story | | |
| Story ID | Low | Mid | High |
| S2-1 | 11 | 20 | 16 |
| S2-2 | 33 | 11 | 0 |
| S2-3 | 28 | 16 | 2 |

results for the agreeableness factor. The frequency table and the results of the Chi-square test on the table data are shown in Tables 2 and 3. Results are first shown for each individual story, followed by results for the combined dataset.

**Measuring the Consistency of Character Behavior.** The third story that was presented to the study participants was designed to evaluate whether they could perceive the existence of inconsistent character behavior. In this story, the main character performs several actions that are typical of a low-agreeableness personality factor. Toward the end of the control version of the story (S3-2), the character's final action is consistent with his personality factor, i.e., he behaves according to the personality traits typical of low-agreeableness. In the treatment version of the story (S3-1), the character's final action is not consistent with his personality factor. The action he performs is an example of altruism, which is

**Table 3.** Agreeableness - Chi-square test results

| First story (S1) | | |
| --- | --- | --- |
| $X^2$ | DF | p-value |
| 32.564 | 4 | 1.467e-06 |
| Second story (S2) | | |
| $X^2$ | DF | p-value |
| 38.586 | 4 | 8.482e-08 |
| Combined dataset (S1 and S2) | | |
| Pearson's Chi-squared test with simulated p-value (based on 2000 replicates) | | |
| $X^2$ | DF | p-value |
| 145.78 | NA | 0.0004998 |

a trait typical of a high-agreeableness personality factor and hence in contrast with the personality portrayed by the character up to that point in the story.

For Story S3-1, 86.81 % of subjects (79 out of 91) reported perceiving inconsistency in the main character's behavior, while 13.19 % (12 out of 91) reported not perceiving inconsistency. For Story S3-2, 17.39 % of subjects (8 out of 46) reported perceiving inconsistency in the main character's behavior, while 82.61 % (38 out of 46) reported not perceiving inconsistency. The percentage of responses from participants within each group who reported inconsistent behavior clearly indicates that such behavior was perceivable by the audience. This further supports our thesis, by strengthening the argument that audiences are able to detect contrast between different character actions when such contrast exists.

We also analyzed the consistency data using *Pearson's Chi-square test of independence with Yates' continuity correction*. The results yielded a $\chi^2$ value of 60.576, with 1 degree of freedom and a p-value of 7.078e-15. These results allow us to reject the null hypothesis and provide support for our hypothesis that given a sequence of actions, performed by the same character, an audience will be able to perceive that a character's actions are inconsistent with the personality factor that is exhibited in the character's previous actions. In essence, this data supports the idea that contrasting story actions can in fact be perceived by an audience that reads the story. This is one of the foundations of our work.

These results indicate that given a sequence of actions performed by the same character, an audience will be able to perceive when the character's actions are inconsistent with the personality factor that is exhibited in his previous actions.

**Personality Measurement.** In addition to the consistency data, participants also completed a personality evaluation of the main character in the third story (S3). This evaluation was conducted using the BFI instrument described earlier in this document. Because both versions of the story were designed to portray the main character as having a low-agreeableness personality factor, we expected scores to be in the 1.0 to 3.0 range. The average personality score for the Agreeableness factor of this character was **2.28** for the treatment version of the story,

whereas the average was **1.86** for the control version. Both scores are indicative of a low-agreeableness personality factor. This is precisely what the story was designed to portray. Also, note that the score is significantly higher (22.58 %) for the version of the story where the character performed one action that was consistent with a high-agreeableness factor.

**Discussion.** Analysis of the data collected from this study indicates that the personality scores for the **agreeableness** factor and their relationship with the story read by the participant are statistically significant in favor of rejecting the null hypothesis. The results of both tests, ANOVA and the Chi-square test of independence, provide enough evidence to support this conclusion. Additionally, analysis of the agreeableness scores for each story, independently from each other, yielded results that disprove the existence of an imbalance between the individual results. Each story had the expected effect on the audience when considered on its own and when considered within the context of both stories read.

Finally, data from this study also provides evidence that audiences are able to perceive contrast in a character's actions when such contrast is present. This was observed in the distribution of responses from participants who indicated the existence of an action that was indicative of inconsistent character behavior. It was also measured through the application of a Chi-square test of independence, which showed that the story version and the perceived consistency of the story actions were not independent from each other.

# 5    Conclusion

The results of the experiment provided statistically significant evidence to support our hypothesis that *an audience presented with a set of alternate action sequences generated for a story character will select personality trait ratings that have significant correlation with the choices made by such character.* This evidence was crucial to justify the merits of continuing the research and dedicating the resources needed to implement the algorithm at the core of *Mask*.

The data obtained from this experiment clearly indicated that the choice-based narrative generation approach used in the design of *Mask* was feasible. This was particularly true in the portrayal of traits linked to the Agreeableness factor, which lends itself well to the representation of good (high-agreeableness) vs. evil (low-agreeableness) characters in storytelling [21]. This enabled us to focus our design efforts on a specific factor and to fine-tune the implementation of the mechanism used to evaluate and rank multiple intention frames.

# References

1. André, E., Klesen, M., Gebhard, P., Allen, S., Rist, T.: Integrating models of personality and emotions into lifelike characters. In: Paiva, A. (ed.) IWAI 1999. LNCS (LNAI), vol. 1814, pp. 150–165. Springer, Heidelberg (2000). doi:10.1007/10720296_11
2. Anonymous: In: Rudder, R.S., Puertolas, C., de Rodriguez, C.: The Life of Lazarillo of Tormes: His Fortunes and Misfortunes As Told by Himself, p. 245. Ungar, New York (1973)
3. Assanie, M.: Directable synthetic characters. In: Proceedings of the AAAI Spring Symposium on Artificial Intelligence and Interactive Entertainment, pp. 1–7 (2002)
4. Bahamón, J.C., Young, R.M.: CB-POCL: a choice-based algorithm for character personality in planning-based narrative generation. CMN **2013**, 4–23 (2013)
5. Barthes, R., Duisit, L.: An introduction to the structural analysis of narrative. New Literary Hist. **6**(2), 237–272 (1975)
6. Bouchet, F., Sansonnet, J.P.: Influence of personality traits on the rational process of cognitive agents. In: Proceedings of WI - IAT, pp. 81–88. IEEE CS (2011)
7. Bulman, C.: Creative Writing: a Guide and Glossary to Fiction Writing. Polity, Cambridge (2007)
8. Chatman, S.B.: Story and Discourse: Narrative Structure in Fiction and Film. Cornell University Press, Ithaca (1978)
9. Doce, T., Dias, J., Prada, R., Paiva, A.: Creating individual agents through personality traits. In: Allbeck, J., Badler, N., Bickmore, T., Pelachaud, C., Safonova, A. (eds.) IVA 2010. LNCS (LNAI), vol. 6356, pp. 257–264. Springer, Heidelberg (2010). doi:10.1007/978-3-642-15892-6_27
10. Funder, D.C., Sneed, C.D.: Behavioral manifestations of personality: an ecologicalapproach to judgmental accuracy. J. Pers. Soc. Psychol. **64**(3), 479–490 (1993)
11. Goldberg, L.R.: An alternative "description of personality": the big-five factor structure. J. Pers. Soc. Psychol. **59**(6), 1216 (1990)
12. Gonzalez-Abril, L., Cuberos, F.J., Velasco, F., Ortega, J.A.: Ameva: an autonomous discretization algorithm. Expert Sys. Appl. **36**(3), 5327–5332 (2009)
13. Harris, J., Young, R.M.: Proactive mediation in plan-based narrative environments. IEEE TCIAIG **1**(3), 233–244 (2009)
14. John, O.P., Donahue, E.M., Kentle, R.L.: The big five inventory - versions 4a and 54. UC Berkeley Institute of Personality and Social Research (1991)
15. John, O.P., Naumann, L.P., Soto, C.J.: Paradigm shift to the integrative big five trait taxonomy. Handb. Pers. Theory Res. **3**, 114–158 (2008)
16. Laird, J.E., Jones, R.M.: Building advanced autonomous AI systems for large scale real time simulations. In: Computer Games Development Conference (1998)
17. LaPlante, A.: The Making of Story: a Norton Guide to Creative Writing. W.W. Norton, New York (2007)
18. Lazarus, R.S.: Progress on a cognitive-motivational-relational theory of emotion. Am. Psychol. **46**(8), 819–834 (1991)
19. Lebowitz, M.: Creating characters in a story-telling universe. Poetics **13**(3), 171–194 (1984)
20. Mairesse, F., Walker, M.: PERSONAGE: personality generation for dialogue. In: Annual Meeting-Association for Computational Linguistics, pp. 496–503 (2007)
21. McCrae, R.R., John, O.P.: An introduction to the five-factor model and its applications. J. Pers. **60**(2), 175–215 (1992)

22. Meehan, J.R.: Tale-spin, an interactive program that writes stories. In: Fifth International Joint Conference on Artificial Intelligence, pp. 91–98 (1977)
23. Mehl, M.R., Gosling, S.D., Pennebaker, J.W.: Personality in its natural habitat: manifestations and implicit folk theories of personality in daily life. J. Pers. Soc. Psychol. **90**(5), 862–877 (2006)
24. Riedl, M.O., Stern, A.: Failing believably: toward drama management with autonomous actors in interactive narratives. In: Göbel, S., Malkewitz, R., Iurgel, I. (eds.) TIDSE 2006. LNCS, vol. 4326, pp. 195–206. Springer, Heidelberg (2006). doi:10.1007/11944577_21
25. Riedl, M.O., Young, R.M.: Character-focused narrative generation for execution in virtual worlds. In: Balet, O., Subsol, G., Torguet, P. (eds.) ICVS 2003. LNCS, vol. 2897, pp. 47–56. Springer, Heidelberg (2003). doi:10.1007/978-3-540-40014-1_6
26. Riedl, M.O., Young, R.M.: Narrative planning: balancing plot and character. J. Artif. Intell. Res. **39**(1), 217–268 (2010)
27. Tolkien, J.R.R.: The Hobbit. Houghton Mifflin, Boston (2001)
28. Twain, M.: The Adventures of Tom Sawyer (Tom Sawyer & Huckleberry Finn Series Book 1). kindle edn. Amazon Digital Services Inc. (2011)
29. Ware, S., Young, R., Harrison, B., Roberts, D.: A computational model of plan-based narrative conflict at the fabula level. IEEE TCIAIG **6**(3), 271–288 (2014)
30. Ware, S.G., Young, R.M.: Glaive: a state-space narrative planner supporting intentionality and conflict. In: AIIDE, pp. 80–86 (2014)

# Asking Hypothetical Questions About Stories Using QUEST

Rachelyn Farrell[(✉)], Scott Robertson, and Stephen G. Ware

Narrative Intelligence Lab, University of New Orleans, New Orleans, LA 70148, USA
{rfarrell,sgware}@uno.edu, srobert6@my.uno.edu

**Abstract.** Many computational models of narrative include representations of possible worlds—events that never actually occur in the story but that are planned or perceived by the story's characters. Psychological tools such as QUEST are often used to validate computational models of narrative, but they only represent events which are explicitly narrated in the story. In this paper, we demonstrate that audiences can and do reason about other possible worlds when experiencing a narrative, and that the QKSs for each possible world can be treated as a single data structure. Participants read a short text story and were asked hypothetical questions that prompted them to consider alternative endings. When asked about events that needed to change as a result of the hypothetical, they produced answers that were consistent with answers generated by QUEST from a *different* version of the story. When asked about unrelated events, their answers matched those generated by QUEST from the version of the story they read.

**Keywords:** Hypothetical reasoning · Planning · Possible worlds · QUEST

## 1 Introduction

Narrative theorists often analyze stories in terms of *possible worlds* [1–3]. A story's meaning may arise not only from the events which did happen but also from the events which did not happen or might have happened instead.

This theory of possible worlds is informed by the idea that when a speaker communicates a narrative, the hearer is an active participant [4]. The audience engages in a complex cognitive process of constructing a mental model of the story while consuming it. Cognitive scientists have demonstrated that the hearer constantly updates this mental model by revising working memory [5], shifting the focus of attention [6], making assumptions about missing information [7], and making inferences about the future [8], among other tasks.

The possible worlds theory has recently informed computational models of narrative as well. Riedl and Young [9] developed a formal, generative, plan-based representation of stories which ensures that every action in the plan can be explained not only in terms of the author's goals for the story as a whole,

© Springer International Publishing AG 2016
F. Nack and A.S. Gordon (Eds.): ICIDS 2016, LNCS 10045, pp. 136–146, 2016.
DOI: 10.1007/978-3-319-48279-8_12

but also in terms of the individual goals of the characters who are acting. This model made the story's characters more believable, but it was unable to represent characters' plans which failed or were only partially completed, which is an essential element of conflict [10].

Ware and Young [11] solved this problem by extending that representation to model other possible worlds. The Glaive narrative planning algorithm [12] treats the search space of a planning problem as a Kripke structure [1], where each branch represents a different way the story might have unfolded. Each event in the story still needs to be explained in terms of character goals, but it is sufficient for that explanation to appear in a different possible world from the actual story. They give an example from *Indiana Jones and the Raiders of the Lost Ark* (1981), in which Jones excavates the Ark of the Covenant only for it to be stolen by the antagonists. We can explain that Jones excavated the Ark with the intention of taking it to safety, even though this plan fails and we never see it happen. It is enough to know that there exists a possible world in which Jones took the Ark to safety. Similar possible worlds reasoning has been proposed for representing other narrative phenomena, such as the differing beliefs of characters [13].

These computational models of narrative are often evaluated using psychological tools such as QUEST [14], which represents the audience's cognitive state in terms of question-answering ability. However, these tools only reason about those events which are actually narrated, making it impossible to apply them to models which require the reader to reason about other possible worlds. Reasoning about possible alternatives is also an essential task for analyzing interactive narratives.

In this paper, we demonstrate that QUEST can be used to model how audiences reason about other possible worlds when experiencing a narrative. After reading a short text story, participants were asked hypothetical questions that made some events in the story impossible or enabled new events which were previously impossible. By translating these hypothetical prompts into modifications on the QUEST knowledge structure, we generated new structures that represented the hypothetical worlds that the audience was prompted to imagine. When asked hypothetical questions, participants gave answers that corresponded to the QUEST model of the *alternate* version of the story. We consider this investigation to be preliminary evidence that empirical tools such as QUEST can be applied to validate computational models which are based on possible worlds reasoning.

## 2    Related Work

QUEST is a framework developed by cognitive scientists to predict how adults answer open-ended questions about finite sets of information. Short text narratives can be encoded as a QUEST Knowledge Structure (QKS), a directed graph composed of nodes whose content is a simple sentence statement about some element of the story. QUEST defines five types of nodes and six types of

edges that correspond to different types of content and relationships in a narrative. QUEST also defines graph search procedures for answering *why? how? when? what enabled?* and *what are the consequences of?* questions. Graesser et al. [14] demonstrated that when human subjects are given a question and asked to rank a set of answers, these search procedures reliably predict Goodness of Answer (GoA) and can serve as a proxy for elements of human narrative understanding.

QUEST has been used to validate computational models of narrative. Christian and Young [15] developed a mapping of plan-based models of narrative onto QKSs. This mapping was later updated by Riedl and Young [9] to incorporate character goals. Recently Cardona-Rivera et al. [16] introduced a variant mapping to improve the accuracy of *why?* questions. These mappings facilitated the validation of several plan-based computational models of narrative. For example, Riedl and Young [9] used it to demonstrate that intentional planning generated more believable stories by showing that human subjects consistently choose answers with higher goodness (according to QUEST GoA measures) when reading stories generated by their planner.

The trouble with QUEST is that a QKS is defined only for those events which are actually narrated. Events which did not happen or might have happened instead are not represented, so one cannot ask questions about them or consider them when answering other questions. In short, QUEST lacks support for hypothetical questions, and thus is of limited usefulness for validating models based on possible worlds.

Boyd [17] argues that storytelling contributed to human evolutionary success because (among other factors) it exercised the ability to reason hypothetically. Bruner [2,18] claims that narrative is the primary way that we structure experiences into an understandable reality and that our ability to perceive the actual world is based on a general ability to imagine possible worlds. Hypothetical reasoning is essential to narrative, and it has prompted numerous theorists to develop systems of analysis based on the idea that when someone experiences a narrative he or she can reason about a network of possible worlds [13,19–21]. These theories are based on Kripke's semantics for modal logic [1] about what is necessary, possible, and impossible.

Some work has been done related to cognitive tools and hypothetical reasoning. Graesser and Olde [22] studied how people ask questions (including *what if?* and *what if not?* questions) when learning how a device works and how it can malfunction. Gerrig and Bernardo [8] demonstrated that when reading short James Bond stories the audience experienced higher suspense when the number of foreseeable possible worlds that are good for the protagonist decreases. This model of suspense was leveraged by Cheong and Young [23] in the *Suspenser* story generation system.

We propose that we can incorporate events from other possible worlds into a QKS by treating multiple QKSs as if they were one structure, and thereby extend QUEST to be able to reason about events that never actually happened. We do this by translating hypothetical prompts into insertions or deletions of

QUEST nodes on a QKS. For example, to represent the possible world prompted by the hypothetical "What if X had happened?", we add a node X to the QKS. Similarly, for "What if X had not happened?" we remove node X. We demonstrate that these models of possible worlds can accurately predict the audience's answers to hypothetical questions involving events that were not explicitly narrated.

## 3    QKS Mapping

Although we mapped each story to a QKS using Riedl and Young's complete mapping algorithm [9], we only ask one type of question in our experiment—*how?*—and therefore limit our discussion to the node and arc types accessed by the arc-search procedure for *how?* questions. The mapping introduced by Cardona-Rivera et al. [16] is identical to Riedl and Young's for these kinds of questions.

Figure 1 gives an example of a Goal-node hierarchy, in which subordinate goals are connected to super-ordinate goals via Reason arcs. This example shows how the character Sarah plans to achieve her goal of being a parent. The Reason arcs between the Goal nodes indicate that her goal *Sam and Sarah get married* is explained by her higher-level goal *Sam and Sarah have a baby named Hope*, which is in turn explained by her top-level goal, *Sarah is a parent*.

**Fig. 1.** Example QKS goal node hierarchy

QUEST answers questions by first identifying the type of question being asked and the node being queried, and then performing a breadth-first search of the QKS starting at the queried node and traversing only the arcs that are legal for that question type. The set of candidate answers to the question is the set of all nodes reached by this search. The arc-search procedure for the *how?* question allows backward Reason and Manner arcs, so if we asked the question, "How does Sarah become a parent?", we would generate the answer set {*Sam and Sarah have a baby named Hope, Sam and Sarah get married*}.

Our goal node hierarchies were created by the following subset of the mapping algorithm:

- For every action taken in the story, we create a Goal node for each character who must consent to take that action. For example, the event *Sam and Sarah get married* has two corresponding Goal nodes—one representing Sam's goal for them to get married, and one for Sarah's.
- A *causal link* is a structure in a plan that represents a dependency between two actions; the first action establishes some necessary precondition for the second action. For each causal link in the plan, we add a Reason arc from the Goal node for the first action to the Goal node for the second action.

## 4    Experimental Design

We tested the ability of an audience to reason hypothetically by having them read a story and consider hypothetical situations. We hypothesized that when those situations made important events possible or impossible, they would answer as if they had read an alternate version of the story where that hypothetical was the reality, demonstrating that they can reason about other possible worlds even when the author does not explicitly narrate them. We also sought to observe the absence of this phenomenon. When asked to consider a hypothetical that would not affect the answer to a question, they would answer consistently with the story they read.

### 4.1    Materials

We used the Glaive narrative planning system [12] to generate four stories. Each had the same beginning but a different ending, representing four possible worlds. Each of these stories was translated into a QKS. QUEST search procedures were used to generate candidate answers to the questions we intended to ask. Human subjects were shown one of the four stories and asked to consider a hypothetical scenario. Subjects then answered questions by ranking a set of possible answers from best to worst. This set of answers was generated by combining QUEST's candidate answers to the same question across all four stories (the story that subject read, plus the other stories they did not read). The order in which readers ranked answers revealed which of the four stories they were reasoning about.

Figure 2 gives the text of the four stories. In all versions, Sarah has two important character goals which can be satisfied in two different ways: she wants to get a job and she wants to be a parent. In all versions, she applies to work at Google, indicating that she plans to achieve her goal of having a job by working for Google. In stories A1 and B1, Google offers her a job and she accepts, but in versions A2 and B2, Google never offers her the job. Instead, she applies for and accepts a different job at Home Depot. In stories A1 and A2, Sarah achieves her goal of becoming a parent by having a child with her spouse. In stories B1 and B2, she achieves this goal by adopting a child.

| | |
|---|---|
| William visits an adoption agency. | **All Stories** |
| William adopts a child named Jude. | |
| William and Candace fall in love. | |
| William and Candace get married. | |
| William and Candace have a baby named Sarah. | |
| A boy named Sam grows up. | |
| Sarah grows up. | |
| Sam applies for a job at Home Depot. | |
| Home Depot offers Sam a job. | |
| Sam takes the job at Home Depot. | |
| Sam and Sarah fall in love. | |
| Sam and Sarah get married. | |
| Sarah applies for a job at Google. | |

| | |
|---|---|
| Google offers Sarah a job. | **Story A1** |
| Sarah takes the job at Google. | |
| Sam and Sarah have a baby named Hope. | |

| | |
|---|---|
| Google offers Sarah a job. | **Story B1** |
| Sarah takes the job at Google. | |
| Sarah visits an adoption agency. | |
| Sarah adopts a child named Abe. | |

| | |
|---|---|
| Sarah applies for a job at Home Depot. | **Story A2** |
| Home Depot offers Sarah a job. | |
| Sarah takes the job at Home Depot. | |
| Sam and Sarah have a baby named Hope. | |

| | |
|---|---|
| Sarah applies for a job at Home Depot. | **Story B2** |
| Home Depot offers Sarah a job. | |
| Sarah takes the job at Home Depot. | |
| Sarah visits an adoption agency. | |
| Sarah adopts a child named Abe. | |

**Fig. 2.** Story text for all four variations

When participants read a story in which Sarah got the job at Google (A1 and B1), they were asked to consider the hypothetical, "What if Google had not offered Sarah a job?" If they read a story where she did not get the job (A2 and B2), they were asked to consider, "What if Google *had* offered Sarah a job?"

## 4.2   Questions

To summarize the experiment so far, participants read one of four variants of the same story and were asked to consider a hypothetical. They then answered two questions, one whose answer should be affected by the hypothetical and one whose answer should not be affected.

The first question was, "How would Sarah have achieved her goal of having a job?" The answers we provided included all candidate answers generated by QUEST using the *how* arc search procedure on all story versions:

– Sarah takes the job at Google.
– Sarah applies for a job at Google.
– Sarah takes the job at Home Depot.
– Sarah applies for a job at Home Depot.

We expected subjects to prioritize the answers that came from a version of the story they *did not* read. If they read a story where Sarah was offered the job at Google, and were asked to consider what would have happened if she had not gotten that offer, we expected them to say she would seek a job elsewhere. If they read a story where she did not get the offer, and were asked to consider what would have happened if she *had* gotten the offer, we expected them to say she would take the job at Google instead.

The second question was, "How would Sarah have achieved her goal of becoming a parent?" The candidate answers were:

– Sam and Sarah have a baby named Hope.
– Sam and Sarah get married.
– Sarah adopts a child named Abe.
– Sarah visits an adoption agency.

Here we expected participants to prioritize the answers that came from the version of the story they *did* read. The hypothetical affects her career goal by making her ideal career possible or impossible; however it does not directly affect her family goal. If subjects read a story where she had a child with her spouse, we expected them to prioritize that answer despite the hypothetical. Likewise, if they read a story where she chose to adopt a child, we expected them to prioritize that answer, despite the hypothetical. This second question was important because we not only want to demonstrate that people can change their mental model of the story when they have to, but also that they do not change it when they don't have to.

## 4.3    Controlling for Story Content and Response Quality

One potential complication that arises from hypothetical reasoning is that there is a potentially infinite number of other ways something might happen. We attempted to control for this in two ways. Firstly, we do not allow open-ended responses but rather ask users to rank a pre-generated set of candidate responses. Secondly, the beginning common to all stories was designed to introduce all the people, places, things, and types of actions that could occur. The four possible endings all reuse the existing entities and actions. For example, the beginning of the story includes examples of a child being born and a child being adopted. Thus, even if subjects read a story where Sarah's child was born, they knew that adoption was also possible.

Subjects were recruited via Amazon Mechanical Turk. To account for the large amount of noise, we asked all participants to complete an initial training task with a different story (without being asked to consider any hypothetical situations). This training task may have had a priming effect that influenced in what order subjects ranked their answers from the same story. This was an acceptable risk because this experiment is not designed to validate QUEST search procedures or question answering tasks. We consider that task already accomplished by Graesser et al. [14]. We are only interested in testing whether or not a hypothetical situation causes subjects to report answers from the same story or a different story.

Finally, as a further quality control, each subject was asked two non-hypothetical comprehension questions after they read the story. For each question, they were instructed to rank a given set of answers from best to worst. Of the answers we provided, two were produced by QUEST's arc-search procedure for the given question, and the other two were chosen arbitrarily from the other events in the story, such that they had no relation to the question being asked. We assume that if the reader fully comprehended the story they would rank the two answers produced by QUEST higher than the two unrelated events. Again, this assumption arises from previous work on QUEST and is not the goal of this study. If they did not rank the answers for both questions accordingly, we assumed they did not pay close attention to the story and discarded their data as noise.

## 5    Results

We recruited 180 participants in total and retained 88 responses after discarding noisy data. Table 1 shows the number of responses from each story version and the distribution of responses to each question. For example, of the 26 participants who read version A1, there were 5 who answered the *job* question using events from the version-1 stories (A1/B1), and 21 who answered it with events from the version-2 stories. Similarly, there were 23 who answered the *child* question using events from version A, and 3 who answered it with events from version B.

**Table 1.** Response distribution for each question and all story versions

| Story Read | Number of responses | Job question | | Child question | |
|---|---|---|---|---|---|
| | | Answered 1 | Answered 2 | Answered A | Answered B |
| A1 | 26 | 5 | 21 | 23 | 3 |
| B1 | 22 | 5 | 17 | 10 | 12 |
| A2 | 20 | 20 | 0 | 18 | 2 |
| B2 | 20 | 18 | 2 | 8 | 12 |

**Hypothesis #1.** When presented with a hypothetical that makes critical events become impossible, people will answer using events from a story other than the one they read.

In other words, for participants who read story A1 or B1, we expect the highest ranked answer to the hypothetical *job* question to come from story A2 or B2. The binomial exact test supports this hypothesis with $p < 3.085e^{-5}$.

**Hypothesis #2.** When presented with a hypothetical that makes new events possible that were not possible before, but that were part of a character's plan, people will also answer using events from a story other than the one they read.

In other words, for participants who read story A2 or B2, we expect the highest ranked answer to the hypothetical *job* question to come from story A1 or B1. The binomial exact test supports this hypothesis with $p < 7.467e^{-10}$.

The first two hypotheses consider the two cases individually and test how the results deviate from the null hypothesis that there is an underlying binomial distribution. However, there are many reasons outside of our experiment why a binomial distribution may not hold in these cases. To provide further evidence that we are observing a real effect, we now group hypothesis #1 and #2 together into a more general hypothesis.

**Hypothesis #3.** When presented with a hypothetical about a critical event, people will answer using events from a story other than the one they read.

Fisher's exact test shows that there is a significant association ($p < 2.823e^{-13}$) between the story that participants read and the story that their answers came from; that they tended to select answers from the opposite story. There are several ways to measure effect size when using Fisher's exact test. The odds ratio for this contingency table is ≈66.96, meaning there are about 67 to 1 odds that users chose answers from the alternate story.

**Hypothesis #4.** When presented with a hypothetical about a *non-critical* event, people will answer using events from the story they read.

In other words, we expect all participants to answer the *parent* question using answers from the story they read, since Sarah's plan for becoming a parent is unrelated to the event of Google offering her a job.

Fisher's exact test supports this with $p < 3.497e^{-6}$, with an odds ratio of $\approx 10.6$. We conclude that readers are indeed only using answers from a different story when it makes sense to.

## 6  Conclusion and Future Work

Computational cognitive tools like QUEST can be a valuable resource for validating formal models of narrative, especially plan-based models which have a fairly direct mapping from plan to QKS. However, QUEST only represents the actual world. Many phenomena, especially in interactive narratives, require reasoning about alternative possible worlds.

In this paper we have provided preliminary evidence that, for certain kinds of content, QUEST can be extended to reason about other possible worlds by treating multiple QKSs as if they were one graph. Given the appropriate prompts, users realize when events have become impossible and can reason about alternative ways to complete the story. Likewise, when new events are introduced, they can update their expectations to incorporate these new events. They are also able to distinguish when these hypotheticals are relevant and avoid updating their expectations when it is unnecessary.

It is important to point out that we have only used a single story domain and only tested *how?* questions, which use a limited subset of QUEST's available features. We chose to focus on *how?* questions because reasoning about the ways characters achieve their goals is frequently needed in plan-based interactive stories. Obviously the value of our results can be enhanced through replication in different domains. It will also be important to study whether or not other kinds of questions, like the *why?* questions used by Riedl and Young [9] and Cardona-Rivera et al. [16], are affected by hypothetical reasoning.

We suspect that the audience's mental model contains information about many possible worlds, not just the actual world that corresponds to the story as narrated. By incorporating other possible worlds into a QKS, it more closely reflects the reader's mental model and can reliably answer certain kinds of *what if?* and *what if not?* questions. Narrative generation systems which reason about these other possible worlds can better reflect the human comprehension process. We hope these results will be valuable to other researchers using empirical tools such as QUEST to study computational models of narrative.

## References

1. Kripke, S.A.: Semantical considerations on modal logic. Math. Logic Q. **9**, 67–96 (1963)
2. Bruner, J.S.: Actual Minds, Possible Worlds. Harvard University Press, Cambridge (1986)
3. Ryan, M.L.: Possible worlds (2016)
4. Gerrig, R.J.: Experiencing Narrative Worlds: On the Psychological Activities of Reading. Yale University Press, New Haven (1993)

5. Baddeley, A.D., Hitch, G.: Working memory. Psychol. Learn. Motiv. **8**, 47–89 (1974)
6. Zwaan, R.A., Radvansky, G.A.: Situation models in language comprehension and memory. Psychol. Bull. **123**, 162 (1998)
7. van den Broek, P.: Causal inferences and the comprehension of narrative texts. Psychol. Learn. Motiv. **25**, 175–196 (1990)
8. Gerrig, R.J., Bernardo, A.B.I.: Readers as problem-solvers in the experience of suspense. Poetics **22**, 459–472 (1994)
9. Riedl, M.O., Young, R.M.: Narrative planning: balancing plot and character. J. Artif. Intell. Res. **39**, 217–268 (2010)
10. Herman, D.: Story Logic. University of Nebraska Press, Lincoln (2002)
11. Young, R.M., Harrison, B., Roberts, D.L.: A computational model of narrative conflict at the fabula level. IEEE Trans. Comput. Intell. Artif. Intell. Games **6**, 271–288 (2014)
12. Young, R.M.: Glaive: a state-space narrative planner supporting intentionality and conflict. In: Proceedings of the 10th AAAI International Conference on Artificial Intelligence and Interactive Digital Entertainment, pp. 80–86 (awarded Best Student Paper) (2014)
13. Ryan, M.L.: Possible Worlds, Artificial Intelligence, and Narrative Theory. Indiana University Press, Bloomington (1991)
14. Graesser, A.C., Gordon, S.E., Brainerd, L.E.: QUEST: a model of question answering. Comput. Math. Appl. **23**, 733–745 (1992)
15. Christian, D.B., Young, R.M.: Comparing cognitive and computational models of narrative structure. In: Proceedings of the 19th National Conference of the American Association for Artificial Intelligence, pp. 385–390 (2004)
16. Cardona-Rivera, R.E., Price, T., Winer, D., Young, R.M.: Question answering in the context of stories generated by computers. Adv. Cogn. Syst. **4**, 227–245 (2016)
17. Boyd, B.: On the Origin of Stories: Evolution, Cognition, and Fiction. Harvard University Press, Cambridge (2009)
18. Bruner, J.: The narrative construction of reality. Crit. Inq. **18**, 1–21 (1991)
19. Lewis, D.: Truth in fiction. Am. Philos. Q. **15**, 37–46 (1978)
20. Eco, U.: The Role of the Reader: Explorations in the Semiotics of Texts, vol. 318. Indiana University Press, Bloomington (1984)
21. Pavel, T.G.: Fictional Worlds. Harvard University Press, Cambridge (1986)
22. Graesser, A.C., Olde, B.A.: How does one know whether a person understands a device? the quality of the questions the person asks when the device breaks down. J. Educ. Psychol. **95**, 524 (2003)
23. Cheong, Y.G., Young, R.M.: Suspenser: a story generation system for suspense. IEEE Trans. Comput. Intell. Artif. Intell. Games **7**, 39–52 (2015)

# Predicting User Choices in Interactive Narratives Using Indexter's Pairwise Event Salience Hypothesis

Rachelyn Farrell[(✉)] and Stephen G. Ware

Narrative Intelligence Lab, University of New Orleans,
New Orleans, LA 70148, USA
{rfarrell,sgware}@uno.edu

**Abstract.** *Indexter* is a plan-based model of narrative that incorporates cognitive scientific theories about the salience of narrative events. A pair of *Indexter* events can share up to five indices with one another: *protagonist, time, space, causality,* and *intentionality*. The *pairwise event salience hypothesis* states that when a past event shares one or more of these indices with the most recently narrated event, that past event is more salient, or easier to recall, than an event which shares none of them. In this study we demonstrate that we can predict user choices based on the salience of past events. Specifically, we investigate the hypothesis that when users are given a choice between two events in an interactive narrative, they are more likely to choose the one which makes the previous events in the story more salient according to this theory.

**Keywords:** Indexter · Computational models of narrative · Salience · Planning

## 1 Introduction

Skilled narrative authors pay close attention to how a story's events and discourse affect the audience's experience. The ability to predict what choices a user would make in an interactive narrative is useful in the context of both interactive and non-interactive narrative generation, because it can provide insight into what the user desires or expects from the future of the story. Narrative generation systems can leverage this insight to better control the audience's experience, for example by reasoning about discourse phenomena such as suspense and surprise.

The *salience* of a narrative event is defined as the ease with which the audience can recall that event. Prior research into event salience resulted in the *Indexter* model [3], which incorporates a set of features identified by cognitive science research into a plan-based computational model of narrative that measures the salience of events according to those features. Events in an *Indexter* plan can share up to five narrative situation indices with one another: *protagonist, time, space, causality,* and *intentionality*.

© Springer International Publishing AG 2016
F. Nack and A.S. Gordon (Eds.): ICIDS 2016, LNCS 10045, pp. 147–155, 2016.
DOI: 10.1007/978-3-319-48279-8_13

A previous study [11] confirmed the *pairwise event salience hypothesis*, which states that a past event is more salient if it shares one or more of these indices with the most recently narrated event. For example, if some past event takes place in the same room as the most recent event in the story, that past event is easier to remember than it would have been had it taken place in a different room. We now apply this theory about the salience of past events to reason about the audience's expectation of the future. In this study we investigate the hypothesis that when readers of an interactive narrative are given a choice between two future events, they are more likely to choose the one which will share a greater total number of *Indexter* indices with previous events in the story—that is, the future event which will make the past the most salient.

Participants read an interactive narrative and were prompted to choose between two possible endings. The number of indices that each ending shared with previous events in the story depended on prior choices made by the user while reading the story. Fisher's exact test rejected the null hypothesis that the users' choices were independent of the *Indexter* indices of past events with $p < 0.002$.

## 2   Related Work

Related research has focused on influencing users in interactive narratives to make choices that are in line with the author's goal, using concepts from social psychology, discourse analysis, and natural language generation [14]. Others have proposed lighting techniques that can be used in game environments to draw the player's attention to important elements in order to influence them to take specific actions [7]. Although we do not attempt to influence users' choices in this study, the implications of our findings are relevant to that area of research.

*Indexter* is a computational cognitive model that reasons about how the audience comprehends a story's *discourse*, or how the story is told [2]. The story is divided into a series of discrete events, and at each moment *Indexter* measures the salience of each past event. Plan-based models have been applied to other discourse phenomena, such as suspense [6], surprise [1], and cinematic composition [10]. Numerous plan-based models have been used to reason about story structure and to control interactive stories (see survey by Young et al. [19]). As with these other models of discourse, *Indexter* can inform story generation as well as discourse generation.

*Indexter* defines a plan data structure augmented with a cognitive scientific model of narrative comprehension called the event-indexing situation model, or EISM [21]. EISM is the result of decades of empirical research on how audiences store and retrieve narrative information in short-term memory while experiencing a narrative. Zwaan and Radvansky [21] identify five important dimensions, or indices, of narrative events which have been shown to play a role in narrative comprehension: *protagonist* (who), *time* (when), *space* (where), *causality* (what enabled or impelled), and *intentionality* (why).

*Indexter* has also been used to predict agency in interactive stories [4]. When choosing between two alternatives in a hypertext adventure game, players self-reported a higher sense of agency when the perceived next state that would result from making each choice differed from one another in at least one index.

This study and [11] suggest that *Indexter* might be used not only to measure the salience of past events but also the degree to which the audience expects future events—what Young and Cardona-Rivera [18] call a *narrative affordance*. Recent work by these researchers [5] has explored a more nuanced model of narrative memory, but we demonstrate that interesting results can be obtained even with the simple pairwise event salience model.

## 3   The *Indexter* Model

*Indexter* defines a data structure for representing stories as plans. Under the pairwise event salience model, a pair of events in a story can share up to five dimensions with one another: *protagonist, time, space, causality,* and *intentionality*. This section reproduces very briefly those definitions needed to understand the evaluation described in this paper; for a detailed description of how *Indexter* maps EISM indices to plan structures, see the description by Cardona-Rivera et al. [3].

A plan is a sequence of events that achieves some goal [15]. Each event has preconditions which must be true immediately before it is executed and effects which modify the world state. The kinds of events that can occur are represented by abstract, parameterized templates called operators, as described by the STRIPS formalism [8]. For example, the domain might define an operator *attack (?attacker, ?victim, ?place, ?time)*. Each term starting with a '?' is a free variable which can be bound to a constant corresponding to some specific thing in the story world. The preconditions might be that the attacker and victim are both alive, that both are in the same place at the same time, that the attacker is armed, and that the victim is unarmed. The effects might be that the victim is no longer alive. An *Indexter* event is a fully ground instance of such an operator.

A narrative plan [13] reasons about two kinds of goals: the author's final goal for the story and each individual character's goals. Each event template specifies zero, one, or many of its parameters as being the consenting characters responsible for taking that action. For the *attack* example, the *?attacker* is the sole consenting character, because it carries out the action. While the *?victim* may be a character involved in the action, it need not be a consenting character.

**Definition 1.** *Two events share the* protagonist *index iff they have one or more consenting characters in common.*[1]

Each event in an *Indexter* plan must also specify two additional required parameters: the time frame in which it occurs and the location at which it

---

[1] Here we use the one protagonist per event (as opposed to one per story) definition discussed by Cardona-Rivera et al. [3].

occurs. For example, the *attack* action might specify that *?time* = *day2* and *?place* = *gym*.

**Definition 2.** *Two events share the* time *index iff their time parameters are the same symbol.*

**Definition 3.** *Two events share the* space *index iff their location parameters are the same symbol.*

Cognitive science research [12, 20] has demonstrated that time and space can be hierarchically organized in memory. Whether different rooms in the same house count as different locations depends on the discourse. *Indexter* uses a simplified representation of these concepts as unique symbols. For this to be effective, the appropriate level of granularity must be communicated to the audience.

One strength of the plan-based models of narrative on which *Indexter* is based is the ability to reason about causal relationships between events. While cognitive scientists have studied several forms of causality [16, 17, 21], one in particular is easily available in plans using causal links: the ways in which the effects of earlier events enable later events by establishing their preconditions.

**Definition 4.** *A causal link* $s \xrightarrow{p} t$ *exists from event s to event t for proposition p iff s occurs before t, s has the effect p, t has a precondition p, and no event occurs between s and t which has the effect* ¬p. *We say s is the* causal parent *of t, and that an event's* causal ancestors *are those events in the transitive closure of this relationship.*

**Definition 5.** *Two events share the* causality *index iff the earlier event is the causal ancestor of the later event.*

Riedl and Young's intentional planning framework organizes events into *frames of commitment* to explain how characters achieve their individual goals. These structures also rely on consenting characters and causal relationships.

**Definition 6.** *Let c be a character and g some goal that character c intends to achieve. Let s be an event with effect g for which c is a consenting character. Two events share the* intentionality *index iff both events have c as a consenting character and both are causal ancestors of s. (Note: s may be one of the events.)*

In other words, two events share *intentionality* when both are taken by the same character for the same purpose.

## 4    Experimental Design

We designed an interactive story wherein the user must choose between two possible endings. We hypothesize that they will choose the ending whose *Indexter* event shares more indices with previous events in the story. We allowed the user to make four intermediate choices throughout the story, each of which determines the symbol for a specific index of a single event. There are two possible symbols

for each index tested, thus a total of 16 possible story configurations. (We chose not to include the *causality* index due to the added complexity of including a choice which toggles arbitrarily between two events, where one is causally related to the ending and the other is not.) When the reader reaches the final choice, the number of indices that each possible ending event shares with the rest of the story is determined solely by their four intermediate choices.

The story is about two prisoners who are threatened by the prison bully, and each comes up with a different plan in response. Ernest plans to break out of prison and escape onto the highway, while Roy plans to get revenge by killing the bully in the gym. Both plans involve stealing an item and then crawling into the ductwork through a loose vent. In all versions of the story, both characters end up inside the ductwork ready to complete one of the two plans together, but a guard discovers their whereabouts at the last minute. However, the guard believes there is only one prisoner in the duct, not two. Roy and Ernest realize that if they continue, they will both be caught and neither goal will be accomplished; but if one of them turns himself in, the other can still proceed with his original plan. The user must choose which character gets to accomplish his goal in the end.

The following is a description of how we manipulate each *Indexter* index before arriving at our experimental choice.

**Protagonist:** The story begins with the two prisoners discovering a hidden pack of cigarettes which turns out to belong to the prison bully. This angers the bully, who threatens to kill them both. The user makes the seemingly arbitrary choice of which character takes the cigarettes. The chosen character will later be given an extra scene; after being caught by a guard while stealing his item, that character must complete a punishment duty. The additional scene of this character fulfilling his punishment introduces a new event into the story which shares the *protagonist* index with that character's ending.

**Space:** In the same scene, the user chooses between two punishments—picking up trash off the highway, or cleaning the equipment in the gym. This introduces an additional event matching the *space* index of one of the two endings, since the escape ending will take place on the highway, and the revenge ending will take place in the gym. To communicate the appropriate level of granularity for the space index, we displayed a graphic on each passage showing the layout of the prison with the location of the current event highlighted and labeled, e.g. "highway", "gym", "cafeteria", etc.

**Time:** The two theft scenes—Ernest stealing some disguises for his escape plan, and Roy stealing a knife for his revenge plan—are told in variable order depending on the user's choice; one takes place on Day 1, and the other on Day 2. For the *time* index we deviate slightly from our pattern. Since both of the endings will have the same symbol for *time* (Day 2), we cannot simply add a new event that shares the *time* index with one ending but not the other. Instead we hypothesize that the user will choose the event which shares the most *other* indices with the more salient of the two theft scenes: the one that took place on Day 2. In other words, if the most recent theft event was Roy stealing the knife for the goal of revenge, we believe the user

is more likely to choose Roy's revenge ending over Ernest's escape ending. To communicate the granularity of the time index, we displayed a graphic of a calendar on each passage, showing either "Day 1" or "Day 2" according to the time of the current event.

**Intentionality:** After the second theft is completed on Day 2, the user chooses between two preparatory actions which both characters will take together: either donning the disguises for the goal of escape—which introduces a new event sharing the *intentionality* index with the escape ending—or locking the bully in the gym, which does the same for the revenge ending.

Next, the characters take the necessary step of sneaking into the air duct—from which they plan to exit either into the gym where they can kill the bully, or outside where they can escape to the highway. Finally, the guard catches up to them and we prompt the user for the final choice.

If the escape ending is chosen, the final event will have the parameters *(character=Ernest, location=highway, day=2, goal=escape)*. If the revenge ending is chosen, it will have the parameters *(character=Roy, location=gym, day=2, goal=revenge)*. The hypothesis is that the user will choose the ending event for which more of the following are true:

– its character is the same as the character who had one extra scene (*protagonist*)
– its location is the same as the location of the punishment scene (*space*)
– its character is the same as the character who stole his item on Day 2 (*time*)
– its goal is the same as the goal of the preparatory action (*intentionality*)

We built the story using Twine, an open-source tool for writing branching stories. We recruited 350 participants through Amazon Mechanical Turk, and paid them each $0.25 for completing the story. To adjust for the high volume of noise on Mechanical Turk, we asked each user a series of comprehension questions after they completed the story. The questions were designed to verify that the story accurately communicated the pertinent information to the user. Each question displayed two events from the version of the story they read—one from the ending scene and one from a previous scene—and asked a question such as, "Were these two actions taken by the same character?" or "Did these two events happen in the same place?" We discarded the data from participants who did not answer all of the comprehension questions correctly, and gave an additional $0.75 bonus to those who did. Participants were aware of the available bonus from the start.

## 5    Results

Of the 350 results, we discarded 225 and were left with 125 responses from participants who demonstrated full comprehension of the story. Because we are not attempting to influence readers to choose one path or the other, many users made exactly two choices in favor of the *Escape* ending and two in favor the *Revenge* ending; in these cases, we make no prediction as to which ending they would choose. Of the remaining 125 results, there were 78 for which a majority

of the user's choices were in favor of one ending or the other. We conducted the following evaluation using those 78 results.

To evaluate our hypothesis we used Fisher's exact test, which is similar to the $\chi^2$ test but performs better for distributions with small expected values [9]. Fisher's exact test is nonparametric, meaning it does not assume any underlying distribution of the population. This is important because participants chose more *Escape* options overall than *Revenge* ones (most likely due to the morality differences between the two paths). Fisher's exact test is not skewed by this imbalance. Table 1 shows the contingency table giving the frequency distribution of results according to their expected outcomes.

**Table 1.** Contingency table for Fisher's Exact Test

|  | Chose *Escape* | Chose *Revenge* |
|---|---|---|
| Expected *Escape* | 32 | 14 |
| Expected *Revenge* | 11 | 21 |

The null hypothesis was that the ending choices were independent of the *Indexter* indices of previous events. Fisher's exact test rejected this with $p < 0.0022$. There are several ways to measure effect size when using Fisher's exact test. The odds ratio for this contingency table is $\approx 4.27$, meaning there are about 4 to 1 odds that users chose the ending we expected them to choose. We conclude that users are indeed more likely to choose future events which will make past events more salient.

## 6   Conclusion

We have demonstrated that interactive narrative systems can make use of *Indexter* indices to predict user choices. As the *pairwise event salience hypothesis* states, a past event is more salient if it shares at least one index with the most recently narrated event. We have shown that when users are presented with choices for future events, they generally prefer those which have more indices in common with past events. In this study we did not attempt to influence users to make specific choices, but our results suggest that future work could accomplish this using a similar method of manipulating *Indexter* indices of story events. In addition, we believe that plan-based narrative systems can utilize this information about the audience's desires and expectations to reason about discourse phenomena such as suspense and surprise.

# References

1. Bae, B.C., Young, R.M.: A computational model of narrative generation for surprise arousal. IEEE Trans. Comput. Intell. Artif. Intell. Games **6**(2), 131–143 (2014)
2. Bal, M.: Narratology: introduction to the theory of narrative. University of Toronto Press (1997). http://books.google.com/books?isbn=1442692227
3. Cardona-Rivera, R.E., Cassell, B.A., Ware, S.G., Young, R.M.: Indexter: a computational model of the event-indexing situation model for characterizing narratives. In: Proceedings of the 3rd Workshop on Computational Models of Narrative, pp. 34–43 (2012). (Awarded Best Student Paper on a Cognitive Science Topic)
4. Cardona-Rivera, R.E., Robertson, J., Ware, S.G., Harrison, B., Roberts, D.L., Young, R.M.: Foreseeing meaningful choices. In: Proceedings of the 10th AAAI Conference on Artificial Intelligence and Interactive Digital Entertainment, pp. 9–15 (2014)
5. Cardona-Rivera, R.E., Young, R.M.: A knowledge representation that models memory in narrative comprehension. In: Proceedings of the 28th AAAI Conference on Artificial Intelligence - Student Abstracts Track, pp. 3098–3099 (2014). https://liquidnarrative.csc.ncsu.edu/wp-content/uploads/sites/15/2015/11/cardona-rivera2014knowledge.pdf
6. Cheong, Y.-G., Young, R.M.: Narrative generation for suspense: modeling and evaluation. In: Spierling, U., Szilas, N. (eds.) ICIDS 2008. LNCS, vol. 5334, pp. 144–155. Springer, Heidelberg (2008). doi:10.1007/978-3-540-89454-4_21
7. El-Nasr, M.S., Vasilakos, A.V., Rao, C., Zupko, J.A.: Dynamic intelligent lighting for directing visual attention in interactive 3-D scenes. IEEE Trans. Comput. Intell. AI Games **1**(2), 145–153 (2009). http://dx.doi.org/10.1109/TCIAIG.2009.2024532
8. Fikes, R.E., Nilsson, N.J.: STRIPS: a new approach to the application of theorem proving to problem solving. Artif. Intell. **2**(3), 189–208 (1972)
9. Fleiss, J., Levin, B., Paik, M.: Statistical Methods for Rates and Proportions. Wiley Series in Probability and Statistics, Wiley (2013). http://books.google.co.in/books?id=9Vef07a8GeAC
10. Jhala, A., Young, R.M.: Cinematic visual discourse: representation, generation, and evaluation. IEEE Trans. Comput. Intell. Artif. Intell. Games **2**(2), 69–81 (2010)
11. Kives, C., Ware, S.G., Baker, L.J.: Evaluating the pairwise event salience hypothesis in Indexter. In: Proceedings of the 11th AAAI International Conference on Artificial Intelligence and Interactive Digital Entertainment, pp. 30–36 (2015)
12. Magliano, J.P., Miller, J., Zwaan, R.A.: Indexing space and time in film understanding. Appl. Cogn. Psychol. **15**(5), 533–545 (2001)
13. Riedl, M.O., Young, R.M.: Narrative planning: balancing plot and character. J. Artif. Intell. Res. **39**(1), 217–268 (2010)
14. Roberts, D.L., Isbell, C.L.: Lessons on using computationally generated influence for shaping narrative experiences. IEEE Trans. Comput. Intell. AI Games **6**(2), 188–202 (2014)
15. Russell, S., Norvig, P.: Artificial Intelligence: A Modern Approach, 3rd edn. Prentice Hall, Upper Saddle River (2010)
16. Trabasso, T., Sperry, L.L.: Causal relatedness and importance of story events. J. Mem. Lang. **24**(5), 595–611 (1985)
17. Trabasso, T., Van Den Broek, P.: Causal thinking and the representation of narrative events. J. Mem. Lang. **24**(5), 612–630 (1985)

18. Young, R.M., Cardona-Rivera, R.E.: Approaching a player model of game story comprehension through affordance in interactive narrative. In: Proceedings of the 4th Workshop on Intelligent Narrative Technologies, pp. 123–130 (2011)
19. Young, R.M., Ware, S.G., Cassell, B.A., Robertson, J.: Plans and planning in narrative generation: a review of plan-based approaches to the generation of story, discourse and interactivity in narratives. Sprache und Datenverarbeitung, Special Issue Formal Comput. Models Narrative **37**(1–2), 41–64 (2013)
20. Zacks, J.M., Speer, N.K., Reynolds, J.R.: Segmentation in reading and film comprehension. J. Exp. Psychol. Gen. **138**(2), 307 (2009)
21. Zwaan, R.A., Radvansky, G.A.: Situation models in language comprehension and memory. Psychol. Bull. **123**(2), 162 (1998)

# An Active Analysis and Crowd Sourced Approach to Social Training

Dan Feng[1]([✉]), Elin Carstensdottir[1], Sharon Marie Carnicke[2],
Magy Seif El-Nasr[1], and Stacy Marsella[1]

[1] Northeastern University, Boston, MA 02115, USA
{danfeng,elin,magy,marsella}@ccs.neu.edu
[2] University of Southern California, Los Angeles, CA 90089, USA
carnicke@usc.edu

**Abstract.** Interactive narrative (IN) has increasingly been used for social skill training. However, extensive content creation is needed to provide learners with flexibility to replay scenarios with sufficient variety to achieve proficiency. Such flexibility requires considerable content creation appropriate for social skills training. The goal of our work is to address these issues through developing a generative narrative approach that re-conceptualizes social training IN as an improvisation using Stanislavsky's Active Analysis (AA), and utilizes AA to create a crowd sourcing content creation method. AA is a director guided rehearsal technique that promotes Theory of Mind skills critical to social interaction and decomposes a script into key events. In this paper, we discuss AA and the iterative crowd sourcing approach we developed to generate rich, coherent content that can be used to develop a generative model for interactive narrative.

**Keywords:** Intelligent narrative technologies · Active analysis · Theory of mind · Crowd sourcing · Social skills training

## 1 Introduction

Effective social interaction is a critical human skill. To train social skills, there has been a rapid growth in narrative-based simulations that allow learners to role-play social interactions with virtual characters, and, in the process, ideally learn social skills necessary to deal with socially complex situations in real-life. Examples include training systems to address doctor-patient interaction [1], cross-cultural interaction within the military [2], and childhood bullying [3].

Although interactive narrative systems represent a major advancement in training, their designs often do not provide learners with flexibility to replay scenarios with sufficient variety in choices to support learning and achievement of proficiency. Attempts to create more generative experiences face various challenges. First, the combinatorial explosion of alternative narrative paths poses an overwhelming challenge to create content for all the paths, especially if there are

F. Nack and A.S. Gordon (Eds.): ICIDS 2016, LNCS 10045, pp. 156–167, 2016.
DOI: 10.1007/978-3-319-48279-8_14

long narrative arcs. Second, current narrative systems are often brittle and constrained in terms of their generativity and flexibility to adapt to the interaction.

Additionally, training systems are often designed around exercising specific skills in specific situations. However, it is also important for social skill training to teach skills more broadly. Fundamental to effective human social interaction is the human skill to have and use beliefs about the mental processes and states of others, commonly called Theory of Mind (ToM) [4]. ToM skills are predictive of social cooperation [5] and collective intelligence [6] as well as being implicated in a range of other social interaction constructs, e.g., cognitive empathy [7] and shared mental models [8]. Although children develop ToM at an early age, adults often fail to employ it [9]. On the other hand, people engaging in ToM across multiple situations, including actors, have improved ToM skills [10].

Our goal is to develop generative social training narrative systems that support replay as well as embed ToM training. Achieving this requires: (1) a new generative model for conceptualizing narrative/role-play experiences, (2) new methods to facilitate extensive content creation for those experiences and (3) an approach that embeds ToM training in the experience to support better learning outcomes.

Our approach begins with a paradigm shift that re-conceptualizes social skill simulation as rehearsing and improvising roles instead of performing a role. We have adapted Stanislavsky's Active Analysis (AA) rehearsal technique [11] as the design basis for social simulation training. AA was developed to help theater actors rehearse a script or text. The overall script is divided into key events (i.e., short scenes) that actors rehearse and improvise under a director's guidance. AA has two attributes especially relevant to social skills training. First, AA is designed to foster an actor's conceptualization of the beliefs, motivations and behavior of their own as well as other actors, and thus is developed to engender ToM reasoning. Second, by adopting AA to simulation based social skills training, the emphasis shifts to developing short scenes that allow variability and re-playability. Decomposition into short rehearsal scenes *helps*: (a) break the combinatorial explosion that exacerbates content creation for long narrative arcs, (b) support users replaying scenes, possibly in different roles with different virtual actors, and (c) users to directly experience in subsequent scenes the larger social consequences of behaviors.

AA provides a basis for experience design that uses ToM constructs and enables crowd sourcing to generate content for rich, coherent interactive experiences. Several researchers have proposed crowd sourcing techniques for narrative creation (e.g., [12,13]). The work presented here differs in that we focus on an iterative crowd sourcing method designed to create content for crafting a space of rich social interactions in which players explore a wide range of social gambits, from ethical persuasion and personal appeals to even deception; the content is created through the crowd using carefully designed tasks and interfaces that use AA and ToM as theoretical foundation.

In this paper, we present our approach in detail. Specifically, we will start by discussing the theoretical foundation for our work: Active Analysis. We then outline    our    overall    approach    to    interactive    narrative    system    design.

Following this, we discuss the 3-step iterative crowd sourcing approach outlining the method, as well as the results for each step of the process. We then discuss overall results of the current work and projections for future work. Following this discussion, we outline previous related work and then conclude the paper.

## 2  Active Analysis Primer

AA serves several purposes in our project. It defines the overall structure of the learning experience as rehearsals of key scenes. Also, it helps define ways to manipulate the challenges the learner faces in those scenes as well as the feedback the learner gets. Most critically, AA provides a novel and potentially very powerful tool for ToM and more generally social skills training. Through AA, the human role-player/learner is called upon to conceive their behavior in terms of how other participants as well as observers understand and react to it. Further, they may have flawed mental models of others. Additionally, re-conceptualizing interactive narrative as performance rehearsal brings in elements of game play, such as repeat play as a form of rehearsal/mastery.

Stanislavsky developed AA in the latter part of his career to transform actor training and performance rehearsal techniques by emphasizing the importance of cognitive-social-affective mental states. As prelude to actors engaging in active analysis, the script is broken into small key scenes that the actors improvise and analyze. For our purposes in automating AA, this breakdown of a script would be part of the design, and therefore a larger training scenario is assumed to be broken into these brief key events/scenes. Consider the following simple multi-scene scenario that is currently the basis of our work:

**Scenario: 3 Scenes from Mistaken Guilt on a Train**

1. Scene 1: A novice reporter ($R$) witnesses a passenger attacking other passengers and a black good Samaritan tackles the rampaging passenger to protect the other passengers. A policeman enters and arrests the good Samaritan.
2. Scene 2: $R$ goes to interview police chief ($PC$) at his house but a guard ($G$) at the house may have orders to block reporters.
3. Scene 3: $R$ meets $PC$ to persuade him to let the good Samaritan go.

AA of a scene consists of three phases: Framing, Improvisation and Performance Analysis. These phases are repeated, the rehearsal director often changing the motivations and tactics of the actors as well as the roles they play.

**Framing:** The actors and director determine what the overall context of the scene is and what event (or goals) should occur. This guides the actors as they improvise. Some actors will play 'impelling actions' which move purposefully toward the event. Others play 'counter-actions' which resist, delay or block the targeted event/goal. Using Scene 2 from the above scenario, impelling actions for $R$ might be to explain or justify her purpose to meet $PC$, to elicit empathy from $G$ or even threaten or attack $G$. The rehearsal director helps the actors explore different motivations and approaches to their role. In particular, he/she can selectively provide information about goals and actions to an actor without the other actors knowing that information. Thus, an actor may have a flawed

mental model of the other actors leading into the improvisation. This mental model manipulation provides a powerful tool in social skills training.

**Improvisation:** During improvisations, actors explore different tactics to achieve their goals. Sometimes this improvisation fails without the goal being achieved and the actors not knowing how to proceed. This also can be a key point for the design of social training simulations, as sometimes the interaction may just simply break down and a different approach must be taken.

**Performance Analysis:** After completing the improvisation, the director and actors evaluate the work at three levels of analysis: (1) the individual, the actor thinking of their own actions, (2) the social, how those actions are countered by other actors, and (3) the audience, how the actions expressed information to others observing the performance. The actors then revise their preliminary analysis and repeat the improvisation. This process of framing, improvisation and analysis is repeated until the group has achieved what they wish.

## 3   Overview of the AA Social Skill Training System

Figure 1 presents the current overall design of our system. In line with AA rehearsals, we assume the overall scene is broken into highly variable interaction scenes that constitute key events. These scenes will be performed by the human and virtual actors through the director agent's guidance. To represent this structure, we use a high level state graph adapted from StoryNet [14]. The nodes in each scene represent the AA's key events/scenes. They are free-play areas in which the human participant can rehearse their role with virtual characters, exploring different approaches to their role within a scene. The edges in the graph connect the scenes. Traversal along an edge constitutes a completion of the rehearsal of a scene and a move onto a subsequent scene to rehearse. This traversal is dependent on whether the rehearsal has achieved its goal or some minimal number of improv sessions have occurred. *Framing* sets up the learner's role in the scene. *Performance Analysis*, as in AA, provides feedback on the characters' beliefs and motivations as well as cues on how to achieve scene goals. This feedback would leverage knowledge acquired during the crowd sourcing process.

In the following sections we discuss our progress in automating the collection of AA structured content within scenes, using crowd sourcing techniques. Other parts of the architecture, including the director agent, are left to future work.

**Fig. 1.** The AA social skill training system

# 4    Within Scene Content

To craft scenes, we implemented a multi-step crowd method, as seen in Fig. 2, that intentionally separates the creative, analytical and assessment processes. During the creative step, crowd workers generate a scene based on an initial situation, goals and beliefs of the characters, resulting in a richly varied and creative set of alternative scenes. In the analytical step, a separate set of crowd workers are tasked to annotate the scenes generated from the creative step using a novel ToM inspired annotation scheme that identifies how the actions seek to alter the beliefs, goals and attitudes of the characters. These annotations are critical to the pedagogy and also help constrain how elements across stories can be intermixed to provide variation in both learner's action choices as well as the non-player actions. In the assessment step, the results from these efforts provide a set of distinct actions that are then recombined using constraints generated from the annotation step and fed to a third set of crowd workers to further evaluate coherence. The result is a large space of coherent stories that support rich, meaningful variations in both learner's and non-player characters' choices and thus allowing for rehearsal and replay. These stories can then be used as a base for the interactive narrative system described above. Details on these steps are discussed below.

## 4.1    Creative Step: Crowd Sourcing Scenes

The task for the scene creation is to create very different variants of how a particular scene plays out from which a space of possible actions can be isolated and recombined to create a rich interactive experience. We designed and deployed multiple interfaces. Due to space constraints we only discuss the most promising design, the AA Interface, which was based on AA techniques for eliciting variations from actors improvising a scene. The AA interface seeks to limit the worker to craft relatively simple sentences where a sentence describes one action that a character performs (in line with [15]). The same scenario description was used for both tasks: *R, an aspiring reporter, wants to interview PC at his house. PC employs G to make sure that nobody is able to bother him. G guards the door. R is in front of PC's house and is planning to attempt to interview him.*

**Fig. 2.** An iterative crowd sourcing method based on AA and ToM

**Fig. 3.** A section of the AA Interface. Each worker has 6 lines presented to them initially as a default but is allowed to add as many additional lines as they see fit.

The design of the AA interface is segmented into three steps. This is to mimic the repeated rehearsal element of AA. In every step the worker is asked to write a new story (one sentence in a line as shown in Fig. 3), where instructions differ slightly from previous steps. Step 1 offers a basic description of the scene. Steps 2 and 3 give workers one piece of new information respectively, in addition to the scenario description. This information relates to one of the character's motivations, relationships or traits. This design is to encourage the worker to re-evaluate the same scenario but from different perspectives, much like AA rehearsal directors do with their actors. Such process will ideally (a) spur the creativity of the worker by mimicking the AA rehearsal experience and (b) guide the worker to provide the varied content needed to support replay and pedagogical goals in the training system built from this content.

**Story Collection Results:** We collected 108 stories using the same AA interface. Most stories consisted of adjacency and act/react pairs, where $R$ would take an action and $G$ would then respond. The average length of a story was 6 lines.

The stories are very rich in terms of character actions and the intention of each action. This applies to $R$ in particular, while $G$'s behaviors varied in terms of responses to actions. The intentions for the actions however, remain relatively static throughout for most of the stories until the conclusion is reached where $G$ either changes his goal of blocking $R$ or successfully blocks $R$. The stories collected show an impressive range in complexity, richness and variety in tactics that $R$ employs, resulting in a sizable action set for our characters. To give a better sense of the variety of actions collected, we provide two examples, a relatively simple bribe story and a more complex manipulation story:

*Bribe: R asks G to see PC. G declines her request. R tries to bribe G. G declines R's bribe. R adds $50.00 more to the bribe. G accepts the bribe.*

*Manipulation: R flirts with G. G tries to ignore R. R compliments G a lot. G begins to flirt with R. R tells G that she just needs a few teeny minutes with PC. G becomes wary and tells her to leave.*

For each sentence, the intention was described by the worker as previously mentioned. It's worthwhile to note that despite some of the stories having similar or even identical actions, the actions in question can have very different intentions assigned to them. One example of this, '$R$ throws a stone (a pebble) to the window' in one case intended to get $PC$'s attention directly. In another, the same action has the intention to distract $G$ so $R$ can sneak into the house. This was in line with our original goal of not only gathering enough information to map the potential action space of the characters but also the variety of the possible intentions that motivated the actions the characters employed. Reaching

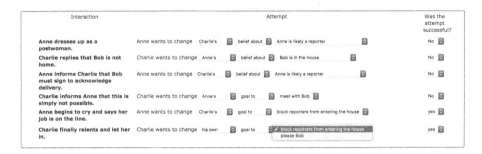

**Fig. 4.** The ToM annotation interface. Left column shows actions. Middle column is the ToM annotation choices. Right column allows the crowd to report whether the intended effect was successful. Workers selected the description from a drop-down list which is generated based on the intention of each action collected in the creative step. The list changes dynamically depending on other choices.

this level of richness in the collected stories is key in the context of our work, as our goal is to collect as many actions and intentions as possible, to allow our players as much variety as possible in exploring social situations from a ToM standpoint. At a more detailed level, we found that the AA interface could successfully influence the type of stories being generated. For instance, as shown in Fig. 3, by framing $R$ as 'manipulative', we collected actions like 'tell $G$ his mother is in the hospital'. By framing $R$ as $G$'s 'ex-girlfriend', we got actions like 'ask $G$ to get back together'.

## 4.2   Analytical Step: Crowd ToM Annotation

As noted, ToM annotations are critical for: the pedagogy provided during Performance Analysis and constraining how actions are intermixed to create variation for the learners' experience in the interactive narrative. To get this information, we conducted a second crowd task using the annotation interface seen in Fig. 4.

The challenge in employing non-expert workers for this annotation task is to help them correctly parse character actions into intention descriptions in ToM terms. To set up the initial goals and beliefs for each character as a director would in an AA rehearsal, we provided workers with an initial list of goals and beliefs for each character as shown in Table 1. Instructions to workers also included the scenario description. Each sentence in a story represents one action. For each sentence the worker is asked to stipulate how the character taking the action intends to change another character's goal, belief, liking or trust, the subject of the change and, whether the attempt is successful. Since each action may have multiple intended effects, we combined the output of multiple workers to get the multiple intentions, instead of requiring each worker to provide all the intentions.

**Annotation Result and Discussion:** We randomly selected 3 stories to annotate from the story corpus obtained through the first crowd stage, described in the previous section. Data from 120 workers was collected; each story was annotated by 40 workers. For each action, the 2 most agreed upon combinations were selected as that action's potential effects.

**Table 1.** Initial goals and beliefs given to the workers

| Character | Object | Content |
|---|---|---|
| The Reporter ($R$) | goal | meet with the police chief ($PC$) |
| | belief | $PC$ is in the house |
| | | $G$ is likely to block her |
| The Guard ($G$) | goal | block $R$ from entering the house |
| | | please $PC$ |
| | belief | $PC$ is in the house |
| | | $PC$ doesn't want to meet any reporters |
| | | $R$ is likely a reporter |

**Table 2.** Examples of the annotation result

| Sentence | Intentions (wants to change) | % |
|---|---|---|
| $R$ dresses up like a postman | $G$'s belief about she is likely a reporter | 55 |
| | $G$'s goal to block her from entering the house | 25 |
| $G$ accepts the bribe | $G$'s own goal to block $R$ from entering the house | 43 |
| | $G$'s own goal to please $PC$ | 28 |
| $R$ tells $G$ the interview has already been scheduled | $G$'s belief about $PC$ does not want see reporter | 60 |
| | $G$'s goal to block $R$ | 30 |

Examples of the annotation results are shown in Table 2. It lists the sentence/action, the two most popular annotations of the intention of the action described in the sentence and the corresponding ratio of workers who chose that annotation option. Possible choices for one annotation can be as many as 20 (3 characters, 1–2 goals, beliefs, liking and trust for each character). Inter-rater reliability was determined with Chance-corrected agreement (Krippendorff's alpha) for all annotated stories. The average Krippendorff's alpha value across all stories is 0.887 with a standard derivation of 0.01. This relatively high agreement implies the design of the annotation scheme is not overwhelming and easy for non-technical personal to understand.

## 4.3   Assessment Step: ToM Causal Model

To develop an interactive system with a rich and generative action space, we need to reorganize and recombine collected actions but maintain the coherence of the story. As discussed above, we decided to use the crowd to assess stories developed through the crowd sourcing process. However, the combinatorial explosion caused by random recombination makes it a daunting task for workers to assess the result. For instance, in the 3 stories we annotated, there are just 20 sentences including 10 actions for each character. If we randomly combine 6 sentences to generate a new story, the number of possible combinations is $10 * 10 * 9 * 9 * 8 * 8 = 518400$. Most of these narratives are nonsensical or incoherent. Thus in order to eliminate them, the crowd provided ToM annotation data was used to create a causal

model, namely the ToM Causal Model (TCM), that establishes a precedence relation between sentences. The basic assumption for the TCM is that the intention of an action selected by a character should be consistent with the intention of previous actions in the story, which can be used to determine what actions follow a particular prefix of actions in a generated story.

The TCM is based on the idea of an intention being in play. An intention is in play at some point in a seed story, if in that story a preceding action has that intended effect. For example, from the annotation data we know the intended effects of 'bribe' are 'changing $G$'s goal of blocking her' ($I1$) and 'increasing $G$'s liking of her' ($I2$). Thus, after 'bribe' happens, $I1$ and $I2$ are defined as 'in-play'.

From this information, we can construct an abstract model of actions that describe their in play intentions as well as intended effects, as a heuristic model of preconditions and effects. Specifically, an action is defined as a tuple $A =<PI, EI, \Phi >$ where $PI$ is a set of 'in-play' intentions that existed when action $A$ happened in the seed story and $EI$ is the set of intended effects by taking this action. $\Phi$ defines the phase where the action occurs: beginning, middle or end.

When generating new stories, an action can only be selected if all the intentions in its $PI$ are in play. For example, in the 'bribe' story, $R$ bribes $G$. After the bribe is declined, she bribes \$50 more. Thus, 'bribe-more' can only happen when intentions $I1$ and $I2$ are in play. Given our TCM model, these constraints: intentions $I1$ and $I2$, are set as $PI$ for the action 'bribe-more'. After an action is selected, its intended effects $EI$ will added to the set of 'in-play' intentions. Additionally, we constrained the action selection based on the phase $\Phi$. We assume the initial/ending actions in the seed stories like 'greet', 'introduce herself', 'let $R$ in' or 'arrest $R$' are more likely to happen at the beginning/end of the story. All intermediate actions can happen at any place in between.

**The TCM Result and Discussion:** Obviously, the TCM is not a perfect coherency filter, in particular it over prunes. Still, pruning makes it feasible to further test coherence using the crowd. So, we asked another group of workers to evaluate the results using 5-point Likert items adapted from [16] to assess stories' coherence and consistency: I understand the story; The story makes sense; Every sentence in the story fits into the overall plot; The characters behaviors are consistent with their goals and beliefs; The characters' interaction is believable.

We collected evaluations from 40 workers for each story. We mapped the 5-point Likert items to a score ranging from $[-2, 2]$. We eliminated all stories that have at least one non-positive score leaving us with 12 stories[1]. To validate the workers' assessment, we asked an expert who is familiar with ToM and interactive narrative to evaluate all generated stories. The crowd result was generally more selective than the expert's. We found one story with an illicit action pair (decline bribe before bribe is offered) excluded by the expert but not by the crowd. This suggests we may need to consider alternative criteria. For example, eliminating stories based on total score across 5 questions less than a threshold $T_e = 2.5$ leads to better agreement with the expert.

---

[1] All generated stories can be found at http://www.northeastern.edu/cesar/project/IxN.

# 5   Discussion and Future Directions

Our results show the promise of adapting AA and crowd sourcing to generate rich and varied stories from a simple initial scene. The results indicate the utility of designing crowd tasks using AA principles to inspire creative output. In particular, we found directorial guidance from the AA interface can directly influence the stories. For example, the AA interface successfully primed the workers to focus on manipulative and deceptive behavior. This suggests that going forward we will be able to influence the worker to get the needed pedagogical content.

We also found in the ToM annotation task, the crowd was able to annotate these stories with sophisticated ToM concepts and with high agreement. We showed how these annotations can provide critical pedagogical content but we also demonstrate how they can be incorporated into the TCM to help assess generated stories. This led to a significant reduction in the number of stories and enabled us to successfully go to the crowd to do a final validation check.

While giving us significant amount of ToM information, the ToM annotation scheme is still simple. Adding more layers in subsequent schemes might get to more detailed information such as tactics. The high agreement suggests the crowd might be capable of performing more detailed annotation. Using finer-grained annotation schemes would help categorize content to a greater degree, benefiting both the design of the pedagogy and the performance of the TCM.

In addition, we can improve the TCM in other ways to ensure its scalability. With the assessment result, we can construct a stronger TCM by abstracting the conditional relation between 2 actions based on whether they (1) have high mutual information in good stories and (2) are only found in reverse order in eliminated stories. With these 2 criteria, we can derive 2 conditional constraints, 'bribe more' and 'decline bribe', that only happen if 'bribe' already occurred. These causal relations, combined with TCM can be used to filter out incoherent stories. As an alternative to using the TCM, we will also explore machine learning techniques to learn a probabilistic model that can evaluate the generated stories.

To date, we implemented a prototype, using the crowd results reported here, that allows a player to play the role of $R$ or $G$. This prototype does not include the AA director agent however, depicted in Fig. 1. To that end, our next step is to collect data from the rehearsal practice of leading expert on AA, which will be used to inform the director agent design.

# 6   Previous Work

Successful examples of systems using crowdsourced narratives to generate new stories include SayAnything [17], the Scheherazade System [18] and, its interactive counterpart [16]. Crowdsourcing has also been used to model behavior such as in the Restaurant Game [19]. A key challenge in our work lies in populating the action space with complex social actions, especially since a sufficient number can mean thousands of actions. For example, the social game PromWeek [20] utilized over 5000 human-authored social rules, a complex and time consuming task and, [19] uses a set of known actions. Our approach has actions extracted

from crowdsourced narratives but additionally, uses those actions to generate new stories to explore the possible causal relationships between them.

Annotating potentially large narrative corpora, like those generated in our work is also a non-trivial task. The Scheherazade annotation tool [21] utilizes Story Intention Graphs (SIG) which capture ToM concepts. However, SIG requires expertise. Annotation frameworks often have a detailed structure requiring expertise to achieve adequate levels of inter-rater reliability, giving rise to much simpler annotation schemes, such as the two compared in [22]. Neither of those two however focuses explicitly on annotating detailed social interactions nor ToM reasoning. Any annotation scheme we use needs to reflect our ToM focus, yet be simple enough not to require training or expertise of the worker.

[23] also uses a multi-step iterative crowd sourcing approach to content creation, similar to the work presented here. However, their work focuses on activity oriented non-interactive narratives and actions, whereas we focus on interactive narratives involving social interaction and ToM reasoning.

In terms of focus on ToM, our work is similar to the interactive drama system Thespian [24]. However, Thespian employs ToM reasoning to generate behavior by modeling the player and characters as autonomous agents, while we use ToM to describe and recompose character behavior without an explicit agent model.

## 7   Conclusion

In this paper, we introduced an iterative crowd sourcing method for interactive narrative, based on AA and ToM. Designed to realize a space of rich social interactions, it will allow players to explore a wide range of social gambits, from ethical persuasion and personal appeals to deception. The result of using AA and ToM as theoretical foundations show the promise of using such a framework to collect, annotate and generate interactive narratives for social skills training. Going forward, we plan to use a data-driven technique to create a director agent that will incorporate more aspects of AA into the experience.

**Acknowledgment.** Funding for this research was provided by the National Science Foundation Cyber-Human Systems under Grant No. 1526275.

## References

1. Lok, B., Ferdig, R.E., Raij, A., Johnsen, K., Dickerson, R., Coutts, J., Stevens, A., Lind, D.S.: Applying virtual reality in medical communication education: current findings and potential teaching and learning benefits of immersive virtual patients. Virtual Reality **10**(3–4), 185–195 (2006)
2. Kim, J.M., Hill, J., Durlach, P.J., Lane, H.C., Forbell, E., Core, M., Marsella, S., Pynadath, D., Hart, J.: BiLAT: a game-based environment for practicing negotiation in a cultural context. IJAIED **19**(3), 289–308 (2009)
3. Zoll, C., Enz, S., Schaub, H., Aylett, R., Paiva, A.: Fighting bullying with the help of autonomous agents in a virtual school environment. In: 7th International Conference on Cognitive Modelling (2006)

4. Whiten, A.: Natural Theories of Mind: Evolution, Development and Simulation of Everyday Mindreading. Basil Blackwell, Oxford (1991)
5. Artinger, F., Exadaktylos, F., Koppel, H., Sääksvuori, L.: In others' shoes: do individual differences in empathy and theory of mind shape social preferences? PloS one **9**(4), e92844 (2014)
6. Engel, D., Woolley, A.W., Jing, L.X., Chabris, C.F., Malone, T.W.: Reading the mind in the eyes or reading between the lines? theory of mind predicts collective intelligence equally well online and face-to-face. PloS one **9**(12), e115212 (2014)
7. Davis, M.H.: Measuring individual differences in empathy: evidence for a multidimensional approach. J. Person. Soc. Psychol. **44**(1), 113 (1983)
8. Converse, S.: Shared mental models in expert team decision making. In: Individual and Group Decision Making: Current (1993)
9. Lin, S., Keysar, B., Epley, N.: Reflexively mindblind: using theory of mind to interpret behavior requires effortful attention. J. Exp. Soc. Psychol. **46**(3), 551–556 (2010)
10. Goldstein, T.R., Wu, K., Winner, E.: Actors are skilled in theory of mind but not empathy. Imagination Cogn. Person. **29**(2), 115–133 (2009)
11. Carnicke, S.M.: Stanislavsky in Focus: An Acting Master for the Twenty-First Century. Taylor & Francis, New York (2009)
12. Li, B., Lee-Urban, S., Appling, D.S., Riedl, M.O.: Crowdsourcing narrative intelligence. Adv. Cogn. Syst. **2**, 25–42 (2012)
13. Orkin, J., Roy, D.K.: Understanding speech in interactive narratives with crowd sourced data. In: Proceedings of the 8th AAAI Conference on Artificial Intelligent and Interactive Digital Entertainment. The AAAI Press (2012)
14. Swartout, W., et al.: Toward the holodeck: integrating graphics, sound, character and story. In: Proceedings of 5th International Conference on Autonomous Agents, pp. 409–416. ACM (2001)
15. Li, B., Appling, D.S., Lee-Urban, S., Riedl, M.O.: Learning sociocultural knowledge via crowdsourced examples. In: Proceedings of the 4th AAAI Workshop on Human Computation (2012)
16. Guzdial, M., Harrison, B., Li, B., Riedl, M.O.: Crowdsourcing open interactive narrative. In: The 10th International Conference on the Foundations of Digital Games (2015)
17. Swanson, R., Gordon, A.S.: Say anything: a massively collaborative open domain story writing companion. In: Spierling, U., Szilas, N. (eds.) ICIDS 2008. LNCS, vol. 5334, pp. 32–40. Springer, Heidelberg (2008). doi:10.1007/978-3-540-89454-4_5
18. Li, B., Lee-Urban, S., Johnston, G., Riedl, M.: Story generation with crowdsourced plot graphs. In: Proceedings of the 27th AAAI Conference on Artificial Intelligence (2013)
19. Orkin, J., Roy, D.: The restaurant game: learning social behavior and language from thousands of players online. J. Game Dev. **3**(1), 39–60 (2007)
20. McCoy, J., Treanor, M., Samuel, B., Reed, A.A., Mateas, M., Wardrip-Fruin, N.: Prom week: designing past the game/story dilemma. In: FDG, pp. 94–101 (2013)
21. Elson, D.: Modeling narrative discourse. Ph.D. thesis, Columbia University (2012)
22. Rahimtoroghi, E., Corcoran, T., Swanson, R., Walker, M.A., Sagae, K., Gordon, A.: Minimal narrative annotation schemes and their applications. In: 7th Intelligent Narrative Technologies Workshop (2014)
23. Sina, S., Rosenfeld, A., Kraus, S.: Generating content for scenario-based serious-games using crowdsourcing. In: AAAI, pp. 522–529 (2014)
24. Si, M., Marsella, S.C., Pynadath, D.V.: Thespian: an architecture for interactive pedagogical drama. In: Proceedings of the 2005 Conference on AIED, pp. 595–602 (2005)

# Generating Abstract Comics

Chris Martens$^{(\boxtimes)}$ and Rogelio E. Cardona-Rivera

Department of Computer Science, North Carolina State University, Raleigh, USA
{crmarten,recardon}@ncsu.edu

**Abstract.** We investigate a new approach to comic generation that explores the process of generating the contents of a panel given the contents of all previous panels. Our approach is based on leading discourse theories for comics by McCloud (panel transitions) and Cohn (narrative grammar), unified by cognitive theories of inference in visual language. We apply these theories to comics whose panel parameters are abstract geometric shapes and their positions, contributing a computational realization of McCloud's and Cohn's comics theories, as well as a modular algorithm that affords further experimentation and evaluation of visual discourse theories.

**Keywords:** Intelligent narrative technologies · Comics · Narrative generation

## 1 Introduction

Interactive digital storytelling has traditionally been concerned with text-based modes of discourse. Despite the fact that the word *fiction* makes no commitments to medium (book, film, play, et cetera), the term *interactive fiction* is used nearly synonymously with text-based digital storytelling. Meanwhile, comics, a relatively unexplored domain of computational narratology [10], present a wide range of expressive opportunities for interactive storytelling not afforded by text. Interactive comics invite many of the same questions addressed by interactive textual narrative research: what modes are available for a machine to tell visual stories in collaboration with a human player or author? How can algorithms introduce novel, generative content into a partially-constructed comic? Which decisions will the human and algorithmic components have available to them?

This work begins to address these questions by exploring generation of *purely visual, abstract* comics. "Purely visual" means that panels do not use words and text to communicate narrative, as in Fig. 1. "Abstract," as in abstract art, means that, aside from repetition of elements with a shape, color, and size, and spatial placement of said entities within panels, we do not intentionally ascribe literal meaning to the components of generated panels. Our purpose in choosing an abstract representation is partially due to ease of implementation, but partially also to separate issues of *structure* of comics (which can be perceived with abstract representations) from issues of contextual, reference-laden meaning that would be found especially in anthropomorphic figures [11].

© Springer International Publishing AG 2016
F. Nack and A.S. Gordon (Eds.): ICIDS 2016, LNCS 10045, pp. 168–175, 2016.
DOI: 10.1007/978-3-319-48279-8_15

**Fig. 1.** This wordless Calvin and Hobbes comic strip (© Bill Watterson) exemplifies the kind of output we are targeting with our generator. The strip also illustrates how little plot structure informs this kind of short-form visual storytelling.

Two leading theories on comics have examined constraints on sequences of panels and the relationships among them. McCloud [11] proposes a taxonomy of *transitions* between a panel and the one following it, enumerating six different ways readers might make sense of the connection between two consecutive panels "across the gutter" (gap between panels). Cohn [1], on the other hand, eschews transitions as a basis for comic structure and asserts that grammar-like syntax trees govern the formation of legible comics. We present a small-scale computational system [12] that operationalizes a hybrid of these two approaches. Our primary takeaway is that both *global and local* reasoning contribute important techniques to narrative generation: local reasoning is important for maintaining narrative coherence, and global reasoning is important for maintaining satisfying narrative structure. Both are thus important parts of creating comprehensible comics, and we present an outline of future work designed to explore the human interpretation of our generated artifacts.

## 2   Comics Theory

The basis of McCloud's theory about making sense of panel sequences across the gutters, later validated experimentally, is that readers of comics optimize their consumption of relevant information [16], and work to construct inferences [9] about story content in these liminal spaces of discourse. Inferences for story content are constructed when they are needed for comprehension and enabled by what has been narrated thus far [13]. The dynamic between story authors and audiences parallels the dynamics of people engaged in cooperative conversation as outlined by the philosopher of language Grice [5]: the storyteller, as the active contributor to the ongoing communicative context, is expected to make her contributions to the discourse based on what is relevant to her narrative intent. McCloud's introduced six *panel transition types* for comics [11], enumerate the different roles that the reader may infer from a well-written comic. These transition types are *moment-to-moment, action-to-action, subject-to-subject, aspect-to-aspect, scene-to-scene,* and *non sequitur.* While it is tempting to think we could

simply operationalize these transitions in a generator, as Cohn [1] (Chap. 4) points out, so much of their meaning relies on contextual, real-world-situated understanding that it lends little help to computational authoring.

**Fig. 2.** The spectrum of *relatedness* as discussed by Saraceni [17]. Relatedness indicates how comic panels are connected or associated in the minds of readers, spanning from textual factors to cognitive factors. Along that spectrum, there are three distinguished categories of relatedness: *repetition*, *collocation*, and *closure*, which have demonstrably different effects on the construction of narrative mental models.

However, Saraceni [17] supports McCloud's hunch that readers create meaning from comics from perceived relationships between panels. Saraceni describes three notions of *relatedness* between comic elements, which are the building blocks from which readers may construct meaning inferences. Relatedness creates a comic's *cohesion* – the lexico-grammatical features that tie panels together – and *coherence* – the audience's perception of how individual panels contribute to her mental model of the unfolding events. Relatedness emerges from a spectrum of *textual*[1] factors to *cognitive* factors, illustrated in Fig. 2. Closer to the textual end of the spectrum is the *repetition* of visual elements across panels. Beyond repetition is *collocation*, which refers to an audience's expectation that related visual elements will appear given the ones that have been perceived. Closer to the cognitive end of the spectrum is the *closure* over comic elements, which refers to the way our minds complete narrative material given to us. Closure is terminologically borrowed from the field of visual cognition, but is intended as the mental process of inference that occurs as part of an audience's *search for meaning* [4]. The comic in Fig. 1 depends on these three aspects of relatedness: first, repetition of the sled, snowman, and other figures maintains cohesion across panels. Second, the humor of the sled carrying off the snowman depends on our (non-grammatical) domain knowledge that the snowman is not a living character in the same sense as the other figures. Finally, the comic depends on closure for the audience to "fill in the gaps" to infer what must have happened during the third panel.

## 3    Related Work

In terms of visual storytelling, Heider and Simmel [6] formulated an experiment based on abstract shapes in animation and evaluated whether audiences

---

[1] *Textual* here does not mean the use of actual text, but rather is a shorthand for *surface code* [19].

perceived consistent stories. Their work also depends on cognitive closure to achieve a narrative goal; however, the animations themselves were hand-authored rather than generated. Pioneering work on visual discourse by Jhala and Young [8] addresses visual storytelling in terms of camera control for cinema-style storytelling. We consider the representation and generation strategies emerging from this work [7] as strong candidates for future work in terms of scene specification; however, we look to comics as a simpler, more discretize domain that does not depend on a deeply simulated underlying narrative. Pérez y Pérez et al. [14] developed a visual illustrator to the MEXICA system [15], and verified the degree to which their 3-panel comic generator elicited in readers the same sense of story as a textual realization of the same MEXICA-generated plot. While this system also follows the pipeline model of narrative generation, we see their work as complementary: they developed an experiment methodology through which it is possible to empirically assess if their palette of designed visual elements denote story concepts as intended. Future work in comic generation will have to address this point going forward, and Pérez y Pérez et al. provide a step toward understanding the gap between story concepts and the pictorial symbols meant to encode them.

## 4    System Description

Our approach to generating visual narratives begins as a linear process that selects next comic panels based on the contents of previous panels, choosing randomly among indistinguishably-valid choices. The concepts we represent formally are *transitions*, *frames*, and *visual elements*, which we define below. There are two levels on which to make sense of these terms: the symbolic level, i.e. the intermediate, human-readable program data structures representing a comic, and the rendered level, designed to be consumed by human visual perception.

**Fig. 3.** Example of generator output. While the narrative here is ambiguous, we suggest the following readings: the repetition of the grey (largest) rectangle in every frame suggests it as a focal point, and the sudden appearance of the pink (smallest) rectangle suggests an interloper removing the grey rectangle from its initial context (established by the blue rectangle and yellow circle). Together with the names of the frames (reported in symbolic form above the comic), we can read the sequence as follows: the grey rectangle whispers to the blue rectangle, then is carried off by a pink rectangle, who whispers to the grey rectangle and then aids the grey rectangle. (Color figure online)

A **visual element (VE)** is a unique identifier from an infinite set, each of which is possible to map to a distinct visual representation. We do not explicitly tag visual elements with their roles in the narrative, such as characters, props, or scenery, making the symbolic representation agnostic to which of these narrative interpretations will apply. In the visual rendering, of course, our representation choices will influence readers' interpretation of VEs' narrative roles. A **frame** is a panel template; at the symbolic level, it includes an identifier or set of tags and a minimum number of required visual elements. The reason a frame specifies a minimum number of VEs is to allow for augmentation of the frame with pre-existing elements: for example, the *monologue* frame requires at least one visual element, indicating a single, central focal point, but other visual elements may be included as by standing characters or scenery elements. At the rendering level, a frame includes instructions for where in the panel to place supplied VEs. A **panel** is a frame instantiated by specific visual elements. Finally, a **transition** is a specification for how a panel should be formed as the next panel in a sequence. We took inspiration from McCloud transitions [11], developing a more syntactic notion defined purely in terms of frames and (abstract) visual elements, for which Saraceni's theory of relatedness [17] could be applied. For example, while McCloud could refer to an action-to-action transition as one where a character is depicted carrying out two distinct actions, we have no notion of *character* and *action* (these being semantic and contextual categories), so instead must refer to which visual elements appear, where they have appeared previously, and what their spatial relationships might be (potential frames). The rendering of a frame itself may position VEs in such a way that an audience would read certain actions or meaning into it; however, this kind of audience interpretation is not modeled to inform generation. Thus, we introduce six formal transition types: **Moment** transitions retain the same set of VEs as the previous panel, changing only the frame. **Add** transitions introduce a VE that didn't appear in the previous panel, but might have appeared earlier (or might be completely new). A new frame may be selected. **Subtract** transitions remove a VE from the previous panel and potentially choose a new frame. **Meanwhile** transitions select a new frame and show *only* VEs that did not appear in the previous panel, potentially generating new VEs. **Rendezvous** transitions select a random subset of previously-appearing VEs and selects a new frame to accommodate them. We implemented our generator in OCaml and additionally implemented a front-end, a web-based renderer.[2] The renderer assigns each frame type to a set of coordinates given by percentage of the vertical and horizontal panel size, and then renders panels by placing visual elements at those coordinates. Visual elements are represented by randomly generated combinations of size, shape (circle or rectangle), and color. An example of the generator's output can be seen in Fig. 3. The generator accepts as inputs length constraints (minimum and maximum) and a number of VEs to start with in the first panel. Its output is a sequence of panels (frame names and VE sets) together with a record of the transitions that connect them.

---

[2] http://go.ncsu.edu/comicgen.

Generating random transition sequences may result in nonsensical output, such as ending a comic with a *meanwhile* frame in which completely new visual elements are introduced at the end of the comic, but not connected to previous elements; see Fig. 4 for an example. To constrain output, we used Cohn et al.'s theory [3] of linguistic structure for visual narrative. They claim that understandable comics follow a grammar that organizes its global structure. Instead of transition types, Cohn's grammar of comics consists of grammatical categories (analogous to nouns, verbs, and so on) indicating the role that each panel plays in the narrative. These categories are **establisher, initial, prolongation, peak,** and **release**, which allow the formation of standard narrative patterns including the Western dramatic arc of *initial – peak – release*. Formally, Cohn gives the following grammar as a general template for comic "sentences," or well-formed arcs:

*(Establisher) – (Initial (Prolongation)) – Peak – (Release)*[3]

In our second iteration of the generator, we combine two approaches to discourse, using *global* Cohn grammars to guide the *local* selection of syntactically-defined transitions. In particular, we enumerate every possible category bigram in Cohn's grammar, such as *initial to prolongation, prolongation to peak*, and so on, and describe sets of transition types that could plausibly model the relationship. With this mapping established, we randomly generate an instance of the arc grammar and populate it with an appropriate set of transitions, after which point we simply hook the transition sequence up to the same panel selector from before. An example of the constrained generator's output can be found in Fig. 5.

## 5    Future Work

Future directions for this project include expanding the set of visual elements beyond abstract, geometric shapes (one candidate being the modular XKCD sprite set.[4] We would also like to incorporate generation into an interactive framework, either for the purpose of interactive visual storytelling or mixed-initiative comics design. Finally, we have two candidate evaluation plans for

**Fig. 4.** Example of underconstrained output. The final panel follows a Meanwhile transition and does not maintain relatedness to the preceding sequence.

---

[3] Symbols in parentheses are optional. In our expression of this grammar (and in several of Cohn's examples), we also assume that prolongations may occur arbitrarily many times in sequence.

[4] http://cmx.io/.

**Fig. 5.** Example of grammatically-constrained output following the generated pattern *establisher, initial, peak, release*. This example introduces a new visual element with a Meanwhile transition for the peak, then releasing with a Rendezvous.

distinct hypotheses: one involves analyzing the style and variety of our comic generator's output; i.e. our system's *expressive range* [18]. For this, and as suggested by Smith and Whitehead, we would need to identify appropriate metrics for describing the generated output, which "should be based on global properties ... and ideally should be emergent qualities from the point of view of the generator;" for example, the number and type of transitions that are generated. The other evaluation involves analyzing the level of comprehension that our generated comics afford an audience. While there has been work in understanding how people read into narratives involving abstract shapes (e.g. the Heider-Simmel experiment [6]), this evaluation would be more concerned with whether the discourse categories (as discussed by Cohn) that guide the selection of transitions are recognizable by an audience during comprehension. Cohn [2] discusses a methodology through which panel discourse categories can be analytically identified; this analysis would ask whether comic panel categories can be analytically identified by an audience when they are intentionally selected by our generative system.

## 6 Conclusion

In this work we have presented an approach to comic generation combining local, transition-driven decisions with global syntactic structure. We initially designed our system to tend only to textual factors in comic discourse: the repetition of comic actants across the narrative provides a minimal cohesive backbone on which to pin comic understanding. However, as discussed, this form of generation could generate non-sensical output (e.g. ending comics with a *meanwhile* discourse transition). We therefore appealed to more cognitively-oriented factors via the theory of visual grammar, which helped structure the output in a way that enables other senses of relatedness to contribute to the output's coherence. Thus, through our small-scale system, we have begun to explore the scale and limits of human story sense-making faculties, as well as how they come to bear on narrative generation systems: in our case, through both local and global procedures, which inform cohesion and coherence, respectively.

# References

1. Cohn, N.: The Visual Language of Comics: Introduction to the Structure and Cognition of Sequential Images. Bloomsbury, London (2013)
2. Cohn, N.: Narrative conjunction's junction function: the interface of narrative grammar and semantics in sequential images. J. Pragmatics **88**, 105–132 (2015)
3. Cohn, N. (ed.): The Visual Narrative Reader. Bloomsbury Publishing, New York (2016)
4. Gerrig, R.J., Bernardo, A.B.I.: Readers as problem-solvers in the experience of suspense. Poetics **22**(6), 459–472 (1994)
5. Grice, H.P.: Logic and conversation. In: Cole, P., Morgan, J.L. (eds.) Syntax and Semantics 3: Speech Arts. Elsevier, New York (1975)
6. Heider, F., Simmel, M.: An experimental study of apparent behavior. Am. J. Psychol. **57**(2), 243–259 (1944)
7. Jhala, A., Young, R.M.: Cinematic visual discourse: representation, generation, and evaluation. IEEE Trans. Comput. Intell. AI Games **2**(2), 69–81 (2010)
8. Jhala, A., Young, R.M.: A discourse planning approach to cinematic camera control for narratives in virtual environments. In: AAAI, vol. 5, pp. 307–312 (2005)
9. Magliano, J.P., Kopp, K., Higgs, K., Rapp, D.N.:. Filling in the gaps: memory implications for inferring missing content in graphic narratives. Discourse Processes (2016)
10. Mani, I.: Computational modeling of narrative. Synth. Lect. Hum. Lang. Technol. **5**(3), 1–142 (2012)
11. McCloud, S.: Understanding Comics: The Invisible Art. Harper Collins, New York (1993)
12. Montfort, N., Fedorova, N.: Small-scale systems and computational creativity. In: Proceedings of the 3rd International Conference on Computational Creativity, pp. 82–86 (2012)
13. Myers, J.L., Shinjo, M., Duffy, S.A.: Degree of causal relatedness and memory. J. Mem. Lang. **26**(4), 453–465 (1987)
14. Pérez y Pérez, R., Morales, N., Rodríguez, L.: Illustrating a computer generated narrative. In: Proceedings of the 3rd International Conference on Computational Creativity, pp. 103–110 (2012)
15. Pérez y Pérez, R., Sharples, M.: MEXICA: a computer model of a cognitive account of creative writing. J. Exp. Theor. Artif. Intell. **13**(2), 119–139 (2001)
16. Pirolli, P.: Information Foraging Theory: Adaptive Interaction with Information. Oxford University Press, New York (2007)
17. Saraceni, M.: Relatedness: aspects of textual connectivity in comics. In: Cohn, N. (ed.) The Visual Narrative Reader, Chap. 5, pp. 115–128. Bloomsbury (2016)
18. Smith, G., Whitehead, J.: Analyzing the expressive range of a level generator. In: Proceedings of the 2010 Workshop on Procedural Content Generation in Games at the 5th Interational Conference on the Foundations of Digital Games (2010)
19. Zwaan, R.A., Radvansky, G.A.: Situation models in language comprehension and memory. Psychol. Bull. **123**(2), 162–185 (1998)

# A Rules-Based System for Adapting and Transforming Existing Narratives

Jo Mazeika[(✉)]

UC Santa Cruz, Santa Cruz, USA
jmazeika@ucsc.edu

**Abstract.** This paper describes a rules-based computational system that utilizes a semantic framework to produce transformations of an existing narrative. We describe how we can use a Rete rules system to transform a semantic representation of a narrative, as well as laying out groundwork for the types of rules that a system like this would consider. To provide an example of our system in action, we describe a semantic encoding of the Brothers Grimm version of Sleeping Beauty, and provide rules for transforming it to fit the style of Disney.

**Keywords:** Intelligent narrative technologies · Rules system · Narrative transformation · Narrative representation

## 1  Introduction

Narrative transformation is the act of modifying a pre-existing narrative, whether to serve some purpose or to fit an externally imposed constraint. We see a ready example of this in adaptations, where an existing narrative is taken and transformed to fit the conventions, strengths and limitations of a new medium. When books are adapted into films, for instance, characters are combined or removed and plot lines are dropped to allow the narrative to fit within the appropriate length of time. Additionally, when telling a story, we often change details to fit our audience. For instance, a parent will skip events deemed inappropriate for their children when reading a book, or the creators of a film adaptation of an old cartoon will make a new narrative to fit what they believe the now-older audience would like.

In this work, we propose a system designed to make targeted modifications to a semantic representation of a narrative, designed around changing the narrative to fit some higher level goal. We provide a rules-based system for describing the constraints and transformations that will be imposed on the narrative to fit the given requirements.

## 2  Related Work

Several different techniques have been commonly used for narrative generation. In [6], the authors provide four separate methods for generalizing Propp's theory

© Springer International Publishing AG 2016
F. Nack and A.S. Gordon (Eds.): ICIDS 2016, LNCS 10045, pp. 176–183, 2016.
DOI: 10.1007/978-3-319-48279-8_16

of narrative grammars. The initial grammar that the authors describe operates over 5 levels of increasing specificity – the system first determines the high-level structure of the narrative, and at the bottom level, determines the individual actions that the characters take.

Additionally, we have systems such as Minstrel [13] and an improvement, Skald [11], which generate novel narratives. Minstrel operates by modeling some aspects of creativity to generate novel stories. To do so, the authors rely on transform-recall-adapt methods, or TRAMs, heuristics that offer solutions to problems that may arise during the generation process. In this way, it is able to transform the representations of narratives to fit an encountered narrative model. Using this technique, dubbed imaginative recall by Turner, Minstrel is able to generate novel narratives from an existing repository of reference narratives. Skald does not differ from Minstrel on the surface, but instead serves as a more-modern re-implementation that codifies and strengthens Turner's work by improving the TRAM selection process and updating several other mechanisms within Minstrel.

Finally, we have two systems that construct new stories from existing ones by analogy: the Story Translator [8], and SAM [14]. Both systems operate using very similar approaches, to the point of the authors in [14] observing that the Story Translator can be modeled within SAM. Both systems focus on taking existing narratives and converting them into an analogous one in a new domain; one example given is a fantasy story of a kidnapped princess being reworked to invoked cowboys holding each other at gunpoint. In contrast to the system described here, the authors view the changes in the events as a side-effect of the systems not being able to find a perfect mapping between the domains. However, these systems to provide an example of modifying a narrative to fit a given set of constraints.

## 3   System Description

Within our system, we have three representational elements that we need to consider: first, our representation of the narrative itself; second, the ontology that the rules operate within; and third, the set of rules that define the restrictions and transformations that we wish to impose upon the narrative.

To encode the stories that we wish to transform, we use a novel semantic framework, Rensa [5], to encode the representation of the narrative itself. Rensa is designed to be a generalization of Elson's Story Intention Graph [3], and as such offers all of the affordances that SIGs do while also incorporating a semantic network representation of the space around the narrative. In this framework, we represent characters as collections of mutable attributes, ranging from character tropes (protagonist, villain, etc.) to emotional attributes (happy, afraid, etc.). Because of the flexibility of Rensa, he particular set of attributes that comprise a character is defined by the user, and the set we choose is elaborated on in Sect. 5. The narrative itself is represented as a series of actions taken by the characters.

On top of the description of the narrative, we also provide the system with an ontology of the domain that the story takes place in, specifically, information

about particular actions, character types Similarly to other works that use similar ontologies to generate stories [7, 8, 14], by defining this representation of the domain, we gain two major benefits. First, it allows us to reason over properties and actions that are not part of the initial narrative. If we want to substitute an action for a less violent one, for instance, we need a set of possible actions to choose from. By having and maintaining an action ontology, we are able to ensure that the action we choose fits within the setting for the narrative. Secondly, this ontology allows us to specify additional information about the encoded elements. For example, in order to remove violent actions from a narrative, we need some notion of how violent an action is. By including this non-narrative-specific information, we gain the ability to reason over the additional information that we have included in our ontology.

## 4    Rules Representation

With the narrative and the space of the narrative we wish to generate in, we now need to build our series of rules for transforming the narrative. To do this, we take our semantic representation and encode it in a Rete algorithm-based rules system [4], which allows us to efficiently identify and execute rules over a collection of statements. The state is represented as a collection of facts, which in our case are simply the assertions that we have created to represent our narrative and the information contained within the ontology.

Rules can have three different effects when they fire: they can add any number of new facts to the system, they can modify any number of existing facts, or they can remove existing facts. When the state is changed in this way, we have might have a new space of rules that will be able to fire next.

In this system, we implement several major classes of rules that represent different kinds of transformations that we want to be able to make to the narrative representation. Note that not all of these can be represented as a single rule, but sometimes instead must be implemented as a set or series of interrelated rules to produce the effect desired. Side effects are certainly possible, but should be minimized for rules that may need to fire multiple times.

First, we have a collection of general types of rules that we use within the system. These include rules to include additional information or actions as required (for instance, some narratives will require all of their characters to have names), to modify or remove existing components of the narrative, and, most importantly, to ensure consistency within the narrative because of these modifications. As the rules fire, we may find ourselves in states that are not valid – perhaps an action is added to the narrative, but the character performing the action does not exist at that location at that time. The consistency rules fire to trigger modifications to ensure that these issues are resolved.

With the general sorts of rules in place, we then incorporate a rule set that defines the requirements for the target narrative. Beyond rules that can be modeled in the above class (such as the removal of violent actions), we can include rules such as requiring a character of a particular archetype to be present

(whether that character has to be added to the narrative on the fly, or an existing character can be modified to fit the archetype).

Once we have our rules set in place, constructing the modified narrative happens by allowing the Rete algorithm to use the rules to modify the narrative until it reaches a state in which no further rules can fire. At that point, we take the current state of the engine and transform it back into the semantic representation, so that we can examine the output.

## 5   Example

To test this framework, we focused our efforts on constructing an adaptation the story of Sleeping Beauty. Since there's a culturally salient transformation for that particular story – namely the Disney adaptation of the original story from the Brothers Grimm. To do this, we used the text provided at http://www.pitt.edu/~dash/grimm050.html as our reference for the original tale [2].

First, we discuss how we have encoded the narrative into the system. Characters are initialized with the following attributes: Name, Gender, the character's Narrative Role (Protagonist, Villain, Sidekick, etc.), and any other necessary attributes (Character is a faerie or an animal, etc.)

Then, the narrative is comprised of three different kinds of statements: a character can take an action, a character can move to a new location, a character can acquire a prop, or a character can gain or lose a property. Each of these has the following attributes:

- Actor (The focus character)
- Type (Action, Location, Prop, Property)
- Subject (The Action taken, the Location moved to, the Prop acquired, or the property gained or lost)
- Time Step(s) (This statements can have one of two time step attributes – either the statement happens at a single time step, or it has a time step where it starts and a time step where it finishes)

In our encoding of Sleeping Beauty, the narrative happens over 12 time steps, consisting of 26 different statements.

The system uses the following rules to create a mapping from Grimm to Disney:

- Every character has a name.
- The hero has an animal companion as a sidekick.
- Repeated characters, or characters who serve identical narrative functions, are keep to a minimum of two.
- The villain is defeated.
- No excessively violent actions occur.

These rules are not entirely inclusive of the rules that would transform the narrative to match the Disney version of Sleeping Beauty – for instance, there is no rule that handles Maleficent transforming into a dragon in Disney version.

Additionally, our encoding is on a high enough level that some features aren't considered, such as the individual blessings that the different fairies grant to Sleeping Beauty. However, the point of these rules is not to ensure that the actual Disney script is re-created, but instead are focused on transforming the narrative into one that fits within the style of the Disney.

Figure 1 shows an example of the expression of the first rule. In the original narrative, many of the characters are not actually given names: the king and queen, for instance, are only referred to by their titles. To demonstrate how we correct this, we take a character (in this case, Sleeping Beauty) who doesn't have a name. Names are a property of characters, and so to give her a name, we need to create a new fact that says what her name is.

We implement this by having a rule that fires when there is a character who doesn't have a name property. When said rule fires, we pull randomly from a gendered list of names, and create a new fact within the system that says that character has the chosen name. If the character does not have a gender at this time, we resolve this by randomly assigning a gender and then a corresponding name. In Fig. 1, we see that the character "Sleeping Beauty" has the name Aurora chosen and assigned.

**Fig. 1.** A realization of the first rule.

The animal sidekick rule is similar. If any animal already exists within the narrative, we give that animal the property of sidekick; otherwise we create a new animal with the property in place from the get-go. Afterwards, we then include what being a sidekick means. In this case, the property we wish to include is that at each time stamp, the sidekick and protagonist are both in the same location.

Next, we have the repetition reduction. This isn't necessarily an important function – plenty of narratives can feature a large number of characters who all take the same actions. This particular rule was created with the Good Fairies from Disney's Sleeping Beauty in mind. The original Grimm tale instead featured twelve wise woman who filled the same role.

In this, first we need to get a count of the number of characters who all share the same set of actions over the course of the story – specifically, characters who all do the same thing at the same time. When we have three or more characters who fall under that criteria, we select one of them for removal – since all of these characters are considered identically under the narrative, it does not matter

**Fig. 2.** Removing an extraneous character.

which one we select for removal. We then need to remove all of the lingering associations and facts that involve that the removed character. This is shown in Fig. 2.

For the next rule, we ensure that the villain is defeated. This is requires multiple different checks – if an action in the narrative itself would cause the villain's defeat, then it is a simple matter of appending that particular piece of information. Otherwise, we need to find an action that causes defeat, and have it performed. Most of these actions are performed by a different character (although there is no reason that the villain couldn't perform the action that causes their defeat), and so we need to ensure that character is in the correct place in the story to perform that action. Finally, if the action contains any prerequisites, we need to ripple back through the story to ensure that all of them are met before continuing.

In Fig. 3 we model a transforming part of the story to remove an action that has been labeled within the ontology as too violent. This notion of what qualifies as too violent is subjective, and several Disney movies do feature their villains coming to rather bad ends – in particular, Disney's Sleeping Beauty features Maleficent being stabbed with a magical sword. However, for the purposes of illustration, we have picked that particular scene as too violent, and in need of replacement.

To do this, we first need to find a replacement action that has the same set of consequences – in this case, we're looking for a non-violent action that causes defeat for Maleficent. Our system identifies "Break Weapon" as a replacement for "Stab", and so substitutes that in its place. However, both of the actions have preconditions: while Stab requires a blade, Break Weapon requires that the character has the property Distracting. So, we give the character the Distracting property. If the character has no other actions that require them to have a blade, we can also remove that from the character's list of properties as a tidying measure.

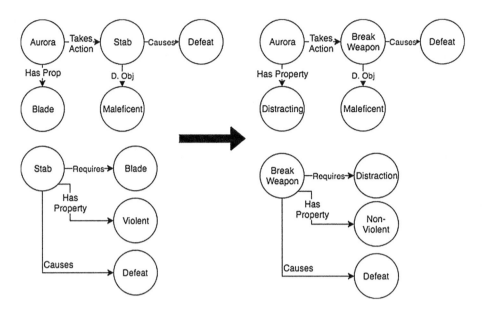

**Fig. 3.** Replacing a violent action.

## 6    Discussion and Future Work

While this work has shown reasonable results over the space that its generated in, it is not without limitations. The most obvious is that the Rete rules system used within this system is deterministic; if the same set of conditions and rules are true at any point during execution, the same set of rules with always fire in the same order. While this is useful under certain circumstances, for this work it is a limitation. We want to be able to explore the space of possible stories, which we can do by choosing different possible orders for firing rules, or by choosing different facts to match with the preconditions.

Next, the ontology used for generation is hand-authored. While is it certainly possible to have a system learn the ontology of fairy tales (both Disney and Grimm) and use that for generation, we chose for this initial outing to focus on a small, handcrafted ontology.

Finally, the pipeline that this sort of generation would be a part of is not complete. While we are able to manipulate the narrative on the representational level, we do not yet have a mapping from the story representation to natural language.

However, this work does lay the groundwork for the constructing narratives that fit a particular style, as well as an example of doing so. Future research will allow us to refine and improve the both the particular rule sets and the generation system.

# References

1. Akimoto, T., Ogata, T.: A narratological approach for narrative discourse: implementation and evaluation of the system based on genette and jauss. In: Proceedings of the 34th Annual Conference of the Cognitive Science Society, pp. 1272–1277 (2012)
2. Ashliman, D.L.: Grimm Brothers' Home Page. Accessed 2 June 2016. http://www.pitt.edu/dash/grimm.html
3. Elson, D.K.: Detecting story analogies from annotations of time, action and agency. In: Proceedings of the LREC 2012 Workshop on Computational Models of Narrative, Istanbul, Turkey (2012)
4. Forgy, C.L.: Rete: a fast algorithm for the many pattern/many object pattern match problem. Artif. Intell. **19**(1), 17–37 (1982)
5. Harmon, S.: An expressive dilemma generation model for players and artificial agents. In: Twelfth Artificial Intelligence and Interactive Digital Entertainment Conference (2016)
6. Imabuchi, S., Ogata, T.: Methods for generalizing the propp-based story generation mechanism. In: Yoshida, T., Kou, G., Skowron, A., Cao, J., Hacid, H., Zhong, N. (eds.) AMT 2013. LNCS, vol. 8210, pp. 333–344. Springer, Heidelberg (2013). doi:10.1007/978-3-319-02750-0_36
7. Ogata, T.: Building conceptual dictionaries for an integrated narrative generation system. J. Robot. Netw. Artif. Life **1**(4), 270–284 (2015)
8. Riedl, M., Len C.: Generating story analogues. In: AIIDE (2009)
9. Rishes, E., Lukin, S.M., Elson, D.K., Walker, M.A.: Generating different story tellings from semantic representations of narrative. In: Koenitz, H., Sezen, T.I., Ferri, G., Haahr, M., Sezen, D., Çatak, G. (eds.) ICIDS 2013. LNCS, vol. 8230, pp. 192–204. Springer, Heidelberg (2013). doi:10.1007/978-3-319-02756-2_24
10. Speer, R., Havasi, C.: ConceptNet 5: a large semantic network for relational knowledge. In: Gurevych, I., Kim, J. (eds.) The People's Web Meets NLP. Theory and Applications of Natural Language Processing, pp. 161–176. Springer, Heidelberg (2013)
11. Tearse, B.R., Mawhorter, P.A., Mateas, M., Wardrip-Fruin, N.: Skald: minstrel reconstructed. IEEE Trans. Comput. Intell. AI Game **6**, 156–165 (2014)
12. Theune, M., Slabbers, N., Hielkema, F.: The automatic generation of narratives. In: Proceedings of the 17th Meeting of Computational Linguistics in the Netherlands (CLIN17), pp. 131–146. Leuven, Belgium (2007)
13. Turner, S.: Minstrel: a computer model of creativity and storytelling. Technical report CSD-920057, Ph.D. thesis, Computer Science Department, University of California, Los Angeles, CA (1992)
14. Zhu, J., Ontañón, S.: The sam algorithm for analogy-based story generation. In: Artificial Intelligence, pp. 67–72 (2011)

# Evaluating Accessible Graphical Interfaces for Building Story Worlds

Steven Poulakos[1]([✉]), Mubbasir Kapadia[2], Guido M. Maiga[3], Fabio Zünd[3], Markus Gross[1,3], and Robert W. Sumner[1,3]

[1] Disney Research, Zurich, Switzerland
`steven.poulakos@disneyresearch.com`
[2] Rutgers University, New Brunswick, NJ, USA
[3] ETH Zurich, Zurich, Switzerland

**Abstract.** In order to use computational intelligence to assist in narrative generation, domain knowledge of the story world must be defined, a task which is currently confined to experts. In an effort to democratize story world creation, we present an accessible graphical platform for content creators and end users to create a story world, populate it with smart characters and objects, and define narrative events that can be used to author digital stories. The system supports reuse to reduce the cost of content production and enables specification of semantics to enable computer assisted authoring. Additionally, we introduce an iterative, bi-directional workflow, which bridges the gap between story world building and story authoring. Users seamlessly transition between authoring stories and refining the story world definition to accommodate their current narrative. A user study demonstrates the efficacy of our system to support narrative generation.

**Keywords:** Story world · Domain specification · Narrative generation

## 1 Introduction

A prerequisite to using computational intelligence for authoring digital stories [1] is to specify the underlying logical formalisms that describe the problem domain, also referred to as the *story world*. While a lot of work exists in making story authoring accessible to everyone [1], all these contributions assume a story world definition already exists. The story includes annotated semantics that characterize the attributes and relationships of objects and characters in a scene (state), different ways in which they interact (affordances), and how these affordances manipulate their state. The domain knowledge definition entails both the state and action space within a story world. Current languages and interfaces for specifying domain knowledge are confined to experts and the overhead of domain specification is high, often comparable to authoring the story from scratch [2]. This work aims to provide an accessible interface for building story worlds to democratize the use of computational narrative intelligence.

© Springer International Publishing AG 2016
F. Nack and A.S. Gordon (Eds.): ICIDS 2016, LNCS 10045, pp. 184–196, 2016.
DOI: 10.1007/978-3-319-48279-8_17

Event-centric authoring [3] encapsulates interactions that have narrative significance as logical constructs and provides an appropriate level of abstraction for authoring and reasoning about stories. This imposes an additional authoring overhead, as these events need to be specified, but mitigates the complexity of automation as it is now independent in number of actors and actor capabilities [2]. Recent research [4] has demonstrated the promise of event-centric representations for defining story worlds, in comparison to agent-centric approaches, and is the choice of domain representation used in this work.

We first describe an end-to-end graphical platform for systematically defining the building blocks of the story world using an intuitive, visual graphical interface. Story world building constitutes creating smart objects, defining their state and actions (or affordances), as well as defining a lexicon of events (multi-actor behaviors of narrative significance) that may take place in this story world. We then demonstrate the efficacy of our system through a user study, which involves the creation of a Haunted Castle story world and authoring of stories within that world. The evaluation results reveal the potential of our graphical platform as well as the following benefits: bi-directional, iterative story world and story authoring process, reuse to reduce the cost of content creation and specification of event-level conditions to enable computational reasoning and assistance in authoring process, which reduces authoring complexity.

## 2   Related Work

The research community has addressed the problem of authoring digital narratives in two main ways. Manual approaches provide domain specialists with complete control over creating rich narrative content, while automated approaches rely on computational techniques to generate emergent interactive experiences. We refer the readers to comprehensive surveys on narrative authoring [1,5].

**Manual Authoring.** Scripted approaches [6] describe behaviors as pre-defined sequences of actions. While providing fine-grained control, small changes often require far-reaching modifications of monolithic scripts. Improv [7] and LIVE [8] describe actor behaviors as rules based on certain conditions. These systems produce pre-defined behaviors appropriate for specific situations. However, they are not designed to generate complicated agent interactions with narrative significance. Facade [9] utilizes authored beats to manage the intensity of the story in addition to a generalized scripting language [10,11] to manually authoring character interactions based on preconditions for successful execution.

Story Graphs can represent branching story lines [12] enabling user interaction as discrete choices at key points in the authored narrative. Behavior Trees (BT's) are applied in the computer gaming industry to design the artificial intelligence logic for non-player characters [13]. BT's enable the authoring of modular and extensible behaviors, which can be extended to control multiple interacting characters [14] and to provide a formalism for specifying narrative events.

**Automated Narrative Generation.** Domain-independent planners [15] provide a promising direction for automated narrative generation [16], however,

at the cost of requiring the specification of domain knowledge. The complexity of authoring is transferred from story specification to domain specification. For example, domain specification has been demonstrated to enable multi-actor interactions that conform to narrative constraints [17,18]. However, they cannot be dynamically changed to accommodate user input. Narrative mediation systems [19] automatically generate sub stories that consider the ramifications of possible user interaction. However, these systems produce story graphs with significant branching that are difficult to edit by humans. Virtual directors or drama managers [20] may also accommodate user input while steering agents towards pre-determined narrative goals [21]. Thespian [22] uses social awareness to guide decision-theoretic agents. PaSSAGE [23] estimates a player's ideal experience to guide the player through predefined encounters.

*Agent-Centric Domain Specification.* Agent-centric approaches [24] build up each character as an individual and explore the space of all possible combinatorial character actions to generate stories. Authoring the characteristics and capabilities of individual characters is decoupled from specifying the story itself, and the complexity of automated narrative generation is combinatorial in the number of characters and the different capabilities of each character.

*Event-Centric Domain Specification.* Events are a layer of abstraction on top of agent-centric authoring which encapsulate multi-actor interactions that have narrative significance. Event-centric approaches [2,3,25] plan in the space of pre-authored narratively significant interactions, thus mitigating the combinatorial explosion of planning in the action space of individual character actions.

**Story World Building.** Regardless of the mode of story authoring, an underlying representation of the domain in which the story is authored, referred to as the story world, needs to be first specified. This task is traditionally tedious and confined to experts. Wide Ruled [26] offers intuitive graphical interfaces for specifying the problem domain which can be used by narrative generation engines. However, these systems are not compatible with animated stories. Recent work [4] demonstrates the potential of event-centric representations for building story worlds that can be used to author animated stories. However, the task of story world building and story authoring are isolated from each other.

**Comparison to Prior Work.** Our work complements ongoing research in computational narrative intelligence and advocates for providing accessible metaphors for building story worlds. We build on top of prior work [4] to enhance the features of the system to include affordance and behavior creation. We propose a bi-directional workflow, leveraging reuse and supporting automation, that allows authors to seamlessly transition between story world building and story authoring.

# 3  Domain Specification for Automated Narrative Generation

In order to use computational intelligence for narrative generation, content creators and story writers need to specify the domain knowledge of the story world, which can be used by an intelligent system for reasoning, inference, and ultimately story generation. This includes annotating semantics that characterize the attributes and relationships of objects and characters in the scene (state), different ways in which they interact (affordances), and how these affordances manipulate their state. Many intelligent systems for automated generation are similar in this regard [1]. However there exists a tradeoff between the complexity of authoring and the computational complexity of generating stories depending on type of domain representation used. Our previous work [4] introduces preliminary concepts for story world building, and we include these concepts here for completeness. Using these building blocks, we describe an event-centric representation of domain knowledge for narrative generation [2].

**Preliminaries.** We introduce smart objects and affordances as the building blocks for creating story worlds.

*Smart Objects.* The virtual world $\mathbf{W}$ consists of smart objects [27] with embedded information about how an actor can use the object. We define a smart object $w = \langle \mathbf{F}, s \rangle$ with a set of advertised affordances $f \in \mathbf{F}$ and a state $s = \langle \theta, R \rangle$, which comprises a set of attribute mappings $\theta$, and a collection of pairwise relationships $R$ with all other smart objects in $\mathbf{W}$. An attribute $\theta(i, j)$ is a -bit that denotes the value of the $j^{th}$ attribute for $w_i$. Attributes are used to identify immutable properties of a smart object such as its role (e.g., a button or a person) which never changes, or dynamic properties (e.g., `IsPressed` or `IsStanding`) which may change during the story. A specific relationship $R_a$ is a sparse matrix of $|\mathbf{W}| \times |\mathbf{W}|$, where $R_a(i, j)$ is a bit that denotes the current value of the $a^{th}$ relationship between $w_i$ and $w_j$. For example, an `IsFriendOf` relationship indicates that $w_i$ is a friend of $w_j$. Note that relationships may not be symmetric, $R_a(i, j) \neq R_a(j, i) \ \forall \ (i, j) \in |\mathbf{W}| \times |\mathbf{W}|$. The state of each smart object is stored as a bit vector encoding both attributes and relationships.

*Affordances.* An affordance $f = \langle w_o, \mathbf{w}_u, \mathbf{\Phi}, \Omega \rangle$ is an advertised capability offered by a smart object that takes the owner of that affordance $w_o$ and one or more smart object users $\mathbf{w}_u$, and manipulates their states. For example, a smart object such as a ball can advertise a *Throw* affordance, allowing another smart object to throw it. A precondition $\mathbf{\Phi} : \mathbf{s_w} \leftarrow \{\text{TRUE}, \text{FALSE}\}$ is an expression in conjunctive normal form on the compound state $\mathbf{s_w}$ of $\mathbf{w} : \{w_o, \mathbf{w}_u\}$ that checks if $f$ can be executed based on their current states. A precondition is fulfilled by $\mathbf{w}$ if $\mathbf{\Phi}_f(\mathbf{w}) = \text{TRUE}$. The postcondition $\Omega : \mathbf{s} \rightarrow \mathbf{s'}$ transforms the current state of all participants, $\mathbf{s}$ to $\mathbf{s'}$ by executing the effects of the affordance. When an affordance fails, $\mathbf{s'} = \mathbf{s}$.

*Narrative Generation.* The aim is to generate a narrative $\Pi(\mathbf{s}_s, \mathbf{s}_g)$, which satisfies an initial state $\mathbf{s}_s$ and through a series of state transitions results in the desired goal state $\mathbf{s}_g$.

**Event-centric Domain Knowledge.** Event-centric domains introduce events as an additional layer of abstraction. Events are pre-defined context-specific interactions between any number of participating smart objects whose outcome is dictated by the current state of its participants. Events serve as the building blocks for authoring complex narratives. An event is formally defined as $e = \langle t, \mathbf{r}, \mathbf{\Phi}, \Omega \rangle$ where $t$ is a logical representation of a coordinated interaction between multiple actors. $t$ takes any number of participating smart objects as parameters where $\mathbf{r} = \{r_i\}$ define the desired roles for each participant. $r_i$ is a logical formula specifying the desired value of the immutable attributes $\theta(\cdot, j)$ for $w_j$ to be considered as a valid candidate for that particular role in the event. A precondition $\mathbf{\Phi} : \mathbf{s_w} \leftarrow \{\texttt{TRUE}, \texttt{FALSE}\}$ is a logical expression on the compound state $\mathbf{s_w}$ of a particular set of smart objects $\mathbf{w} : \{w_1, w_2, \ldots w_{|\mathbf{r}|}\}$ that checks the validity of the states of each smart object. $\mathbf{\Phi}$ is represented as a conjunction of clauses $\phi \in \mathbf{\Phi}$ where each clause $\phi$ is a literal that specifies the desired attributes of smart objects, and relationships between pairs of participants. A precondition is fulfilled by $\mathbf{w} \subseteq \mathbf{W}$ if $\mathbf{\Phi}_e(\mathbf{w}) = \texttt{TRUE}$. The event postcondition $\Omega : \mathbf{s} \rightarrow \mathbf{s}'$ transforms the current state of all event participants $\mathbf{s}$ to $\mathbf{s}'$ by executing the effects of the event. When an event fails, $\mathbf{s}' = \mathbf{s}$. An event instance $I = \langle e, \mathbf{w} \rangle$ is an event $e$ populated with an ordered list of smart object participants $\mathbf{w}$.

*State Space.* The overall state of the world $\mathbf{W}$ is defined as the compound state $\mathbf{s} = \{s_1, s_2 \cdots s_{|\mathbf{W}|}\}$ of all smart objects $w \in \mathbf{W}$, which is encoded as a matrix of bit vectors. $\mathbf{s_w}$ denotes the compound state of a set of of smart objects $\mathbf{w} \subseteq \mathbf{W}$. The state space $\mathbb{S}_e$ represents the set of all possible world states $\mathbf{s}$.

*Action Space.* The event-centric action space $\mathbb{A}_e = \{e_1, e_2 \cdots e_m\}$ is defined as the set of all $m$ events that may occur between any permutation of smart objects in the world $\mathbf{W}$.

*Narrative Generation.* A narrative $\Pi(\mathbf{s}_s, \mathbf{s}_g) = \langle e_1, e_2 \ldots e_n \rangle$ is defined as a sequence of events that transform the state of the world from its initial state $\mathbf{s}_s$ to the desired goal state $\mathbf{s}_g$ that represents the desired outcome of the narrative. An event-centric representation of domain knowledge helps mitigate the combinatorial complexity of authoring individual characters in complex multi-character interactions and its variants have recently gained prominence in the games industry [2]. While this does impose the additional overhead of authoring events, it offers greater control of narrative progression.

## 4   A Graphical Platform for Building Story Worlds

Our Story World Builder (SWB) is designed to build up components of a full story world with required semantics to enable computer-assisted narrative generation. The graphical platform is built within the Unity3D game engine.

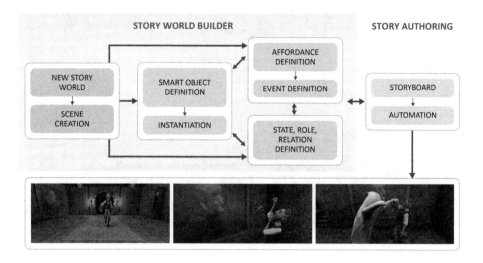

**Fig. 1.** Overview for building a story world and authoring stories. A scientist enters the haunted castle, investigates a painting and is then spooked by a ghost.

Our demonstration system conforms to the event-centric representations of Shoulson et al. [3] and integrates with the CANVAS story authoring system of Kapadia et al. [2]. CANVAS provides a storyboard-based metaphor for visual story authoring of event and event participants, and it utilizes partial-order planning to enable computer-assisted generation of narratives. The underlying representation of the story world is general and can be easily used within other computer assisted narrative generation systems, such as PDDL.

Story world building begins with the creation of a new story world project and the specification of a scene. The scene specification can involve inclusion of static scene elements, environment lighting and navigation paths in the environment. Building a story world continues with three system components, which are described below: (1) Smart Object Editor: defining a set of smart objects and characters, and instantiating them in the scene. (2) State Editor: defining states, roles and relationships. (3) Affordance and Event Editors: defining capabilities for smart objects and the events which use them. Figure 1 illustrates bi-directional relationship between these components and illustrates an example story that was generated within the Haunted Castle scenario.

**Smart Object Editor.** Smart objects represent all of the characters and props that influence the story world. In the context of our overall formalism, smart objects have state and offer capabilities to interact with other smart objects and influence the state of the story world. Smart object characters are identified as "smart characters". We differentiate smart characters because they require additional components to, for example, support inverse kinematics to do complex

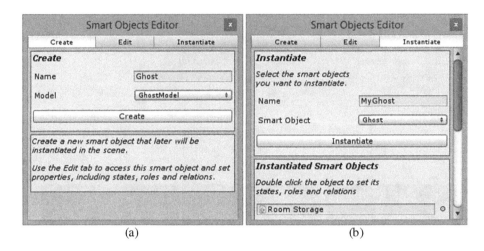

Fig. 2. Smart Objects Editor. (a) Create and (b) Instantiate smart objects.

physical actions, such as pressing a button and grasping objects. All humanoid smart characters can have the same base set of capabilities.

Figure 2(a) shows the interface for creating a smart character called "Ghost", which is embodied by a ghost model. Once the smart character is created, the user may then edit properties of the smart object, accessed via the Edit tab. The Instantiate tab, visualized in Fig. 2(b), is then used to create one or more instances of the Ghost smart object within the scene. Each instance has a unique name, for example "MyGhost". Instantiated smart objects are listed at the bottom of the tab. Additional components are provided to specify other properties, including a representative icon for use in the authoring system.

**State, Role and Relation Editor.** The State Editor enables the creation of state attributes, roles and relationships available for use with smart objects in the world. States include high level descriptions of objects. For example, the state IsInhabiting is true when a ghost is inhabiting another object. Roles may be created to specify that all ghost smart objects have the role IsGhost. Relationships existing in the world may also be defined. For example, ghosts may have an IsAlliedWith or IsInhabitedBy relation. Each smart object provides a component for editing its states, roles and relations.

**Affordance and Event Editors.** Following the event-centric representation [3], events are defined as Parameterized Behavior Trees (PBT) [28], which provide a graphical, hierarchical representation for specifying complex multi-actor interactions in a modular, extensible fashion. Event creation involves specification of Affordance PBT, Event PBT, and event-based planning.

*Affordance PBT.* Affordances specify the capabilities of smart objects. An affordance owner offers a capability to the affordance user. Figure 3(a) demonstrates an example "InhabitAffordance", which is owned by a smart object and used by

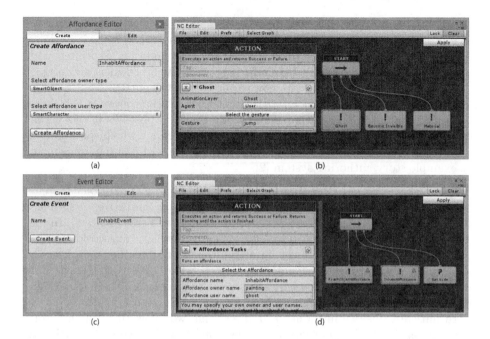

**Fig. 3. Affordance and Event Editors.** (a) The Inhabit affordance is created, which is owned by a smart object and used by a smart character to inhabit the smart object. (b) The affordance behavior tree represents the series of actions. (c) An Inhabit event is created. (d) An event behavior tree specifies a sequence of affordances and condition nodes.

a smart character. Figure 3(b) represents an example behavior tree to achieve the affordance. A sequence control node is used to specify that a smart character user (a ghost) will jump into a smart object (the painting) and become invisible. The material property of the smart object will change to reflect that it is now inhabited. Affordances can be much more complex. An advantage of specifying affordances is that they may be reused in many events.

*Event PBT.* Events utilize the affordances and conditional logic to compose more complex forms of interaction. Figure 3(c) and (d) present the creation of the InhabitEvent. This simple example uses a sequential control node to specify that a smart character (a ghost) will first approach a smart object (the painting) before inhabiting it. Events may have multiple smart object and character participants, however they must be consistently specified throughout the event behavior tree nodes. We use names of characters from an example scenarios to maintain consistency. Additional components are provided to specify a representative icon for use in the authoring system. Both events and affordance PBTs may be cloned and modified to support reuse.

*Event-based planning.* Additional semantics are specified at the event-level to enable reasoning about the logical connectivity of events. Preconditions and

postconditions are defined as conjunctive normal form (CNF) expressions on the state and relations of the PBT participants. The event behavior tree in Fig. 3(d) includes a *Set Node*, which specifies a postcondition associated with the event. In our example, the `IsInhabiting` state of the ghost is set to true. In the context of our example, we may required that the smart object has role `IsInhabitable` or we may set an `IsInhabitedBy` relation between the smart object and character. The author may specify pre- and post-conditions within both Affordance and Event PBTs. The SWB will determine which conditions to use to support event-based planning and is compatible with the requirements of our example story authoring system [2].

**Coupled Story World Building and Story Authoring.** Traditional systems decouple the act of building story worlds and defining narratives, which are often executed by different users (story world builders and story writers). In this paper, we present a system that takes steps towards making story world building accessible to non-experts. However, in a traditional uni-directional workflow, a story world, once finalized, cannot be modified while authoring stories. This introduces certain limitations where users need to forecast all the foundational blocks (smart objects and events) that need to exist in a story world.

To mitigate this, we introduce a bi-directional workflow that couples story world building and story authoring. Our system naturally extends to facilitate seamlessly transitioning between these two acts. This workflow affords several benefits allowing traditional story authors to easily edit and modify existing story world definitions to accommodate new features, and introduce new smart objects or events, that may be necessary to realize their narrative.

## 5    Evaluation

**Method.** We conducted a user study to evaluate the usability and observed benefit offered by the Story World Builder (SWB). Eight computer science students participated in the evaluation. All participants had no prior experience with SWB, 63 % had prior experience authoring stories with CANVAS and 38 % reported prior experience using the Unity3D game engine. The task involved the iterative and bi-directional process of building a Haunted Castle story world with SWB and authoring stories with CANVAS. Text-based instructions provided an overview of the system and specified a list of story world elements to produce. This ensured that all experiment participants created similar set of affordance and events, although some variation was possible in the implementation.

The user study was conducted in four parts. Part 1 involved an introduction video, which demonstrated how to build a painting smart object, a scientist smart character and an experiment event. Test subjects were then provided with a story world containing elements described in the video. Part 1 concluded by guiding the participant to author a story from the story world produced during the video demonstration. Part 2 involved extending that story world. Experiment participants were asked to create an investigate event, which involved reusing a ReachObjectAffordance in addition to creating new affordances. After playing a

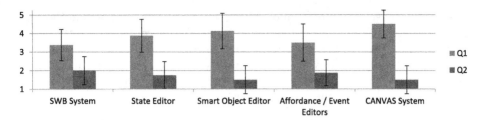

**Fig. 4.** Subject responses to the following statements: (Q1) "I thought the [fill-in with column label] system was easy to use." (Q2) "I think that I would need the support of a technical person to be able to use this [fill-in with column label]." Likert Scale: Strongly Agree (5) to Strongly Disagree (1). Error bar is 95 % confidence interval.

story involving the new event, participants then created a ghost smart character and a spook event, in which a ghost spooks the scientist. A longer story was then authored. Part 3 involved updating events in the story world to enable planning-based computer-assisted authoring. An IsInhabiting state and IsInhabitable role were created and integrated into the existing current events. The pre- and post-conditions made it possible to author a subset of the events in the previously authored story. The authoring system automatically completed the story using the semantic event-level specification. Part 4 concluded the user study with a questionnaire.

**Results.** All experiment participants successfully created the intended Haunted Castle story world and authored stories before proceeding to the questionnaire. The questionnaire began with the ten question System Usability Scale (SUS) [29]. The SUS was selected because it is easy to administer and can provide reliable results for small sample sizes. We applied the ten standard questions to evaluate the SWB system. The resulting SUS score of 66.88 demonstrates that we have a usable system.

Two SUS questions were reused to evaluate subcomponents of the system to edit states, smart objects and events, as well as the story authoring system (CANVAS). One-sample t-Tests were computed on the Likert scale responses to determine if agreement significantly differed from a neutral response. The questions and results are provide in Fig. 4. For all systems and subcomponents, participants disagreed that they would require support of a technical person. We interpret this to mean novice users can independently use the system. Participants agreed that the CANVAS System was easy to use and tended to agree that the State Editor and Smart Object Editor were easy to use. The SWB and Affordance/Event Editors had more neutral responses, likely due to the process of specifying affordance and event PBTs, which may be less intuitive and more challenging for users. Further improvements in our system should focus on this aspect of domain specification.

We concluded the questionnaire with the following three questions about the benefits of specific aspects of our system (average Likert response score in parentheses): "I benefited from the ability go back and change the story world

(changing state, smart objects, affordances, and/or events) as I was authoring the story."-(score: 4.38) "I benefited from reusing existing contents from the story world."-(score: 4.75) "I benefited from automatically completing stories based on the event conditions provided in the story world."-(score 4.38) Participants observed the greatest benefit in the ability to reuse content, and also agreed that bi-directionality and automation were beneficial.

## 6   Conclusions

This paper motivates the importance of accessible metaphors for domain specification, as a precursor to computational narrative generation. We describe the representation of domain knowledge, which utilizes an event-centric layer of abstraction. We demonstrate a graphical platform for event-centric authoring of story worlds, which includes specification of smart objects, states, affordances and events. Our system enables a bi-directional, iterative story world and story authoring design process. The principle of reuse is integrated to reduce the cost of content creation. The system streamlines the process of condition specification to enable computational reasoning and assistance in the story authoring process, which importantly reduces authoring complexity. Our user study demonstrates the efficacy of our system, accessible to novice users, to build story worlds.

**Limitations and Future Work.** The user study has motivated several future improvements. Affordance and Event PBT specification is the most challenging aspect of the system. Users have requested that the system provide more assistance with PBT specification. The formalism for affordance specification is unintuitive in some situations. Users also requested that the story world domain specification be directly edited within the 3D story world. We intend to extend the platform to give more creative freedom to the author and also to assist in the development of interactive narratives [30,31]. The far-reaching goal of our research is to democratize story world building and digital story generation, by providing accessible metaphors for narrative content creation.

## References

1. Riedl, M.O., Bulitko, V.: Interactive narrative: an intelligent systems approach. AI Mag. **34**(1), 67–77 (2013)
2. Kapadia, M., Frey, S., Shoulson, A., Sumner, R.W., Gross, M., Canvas: Computer-assisted narrative animation synthesis. In: Proceedings of of SCA 2016, Aire-la-Ville, Switzerland, pp. 199–209. Eurographics Association (2016)
3. Shoulson, A., Gilbert, M.L., Kapadia, M., Badler, N.I.: An event-centric planning approach for dynamic real-time narrative. In: MIG (2013)
4. Poulakos, S., Kapadia, M., Schupfer, A., Zund, F., Sumner, R., Gross, M.: Towards an accessible interface for story world building. In: Interactive Narrative Technologies 8, AIIDE Technical Report (2015)
5. Kapadia, M., Shoulson, A., Durupinar, F., Badler, N.: Authoring multi-actor behaviors in crowds with diverse personalities. In: Modeling, Simulation and Visual Analysis of Crowds, vol. 11, pp. 147–180 (2013)

6. Loyall, A.B.: Believable agents: building interactive personalities. Ph.D. thesis, Pittsburgh, PA, USA (1997)
7. Perlin, K., Goldberg, A.: Improv: a system for scripting interactive actors in virtual worlds. In: Proceedings of ACM SIGGRAPH, pp. 205–216. ACM, New York (1996)
8. Menou, E., Bonnafous, V., Jessel, J.-P., Caubet, R.: Real-time character animation using multi-layered scripts and spacetime optimization. In: Balet, O., Subsol, G., Torguet, P. (eds.) ICVS 2001. LNCS, vol. 2197, pp. 135–144. Springer, Heidelberg (2001). doi:10.1007/3-540-45420-9_15
9. Mateas, M., Stern, A.: Integrating plot, character and natural language processing in the interactive drama facade. In: TIDSE, vol. 2 (2003)
10. Mateas, M., Stern, A.: A behavior language for story-based believable agents. IEEE Intell. Syst. **17**(4), 39–47 (2002)
11. Mateas, M., Stern, A.: A behavior language: joint action and behavioral idioms. In: Prendinger, H., Ishizuka, M. (eds.) Life-Like Characters, pp. 135–161. Springer, Heidelberg (2004)
12. Gordon, A., van Lent, M., Velsen, M.V., Carpenter, P., Jhala, A.: Branching storylines in virtual reality environments for leadership development. In: AAAI, pp. 844–851 (2004)
13. Isla, D.: Handling complexity in the Halo 2 AI. In: Game Developers Conference, March 2005
14. Shoulson, A., Marshak, N., Kapadia, M., Badler, N.I.: ADAPT: the agent development and prototyping testbed. IEEE TVCG **20**(7), 1035–1047 (2014)
15. Weld, D.S.: An introduction to least commitment planning. AI Mag. **15**(4) (1994)
16. Young, R.M.: Notes on the Use of Plan Structures in the Creation Of Interactive Plot. Technical Report. AAAI Press, Cape Cod (1999)
17. Kapadia, M., Singh, S., Reinman, G., Faloutsos, P.: Multi-actor planning for directable simulations. In: Digital Media and Digital Content Management (DMDCM), pp. 111–116, May 2011
18. Kapadia, M., Singh, S., Reinman, G., Faloutsos, P.: A behavior-authoring framework for multiactor simulations. IEEE CGA **31**(6), 45–55 (2011)
19. Riedl, M.O., Michael Young, R.: From linear story generation to branching story graphs. IEEE CGA **26**(3), 23–31 (2006)
20. Magerko, B., Laird, J.E., Assanie, M., Kerfoot, A., Stokes, D.: AI characters and directors for interactive computer games. Artif. Intell. **1001**, 877–883 (2004)
21. Weyhrauch, P.W.: Guiding interactive drama. Ph.D. thesis, Pittsburgh, PA, USA (1997). AAI9802566
22. Si, M., Marsella, S.C., Pynadath, D.V., Thespian: an architecture for interactive pedagogical drama. In: Proceeding of the 2005 Conference on Artificial Intelligence in Education, pp. 595–602 (2005)
23. Thue, D., Bulitko, V., Spetch, M., Wasylishen, E.: Interactive storytelling: a player modelling approach. In: AIIDE (2007)
24. Mosher, R., Magerko, B.: Personality templates and social hierarchies using stereotypes. In: Göbel, S., Malkewitz, R., Iurgel, I. (eds.) TIDSE 2006. LNCS, vol. 4326, pp. 207–218. Springer, Heidelberg (2006). doi:10.1007/11944577_22
25. Shoulson, A., Kapadia, M., Badler, N.: PAStE: a platform for adaptive storytelling with events. In: INT VI, AIIDE Workshop (2013)
26. Skorupski, J., Jayapalan, L., Marquez, S., Mateas, M.: Wide ruled: a friendly interface to author-goal based story generation. In: Cavazza, M., Donikian, S. (eds.) ICVS 2007. LNCS, vol. 4871, pp. 26–37. Springer, Heidelberg (2007). doi:10.1007/978-3-540-77039-8_3

27. Kallmann, M., Thalmann, D.: Direct 3D interaction with smart objects. In: Proceedings of the ACM Symposium on Virtual Reality Software and Technology, VRST 1999, pp. 124–130, ACM, New York (1999)

28. Shoulson, A., Garcia, F.M., Jones, M., Mead, R., Badler, N.I.: Parameterizing behavior trees. In: Allbeck, J.M., Faloutsos, P. (eds.) MIG 2011. LNCS, vol. 7060, pp. 144–155. Springer, Heidelberg (2011). doi:10.1007/978-3-642-25090-3_13

29. Brooke, J.: SUS: a quick and dirty usability scale. In: Usability Evaluation in Industry. Taylor and Francis, London (1996)

30. Kapadia, M., Falk, J., Zünd, F., Marti, M., Sumner, R.W., Gross, M.: Computer-assisted authoring of interactive narratives. In: Proceedings of the 19th Symposium on Interactive 3D Graphics and Games, i3D 2015, pp. 85–92. ACM, New York (2015)

31. Kapadia, M., Zünd, F., Falk, J., Marti, M., Sumner, R.W., Gross, M.: Evaluating the authoring complexity of interactive narratives with interactive behaviour trees. In: Foundations of Digital Games, FDG 2015 (2015)

# Reading Between the Lines: Using Plot Graphs to Draw Inferences from Stories

Christopher Purdy$^{(\boxtimes)}$ and Mark O. Riedl

School of Interactive Computing, Georgia Institute of Technology, Atlanta, GA, USA
{cpurdy3,riedl}@gatech.edu

**Abstract.** Intelligent agents designed to interact with humans need to be able to understand human narratives. Past attempts at creating story understanding systems are either computationally expensive or require a vast amount of hand-authored information to function. To combat these difficulties, we propose and evaluate a new story understanding system using plot graphs, which can be learned from crowdsourced data. Our system is able to generate story inferences much quicker than the baseline alternative without significant loss of accuracy.

**Keywords:** Intelligent narrative technologies · Computational understanding of narratives · Narrative intelligence · Artificial intelligence

## 1 Introduction

Human beings use stories to describe routine or exciting experiences, communicate with each other, and make sense of the world. The ability to understand stories told by others is an important part of human intelligence. If we want digital agents to communicate effectively with human beings, they need to understand the narratives that humans communicate with.

Story understanding is difficult to model largely because of what humans *don't* say: for example, if somebody tells us, "I went to the grocery store and then went back home," most of us will recognize that the speaker also had to park the car at the grocery store, enter the store, and purchase groceries at the store, despite none of this being mentioned in the narrative. The ability to make these inferences is critical in understanding human-authored stories.

Story understanding is hard to define but easy to evaluate if treated as a question-answering problem: given a story with events $e_1...e_n$, what is the probability that predicate $p_x$ is true? As an example, we can have a virtual agent examine a human-authored story: *"John entered the bank. John approached the teller and pulled out a gun. John left the bank with ten thousand dollars. John went to jail."* To test its understanding, we might ask it some questions about the story:

© Springer International Publishing AG 2016
F. Nack and A.S. Gordon (Eds.): ICIDS 2016, LNCS 10045, pp. 197–208, 2016.
DOI: 10.1007/978-3-319-48279-8_18

(a) Did John ask the teller for the money?
(b) Was the teller afraid of John?
(c) Did the police arrest John?

We can use the answers it supplies to assess its understanding capabilities.

Humans require a large amount of commonsense knowledge (knowledge about the facts and procedures shared by a human population) in order to perform accurate reasoning. Existing story understanding systems rely either on hand-authored scripts or large commonsense knowledge bases to capture this kind of information. Scripts are useful, structured tools for reasoning, but requiring human authors to hand-engineer granular information for a virtual agent is mentally taxing and time-consuming. Commonsense knowledge bases suffer the same difficulty, have little procedural knowledge, and are also computationally expensive to search through: knowledge bases can contain millions of facts which must be iterated through whenever the agent is asked a question. We want a story understanding system that is computationally efficient and does not rely on hand-authored scripts.

To address these difficulties, we built off of research on *Scheherazade* [4], an open story generation system, in order to build a system that can make commonsense inferences (inferences requiring commonsense knowledge) about stories. This work made two main contributions. First, we present an inference technique that is more efficient than the alternative brute-force inference technique. Our technique accepts stories in natural language questions, unlike prior story understanding systems that assume questions are posed in symbolic form. Second, we compare our technique to the alternative brute-force inference technique in terms of computational complexity, efficiency, and accuracy. We find that our inference technique is significantly more efficient at the expense of some loss in accuracy.

## 2   Background and Related Work

Efforts in story understanding date back to the mid-1970s with the *Script Applier Mechanism* (SAM) system [3], which provided a script-based framework to produce inferences from natural-language stories. The *Plan Applier Mechanism* (PAM) [11] focused on goals and explanations in order to aid in the understanding of never-before-seen stories. The AQUA system [9] introduced meta-reasoning to question-answering. Mueller [8] applied commonsense knowledge bases and templates to understand script-based news stories. Recent work by Cardona-Rivera et al. [2] applied cognitive models and computational models to reason over computer-generated stories as opposed to human-authored ones. These approaches require hand-built knowledge bases. Deep learning has been used in order to answer questions with a new kind of learning model that combines long short-term memory with inference operators [10].

*Scheherazade* [4,5] is a story generation system that learns to tell novel stories from example stories crowdsourced from the general public. This alleviates the

limitation of many story generation systems' reliance on knowledge engineering. Of particular interest to us is the knowledge representation used by *Scheherazade* to generate stories: the plot graph. The plot graph data structure describes all of the possible sequences of events that could occur in a specific scenario (including sequences not contained in the training corpus): for example, a plot graph constructed from crowdsourced bank robbery stories can be used to generate its own stories about bank robberies. While the plot graph's original purposes were to aide in story generation, the plot graph is itself a knowledge representation which encapsulates narrative information about scenario-specific stories. We thus posit that plot graphs can be used to demonstrate story understanding.

To draw inferences using a plot graph, the naive approach would be to adopt a sampling or brute-force approach. Given events $A$ and $B$, what is the probability that event $C$ happened? The system would either have to sample stories generated using *Scheherazade's* story generation algorithm and calculate relative frequencies (while sacrificing accuracy) or compute *all* stories and search through each of them. In the worst case this would result in searching $n!$ stories, where $n$ is the number of nodes in the plot graph. We present an inference algorithm that can intelligently use the structure of the plot graph to draw inferences from input stories.

## 3   Plot Graphs

A plot graph is a compact representation of the space of possible stories that can describe a certain scenario. Plot graphs are mainly composed of three kinds of elements [4]:

- Event nodes: These are the vertices of the graph. Each of these nodes represents exactly one event (e.g. "John drove to the store" or "John opened the door"). Each node contains a set of sentences that semantically describe the event, which are learned from the crowdsourced exemplar stories.
- Temporal orderings: These are unidirectional edges of the graph. They are a kind of partial ordering that indicate a necessary order for events in a story: if event $A$ is ordered before event $B$, $B$ may not occur until $A$ has occurred in the story (symbolically, we notate this as $A \prec B$)
- Mutual exclusions: These are bidirectional edges of the graph. They indicate situations where two events cannot take place in the same story (symbolically, we notate this as $A \otimes B$). Practically speaking, mutual exclusions result in story branches.

Additionally, plot nodes can be *optional*—they do not need to occur in a story— or *conditional*—they only occur if a linked optional event does not occur first. When $A \prec B$, we call $A$ a *parent* of $B$ and $B$ a *child* of $A$. The transitive enclosure of the parent relation is the *ancestor* relation and the transitive closure of the child relation is the *descendant* relation.

A story generated from a plot graph is a sequence of events that obeys all of the constraints given by the temporal orderings and mutual exclusions. In Fig. 1, legal stories for the left plot graph are:

**Fig. 1.** Two plot graphs. Solid, directional arrows correspond to temporal orderings and dashed lines correspond to mutual exclusions.

- C1, C2, C3, C4
- C1, C3, C2, C4

The mutual exclusion in the right plot graph constrains the space of legal stories:

- C1, C2, C4
- C1, C3, C4

Fig. 2 is an example of a plot graph showing the procedure for going to a fast-food restaurant.

## 4    Inference Drawing with Plot Graphs

The purpose of our system is to answer questions of the form: given a story in natural language and a relevant plot graph, what other events (called inferences) could also have occurred in the story, and how likely are each of these inferences? In other words, it fills in gaps in human-authored stories with events left out and lists probabilities of each of its results. This gap filling demonstrates story understanding because the story could contain as few as two events and check for a third in the set of generated inferences. Additionally, and unlike prior story understanding systems, we start from natural language inputs.

The next sections describe the three components of the inference algorithm: (1) Matching input sentences with event nodes in the graph; (2) finding all candidate inferences to be drawn based on the matches; and (3) determining the confidence in each of those inferences.

### 4.1    Plot Event Matching

Our system first attempts to find matches between input sentences and event nodes in the plot graph. Each event node is composed of multiple sentences, so we select one representative sentence from each node to compare with the input sentences. Given sentence $X$ and sentence $Y$, our system needs a numerical representation for the semantic similarity between the two. Our system employs

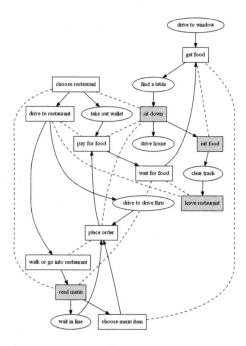

**Fig. 2.** The plot graph describing a trip to a fast-food restaurant. Ovals and boxes are events (the white boxes are optional and the gray boxes are conditional). Solid lines are temporal relations and dashed lines are mutual exclusions.

the Stanford Parser [6] to find specific parts of speech to compare. Specifically, our system uses the parser to find the nouns and verbs of the sentence. It then uses a Word2Vec [7] model trained on the Google News corpus to produce word embeddings (vector representations) of the selected tokens. From there, summation vectors are created from these Word2Vec vectors:

$$NounVector_X = \sum_{i=1}^{n_1} Noun_{X_i} \tag{1}$$

$$VerbVector_X = \sum_{i=1}^{n_2} Verb_{X_i} \tag{2}$$

where $Noun_X$ is the set of noun Word2Vec vectors from sentence $X$ and $n_1$ is the number of nouns in X, and $Verb_X$ is the set of verb Word2Vec vectors from sentence $X$ and $n_2$ is the number of verbs in $X$. With cumulative noun and verb vectors from both sentences, we can compute $NounSim$ and $VerbSim$ as the cosine similarity between $X$ and $Y$, resulting in numbers in the range $[-1.0, 1.0]$.

For our purposes, different parts of speech are more important to the meaning of the sentence than others. In a sentence describing an event, the verbs are the most important tokens to analyze, so we assign numerical weights $\alpha$ and $\beta$ to $NounSim$ and $VerbSim$ such that $\alpha + \beta = 1$:

$$Sim = \alpha * NounSim + \beta * VerbSim \qquad (3)$$

We have assigned $\alpha = 0.4$ and $\beta = 0.6$ to give slightly stronger weight to verb similarity.

By comparing two sentences this way, we are left with a single scalar value. However, every sentence will match to every other sentence with some similarity. By comparing the scalar against an empirically determined threshold, the system is able to filter out false matches. For our purposes, a threshold value of $\gamma = 0.6$ performs adequately. If one input sentence matches (with similarity above $\gamma$) with multiple event nodes in the plot graph, we select the top match. Multiple event nodes may have an equal highest match to an input sentence, in which case the following steps are performed with each top match.

## 4.2   Locating Candidate Inferences

At this stage, our system has a list of event nodes, $E$, that were matched with sentences from the input story. The system then begins searching for candidate inferences in the plot graph.

For every pair of events $a$ and $b$ contained in $E$, our system records all other events in the graph that can occur after $a$ and before $b$. This list, $I_{ab}$, represents possible inferences that can be drawn from information contained in $a$ and $b$. Our system must then assign a confidence measure to these inferences. Given a single inference $I_{ab_i}$, our system employs the following heuristics to determine how likely that inference is correct given $a$ and $b$:

1. If $I_{ab_i}$ is an ancestor of $b$, then $I_{ab_i}$ is guaranteed to have occurred unless $I_{ab_i}$ is mutually excluded with another possible parent of $b$. If the latter is the case, the probability is inversely proportional to the number of parents mutually exclusive with $I_{ab_i}$.
2. Otherwise, if there are no temporal orderings between $a$ and $I_{ab_i}$, $I_{ab_i}$ has a very high chance of occurring, since it can be inserted anywhere into the story without consequence, unless a mutual exclusion prevents it.
3. Otherwise, if $a$ is a parent of $I_{ab_i}$, the likelihood of $I_{ab_i}$ being selected is inversely proportional to the distance between $a$ and $I_{ab_i}$, since additional mutual exclusion constraints reduce the probability of an event being selected.

Finding nodes' ancestors and successors is performed with breadth-first search on the graph of temporal links.

In case multiple heuristics apply for the inference, the one highest on the list is selected. Depending on which heuristic is selected for $I_{ab_i}$, the inference is given confidence according to a confidence category (since assigning specific numerical values is difficult with such limited information). These confidence categories are given numerical intervals ahead of time; for example, an inference that falls under the conditions of heuristic 3 might be determined to have a "Near 50 % confidence". The complete list is given in Table 1.

**Table 1.** List of confidence categories and their confidence intervals.

| Confidence category | Confidence interval |
|---|---|
| 100 % confidence | [1.00, 1.00] |
| High confidence | [0.7, 1.00] |
| Near 50 % confidence | [0.3, 0.7) |
| Low confidence | [0.0, 0.3) |

## 4.3 Arriving at an Answer

The above approach produces sets of "local" inferences, but does not consider the larger scope of the story. An inference drawn from two events in the input story might be disproven by evidence given by another set of matches. For example, upon hearing that "John loves Sally" and "John treated Sally to dinner", a reasonable inference might be that "John and Sally are married," but if we learn that "John took Sally to the vet", our original inference should be discarded. To remove globally inconsistent references, we must also compute all "impossible" inferences from each match and compare those with candidate inferences from other pairs. We can accomplish this by looking at the mutual exclusions of every event match.

We first consolidate all of the inference sets $I_{ab}$ into one larger set:

$$I_{candidate} = \bigcup I_i \qquad (4)$$

where $I_i$ is the $i$th event pair and $I_{candidate}$ is the resulting superset. If two equivalent inferences get merged in the set union, the higher confidence measure is kept. We then can consolidate all of the learned "impossible" events by performing set union:

$$I_{impossible} = \bigcup MutExc_i \qquad (5)$$

where $MutExc_i$ is the set of mutually exclusive events with event $E_i$ in the matched event set. Finally, the set of legal inferences is given as the set subtraction of the impossible inferences from the candidate inferences:

$$I_{final} = I_{candidate} - I_{impossible} \qquad (6)$$

To determine the probability of event $e_q$ one merely has to look up the confidence interval of the event in $I_{final}$.

## 5 Evaluation

The motivation for using plot graphs was to harness the power of crowdsourced knowledge engineering for use in story understanding. Without our inference technique, the only known way to produce inferences with plot graphs is to perform an exhaustive search. This brute-force story understanding method is

computationally inefficient (considering that the number of possible stories from a single plot graph is, in the worst case, proportional to $n!$, where $n$ is the number of event nodes in the graph) but completely captures the information of the plot graph. For the purposes of this evaluation, we treat the results of this method as ground-truth. We thus evaluate our system's inference algorithm's complexity and accuracy against the brute-force baseline. We do not include the similarity matching in the evaluation to control for variance in human-written sentences.

For these evaluations, we test on two crowdsourced plot graphs: one graph describing a restaurant scenario (shown in Fig. 2) and one truncated graph describing a bank robbery. Both plot graphs were generated using the data and algorithms from [4]. It can produce 21,016 unique trajectories (stories). The bank robbery plot graph had six event nodes and all related links manually removed from it to produce a simplified version for tractability purposes in evaluation. It was found to be intractable to generate all stories for the unmodified bank robbery plot graph, which had 34 nodes and could produce over 30 million unique stories. The modified plot graph can produce 127,116 unique trajectories.

In this section, we first provide a description of the brute-force method, follow with an analysis of the computational complexities of our inference method and the brute-force baseline, and conclude with analysis on the inference method's accuracy with respect to the brute-force baseline.

## 5.1   Brute-Force Baseline

This method provides an exhaustive answer to the following question:

> Given events $e_1...e_n$, what is the probability of event $e_i$, with $e_i \notin \{e_1...e_n\}$, also having occurred?

The answer is determined by generating all possible stories in the plot graph containing $e_1...e_n$ and counting the frequency of $e_i$ in-between $e_1$ and $e_n$ (since we are not concerned with what occurs before or after the story). We can break down this method as follows:

1. Generate all possible stories from the plot graph.
2. Find the set of all stories, $E_n$, that contain each event $e_1...e_n$.
3. Count the number of stories within $E_n$ that contain $e_i$ in-between them and then divide by $\|E_n\|$ to obtain a relative frequency.

## 5.2   Complexity Analysis

Both the brute-force method's and the inference method's complexity depend on four factors:

1. The set of events in the plot graph, $N$, with size $n$
2. The set of temporal links in the plot graph, $L$, with size $l$
3. The set of mutual exclusions in the plot graph, $M$, with size $m$
4. The set of events in the input story, $S$, with size $s$

Below we describe how computational complexity of the method is affected by these steps.

**Brute-Force Runtime Complexity.** The majority of the complexity of this algorithm comes from generating all possible stories from the plot graph. The complexity is directly proportional to the number of stories to be generated. The worst-case number of stories represented by a plot graph is $\mathcal{O}(n!)$, since legal stories are permutations of each event in the plot graph. The mutual exclusions and temporal orderings place additional constraints on this worse-case scenario.

It is difficult to compute an average-case complexity with $l$ temporal links, since the exact configuration of links affects the graph structure differently; subsets of nodes can be arranged in sequence reducing the number of story permutations, or in trees increasing the number of story permutations. Determining the number of legal stories is equivalent to finding the number of topological sortings of a partial order graph (which, in itself, is equivalent to counting the number of linear extensions of a partial-ordered set), which has been shown to be a $\sharp P$-complete problem [1]. The effect of the number and placement of edges is unknown, but we denote it as $f(n, l)$.

Analyzing the effect of mutual exclusions is an easier problem. A single mutual exclusion causes branching in the plot graph. If we treat this as partitioning the graph, we can approximate the number of stories and thus the complexity of generating all stories as:

$$Complexity \approx \mathcal{O}(f(n, l) * (n - m)!) \qquad (7)$$

which is at best $\sharp P$-complete and at worst factorial. The remainder of the algorithm's runtime is eclipsed by the generation step; subsequent steps of the brute-force baseline technique pertain mostly to scanning over the set of all possible stories.

**Inference Algorithm's Complexity.** To reiterate, the main steps in our system's inference algorithm are as follows: (1) match input events with event nodes in the graph, (2) find all candidate inferences to be drawn based on the matches, (3) determine the confidence in each of those inferences, and (4) provide global analysis of the local inferences. We address each of these complexities separately.

The first step is of $\mathcal{O}(n * s)$ complexity, where $s$ is the number of input sentences, since $s$ story events are compared against every node in the plot graph. The second step requires lookup in the table of mutual exclusions, resulting in complexity $\mathcal{O}(m)$. The complexity required for the third step depends on which heuristics are applied, but we can provide an upper bound. The most difficult heuristic to apply is Heuristic 3, wherein our system must attempt to find the shortest distance between two nodes guaranteed to be connected by temporal edges. Since this is accomplished with breadth-first search, this step has worst-case time complexity $\mathcal{O}(l+n)$. The final step, which involves set union and difference, depends on the number of event nodes and number of inference sets (which, in turn, depends on $s$), resulting in an upper-bound complexity of $\mathcal{O}(n * s)$.

Composing the individual complexities of these steps together, we get a final complexity of:

$$Complexity = \mathcal{O}(n * s + m + l) \tag{8}$$

Thus, our inference algorithm runs in linear time versus the brute-force baseline's $\sharp P$-complete or factorial time.

**Runtime Comparison.** In terms of runtime, there is a noticeable improvement over the brute-force method. In practice, when run on a standard desktop/laptop machine with an Intel Core i5-4200H CPU and 8.00 GB RAM, our system requires only around 1 % of the time required by the brute-force method on average, resulting in a 60x–100x increase in performance. This performance increase occurs in both plot graphs tested. This is important for conversational virtual agents where a user might expect a relatively quick response to a question that seems to the user to be trivial but it in fact computationally expensive.

If the brute-force method is allowed to perform the story generation step in advance and save data to disk, this improvement is less pronounced: our system performs only 0.5x–8x faster on average for the restaurant plot graph and 7x–20x faster for the bank robbery plot graph, but this still confirms our intuition that the brute-force's complexity grows rapidly with respect to the number of event nodes in the plot graph. When we consider that brute-force computation on large plot-graphs is likely to be intractable, this result is promising.

## 5.3   Accuracy Analysis

We randomly sampled 2000 legal stories from the fast-food and simplified bank robbery plot graphs and randomly removed events from each of them. We pit the brute-force baseline versus our system's inference algorithm to see how well each of them was able to correctly infer the removed events. We treat the brute-force method as the ground truth since it exhaustively iterates over all possible stories contained by the plot graph. Accuracy is determined by the coalignment between both method's results. Specifically, the brute-force method will return a value between 0 and 1 which indicates the relative frequency of each removed event: this value is compared against the numerical interval associated with our system's inferences' confidence categories. Accuracy is computed as the percentage of times our inference technique agrees with the brute-force technique as to which confidence interval an event belongs to over the 2000 trials.

**Table 2.** Results of evaluation with two plot graphs.

| Plot graph | Graph size (# Nodes) | Accuracy | # of Brute-force string matches | # of Heuristic string matches |
|---|---|---|---|---|
| Restaurant | 19 | 0.7395 | 430,931,917 | 54,060,547 |
| Bank robbery | 28 | 0.6980 | 5,705,264,000 | 285,024,000 |

Table 2 displays the results from the accuracy evaluation. With four likelihood classes, a random baseline would achieve 25 %. When evaluating the brute-force method, we had cached the complete list of stories in advance, so the number of computations only pertains to those done with string matching. The number of brute-force computations thus describes the number of string matching operations. The number of computations in the inference method relates to the number of heuristics called. Specifically, since each of the implementations of the heuristics relies on finding nodes in the graph, the number of computations in the inference method is equal to the number of nodes examined in breadth-first search.

The accuracy decreases slightly when the size of the graph increases, but this is expected since the complexity of the graph increases vastly with insertion of event nodes. This accuracy can be improved by developing more intelligent heuristics. Importantly, our inference method outperforms the brute-force method in speed by a factor of ten with only a 30 % tradeoff in accuracy.

# 6    Conclusions

Story understanding systems have previously relied on hand-built knowledge-bases or models, making their utility constrained by the ability of human authors to hard-code scripts or commonsense knowledge bases. Plot graphs learned from crowdsourcing provides a means of acquiring commonsense procedural knowledge for story understanding. Plot graphs compactly encode a space of possible stories about a given situation, but exhaustively searching this space in order to make question-answering inferences can be intractable. Our heuristic technique makes question-answering inferences from plot graphs without the extensive computation, reducing the runtime by a scale of 10x–100x for only a 30 % tradeoff in total accuracy. We take the additional step of performing question-answering about stories that are provided in natural language as a means of bringing story understanding closer to real world applications such as virtual agents and chat bots. Our story understanding system is the first of its kind to rely on crowd-sourced story knowledge instead of human-authored knowledge-bases, increasing the potential for understanding of a large range of story scenarios in real time.

**Acknowledgements.** This material is based upon work supported by the National Science Foundation under Grant No. IIS-1350339. Any opinions, findings, and conclusions or recommendations expressed in this material are those of the author(s) and do not necessarily reflect the views of the National Science Foundation.

# References

1. Brightwell, G., Winkler, P.: Counting linear extensions. Order **8**(3), 225–242 (1991)
2. Cardona-Rivera, R., Price, T., Winer, D., Young, R.M.: Question answering in the context of stories generated by computers. Adv. Cogn. Syst. **4**, 227–245 (2016)
3. Cullingford, R.: SAM and micro SAM. In: Schank, R., Riesbeck, C. (eds.) Inside Computer Understanding, Erlbaum (1981)

4. Li, B., Lee-Urban, S., Johnston, G., Riedl, M.O.: Story generation with crowd-sourced plot graphs. In: Proceedings of the 27th AAAI Conference on Artificial Intelligence, Bellevue, Washington, July 2013

5. Li, B., Thakkar, M., Wang, Y., Riedl, M.O.: Data-driven storytelling agents with adjustable personal traits and sentiments. In: Proceedings of the 7th International Conference on Interactive Digital Storytelling (2014)

6. de Marneffe, M.C., MacCartney, B., Manning, C.: Generating typed dependency parses from phrase structure parses. In: Proceedings of the 5th International Conference on Language Resources and Evaluation (2006)

7. Mikolov, T., Sutskever, I., Chen, K., Corrado, G.S., Dean, J.: Distributed representations of words and phrases and their compositionality. In: Burges, C.J.C., Bottou, L., Welling, M., Ghahramani, Z., Weinberger, K.Q. (eds.) Advances in Neural Information Processing Systems, vol. 26, pp. 3111–3119. Curran Associates, Inc., New York (2013)

8. Mueller, E.: Understanding script-based stories using commonsense reasoning. Cogn. Syst. Res. **5**(4), 307–340 (2004)

9. Ram, A.: AQUA: questions that drive the explanation process. In: Schank, R., Kass, A., Riesbeck, C. (eds.) Inside Case-Based Explanation, Erlbaum (1994)

10. Weston, J., Chopra, S., Bordes, A.: Memory networks. In: Proceedings of the 2015 International Conference on Learning Representations (2015)

11. Wilensky, R.: PAM and micro PAM. In: Schank, R., Riesbeck, C. (eds.) Inside Computer Understanding. Erlbaum (1981)

# Using BDI to Model Players Behaviour in an Interactive Fiction Game

Jessica Rivera-Villicana[1(✉)], Fabio Zambetta[1(✉)], James Harland[1],
and Marsha Berry[2]

[1] School of Science, RMIT University, Melbourne, VIC, Australia
{jessica.riveravillicana,fabio.zambetta,james.harland}@rmit.edu.au
[2] School of Media and Communication, RMIT University, Melbourne, VIC, Australia
marsha.berry@rmit.edu.au

**Abstract.** Player Modelling is one of the challenges in Interactive Narratives (INs), where a precise representation of the players mental state is needed to provide a personalised experience. However, how to represent the interaction of the player with the game to make the appropriate decision in the story is still an open question. In this paper, we aim to bridge this gap identifying the information needed to capture the behaviour of players in an IN using the Belief-Desire-Intention (BDI) model of agency. We present a BDI design method to mimic the interaction of players with a simplified version of the Interactive Fiction Anchorhead. Our preliminary results show that a BDI agent based on our player model is able to generate game traces more similar to humans than optimal traces.

**Keywords:** Intelligent narrative technologies · User modelling · Player Modelling · BDI · Interactive Narratives · Interactive Fiction

## 1 Introduction

Interactive Narratives (INs) have long been popular in computer games, delivering non-linear stories, so that players can affect the direction of the narrative with their actions. Titles such as Heavy Rain [16], The Elder Scrolls [2] and The Witcher [4] implement this technique. However, the task of writing every branch of the story becomes more expensive as the author wants to give more freedom to the player, because the number of different sub-stories that need to be written increases significantly [18].

To address this issue, research in *Narrative Generation*[1] aims to automatically generate the story tree with all its possibilities given a *plot graph* that contains a set of conditions established by the author in order to ensure the coherence of the story. These conditions include precedence of events and status of the main character, among other elements [18]. The variety of skills and preferences among players raises the need to provide a tailored experience making

---

[1] Also referred to as *Story Generation* [8].

© Springer International Publishing AG 2016
F. Nack and A.S. Gordon (Eds.): ICIDS 2016, LNCS 10045, pp. 209–220, 2016.
DOI: 10.1007/978-3-319-48279-8_19

use of Player Modelling (PM) [22]. While it can be used to adapt the speed of objects or level of difficulty in some games, PM can be used in INs to predict the "story branch" to be discovered by a player. This information can be used by a Drama Manager to guide each player towards a story that maximises the kind of interactions they enjoy.

We propose a PM using the Belief-Desire-Intention model of agency, a model commonly used in Agent Programming (e.g., Non-Player Characters [12]) that is based on a model of human practical reasoning [3]. By using a model that is applicable to both the real and virtual worlds, we expect to have a player model that gives us a preliminary insight into how each player discovers a specific branch of an IN.

In this paper, our aim is to design a Belief-Desire-Intention (BDI) Player Model that captures the way players interact with an Interactive Narrative (IN). We will explain the difference between the usual BDI design, where the possible states of the world are usually known by the agent, and our design to model a player with an IN. Our contribution is a BDI design that results into an agent whose goal is not an optimal solution (in our case, the resulting trace to finish the game), since our preliminary study shows that a player's interaction with this IN is unlikely to be optimal.

The IN we use to develop this work is an extract of the Interactive Fiction "Anchorhead". This same extract has been previously used by other researchers because it captures the main structure of an IN in a relatively short game [11,19].

## 2 Background

In this section we define the concepts related to this research project, such as Interactive Narratives, Player Modelling and BDI Agents. We then introduce the interactive fiction Anchorhead and its dynamics.

### 2.1 Interactive Narratives

An Interactive Narrative (IN) is a form of storytelling where the listener (reader, player or user) is given freedom to affect the direction of the story by choosing which actions to take at different *plot points* [18]. Some examples of INs are the "Choose your own adventure" books, hypertexts, or Interactive Fictions (text-based adventure games) such as Anchorhead, described later in this section. We have recently seen INs in AAA video games such as those mentioned in Sect. 1. Some of the appeal of these games lies in their re-playability and the freedom they offer to affect the environment in which they are immersed (known as *player agency* [9]), while still enjoying a good narrative arc planned by the author.

Games with INs may use an entity called Drama Manager (DM) to drive the experience and deal with the *boundary problem* [7], i.e., to balance player agency with the author's intended outcome. The DM should possess intelligence to make decisions as a surrogate of the author, or a game master, but for this, it is necessary to have a proper representation of the story that captures the

author's intent and allows for the DM to adjust the story in real time depending on the player's actions [17]. A way to represent an IN is a plot graph (see Fig. 2), which is a directed, acyclic graph, where the nodes represent important plot points, and the arcs represent order constraints defined by the author to ensure the quality of the story unfolded by the player [15].

A DM can use a Player Modelling module to capture knowledge about the current interaction of each user with the game; knowing the right information about a player would help to choose the best branch of the story when more than one is available.

## 2.2  The BDI Model of Agency

An Intelligent Agent is defined as "A computer system that is situated in some environment, and that is capable of autonomous action in its environment to meet its design objectives" [21]. We previously introduced the term *player agency* as the freedom of a player to affect the outcome of a game with his/her actions. Thus, we can represent a player as an Intelligent Agent, because he/she is situated in a virtual environment (the game) and is capable of performing autonomous actions to meet his/her objectives. We aim to represent this player agency in terms of Beliefs, Desires and Intentions, given the theory that human behaviour can be understood with these mental properties [5].

The Belief-Desire-Intention (BDI) model is a framework commonly used to build Intelligent Agent Systems [14] based on the model of practical reasoning developed by Bratman [3]. The philosophy behind this model is that humans interact with their environment using three main characteristics: A set of *beliefs* composed by the information sensed about the environment, a set of *desires* that constitute the motivational aspect of reasoning (i.e., the goals that will drive our behaviour) and a set of *intentions*, a selection of plans to achieve our current goals given our current beliefs.

## 2.3  Anchorhead

Anchorhead is a Lovecraftian Interactive Fiction written by Michael S. Gentry in 1998. The story takes place in the fictional town of Anchorhead, where the protagonist and her husband, Michael, move into because they inherited a mansion from Michael's distant family. The previous owner of the house, Edward Verlac, killed his family and committed suicide. From this point, the player needs to explore the world by visiting places, observing objects, talking to characters, etc. to find out the truth behind the Verlac family. The original story is divided into five days, with over one hundred relevant plot-points as stated by Nelson et al. [10]. In this project, we use only the second day, identified by these same authors and used in player modelling research before [19]. In our sub-plot, the player can reach two possible endings, identified with bold frames in Fig. 2.

## 3   Related Work

In this section, we present a survey of work in Player Modelling for Interactive Narratives.

The work in PaSSAGE [20] is an attempt to predict the players actions and intentions, with the objective to adjust the story presented to the player based on the model created. This model is built assigning weights for each of the play styles defined by the authors (based on the definitions by Robin Laws [6]). The style with the higher weight represents the style the player is most likely to prefer. These style weights are updated with every action of the player. PaSSAGE bases the selection of the next story "encounter" on a player model that is built and updated during play time. However, the main focus of this work is in the decision-making process to shape the story. Our research, in contrast, focuses on the process of building and updating the player model.

Yu and Riedl use a Prefix Based Collaborative Filtering algorithm based on users feedback to generate an optimal story according to the users preferences [24]. They assume that players with the same preferences in the past will be likely to share them again in the future. They test their approach with Choose Your Own Adventure stories with real and simulated users, reporting positive results about the accuracy of the algorithm to generate user-specific stories.

Sharma et al. use Case Based Reasoning to build a player model on the Interactive Fiction Anchorhead [19]. The player model is able to predict the players preferences based on feedback provided by them at the end of a game about different plot points. The evaluation showed different aspects of why Player Modelling is relevant in Drama Management. For example, the Drama Manager is able to help inexperienced players guiding them through the game in a different way (if actually needed) than experienced players. The authors also mention the need for a more accurate Player Model, that captures the different preferences each player may have.

The work mentioned focuses on using players characteristics to help the Drama Manager decide which plot-point to deliver based on the Player Model. Our work, in contrast, focuses on building a Player Model that will be able to generate a similar game trace to that generated by a specific real player. We consider that before making decisions that will affect a players experience in a game, we should be able to understand their behaviour.

Another interesting approach is using Plan Recognition to model players [23]. However, this work assumes that players act aiming for the optimal game solution. As the authors mention, this assumption is a limitation of the approach, as this is not true for all players. Our work in contrast, assumes that players in INs are unlikely to play optimally, and our design tries to replicate this sub-optimal behaviour.

## 4   Methodology

This initial work focuses on designing a BDI model of IN players that captures human behaviour in general. Our aim in future work is to use player-specific

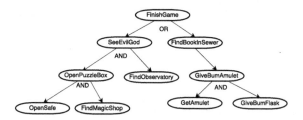

**Fig. 1.** A basic goal tree design following the Prometheus methodology

information in order to perform predictions during play time with the player model. In this paper, however, we focus on capturing players interaction with the game and observe if we can generate human-like traces using this "uninformed" model. The main contribution of this work lies in the assumption that the way we would design an accurate player model is different than the way we would design a normal "bot" or artificial player. If our aim was to create an optimal BDI artificial player for an IN, in this case Anchorhead, the way to do it according to the Prometheus Methodology [14] would be to take the plot graph of the IN and turn it into a goal tree. Figure 1 shows how a basic goal-plan tree of the BDI agent would look like. However, this design assumes that the player knows what to aim for since the beginning of the game. For example, an agent based on this design would go after the combination for the safe, knowing that this is the first step to reach one of the ends.

The resulting game trace of such agent would be much shorter in comparison with that of a real player, and it will unlikely contain plot points from the other branch. This is an unlikely behaviour in real players, unless they know the game and have played it previously. We have observed that players without prior knowledge are usually lost at the beginning, exploring the places and trying to figure out what the goals are. The resulting trace is then much larger than the optimal, with interactions with plot-points from both story branches. In this section, we explain our BDI design approach based on the premise that players do not interact with an IN in an optimal way, but they rather explore the world, and as they do so, they discover and prioritize their goals, until they eventually complete the game.

We have two executable versions of Anchorhead, using code from previous research with the authors permission [13]. The first version is a socket-based modification of the original that communicates with our BDI Agent through XML messages. Our second version of the game is mostly the original 2D interface. This version was used to collect data from real players. We added a login interface that creates one anonymous account per player, providing an auto-generated user name, and allows the players to create a password to login in the future if they wish to play more than once. The original logging feature was modified to print a summary of the game at the end of each trace file. This summary was composed only by plot-points of the story, in the order in which the player reached them. Figure 2 shows the plot graph of the story of Anchorhead

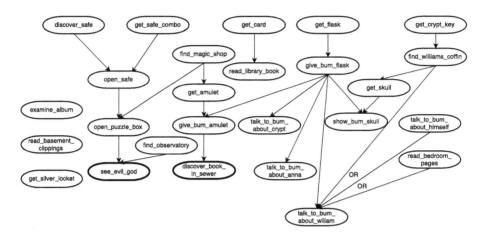

**Fig. 2.** Plot graph of Anchorhead's second day

we used. In the figure, where not specified, all the arcs leading to the same node are joined by an AND operator, meaning that all the previous plot-points or conditions must be met in order to reach the plot point that they point to. The plot-points with bold borders are the possible ends of the story.

### 4.1  BDI Player Model

To design our BDI Model, we followed the Prometheus methodology [14] and implemented an agent using the version 3.0 of Jadex [1]. We used goal diagrams to define the players behaviour. This behaviour can be represented similarly with other methods such as Behaviour Trees or Hierarchical Task Networks. The reasons why we use goal diagrams are (1) They are the representation method described in the Prometheus methodology and (2) We consider them easier to understand for people from areas different than Computer Science.

### 4.2  Plot Graph vs. BDI Goal Tree

We presented in Fig. 1 how we would design a goal-plan tree for a BDI agent with the aim of completing the game in an optimal way, meaning that the resulting agent will be aware of its goals from the beginning. However, a real player is not fully, if at all, informed about the objectives within an Interactive Narrative (IN), as opposed to other genres such as board games or sports. In INs, the goal is not to win or lose, but to complete the game, and the way one player reaches the end is different from others. This means that we cannot assume any "general rules" to identify how players will behave throughout the game.

Since our aim is not to create an optimal player, but replicating real players understanding and interaction with the IN, we were led to re-think our design of the BDI model, still taking as a base the Prometheus Methodology. As a result,

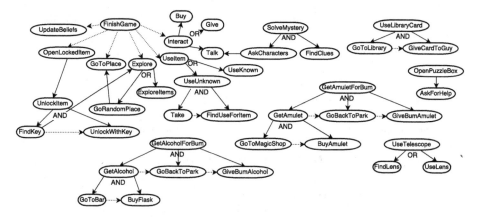

**Fig. 3.** The goal diagram of our BDI design

instead of having one single goal tree with a top level goal, we designed several scattered goal trees that might interact or run concurrently as players define their goals. Figure 3 shows the set of goal trees in the BDI Player Model.

Regarding the deliberation process, we identified four main factors that define the resulting behaviour of an agent implementing this model. These factors are applicable on INs where the player needs to move between places and interact with objects, as well as characters. The first factor (Goal priorities) was devised by observing all the traces collected from our recruits. In this case, we considered complete and incomplete traces, as we focus in identifying the information that triggers a goal or sub-goal and how players in general try to achieve them. After implementing the goal diagram in Jadex, we compared the traces generated by the BDI agent with those by real players, we investigated the possible reasons that made them different from each other and we identified the last three factors in the following list:

– **Goal Priorities:** As mentioned before, we consider that a player in this kind of IN will perform more exploratory actions at the beginning of the game. As such player discovers more elements and story constraints, they will commit to certain goals. We replicated this behaviour in the player model, in such a way that the exploratory goals have a lesser priority than the goals triggered to solve quests. For example, if the agent discovers a key, and later on, a locked door, the goal to open such door will be triggered. While the agent will still continue exploring, the task of opening the door will have priority depending on whether the agent has the key in its inventory. If the key's existence is known but not in the inventory, the agent will try to go to its location and take it to then open the door.
– **Navigation:** At this stage, the movement module is quite basic; whenever the agent needs to reach a place as part of another goal (or just to explore the world), it randomly selects one of the available locations to go and moves there until the current location and the destination are the same. The only

heuristic used in this module is to give priority to the locations that haven't been visited yet.

– **Action selection when Idle:** If there are no achievable goals in the current state, the agent will send the "explore" command, and see if there are objects that have not been examined or discovered as a first choice. Otherwise, the agent will randomly move to a different room.

– **Decisions about objects:** By default, the agent will pick any key found in the environment. When finding a new element, the agent will automatically analyse it. If the element is a door or container, and can be opened or unlocked, the goal unlock will be triggered for that element. Any element found inside a locked or closed container will be taken. The agent will not try to pick or interact with any other type of element (e.g. a clock), unless the game indicates that such object is needed (for instance, a character asks for it).

## 5   Evaluation

We compared the traces collected from real players with traces generated by an agent based on our Player Model. There was no specific requirement to recruit players, as we aim to model people in general who wants to play this genre (INs). From 22 subjects participating in the experiment, only 9 managed to complete the game, and one of them re-played it, discovering both game ends. From the 13 remaining subjects, we discarded 7 traces which had 3 or less commands issued and did not reach any plot-point. Other 6 traces indicate that the subjects gave up after they spent a substantial amount of time playing, discovering at least 10 plot-points.

In the following evaluation, we only consider the 10 complete traces, since the traces generated by the agent are all complete and we compare them to optimal traces (those with the minimum number of plot points needed to reach one end). We ran 20 games using the BDI agent to compare the resulting plot-point summaries with those of real players. Instead of running the agent the same amount of times as our number of real user traces (10), we decided to have twice the data for two main reasons: First, because the behaviour of the BDI agent is not deterministic and it generates different traces in each run; we considered the need for more data to compare its performance with a real human's behaviour. Second, while running the first 10 iterations with the agent, we noticed that it only reached the second end once (*discover-book-in-sewer*). This behaviour will be explained later in this section, but in order to confirm this pattern, we decided to collect twice as many traces from the agent than for real players.

The first matter to discuss is how human-like the generated trace of our BDI agent looks. As we mentioned in Sect. 4.2, we are not looking to generate a perfect trace where the agent knows how that seeing the evil god in the observatory will lead to completing the game, and then obtain a clean trace summary like the following:

*[get-safe-combo, open-safe, find-magic-shop, open-puzzle-box, see-evil-god]*

**Table 1.** Average plot-point count and end frequencies of users vs. agent.

| Trace type | Average p-p count | End1 frequency | End2 frequency |
|---|---|---|---|
| Users | 16.6 | 50 % | 50 % |
| Agent | 14.9 | 90 % | 10 % |

**Table 2.** Comparison of plot-point counts for each end.

| End | Optimal trace | User average | Agent average |
|---|---|---|---|
| End1 | 5 | 10.2 | 14.3 |
| End2 | 14 | 23 | 20 |

In this trace, every single plot-point is followed by exactly its successor in a plot branch. On the other hand, the following is the summary generated by a human:

*[examine-album, get-card, get-crypt-key, get-silver-locket, read-bedroom-pages, read-basement-clippings, find-williams-coffin, see-skull, get-skull, find-magic-shop, get-library-book, get-amulet, buy-magic-ball, open-safe, get-safe-combo, open-puzzle-box, see-evil-god]*

Lastly, the following is a summary trace generated by the BDI agent:

*[find-magic-shop, start-talking-to-bum, get-crypt-key, read-basement-clippings, read-bedroom-pages, get-card, get-safe-combo, open-safe, examine-album, get-flask, give-bum-flask, ask-bum-about-william, show-bum-skull, ask-bum-about-crypt, open-puzzle-box, see-evil-god]*

The three examples reach the same end. But we can see how the real human trace and the model generated trace are considerably longer than the optimal trace presented first. However, it does not contain all the plot points in the game. We aim to evaluate whether the BDI model can resemble this reasoning by discovering a similar number of plot points. Table 1 shows the average number of plot-points and the frequency of each of the two possible endings, comparing the real user traces and the agent traces. The results show that the average plot-point count of the agent is slightly below its equivalent for real users. This can be explained by the fact that the agent tends to reach the first ending 90 % of the time, and as Table 2 shows, the optimal number of plot-points needed to reach the first ending is much less than that to reach the second ending.

The agent reaches the see-evil-god ending 18 out of 20 times. This is a consequence of the need for more interaction with characters to unfold this ending, as well as going back and forth between places such as the park and the bar in order to get the bottle of alcohol requested by the bum and get him to reveal the secrets. Even after doing this, it is necessary to buy an amulet from the magic shop and bring it back to the bum to unlock the plot-point where a book can be found in the sewers, leading to the second end of the story. Given the current design of the Player Model, it is understandable that by moving almost randomly, the agent will be less likely to bring back the items requested by the bum even when the goals are being prioritized.

Since we noticed that the plot-point (p-p) count needed to achieve the two endings are considerably different, we report in Table 2 the minimum plot-points required for each ending (generating an "optimal trace") for *End1* = "see-evil-god" and *End2* = "discover-book-in-sewer". If we compare the p-p count in an

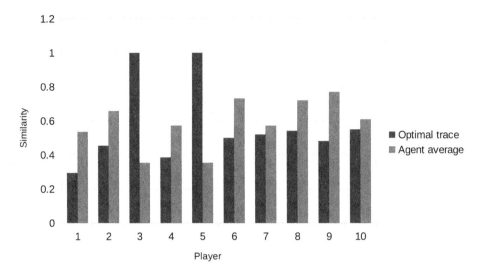

**Fig. 4.** Similarity between optimal traces and agent traces compared to real player traces

optimal trace versus the average p-p count for real users and the agent, we can observe that the agent and user counts are more similar to each other than they are to the optimal trace.

Another way to evaluate our player model is observing how similar the traces generated by the agent are to those generated by real players. Given the nature of INs, it is very unlikely to find two traces with exactly the same number of plot-points and the same sequence. However, we could consider two traces as similar if they share the same plot-points regardless of their order in each trace. This would mean that both traces revealed the same story branch of the game, but in different order. Also, since each complete trace can have an indefinite number of elements, we cannot assume that two given traces will have a similar length. For these reasons, we consider the Jaccard index the most appropriate way to measure the similarity between traces. The Jaccard index of two sets is defined as the cardinality of their intersection divided by the cardinality of their union, giving a result between 0 and 1. Figure 4 shows the similarity of the respective optimal trace and the average similarity of the traces generated by the BDI agent for that end. Both similarities are calculated with respect to each player trace. Players 1 to 5 reached the first ending, while players 6 to 10 reached the second ending.

Two users managed to generate the optimal trace for End1, making the similarity for that trace with the corresponding users 100 %, surpassing in only these instances the agent's average similarity with the players. An interesting note, except for the cases with 100 % similarity, is that all the agent scores are over 50 %. While the traces generated by our BDI design do not have a similarity beyond 80 %, most of them are more similar to the player traces than the optimal.

As for the two cases where the optimal traces are 100 % similar to the player traces, we believe that those players had previous knowledge about the game we used when doing the experiment. We aim to consider this factor in our future work to manage players who are familiar with the game.

## 6 Conclusions and Future Work

We have designed a BDI Player Model for the Interactive Fiction Anchorhead, showing that modelling a human player's interaction with an IN needs a different way to model goals, depending on the current information discovered by the player or agent. Our design method can be generalised to other INs by taking these facts into account. The preliminary results after trying to replicate real players traces shown in Sect. 5 show promise for this BDI approach to model real player behavior on Interactive Narratives.

As future work, we propose to improve the BDI Player Model by using a player profile to manage more accurately the goal priorities, navigation and selection of actions when idle or when finding new objects. We want to analyse whether our agent can generate more player-specific traces with this information about each player. We can either infer such profile from the traces we have collected or run new experiments and acquire the player profile through a questionnaire before starting the game. A questionnaire, besides giving us a different perspective to inform the Player Model, would give us the chance to analyse the self-representation of each player and how it varies depending on their experience or other factors. With this player-specific information, we can run a more strict similarity evaluation, perhaps considering the order of plotpoints in traces being compared besides their length. The downside of using a questionnaire is the intrusive nature of this method and the risk of collecting incorrect data, as some people might give unreliable answers to quickly move on to the game.

Finally, we observed that over half of the real player traces collected had to be discarded for our evaluation because they were not complete. We consider it worthwhile investigating the reasons why players decide to quit playing, as identifying these during a game might contribute to a better behaviour prediction. Considering the small sample size of the study presented in this paper, a good approach to identify such reasons is to use semi-structured interviews in addition to the quantitative data collected from users in future experiments.

## References

1. Active Components: Jadex (2016). https://www.activecomponents.org/bin/view/About/New+Home
2. Bethesda Game Studios: The Elder Scrolls (2014). http://www.elderscrolls.com/
3. Bratman, M.: Intention, Plans, and Practical Reason. Harvard University Press, Cambridge (1987)
4. CD Project RED: The Witcher (2016). www.thewitcher.com
5. Dennett, D.C.: The Intentional Stance. MIT press, Cambridge (1989)

6. Laws, R.D.: Robin's Laws of good Game Mastering. Steve Jackson Games, Austin (2002)
7. Magerko, B.: Evaluating preemptive story direction in the interactive drama architecture. J. Game Dev. **2**(3), 25–52 (2007)
8. Mateas, M., Stern, A.: Façade: an experiment in building a fully-realized interactive drama. In: Game Developers Conference, Game Design Track. vol. 2, p. 82 (2003)
9. Murray, J.H.: Hamlet on the Holodeck: The Future of Narrative in Cyberspace. The Free Press, New York (1997)
10. Nelson, M.J., Mateas, M.: Search-based drama management in the interactive fiction anchorhead. In: Proceedings of the First Annual Conference on Artificial Intelligence and Interactive Digital Entertainment, pp. 99–104 (2005)
11. Nelson, M., Mateas, M., Roberts, D., Isbell, C.: Declarative optimization-based drama management in interactive fiction. IEEE Comput. Graphics Appl. **26**(3), 32–41 (2006)
12. Norling, E., Sonenberg, L.: Creating interactive characters with BDI agents. In: Australian Workshop on Interactive Entertainment, p. 8 (2004)
13. Ontanon, S.: IFEngine (2015). https://www.cs.drexel.edu/santi/teaching/2012/CS680/IFEngine.html
14. Padgham, L., Winikoff, M.: Developing Intelligent Agent Systems: A Practical Guide. Wiley, Chichester (2005)
15. Porteous, J., Cavazza, M., Charles, F.: Applying planning to interactive storytelling: Narrative Control using state constraints. ACM Trans. Intell. Syst. Technol. **1**(2), 1–21 (2010)
16. Quantic Dream: Heavy Rain (2010). http://www.quanticdream.com/en/game/heavy-rain
17. Riedl, M.: Interactive narrative: a novel application of artificial intelligence for computer games. In: Proceedings of the Twenty-Sixth AAAI Conference on Artificial Intelligence. AAAI Press (2012)
18. Riedl, M.O., Bulitko, V.: Interactive narrative: an intelligent systems approach. AI Mag. **34**(1), 67–77 (2013)
19. Sharma, M., Ontanon, S., Mehta, M., Ram, A.: Drama management and player modeling for interactive fiction games. Comput. Intell. **26**(2), 183–211 (2010)
20. Thue, D., Bulitko, V., Spetch, M., Wasylishen, E.: Interactive storytelling: a player modelling approach. In: Schaeffer, J., Mateas, M. (eds.) Proceedings of the Third Artificial Intelligence and Interactive Digital Entertainment Conference. Lecture Notes in Computer Science, pp. 43–48. AAAI Press (2007)
21. Wooldridge, M.: An Introduction to MultiAgent Systems. Wiley, Hoboken (2002)
22. Yannakakis, G.N.: Game AI revisited. In: Proceedings of the 9th Conference on Computing Frontiers - CF 2012, p. 285. ACM Press (2012)
23. Young, R.M., Cardona-Rivera, R.: Approaching a player model of game story comprehension through affordance in interactive narrative. In: Intelligent Narrative Technologies (2011)
24. Yu, H., Riedl, M.O.: A sequential recommendation approach for interactive personalized story generation. In: Proceedings of the 11th International Conference on Autonomous Agents and Multiagent Systems, vol. 1, pp. 71–78. International Foundation for Autonomous Agents and Multiagent Systems (2012)

# Expressionist: An Authoring Tool for In-Game Text Generation

James Ryan$^{(\boxtimes)}$, Ethan Seither, Michael Mateas, and Noah Wardrip-Fruin

Expressive Intelligence Studio, University of California, Santa Cruz, Santa Cruz, USA
{jor,michaelm,nwf}@soe.ucsc.edu, eseither@ucsc.edu

**Abstract.** We present Expressionist, an authoring tool for in-game text generation that combines the raw generative power of context-free grammars (CFGs) with the expressive power of free-text markup. Specifically, authors use the tool to define CFGs whose nonterminal symbols may be annotated using arbitrary author-defined tagsets. Any content generated by the CFG comes packaged with explicit metadata in the form of the markup attributed to all the symbols that were expanded to produce the content. Expressionist has already been utilized in two released games and it is currently being used in two ongoing projects. In this paper, we describe the tool and discuss these usage examples in a series of case studies. Expressionist is planned for release in late 2016.

**Keywords:** Text generation · Authoring tools · Modular content · Grammars

## 1 Introduction

Why have so few completed works of interactive storytelling featured generative text? The dearth of examples is troubling, and especially so given the widely held belief that current authoring practice in interactive storytelling—in which individuals or teams of writers tirelessly produce huge amounts of static content by hand—is limiting the medium [13]. Elsewhere we have argued that previous approaches to this challenge that have employed conventional techniques from *natural language generation* (NLG), though important, have suggested a disturbing reality: full NLG pipelines are not yet ready for use in fully realized works of interactive storytelling [22]. A major reason for this is that NLG pipelines demand NLG expertise, but content authoring in interactive storytelling requires other kinds of expressive expertise—some may have command of all these skills, but NLG practitioners should not be the sole purveyors of generative text.

At the Expressive Intelligence Studio, we are working to democratize the practice of procedural text generation through the development of authoring tools that are intended for use by non-NLG practitioners. A particular such tool

© Springer International Publishing AG 2016
F. Nack and A.S. Gordon (Eds.): ICIDS 2016, LNCS 10045, pp. 221–233, 2016.
DOI: 10.1007/978-3-319-48279-8_20

is Expressionist, the subject of this paper, which is intended for *in-game* expressive text generation.[1] By this, we mean the generation of text at runtime that depends on the current game state and satisfies authorial goals. This could be in support of procedural dialogue interaction [11] or any other application involving content that is textual in composition (*e.g.*, storyworld artifacts). In designing and developing Expressionist, our core aim has been to produce an authoring environment that maximally utilizes two complementary strengths of humans and computers—humans' deep knowledge of natural-language expressivity (and all its attendant nuances), and a computer's capacity to efficiently operate over probabilities and large treelike control structures—while simultaneously minimizing both entities' huge deficiencies in the converse. In other words, we have strived to produce a configuration that holds humans responsible for things they are good at and not for things they are bad at, and likewise with computers.

Toward these aims, Expressionist combines the raw generative power of *context-free grammars* (CFGs), described in Sect. 2, with the expressive power of *free-text markup*. Specifically, authors specify CFGs whose symbols may be annotated using arbitrary author-defined tags, and all generated outputs elegantly accumulate all the markup attributed to the symbols that were expanded to produce them. The validity of this approach is demonstrated by the use of Expressionist in two released games, *Snapshot* [26] and *Project Perfect Citizen* [1], as well as two ongoing projects, all of which we discuss in Sect. 4. While the Expressionist authoring interface is currently being refined, we plan to publicly release the tool in late 2016.

## 2   Background and Related Work

Though preceded by related concepts in mathematics by Post and Thue, and in linguistics by the ancient Pāṇini, the *context-free grammar* (CFG) formalism was introduced by Noam Chomsky in his seminal work of the mid-1950s (see [2] for this history). CFGs are foundational in theories of natural and computer languages, and the formalism, in the form of *story grammars*, has a colorful history in the field of computational narrative (which is nicely recounted in Sect. 3.2 of [6]). There are three simple notions that are central to the CFG formalism: terminal symbols, nonterminal symbols, and production rules. A *terminal symbol* is simply a string, and a *nonterminal symbol* (or just *nonterminal*) is a symbol that is associated with one or more *production rules* by which the symbol can be *expanded* into a concatenation of other symbols, which may be either terminal or nonterminal (the latter of which will have their own production rules).

Expressionist's design is meant to instantiate the *modular content* approach put forward in [23], a notion that itself emerged from an earlier project in which we procedurally recombined existing *Prom Week* dialogue by annotating individual lines for how they could be resequenced and what they could express about the underlying system state [21]. While we appropriated an existing annotation

---

[1] We use the term 'game' here for brevity and convenience, but we more generally mean any work of interactive storytelling or playable media.

interface for this task, the project led us to envision an environment for specifying recombinable content that would be annotated *at the time of authoring*. This line of thinking eventually culminated in the design of Expressionist.

The particular utilization of *context-free grammars* (described in the next section) as Expressionist's resequencing method was influenced by a related tool called Tracery [5], which also utilizes them. Expressionist differs from Tracery in both its design goals and authoring features. Tracery is aimed at naive procedural authors who wish to generate standalone text by lightweight means—this is demonstrated by the success it has found in fueling generative Twitter bots [5], a task for which Expressionist would be overkill (since metadata is not needed when any generable output will suffice). Expressionist, on the other hand, is intended as a way of supporting the generation of content that satisfies *targeted requests* made by an external application, like a game. This difference manifests in terms of authoring features, where Expressionist diverges from Tracery by affording free-text markup. This allows generated content to accumulate associated metadata, which is necessary for satisfying targeted content requests and for coherently sequencing multiple units of generated content. For example, metadata is used in *Talk of the Town*, discussed below, to specify how generated lines of dialogue may precede and succeed one another in procedural conversations [20]. Using Tracery, such metadata would have to be injected into the symbol names themselves, which would quickly grow unwieldy.

In [19], we review the literature on text generation in games, so we will only summarize here. Early exploration in this young area utilized domain-specific languages [12] and full NLG pipelines [4,17], with the latter approach notably being employed in the *SpyFeet* prototype [16] and the commercially released *Bot Colony* [10]. As we articulate at length in [19], our approach is a considered reaction to full NLG pipelines that is intended to be more approachable and provide greater authorial control. In the interactive-fiction community, a number of bespoke methods have been employed [24], including *templated dialogue*, which is also used in projects like Curveship [15], Versu [7], and the LabLabLab trilogy [11]. By employing CFGs, Expressionist harnesses the superset generative power of template-based approaches, since a CFG defines a system of arbitrarily nested templated structures. By virtue of its markup affordance, Expressionist also provides more authorial control, for the reasons described above. In addition to Tracery and Expressionist, two other recent systems, *MKULTRA* [9] and Dunyazad [14], have employed grammar-based approaches. Instead of CFGs, these systems use variants of a definite-clause grammar. This allows for constraints (such as variable bindings) to flow downstream during the generation process, which in Expressionist can be handled by markup. A primary difference between our system and these is that Expressionist has a graphical authoring interface. Finally, SimpleNLG is another tool aimed at democratizing text generation [8], but one that is dedicated to facilitating realization details, like agreement and conjugation, rather than supporting broader expressive aims.

# 3   Expressionist

Expressionist is a tool for authoring CFGs whose generated content comes packaged with explicit metadata; it is designed to support live text generation in games and other interactive media. While its authoring interface is still being refined in terms of aesthetics and usability, Expressionist has already been used in multiple projects, including two completed games, as we discuss in Sect. 4. In this section, we describe the tool in detail.

## 3.1   Overview

Using Expressionist, an author specifies a CFG by defining its nonterminal symbols and the production rules that may work to produce terminal expansions. Crucially, nonterminal symbols may be annotated using arbitrary *tagsets* and *tags*, which are defined by the author; this is the core appeal of Expressionist, and the source of its expressive power. When a terminal expansion is produced in a CFG, it will have expanded a set of nonterminal symbols along the way. In Expressionist, such an expansion accumulates all of the markup that an author has attributed to the symbols in this set. This allows an author to modularly specify capsules that contain both symbolic markup (*e.g.*, a speech act, a character personality trait, a specific authorial goal) and the rules for producing variations of the linguistic expression of that markup. Appealingly, because it is inherited from expanded symbols during the generation process, markup does not have to be reduplicated at the level of terminal symbols. In addition to symbol annotation, Expressionist allows production rules to be assigned probabilities of being executed, which more specifically makes the structure authored using the tool a *probabilistic* CFG (which is another difference with Tracery).

## 3.2   Workflow

Expressionist is implemented as a web application that imports and exports authored CFGs, which are defined as JSON files. To begin an authoring session with the tool, the user navigates to the URL where it is hosted and either uploads an existing grammar or elects to start a new one. From here, the authoring interface, described in the next section, appears. Authoring takes the form of defining nonterminal symbols, production rules (and associated probabilities), tagsets, and tags, and attributing tags to nonterminal symbols. Additionally, the author may utilize a built-in expansion engine to generate terminal expansions of any nonterminal symbol (or the terminal results of executing any production rule) as a way of checking the quality of generable outputs. This *live feedback* feature critically utilizes the probabilities assigned to production rules and accumulates all markup attributed to nonterminal symbols. Finally, to conclude an authoring session, the user exports her work as an updated JSON file. To generate text from this CFG in-game, the author must first implement an expansion engine in the game code, as we discuss below in Sect. 3.4.

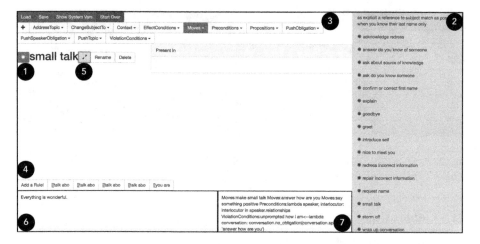

**Fig. 1.** An annotated screenshot of the current version of the expressionist authoring interface. See Sect. 3.3 for descriptions of each of the numbered elements.

### 3.3   Authoring Interface

An annotated screenshot of the current version of the Expressionist authoring interface is shown in Fig. 1. Briefly, we will describe each numbered element:

1. The *active nonterminal symbol* is the one that the author is currently working on. The asterisk icon on the left may be selected to *favorite* the symbol.
2. All of the authored nonterminal symbols in a CFG appear in a scrolling menu on the right. Symbols for which no production rules have been defined appear in red, while expandable ones are displayed in green. Within the list of expandable symbols, favorited symbols are sorted to the top. The user may click on any symbol to make it the active nonterminal symbol. Additionally, new symbols may be defined by clicking an icon at the bottom of the list.
3. Each of these dropdown menus represents an individual tagset that the author has defined. When a tagset is clicked on, the menu expands to display the individual tags that the user has defined for the set. The user may then attribute one or more of these tags to the active nonterminal symbol by clicking on them. New tagsets can be defined at any time by clicking on the plus sign at the far left.
4. New production rules for the active nonterminal symbol can be defined at any time, and the user can explore existing rules by clicking on them. When a rule is selected, it becomes the *active production rule*, allowing it be edited, refined, or targeted for live feedback. Production rules may recursively reference other nonterminal symbols using a simple '[[symbol name]]' syntax.
5. At any time, the user can click this expansion icon to request live feedback in the form of terminal expansions (generated text, 6, and the markup accumulated during the production of that text, 7) of the active nonterminal symbol or the terminal results of executing the active production rule.

This photo is nicely balanced... Looking at it makes me feel happy!

**Fig. 2.** A *Snapshot* player takes a photograph of a deer and posts it to her photoblog, right, where an evaluative comment generated using Expressionist appears.

### 3.4  Generating In-Game Text

While the Expressionist authoring interface has its own expansion engine, it is only intended for live feedback at authoring time (and does not reason about markup during expansion, except to accumulate it). To generate in-game text at runtime, an expansion engine must be implemented as a module in the game code. The purpose of this module will specifically be to operate over an Expressionist JSON at runtime to generate text on the fly according to requests made by the game's content-selection architecture. In Expressionist parlance, we call such a module a *Productionist*. While each implementation will differ according to the expressive aims of a larger application, there is a general pattern that all Productionist modules follow: a request comes in for generated text with *specific desired markup* (*e.g.*, a speech act), and Productionist operates over an Expressionist JSON to produce a terminal expansion that has that markup. As such, a core part of utilizing Expressionist in a game is making good use of grammar markup by operationalizing it with application-specific semantics, which may guide content generation and drive updates to the game state upon content deployment. In the next section, we discuss a series of Productionist modules that have been implemented in both completed games and prototypes.

## 4  Case Studies

Expressionist has been used to generate text in two released games, *Snapshot* [26] and *Project Perfect Citizen* [1], and is also being used in two projects that are currently in development. While eventually we plan to conduct user studies to evaluate the usability of its authoring interface, we believe the successful utilization of Expressionist in these works validates it as a tool for in-game text generation. In this section, we will describe this diverse array of usage examples in a series of short case studies.

### 4.1  Generating Evaluative Photoblog Comments in *Snapshot*

*Snapshot* is a first-person photography simulator set in a nature reserve that is modeled using a compelling low-poly art style [26]; it is written in C# using

**Fig. 3.** A *Project Perfect Citizen* player constructs a theory of the connections in a procedurally generated social network using an in-game graph application. To home in on the suspicious person at the center of the network, she studies character SMS exchanges that are generated using Expressionist (detail shown on right).

the Unity framework. In the game, the player explores the reserve across day and night cycles to take photographs of its wildlife and other natural elements. Between photo sessions in the park, the player can post her favorite shots to an in-game photoblog and view evaluative visitor comments that are generated using Expressionist (as shown in Fig. 2).

Generated photoblog comments in *Snapshot* are surface expressions of the core technology underpinning the game: an automated *photo evaluation system*. This system evaluates player photos according to three heuristics: *balance* (how well visual intrigue is distributed across the photo), *spacing* (the rule of thirds), and *subject quality* (the interestingness of the subject of a photo, *e.g.*, a deer or mountain). Whenever a player posts a photo to her blog, the evaluation system scores it using its three heuristics, isolates the heuristic the photo scored most highly on, and passes the score for this heuristic (binned to **bad**, **good**, **great**, or **perfect**) as a content request to the game's Productionist module. The Productionist module then operates over an Expressionist JSON with tagsets that pertain to the three heuristics and contain tags corresponding to the four possible binned scores that may appear in a content request. To generate a blog comment, the module targets a top-level symbol with the desired markup (the tag corresponding to the binned heuristic score in the content request, *e.g.*, **balance:great**) and returns its terminal expansion.

The *Snapshot* Expressionist grammar contains 30 nonterminal symbols and 121 production rules, and is capable of generating 17,856 unique comments.

## 4.2   Generating SMS Exchanges in *Project Perfect Citizen*

*Project Perfect Citizen* is a "surveillance storytelling" game that tightly combines generative methods, environmental storytelling, and procedural rhetoric [1]; it is written in C++, runs on a custom engine built by its development team, and is beginning to receive press attention [3]. In the game, the player is a low-level employee at a government security agency who is tasked with exploring the private data of individuals to find and report evidence of suspicious activity. This plays out across a series of levels that each require the completion of two related tasks. In the first task (depicted in Fig. 3), the player uses an in-game graph application to construct a theory of a social network with a suspicious person at its center; this is done by referencing character SMS exchanges that are generated using Expressionist. Once the ringleader has been ascertained, the player proceeds to the second task, where she remotely beams into that character's desktop environment to locate and flag suspicious files.

Prior to the generation of SMS exchanges for a given level, a social network is generated by producing a series of characters who have unique personality models and who are linked to one another in specific ways. These network links are expressed as tuples specifying a level of suspiciousness (on a five-point scale) and a relationship type (family, work, or other community). While the representation of the character who is central to the level (the one whose desktop the player will explore) is held constant across playthroughs, the other characters in the network vary. A core authorial goal of the first phase of each level is to prime the player to the type of suspicious activity that she is meant to look out for in the second phase (*e.g.*, hacking, political corruption, sex crimes).

*Project Perfect Citizen*'s Productionist module, written by the team in C++, satisfies targeted content requests for each link in a given network by generating SMS exchanges that evoke the link's suspiciousness level and relationship type, as well as the personalities of its characters. To do this, the module operates over an Expressionist JSON whose terminal expansions are complete SMS exchanges and whose tagsets correspond to link suspiciousness levels, relationship types, and character personality traits. Specifically, their Productionist starts at the single top-level symbol of the grammar and then traverses it in a randomized depth-first search (DFS), expanding symbols along the way. If at any time a symbol is encountered whose markup contradicts the content request, Productionist abandons the path that led to it. The result of this procedure is a terminal expansion of the top-level symbol in the form of a generated SMS exchange whose markup corresponds to (or at least does not contradict) the content request. Most often, this will mean that the generated exchange evokes the very characteristics captured in the content request, though it is possible to generate a default exchange that works for any pair of characters (to ensure that content can be generated for every possible case). The employment of DFS expansion with *backtracking* (*i.e.*, abandoning symbols with incompatible markup) makes this Productionist more complex than the one built for *Snapshot*.

Because each *Project Perfect Citizen* level surrounds a unique central character, each one has its own authored Expressionist grammar. These four grammars

feature between 235 and 346 nonterminals, 571 and 956 production rules, and a staggering 1.3 trillion to 65.3 quadrillion generable SMS exchanges.

### 4.3   Generating Character Dialogue in *Talk of the Town*

Our next case study is the subject of a recent paper [19], so we will only briefly outline it here. It concerns dialogue generation in *Talk of the Town*, a deeply AI-driven game that we are currently developing. Underpinned by a rich simulation of character knowledge phenomena, players in this game will have to home in on the truth of a central mystery by engaging in dialogue interaction with non-player characters (NPCs) who form subjective beliefs about the world (which may be inaccurate). Dialogue interaction will be fully procedural, integrating dialogue management [20], natural language understanding (via Expressionist) [25], and natural language generation [19]. Expressionist is central to our approach to the latter. Specifically, we rely on a CFG whose tagsets correspond to the concerns of our dialogue manager (enumerated in [20]) and a Productionist module that handles requests for lines of dialogue with desired markup (typically a tag corresponding to a speech act targeted by the dialogue manager).

While the Productionist modules in the previous two examples produced content by terminally expanding top-level symbols—the conventional way of generating from a CFG—this Productionist employs a unique *middle-out* expansion procedure [19]. Specifically, the module targets *mid*-level nonterminal symbols and then attempts to both forward-expand (by terminally expanding the symbol) and backward-chain (by executing production rules that have the symbol on its righthand side) from the targeted symbol. The result is a terminal expansion of a top-level symbol, but one that was in actuality built by chaining bidirectionally from a targeted mid-level symbol. As an example, consider a content request that solicits a line of dialogue that would express certain information to the player, say, details about a relative of the NPC speaker. In our grammar, we can author a nonterminal that expands to produce such dialogue (and is tagged with markup specifying this), but that (as a mid-level symbol) can also be included in larger contexts, *e.g.*, an extended monologue about the NPC's family history. This allows the Productionist to target the particular kind of snippet that it seeks—one with details about the relative—without having to reason about, in this case, the entire family monologue. Alternatively, a content request might only prescribe the gist of a larger structure, in which case Productionist would not have to worry about finer details. As we argue more deeply in [19], this supports a modular, hierarchical authoring scheme that makes it tractable (and less burdensome) to specify huge spaces of generable text. While the Productionist in *Project Perfect Citizen* will not expand a symbol whose markup contradicts the content request (backtracking), in *Talk of the Town* we generalize this to allow authors to attach arbitrary *preconditions* to nonterminal symbols in the grammar. This is simply implemented as a tagset, called `Preconditions`, whose tags are snippets of raw code that can be evaluated at runtime against the game and conversation state. As we assert in [19,20], this is a very powerful authorial affordance that may be utilized to reduce repetition (*e.g.*, symbol can

only be expanded if the last generated line did not have certain lexical content) and express underlying game state (*e.g.*, symbol can only be expanded if speaker has a certain personality trait). Finally, *Talk of the Town* makes use of an Expressionist authoring convention that is not used in *Snapshot* or *Project Perfect Citizen*: runtime variables. Rather than fully realized lines of dialogue, the terminal expansions of the *Talk of the Town* grammar are *templated* lines of dialogue, *e.g.*, "Hello, [interlocutor.name].". Gaps in these templates are called *runtime variables* and are specified as raw code snippets that Productionist can evaluate to a string at runtime (by binding to entities in the game state).

The *Talk of the Town* Expressionist grammar currently features 246 non-terminals and 665 production rules, and is capable of generating 2.8M lines of dialogue. Examples of the generated dialogue can be found in example procedural conversations included in [20, 25].

### 4.4 Generating Character Thoughts in *Juke Joint*

*Juke Joint* is a small work of interactive storytelling that demonstrates an extension to the *Talk of the Town* AI framework by which characters form thoughts, expressed in natural language, that are elicited by environmental stimuli. Because it is the subject of another publication [18], we will remain brief in this case study as well. *Juke Joint* is set in a bar with a jukebox and two patrons who are each facing personal dilemmas, and the player's only action is to select which song from the jukebox will play. As the lyrics of the selected song emanate from the machine, thoughts are elicited in the minds of the characters, constituting streams of consciousness that eventually lead them to resolutions of their respective dilemmas.

*Juke Joint*'s Productionist module utilizes all the same tricks as the *Talk of the Town* one—backtracking, preconditions, runtime variables, middle-out expansion—with an additional rub: heuristic expansion. Song lyrics in the game are annotated for their *themes* (*e.g.*, love, deception), and nonterminal symbols in its Expressionist grammar are annotated for the themes they are associated with. Critically, this allows for *heuristic evaluation* of nonterminal symbols: we have developed a scoring procedure that computes how well the themes of a span of lyrics match the themes associated with a nonterminal. With the themes of the current lyrics functioning as environmental stimuli, Productionist builds an elicited thought by targeting the highest scoring nonterminal symbol in the grammar. From here, it carries out middle-out expansion (as described in Sect. 4.3), but also *heuristic expansion*: whenever it has to choose between multiple viable production rules, it scores them (as the sum of the scores of the symbols on their left- and righthand sides) and selects a rule probabilistically (according to the scores). While it would not be tractable to compute the maximally optimal expansion trace for a set of stimuli (given the grammar's massive possibility space, noted below), this greedy expansion procedure works to ensure that the elicited thought will be reasonably associated with the stimuli. More generally, it allows us, as procedural authors, to specify expressive aims for generated content—in this case, to maximize the association between song lyrics and the

**Table 1.** The array of strategies utilized by the four productionist modules described in our case studies, all of which are made possible by Expressionist's markup affordance.

|  | Snapshot | Project perfect citizen | Talk of the town | Juke joint |
|---|---|---|---|---|
| Top-down expansion | ✓ | ✓ | ✓ | ✓ |
| Backtracking |  | ✓ | ✓ | ✓ |
| Preconditions |  |  | ✓ | ✓ |
| Runtime variables |  |  | ✓ | ✓ |
| Middle-out expansion |  |  | ✓ | ✓ |
| Heuristic expansion |  |  |  | ✓ |

character thoughts they elicit—while relying on Productionist to do the work of actually pursuing these aims (by consulting the explicit metadata attributed during authoring). Appealingly, this advance in system expressivity does not in turn affect the well-formedness of generated content, since Productionist still operates over a fully specified control structure—our Expressionist grammar.

The *Juke Joint* Expressionist grammar currently features 292 nonterminals, 801 production rules, and the largest possibility space of the Expressionist grammars discussed in this paper: 6.3 quintillion unique character thoughts.

## 5 Discussion and Conclusion

The Expressionist grammars discussed in the above case studies support possibility spaces spanning upward of *quintillions* of generable outputs, each instance of which comes packaged with metadata that is tailored to the particular expressive aims of a larger application. The tool's simple markup affordance—authors attach free-text markup to symbols that elegantly accumulates during expansion—yields a rich design space supporting an array of application-specific generation approaches, which Table 1 illustrates. As a slightly augmented way of generating from a CFG, *Snapshot* uses markup as a way of representing start symbols by their semantic functions. *Project Perfect Citizen* utilizes markup more deeply, employing a top-down expansion procedure that backtracks from nonterminals whose markup contradicts the content request. This notion is generalized in *Talk of the Town*, where markup may be used to attach arbitrary expansion *preconditions* to nonterminals, formatted as raw code that can be checked against the system state at runtime. Similarly, this Productionist utilizes *runtime variables*: generated outputs may be templates with gaps specified as raw code snippets that evaluate to strings at runtime. More drastically, the *Talk of the Town* Productionist provides additional authorial leverage by employing a unique *middle-out* expansion procedure that utilizes backward chaining in addition to conventional top-down expansion. Further still, the *Juke Joint* productionist carries out *heuristic* middle-out expansion, scoring candidate production rules for their appeal with regard to expressive aims asserted in automated

content requests. These examples all work to demonstrate how Expressionist's markup affordance allows authors to move beyond the expressive power that is typical of CFGs, supporting application-specific semantics and diverse expansion approaches.

We believe that the usage of Expressionist in these four applications—and the fact that these projects integrate the tool into different technological ecosystems, including a Unity C# project and a custom C++ game engine—validates it as a powerful new method for in-game text generation. Even more promisingly, the authors who used Expressionist in these projects were not NLG practitioners. We view this as an encouraging indication of the potential of this tool to allay the burden of generative text in interactive storytelling, which we articulated at the beginning of this paper. Expressionist will be publicly released in late 2016, and we hope that others will consider using it in their own future projects.

# References

1. Bad Cop Studios: Project Perfect Citizen (2016)
2. Bona, D.J.L.: Recursion in cognition: a computational investigation into the representation and processing of language. Ph.D. thesis, University Rovira i Virgili (2012)
3. Caldwell, B.: Free Loaders: This Desktop is Under Investigation. Rock, Paper, Shotgun, Bath (2016)
4. Cavazza, M., Charles, F.: Dialogue generation in character-based interactive storytelling. In: Proceedings of AIIDE (2005)
5. Compton, K., Kybartas, B., Mateas, M.: Tracery: an author-focused generative text tool. In: Schoenau-Fog, H., Bruni, L.E., Louchart, S., Baceviciute, S. (eds.) ICIDS 2015. LNCS, vol. 9445, pp. 154–161. Springer, Heidelberg (2015). doi:10.1007/978-3-319-27036-4_14
6. Elson, D.K.: Modeling narrative discourse. Ph.D. thesis, Columbia University (2012)
7. Evans, R., Short, E.: Versu–a simulationist storytelling system. In: TCIAIG (2014)
8. Gatt, A., Reiter, E.: SimpleNLG: a realisation engine for practical applications. In: Proceedings of ENLG (2009)
9. Horswill, I.D.: Architectural issues for compositional dialog in games. In: Proceedings of GAMNLP (2014)
10. Joseph, E.: Bot colony–a video game featuring intelligent language-based interaction with the characters. In: Proceedings of GAMNLP (2012)
11. Lessard, J.: Designing natural-language game conversations. In: Proceedings of DiGRA-FDG (2016)
12. Loyall, A.B., Bates, J.: Personality-rich believable agents that use language. In: Proceedings of AGENTS (1997)
13. Mateas, M.: The authoring bottleneck in creating AI-based interactive stories [panel]. In: Proceedings of INT (2007)
14. Mawhorter, P.A.: Artificial intelligence as a tool for understanding narrative choices. Ph.D. thesis, University of California, Santa Cruz (2016)
15. Montfort, N.: Generating narrative variation in interactive fiction. Ph.D. thesis, University of Pennsylvania (2007)

16. Reed, A.A., et al.: A step towards the future of role-playing games: the SpyFeet mobile RPG project. In: Proceedings of AIIDE (2011)
17. Rowe, J.P., Ha, E.Y., Lester, J.C.: Archetype-driven character dialogue generation for interactive narrative. In: Prendinger, H., Lester, J., Ishizuka, M. (eds.) IVA 2008. LNCS (LNAI), vol. 5208, pp. 45–58. Springer, Heidelberg (2008). doi:10.1007/978-3-540-85483-8_5
18. Ryan, J., Brothers, T., Mateas, M., Wardrip-Fruin, N.: Juke joint: characters who are moved by music. In: Proceedings of Experimental AI in Games (2016)
19. Ryan, J., Mateas, M., Wardrip-Fruin, N.: Characters who speak their minds: dialogue generation in talk of the town. In: Proceedings of AIIDE (2016)
20. Ryan, J., Mateas, M., Wardrip-Fruin, N.: A lightweight videogame dialogue manager. In: Proceedings of DiGRA-FDG (2016)
21. Ryan, J.O., Barackman, C., Kontje, N., Owen-Milner, T., Walker, M.A., Mateas, M., Wardrip-Fruin, N.: Combinatorial dialogue authoring. In: Mitchell, A., Fernández-Vara, C., Thue, D. (eds.) ICIDS 2014. LNCS, vol. 8832, pp. 13–24. Springer, Heidelberg (2014). doi:10.1007/978-3-319-12337-0_2
22. Ryan, J.O., Fisher, A.M., Owen-Milner, T., Mateas, M., Wardrip-Fruin, N.: Toward natural language generation by humans. In: Proceedings of INT-SBG (2015)
23. Ryan, J.O., Mateas, M., Wardrip-Fruin, N.: Open design challenges for interactive emergent narrative. In: Schoenau-Fog, H., Bruni, L.E., Louchart, S., Baceviciute, S. (eds.) ICIDS 2015. LNCS, vol. 9445, pp. 14–26. Springer, Heidelberg (2015). doi:10.1007/978-3-319-27036-4_2
24. Short, E.: Procedural text generation in IF. https://emshort.wordpress.com/2014/11/18/procedural-text-generation-in-if/
25. Summerville, A.J., Ryan, J., Mateas, M., Wardrip-Fruin, N.: CFGs-2-NLU: sequence-to-sequence learning for mapping utterances to semantics and pragmatics. Techical report. UCSC-SOE-16-11, UC Santa Cruz (2016)
26. Vacuous Games: Snapshot (2016)

# Recognizing Coherent Narrative Blog Content

James Ryan[1]([✉]) and Reid Swanson[2]

[1] Expressive Intelligence Studio, University of California, Santa Cruz,
Santa Cruz, USA
jor@soe.ucsc.edu
[2] Institute for Creative Technologies,
University of Southern California, Los Angeles, USA
rswanson@ict.usc.edu

**Abstract.** Interactive storytelling applications have at their disposal
massive numbers of human-authored stories, in the form of narrative
weblog posts, from which story content could be harvested and repur-
posed. Such repurposing is currently inhibited, however, in that many
blog narratives are not sufficiently *coherent* for use in these applications.
In a narrative that is not coherent, the order of the events in the narrative
is not clear given the text of the story. We present the results of a study
exploring automatic methods for estimating the coherence of narrative
blog posts. In the end, our simplest model—one that only considers the
degree to which story text is capitalized and punctuated—vastly outper-
formed a baseline model and, curiously, a series of more sophisticated
models. Future work may use this simple model as a baseline, or may
use it along with the classifier that it extends to automatically extract
large numbers of narrative blog posts from the web for purposes such as
interactive storytelling.

**Keywords:** Coherence · Blogs · Content harvesting · Machine learning

## 1  Introduction

Millions of weblog posts are published online each day, making up a text corpus
of immense proportions for use in natural language processing (NLP) applica-
tions. A particular focus of some of these applications has been blog posts that
are *personal narratives*, in which the author recounts a series of related events
that happened in the past to her or a close associate. These narrative blog posts,
examples of which are shown in Figs. 1 and 2, present massive potential in the
form of story content that could be harvested and appropriated for use in inter-
active storytelling applications.

One promising avenue for such work would be to harvest content in support of
a narrative-based virtual agent, a format that recent work on intelligent virtual
agents suggests can be effective in a wide variety of applications. Narrative-based
interaction discussing past emotional experiences, for example, is known to be
highly beneficial for well-being: meta-analyses of 200 studies in which people

© Springer International Publishing AG 2016
F. Nack and A.S. Gordon (Eds.): ICIDS 2016, LNCS 10045, pp. 234–246, 2016.
DOI: 10.1007/978-3-319-48279-8_21

*Keep thinking of those accomplishments, guys. It's really neat to experience the payoff. My small victory today was in going to get my hair cut and dealing with my nerves. As always, I seem to forget how it goes because it's been a couple of months so I anxiety comes back despite having done this many times before, and it had me on edge about calling to see if my hairdresser was working today. I was worried she'd pick up like last time and I'd have no idea what to say and sound foolish like last time, but I made myself call anyway, despite feeling unprepared. Then when I got there, she wasn't ready for me yet so I sat down and felt my heart pounding and I wasn't sure what to do with my hands and worried about my posture. But I repeated some rational statements to myself about how I'd done this before and I could do it again etc, and within a few minutes I felt much better. Actually, I was more sociable than my hairdresser this time (she's bubbly so that's unusual) and I think I did just fine.*

**Fig. 1.** An anonymously authored blog personal narrative about social anxiety.

actively retell personal stories demonstrate a striking impact on physical health in the form of reduced doctor visits and improved immune antibody responses [10,38]. Building a narrative-based agent typically requires specification of the narrative world, with its causal and temporal relationships, as well as all the possible interactions between the virtual agent and the user. This handcrafting approach has been used to produce compelling interactive agents for health and wellness [5], training [47], and entertainment [1]. But because considerable investment is required to author for this approach, recent work has investigated the prospect of harvesting narrative content from weblogs and developing methods to repurpose such material according to application-specific aims [15,35,46]. As an example, let us consider the personal narrative about social anxiety shown in Fig. 1. Perhaps stories like this could provide narrative content that could be repurposed for a virtual storytelling agent specifically targeted at treating social anxiety. Similarly, stories about other medical conditions, such as strokes [15], could be used to support storytelling agents built to help users who are living in the wake of those circumstances.

More broadly, narrative blog content could be repurposed for use in a wide array of storytelling applications, and in fact a number of existing projects have already done this. An early example, *Buzz*, is an installation piece that renders harvested blog stories as monologues delivered by virtual agents [35]. More recently, in [20] blog stories are performed as dialogues between two embodied agents with adaptable personalities that affect the retellings. This is made possible by first encoding the blog stories into a semantic representation that the agent dialogue is generated from. Other recent applications have used this same method to generate story retellings that vary according to adjustable parameters, such as the teller's personality, using content originating in fables [41], videogames [2,31], and blogs [30,32]; a corpus of semantic encodings of blog stories has even been released [29]. In [26], character dialogue is generated by repurposing natural language extracted from books. Other projects have demonstrated the plausibility of learning narrative models from story corpora [17,19,24,25]. Another line of work has repurposed narrative blog content for mixed-initiative story cocreation. An example of this is *Say Anything* [46], a system that collaborates

with human users to build stories composed of user-submitted free text and related content that is extracted from blogs on the fly. More recently, Roemmele and Gordon [43] introduced *Creative Help*, which is a collaborative authoring tool that extends this method to give the user more authorial control [43], with plans for further extensions utilizing deep learning [42]. Clearly, the repurposing of narrative blog content affords a rich space of expressive possibility for works of interactive storytelling.

While in a single week the blogosphere may produce a million or more personal narratives, these must be sifted out from the non-story blog posts that outnumber them considerably—previous work estimates that only around 15 % of blog posts are narratives [14]. Gordon and Swanson [13] built a classifier to automatically identify stories from non-stories in weblog posts with a 66 % precision, which they used to construct a corpus of over one million personal narratives. Many of these stories, however, are not sufficiently *coherent* for use in secondary applications. In a narrative that is not coherent, the order of the events in the narrative is not clear given the text of the story. For example, there may be a confusing disconnect between fabula and discourse.[1] We specifically refer to this concept as *temporal coherence*. (Figure 2 gives examples of both coherent and incoherent narrative blog posts taken from Gordon and Swanson's corpus.) This lack of coherence can trouble the kinds of promising applications of interactive storytelling that are made possible by harvesting coherent narrative blog content, an area we outlined above. This is because the appeal of harvesting narrative material for free is offset when additional inference is needed to determine the actual ordering of the events in the extracted stories. Non-narrative applications are undermined too, such as the emerging area that uses blog stories to learn causal relations between everyday events in support of automated knowledgebase construction [11,12,15,33].

Our goal in this work is to identify the stories in Gordon and Swanson's corpus that have the *strongest temporal coherence*, specifically through the use of machine learning techniques that may do such sifting automatically. This is related to work in automated discourse coherence models that aims primarily to improve multi-document summarization tasks. A wide range of techniques have been developed in this area [3,4,8,9,16,23,27,28,39,45], but these tend to require high-quality NLP tools, such as syntactic parsers and entity recognizers. In our work, we focus on shallow features because the very noisy nature of blog text is not handled well by current NLP tools.

To our knowledge, this represents the first investigation into developing automatic methods for estimating the temporal coherence of blog narratives. If successful, this project would yield a number of interesting benefits. First, it would produce a new corpus containing blog stories that are coherent enough to be used in the kinds of secondary applications that we have referenced above. Second, since the larger corpus of blog stories that we are sifting is varied and domain-independent, our project could provide a generalized method for the recognition

---

[1] Here, we acknowledge that such decoupling is used productively in certain storytelling forms and that audience confusion may be socioculturally subjective [22,34].

| COHERENT | INCOHERENT |
| --- | --- |
| The scariest thing happened to me this morning. I was all ready to go to school & eating my breakfast **when** I got this really weird feeling and it felt like my heart was skipping beats. I couldn't move or anything, like my whole body was paralyzed. **Then** it hurt so bad. I started freaking out to the point where I wanted to go to the hospital. **At first** I thought it was just a panic attack **but** then I was like, uhh that's never happened when im having one before. **So** I stayed home and went to the doctors at 10. Ive been through this before but it just felt like my heart skipped; it never hurt. **So** I got blood taken and an EKG. **On the 26th** I have to go Dupont to get a echo cardiogram and wear a holter monitor for a few days or so. Ive done it before **so** its no big deal. | Went to school yesterday. It felt as though the past one semester of gip didnt happen at all. Everything was very much the same. Just that the HSS library is now hidden at some ulu part of the campus, and the foodcourt at North spine is crazily crowded... very different from what I saw during the sem break when I went back for special sem. **Well**, this is school. **Oh and** I have to go back to the routines of logging onto edventure to check for announcements and photostating texts! haha... havent done this for so long. Bumped into yingyu and Kian Ming in school **and** seeing them reminded me of gip. Haha. **So** its really did happen. I guess the whole gip part will only be less surreal when I bump into more gip ppl in school. **Anyway**, going to school for one day was enough to make a portion of my hair turn green. **Since** it was green **and** I didnt really mind, I left it as it is. Hahaha. Lets all immerse ourselves in the essence of school in this final year. |

**Fig. 2.** Coherent and incoherent personal-narrative blog posts, authored anonymously. Notice that the order of events is much easier to infer in the coherent narrative. Discourse connectives are emphasized in **boldface**.

of coherent narrative blog content—one that could be used by anyone to extract such content from other sources. Lastly, the development of such a generalized method could tell us about what makes blog stories coherent, thereby shedding light on the very essence of temporal coherence in narrative, more broadly.

In this paper, we outline the development of several regression models that automatically predict the temporal coherence of personal narratives found in weblogs. These models were trained on 200 blog posts that were sampled from Gordon and Swanson's corpus and annotated for their coherence by Amazon Mechanical Turkers. Several types of features were extracted from the text of these posts and used to train regression models. As a baseline, we used twelve standard readability metrics similar to and including the Flesch-Kincaid grade-level measure of text readability [21] to train a comparable model, which underperformed each of ours in an evaluation procedure. In the end, our simplest model—one that only considers text punctuation and capitalization—performed best, showing high enough correlation with temporal coherence to be of immediate practical use in corpus sifting. While this does not teach us much about temporal coherence in narrative, or even in blog stories specifically, the failures of our more sophisticated models may. Moreover, the simplicity of our best-performing model (and the classifier that it extends) indicates that our technique could easily be duplicated by others to obtain huge numbers of blog posts from the wild that are temporally coherent narratives. We are excited at the prospect of future applications of interactive storytelling that could be enabled by such abundances of raw narrative material.

## 2  Background

This study extends work by Gordon and Swanson, who built a corpus of 1.7M personal narratives [13], as described above. This corpus was extracted from the

ICWSM 2009 Spinn3r Dataset, a collection of 44M English blog posts published between August and October of 2008 [6], using a linear classifier. However, as noted above, much of these automatically recognized stories are not sufficiently coherent for use in secondary applications. As an extension to this earlier work, we see our current project as concerning the development of a *second-order* classifier that may be used in conjunction with Gordon and Swanson's. Specifically, we envision an extraction pipeline that proceeds as follows: assemble a large collection of blog posts scraped from the web; use Gordon and Swanson's classifier to refine this collection to a subset that are identified as stories; finally, further refine this set to only the stories that our classifier recognizes as being temporally coherent.

## 3   Method

In this section, we describe our data collection and annotation processes, feature extraction methods, and model training and evaluation procedures in detail.

### 3.1   Data Collection and Annotation

We randomly sampled 200 blog posts from Gordon and Swanson's corpus, described above, for annotation in a task posted online through Amazon Mechanical Turk [36]. Only posts of between 150–200 words were selected during sampling, and abridged posts in the corpus, identifiable by a final ellipsis, were also excluded. Figure 2 shows two typical examples taken from this sample.

After selection, the 200 posts were subjected to a crowdsourced annotation procedure administered online as an Amazon Mechanical Turk Human Intelligence Task (HIT) [36]. Each task in the HIT included two triplets of blog posts that were preceded by a set of instructions defining narrative temporal coherence. For each triplet, the annotator was asked to rank its three stories in order of temporal coherence. Additionally, as a way to ensure that the tasks were completed in good faith, annotators were required to give a one-sentence summary characterizing the main point of the narrative. Every blog post appeared in two triplets, and each triplet was annotated by three separate individuals. In total, 70 unique annotators attempted the HIT, of which the work of three was rejected for being incomplete or indicative of poor-faith effort. Of the 67 annotators whose work was accepted, each completed an average of three tasks. Using the annotator's choices for most-coherent narrative for each triplet, Cohen's kappa coefficient was 0.41 across all annotators, indicating moderate agreement.

As each blog post appeared in two triplets that in turn were each annotated three times, each post received six coherence rankings in total. These rankings were treated as real numbers—$1.0$ for *most coherent*, $2.0$ for *second-most coherent*, and $3.0$ for *least coherent*—and were used to compute mean coherence rankings for each post, which we then used as the posts' gold-standard labels.

**Table 1.** Feature sets extracted for each blog post.

| Features | N | Description |
|---|---|---|
| Unigrams | 5,374 | Relative frequency of the lexical unigrams. |
| Bigrams | 24,202 | Relative frequency of the lexical bigrams. |
| POS unigrams | 39 | Relative frequency of the POS-tag unigrams. |
| POS bigrams | 861 | Relative frequency of the POS-tag bigrams. |
| LIWC | 81 | Relative frequency of Linguistic Inquiry and Word Count categories. |
| Discourse | 83 | Combination of relative frequency of discourse-connective categories and the relative frequency of the individual connectives from the Penn Discourse Treebank 2.0 annotation manual [40]. |
| Capitalization/punctuation | 3 | Percentage of words capitalized, percentage of sentence-initial words capitalized, and percentage of unigrams that are punctuation. |
| Readability | 12 | Scores from standard readability metrics. |
| Syntax | 2,533 | Combination of average per-word probability of parse trees (Syntax:TreeScoreMean) and relative frequency of each context-free production rule |

## 3.2 Feature Extraction

Over 40,000 total features across several features sets were extracted from each blog post. These sets, shown in Table 1, include both low-level and high-level linguistic features, and also superficial text features pertaining to capitalization and punctuation. Feature values were generally frequencies, as we explain below.

Unigrams are the lowest-level linguistic features that were extracted. Intuitively, these may not seem to be good predictors of narrative structure, but these were the best performing feature used in Gordon and Swanson's classifier [13], and so we deemed them a good starting point. For similar reasons, we also extracted lexical bigram features. Across all 200 blog posts, there were 5,374 unique unigrams and 24,202 unique bigrams. Values for these features represent the frequency—normalized to the maximum frequency count for that feature, given all 200 blog posts—with which a particular $n$-gram occurred in the post at hand. At a higher linguistic level, we calculated relative frequencies for POS-tag unigrams and bigrams using the Penn Treebank tagset [44]. These are easy features to extract and could conceivably be predictive of narrative coherence—for instance, it could be that certain verb tenses are used more often in coherent narratives. At a higher level yet, we also parsed the stories to extract two features that characterize syntactic well-formedness: the average probability of their parse trees and the relative frequency of each context-free production rule.

We also extracted features corresponding to categories from the Linguistic Inquiry and Word Count (LIWC) dictionary [37], which maps over 2500 English words to one or more syntactic or semantic categories. These include categories pertaining to positive emotions, negative emotions, causal words, time markers, as well as function words, past-tense words, present-tense words, and several more classes. Among these, we were especially interested in the causal-word and time-marker categories, which we expect to appear in coherent narratives. The features that we most expected to predict narrative coherence were those corresponding to the 43 categories of *discourse connectives* given in the Penn Discourse TreeBank 2.0 Annotation Guidelines [40]. As many discourse connectives specifically describe causal or temporal relations, it is quite intuitive that these would appear often in coherent narratives. 254 unique discourse connectives are included across the 43 Penn Discourse TreeBank categories, some examples of which are shown in Table 2. While several connectives appear in multiple categories, due to resource constraints we did not enact any sense-disambiguation procedure. Values for the features in these two sets were relative frequencies, as with the above feature sets.

Our final feature set is not linguistic, but rather comprises three superficial text features pertaining to capitalization and punctuation. These were included not because they cause narrative coherence, but because they could conceivably be *associated* with narrative coherence. That is, it is reasonable that writers of well-formed blog narratives would use capitalization and punctuation more often than writers of poorly formed ones. The three features in this set were the percentage of words that are capitalized, percentage of sentence-initial words that are capitalized, and percentage of unigrams that are punctuation. These percentages were not normalized in the way that the above feature values were.

### 3.3   Model Derivation and Evaluation

Each of the feature sets described in Sect. 3.2, as well as a superset of all features and additional sets derived by feature selection, were used to train regression models with WEKA [48]. Additionally, we built a simple baseline model using twelve readability metrics similar to and including the Flesch-Kincaid grade-level measure of text readability [21]—standard measures that could conceivably predict narrative coherence. After initial exploration using several algorithms trained on the various feature subsets, we found the M5P model tree with default parameters to give the best results, so we used this exclusively. We employed 10-fold cross-validation to evaluate the models.

## 4   Results and Discussion

Table 2 shows the performance of the models that we trained. For each model, correlation coefficients and root relative squared errors were averaged across ten trials of 10-fold cross-validation, *i.e.*, over testing on 100 10 % folds. A 100 % root

**Table 2.** Performance of the models trained using each feature set. Coefficients and errors represent averages across ten iterations of 10-fold cross-validation.

| Feature subset | 10-fold cross-validation | |
|---|---|---|
| | Correlation coefficient | Root relative squared error |
| Capitalization/punctuation | 0.474 | 88.2 % |
| Feature selection (top 30) | 0.454 | 89.7 % |
| POS unigrams | 0.385 | 93.94 % |
| LIWC | 0.379 | 93.96 % |
| POS bigrams | 0.376 | 98.52 % |
| All features | 0.331 | 98.75 % |
| Unigrams | 0.309 | 103.53 % |
| Syntax | 0.301 | 102.21 % |
| Discourse | 0.294 | 96.84 % |
| Bigrams | 0.278 | 102.71 % |
| Readability (baseline) | 0.141 | 103.75 % |

**Table 3.** The top twenty features (determined by feature selection), along with their weights. A model trained using the top thirty performed second-best.

| Features | Weight |
|---|---|
| LIWC:Unique Words | 0.154 |
| SyntaxRule:ROOT → S | 0.150 |
| Syntax:TreeScoreMean | 0.149 |
| LIWC:Total Function Words | 0.121 |
| POS Bigrams:[DT, NN] | 0.112 |
| LIWC:Dictionary Words | 0.111 |
| Unigrams:'-' | 0.104 |
| SyntaxRule:NP → NP NP | 0.103 |
| Readability:Gunning-Fog | 0.103 |
| Readability:Flesch-Kincaid | 0.103 |
| POSUnigrams:':' | 0.103 |
| POSBigrams:[NNP, :] | 0.103 |
| POSBigrams:[:, NNP] | 0.103 |
| Unigrams:';' | 0.103 |
| Unigrams:'.' | 0.103 |
| LIWC:Dash | 0.103 |
| POSUnigrams:CC | 0.103 |
| POSBigrams:[:, CD] | 0.102 |
| POSBigrams:[:, NN] | 0.102 |
| CaptPunct:SentenceCap | 0.098 |

**Fig. 3.** A learning curve showing model performance as a function of training set size, which suggests that more data would help.

relative squared error is equivalent to always estimating the *mean* label value (*i.e.*, the mean coherence ranking, which is naturally 2.0).

Clearly, the baseline model trained using text readability metrics was outperformed by the other models. Unexpectedly, the best model was the simplest—one that considers only the percentage of words that are capitalized, percentage of sentence-initial words that are capitalized, and percentage of unigrams that are punctuation. We believe that these superficial text features do not *cause* narrative coherence, but rather are merely associated with it. That is, writers of temporally coherent narrative blog posts are likely to use more punctuation and capitalization than writers of incoherent posts are. In any case, this is another example of a cheap and simple feature set performing surprisingly well [18].

The model that we did expect to perform best, trained on the Penn Discourse Treebank discourse-connective categories, did not produce an exceptionally high correlation coefficient. A possible explanation comes from the fact that we performed no sense disambiguation on the connectives appearing in the blog posts. Because of this, the counts for *every* category that was associated with *any* sense of a connective token were incremented for each appearance of that token, and this may have brought consequential noise into these feature values.

Interestingly, models trained with feature selection perform better on this task than models that use all the features. We examined the top selected features in order to further investigate why some features were not performing as well as expected. As shown in Table 3, none of the discourse-connective features appear among these, although we do observe other features appearing here that belong to sets whose models performed poorly. Another potential issue is the small amount of training data that we used—only 200 stories. While our data collection was fairly costly, it appears that collecting annotations for several hundred more blog narratives would be helpful. Figure 3 plots correlation of the best-performing

model with the test set as a function of training set size, suggesting that more data would help performance.

# 5   Conclusion and Future Work

Interactive storytelling applications have at their disposal massive numbers of human-authored stories, in the form of narrative blog posts, from which story content could be harvested and repurposed. Such repurposing is currently inhibited, however, in that many blog narratives are not sufficiently *coherent* for use in these applications. In a narrative that is not coherent, the order of the events in the narrative is not clear given the text of the story. In this paper, we have presented the results of a study exploring automatic methods for estimating the coherence of narrative blog posts. In the end, we found that our simplest and best-performing model, one that considers only the degree of capitalization and punctuation in a blog narrative, shows correlation coefficients sufficient for immediate use in extracting many thousands of temporally coherent stories from Gordon and Swanson's corpus of over one million blog posts [13].

While the model trained using text readability metrics served as a suitable baseline here, it is not surprising that it was outperformed. This measure, though in wide use, merely considers the number of words per sentence and the number of syllables per word in a text. Of course, as our best-performing model was hardly more sophisticated, this baseline model could have also proven to correlate well with narrative temporal coherence—but it did not. Future work exploring automatic methods for determining the temporal coherence of narrative blog content should use our punctuation-and-capitalization model as a baseline.

We still maintain that discourse connectives, particularly ones cuing temporal or causal relations, may be a good predictor of narrative temporal coherence. Unfortunately, we believe that our method for extracting features of this type— particularly our lack of disambiguation of connective sense—introduced enough noise to significantly hamper performance of the corresponding model. In future work, connective-sense disambiguation should be used before extracting such features, and ideally a much larger training set should be used, as our findings suggest that this may produce better or more discriminative models. We also believe, following findings by others [7,39], that we will have to incorporate more complex features and leverage models that consider the sequential nature of text.

While additional work is needed to home in on the recognizable expressions of temporal coherence in surface-level story discourse—one of the goals of this study—both our regression model and the classifier that it extends are simple enough for others to use for their own purposes. Given how feasible this makes the extraction of massive numbers of coherent blog stories from the web, we are excited at the prospect of future applications of interactive storytelling that would be enabled by such abundances of raw narrative material.

**Acknowledgments.** This work would not have been possible without Marilyn Walker, who provided mentorship and funded the annotation procedure presented in this paper.

# References

1. Adam, C., Cavedon, L.: A companion robot that can tell stories. In: Proceedings of Intelligent Virtual Agents (2013)
2. Antoun, C., Antoun, M., Ryan, J.O., Samuel, B., Swanson, R., Walker, M.A.: Generating natural language retellings from Prom Week play traces. In: Proceedings of the Procedural Content Generation (2015)
3. Barzilay, R., Lapata, M.: Modeling local coherence: an entity-based approach. In: Proceedings of the ACL (2005)
4. Barzilay, R., Lee, L.: Catching the drift: probabilistic content models, with applications to generation and summarization. In: Proceedings of the NAACL HLT (2004)
5. Bickmore, T., Schulman, D., Yin, L.: Engagement vs. deceit: virtual humans with human autobiographies. In: Ruttkay, Z., Kipp, M., Nijholt, A., Vilhjálmsson, H.H. (eds.) IVA 2009. LNCS (LNAI), vol. 5773, pp. 6–19. Springer, Heidelberg (2009). doi:10.1007/978-3-642-04380-2_4
6. Burton, K., Java, A., Soboroff, I.: The ICWSM 2009 Spinn3r dataset. In: Proceedings of the Weblogs and Social Media (2009)
7. Eisenberg, J.D., Yarlott, W.V.H., Finlayson, M.A.: Comparing extant story classifiers: results and new directions. In: Proceedings of the CMN (2016)
8. Elsner, M., Charniak, E.: A unified local and global model for discourse coherence. In: Proceedings of the NAACL (2007)
9. Elsner, M., Charniak, E.: Coreference-inspired coherence modeling. In: Proceedings of the ACL (2008)
10. Frisina, P.G., Borod, J.C., Lepore, S.J.: A meta-analysis of the effects of written emotional disclosure on the health outcomes of clinical populations. Nerv. Ment. Dis. 192(9), 629–634 (2004)
11. Gerber, M., Gordon, A.S., Sagae, K.: Open-domain commonsense reasoning using discourse relations from a corpus of weblog stories. In: Proceedings of the Formalisms and Methodology for Learning by Reading (2010)
12. Gordon, A., Bejan, C., Sagae, K.: Commonsense causal reasoning using millions of personal stories. In: Proceedings of the AAAI (2011)
13. Gordon, A., Swanson, R.: Identifying personal stories in millions of weblog entries. In: Proceedings of the Weblogs and Social Media (2009)
14. Gordon, A.S., Cao, Q., Swanson, R.: Automated story capture from internet weblogs. In: Proceedings of the Knowledge Capture (2007)
15. Gordon, A.S., Wienberg, C., Sood, S.O.: Different strokes of different folks: searching for health narratives in weblogs. In: Proceedings of the Social Computing (2012)
16. Guinaudeau, C., Strube, M.: Graph-based local coherence modeling. In: Proceedings of the ACL (2013)
17. Guzdial, M., Harrison, B., Li, B., Riedl, M.O.: Crowdsourcing open interactive narrative. In: Proceedings of the Foundations of Digital Games (2015)
18. Hand, D.J., et al.: Classifier technology and the illusion of progress. Stat. Sci. 21, 1–15 (2006)
19. Harrison, B., Riedl, M.O.: Towards learning from stories: an approach to interactive machine learning. In: Proceedings of the AAAI (2015)
20. Hu, C., Walker, M.A., Neff, M., Fox Tree, J.E.: Storytelling agents with personality and adaptivity. In: Brinkman, W.-P., Broekens, J., Heylen, D. (eds.) IVA 2015. LNCS (LNAI), vol. 9238, pp. 181–193. Springer, Heidelberg (2015). doi:10.1007/978-3-319-21996-7_19

21. Kincaid, J.P., et al.: Derivation of new readability formulas for Navy enlisted personnel. Technical report, DTIC Document (1975)
22. Labov, W.: Uncovering the event structure of narrative. In: Round Table on Language and Linguistics (2003)
23. Lapata, M., Barzilay, R.: Automatic evaluation of text coherence: models and representations. In: Proceedings of the IJCAI (2005)
24. Li, B., Lee-Urban, S., Appling, D.S., Riedl, M.O.: Crowdsourcing narrative intelligence. Adv. Cogn. Syst. **2**(1), 25–42 (2012)
25. Li, B., Lee-Urban, S., Johnston, G., Riedl, M.: Story generation with crowdsourced plot graphs. In: Proceedings of the AAAI (2013)
26. Li, B., Thakkar, M., Wang, Y., Riedl, M.O.: Data-driven alibi story telling for social believability. In: Proceedings of the Social Believability in Games (2014)
27. Lin, Z., Ng, H.T., Kan, M.Y.: Automatically evaluating text coherence using discourse relations. In: Proceedings of the ACL: HLT (2011)
28. Louis, A., Nenkova, A.: A coherence model based on syntactic patterns. In: Proceedings of the EMNLP-CoNLL (2012)
29. Lukin, S.M., Bowden, K., Barackman, C., Walker, M.A.: Personabank: a corpus of personal narratives and their story intention graphs. In: Proceedings of the LREC (2016)
30. Lukin, S.M., Reed, L.I., Walker, M.A.: Generating sentence planning variations for story telling. In: Proceedings of the SIGDIAL (2015)
31. Lukin, S.M., Ryan, J.O., Walker, M.A.: Automating direct speech variations in stories and games. In: Proceedings of the GAMNLP (2014)
32. Lukin, S.M., Walker, M.A.: Narrative variations in a virtual storyteller. In: Brinkman, W.-P., Broekens, J., Heylen, D. (eds.) IVA 2015. LNCS (LNAI), vol. 9238, pp. 320–331. Springer, Heidelberg (2015). doi:10.1007/978-3-319-21996-7_34
33. Manshadi, M., Swanson, R., Gordon, A.S.: Learning a probabilistic model of event sequences from internet weblog stories. In: Proceedings of the FLAIRS (2008)
34. Michaels, S.: "Sharing time": children's narrative styles and differential access to literacy. Lang. Soc. **10**(03), 423–442 (1981)
35. Owsley, S.H., Hammond, K.J., Shamma, D.A., Sood, S.: Buzz: telling compelling stories. In: Proceedings of the Multimedia (2006)
36. Paolacci, G., Chandler, J., Ipeirotis, P.G.: Running experiments on amazon mechanical turk. Judgment Decis. Making **5**(5), 411–419 (2010)
37. Pennebaker, J.W., Francis, L.E., Booth, R.J.: LIWC: Linguistic Inquiry and Word Count. LIWC.net, Austin (2001)
38. Pennebaker, J.W., Seagal, J.D.: Forming a story: the health benefits of narrative. Clin. Psychol. **55**(10), 1243–1254 (1999)
39. Pitler, E., Nenkova, A.: Revisiting readability: a unified framework for predicting text quality. In: Proceedings of the EMNLP (2008)
40. Prasad, R., et al.: The Penn Discourse Treebank 2.0 annotation manual (2007)
41. Rishes, E., Lukin, S.M., Elson, D.K., Walker, M.A.: Generating different story tellings from semantic representations of narrative. In: Koenitz, H., Sezen, T.I., Ferri, G., Haahr, M., Sezen, D., Ç atak, G. (eds.) ICIDS 2013. LNCS, vol. 8230, pp. 192–204. Springer, Heidelberg (2013). doi:10.1007/978-3-319-02756-2_24
42. Roemmele, M.: Writing stories with help from recurrent neural networks. In: Proceedings of the AAAI (2015)
43. Roemmele, M., Gordon, A.S.: Creative help: a story writing assistant. In: Schoenau-Fog, H., Bruni, L.E., Louchart, S., Baceviciute, S. (eds.) ICIDS 2015. LNCS, vol. 9445, pp. 81–92. Springer, Heidelberg (2015). doi:10.1007/978-3-319-27036-4_8

44. Santorini, B.: Part-of-speech tagging guidelines for the Penn Treebank Project (3rd revision) (1990)
45. Soricut, R., Marcu, D.: Discourse generation using utility-trained coherence models. In: Proceedings of the COLING/ACL (2006)
46. Swanson, R., Gordon, A.S.: Say anything: a massively collaborative open domain story writing companion. In: Spierling, U., Szilas, N. (eds.) ICIDS 2008. LNCS, vol. 5334, pp. 32–40. Springer, Heidelberg (2008). doi:10.1007/978-3-540-89454-4_5
47. Traum, D., et al.: Hassan: a virtual human for tactical questioning. In: Proceedings of the SIGDIAL (2007)
48. Witten, I.H., Frank, E.: Data Mining: Practical Machine Learning Tools and Techniques. Morgan Kaufmann, San Francisco (2005)

# Intertwined Storylines with Anchor Points

Mei Si$^{(\boxtimes)}$, Zev Battad, and Craig Carlson

Rensselaer Polytechnic Institute, Troy, NY 12180, USA
{sim, battaz, carlsc2}@rpi.edu

**Abstract.** Narrative and dialogue are effective ways for engaging people and helping people organize and memorize information. In this work, we present an automated narration system that takes structured information from the Internet and tailors the presentation to a user using storytelling techniques. It is aimed at presenting the information as an interesting and meaningful story by taking into consideration a combination of factors ranging from topic consistency and novelty to user interests. In particular, the designer of the agent can specify a number of anchor points for the presentation, and the agent will automatically decide its strategy for covering these anchor points and emphasizing them in its presentation using multiple intertwining storylines and contrasts.

**Keywords:** Intertwined storylines · Anchor points · Computational creativity · DBpedia

## 1 Introduction

The development of Internet technologies has changed how we look for and share information. A lot more information is available online. For example, online encyclopedias like Wikipedia, with over five million articles in English, can be easily accessed. Similarly, a huge amount of information is being generated every moment on Twitter and other social media at every moment.

The goal of this project is to create a personal guide to help people explore such a large network of information by leveraging narrative technologies. Narrative has always been a vital part of human communication. Many researchers have argued that narrative is essential for helping people understand and organize their experiences [1, 4, 9, 10, 13]. The power of using narrative and dialogue in engaging the audience and providing an entertaining experience has also been demonstrated in numerous movies, novels and computer games.

Many attempts have been made to design virtual characters that can make presentations, such as [5–7, 12, 14]. Most existing work requires the domain knowledge to be encoded in a particular format for the agent to reason about, and in many cases, the agent uses domain-specific rules for generating its presentations. In this work, we experiment with loosening up such constraints and making minimal assumptions about the type of information the agent receives for enabling the agent to generate presentations for a wider range of domains automatically. We also emphasize the use of storytelling techniques, such as multiple intertwined story lines and foreshadowing, for making the presentation more interesting and more memorable.

© Springer International Publishing AG 2016
F. Nack and A.S. Gordon (Eds.): ICIDS 2016, LNCS 10045, pp. 247–257, 2016.
DOI: 10.1007/978-3-319-48279-8_22

In our previous work [11], we defined an intermediate XML format for crawling data from the Internet or for people to manually design a knowledge base. An automated storytelling system is developed to take the XML files and present them to the user. This system is aimed at presenting the information as an interesting and meaningful story by taking into consideration a combination of factors ranging from topic consistency and novelty to user interests. Just like a human presenter, the agent chooses and presents topics from the knowledge base one by one. The user can interrupt and change the topic. The user can also influence how the agent selects future topics by directly changing the relative weights of the agent's various objectives. At a more local level, the agent also illustrates and emphasizes the relationships between adjacent topics by constructing transition sentences using analogies and contrasts.

Using [11] the conversation with the user starts from a given point in the knowledge network and gradually wanders around by moving through related topics. It also occasionally jumps to distant topics for expanding the span of the conversation. There is no guarantee certain topics will be visited. In [2] we allowed the designers of the agent to specify a sequence of topics as anchor points, which have to be covered in the agent's narration. Using the algorithms proposed in [11], the narrative agent generates a segment of narrative following each anchor point. Then it decides whether adjacent pair of narrative segments should be presented sequentially or interweaved.

This work extends the system described in [2] for providing better support for using anchor points to guide the presentation. First, the narrative agent can automatically decide the sequence for visiting the anchor points, and this sequence is dynamically adjusted as the user interacts. Secondly, the importance of the anchor points is emphasized by having the agent relate back and make comparisons to previous anchor points in its presentation when possible. Finally, anchor points are also used to facilitate addressing the user's interests. The topics the user showed interest in become a special set of anchor points. Not only those topics, but also closely related topics are given priorities for being addressed. Thus, the agent is able to carry its own agenda – presenting a set of topics (anchor points) – and take care of the user's interests.

In the next sections, we first describe our example domain, and the XML specification as the basis for representing the knowledge base. Then we present the algorithms for automatically constructing presentations using anchor points, followed by a detailed example, discussions, and future work.

## 2   Example Domain

Throughout this paper, we will illustrate the working of our systems by introducing the history of ancient Rome. We created a simple XML format that encodes knowledge as a directed graph (Fig. 1). Each topic the system can talk about is represented as a node with a unique ID, and the nodes are linked to each other by relationships, thus forming a directed graph, which is very similar to a concept net [8]. The difference is that in our system each node is not necessarily a distinct concept. It can contain any information the designers want to include in the presentation. The example domain used in this study was generated by crawling information from DBpedia [3] using a tool we developed in the lab. Each entry in DBpedia is converted to a node in our knowledge graph.

**Fig. 1.** Part of the knowledge base in the rome domain

For simplicity in the presentation, we only use the first couple of sentences from the DBpedia entry as the description of the node. The type of link between nodes in DBpedia becomes the relationship link between them. This domain includes 500 unique nodes.

# 3   Create Presentations with Anchor Point

## 3.1   Overview

This section introduces our algorithms to form a presentation of the topics in the knowledge graph that visits every anchor point within a set number of turns. The narration agent works progressively by taking one anchor point at a time and generating a piece of narrative related to it using the algorithms we proposed in [11]. Then it looks for the closest anchor point from the end of the first piece of narrative, and generates a piece of narrative related to the second anchor point. Depending on the distance between these two segments, it decides whether they should be intertwined, and if so interweaves them using the algorithms we proposed in [2]. At this point, the user is given a chance to respond. If the user's input can be mapped to a node in the knowledge base, it will become a special anchor point – the agent will generate a narrative segment that is more focused around it than for other anchor points, and this segment will not be intertwined with other narrative segments. After addressing the user's query, the agent will go on to the next cycle of deciding the next anchor point which will be based on the end of the description so far.

Currently, the algorithms distribute the anchor points evenly in the presentation/ interaction, i.e. each anchor point is followed by the same number of related topics, and keeps the total number of turns fixed. If the user interacts, the lengths of narrative segments related to all later anchor points would be reduced to maintain the overall length of the presentation/interaction. The **Analogy_and_Contrast** function is called upon at the end of each piece of narrative for making a comparison between the current and the previous anchor points if applicable, and thus reinforcing the connections between different parts of the narration.

Algorithm 1 – **Anchor_Point_Narration** – provides the overall flow of how the presentation agent works with anchor points. The **Narrative_Sequence** function generates a sequence of nodes to talk about from the anchor point (line 8) based on our previous work in [11]. Each node in the sequence represents a turn in the presentation, and the turn count is updated accordingly (line 12). It will also try to form an analogy or contrast with the previous anchor point visited using the **Analogy_and_Contrast**

function (line 9). The next anchor point to visit is decided from the last node in the sequence by the **Next_Anchor** function (line 11). For each pair of sequences, a combined sequence is created using the **Interweave** function, which will either interweave the two sequences or simply place one before the other (line 18). Finally, after the two sequences are presented (line 22), the user is given a conversation turn to respond.

| |
|---|
| 1 **Algorithm 1. Anchor_Point_Narration** *(ANCHORS, turn_limit)* |
| 2     *ANCHORS*                    // A set of anchor points |
| 3     *turn_limit*                    // how many turns total the conversation can go |
| 4     *ANCHORS_VISITED = {}*   // Anchor points that have been visited |
| 5     *current_anchor = ANCHORS.first* |
| 6     *turn = 1* |
| 7     **while** *ANCHORS* is not empty |
| 8         *SEQUENCE1*   =   **Narrative_Sequence**   *(current_anchor,   turn,   turn_limit,   ANCHORS.length)* |
| 9         **Analogy_and_Contrast** *(current_anchor, ANCHORS_VISITED.last)* |
| 10        **move** *current_anchor* from *ANCHORS* to *ANCHORS_VISITED* |
| 11        *current_anchor* = **Next_Anchor***(ANCHORS, SEQUENCE1.last)* |
| 12        *turn = turn + SEQUENCE1.length* |
| 13        *SEQUENCE2*   =   **Narrative_Sequence**   *(current_anchor,   turn,   turn_limit,   ANCHORS.length)* |
| 14        **Analogy_and_Contrast** *(current_anchor, ANCHORS_VISITED.last)* |
| 15        **move** *current_anchor* from *ANCHORS* to *ANCHORS_VISITED* |
| 16        *turn = turn + SEQUENCE2.length* |
| 17        *current_anchor* = **Next_Anchor** *(ANCHORS, SEQUENCE2.last)* |
| 18        *COMBINED_SEQUENCE* = **Interweave** *(SEQUENCE1, SEQUENCE2)* |
| 19 |
| 20        **Present** *(COMBINED_SEQUENCE)* |
| 21 |
| 22        *user_anchor* = **Userresponse***()* |
| 23        **if** *(user_anchor* is not null) |
| 24            *ANCHORS*.**add** *(user_anchor)* |
| 25            *RESPONSE_SEQUENCE*  =  **User_Sequence**  *(user_anchor,  turn,  turn_limit,  ANCHORS)* |
| 26            **move** *user_anchor* from *ANCHORS* to *ANCHORS_VISITED* |
| 27            *current_anchor* = **Next_Anchor** *(ANCHORS, RESPONSE_SEQUENCE.last)* |
| 28        **end if** |
| 29    **end while** |

**Next_Anchor** *(ANCHORS, p)* -- Using the algorithms proposed in [11], this function picks the next node in *ANCHORS* to follow node *p*, by optimizing the narrative objectives the narration agent has, e.g. satisfying hierarchical and spatial ordering constraints in its description.

**Analogy_and_Contrast** *(p, q)* – This function compares and summarizes the links *p* and *q* have and their destination nodes, e.g. "both the Novgorod Republic and the Pskov Republic's religion is the Eastern Orthodox Church." We have multiple templates for the agent to randomly choose from for generating the summaries. If the two nodes do not share anything in common, no output will be produced.

## 3.2    Form Narrative Around Anchor Points

The **Narrative_Sequence** and **User_Sequence** functions take an anchor point – *anchor*, the current turn of conversation – *turn*, the overall turn limit for the conversation – *turn_limit*, and the number of anchor points left to talk about besides the one passed in – *anchors_left* as input. Both functions calculate how many turns the sequence should be so that each remaining anchor point can be given an equal number of turns before the turn limit is reached (line 6). It will then generate a sequence of nodes. From each node, the next node to add is identified using the **Chose_Next_Topic** function (line 9) described in [11]. In the **Narrative_Sequence** function, the next node is chosen relative to the previous node. The **User_Sequence** function always picks the next node based on the user-specified anchor point, rather than the last picked node. As a result, the presentation will be more centered on the user's interested node. Otherwise, the user-specified anchor point is handled the same as other anchor points. Algorithm 2 – **Narrative Sequence** – is presented below. The **User_Sequence** function is exactly the same as Algorithm 2, except that in line 9, the **Chose_Next_Topic** function takes *anchor* as its input, rather than *SEQUENCE.last*.

| |
|---|
| 1 **Algorithm 2. Narrative_Sequence** *(anchor, turn, turn_limit, anchors_left)* |
| 2    *anchor*        // the anchor point to generate a sequence off of |
| 3    *turn*          // the current conversation turn |
| 4    *turn_limit*   // how many turns in total the conversation can go |
| 5    *anchors_left*   //How many anchor points are left. |
| 6    *sequence_length* = **floor**((*turn_limit —turn*)/*anchors_left*) |
| 7    *SEQUENCE* = *{anchor}* |
| 8    **for** (*i* from 0 to *sequence_length*) |
| 9        *next_node* = **Chose_Next_Topic** *(SEQUENCE.last)* |
| 10        *SEQUENCE*.**add**(*next_node*) |
| 11    **end for** |
| 12    **return** *SEQUENCE* |

## 3.3    Interweave Storylines

Algorithm 3 judges whether interweaving is needed, and if so interweaves two storylines. This function is proposed in [2]. Because it plays an important role in generating the example output in Sect. 4, we briefly review it here. The function **Interweave** takes two node sequences, *P* and *Q* as input. Without interweaving, the second storyline is simply placed behind the first (line 23). Interweaving is performed when the last node of the first storyline and the first node of the second storyline are far away from each other (line 5), which may lead the user to feel a disconnection between the two storylines. Here distance is simply measured as the Euclidian distance between the two nodes in the knowledge base.

When interweaving happens, the first storyline is split into two parts, and the second storyline is placed between them (line 20). The node in the first storyline where the split occurs is called the switch point. At the switch point, information that will be

presented in the second part of the first storyline is hinted at relative to information already presented in the first part of the first storyline through the **HINT-AT** function (line 17). To maximize this foreshadowing, the switch point is determined by picking the node where the most number of links exist between the nodes prior to it and after it (line 6–7). Each foreshadowing is later resolved in the second half of the first storyline when $w$ is visited. To relate the second storyline to the first storyline and take advantage of the context that the first storyline gives us, nodes in the second storyline are related to nodes in the first half of the first storyline using the **TIE-BACK** function (line 12). When using **HINT-AT,** or **TIE-BACK,** we have multiple templates for the agent to randomly choose from to prevent the appeared repetition in the final narration.

| |
|---|
| 1 **Algorithm 3. INTERWEAVE** *(P, Q, t)* |
| 2    *P*                                       // first storyline, a list of nodes |
| 3    *Q*                                       // second storyline, a list of nodes |
| 4    *t*                                        // threshold relatedness value |
| 5    **if relatedness**(*P.end, Q.first*) < *t* **then** |
| 6       *j* = **index** *j of P* where **MAX**(# of edges from each *P[n]*, |
| 7                  *n <= j* to each *P[k], k > j*) // switch point |
| 8       *P1* = *{P[0] through P[j]}*        //1<sup>st</sup> half of the first storyline |
| 9       *P2* = *{P[j+1] through P.end}* //2<sup>nd</sup> half of the first storyline |
| 10      **for** each node *q in Q* |
| 11         **if** *q* is neighbors with any node *p in P1* **then** |
| 12            **TIE-BACK***(q, p)* |
| 13         **end if** |
| 14      **end for** |
| 15      **for** each node *p in P1* |
| 16         **if** *p* is neighbors with any node *w in P2* **then** |
| 17            **HINT-AT***(p, w)* |
| 18         **end if** |
| 19      **end for** |
| 20      **return** *{P1 + Q + P2}* |
| 21   **end if** |
| 22   **else** |
| 23      **return** *{P + Q}* |
| 24   **end else** |

**TIE-BACK***(q, p)* -- Relate information in node *q* from the second storyline back to information in node *p* from the first storyline, e.g. "We mentioned Latin before. Latin is in the language family Latino-Faliscan languages." Here is *q* is "Latino-Faliscan languages," and *p* is "Latin." The link between them is "Language family."

**HINT-AT***(p, w)* — Allude to undisclosed information for node *p* from the first half of the first storyline based on relationship to node *w* from the second half of the first storyline, e.g. "We'll hear more about what places Latin was a common language in soon." This will be resolved when node *w* is visited, e.g. "I said earlier we'd hear more about the places where Latin was a common language. As it turns out, the Western Roman Empire's common language was Latin." Here *p* is "Latin," and *w* is "Western Roman Empire." The link between them is "Common language."

# 4  Example Output

In this section, we present a 20-turn transaction of the agent presenting knowledge about ancient Rome to a user and interacting with the user. For succinctness in the presentation, we only allowed the user to interact once. The transaction is annotated for illustrating the working of our algorithms. The annotation lines always start with "Note," and other lines start with their turn ID. In the presentation, all the system generated text is enclosed in braces. This includes the sentences for contrasting two anchor points, the sentences for interweaving two story lines, and the transition phrases for connecting two topics. In particular, the system added a transition sentence at the beginning of each paragraph for helping the user understand the relationships between two adjacent topics mentioned by the system. This sentence is simply constructed by linking the names of the two nodes with the type of link between them. If the two nodes are not related, it will use a general lead in phrase, such as "I'll also mention the Roman Republic." The rest of the sentences come directly from DBPedia.

We include a rather extensive example below to demonstrate the capacity of our algorithms for generating reasonable presentations. The anchor points used for this presentation are Italica, the Pskov Republic, the Novgorod Republic, and Vulgar Latin. Italica is chosen as the first topic.

---

*Note: Turn 1 has intro phrase. The first anchor point, Italica, is visited on turn 1.*
1. {First, let's talk about Italica.} Italica is a magnificent and well-preserved Roman city and the birthplace of Roman Emperors Trajan and Hadrian. The modern town of Santiponce overlies part of the pre-Roman Iberian settlement and the Roman city.
2. {Italica's culture was Ancient Rome.} Ancient Rome was an Italic civilization that began on the Italian Peninsula as early as the 8th century BC.
3. {Ancient Rome's common language was Latin.} Old Latin had been standardized into Classical Latin.

*Note: Turn 4, a switch occurs as the two anchor point storylines interweave. Switch point is node Latin. Turn 4 starts by promising more information in the future, when the first storyline resumes. Second anchor point, Vulgar Latin, is visited on turn 4, and the second storyline begins.*
4. {We'll hear more about what places Latin was a common language in soon. But now, let's talk about something else. Vulgar Latin is in the language family Latin.} Vulgar Latin is a generic term for the nonstandard. In Renaissance Latin, Vulgar Latin was called vulgare Latinum or Latinum vulgare.

*Note: Turn 5, we draw a connection between a node in the second storyline, Latino-Faliscan languages, and a node in the first half of the first storyline, Latin.*
5. {Vulgar Latin belongs to the family of Latino-Faliscan languages.} The Latino-Faliscan languages are a group of languages that belong to the Italic language family of the Indo-European languages. {We mentioned Latin before. Latin is in the language family Latino-Faliscan languages. }

*Note: Turn 6, another connection is made to Latin (as in turn 5).*
6. {Now, let's talk about Classical Latin.} Classical Latin is the modern term used to describe the form of the Latin language recognized as standard by writers of the late Roman Republic and the Roman Empire. {And do you remember Latin? Well, Classical Latin is in the language family Latin. }

7. {Quintus Curtius Rufus was part of the movement for Classical Latin.} Quintus Curtius Rufus was a Roman historian, probably of the 1$^{st}$ century, author of his only known and only surviving work, *Historiae Alexandri Magni*, "Histories of Alexander the Great," or more fully *Historiarum Alexandri Magni Macedonis Libri Qui Supersunt*, "All the Books That Survive of the Histories of Alexander the Great of Macedon."
8. {Quintus Curtius Rufus' occupation was as a historian.} A historian is a person who researches, studies, and writes about the past, and is regarded as an authority on it.

*Note: Turn 9, the first storyline resumes. Turn 9 starts by reminding the user of the anchor point for the first storyline -- Italica, as well as the last node mentioned from the first storyline -- Latin. It then resolves the promise for further information when the first storyline was suspended in the last sentence.*
9. {Let's get back to what we were discussing before with Italica. When we left off, we were talking about Latin. I should touch on the Western Roman Empire.} In historiography, the Western Roman Empire consists of the western provinces of the Roman Empire at any one time during which they were administered by a separate independent Imperial court, coequal with after the death of Western Emperor Julius Nepos, and proclaimed himself sole emperor of the Roman Empire. {I said earlier we'd hear more about what places Latin was a common language. As it turns out, the Western Roman Empire's common language was Latin. }

*Note: User turn, user asks for more information about the node Classical Latin seen before.*
User: Tell me about Classical Latin.

*Note: Turn 10, the agent starts talking about the new user-requested anchor point -- Classical Latin. A comparison is made between Classical Latin and Vulgar Latin -- the previous anchor point.*
10. {Quintus Curtius Rufus was part of the movement for Classical Latin.} Classical Latin is the modern term used to describe the form of the Latin language recognized as standard by writers of the late Roman Republic and the Roman Empire. {We were talking about Vulgar Latin earlier, and I want to highlight it again. Both Classical Latin and Vulgar Latin were spoken in the Roman Empire, and the Roman Republic. Latin was also spoken in the Roman Kingdom. Both Classical Latin and Vulgar Latin are in the family Latin. }
11. {Classical Latin is Late Latin's ancestor.} Late Latin is the scholarly name for the written Latin of Late Antiquity.
12. {I'll also mention the Roman Republic.} The Roman Republic was the period of ancient Roman civilization beginning with the overthrow of the Roman Kingdom, traditionally dated to 509 BC, and ending in 27 BC with the establishment of the Roman Empire.

*Note: Turn 13, user-requested anchor point discussion ends and the next anchor point -- Pskov Republic -- is visited.*
13. {Now, let's talk about the Pskov Republic.} Pskov, known at various times as the Principality of Pskov or the Pskov Republic, was a medieval state on the south shore of Lake Pskov.
14. {The Pskov Republic's government type is mixed government.} Mixed government (or a mixed constitution) is a form of government that combines elements of democracy, aristocracy, and monarchy, making impossible their respective degenerations (conceived as anarchy, oligarchy and tyranny)

*Note: Turn 15, a switch occurs as the two anchor point storylines interweave. Switch point is the node Mixed Government. Turn 15 starts by promising more information in the future, when the first storyline resumes. The third anchor point, Novgorod Republic, is visited on turn 15,*

*and the second storyline begins. A comparison is made between the Novgorod Republic and the Pskov Republic.*

15. {We'll hear more about other mixed governments later, too. I'd like to mention something else. The Novgorod Republic's government is a mixed government.} The Novgorod Republic was a medieval East Slavic state from the 12$^{th}$ to 15$^{th}$ centuries, stretching from the Baltic Sea to the northern Ural Mountains, including the city of Novgorod and the Lake Ladoga regions of modern Russia. {We mentioned the Pskov Republic earlier, and I want to highlight it again. Both the Novgorod Republic and the Pskov Republic's religion is the Eastern Orthodox Church. Both the Novgorod Republic and the Pskov Republic's government type is mixed government.}

*Note: Turn 16, information in the second storyline, the Eastern Orthodox Church, is related to information from the first storyline —the Pskov Republic.*

16. {The Novgorod Republic's religion is the Eastern Orthodox Church.} The Eastern Orthodox Church, officially the Orthodox Catholic Church, also referred to as the Orthodox Church, Eastern Orthodoxy, and Orthodoxy, is the second largest Christian Church in the world, with an estimated 225–300 million adherents. {And do you remember the Pskov Republic? Well, the Pskov Republic's religion is the Eastern Orthodox Church. }

17. {Constantine the Great is venerated in the Eastern Orthodox Church.} Constantine the Great is a significant figure in the history of Christianity.

18. {Constantine the Great held the title of Roman emperor.} The Roman emperor was the ruler of the Roman State during the imperial period until the Ottoman Empire ended in 1922.

19. {Trajan held the title of Roman emperor.} Trajan was Roman emperor from 98 AD until his death in 117 AD. Officially declared by the Senate optimus princeps ("the best ruler"), Trajan is remembered as a successful soldier-emperor who presided over the greatest military expansion in Roman history, leading the empire to attain its maximum territorial extent by the time of his death.

*Note: Turn 20, the second storyline ends and the first storyline resumes. The user is reminded of the anchor point of the first storyline, the Pskov Republic, and the node that the storylines switched from, mixed government. Promised information is given as well about mixed government.*

20. {Let's get back to what we were discussing before about the Pskov Republic. When we left off, we were talking about mixed government. Trajan was a leader of the Roman Empire.} The Roman Empire was the post-Roman Republic period of the ancient Roman civilization, characterized by government headed by emperors and large territorial holdings around the Mediterranean Sea in Europe, Africa and Asia. {As it turns out, the Roman Empire's government type is mixed government.}

---

By the turn limit of 20, all four anchor points fed into the system, as well as the 5$^{th}$ anchor point requested by the user, have been visited.

## 5    Discussion and Future Work

As shown in Sect. 4, though not as effective as a human presenter, the narration agent can generate a fairly long piece of presentation with reasonable readability. It addressed all the anchor points, as well as the user's request. In general, our algorithm prevents the agent from repeatedly talking about the same or similar content. However, when the

user explicitly asked about a topic, even though it had been presented before - Classical Latin was presented in turn 7 - the agent was able to go back to the topic and look for related information that had not been mentioned (turn 10). This way, the agent is reactive to the user, and at the same time always tries to provide new information.

The agent tried to help the user understand and remember the content by forecasting its future narration plans, e.g. "We'll hear more about other mixed governments later." It also constantly tries to establish relationships with content that has been talked about before, e.g. "And do you remember the Pskov Republic?" We haven't formally evaluated the effectiveness of these techniques yet. It is part of our planned future work to conduct evaluations with human subjects on the readability, comprehensibility, and interestingness of the generated text, as well as to examine the effectiveness of our approach for helping people explore and remember information.

In addition, we have planned future work in several directions for improving the generated presentation. First of all, we want our agent to have some common sense about what the user would normally know. Thus, the agent won't try to explain points that are obvious to the user. For example, in turn 6 the agent says "And do you remember Latin? Well, Classical Latin is in the language family Latin." Computationally, the agent tries to illustrate the relationship between the two concepts, in the same way as when it says, "The Novgorod Republic's religion is Eastern Orthodox Church." However, Classical Latin and Latin are obviously related and therefore the sentence sounds redundant. In turn 8, the agent explains what a historian is, which again is not necessary.

Secondly, we want to reduce the redundancy in generated text. Currently the same information may be used and presented multiple times by multiple functions. For example, in turn 15 when comparing the two anchor points – the Novgorod Republic and the Pskov Republic – the system has already said, "both the Novgorod Republic and the Pskov Republic's religion is the Eastern Orthodox Church." However, in turn 16 the same information is repeated in the lead-in phrases, as well as in the tieback sentence by the end.

Thirdly, we want to improve the technique for generating multiple intertwined storylines. Currently, our narration algorithm is only able to combine two storylines. As a result, when there are more than two anchor points, we divide them into pairs, e.g. 1 & 2 and 3 & 4 and decide on whether the storylines need to be intertwined for each pair. This way, there is no way to prevent the user from experiencing a disconnect between topics related to anchor points 2 and 3.

Finally, we will be searching for a better algorithm for automatically distributing the anchor points in the narration based on their relationships. Currently, they are evenly distributed, i.e. we spend equal effort introducing each anchor point. This works most of the time because the anchor points are relatively far from each other. If we have significantly more anchor points, we will probably want to group them together to reduce the chance of presenting repeated content.

# References

1. Abbott, H.P.: The Cambridge Introduction to Narrative. Cambridge University Press, Cambridge (2008)
2. Battad, Z., Si, M.: Using multiple storylines for presenting large information networks. In: Proceedings of the International Conference on Intelligent Virtual Agents (IVA). Springer, (2016)
3. Bizer, C., Lehmann, J., Kobilarov, G., Auer, S., Becker, C., Cyganiak, R., Hellmann, S.: Dbpedia - a crystallization point for the web of data. Web Seman. Sci. Ser. Agents WWW **7** (3), 154–165 (2009)
4. Bruner, J.: The narrative construction of reality. Crit. Inq. **18**, 1–21 (1991)
5. André, E., Rist, T., Van Mulken, S., Klesen, M., Baldes, S.: The automated design of believable dialogues for animated presentation teams. In: Embodied Conversational Agents, pp. 220–255 (2000)
6. Cassell, J., Bickmore, T., Billinghurst, M., Campbell, L., Chang, K., Vilhjálmsson, H., Yan, H.: Embodiment in conversational interfaces: Rea. In: Proceedings of the SIGCHI conference on Human Factors in Computing Systems, pp. 520–527. ACM (1999)
7. Binsted, K., Luke, S.: Character design for soccer community. In: Asada, M., Kitano, H. (eds.) RoboCup 1998. LNCS (LNAI), vol. 1604, pp. 22–33. Springer, Heidelberg (1999)
8. Liu, H., Singh, P.: ConceptNeta practical commonsense reasoning tool-kit. BT Technol. J. **22**(4), 211–226 (2004)
9. Nelson, K.: Narratives from the Crib. Harvard University Press, Cambridge (1989)
10. Perry, W.: Thorndyke: cognitive structures in comprehension and memory of narrative discourse. Cogn. Psychol. **9**(1), 77–110 (1977)
11. Si, M.: Tell a story about anything. In: Schoenau-Fog, H., Bruni, L.E., Louchart, S., Baceviciute, S. (eds.) ICIDS 2015. LNCS, vol. 9445, pp. 361–365. Springer, Heidelberg (2015). doi:10.1007/978-3-319-27036-4_37
12. Kopp, S., Gesellensetter, L., Krämer, N.C., Wachsmuth, I.: A conversational agent as museum guide – design and evaluation of a real-world application. In: Panayiotopoulos, T., Gratch, J., Aylett, R.S., Ballin, D., Olivier, P., Rist, T. (eds.) IVA 2005. LNCS (LNAI), vol. 3661, pp. 329–343. Springer, Heidelberg (2005)
13. Wilkens, T., Hughes, A., Wildemuth, B.M., Marchionini, G.: The role of narrative in understanding digital video: an exploratory analysis. In: Proceedings of the Annual Meeting of the American Society for Information Science, pp. 323–329 (2003)
14. Swartout, W., et al.: Ada and grace: toward realistic and engaging virtual museum guides. In: Allbeck, J., Badler, N., Bickmore, T., Pelachaud, C., Safonova, A. (eds.) IVA 2010. LNCS (LNAI), vol. 6356, pp. 286–300. Springer, Heidelberg (2010). doi:10.1007/978-3-642-15892-6_30

# Delayed Roles with Authorable Continuity in Plan-Based Interactive Storytelling

David Thue[(✉)], Stephan Schiffel, Ragnar Adolf Árnason,
Ingibergur Sindri Stefnisson, and Birgir Steinarsson

School of Computer Science, Reykjavik University,
Menntavegur 1, Reykjavik 101, Iceland
{davidthue,stephans,ragnara13,ingibergur13,birgir15}@ru.is

**Abstract.** We present a plan-based story generator that allows authors to ensure continuity over the entities in a story without committing to which entities will fulfill the story's roles. By combining the ideas of authorable continuity and delayed role assignment in a plan-based storytelling context, our solution obtains benefits from both and mitigates some disadvantages. We introduce two notions of soundness for solutions that combine these ideas and then prove the soundness of our approach.

## 1  Introduction

Continuity is important in storytelling. In addition to being associated with enhanced feelings of meaning, it can aid in improving an audience's understanding of a story [6]. In interactive storytelling, the ability to delay authoring decisions until run-time is also important; it affords more opportunities to gather information about the audience before each decision is made, and it helps to avoid the pitfalls of having pre-made decisions thwarted by unexpected interactions [10]. In the context of plan-based interactive storytelling, the most common way to ensure continuity for the entities in a story (including characters, objects, locations, etc.) has been to name specific entities as part of an Artificial Intelligence (AI) planning problem [1,7–9] (e.g., Red should start the story at home, and have been distracted and eaten by the Wolf before the story ends). In the context of delayed authoring, however, naming specific entities in advance is both presumptive (e.g., the audience might prefer a different villain) and prone to failures (e.g., the Wolf might be killed before it can distract Red). Writing a less specific planning problem (e.g., stating that Red must be both distracted and eaten, but not by whom) can help avoid these problems [9], but doing so compromises the author's ability to ensure continuity; Red might be distracted by one character and eaten by another. Is there a way to author continuity for story entities without requiring specific ones to be named? The concept of *roles* – abstract versions of story entities that can be assigned to concrete entities just-in-time [5] – hints at a solution: allow authors to define and constrain a set of roles, and have them specify the story's progression constraints using those roles. For example: "Given a Hero and a Villain such that the Villain can eat the

F. Nack and A.S. Gordon (Eds.): ICIDS 2016, LNCS 10045, pp. 258–269, 2016.
DOI: 10.1007/978-3-319-48279-8_23

Hero, the Hero must start at home and have been distracted and eaten by the Villain before the story ends." While this specification permits both authorable continuity and the delayed assignment of roles, it complicates the task of plan-based story generation. Which entities should be available for the planner to use, and how can we ensure that the planner's output will always permit a valid assignment of roles to concrete entities?

In this paper, we explore the challenge of enabling both delayed role assignment and authorable continuity in a plan-based storytelling context. We begin by analyzing the problem, noting its differences from related tasks and demonstrating key properties that its solution must hold to ensure that valid role assignments can be made. We follow with a discussion of related work. We then present an algorithmic solution with the desired properties, prove two aspects of its soundness, and discuss our initial implementation of it using an off-the-shelf planner. We conclude by reviewing our solution's benefits and limitations and offering some suggestions for future work.

## 2    Problem Formulation

We wish to extend plan-based story generation in a way that supports both authorable continuity and delayed role assignment. We clarify each of these terms in this section and follow with our analysis of the problem.

In plan-based story generation, a story is represented as a plan. A *plan* is a sequence or partial order of *operators*, each of which transforms the state of the story's world to bring it from some initial state to some desired state. Each *state* is represented as a conjunction of logical predicates, each of which describes some property of one or more entities in the world (e.g., Knows/(Wolf, Red)). A *planning domain* specifies the set of possible operators and the set of possible predicates, and a *planning problem* specifies the initial and desired states of the world. A *planner* is software that accepts a domain and a planning problem and automatically outputs a plan (if one exists) which, when executed, transforms the problem's initial state to its goal state. *Executing a plan* means applying each of its operators to the world state in the order that the plan specifies.

In general, we say that an Interactive Storytelling (IS) system supports *authorable continuity* (AC) if it allows authors to: (i) describe constraints over a set of story entities, (ii) assert that different constraints should hold for those entities at different times in the story, and (iii) rely on the IS system to ensure that the given constraints are respected at the appropriate times during the story's execution. Plan-based systems usually support authorable continuity inherently, as their initial and goal states can require different predicates to hold for any specific entity at different times in the story. For example, one could author a plan-based story in which Red is hungry at the beginning and not hungry at the end. However, as we explain later on, in plan-based systems that also support delayed role assignment, support for authorable continuity is *not* guaranteed.

We say that an IS system supports *delayed role assignment* (DRA) if it allows authors to: (i) refer to the entities of a story using abstract terms (which are

often called *roles* [5,11]), (ii) describe constraints governing how each abstract term should be assigned to a concrete story entity in the story's world, and (iii) rely on the IS system to assign each abstract term to a concrete entity at run-time, in a just-in-time way that respects the authored constraints.

Taken together, our desire to support both authorable continuity and delayed role assignment leads to the following requirements. In every solution to our problem, authors must be able to:

1. use abstract roles to refer generally to story entities (DRA i, AC i);
2. assert that different constraints should hold for the abstract roles at different times in the story (DRA ii, AC ii); and
3. rely on an IS system to ensure:
   (a) that every abstract role is assigned just-in-time to a concrete entity that respects the role's constraints (DRA iii), and
   (b) that every given constraint is respected at the appropriate time during the story's execution (AC iii).

## 2.1    Problem Analysis

To present our analysis of this problem, we consider it from two common perspectives in the field of Artificial Intelligence: planning and constraint satisfaction.

From the perspective of AI planning, we wish to construct and solve a planning problem that refers to a given set of abstract roles as entities in its initial state and goals (to meet requirements 1 & 2). To meet requirement 3a, the operators in the output plan must also use these abstract roles. Furthermore, it is important to guarantee that the planner will never return a plan which, by some properties of the operators therein, makes it impossible to assign one or more of its abstract roles. We will refer to solutions that uphold this guarantee as being *plan-sound*. Without this guarantee, it would be possible to obtain a plan containing some operators that could never be executed.

In addition to abstract roles, it is desirable for the plan to also involve concrete entities from the story's world. There are two reasons why. First, consider the case in which the planner could only use the given abstract roles as entities in its plans. If an author decided to specify a story with only a few abstract roles and a few constraints over them, the planner's operation would be severely restricted; it could only begin the plan with operators whose preconditions were satisfied by the given (few) constraints, and it could only use operators whose parameters could be filled by the given (few) abstract roles. For example, an operator requiring three entities could not be used if only two abstract roles had been given to the planner. If concrete entities could be used by the planner in addition to the abstract roles, these restrictions would be eased. Second, having more entities and relations available to the planner allows a wider variety of plans to be created. Henceforth, we refer to the kind of plan that we desire as *semi-abstract*, since it involves both abstract roles and concrete entities.

Creating semi-abstract plans is non-trivial. While it is common for *least commitment planners* to leave certain variables unbound during the planning process

(see [13] for a review), what we aim for is different. First, a semi-abstract plan's "variables" (i.e., abstract roles) arise as inputs to the planner, rather than being created by the planner during least-commitment planning. Second, we require roles to remain unbound in the final plan, rather than being bound before the plan is returned. Furthermore, while one could modify such a planner to leave some variables unbound in the final plan, more (and potentially extensive) modifications would be required to ensure that plan-soundness was maintained. We present an alternative in Sect. 4, wherein we obtain semi-abstract plans by automatically augmenting the inputs of an unmodified, off-the-shelf planner.

From the perspective of constraint satisfaction, we wish to solve a constraint satisfaction problem incrementally (e.g., for just one entity at a time) at runtime (to meet req. 3a). Specifically, given a set of roles and a set of constraints between them, we wish to assign each role to some concrete entity in the story's world in a way that respects those constraints (to meet req. 3b). Furthermore, we wish to do so in a just-in-time fashion; by delaying each step of the assignment until the moment that it becomes necessary, the benefits of delayed authoring can be brought within reach[1]. For the solution to be sound, we must guarantee that no (prior) step of the assignment can make it impossible to perform a later step. We will refer to solutions that uphold this guarantee as being *assignment-sound*. As we noted earlier, the interdependence of assignment steps precludes simply tweaking a least-commitment planner to leave some variables unbound.

At what point does each step of an assignment become necessary? Given a semi-abstract plan, its operators can be executed (perhaps in parallel) according to their partial order in the plan. Operators that involve only concrete entities can be executed immediately, but operators that involve abstract roles must have each of their roles assigned to a concrete entity before all of their preconditions can be checked. Therefore, for a given abstract role $r$ and semi-abstract plan $p$, we say that $r$'s assignment *becomes necessary* the first time that the execution of $p$ needs to check the preconditions of an operator that involves $r$.

While different types of *narrative mediation* [8] could conceivably be used to work around impossible assignments (e.g., by finding a different plan), we instead seek to discover whether a solution exists that is both plan-sound and assignment-sound, and if so, how it might be made.

## 3    Related Work

Fairclough's OPIATE [2] used *case-based planning* to automatically adapt a set of hand-authored plans that involved abstract roles, and it assigned concrete entities to roles just-in-time as the plan was executed. Authors could create plans for the case base that constrained the same abstract characters at different times in the story. OPIATE technically meets the solution requirements that we stated in Sect. 2, but it assumed that every planning operator would be tightly coupled to a particular role in a story-universal set (e.g., the Victory operator could only ever be performed by the Hero). It could thus only generate stories that had

---

[1] A discussion of how these might be seized is beyond the scope of this paper.

roles from this set; generating stories with different roles would require both a new set of operators and a new case base. Our solution can generate stories with different roles using a single set of operators (and no case base).

As we noted in Sect. 2, when delayed role assignment is *not* part of a given IS system, plan-based story generation inherently supports authorable continuity; the initial and goal states allow constraints to be specified over any of the entities that could be involved in the plan, and they each describe different time points in the story. While previous attempts to add delayed role assignment to such systems have supported authorable continuity for concrete entities, there has been no similar support for abstract roles. For example, Riedl & Stern's Automated Story Director [9] could change which characters would achieve certain important world states (e.g., different agents could cause unrest in a marketplace), but there was no way for an author to create constraints for an abstract role (e.g., UnrestCauser) that spanned different points of time in the story's progression. Similarly, a system by Porteous and Cavazza [7] used *state constraints* to allow authors to constrain story entities at arbitrary points in the story's progression (not just the initial and goal states), but these entities could only be concrete. Barber's GADIN [1] allowed authors to describe and constrain abstract roles in the context of *dilemmas* (states requiring a character to choose between two costly actions), and it assigned concrete entities to each dilemma's roles at runtime. However, GADIN only used its planner *after* all assignments were complete; it thus did not support authorable continuity for its abstract roles.

Thue et al.'s PaSSAGE [11] allowed authors to constrain abstract roles that it then assigned just-in-time during the story, and constraints could be specified for any role across different times of the story (e.g., a Rival met early in the story could appear again later on). However, while PaSSAGE thus supported both delayed role assignment and authorable continuity, it did not use a planner to generate its stories; it relied instead on a pre-authored tree of possible events.

## 4    Proposed Approach

We now present a novel extension to plan-based story generation that supports both authorable continuity and delayed role assignment. To structure our presentation, we consider each of our stated solution requirements in turn (Sect. 2).

To allow authors to both refer to story entities generally using abstract roles (req. 1) and assert that different constraints should hold for those roles at different times in the story (req. 2), we adopt Thue & Halldórsson's notion of an *outline* [12]. An outline is a construct that allows authors to specify both a set of abstract story entities (i.e., roles) and constraints over them that should hold at different times during a story (e.g., Roles: Hero, Villain; Initial State: CanEat(Villain, Hero); Goal State: Distracted(Villain, Hero) ∧ Ate(Villain, Hero)). Each outline can be used to generate multiple varied stories.

Meeting reqs. 3a (enabling just-in-time role assignment) and 3b (ensuring correct plan execution) is more complicated. At a high level, we: (i) construct a semi-abstract planning problem from the outline and the story world's current

state, (ii) find a relaxed solution for assigning the outline's roles and add this to the planning problem, (iii) solve the plan, letting a planner explore potential role assignments alongside choosing operators for the plan, (iv) post-process the plan to recover any new role constraints and "forget" the planner's assignments, and (v) execute the plan, assigning roles to concrete entities when doing so becomes necessary. We describe these steps in the following paragraphs.

## 4.1 Detailed Approach

We first need a way to generate semi-abstract plans (Sect. 2.1). While any outline's constraints can be used to define a completely abstract planning problem, concrete entities and relations are needed to make a problem that can yield semi-abstract plans. For a given outline, we meet this need as follows. We begin by defining the initial state of a planning problem as the union of three components: (i) the outline's initial state, (ii) the current state of the story world, and (iii) a set of extra CanBe relations. $CanBe(r, c)$ is a predicate that relates an abstract role $r$ to a concrete entity $c$; it is true only when assigning $r$ to $c$ is part of a valid complete assignment for the outline's roles, given their constraints (i.e., when $r$ "can (safely) be" $c$). We use a constraint solver to compute the CanBe relations just prior to building the planning problem. In general, if $r$ is assigned to $c$ in *any* solution, $CanBe(r, c)$ will be true (even if $r$ cannot be $c$ in *some* solutions). Doing so is a relaxation of the problem that temporarily ignores any potential interdependence between roles, which allows the planner to start exploring potential assignments as part of its search. The interdependence of roles is accounted for during the planning process, as we describe later on.

To allow a planner to solve our semi-abstract problem while maintaining *plan-soundness* (Sect. 2), it is necessary to have the planner reason about potential role assignments while it searches for a sequence of operators that meets the plan's goals. We accomplish this task by automatically augmenting the domain of our planning problem. To begin, an author creates a set of predicates for describing the state of the world (e.g., $Knows(c_1, c_2)$) and a set of operators that define how the world can change. The author also uses this set of predicates to specify every constraint in the outline. The operators can be defined using PDDL syntax [3], as sketched in Listing 1 (our entities are PDDL "objects").

Defining an operator consists of specifying its parameters as entity variables and its preconditions and effects as logical statements. Taken together, the authored predicates and operators make up the initial planning domain that we then augment. Two augmentation steps are necessary.

---

**Listing 1.** A simple operator: $c_1$ distracts $c_2$ using $a_1$.

```
1  operator: distract(c₁, c₂, a₁)
2      preconditions: c₁ ≠ c₂ ∧ Knows(c₁, c₂) ∧ Knows(c₁, a₁)
3      effects: Distracted(c₁, c₂) ∧ Knows(c₂, a₁)
```

**4.1.1   A Mapping Operator.** First, we generate a new operator: $map(r, c)$. This operator allows the planner to experiment with assigning roles to concrete entities (e.g., Hero to Red) as it searches for a valid plan that includes the authored operators. Each of these operators records that the assignment is (temporarily) in force using the predicate: Mapped($r$, $c$). For example, if successful, the operator map(Hero, Red) would yield the effect Mapped(Hero, Red).

To ensure both plan-soundness and assignment-soundness, we must only allow the planner to make temporary assignments which, when considered in the context of its previous assignments, correctly satisfy the outline's constraints. For example, if the outline constrained two roles with CanEat(Villain, Hero) and the planner had already "mapped" Hero to Red, then the possible assignments for Villain would need to be restricted to entities that can eat Red. Enforcing this sort of restriction requires extra logic in the preconditions of the map operator, as shown in Listing 2. Line 3 ensures that the planner can only (temporarily) assign each role once, and the CanBe ensures that the planner's first assignment will be part of a valid solution to the outline's constraints.

---

**Listing 2.** The map operator with sample tests of outline constraints.

```
1  operator: map(r, c)
2      preconditions:
3          ¬Bound(r) ∧ Abstract(r) ∧ ¬Abstract(c) ∧ CanBe(r, c) ∧
4          ∀r′, c′ : Abstract(r′) ∧ (r ≠ r′) ∧ Mapped(r′, c′) ⇒
5              [ (CanEat(r, r′) ⇒ CanEat(c, c′)) ∧ ··· ∧ (Knows(r, r′) ⇒ Knows(c, c′)) ]
6      effects: Mapped(r, c) ∧ Bound(r)
```

---

For every role/concrete entity pair that has already been temporarily mapped ($r′$ and $c′$ on line 4), we must verify that the new candidates for mapping ($r$ and $c$) will respect every outline constraint that exists between $r$ and $r′$. In other words, for every outline constraint that holds between $r$ and $r′$, we must ensure that it also holds between $c$ and $c′$. Line 5 shows examples of how testing these constraints might look, but in general these tests are automatically generated to suit the given outline. The map operator is thus unique to each outline. We explain our need for the Bound($r$) predicate in Subsect. 4.1.3.

**4.1.2   Effect Synchronizers.** Our second augmentation to the planning domain involves modifying every authored operator. Once the planner has mapped a role to a concrete entity, it is important for plan-soundness that any effect that occurs to one of the two also occurs to the other. For example, if Hero was mapped to Red, Villain was mapped to Wolf, and the operator distract(Villain, Hero, Flowers) occurred, then the effects that should come true would be more than just Distracted(Villain, Hero) ∧ Knows(Hero, Flowers). Distracted(Wolf, Hero) and Distracted(Villain, Red) should also be true, along with

all of the other variations that can be generated by exchanging roles with concrete entities in each of the effects' parameters. To keep each operator's effects synchronized across roles and concrete entities once they have been mapped, we automatically add new effects to every authored operator, as shown in Listing 3.

---

**Listing 3.** An augmented version of the distract operator from Listing 1.

```
1  operator: distract(c₁, c₂, a₁)
2      preconditions:
       Bound(c₁) ∧ Bound(c₂) ∧ Bound(a₁) ∧ c₁ ≠ c₂ ∧ Knows(c₁, c₂) ∧ Knows(c₁, a₁)
3      effects: Distracted(c₁, c₂) ∧ Knows(c₂, a₁)
4      [ ∀c'₁, c'₂ : (Mapped(c'₁, c₁) ∨ Mapped(c₁, c'₁) ∨ c₁ = c'₁) ∧
5                     (Mapped(c'₂, c₂) ∨ Mapped(c₂, c'₂) ∨ c₂ = c'₂)
6                        ⇒ Distracted(c'₁, c'₂) ]
7      [ ∀c'₂, a'₁ : (Mapped(c'₂, c₂) ∨ Mapped(c₂, c'₂) ∨ c₂ = c'₂) ∧
8                     (Mapped(a'₁, a₁) ∨ Mapped(a₁, a'₁) ∨ a₁ = a'₁)
9                        ⇒ Knows(c'₂, a'₁) ]
```

---

For every possible combination of the operator's parameters that appears in its effects $((c_1, c_2)$ and $(c_2, a_1)$ on line 3), we retrieve all of the roles and concrete entities that have been mapped to or from the terms that the parameters represent (lines 4–5 and 7–8). We then apply each of the effects that use that combination of parameters (one for each combination, in Listing 3) to all possible variations of the parameters and their mapped counterparts (lines 6 and 9).

**4.1.3   Tracking Temporary Assignments.** We use the predicate Bound throughout our solution to track whether or not any role $r$ still needs to be mapped (if so, Bound($r$) will be false). This information is useful in several ways. First, we ensure that the map operator will be used by the planner by adding preconditions in every operator to assert that each of its parameters must be Bound (line 2) n Listing 3). Next, we also ensure that the planner will make use of every role $r$ in the outline by (i) adding Bound($r$) to the goal state of the semi-abstract planning problem for every such $r$ (required for assignment-soundness) and (ii) adding Bound($r$) as an effect of map($r, c$) (line 6 in Listing 2). Finally, to allow the planner to instantiate operators using concrete entities, we add Bound($c$) to the initial state of the problem for every concrete entity $c$.

To continue our example, suppose that the world has the concrete entities {Red, Wolf, Troll, Ogre, Flowers} and an initial state such that the Wolf, Troll, and Ogre all know and can eat Red, and that the Wolf and the Troll know about the Flowers but the Ogre does not. The following is a partial, semi-abstract plan that our approach might generate, with some parts of the story replaced with "…" for brevity: "map(Hero, Red), …, map(Villain,Wolf), distract(Wolf, Red, Flowers), …, eat(Wolf, Red), …". The plan is semi-abstract because it contains both roles (e.g., Hero) and concrete entities (e.g., Flowers).

**4.1.4   Plan Post-processing.** Once a semi-abstract plan has been generated, three post-processing steps are needed. First, every instance of the map operator is removed. Second, since the planner could have instantiated operators that involve mapped concrete entities in their parameters, we must visit each operator in the plan and replace each occurrence of such an entity with the role that it was mapped from (we currently assume that there was only one). We do so to "forget" about the planner's temporary assignments in advance of performing delayed role assignment later on. Applying these two steps to our example plan would yield: "..., distract(Villain, Hero, Flowers), ..., eat(Villain, Hero), ...". Third, we must check the preconditions of every operator that has a role in its parameters. If any precondition that involves roles is satisfied by the world's initial state (which could happen via the role's mapped counterpart), then we must add that precondition as a new constraint on each of the involved roles. In our example plan, the distract operator has the precondition Knows(Villain, Flowers) (recall Listing 3), which, given the planner's temporary mapping of Villain to Wolf, was satisfied by the initial state. As a result, the third post-processing step would add the constraint Knows(Villain, Flowers) to the outline. If this was not done, the role of the Villain could be assigned at runtime to the Ogre (which satisfies CanEat(Villain, Hero) in the outline), and the plan would fail because the Ogre does not know about the Flowers (failing requirement 3b).

**4.1.5   Execution and Delayed Assignment.** Given a post-processed, semi-abstract plan, execution can begin. Similarly to Thue & Halldórsson's approach to execution [12], we keep track of a frontier of operators in the plan; any operator whose preconditions are both satisfied by the current world state and independent from any prior, unexecuted operators are executed in the story's world. However, before a given operator's preconditions can be checked, any unassigned roles that the operator involves must be assigned. To do so, we create a constraint satisfaction problem with the outline's roles and constraints (the latter of which may have been increased during post-processing) as one input and the current story world as the other. To ensure assignment-soundness, we must solve the CSP for *all* of the outline's roles every time that an individual role's assignment becomes necessary. Once one or more solutions are obtained, assignments for the roles in question can be selected using any feasible method. In our example plan, the role of the Villain would be assigned immediately before checking the preconditions of the distract operator. Assuming that the Ogre had not come to know about the Flowers since the story started, the available assignments would be: {Wolf, Troll}.

## 5   Soundness

We are interested in our approach being sound in the two ways that we presented in Sect. 2. First, the plans that are generated must be plan-sound, that is, it must be possible to assign all abstract roles that appear in any operator in the plan. Secondly, we require the incremental solution of the constraint satisfaction

problem to be assignment-sound, that is, no step of the assignment can cause the remaining steps to become impossible to execute. We argue here that our approach ensures both forms of soundness.

**Proposition 1 (Plan-Soundness).** *A legal plan composed of operators augmented as described in Sect. 4 is plan-sound; that is, there exists a mapping $M : R \rightarrow C$ from abstract roles $r \in R$ to concrete entities $c \in C$, such that for every abstract role $r$ appearing in any step of the plan or the goal condition, exchanging every instance of $r$ with $M(r)$ leads to a valid plan involving only concrete entities that achieves the (concrete) goal.*

*Proof* (Sketch) The preconditions of all augmented operators require Bound($r$) for every abstract role $r$ appearing as a parameter of the operator. The only operator resulting in Bound($r$) is map($r, c$), which requires that $c$ be a concrete entity that is similar to $r$ in the sense that whenever $r$ is in a predicate with some other abstract role $r'$ and $r'$ has been mapped to $c'$, $c$ must be in the same predicate with $c'$. Thus $c$ can safely be replaced for $r$ at the time when map($r, c$) would be executed, because it fulfills all the same conditions as $r$, provided that all other roles that $r$ is in predicates with will be replaced in the same way.

Furthermore, by the construction of the augmented operators (Sect. 4.1.2), all effects that apply to any entity (abstract or concrete) are also applied to all entities that are mapped to or from it. Thus, any concrete entity $c$ is similar to the abstract role $r$ that it is mapped from at all times during the plan following the map($r, c$) operator. Thus, $c$ can safely be replaced for $r$ at any time after map($r, c$) in the plan without making the plan invalid.

**Proposition 2 (Assignment-Soundness).** *Let $R$ be the set of all abstract roles occurring in a plan $p$ and $R_p \subset R$. Any partial assignment $M_p : R_p \rightarrow C$ of abstract roles to concrete entities occurring during plan execution (Sect. 4.1.5) can be extended to a full assignment $M : R \rightarrow C$ with $M_p(r) = c \Rightarrow M(r) = c$ for all $r, c$, such that all the constraints are fulfilled.*

*Proof* (Sketch) Proof by induction over the size of $M_p$. Base case: $M_p = \emptyset$ (i.e., no assignment has been made). As given in the final state of the computed plan $p$, Mapped($r, c$) is an extension of $M_p$ to a full assignment that fulfils all constraints, because our approach requires the planner to use and find a mapping for every role $r \in R$ (Sect. 4.1.3).

For the inductive step, assume that $M_p$ is the partial assignment occurring during plan execution just before an operator $o$ that contains an unassigned role $r$ and that there is an extension $M$ of $M_p$ to a full assignment fulfilling all constraints. Our online role-assignment method (Sect. 4.1.5) will pick one of the full extensions as computed by the constraint solver and extend $M_p$ to $M_p' = M_p \cup \{r \mapsto M(r)\}$. Thus, $M$ is also an extension of $M_p'$ to a full assignment.

## 6 Discussion

To the best of our knowledge, this work represents the first attempt since OPI-ATE to combine the three ideas of plan-based story generation, authorable continuity, and delayed role assignment. Unlike OPIATE, our solution supports

the generation of stories with arbitrarily different roles using a single, simply authored domain. Compared to other plan-based IS systems, our solution offers a way to author continuity for story entities without having to name specific ones, which supports increased generative variety. Because all of our augmentations to the planning domain are generated automatically with each new problem, the authoring burden of plan-based storytelling remains nearly unchanged; the only extra work comes from defining the (typically few) extra entities and constraints that outlines require. We have conducted preliminary tests with an unmodified, off-the-shelf planner (Fast Downward [4]), and length 10 plans with roughly 15 concrete entities and 10 possible operators take a few seconds to compute on a single core machine. As might be expected from our effect synchronizers, increasing the number of entities can significantly increase computation time.

In addition to its sensitivity to total entity count, our method has other limitations. Due to the closed world assumption that Fast Downward makes, our mapping operator can only correctly check positive predicates as constraints in the outlines. Due to the complexity of keeping effects synchronized across abstract roles and concrete entities, our code that generates the effect synchronizers can currently only manage binary constraints. However, increasing the arity of constraints beyond two will likely have negative effects on performance, as doing so will require more universally quantified terms. A major strength of the augmentations is that they are almost (aside from the two previous restrictions) completely transparent to the author; we currently generate full PDDL domain and problem files from a more convenient internal representation for outlines, operators, and entity sets. Although we presented our augmentations without discussing any subtypes of entities, in practice we generate them with full support for differently typed entities. We only omitted these types to visually simplify the listings, which became overcomplicated when they were included.

While we have proven that our solution is sound in the sense that its plans will not fail for self-sourced reasons, we cannot generally guarantee that its plans *cannot fail*. In an interactive context, it seems likely that the techniques of narrative mediation will be needed to assist when plans go awry. If the domains of such repairs can be kept within the rough size that we have tested, it might be feasible to use our solution to find new plans in real time.

## 7    Conclusions and Future Work

We have made three contributions in this work. First, we performed a detailed analysis of the challenge of combining authorable continuity with delayed role assignment in a plan-based storytelling context, and we concretely specified a set of requirements for its solutions. Second, we presented a novel approach to solving this problem that meets the stated requirements while simultaneously providing new advantages over existing work. Finally, we introduced two new notions of soundness for our problem (plan-soundness and assignment-soundness) and sketched proofs to show that our approach is sound in those respects.

Given the variety of concerns that must be addressed by solutions to this challenge, many opportunities exist for further research. Beyond working to address

the known limitations of our solution, further experimentation is needed to discover more of its limitations that remain unknown (e.g., how many entities can be handled within a given amount of time?). Further technical extensions are also possible, such as integrating state constraints with semi-abstract plans to make the authorable continuity more fine-grained. Changing logical representations might also be worthwhile, as the constraints of PDDL planning may ultimately be too limiting for the kinds of authoring that we wish to support.

# References

1. Barber, H.: Generator of adaptive dilemma-based interactive narratives. Ph.D. thesis, Department of Computer Science, The University of York (2008)
2. Fairclough, C.: Story games and the OPIATE system. Ph.D. thesis, University of Dublin - Trinity College (2004)
3. Gerevini, A., Long, D.: Plan constraints and preferences in PDDL3. Technical report, Dipartimento di Elettronica per l'Automazione, Uni. degli Studi di Brescia (2005)
4. Helmert, M.: The fast downward planning system. J. Artif. Intell. Res. **26**, 191–246 (2011)
5. Mac Namee, B., Dobbyn, S., Cunningham, P., O'Sullivan, C.A.: Men behaving appropriately: integrating the role passing technique into the ALOHA system. In: Animating Expressive Characters for Social Interactions, pp. 59–62. AISB (2002)
6. Magliano, J.P., Zwaan, R.A., Graesser, A.C.: The role of situational continuity in narrative understanding. In: The Construction of Mental Representations During Reading, pp. 219–245 (1999)
7. Porteous, J., Cavazza, M., Charles, F.: Applying planning to interactive storytelling: narrative control using state constraints. ACM Trans. Intell. Syst. Technol. **1**(2), 111–130 (2010)
8. Riedl, M.O., Saretto, C.J., Young, R.M.: Managing interaction between users and agents in a multi-agent storytelling environment. In: 2nd International Joint Conference on Autonomous Agents and Multiagent Systems, pp. 741–748. ACM (2003)
9. Riedl, M.O., Stern, A.: Believable agents and intelligent story adaptation for interactive storytelling. In: Göbel, S., Malkewitz, R., Iurgel, I. (eds.) TIDSE 2006. LNCS, vol. 4326, pp. 1–12. Springer, Heidelberg (2006). doi:10.1007/11944577_1
10. Swartjes, I., Kruizinga, E., Theune, M.: Let's pretend I had a sword: late commitment in emergent narrative. In: Spierling, U., Szilas, N. (eds.) ICIDS 2008. LNCS, vol. 5334, pp. 264–267. Springer, Berlin/Heidelberg (2008)
11. Thue, D., Bulitko, V., Spetch, M., Webb, M.: Socially consistent characters in player-specific stories. In: The Sixth Artificial Intelligence and Interactive Digital Entertainment Conference, pp. 198–203. AAAI Press (2010)
12. Thue, D., Halldórsson, K.: Opportunities for integration in interactive storytelling. In: Schoenau-Fog, H., Bruni, L.E., Louchart, S., Baceviciute, S. (eds.) ICIDS 2015. LNCS, vol. 9445, pp. 374–377. Springer, Heidelberg (2015). doi:10.1007/978-3-319-27036-4_40
13. Weld, D.S.: An introduction to least commitment planning. AI Mag. **15**(4), 27 (1994)

# Decomposing Drama Management in Educational Interactive Narrative: A Modular Reinforcement Learning Approach

Pengcheng Wang[✉], Jonathan Rowe, Bradford Mott, and James Lester

North Carolina State University, Raleigh, NC 27695, USA
{pwang8,jprowe,bwmott,lester}@ncsu.edu

**Abstract.** Recent years have seen growing interest in data-driven approaches to personalized interactive narrative generation and drama management. Reinforcement learning (RL) shows particular promise for training policies to dynamically shape interactive narratives based on corpora of player-interaction data. An important open question is how to design reinforcement learning-based drama managers in order to make effective use of player interaction data, which is often expensive to gather and sparse relative to the vast state and action spaces required by drama management. We investigate an offline optimization framework for training modular reinforcement learning-based drama managers in an educational interactive narrative, CRYSTAL ISLAND. We leverage *importance sampling* to evaluate drama manager policies derived from different decompositional representations of the interactive narrative. Empirical results show significant improvements in drama manager quality from adopting an optimized modular RL decomposition compared to competing representations.

**Keywords:** Intelligent narrative technologies · Drama management · Modular reinforcement learning · Educational interactive narrative

## 1 Introduction

Data-driven techniques for interactive narrative generation hold considerable promise for creating story experiences that are both rich and personalized. Training computational models from interactive storytelling data offers the potential to enhance narrative systems' capacity to personalize stories to individual players [1], endow machines with narrative intelligence with reduced programming effort [2], and facilitate interactive story content creation [3]. Recent years have seen growing interest in data-driven methods for drama management. For example, Yu and Riedl [4] employed prefix-based collaborative filtering to personalize interactive stories based on recurring player self-reports. Crowdsourcing-based methods task human users with generating narrative scripts—by writing stories or playing brief interactive narratives—in order to train computational models of interactive narrative generation [3, 5]. Supervised machine learning techniques have been employed to induce interactive narrative planners from data gathered in Wizard of Oz studies [2]. These methods leverage large datasets of

© Springer International Publishing AG 2016
F. Nack and A.S. Gordon (Eds.): ICIDS 2016, LNCS 10045, pp. 270–282, 2016.
DOI: 10.1007/978-3-319-48279-8_24

interactive narrative log data to train models that complement manually authored approaches to runtime decision-making in interactive storytelling.

Reinforcement learning (RL) methods are the subject of growing interest within the intelligent narrative technologies community because they align naturally with key characteristics of interactive narrative and drama management [6–9]. RL focuses on training software agents to perform sequential decision-making in uncertain environments with delayed rewards [10]. Despite growing interest in RL, only a small number of RL-based drama managers have been deployed with playable interactive narratives, particularly those involving non-linear storylines and open virtual worlds. These environments yield potentially vast state and action spaces for reinforcement learning and demand large volumes of training data. Because this can be problematic for training models directly from human interaction data, much of the work on RL-based drama management has relied on synthetic training data from simulations [6] or pre-defined plot trajectory distributions [7]. This raises an important open question: how can we formalize drama management to be amenable to RL techniques trained with human interaction data from playable interactive narratives?

In this paper, we investigate an offline optimization framework for modular reinforcement learning-based drama management, with a specific focus on identifying an optimal decomposition of the task in terms of *adaptable event sequences*. We investigate this framework in an educational interactive narrative, CRYSTAL ISLAND, which features a science mystery about a spreading epidemic on a remote island research station. With a corpus of player interaction data from 402 middle school students, we evaluate potential competing structures for decomposing CRYSTAL ISLAND's drama management task by leveraging importance sampling (IS) [11], a statistical off-policy evaluation method. Empirical results suggest that the modular structure of an RL-based drama manager can have a significant influence on the drama manager's effectiveness, and an optimal structure based on *adaptable event sequences* can be identified using the proposed offline framework.

## 2    Related Work

Two families of technical approaches to the design of interactive narrative systems have been investigated: character-based story generation and plot-based story generation [12]. *Character-based* systems feature plots that emerge through interactions between believable, autonomous characters [13, 14]. *Plot-based* approaches typically implement a director agent or drama manager to create, monitor, and adjust narrative event sequences and produce coherent plots [15, 16]. In this work, we focus primarily on plot-based approaches, which to date have used a broad range of computational methods, including adversarial search [17], planning [15, 16], and machine learning-based techniques [2, 4, 7].

RL-based drama managers typically model decisions about interactive narrative in terms of Markov decision processes (MDPs). By modeling sequences of events stochastically, MDPs account for the inherent uncertainty in predicting human player actions. Further, MDPs support encoding *narrative quality* in terms of reward functions, which

guide the process of training a drama manager by optimizing narratives' measured "goodness." Nelson et al. utilized temporal-difference methods to train a drama manager for a text-based interactive fiction, Anchorhead, using simulated user data and an author-specified story evaluation function [6]. This approach was extended by Roberts et al. [7], which applied target-trajectory distribution MDPs (TTD-MDPs) to generate interactive narratives according to an author-specified target distribution over possible stories. Thue and Bulitko [8] used MDPs to model player behavior in a player-adaptive interactive narrative by dynamically augmenting story events based on estimates of player game-play preferences. We build on this foundational work on RL-based drama management to undertake the first systematic investigation of alternate decompositional representations of a drama management task, as well as by training a drama manager exclusively from player interaction data.

Decomposition-based approaches to RL, such as modular reinforcement learning, have long been a subject of interest in the machine learning community [18, 19]. Rowe et al. presented the first example of a modular RL framework for interactive narrative adaptation by introducing the concept of *adaptable event sequences* [1, 9], a decomposition-focused abstraction for recurring story units within interactive narratives. However, Rowe et al. investigated only one type of decompositional representation based on author-specified adaptable event sequences [9]. We extend this work by systematically exploring alternative decomposition structures for modular RL-based drama management. In addition, we utilize off-line evaluation methods to assess drama management policies induced from player interaction data, enabling policy evaluation without the requirement to collect additional data from new groups of human players [1].

## 3    Modular RL-Based Drama Management in Crystal Island

To investigate a data-driven optimization framework for modular RL-based drama management, we utilize Crystal Island, an educational interactive narrative that features a science mystery about an infectious outbreak on a remote island research station (Fig. 1). The player adopts the role of a medical detective who must determine the source and treatment of the outbreak. The player investigates the illness by conversing with non-player characters, collecting data in a virtual laboratory, reading virtual books and articles, and completing a diagnosis worksheet. The drama manager monitors the player's behavior within the story world and makes recurring decisions about how *adaptable event sequences* (AESs) should unfold during the narrative. As defined in [9], an AES is a recurring series of one or more story events that, once triggered, can unfold in several different ways, leading to potentially different plot trajectories and player experiences. An AES can occur multiple times over the course of an interactive narrative, each time unfolding in a potentially distinct manner.

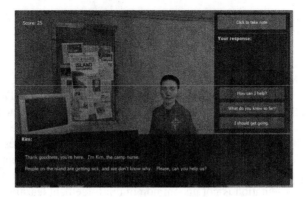

**Fig. 1.** CRYSTAL ISLAND interactive narrative.

In this work, we focus on four AESs in CRYSTAL ISLAND[1]:

- **Teresa Symptoms.** This AES is triggered each time the player initiates a conversation with Teresa, a sick scientist in the camp infirmary. If a player inquires about Teresa's symptoms, the drama manager selects one of three possible conversational responses: providing minimal detail about her symptoms, providing moderate detail about her symptoms, or providing maximal detail about her symptoms.
- **Record Findings Reminder.** Whenever the player uncovers useful information that is relevant to the mystery's solution, such as the result of conducting a laboratory test or information contained in an important (virtual) book, the drama manager determines whether to deliver a hint suggesting the player take in-game notes about the information.
- **Diagnosis Feedback.** When seeking to solve the mystery, if a player submits an incorrect diagnosis to the camp nurse, the drama manager selects one of three options for feedback: minimally detailed feedback, moderately detailed feedback, or maximally detailed feedback.
- **Knowledge Quiz.** When players converse with certain characters, the drama manager optionally delivers an embedded assessment (i.e., quiz) about related microbiology concepts. Each time this occurs, the drama manager decides whether to present the quiz or not to present it.

In order to model AESs computationally, and devise drama management policies using reinforcement learning, we use Markov decision processes (MDPs). An MDP is defined as a quintuple $<S, A, p, r, \gamma>$, in which $S$ is a set of states, $A$ is a set of actions, $p$ is a probabilistic transition function with $p^a_{s,s'}$ representing the probability of taking action $a$ in state $s$ and transitioning to state $s'$, $r$ is a reward function following the form of $r^a_{s,s'} : S \times A \times S \rightarrow \mathbb{R}$, and $\gamma \in (0, 1]$ denotes the discount factor, trading off the importance of long-term rewards versus short-term rewards. In CRYSTAL ISLAND, $p$ and $r$ do

---

[1] There are 13 AESs in CRYSTAL ISLAND. In this work, we focus on four AESs, which were chosen because they were the most commonly occurring in our training corpus.

not have explicit forms due to the inherent uncertainty of the environment, but we can estimate their values from a corpus of player interactions. The solution to an RL problem is a policy $\pi$, which generally takes the form of a conditional probability mass function $Pr_\pi(a|s)$, representing the probability of taking action $a$ in state $s$.

Policies for MDPs can be obtained using reinforcement learning techniques, of which we focus on two broad families: model-based RL techniques and model-free RL techniques [10]. Specifically, we utilize policy iteration and Q-learning to induce drama manager policies under different modular RL representational structures.

To represent AESs in CRYSTAL ISLAND, we utilize five binary features to encode the state representation of each MDP (Table 1). We limit the state representation to these features to reduce potential data sparsity issues. It should be noted that this form of compact state representation is not uncommon in reinforcement learning-based intelligent user interfaces [20]. The first two state features encode key elements of plot state. The third state feature encodes player trait information about prior science knowledge. The final two state features denote AES indices, indicating which subset of AES related actions are available to drama manager when a narrative adaptation is triggered.

**Table 1.** MDP state features for CRYSTAL ISLAND RL-based drama manager.

| State feature | Bits | Description |
|---|---|---|
| Submit solution | 1 | Player has tried to submit solution? |
| Solved mystery | 1 | Mystery solved correctly? |
| Pre-test Score | 1 | Player's pre-test score above median? |
| AES | 2 | AES index |

The action sets for the MDPs represent the drama manager's possible actions, e.g., how much information an NPC reveals to the player, or whether a player receives a hint or quiz after an important event. The action set for each MDP is comprised of the possible event sequences in its corresponding AES, which are described above.

The four AESs shared the same reward function. The reward function was derived from a measure of player knowledge acquisition, normalized learning gain, because of the educational focus of CRYSTAL ISLAND. Data on normalized learning gains were obtained by administering a pre-test and post-test to each player about relevant microbiology concepts and calculating the normalized difference between the two test scores. When generating training episodes for reinforcement learning, rewards were assigned when the terminal state of the game was reached, or at the conclusion of gameplay. The reward value was either 100 when the player's normalized learning gain was above median value, or $-100$ if it was below median.

To induce drama manager policies for the MDPs, we utilized player interaction data from a pair of human subject studies conducted with CRYSTAL ISLAND [9]. All participants utilized the same version of CRYSTAL ISLAND, which was deployed in two public middle schools involving 300 students and 153 students, respectively. Participants played the game until they solved the mystery, or 55 min elapsed, whichever occurred first. While using CRYSTAL ISLAND, participants unknowingly encountered AESs several times. At each AES, the drama manager selected a narrative adaptation according to a random policy, uniformly sampling the planning space. By logging these narrative adaptations,

as well as participants' subsequent responses, the environment broadly sampled the space of policies for controlling adaptable event sequences. In addition, several questionnaires were administered prior to, and immediately after, participants' interactions with CRYSTAL ISLAND. The questionnaires provided data about participants' individual characteristics, curricular knowledge, and engagement with the environment.

The data collected from both studies were combined into a single corpus. After removing data from participants with incomplete records, there were 402 participants remaining in the data set. Out of the total 402 trials, we observed the relevant AESs with the following frequency: the Teresa Symptoms AES occurred 559 times, the Record Findings Reminder AES occurred 3,435 times, the Diagnosis Feedback AES occurred 804 times, and the Knowledge Quiz AES occurred 1,073 times. Each trial, on average, contained 14.6 occurrences of AESs.

## 4   Decomposing Drama Management for Modular Reinforcement Learning

We utilize AESs to represent modular units of interactive narrative that can be shaped by a modular RL-based drama manager in CRYSTAL ISLAND. However, it is difficult to anticipate the optimal grain-size for representing events in drama management. A hand-authored AES-based representation is likely to produce less effective policies than an optimized encoding, which may be more fine- or coarse-grained. Prior work on RL-based drama management has typically utilized a coarse-grained representation: a single monolithic MDP, which encodes all possible state features and actions for a drama manager [6, 7]. An alternate approach is a modular representation, which clusters subsets of narrative events into AESs, each individually modeled as a separate MDP. This approach emphasizes compact RL sub-tasks, which are more readily solved by training policies with datasets of limited size, as one might expect to obtain from logs of human player interactions. However, determining how to best cluster events into AESs is challenging to do manually. We investigate a data-driven framework for evaluating alternate decompositions.

In CRYSTAL ISLAND, one could model all four AESs in terms of a single MDP. In other words, the Teresa Symptoms AES (denoted as "T"), Record Findings Reminder AES (denoted as "R"), Diagnosis Feedback AES (denoted as "D"), and Knowledge Quiz AES (denoted as "Q") are modeled together (denoted as "TRDQ"), and thus solved as a single RL problem. An alternative representation could involve decomposing the task in terms of two modular sub-tasks (Fig. 2), encoding Teresa Symptoms (T) events in one MDP, and the other three types of AESs (denoted as "RDQ") in a separate MDP. In this case, an overall drama management policy would consist of the combined policies from the two modules (denoted as "T_RDQ"), as well as an arbitration procedure for resolving inter-policy conflicts.

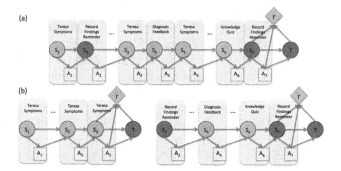

**Fig. 2.** Illustration of two decompositional representations for a modular RL-based drama manager. AESs are color-coded and denoted with boxes. Events progress in temporal order from left to right. *S* and *A* represent states and actions, *T* represents a terminal state, and *r* denotes a reward. (a) A monolithic structure in which all events and actions are encoded as a single MDP. (b) A modular structure in which one AES is modeled as an MDP (left), and the other three AESs are modeled as a different MDP (right).

When the number of AESs is greater than two, there may be multiple modular representations that can be considered. For example, in CRYSTAL ISLAND, the monolithic model TRDQ can be decomposed into the form T_RDQ by isolating the Teresa Symptoms AES (T) from the other AESs, or it can be decomposed into the form TR_DQ, in which events from Teresa Symptoms (T) and Record Findings Reminder (R) are encoded in one MDP and the other two AESs are modeled by a second MDP.

The number of possible modular structures is determined by the number of possible combinations of AESs. Because each sub-task's MDP can potentially exploit a smaller state space and action set, this approach addresses the curse of dimensionality inherent in many reinforcement learning tasks and contributes to improved training speed. Further, alternate decompositional representations change the MDP models' transition dynamics by altering the task environment's transition probability distributions. Thus, although both monolithic and decomposed models can yield locally "optimal" solution policies, the policies produced by each model are likely to be different.

## 5   Offline Policy Evaluation

We consider two primary factors in selecting an offline policy evaluation technique. First, we seek a method that evaluates MDP policies based on sample episodes rather than an explicit environment model. This excludes evaluation metrics such as expected cumulative reward [20]. Second, we seek an evaluation method that accounts for generalizability to unseen situations. Specifically, we utilize cross validation to evaluate policies with corpus data not utilized in model training. To address these two factors, we employ importance sampling [21].

Importance sampling is a statistical evaluation technique that can be used to evaluate a policy $\pi$ when it is infeasible to draw samples under $\pi$ [11]. In CRYSTAL ISLAND, trials were collected with a uniformly random policy $\pi'$. In order to assess policy $\pi$, the following equation can be utilized:

$$v^{IS}_{\pi',h}(\pi) = \frac{1}{N} \sum_i R(h_i) \frac{\Pr(h_i|\pi)}{\Pr(h_i|\pi')} \tag{1}$$

In Eq. 1, $h$ is a set of trials, in which each sampled trial is labeled as $h_i$. $R(h_i)$ is the sum of discounted rewards across the trial $h_i$:

$$R(h_i) = \sum_{t=1}^{T} \gamma^{t-1} \cdot r_{t,h_i} \tag{2}$$

The ratio of likelihoods of observing the trial $h_i$ following evaluating policy $\pi$ and sampling policy $\pi'$ could be simplified as the ratio of likelihoods of making a series of action choices under given policies, as is demonstrated in Eq. 3.

$$\frac{\Pr(h_i|\theta)}{\Pr(h_i|\theta')} = \frac{\prod_{t=1}^{T} \pi_\theta(a_t|s_t)}{\prod_{t=1}^{T} \pi_{\theta'}(a_t|s_t)} \tag{3}$$

Although importance sampling yields an unbiased estimate of policy value, it can introduce a large variance when samples are scarce. A biased estimate with lower variance can be obtained with weighted importance sampling (WIS), as shown in Eq. 4. In this work, we apply both IS and WIS metrics to compare policies from different modular structures.

$$v^{WIS}_{\pi',h}(\pi) = \frac{1}{\sum_i \frac{\Pr(h_i|\pi)}{\Pr(h_i|\pi')}} \sum_i R(h_i) \frac{\Pr(h_i|\pi)}{\Pr(h_i|\pi')} \tag{4}$$

## 6  Results

We empirically evaluate drama management policies generated by model-based and model-free RL techniques under several possible decompositional representations. In this work, there are 15 possible decompositions, each comprised of a different combination of the four AESs, ranging from a monolithic model (TRDQ), to a completely decomposed representation (denoted as "T_R_D_Q"). We also compare to a uniform random policy, a baseline model that was utilized to collect the initial RL training data. It should be noted that in CRYSTAL ISLAND, any interactive narrative generated under a random AES policy is guaranteed to still be coherent because the AESs have been

designed to never introduce events that might threaten future events in the narrative. Random policy-generated narratives may deviate substantially from highly personalized narratives, but they will still be playable and sensible.

Importance sampling and weighted importance sampling were utilized to evaluate policies generated using policy iteration and Q-learning under five-fold cross validation across 20 runs. During each run, all trials were randomly re-assigned across the 5 folds. We utilized approximate randomization to assess the statistical significance of differences in measured quality between different drama manager policies [22]. Approximate randomization is a statistical test that has been broadly used in the natural language processing community and does not assume that data points from two groups are independently sampled. In our experiment, we set the random shuffling parameter in approximate randomization to 5,000.

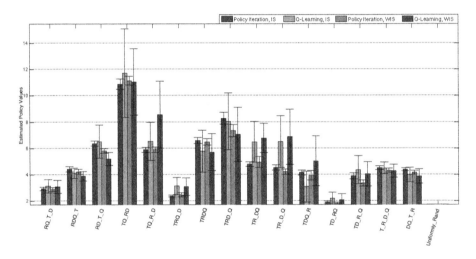

**Fig. 3.** Importance sampling and weighted importance sampling based policy values with 95 % confidence intervals for a discount factor of 1.0.

Our first analysis utilized a discount factor of 1, which treats long-term rewards as equivalent to short-term rewards (Fig. 3). These experiments revealed that an RL-based drama manager's decompositional representation has a significant impact on policy quality. The highest-performing model was TQ_RD, which generated policies that were significantly better than most of the other modular structures, including the monolithic model TRDQ and the fine-grained decomposed model T_R_D_Q, $p < 0.005$. The TQ_RD decomposition groups the Teresa Symptoms AES (T) and Knowledge Quiz AES (Q) together, and the Record Findings Reminder (R) and Diagnosis Feedback (D) AESs in a separate MDP. In addition, we ran a second set of experiments with a discount factor of 0.9 and obtained similar results (Fig. 4).

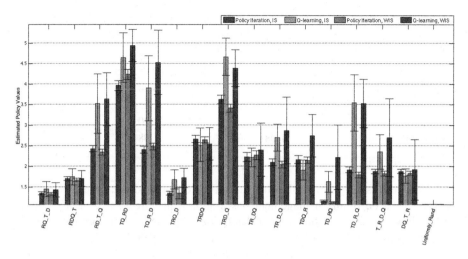

**Fig. 4.** Importance sampling and weighted importance sampling based policy value estimates with 95 % confidence intervals for a discount factor of 0.9.

In Tables 2 and 3, we list the average policy values calculated using importance sampling and weighted importance sampling for the optimized modular RL structure TQ_RD, the monolithic structure TRDQ, and the fully decomposed structure T_R_D_Q, trained by Q-learning. We also add results from a uniform random policy as a baseline. When utilizing a discount factor of 1.0, the policy value for the optimized model yielded a nearly six-fold improvement over the uniform random policy. The optimized model also yielded a policy value that is more than double the monolithic and fully decomposed models. The same trend is observed for weighted importance sampling, as well as when we set the discount factor to 0.9 (Table 3). Notably, for most RL modular structures, we observe no significant differences in policy quality due to the choice of policy iteration or Q-learning as the learning algorithm. When the discount factor is 0.9, several modular structures (e.g., TD_R_Q) yielded higher values under Q-learning. A possible explanation for this is that we utilize an early stopping criterion in Q-learning, which may help reduce overfitting.

**Table 2.** Average policy values from 20 runs of 5-fold cross validation using different modular RL structures with a discount factor of 1.0. All policies are trained using Q-learning. Policies trained with policy iteration yield similar results.

| Modular structure | Policy value based on IS | Policy value based on WIS |
|---|---|---|
| Optimal structure (TQ_RD) | **11.73** | **11.07** |
| Monolithic (TRDQ) | 5.78 | 5.70 |
| Fully decomposed (T_R_D_Q) | 4.49 | 4.28 |
| Uniformly rand | 1.73 | 1.73 |

Note. $N = 20, p < .005$

**Table 3.** Average policy values from 20 runs of 5-fold cross validation using different modular RL structures with a discount factor of 0.9. All policies are trained using Q-learning. Policies trained with policy iteration yield similar comparison results.

| Modular structure | Policy value based on IS | Policy value based on WIS |
|---|---|---|
| Optimal Structure (TQ_RD) | **4.65** | **4.94** |
| Monolithic (TRDQ) | 2.52 | 2.55 |
| Fully Decomposed (T_R_D_Q) | 2.36 | 2.70 |
| Uniformly Rand | 1.08 | 1.08 |

Note. N = 20, $p < .005$

Overall, results suggest that the structure of the decompositional representation in modular RL-based drama management has a significant effect on generated policy quality. However, it is challenging to determine why the best-performing modular structure, TQ_RD, yielded such substantially greater policy values than other competing representations. One possible explanation is that the optimal representation may have benefitted from grouping diagnosis worksheet-related AESs separately from other AESs. However, further analysis is necessary to confirm or refute this explanation. It should be noted that policy value is a reflection of the policy's quality with respect to its associated reward function and RL task environment. In this work, we have utilized a reward function that is based upon normalized learning gains, due to the educational focus of CRYSTAL ISLAND, but any narrative evaluation metric, if properly quantified, can be utilized in the framework (e.g., user engagement, sense of narrative transportation). Because it is difficult to analytically discern how quantitative differences in policy values correspond to differences in user experience or overall narrative quality, a promising direction for future work is to integrate these policies back into a run-time version of CRYSTAL ISLAND and test their effects on actual human players.

# 7   Conclusions and Future Work

We have presented a data-driven framework for evaluating alternate decompositional representations of modular RL-based drama management in the educational interactive narrative CRYSTAL ISLAND. Devising an optimal computational representation for RL-based drama management has a significant impact on the quality of policies induced from a training corpus. Decompositional representations help address data sparsity challenges presented by efforts to train drama managers from human player data. Using an offline evaluation framework based on importance sampling, we find that an optimized decompositional representation for RL-based drama management yields superior policies to traditional monolithic or fully decomposed representations by a significant margin.

There are several promising directions for future work. It will be important to investigate automated procedures for devising high-quality decompositional representations for drama management, thereby automating the process of identifying optimal breakdowns of events into AESs. In addition, it will be important to explore the scalability and generalizability of the modular RL-based interactive narrative generation framework and to understand its applicability to other narrative domains and genres.

# References

1. Rowe, J., Lester, J.: Improving student problem solving in narrative-centered learning environments: a modular reinforcement learning framework. In: Conati, C., Heffernan, N., Mitrovic, A., Verdejo, M.F. (eds.) 17th International Conference on Artificial Intelligence in Education. LNCS, vol. 9112, pp. 419–428. Springer, Heidelberg (2015)

2. Lee, S., Rowe, J., Mott, B., Lester, J.: A supervised learning framework for modeling director agent strategies in educational interactive narrative. IEEE Trans. Comput. Intell. AI Games **6**, 203–215 (2014)

3. Li, B., Lee-Urban, S., Johnston, G., Riedl, M.: Story generation with crowdsourced plot graphs. In: 27th AAAI Conference on Artificial Intelligence, pp. 598–604 (2013)

4. Yu, H., Riedl, M.: Personalized interactive narratives via sequential recommendation of plot points. IEEE Trans. Comput. Intell. AI Games **6**(2), 174–187 (2014)

5. Orkin, J., Roy, D.: Understanding speech in interactive narratives with crowd sourced data. In: 8th AAAI Conference on Artificial Intelligence and Interactive Digital Entertainment, pp. 57–62 (2012)

6. Nelson, M., Roberts, D., Isbell, Jr., C., Mateas, M.: Reinforcement learning for declarative optimization-based drama management. In: 5th International Conference on Autonomous Agents and Multi-Agent Systems, pp. 775–782 (2006)

7. Roberts, D., Nelson, M., Isbell, C., Mateas, M., Littman, M.: Targeting specific distributions of trajectories in MDPs. In: 21st AAAI Conference on Artificial Intelligence, pp. 1213–1218 (2006)

8. Thue, D., Bulitko, V.: Procedural game adaptation: framing experience management as changing an MDP. In: Fifth Workshop on Intelligent Narrative Technologies, pp. 44–50 (2012)

9. Rowe, J., Mott, B., Lester, J.: Optimizing player experience in interactive narrative planning: a modular reinforcement learning approach. In: 10th AAAI Conference on Artificial Intelligence and Interactive Digital Entertainment, pp. 160–166. AAAI Press, Menlo Park, CA (2014)

10. Sutton, R., Barto, A.: Reinforcement Learning: An Introduction. MIT Press, Cambridge (1998)

11. Peshkin, L., Shelton, C.: Learning from scarce experience. In: Proceedings of the Nineteenth International Conference on Machine Learning, pp. 498–505 (2002)

12. Riedl, M., Bulitko, V.: Interactive narrative: an intelligent systems approach. AI Mag. **34**(1), 67–77 (2012)

13. McCoy, J. Treanor, M., Samuel, B., Mateas, M., Wardrip-Fruin, N.: Prom week: social physics as gameplay. In: 6th International Conference on Foundations of Digital Games, pp. 319–321 (2011)

14. Suttie, N., Louchart, S., Aylett, R., Lim, T.: Theoretical considerations towards authoring emergent narrative. In: Koenitz, H., Sezen, T.I., Ferri, G., Haahr, M., Sezen, D., Catak, G. (eds.) ICIDS 2013. LNCS, vol. 8230, pp. 205–216. Springer, Heidelberg (2013)

15. Porteous, J., Lindsay, A., Read, J., Truran, M., Cavazza. M.: Automated extension of narrative planning domains with antonymic operators. In: 14th International Conference on Autonomous Agents and Multiagent Systems, pp. 1547–1555 (2015)

16. Robertson, J., Young, R.: Automated gameplay generation from declarative world representations. In: 11th AAAI Conference on Artificial Intelligence and Interactive Digital Entertainment, pp. 72–78 (2015)

17. Lamstein, A., Mateas, M.: Search-based drama management. In: 2004 AAAI Workshop on Challenges in Game Artificial Intelligence, pp. 103–107 (2004)

18. Singh, S.: Transfer of learning by composing solutions of elemental sequential tasks. Mach. Learn. **8**, 323–339 (1992)
19. Dietterich, T.: Hierarchical reinforcement learning with the MAXQ value function decomposition. J. Artif. Intell. Res. **13**, 227–303 (2000)
20. Chi, M., VanLehn, K., Litman, D., Jordan, P.: Empirically evaluating the application of reinforcement learning to the induction of effective and adaptive pedagogical strategies. User Model. User-Adap. Inter. **21**, 137–180 (2011)
21. Mandel, T., Liu, Y., Levine, S., Brunskill, E., Popovic, Z.: Offline policy evaluation across representations with applications to educational games. In: 13th International Conference on Autonomous Agents and Multi-Agent Systems, pp. 1077–1084 (2014)
22. Riezler, S., Maxwell, J.: On some pitfalls in automatic evaluation and significance testing for MT. In: Proceedings of the ACL Workshop on Intrinsic and Extrinsic Evaluation Measures for Machine Translation and/or Summarization, pp. 57–64 (2005)

# Theoretical Foundations

# Bringing Authoritative Models to Computational Drama (Encoding Knebel's Action Analysis)

Giacomo Albert[1](✉), Antonio Pizzo[1], Vincenzo Lombardo[2],
Rossana Damiano[2], and Carmi Terzulli[2]

[1] Department of Humanities and CIRMA, University of Torino, Turin, Italy
{giacomo.albert,antonio.pizzo}@unito.it
[2] Department of Computer Science and CIRMA, University of Torino,
Turin, Italy
{vincenzo.lombardo,rossana.damiano,carmi.terzulli}@unito.it

**Abstract.** Maria Knebel is one of the most influential scholars in the field of Drama Analysis. Her work with Stanislavsky has been foundational in the history of theatre: she devised the method of Action Analysis to read the play as a score of actions to be executed by the actors. This paper aims at encoding Knebel's principles in a formal representation using a computational ontology (Drammar) to prove its expressiveness and to test its efficacy in a production point of view. As an example we use Knebel's analysis of Pogodin's *Kremlin Chimes*.

**Keywords:** Theoretical foundations · Computable models inspired by drama studies · Drama visualization · Drama analysis · Drama ontology

## 1 Introduction

This paper addresses the formalization of dramatic theory, intended as specific field of study, different from the overall narrative theory, insofar it leverages on the notion of intentional action (see e.g. [3,5,26,33]). Therefore, we neither refer to models of narrative theory, such as Propp's, nor to generative models of interactive storytelling (such as, for example, [25]). We aim to test the expressive qualities of an existing ontology of drama, *Drammar* [20]. We hope to spread the use of ontological representation as tool for analysing and annotating dramatic texts in a productive and didactic environment. Additionally, this annotation can also be augmented with automatic reasoning, as demonstrated in [14], where we have calculated characters' appraisal of a given set of emotions via SWRL rules.

In the literature, a few computational models of storytelling address the description of the story as a cultural object, and take a neuter stance with respect to the realization of storytelling systems.

DramaBank [6] aims at modeling the narrative discourse, introducing the Story Intention Graph, a particular encoding of a narrative. Its encoding consists of three interconnected layers: textual (the spans of the original discourse),

F. Nack and A.S. Gordon (Eds.): ICIDS 2016, LNCS 10045, pp. 285–297, 2016.
DOI: 10.1007/978-3-319-48279-8_25

timeline (story's events and states), interpretative (goals, beliefs, action impacts, intentions as interpreted by the story viewer).

Drammar [20] models drama in terms of an ontological representation that has identified and encoded the significant elements of the drama domain, namely story units, actions, characters, plans, goals, and story states. Drammar has been applied to the definition of drama as form of Intangible Cultural Heritage [28,35] to the safeguard and dissemination of the object "dramatic story" [15,19].

The ultimate goal of such models is the collection of resources annotated with metadata. The goal of this paper is to extend the range of applications of computational models and to move from a resource building perspective to a production perspective. We take an authoritative, influential and historically-settled model of drama production, Knebel's Action Analysis, and provide its formal encoding, then visualized through a map. Maria Knebel, very well-known scholar of Stanislavsky and one of the most influential figures in 20th century theory of acting, theorised Action Analysis, teaching actors how to approach dramatic texts, so that they could properly render their characters (i.e. the relevant dramatic elements for live events).

We believe that modeling her dramatic theory and abstracting theoretical knowledge from the tasks she assigns to actors may also contribute to the modeling of dramatic agents. Her method comprehends both the deliberative directions to enact single actions and the overall direction to sustain the logical inner motivation of the character's behaviour. Thus, her method may indicate the way of merging the character centred approach (best represented by the work of Cavazza [24]) and the drama centred one (represented by Facade [21] and Szilas [32]).

This paper has two main purposes: on the one hand, it aims at bringing authoritative models to computational drama, in order to test it and ground it in historically founded analytical paradigms, already developed and tested within the fields of dramatic and acting theory, and extensively used in productive perspective. On the other hand, building the formal representation of a complex cultural object requires an ongoing dialogue with the literature that has been proven representative of that object. Drammar was built starting from the literature on drama aesthetics and techniques, focusing on the authoring side [20]. Here we start considering the literature that analyses drama from the perspective of the artist in charge of enacting it. We encode Knebel's interpretation into our ontology, also to test the coverage of our model beyond the limits of the annotated resource building task and the feasibility of employing the ontological model within the production task. Moreover, we aim to provide the virtual storytelling community with a comprehensive approach to dramatic agents.

In this paper we will introduce Knebel and Action Analysis; then, we deepen the theoretical principles of Knebel's analytical method and represent her analysis of the VI scene of Pogodin's *Kremlin Chimes* as case study; we describe both our methodology for the formal representation of her analysis using Drammar ontology, and the key points that match Knebel's method with our formal representation; then, we briefly provide a visualisation of the analysis and conclude.

## 2    Introduction to Maria Knebel's Action Analysis

### 2.1    Knebel and Her Background

Stanislavsky's system is a collection of techniques that he developed throughout his whole career, aiming at training actors for preparing their roles (see [8, pp. 1–147]). The texts of his most important scholars and pupils represent a fundamental source for understanding Stanislavsky's praxis. In this paper we refer to the last – and the most important – of his phases, i.e. the "Method of Physical Actions" (see [22, pp. 117–143], [8]). We focus our attention on one of his most famous pupils, Maria Knebel, because, even if also other important figures conveyed us the "Method of Physical Actions" [1,7,30,34], she wrote the most systematic and influential account of this acting technique, and she theorised her system performing, working and teaching with and led by Stanislavsky himself.

We are able to gain a precise insight of her analysis mainly because she has left a book containing her theoretical account *O dejstvennom p'esy i roli*, translated in French [11], and Italian [13]. Of great importance is also Knebel's theoretical handbook *Slovo v tvor'estve aktjra*, translated in French [12]. Finally, her autobiography [10] entails relevant analyses and informations.

### 2.2    Actor's Assignments: Actions and Goals

Stanislavsky has modified his rehearsal methodologies along his whole career, together with the gradual elaboration of his "system" (see [9, pp. 1–16] and [23, pp. 5–20]). This is usually intended as a method for actors to explore the play, in terms of what they would do in the various situations characters has to deal with [1, pp. XIV–XV]. At the core of this system lies the understanding of characters' actions, intended as the byproduct of a rational and intentional behaviour. Knebel and Stanislavsky, understand dramatic works not as simple texts, i.e. sequences of words, but as dramatic constructions, i.e. compound, cognitive entireties, built by ordered sets of purposive and intentional actions.

In Stanislavsky there is a strict connection between the concepts of *tasks* and *actions*, where *actions* enacted by actors come from the understanding and realization of character's *tasks*, and the latters depend from character's *goals*: [8, p. 240]. The intentional behaviour (in terms of action and goal) is relevant and ubiquitous in the tradition of dramatic theory [26, pp. 74–79]. This is particularly true in Knebel's codification of the Method of Physical Action.

Under this perspective, rehearsing for actors is a phase of discovery and experimentation that stems from the analysis of the drama: a process of dramatic investigation of characters' behaviours. The "core chapter" [2, p. 11] of Knebel's most important theoretical writing explains her rehearsing methodology. Here, she divides director's and actors' groundwork into three main stages, i.e. three sequential phases.

Resorting to Stanislavsky's terms, Knebel has defined the first stage of actor's preparation as the "intellectual exploration" ([11, p. 74 ff.] [13, p. 72]) of the dramatic text (see e.g. [22, pp. 15–27; pp. 117–126]). In this initial stage both actors

and director analyse the dramatic text around a table, trying to understand the characters' actions, what they achieve, their aspirations, their reciprocal relationships, and the circumstances that induce them undertaking their actions (see [11, p. 74]): "the actor tries to delineate what his hero does, what he aspires to, who he opposes, who he allies with, and how does he relate to others" [13, p. 72]. Thus, already in this first stage the analysis' core is represented by characters' actions, their goals (or aspirations), and their reciprocal alliances and conflicts.

Then, once actors have understood the "ideological background" of the *pièce* (hence each performer precisely understands the goal of his hero) [11, p. 74], they can go ahead toward the second stage: Action Analysis.

Action Analysis means that actors embody their characters: they do not repeat from memory a text, but enliven characters' actions: they must understand character's behaviour through their own actions. Because actors' expressions, both gestural and textual, depend upon this understanding, the first phases require no learning by heart of the text. The tools and the work that we propose concern these two first phases: the application we are adopting here for analysing and visualizing dramas' structures is able to help us fulfilling this task, that is, the core of Knebel's assignments to actors for approaching their role. Furthermore, Knebel underlines that the third stage, i.e. the enactment of the characters' lines on stage directly stems from the results developed in the previous stages (see, e.g., [12, pp. 207–209]).

### 2.3   The Subtext as a Hierarchy of Actions

The notion of subtext may be slightly ambiguous from the theoretical point of view, but it is of fundamental importance in history of theatre and it constitutes the basis for a productive praxis [31, p. 136]. Stanislavsky puts the concept of subtext at the core of his idea and praxis of acting, being it the main tool and task that performers should explore [29, p. 36]. It is also a key notion in Knebel's theory: "Subtext [...] it is the *life of the human spirit* of the role, that constantly flows under the words of a text, that legitimize them and ceaselessly livens them up. [...] subtext forces us to utter characters' words" [12, p. 201]. Jean Benedetti's glossary of Stanislavsky's terms defines subtext as "the thoughts and mental images that occur in the actor's mind during the action" [29, p. 684]. As Carnicke says, it is the inner life of a character, "that which impels the character to speak" [4, pp. 225–226]. In Knebel's theory subtext represents a psychological construct that actors build up through both "round-the-table" and "action analysis", in order to motivate – to enact – performance, which is a compound element made of actions and gestures, as well as of the "verbal action", and the character's "interior monologue".

Knebel's notion of action stems directly from the subtext. Therefore, its visualization through the analysis of characters' intentions and their preconditions (and of characters' beliefs and emotions), is intended as tool for helping this practical work. In order to grasp the subtext actors should: (1) understand the characters' goals, and the strategies that they enact in order to pursue

them – i.e. their plans ("tasks") –, both through gestures and verbal actions [13, p. 54]; (2) translate the text into actions grounded on the so called "given circumstances" [13, pp. 44–49], i.e. the situations that describe the conditions that the character experiences; (3) define a score made both of actions that fulfil goals, and reactions to circumstances. Thus, the subtext becomes a chain of events in which character's goals, emotions, values and beliefs are clearly stated.

Knebel spurs actors to identify the main and secondary events that occur to a character (see [13, pp. 50–51]), and to focus on the most paramount events, and then to zoom into the details of the single scenes and sections. Implicitly, Knebel theorizes a hierarchical conception of actions and events.

The consistency of character's behaviour in the subtext is enforced by Knebel via the application of hierarchical structure both to action and goals, particularly through the notions of "supergoal" [13, pp. 60–61], "transversal action" [13, pp. 62–64], and "line role" [13, pp. 65–71]. These features of Knebel's system, each other interconnected, define her representation of high-level dramatic structures. The "supergoal" does not represent a practical goal, but it is most often related to values and will; as we will see an example in Pogodin's *Kremlin Chimes*.

## 3   Knebel's Action Analysis of Pogodin's *Kremlin Chimes* – Scene VI

### 3.1   Synopsis of the Scene

In *O dejstvennom p'esy i roli* [13, pp. 88–91], Knebel analysed the sixth scene of Nikolai Pogodin's drama *Kremlin Chimes* [27]. It portrays the meeting of two lovers: the brave and fresh sailor Rybakov, proponent of the new post-revolutionary values, and Masha, daughter of Zabelin, an engineer supporter of the old values. Masha needs to introduce her lover to her father, but suspects that they will bicker. In the previous scene Rybakov met Lenin, who entrusted him with an important task: finding a clockmaker for repairing the Kremlin Chimes. For this reason he arrives late at the appointment, and Masha, offended, went away. Rybakov finds only an old woman, proponent of the old aristocracy. He asks her whether she saw Masha, but she mistook him for a member of the new army, and fears to be arrested. Therefore, she tries to resist, but Rybakov threatens her and obtains the information. In the second part Rybakov meets Masha: he apologizes, but she reproaches him; he justifies himself and she rebukes his justification. Finally, he explains the reason of his delay, and she forgives him. Then, the lovers make peace and arrange to visit Zabelin.

We will now describe Knebel's analysis, and then provide a formal representation of her analysis through Drammar ontology.

### 3.2   Knebel's Analysis

**Stage 1: Round-the-Table.** Knebel identifies the main topic of the scene ("Masha's and Rybakov's meeting" [13, p. 88]), provides a concise description

**Table 1.** Knebel's first stage of description

| Knebel's description of "given circumstances" | Proposed typology |
|---|---|
| Rybakov loves Masha, but arrives late at their appointment | Precondition |
| Masha has to introduce Rybakov to her parents | Precondition |
| Masha did not warn Rybakov about her father's ideas on Revolution | Precondition |
| Rybakov explains Masha the gravity of the reasons that let him delay | Action |
| Lenin asked Rybakov to find a highly-skilled clockmaker | Precondition |
| Rybakov's delay | Precondition |

**Table 2.** Knebel's first stage of analysis.

| Preconditions | Character | Consequent characters' plans |
|---|---|---|
| (1) Lenin's request to finding a clockmaker; (2) the subsequent Rybakov's delay | Rybakov | Finding Masha and making peace with her |
| (1) Lenin's request to finding a clockmaker; (2) the subsequent Rybakov's delay | Masha | Letting Rybakov feeling guilty |

of the main action [13, p. 88] and of its analysis, as plotted in Table 1. As we see, Knebel pinpoints six "given circumstances" that we may describe as five generic preconditions and only one main action: the one that changes the state of affairs (from conflict to peace between the lovers). Knebel's following step is selecting the two most important "given circumstances", that "directly affect the behavior of the two characters". Hence, she describes the consequences, i.e. which tasks – or better, plans – they induce to the characters (Table 2). So, in stage 1 Knebel pinpoints the basic action of the scene, and the two main characters' plans. These form the top level of the hierarchy of actions.

**Stage 2: Action Analysis.** Knebel proceeds to the deeper level of the hierarchy of action and focuses on a more detailed description of the scene. Here it is where usually secondary characters are introduced and where we see further preconditions, plans, and actions. In Table 3 we match the preconditions with the consequent plans ("following actions" in Knebel terms). Through the elements plotted in Table 3 Knebel explains the motivations for the sequence of actions. In the first analysis she explained the whole scene through one single action (and conflict); in the second analysis she defines eight plans of all characters and reports a more detailed description of the scene. Thus, the subtext emerges as a sequence of instructions that describe intentional actions, motivated by individual plans organized hierarchically, each of which depends on what characters know or believe (precondition).

**Table 3.** Knebel's second stage of analysis.

| Preconditions | Characters | Plans |
|---|---|---|
| Rybakov's delay | Rybakov | Knowing from the old woman where Masha has gone |
| Rybakov's delay | Rybakov | Meeting Masha and explaining her the motivations for his delay |
| Rybakov's encounter with Lenin | Rybakov | Telling Masha about his encounter with Lenin |
| (1) Rybakov's delay<br><br>(2) The forthcoming meeting between Rybakov and Zabelin | Masha | Letting Rybakov understand that he is guilty because of his delay |
| Rybakov's encounter with Lenin | Masha | Making peace with Rybakov |
| (1) Kremlin Chimes do not work<br><br>(2) Rybakov's assignement from Lenin to finding a clockmaker | Masha | Knowing whether Rybakov accomplished Lenin's assignment |
| The forthcoming meeting between Rybakov and Zabelin | Masha | Preparing and coaching Rybakov for his forthcoming meeting with Zabelin |
| The Revolution | Old woman | Saving herself from Rybakov |

# 4 Ontological Representation of Knebel's Analysis

Taking as input this set of instructions (yet informal) we may now proceed toward a formal representation using a computational ontology (Drammar), described and tested in other occasions [14, 16, 17, 20].

For the sake of brevity, here we encode only the first part of the scene, focusing on the subclasses that represent structures and entities of the drama, thus excluding the linguistic representation and the references to external knowledge (we do not describe the corresponding FrameNet frames). Therefore, as subclass of structure (**DataStructure Class**), we describe plans, units, and scenes (**Plans Class**, **Unit Class**, and **Scene Class**); as subclass of entity (**DramaEntity Class**) we represent agents, actions, goals, beliefs, state of affairs (**Agent Class**, **Action Class**, **Goal Class**, **Belief Class**, **SOA Class**). This formal encoding of Knebel's description is possible, because the method of Action Analysis shares many seminal elements with the Drammar ontology.

## 4.1 Units and Actions

We begin modeling a seminal shared element, i.e. the dramatic unit: a key feature to partition the drama into chunks of actions. To create our formal representation we consider Knebel's partition of the scene, recognizing ten main chunks. In Table 4 we list dramatic units as they emerge from Knebel's analysis of the scene,

**Table 4.** Knebel's third stage of description.

| Knebel's analysis | Drammar units and actions |
|---|---|
| (1) During the first years of the Revolution an old woman – descendent of a formerly well-known family – sits on the Boulevard [...] The revolution mixed all social classes [...], today it is necessary to save ourselves. Suddenly a tall sailor appears | Unit 01 Sleep Baby (OW) Arriving (R) |
| (2) She has to do her best, in order not being noticed by the sailor | Unit 02 Dozes Off (OW) Looking for M (R) |
| (3) Oh, and it just happened that the sailor asks for something to the old woman | Unit 03 Contacting OW (R) |
| (4) | Unit 04 Rebuke (OW) |
| | Unit 05 Apologize (R) |
| | Unit 06 Justifying (R) Reject (OW) |
| (5) The woman [feigns not hearing what the sailor said her and] pretends being occupied with the kid | Unit 07 Feigning activity (OW) |
| | Unit 08 Questioning (R) |
| | Unit 09 Repel (OW) [pretends not hearing] |
| (6) But the sailor is determined and doesn't give up: on the contrary, he seizes her arm and wants to know something about a girl! | Unit 10 Insists (R) [demanding answer] |
| (7) Oh my God! He undeniably works for the secret service! He will kill me, it is obvious, there's the revolution! | Unit 11 Complaining (OW) |
| | Unit 12 Threaten (R) |
| | Unit 13 Interrogate (R) [Commanding] |
| (8) And now the old woman "betrays" the persecuted young lady, in order to get rid of the sailor | Unit 014 Answering (OW) [pretends not hearing] |
| | Unit 15 Interrogate (R) |
| | Unit 16 Answering (OW) |
| | Unit 17 Interrogate (R) |
| | Unit 18 Answering (OW) |
| | Unit 19 Interrogate (R) |
| | Unit 20 Answering (OW) |
| (9) He runs off | Unit 21 Thanks (R) Reaches M (R) |
| (10) And now the old woman, afraid of the possible coming back of the sailor, takes the pram with her nephew and saves herself running away | Unit 22 Regrets (OW) |
| | Unit 23 Pray (OW) |
| | Unit 24 Leaves (OW) |

and describe them in terms of Drammar units and actions. The first column (Knebel) provides a list of events that we have (in same cases) to atomise in units in order to describe the specific agents' actions. This atomization is the outcome of the matching of Knebel's description with Pogodin's text. Knebel's

**Table 5.** Matching Knebel's description with the Pogodin's text

| Knebel's description | Pogodin's text |
|---|---|
| (3) Oh, and it just happened that the sailor asks for something to the old woman | RYBAKOV? (Quickly, to the old woman) Comrade nurse! |
| (4) | OLD WOMAN (offended): What makes you think I'm a nurse, young man? |
| | RYBAKOV: I beg your pardon, it's all the same to me |
| | OLD WOMAN: It may be to you, but not to me |
| | RYBAKOV: Well, I saw a pram, a baby I wanted to ask you |
| (5) The woman [feigns not hearing what the sailor said her and] pretends being occupied with the kid | OLD WOMAN: Don't make so much noise. Can't you see he's asleep? |
| | RYBAKOV: Sorry. I won't do it again. But tell me, was there a young woman waiting here before I came? |
| | OLD WOMAN: Get along with you, get along, I can't hear a thing you're mumbling |

account doesn't follow a steady pace of description: it is very detailed in some cases, briefer in others, or it can even skip some lines. E.g., in Table 5 we see that action (3) represents a specific and small chunk of the text, while action (4) has no description, and action (5) a larger part of dialogue. This process is consistent with Knebel's methodology, although it is normally left to the actor's work in the third stage of rehearsals. In summary, the first column contains both macro actions and micro actions that are all reduced or directly encoded as Drammar units (instances of Unit Class). Drammar's units contain actions. Thus, we have encoded the actions described in the Pogodin's text. For example, Rybakov's line "Comrade nurse!" is described as an instance of Action Class named Contacting OW (R),[1] and linked to the unit with the hasMember property. Then, we have encoded all units and all the contained actions, obtaining the timeline of our scene (Timeline Class).

## 4.2 Hierarchy of Intentions

Then, we described the unfolding of intentions using Drammar's plans. First, we encode the plans directly connected with single actions. E.g., the deliberation "the sailor asks for something to the old woman" is encoded as an instance of the

---

[1] The names of the instances we use here do not entail any specific meaning; they only aim to the comprehensibility of the analysis.

DirectlyExecutablePlan Class (a sub class of plan) named R_Intends_to_address_OW_a_Question, that contains the action Contacting OW (R). Note that in this case Knebel's description, as in point 3 of Table 4, has been directly encoded as plan. Once we have created instances for all the Directly Executable Plans, we represent the hierarchical structure of intentions as defined in Knebel's notion of subtext (see Sect. 2.3). In Drammar this is represented by the hierarchical organization of plans: instances of the DirectlyExecutablePlan Class are parts of higher level plans. In Table 4 point 4 we have created an instance of AbstractPlan Class, named OW_Intends_Turning_down_R, which contains two Directly Executable Plans (OW_Intends_Blaming_R and OW_Intends_Rejecting_Apologies).

Shifting to Rybakov's actions, Knebel in Table 4 describes his actions performed during units 3–13 with two sentences, respectively Points 3 and 6. Therefore, resorting to this description we devise two Rybakov's Plans, one for each Knebel's point: R_Intends_Making_Acquaintance_with_OW (units 3–6) and R_Intends_Knowing_Whether_OW_Saw_M (units 8; 10; 12–13).

Knebel's analysis enforces furthermore the hierarchical structure in point 1 of Table 3 ("Knowing from the Old Woman where Masha has gone"). Following her instructions, we've included the two Rybakov's plans as part of a higher-level plan: R_Intends_Knowing_Where_M_Is.

Drammar's plans, besides containing actions or other plans, are defined also via preconditions and effects. Also in this case we can resort to Knebel's analysis: e.g., for her, Rybakov's delay is precondition of his action. Thus, the Plan R_Intends_Knowing_Where_M_Is via the property hasPlanPrecondition is connected to the instance of the SOA Class named R_Delay. The effects are mostly deduced by the logical consequences of the actions. In few cases we use Knebel's description. For example, the effect of the plan R_Intends_Threatening_OW (motivation for the unit 12) has an instance of the Belief Class named OW_Believes_R_Dangerous as effect, and we deduce it from the point 6 in Table 4.

## 4.3    Results of Annotation

The annotation (Fig. 1) was conducted following the method described in Sects. 4.1 and 4.2. In order to provide a visualization of the overall annotation we resort to a Processing Sketch [18], that, from the owl, produces a score of intentional and purposive actions, Fig. 2. It is interactive, thus the whole image is zoomable and some details (such as the descriptions of the units or plans) are available "on mouse over" (see Fig. 3). This encoding is able to represent Knebel's hierarchical relationship of characters' plans. We follow the evolution of the characters' thoughts, and the causal relationships betweens plans (achieved or not) and actions (in the units). Moreover, having an intuitive and clear representation at disposal, we can fill some gaps that Knebel left under-described in her informal narrative description.

Our encoding respects the bipartite organization of the scene – of its main conflict: all struggles and unachieved plans in the first half, and all achieved plans after "Masha's betrayal", what both characters concern. Thus, our encoding is able to represent the evolution of conflicts.

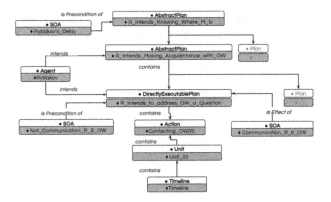

**Fig. 1.** Example of annotation in semi formal terms (instances and their relations).

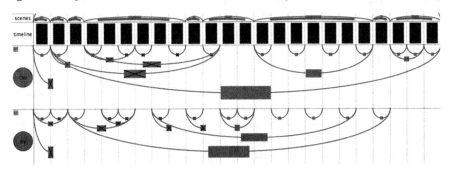

**Fig. 2.** Visualization of Knebel's analysis of scenes, actions and plans in the first part of the VI Scene of Pogodin's *Kremlin Chimes*. Archs on top indicate Knebel's subdivision of the scene; below are units (in black), and the scores of plans and subplans (of Old Woman and Rybakov). Not achieved plans are marked with an x.

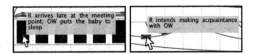

**Fig. 3.** Details of elements with descriptions "on mouse over".

Focusing on Old Woman's plans, we see that the second part is split in two, so that her action gains a tripartite structure: (1) tension and struggle, than (2) "Masha's betrayal", and finally (3) complaint and leaving; structure clearly portrayed by the sequence of the arches: an expressive feature of the map.

Truncated arches represent plans abandoned by characters. We see that the sparking tension of this scene comes from the non-realization of two high level plans in the first units: two parallel and conflicting plans. These are abandoned, and, once the conflict begins (unit 3), substituted with different plans; the two characters try to achieve their goals with different strategies.

Our encoding respects the structural organization of the dramatic scene, giving indications about the rhythm actors should follow. E.g., in units 8–13

Rybakov has a triple iteration of the same plan: the first two are abandoned plans (Units 8 and 10), and the final one achieves the goal (12–13). It clearly represents a crescendo of tension, that brings to the climax/resolution of the scene. This map provides also hints to actors, highlighting the structural difference between a struggling and a plain dialog: an uneven shape in the first part, and the regularly antiphonal structure in the second part of the scene.

Moreover, this encoding helped us to recognize the characters' "supergoal" (in Knebel's terms). E.g. the two Old Woman's high level plans ("be quiet" and "saving herself from Rybakov") point to the same goal, i.e., rescuing herself from the dangers of the revolutionary life: her ideas on revolution constitute the main preconditions of both her highest level plans.

We believe that our encoding provides a formal representation of a dramatic action in computational terms and keeps all the informations for actors. It helps to produce an actional score for digital dramatic storytelling, focusing both on the whole narrative and the agent's deliberative behaviours.

## 5    Conclusion

In this paper we indicate that a computational encoding of agent's behaviours may be proven effective in representing an authoritative models such as Knebel's Action Analysis. Her notions of active action and subtext may be encoded in a computational ontology (Drammar) and they may be also rendered in a visualization. We have demonstrated that the encoding will preserve all the Knebel's features. Furthermore, we have suggested that this approach may be interesting for virtual storytelling, because it provides a new insight on how to design an interactive story that leverages on the consistency of agents' intentional behaviours.

## References

1. Benedetti, J.: Stanislavski and the Actor. Methuen Publishing, London (1998)
2. Bergamo, A.: Introduzione. In: Bergamo, A. (ed.) L'analisi della piece e del ruolo mediante l'azione, pp. 1–28. Ubulibri, Milano (2009)
3. Carlson, M.: Theories of the Theatre : A Historical and Critical Survey from the Greeks to the Present. Cornell University Press, Ithaca (1984)
4. Carnicke, S.M.: Stanislavsky in Focus. Routledge, Abingdon-on-Thames (2009)
5. Dukore, B.F.: Dramatic Theory and Criticism: Greeks to Grotowski. Holt, Rinehart and Winston, New York (1974)
6. Elson, D.K.: Dramabank: annotating agency in narrative discourse. In: Proceedings of the Eighth International Conference on Language Resources and Evaluation (LREC 2012), Istanbul, Turkey (2012)
7. Gorchakov, N.: Stanislavski Directs. Minerva, New York (1968)
8. Gordon, M.: The Stanislavsky Technique. Applause, Russia (1987)
9. Gordon, M.: Stanislavsky in America: An Actor's Workbook. Routledge, Abingdon-on-Thames (2010)
10. Knebel, M.: Vsja zizn'. VTO (1967)

11. Knebel, M.: L'analyse par l'action du pièce et du rôle. Actes Sud-Papiers (2006)
12. Knebel, M.: Le verbe dans l'art de l'acteur. Actes Sud-Papiers (2006)
13. Knebel, M.: L'analisi della pièce e del ruolo mediante l'azione. Ubulibri, Milano (2009)
14. Lombardo, V., Battaglino, C., Pizzo, A., Damiano, R., Lieto, A.: Coupling conceptual modeling and rules for the annotation of dramatic media. Semant. Web J. **6**(5), 503–534 (2015)
15. Lombardo, V., Pizzo, A.: Digital heritage and avatars of stories. In: Proceedings of the 1st International Workshop on Collaborative Annotations in Shared Environment: Metadata, Vocabularies and Techniques in Digital Humanities, pp. 1–8. ACM (2013)
16. Lombardo, V., Pizzo, A.: Ontologies for the metadata annotation of stories. In: Digital Heritage. ACM, Marseille (2013)
17. Lombardo, V., Pizzo, A.: Multimedia tool suite for visualization of drama heritage metadata. Multimedia Tools Appl. Spec. Issue Multimedia Cult. Heritage **75**, 3901–3932 (2014)
18. Lombardo, V., Pizzo, A.: Ontology–based visualization of characters' intentions. In: Mitchell, A., Fernández-Vara, C., Thue, D. (eds.) ICIDS 2014. LNCS, vol. 8832, pp. 176–187. Springer, Heidelberg (2014). doi:10.1007/978-3-319-12337-0_18
19. Lombardo, V., Pizzo, A., Damiano, R.: Safeguarding and accessing drama as intangible cultural heritage. ACM J. Comput. Cult. Heritage **9**(1), 5:1–5:26 (2016)
20. Lombardo, V., Pizzo, A., Damiano, R.: WikiDrammar (2016). https://www.di.unito.it/wikidrammar
21. Mateas, M.: A neo-aristotelian theory of interactive drama (2000)
22. Merlin, B.: Konstantin Stanislavsky. Routledge, Abingdon-on-Thames (2003)
23. Mitter, S.: System of Rehearsal. Routledge, Abingdon-on-Thames (1992)
24. Peinado, F., Cavazza, M., Pizzi, D.: Revisiting character-based affective storytelling under a narrative BDI framework. In: Spierling, U., Szilas, N. (eds.) ICIDS 2008. LNCS, vol. 5334, pp. 83–88. Springer, Heidelberg (2008). doi:10.1007/978-3-540-89454-4_13
25. Peinado, F., Gervás, P.: Evaluation of automatic generation of basic stories. New Gener. Comput. **24**(3), 289–302 (2006)
26. Pizzo, A.: Neodrammatico Digitale. Accademia University Press, Torino (2013)
27. Pogodin, N.: Kremlin chimes. In: Three Soviet Plays, pp. 7–89. Foreign Languages Publishing House (1961)
28. Smith, L., Akagawa, N.: Intangible Heritage. Taylor & Francis, Abingdon (2008)
29. Stanislavsky, K.: An Actor's Work: A Student's Diary. Routledge, Abingdon-on-Thames (2008)
30. Stanislavsky, K.: An Actor's Work on a Role. Routledge, Abingdon-on-Thames (2010)
31. Stanislavsky, K., Hapgood, E.: An Actor's Handbook: An Alphabetical Arrangement of Concise Statements on Aspects of Acting. A Theatre Arts book. Routledge, Abingdon-on-Thames (1963)
32. Szilas, N.: Idtension: a narrative engine for interactive drama. In: Proceedings of the 1st International Conference on Technologies for Interactive Digital Storytelling and Entertainment (TIDSE 2003), Darmstadt, Germany (2003)
33. Szondi, P.: Theory of the moderna drama parts i-ii. boundary 2 **11**(3), 191–230 (1983)
34. Toporkov, V.: Stanislavski in Rehearsal. Routledge, Abingdon-on-Thames (2004)
35. Vecco, M.: A definition of cultural heritage: from the tangible to the intangible. J. Cult. Heritage **11**(3), 321–324 (2010)

# Strong Concepts for Designing Non-verbal Interactions in Mixed Reality Narratives

Joshua A. Fisher[✉]

Georgia Institute of Technology, Atlanta, USA
jadlerfisher@gatech.edu

**Abstract.** As next-generation augmented reality (AR) devices, referred to by companies like Microsoft as mixed reality (MR) headsets, enter the market non-verbal interaction paradigms for storytelling should be designed to take advantage of the new technical affordances. By ascertaining strong concepts, a model used in the HCI community to describe intermediate knowledge that sits between theory and practice for generating new interaction designs, a foundation for future work in MR, based on the existing technical affordances and interaction behaviors of AR and virtual reality (VR), can be developed. Strong concepts free interaction designers to explore potential interaction gestalts based on current behaviors and technologies. The framework is useful for speculating on effective non-verbal interactions in MR narratives as the platform is still being established. Interaction designers can use these foundational strong concepts as a starting point to develop a toolset for non-verbal interactions in future MR interactive digital stories.

**Keywords:** Theoretical foundations · Mixed reality · Augmented reality · Interactive narratives · Non-verbal interactions · Design concepts

## 1 Introduction

Since 2015, companies such as Microsoft and Magic Leap have announced next generation AR devices that purport to integrate the immersiveness of VR into the AR platform. They refer to their platforms as mixed reality (MR). In the mid 90's, Milgram and his colleagues established the relationship between AR and VR on what they defined as the Reality-virtuality continuum (RVC) [1]. They understood that the technologies are intimately connected. VR immerses the user in a digitally simulated world in which every action is mediated; AR utilizes aspects of the user's real world location and posits mediated objects within reality for interaction. An intermediary between with two is augmented virtuality (AV) wherein physical elements are dynamically integrated into the digital world in real time (Fig. 1).

MR encompasses the range of technologies between reality and virtuality. As such, the technical provisions of the various classes along the continuum are available to this generation of MR devices. The affordances themselves are not unique to MR, only their implementation within a single platform is. Until now, industry developers have focused on developing interaction designs that capitalized on the offerings of specific classes

© Springer International Publishing AG 2016
F. Nack and A.S. Gordon (Eds.): ICIDS 2016, LNCS 10045, pp. 298–308, 2016.
DOI: 10.1007/978-3-319-48279-8_26

**Fig. 1.** Reality-virtuality continuum (Source: Taxonomy of Mixed Reality Visual Displays, p. 3)

along the continuum instead of broad comprehensive paradigms. This has led to platform-specific interaction design principles that fall short of utilizing the affordances of MR devices.

For example, VR affords non-verbal interactions that result in the immediate transportation to new digital worlds with only the flick of a threshold object such as an HTC Vive controller. This is not possible in AR; a user in Thailand cannot flick their wrist and transport to the USA. On the other hand, AR designers can embed digital objects in reality that may problematize the user's real world location—Mark Skwarek's *Baghdad Skyline* transforms New York City into a war-torn battleground that parallels Baghdad during the height of the Iraq War [2]. Both AR and VR bring design principles for interactive digital storytelling to the fore, but differently. How and in what ways these distinctive interaction designs will be integrated into a cohesive set of interaction gestalts for MR interactive narratives has not been established and needs to be, not just for the production of enjoyable experiences for audiences, but as a conceptual toolbox for designers.

Strong concepts, a theoretical framework from the HCI community for identifying generative design knowledge, provide the flexibility and freedom necessary to speculate on effective non-verbal interactions [3]. As MR encompasses both AR and AV [1], the non-verbal interactions utilized in the two embodied mediums provide a foundation from which to project potential interaction paradigms.

**Table 1.** Aspects and Affordances of Storytelling in AR, MR, and VR

| Aspects & Affordances | Augmented reality | Mixed reality | Virtual reality |
|---|---|---|---|
| Interactions | Physical | Agnostic | Mediated |
| Display | Monoscopic/ Stereoscopic | Stereoscopic | Stereoscopic |
| Device | Mobile device | Mobile device + HMD | HMD + Computer |
| Control of setting | None | None | Full |
| Flow | Medium | High | Low |
| Gestures | Touch & Gaze | Free hand interaction | Threshold object |
| Digital objects & agents | Occlusion | Integration | Simulation |

In general, non-verbal interactions in MR narratives are reality agnostic and are neither wholly physical nor virtual. MR is displayed via a mobile phone mounted on an HMD or as a standalone device with a stereoscopic display. The flow, or the integration of the virtual environment with reality, is more believable than AR. This is due to the

way digital objects in AR occlude reality and do not integrate. For MR, interaction designers source gestalts from aspects and affordances along the RVC to develop believable digital narratives integrated into physical space. The collation and analysis of these interactions and behaviors frame the necessary conceptual work for developing strong concepts (Table 1).

## 2 The Designer and Author in MR Interactive Narratives

### 2.1 Generating a Story Through the Design of Interactions

The role of the author in interactive narratives is to develop the content of the story world. Authorship involves writing the rules by which the story is told as well as the text itself [4]. This evolution of the author into the author-designer, or cyberbard, means practitioners must focus on access; how interacting with the content will drive the generation of the story. Non-verbal interaction design is focused on how the story is perceived and by what movements or gestures generate its progress. The MR cyberbard shapes one of Andrew Stern's "quintessential requirements of an interactive story", that of agency [5]. Janet Murray lays the foundation for Stern by describing dramatic agency as, "the satisfying power to take meaningful action and the results of our decisions and choices" [4]. As such, the cyberbard in MR must facilitate which user actions will lead to those meaningful results.

MR cyberbards should focus on facilitating events that they have established as an author [6]. The result of these designed non-verbal interactions generates the narrative. The means by which interactive narratives accomplish this in relation to the user in MR is problematized by reality. Wherein relationships between a digital world, the story, and the user can be constrained within VR to maintain and develop an immersive story, the inability to control the physical reality of an MR user requires an approach that puts that user and their interactions at the center of the story making process. This puts an MR cyberbard at a distinct disadvantage, cutting them off from writing extensive settings engendered as visual representations. For example, imagine the classic story of the *Jungle Book* without it ever explicitly, outside of the title, stating that the story takes place in the jungle. There would be no river for Baloo to drift down and Shere Khan does not stalk Mowgli through the grass. Baloo floats; Shere Khan stalks. Unable to develop the setting, MR cyberbards cannot only focus on characters, objects, and their relationships with the user; they must also become arbiters of agency, facilitating those relationships in a digital story integrated within reality to support their narrative's progress.

## 3 Strong Concepts for Non-verbal Interactions in MR

### 3.1 The Types of Strong Concepts

Strong concepts, a term established by Kristina Höök and Jonas Löwgren, comes from HCI and is used to describe a space of workable knowledge; a conceptual framework that sits between particular instances and theories. They posit strong concepts as

generative intermediate-knowledge that influences the creation of new designs. To put it simply, strong concepts are meant for ideation and are better suited for the exploratory work designers do to develop solutions [7]. They are, "design elements abstracted beyond particular instances which have the potential to be appropriated [...] to extend repertoires and enable new particular instantiations". Four characteristics have been established for strong concepts. One, a strong concept must address an interactive behavior rather than a static appearance; two, it resides at the interface between technology and people while at the same time speaking to a use practice and behavior over time; three, embody a core design idea that can be applied to various situations and potential domains; and four, it is situated on an abstraction level above particular instances. The strong concepts being put forward are conceptual tools that further both design and knowledge-based work for MR non-verbal interactions in narratives [3].

As MR encompasses both AR and AV, it is possible to look at current design trends and ascertain that there are two broad families of core design paradigms. The first group is dedicated to the immersive nature of the digital story in the physical world. Ideas in this group might be related to mapping digital textures to walls and the transparency [8] of MR objects in the physical world. This group is concerned with maintaining a believable flow [9] to present a cohesive MR interface that facilitates interactions in the narrative. The second group supports the first but are solely interaction based, focused on the configuration of MR for a story as it is presented to the user, the relation of a non-verbal interaction to the physical space in which it is executed, and the relation of a non-verbal interaction with a physical or digital object for narrative progression.

These concepts have been developed by looking at a spectrum of previous work exploring the affordances of AR technology. Initial research was focused on displaying digital objects in the physical world [1, 12, 33]. Concepts developed in the late 90's and early 2000's focus on interaction with these objects [33, 40, 41]. Many researchers have put forward pieces of concepts, but this paper seeks to thread them together into intermediate knowledge for future MR designers. However, the concepts established in this section should be considered in flux. Undoubtedly, as both VR and AR establish themselves as both mediums and platforms, their influence on the design of interactions in MR will shift. Additionally, as the first generation of MR devices hit a mainstream audience, new concepts will likely need to be generated. Lastly, as with any behavioral gestalt, these concepts are likely to shift as users develop tighter relationships with their devices and designers push the boundaries of the platform.

### 3.1.1   Strong Concepts for the Configuration of Mixed Reality for Interactions

MR involves an active recognition of the environment and unlike VR, does not encompass it. Physical reality is ever present in MR, even if aspects have been augmented digitally. As such, understanding how to design an MR experience for a setting that can't be known by the designer requires strong concepts to address the mapping of space, recognition of physical objects, and their placement. At first, what follows may appear to violate the first characteristic of strong concepts, that of being based in interactivity and not appearance. However, MR requires the dynamic interaction between the user's position, device orientation, and the immediate physical reality to display content. As

such, the rendering of digital objects in MR is not static and so falls within the purview of the first characteristic.

**Real Time Mapping.** Refers to simultaneous localization and mapping, known colloquially as SLAM [10], as the ability to chart and track movement in a space [11]. Yi-Fu Tuan's understanding of space and place, in which movement of the body within a space and the requisite nature of a space make a place, parallels the technology. [12]. Real Time Mapping executed by a body wearing an MR device in a space creates the setting for an interactive narrative. A SLAM system is necessary for the MR device to understand the dimensions of a space, the user's location, and the location of any physical objects that might interrupt movement. Real Time Mapping is the digital assessment of physical reality for the output of an augmented or mixed reality; the fidelity of the input data can be manipulated by the MR designer to suit the needs of their experiences and interfaces [13, 44]. Researchers at MIT have utilized a handheld Kinect with a modified algorithm to continuously map rooms in such detail that even the folds of a bed sheet can be captured [14].

Microsoft's HoloLens and Magic Leap's device have publicized examples of MR real time mapping. Microsoft shows a user standing in a constructed living room playing *XRAY* [15]. The user points his arm at a nearby wall and fires his digital weapon to make holes in it. Moments later, an alien slams through the holes, casting digital debris in all directions. The MR application is aware of the walls in the room, and the aliens scramble along the floor in a realistic manner. Real Time Mapping affords the accurate use of space in relation to a user and their interactions. The ability of MR devices to map environments with such accuracy challenges designers to create spaces with digital props and avatars instead of architectures. The concept of Real Time Mapping emancipates the designer from the constraints of rendering settings, which ostensibly have been wireframes and textures, while at the same time constraining them within the immutability of reality.

**Object Recognition.** Mapping a space enables the device to ascertain the silhouettes of objects, but another step is required to recognize, categorize, and assign interactive elements to them. As of 2001, researchers have developed algorithms that can ascertain and identify objects in a scene [16]. The theory behind object recognition, however, is a departure from physical identification. Instead, theory from Heidegger in regards to phenomenology can be utilized [17].

Remember that the essence of an object is not the object itself [18]. Instead, it is, to take Heidegger's example of the tree, "that which pervades every tree, as tree," Object recognition allows the designer to amend the essence of identified objects, to alter their very thingness and transform them into interfaces [19]. An example of this is SmartReality's AR app that turns physical buildings into interactive elements that, when clicked on via a smartphone, provide the user with information about their design and construction [20]. The essence of the building has changed to that of a digital button. Another is the modification of a piece of paper with a tracking image into a performance stage. In Crayola's *Color Alive*, children draw on coloring book pages. When they point their AR device at their drawing, it comes to life as a 3D agent [21]. The drawing

becomes a performer; the paper becomes a stage—their essences altered. MR extends this capability beyond tracking images or pre-defined models to real time augmentation. Designers can utilize this concept to reimagine the affordances of physical objects as interfaces in MR stories.

**Digital Colonization.** The semantics of this concept are borrowed from colonial theory to signify the domination of reality by digital objects [22]. The way in which these objects are displayed in the physical world facilitates the flow between reality and virtuality [23]. Designers can implement many tactics to accomplish this. One, incrustation, is when a digital object is overlaid atop of a physical one, either completely or partially covering it. The opposite of incrustation is integration, in which a digital object is integrated into reality. True integration necessitates that the digital object reacts to the behavioral associations of the world. For example, a digital model of a red car is displayed via an MR device with its hood in the sun and its trunk in the shade. If the car is displayed with the tactic of integration, then the hood of the car will be of a lighter tint of red than the trunk. The tactics of incrustation and integration are used to alter the degree of immersiveness of the digital objects posited in reality. Truly transparent digital objects are ones that operate appropriately to the context of their environment [8]. However, MR cyberbards may choose to increase the immersiveness of their narratives by applying aesthetic principals that suit their intent [44]. In each instance, the designer is dynamically augmenting the spatial configuration of reality to enable particular inter- actions. Designers of MR interactive narratives develop stages without floors, relying instead on set pieces, i.e. digital objects. In short, the appearance of stages is set through the dynamic interaction of the user with their MR device and their immediate physical reality. Furthermore, the MR cyberbard's efforts are constrained by the unpredictability of reality, and this extends to how users engaging within their narrative will behave.

### 3.1.2   Strong Concepts for MR Non-verbal Interactions in Physical Space

Non-verbal interactions in MR take place in a physical space but do not necessitate engagement with a digital object. The way a user behaves within an MR environment can impact the progression of a story. For example, the Yelp App has an AR mode that tracks the user's location. As they move, digital labels pop up in front of businesses to give ratings [24]. The user has not interacted or engaged in any way other then opening the app and moving. In the Yelp app and others, position and movement through an AR- enabled space is generative. This is enabled by the technical affordances of GPS and wi-fi triangulation. Location-awareness and generative exploration, the two concepts put forward, differ in that the former is about situating the user and the later is about movement. Designing their implementation is critical to the user's relationship with the MR space.

**Location-Awareness.** This concept, based on the aforementioned technical affor- dances, converges with theories of place-making put forward by Lev Manovich, Guy Debord, and the Situationist Movement [25, 26]. The concept is predicated upon the user being situated in a physical space that has been augmented with digital content. The copy and paste concept put forward by Manovich supports MR's ability to place digital

content on top of real locations. A user that accesses this content in a specific location garners a new understanding of the space's psychogeography [27]. For MR narratives, the psychogeography of a place might be considered the story's setting. Location-awareness in MR is about augmenting the emotive aspects of a physical location to match the setting of the interactive narrative. A foundational example, *The AR|AD Takeover* AR app works only within Time Square [27]. The psychogeography of the square is ostensibly neo-liberal and capitalist in nature; when a user utilizes the app the billboards are replaced with works of art, altering the experience. However, it is not only when a user arrives at a location that new content is generated; the journey *to* those locations is also ripe for interaction.

**Generative Exploration.** Voluntary movement affords opportunity and represents agency. Individuals traveling through the world engage in a series of non-verbal inter-actions. Humans act contextually to their environment, dodging a speeding car or jumping over a pothole. Translating this experience into an MR narrative means concep-tualizing voluntary physical movement as an interaction. The technical aspects of this concept are the same as location-awareness. The theoretical aspect, however, is closer to that of the Dérive [28] and Gilles Deleuze's Plane of Immanence [29]; the way in which a person moves from place to place impacts how they understand those spaces. Users are a part of the world in which they move, whether it be augmented or not. As they move through the MR narrative they are engaged in discovering their dynamic powers, their kinetic relationship within that augmented world, and the constraints of those powers. In short, users claim their dramatic agency.

Various AR games have implemented this concept. The AR version of *Façade* utilized an AI to track and assess user movements [30]. If the user's movement appeared to be erratic, one of the protagonists in the game, Trip, would ask the user if they wanted to leave. This is an example of how a non-verbal interaction is articulated to generate written content. Players in *AR Façade* move about and explore a space much in the same way they would in the physical world. This is encouraging for non-verbal interaction designers because it supports the idea that users will not drastically alter their behavior from societal norms when interacting within an MR narrative.

In the canonical AR game, *ARQuake,* movement is a key aspect of the first-person-shooter experience [31]. The user's movement determines the rate of movement within the game world and events are triggered by the user's proximity. For example, doors open when the user is nearby. Almost all of the non-verbal interactions in *ARQuake* are based on movement. Unlike *AR Façade*, *ARQuake* does not use an AI that dynamically generates content based on the user's behavior. Instead, the developers use a highly constrained approach with familiar gameplay to guide the user and design interactions.

Designers implementing the concept of generative exploration utilize logic, AI, or constraints to assess and direct user movements. This connects innate user behavior to narrative generation and lends support to the immersive nature of the MR narrative. How a user interacts with digital and physical objects in an MR environment is governed by a separate series of concepts.

### 3.1.3    Strong Concepts for the Relation of a Non-verbal Interaction with a Physical or Digital Object for Narrative Progression

WIMP interfaces and touch-interfaces do not support real world interactions. They instead focus on human-computer interactions [32]. This presents a series of challenges and affordances for the MR designer, underscoring the necessity for a new brand of gesture-based interactions [33–35]. Due to the advent of SLAM, gestures without threshold objects such as controllers, are available for implementation. These designed interactions activate objects as interfaces, turning them into dispatchers that communicate relevant data to a narrative generation system [36]. Non-verbal interactions with objects are a discourse in expression. These interactions, whether physical or digital, facilitate a new narrative branch. The ways in which gestures dispatch this information is related to the strong concepts of free hand interaction, fingertip rays, and static and dynamic gestures.

**Free Hand Interaction.** Based on the concepts of encumbered and unencumbered VR put forward by Howard Rheingold, free hand interaction is the belief that all interactions in the MR world need not be hampered by a threshold object [37]. Since users utilize their hands to manipulate physical objects, they should be able to do so with digital objects. A similar premise has been put forward by Leap Motion CTO David Holz, who stated that users should be able to manipulate the bits of the digital world as they would atoms in the physical one [38]. Further, this concept enables designers to develop non-verbal interactions related to the movement of the hand. It involves placing a three-dimensional coordinate grid in the palm of the hand and tracking that origin as the hand moves via the MR device's camera [39]. This allows for near space interactions in which a user is able to interact with nearby digital or physical objects. Each interaction is generative, tied into a system that drives the development of a story. In VR apps such as *Lyra VR*, users are able to grab, push, point, and manipulate digital buttons to create musical compositions [40]. *Lyra VR* may be a VR experience, but it serves to highlight the potential for human hand tracking in an MR environment.

**Fingertip Rays.** Fingertip rays are for far space interactions [37]. The concept is an amalgam of the technical methods of ray casting and collision detection. Ray casting is the projection of a line from a 2D point of interaction, such as a user touching an iPhone screen, into a 3D space to hit a digital object. Collision detection is the recognition of that casted ray's hit. In MR, rays are cast by detecting the finger, its orientation, and depth in the environment [41]. The design of the ray casting system and how it operates can be understood through Merleau-Ponty's abstract and concrete movements [42]. Designing ray casting systems in regards to fingertips mean collapsing both the virtual and objective body into one another. The concrete body is, of course, the finger, but the virtual body, as if it were a passenger, rides into the digital world via the ray casting system. In many AR first-person-shooter games the abstract movement is actuated via a touch on a smartphone screen and may appear as ammo being shot, in RPGs as a spell being cast, or in MR as simply pointing to and activating an item.

**Static and Dynamic Gestures.** Reality is complicated; one does not drink from a bottle without unscrewing its cap, placing it to the side, and then raising the bottle to one's

lips. The concept of static and dynamic gestures posits that there are two kinds of inter-actions that occur in MR environments: static, in which the angles between the fingers do not move over time; and dynamic, in which the angles between fingers do indeed change [43]. A static gesture is closely related to the concept of fingertip rays, as it includes pointing to or grasping an object. Dynamic gestures include waving or writing in the air. This concept is particularly important for non-verbal interaction in MR narra-tives because it affords the opportunity to utilize an individual's body language. At its most foundational, waving toward a digital agent in an MR narrative begins a conver-sation. Creating a chain of interactions may include executing a dynamic gesture to pick an object up and then grasping it in a static gesture and carrying it around. Consider for example, an urban planning application using the FingARtips system [45]. Users are able to dynamically pick up a building, statically hold it, and then dynamically place it. Designing non-verbal interactions for MR narratives then is about assigning story content to these different kinds of gestures.

## 4   Conclusion

Strong concepts for non-verbal interactions in MR narratives have been put forward in this paper to introduce an exploratory toolbox for designers. They are based on the current behavioral gestalts and the affordances of AR, AV, and VR devices. MR does not provide any unique affordances that AR and VR do not already currently offer. However, the platform encompasses the majority of the unique technological and behavioral affordances of each. Interaction designers interested in utilizing the MR plat-form are able to implement a wide range of technologies, that have not existed cohe-sively, to integrate digital stories into reality. Focused on facilitating agency in the story world, MR cyberbards can use these strong concepts to create interactive narratives that are integrated with reality. As such, practitioners can implement non-verbal interactions as an arbiter of agency to facilitate the relationship between the digital story, the user, and the immediate physical reality.

## References

1. Milgram, P., Haruo, T., Akira, U., Fumio, K.: Augmented reality: a class of displays on the reality-virtuality continuum. In: Telemanipulator and Telepresence Technologies (1995)
2. Mark Skwarek. http://www.markskwarek.com/
3. Höök, K., Löwgren, J.: Strong concepts. ACM Trans. Comput. Hum. Interact. **19**(3), 1–18 (2012). doi:10.1145/2362364.2362371
4. Murray, J.H.: The Aesthetics of the Medium. Hamlet on the Holodeck: The Future of Narrative in Cyberspace, pp. 97–154. MIT, Cambridge (1998)
5. Mateas, M., Stern, A.: Interaction and narrative. In: The Game Design Reader: A Rules of Play Anthology, pp. 642–669 (2006)
6. Akimoto, T., Ogata, T.: Macro Structure and Basic Methods in the Integrate Narrative Generation System By Introducing Narratological Knowledge, pp. 1–25 (1999)
7. Lawson, B.: How Designers Think. Butterworth Architecture, London (1990)
8. Bolter, J.D., Grusin, R.: Remediation: Understanding New Media. MIT, Cambridge (1999)

9. Nam, Y.: Designing interactive narratives for mobile augmented reality. Cluster Comput. **18**(1), 309–320 (2015). doi:10.1007/s10586-014-0354-3

10. Feng, Z, Been-Lirn Duh, H., Billinghurst, M.: Trends in augmented reality tracking, interaction and display: a review of ten years of ISMAR. In: Proceedings of the 7th IEEE/ACM International Symposium on Mixed and Augmented Reality (ISMAR 2008), pp. 193–202. IEEE Computer Society (2008) doi:10.1109/ISMAR.2008.4637362

11. Yi-fu, T.: Space and Place: The Perspective of Experience. University of Minnesota, Minneapolis (1977). Print

12. Hernández-Aceituno, J., Arnay, R., Toledo, J., Acosta, L.: Using kinect on an autonomous vehicle for outdoors obstacle detection. IEEE Sens. J. **16**(10), 3603–3610 (2016). doi:10.1109/JSEN.2016.2531122

13. Dostal, J., Hinrichs, U., Kristensson, P.O., Quigley, A.: SpiderEyes: designing attention-and proximity-aware collaborative interfaces for wall-sized displays. In: Proceedings of the 19th international conference on Intelligent User Interfaces. (2014)

14. Whelan, T., Kaess, M., Fallon, M.: Kintinuous: Spatially extended kinectfusion. In: RSS Workshop on RGB-D: Advanced Reasoning with Depth Cameras, p. 7 (2012)

15. Hololens, M.S.: https://www.youtube.com/watch?v=C3rNIxMlKmI

16. Viola, P., Jones, M.: Rapid object detection using a boosted cascade of simple features. In: Proceedings of the 2001 IEEE Computer Society Conference on Computer Vision and Pattern Recognition, CVPR (2001)

17. Heidegger, M.: The question concerning technology. In: Technology and Values: Essential Readings, pp. 99–113 (1954)

18. O'Brien, M.: Commentary on Heidegger's "The Question Concerning Technology". In: Thinking Together: Proceedings of the IWM Junior Fellows' Conference, vol. 16, XVI, 2 (2004)

19. Murray, J.: Did it make you cry? Creating dramatic agency in immersive environments. In: Subsol, G. (ed.) ICVS-VirtStory 2005. LNCS, vol. 3805, pp. 83–94. Springer, Heidelberg (2005)

20. SmartReality Augmented and Virtual Reality BIM Mobile App. http://smartreality.co/

21. Crayola Color Alive. http://www.crayola.com/splash/product/colorAlive

22. Collins English Dictionary. HarperCollins (2011)

23. Hugues, O., Fuchs, P., Nannipieri, O.: New augmented reality taxonomy: technologies and features of augmented environment. In: Handbook of Augmented Reality (2011). doi:10.1007/978-1-4614-0064-6

24. Yelp: Yelp on the App Store. App Store. iTunes App Store (2016). https://itunes.apple.com/us/app/yelp/id284910350?mt=8&ign-mpt=uo%3D8

25. Manovich, L.: The poetics of augmented space. Visual Commun. **5**(2), 219–240 (2006)

26. Debord, G.: Theory of the Dérive. Situationist International Online. Trans. Ken Knabb. Internationale Situationniste (2015). http://www.cddc.vt.edu/sionline/si/theory.html

27. Biermaan, B.C., Levy, H.: AR I AD Takeover: Publicadcampaign. AR I ADTakeover: Publicadcampaign. PublicAdCampaign (2012). http://www.publicadcampaign.com/video/ar-i-ad-takeover

28. Tuters, M.: The locative commons: situating location-based media in urban public space. In: Electronic Proceedings of the 2004 Futuresonic Conference (2004)

29. Deleuze, G.: Pure Immanence, p. 27. Zone, New York (2001)

30. Dow, S., Mehta, M., Lausier, A., MacIntyre, B., Mateas, M.: Initial lessons from AR Façade, an interactive augmented reality drama. In: Proceedings of the 2006 ACM SIGCHI International Conference on Advances in Computer Entertainment Technology, Article No.: 28 (2006). doi:10.1145/1178823.1178858

31. Thomas, B., Close, B., Donoghue, J., Squires, J., De Bondi, P., Piekarski, W.: First person indoor/outdoor augmented reality application: ARQuake. Pers. Ubiquit. Comput. **6**(1), 75–86 (2002). doi:10.1007/s007790200007

32. Rekimoto, J., Nagao, K.: The world through the computer: computer augmented interaction with real world environments. In: Proceedings of the 8th Annual ACM Symposium User Interface and Software Technology UIST, pp. 29–36. ACM Press (1995). doi: 10.1145/215585.215639

33. Lee, T., Hollerer, T.: Handy AR: Markerless inspection of augmented reality objects using fingertip tracking. In: International Symposium on Wearable Computers, October 2007 (2007)

34. Klein, G., Murray, D.: Parallel tracking and mapping for small AR workspaces. In: Proceedings of the Sixth IEEE and ACM International Symposium on Mixed and Augmented Reality (ISMAR 2007), Nara, Japan, November 2007 (2007)

35. Lepetit, V., Fua, P.: Monocular model-based 3d tracking of rigid objects. Found. Trends Comput. Graph. Vis. **1**(1), 1–89 (2006)

36. Cavazza, M., Charles, F., Mead, S.: Interacting with virtual characters in interactive storytelling. Agents and Multiagent Systems: Part 1, pp. 241–318 (2002). doi: 10.1145/544741.544819

37. Rheingold, H.: Virtual Reality. Summit, New York (1991)

38. Holz, D.: 2015 SVVR - The Future of Wearable Displays and Inputs. Silicon Valley Virtual Reality. San Jose Convention Center, San Jose. YouTube. Web. https://www.youtube.com/watch?v=xAUG6prB2nA

39. Lee, T., Höllerer, T.: Hybrid feature tracking and user interaction for markerless augmented reality. In: Proceedings - IEEE Virtual Reality, pp. 145–152 (2008). doi:10.1109/VR.2008.4480766

40. Metanaut. Play Your Music (2015) http://lyravr.com

41. Lee, M., Green, R., Billinghurst, M.: 3D natural hand interaction for AR applications. In: 2008 23rd International Conference Image and Vision Computing New Zealand, IVCNZ, pp. 2–7 (2008). doi:10.1109/IVCNZ.2008.4762125

42. Merleau-ponty, M.: Phenomenology of Perception. Philos. Books **4**(2), 17–20 (1963). doi: 10.1111/j.1468-0149.1963.tb00795.x

43. Reifinger, S., Wallhoff, F., Ablassmeier, M., Poitschke, T., Rigoll, G.: Static and Dynamic Hand-Gesture Recognition for Augmented Reality Applications. In: Jacko, J.A. (ed.) HCI 2007. LNCS, vol. 4552, pp. 728–737. Springer, Heidelberg (2007). doi: 10.1007/978-3-540-73110-8

44. Bolter, J., Gromala, D.: Transparency and reflectivity: digital art and the aesthetics of interface design. In: Aesthetic Computing, 7 (2004)

45. Buchmann, V., Violich, S., Billinghurst, M., Cockburn, A.: FingARtips – Gesture based direct manipulation in augmented reality. In: Proceedings GRAPHITE 2004 - 2^(nd) International Conference on Computer Graphics and Interactive Techniques in Australasia and South East Asia, 1(212), pp. 212–221 (2004). doi:10.1145/988834.988871

# Can You Read Me that Story Again? The Role of the Transcript as Transitional Object in Interactive Storytelling for Children

María Goicoechea[1](✉) and Mark C. Marino[2](✉)

[1] University Complutense of Madrid, Madrid, Spain
mgoico@filol.ucm.es
[2] University of Southern California, Los Angeles, USA
markcmarino@gmail.com

**Abstract.** With a special focus in designing interactive stories for children, this article considers transcripts, whether playscripts of interactive stories or recordings of video games, as transitional objects, not as crutch, but as a bridge between the open possibility space of games and the fixed linear realms of video and print. Through a series of examples, the authors argue that transcripts provide a stabilizing aid for reading and interacting in digital environs for users of all levels of experience. The transcript offers the player a means to fulfill and extend the creative collaboration of play by producing a record of their performance. Despite freezing interaction, transcripts provide a tracing, a linearization of experience that may prove to be central rather than secondary to gameplay. We argue that game designers should consider the central role of the transcript in player retention, comfort, and pleasure.

**Keywords:** Theoretical foundations · Reader-response criticism · Interactive storytelling · Children's literature · Transitional object · Transcript

## 1 Introduction

Designing interactive stories and games for children poses diverse challenges, one of them being finding the right balance between free interactivity and guidance. On the one hand, children love to explore and interact (e.g., Minecraft or Choose Your Own Adventure branching narratives), to choose their path and participate in the construction of the story. On the other hand, children also love to hear the same story over and over again, obtaining pleasure in reiteration and the confirmation of their expectations. Choice can offer a sense of empowerment and agency, or it can create feelings of anxiety over paths not taken or disorientation. As it turns out, children are not alone in wanting transcripts or records of their play, as interactors of all ages produce transcripts of all manner of games, from the text-based records of interactive stories to the current live streams and recordings of their gameplay on Twitch and elsewhere. Transcripts are proving to hold a powerful place in play.

© Springer International Publishing AG 2016
F. Nack and A.S. Gordon (Eds.): ICIDS 2016, LNCS 10045, pp. 309–316, 2016.
DOI: 10.1007/978-3-319-48279-8_27

Certainly, we are facing a paradox: though the interactive story or sandbox game ignites the pleasure of discovery and adventure, it frustrates the pleasure of re-reading and the fulfilment of expectations. In this paper, we theorize the role of the transcript as the linearization of experience, providing a bridge between the comparatively open world of the game and the linear world of video or text. However, rather than a crutch, or an intermediary object to be discarded upon the interactor's maturation as a player, the transcript offers a means of re-reading and extending the player's creative performance in collaboration with the system. We propose that game designers should therefore consider the central role of the transcript in player retention, performance and pleasure.

## 2    The Habit of Re-reading

Critics of children and teenager literature coincide in attributing a positive value to the habit of re-reading. It has been recognized that repetition allows children to internalize story patterns, which in turn helps them solve linguistic and cognitive puzzles, reinforcing their understanding of the story as well as their cognitive development [1]. These scholars recommend reading the same story repeatedly to children up to 36 months. As children mature, they will learn to dramatize, tell the story to others (4-year olds), recognize hero and villains and compare self to characters (5-year olds). However, even older children yearn for re-reading.

Re-reading the same story also allows children to recognize details they may have missed in previous readings and fortifies their memory. Moreover, re-reading also gives children the time to connect the words they read on the page with those they hear around them, helping them to establish a connection between the virtual world of the book and their life experience.

According to Piaget's child development theories, children's cognitive evolution progresses from the concrete to the schematic to the symbolic, offering extensive evidence that children learn through embodiment and by handling concrete objects, such as books, with which they can engaged at different emotional levels, even before they learn to read (from pretending they are reading to others, recognizing colors, shapes and figures, to identifying with specific characters) [2].

The pleasure of re-reading, however, is not only part of children's reading development but it has also been identified by teachers, authors, and critics alike as a necessary learning strategy that helps readers of all ages transcend a superficial consumption of the text and to internalize its rich texture, its vocabulary, and structural schemas, so they can fully inhabit the virtual world offered by the text [3].

For example, Susan Sontag, one of the most voracious readers of the 20th century, describes in her diaries how repeated re-reading of her favorite classics has enabled her to assimilate the text to such an extent as to feel she has become a co-participant in the act of creation: *"For, I am not only reading this book, but creating it myself"* [4]. Thus, re-reading becomes another form of interactivity, since it provides the reader with an insider's glance of the text close to that of the producer.

We contend that interactors with digital stories and games also desire this re-reading and that transcripts, in their role as transitional objects, increase reader engagement,

providing another form of cognitive interactivity which complements the exciting and exploratory reading experience carried out in the digital domain.

## 3    What Is a Transitional Object?

Donald Woods Winnicott, a British pediatrician and psychoanalyst, described a transitional object as a tool used by the child to progressively manage the boundaries between the self and the world [5]. Generally an object, though it can be a more abstract entity, like a sound or a space, the transitional object (a security blanket, a teddy-bear, etc.) is closely identified with the child's sense of self, and, at the same time, is also perceived as an entity from the external world. The transitional object is used to provide comfort and to alleviate the child's anxieties, providing a source of pleasure through interaction with it.

Winnicott argued that the transitional object functions as the predecessor to adults' cultural objects since their form of engagement with them also takes place in this transitional space, between the I and the not-I or other. It was the critic Gabriele Schwab who, inspired by George Poulet's phenomenology of reading, transferred Winnicott's concept of the transitional object to the field of reading [6]. Poulet describes reading as a form of engagement with an object in which the object ceases to be felt as one: "*[T]he extraordinary fact in the case of a book is the falling away of the barriers between you and it. You are inside it; it is inside you; there is no longer either outside or inside*" [7]. Schwab found a connection between the type of reading carried out by children and Poulet's description, identifying, in the "intermediate area" created by the creative production and reception of literary works, a privileged space where we can reorganize the boundaries of the self.

Through the act of reading and rereading, the book becomes a transitional object, at once familiar and distinct from the self, helping the child create an illusory space where he can experiment with his relation to the world.

## 4    Reading Proficiency and Engagement with Otherness

But how can we measure this proficiency, when reading is in itself a cultural phenomenon and not just a biological skill, like talking or walking, whose development is easier to assess from an objective perspective? In her essay, Gabriele Schwab argues that our internalized patterns of reacting to otherness will influence our reading habits. She distinguished different stages of reading in which this negotiation between self and other takes place through distinct modes of cultural contact: two very early forms –introjection and rejection–, the most frequent one – projection –, and the most evolved one –reflexivity. These stages also help delineate a typology of readers as they progress from either totally immersing themselves in the illusory world of the text (introjection) or rejecting it completely (rejection), then to apprehending its otherness by projecting their prejudices on the text (projection), finally to becoming conscious of their projection and entering a reflexive mode, both in and out of the virtual world presented by the text (reflexivity).

Though the evolution through these stages depends on the reader's experience and cultural environment rather than on age, Schwab noticed a key to understanding the reading process, that the pleasure of reading is intimately tied to the earlier stage of introjection and to children's enjoyment of books as transitional objects: a type of immersive reading in which the reader manages to fuse completely with the virtual world, forgetting about his or her own identity and enjoying the reenactment of well-known scenes. A trace of this immersive reading, this "archaic fusion," needs to be recollected or revived even in the more sophisticated reflexive readings so that the reader can fully experience the power of the imaginary world the story offers.

As readers vary in their acceptance of otherness and in their strategies to deal with novelty and surprise, they also have different degrees of habituation to new digital reading environments, which can represent another form of otherness to assimilate. As Ramada and Reyes argue, despite the emergence of digital literature and the digital media that surround children, *"they continue to receive an extremely analogue education,"* which affects their ability to process digital storytelling [8].

## 5 The Role of Transcripts as Transitional Objects

The transcript, what Montfort has called a traversal [9], collects what has happened when the interactor "completes" a work of Interactive Fiction by going from the beginning until no more can be narrated, and thus it provides an equivalent sensation to having read the whole book. Whereas Monfort evaluates traversals in terms of success or failure, we could add that reading such textual (by)products provide a deepened experience of the Interactive Fiction akin to re-reading, allowing the user to revive once again the immersive experience and connect at a more emotionally secure level with the fictional world. These linearizations are not limited to text-based games but extend into recordings of image-based games.

We believe that the transcript, understood as a linearization of experience, which can take on various formats, can provide a smooth transition into digital reading environments for readers still tied to analogue reading. Retaining strategies from print reading, such as rereading, can actually prove to be beneficial, as explored in the study of screen reading carried out by Goicoechea and Sanz, who contend that, instead of a gap between digital natives and non-natives, there is a gradual logic in the appreciation of electronic literature and that reading strategies developed by print readers can be very well-suited to the demands of the digital domain [10].

## 6 Case Study: Mrs. Wobbles and the Tangerine House

One of the outputs an interactive narrative can produce is a transcript (or "session text"), which may contain "both the text typed by the interactor and the text produced by the program" (Monfort 24). The term "session text" refers to "a single session" with the program. Transcripts are built into contemporary IDEs for debugging but can also serve

as records for readers. More broadly, a transcript could be called the linear reproduction of interactive experience.

Transcripts are nothing new to text-based interactive fiction. Parser-based interactive fiction has presented logs since their inception. Even Joseph Weizenbaum's ELIZA (1966) communicated via teletype, which by necessity produced a typed record. Similarly as users interacted with Colossal Cave Adventure (1976) via print (as opposed to "glass" or CRT) terminals, they would also produce a typed record. Inform games, which pioneered the commercial IF market, had a "script/unscript" toggle that allowed interactors to create a printout of all interactions. Following this legacy, the current major IF authoring systems, TADS 3 and INFORM 7, produce transcripts. However, in contemporary visually based interactive adventures, transcripts are largely replaced by waypoint saves.

Nonetheless, even visually based interactive stories can produce a transcript, as evidenced by *Façade* (2005). While this system offers tremendous variability, at the end it generates a transcript (or stageplay) presenting all of the text of the game that has been entered by the user and spoken by the NPCs. Because *Façade* allows open input, the transcript in that game functions more like a record of a collaborative performance, archived as standalone artistic creations. Due to the framing of the stageplay as a produced object, this transcript encourages creative player performances while linearizing the interactive drama [11].

Print-based Choose-Your-Own-Adventure stories offer the clearest corollary to interactive stories. They are largely designed for continuous forward progress along a branching narrative. However, it is not uncommon for readers of these stories to keep one finger in the last choice point and then to sample the consequences of each choice before moving on. In this case, the physical book itself acts as a transcript of the reading experience, offering that comforting transitional object and a sense of containment of the uncertainty of the reading experience.

While transcripts record these collaborative performances, young readers can use transcripts of interactive reading experiences as transitional objects to help them as they move from traditional print-based stories into the world of interactive stories. To illustrate we offer the example from a series of interactive stories for children called *Mrs. Wobbles and the Tangerine House* (2013–15) [12], published in three separate episodes on the Undum platform, a free and open-source, JavaScript-based interactive storytelling platform developed by Ian Millington.

In its default settings Undum presents new textual nodes or lexia by extending a continuously scrolling document, leaving readers with a record of their experience on one long Web page. This behavior can be altered by starting over on a new page, but in its basic form a story for Undum will offer a record of what the reader has seen. Similar interactive story systems, like the Lifeline series (3 min Games 2015), also offer continuous scrolls of output. What remains is a single Web page made of the text the reader's choices elicited with the choices themselves removed.

The Mrs. Wobbles tales are middle grade stories set in a magical foster care home and offer readers the chance to navigate a magical world as children in a third-person choice-based story. The visual design is meant to evoke the feeling of reading a physical book, a characteristic of what Jessica Pressman calls "bookishness," [13] and the story

rewards readers with points for reading (or at least clicking on) additional story links as well as choosing links to poems.

After the introductory materials, the Undum page wipes clean the text and leads into the tale of "The Mysterious Floor" (the first episode) on one un-interrupted scroll. Such a transcript not only offers young readers a record, it also presents the opportunity to re-read the same story. Even if the reader does not review it, this record creates a sense of permanence of the story for insecure readers, who may find the disappearing text produces anxiety. Espen Aarseth famously described the anxiety produced by ergodic texts – discussing what he called the sense of aporia produced by hypertext fictions. The transcript offers the trail of breadcrumbs to aid the reader see the effect of their choices [14].

This ongoing transcript is crucial to the evocation of bookishness but it also offers a comfort to readers and a record of their performance. However, these transcripts are not only crucial components of text-based games. Players also seek the linearization of play as a part of their video-game play as well.

## 7   Implications for Other Games

Although we are focused on interactive narratives for children, transcripts and traces have proven to be important for interactive play from AAA games to instructional simulations, where the convention of the "debriefing" serves as transcript. Even in the AAA world, players seem to long for the transcript or record of play, a need supplied by "Let's Play" videos, eSports commentaries, and Twitch. The eSports play-by-play creates a linear verbal transcript of play experience [15], which, though selective, is equivalent to a text-based transcript.

As transitional objects, transcripts offer players some control over the frustration and uncertainty of gameplay. Through transcripts, players create a rendering minus the struggle to operate whereby viewers, comforted with the continuity and stability of the linear record, are freed to observe more elements of play.

Such records appear to be in tension with the aesthetics of frustration that mark game play itself. Jeremy Douglass has theorized the "aesthetics of frustration" [16] as a hall-mark of interactive fiction but this aesthetic manifests itself in most gameplay from PAC-MAN to Flappy Bird, where players constantly bang against constraints of the system. Noting the continuity, Douglass has said, "players could stream Adventure directly to printer but now stream League of Legends directly to Twitch" [17]. Along with the interactive fiction transcript, the video record of play comforts because it subtracts the frustration from the experience.

The desire to produce recordings of video logs suggests that even experienced players of video games desire these transitional objects as a part of their overall encounters with these frustrating and complex systems. Rather than "transitional" in the sense of a phase between stages of psychological development, the transcript is a tool for achieving a sense of control of our play experience. Transcripts, as text or video record-ings, offer a sense of stability that grounds our encounters with complex, multilinear systems and provides opportunities for reflection.

# 8   Future Research

This theorization of the transcript as transitional object suggests the desire for a record of play is a fundamental source of pleasure in the experience of computer games. Since players of all levels of experience seem to crave and enjoy such records, game creators should take this desire into account when creating systems, developing more affordances for recording experience.

We are particularly interested in the role of transcripts of interactive stories for young players as a means of providing comfort and stability while also offering a stepping stone to more exploration and increased literacy in the systems. Reading theories that examine books as transitional objects offer a framework for understanding transcripts as opportunities for engagement through re-reading. In order to examine the role of transcripts further, it would be useful to conduct studies of children's interactions with interactive stories and other computer games to see how these records support the process of acquiring what David Buckingham calls "functional literacy" and mastery of gameplay [18]. Moreover, it would be helpful to test whether transcripts over time provide the means for young readers to transition, to become more comfortable with interactive stories to the point that they no longer feel they need the transcripts.

The re-emergence of the discussions of the transcript as a locus of player activity, in the form of logs, records, or video-capture, suggests that this process of producing linear renderings of play is not merely a way to share play on networks, it is a core component of gaining literacy within a system. While it might be a tool for bragging about one's ability or a source for mass entertainment (as in the case of eSports), it is also a way that players can find comfort in a familiar and predictable environment of the sort our mothers and fathers provided when they yielded to requests to read us that story one more time, a pleasure we indulge when rereading our favorite books or replaying our favorite game.

**Acknowledgements.**   This work was partially supported by the project eLITE-CM: Electronic Literary Edition (reference: H2015/HUM- 3426) within the Program of Research and Development among Research Teams of the Community of Madrid in Social Sciences and the Humanities, and 50 % co-financed by the European Social Fund for the programming period 2014–2020.

# References

1. Stood, B.D., Amspaugh, L.B., Hunt, J.: Emergent literacy: early literary experiences. In: Children's Literature. MacMillan Education, Melbourne (1996)
2. Piaget, J., Inhelder, B.: The Psychology of the Child. Basic Books, New York (1969)
3. Bland, J.: Children's Literature and Learner Empowerment: Children and Teenagers in English Language Education. Bloomsbury Academic, London (2013)
4. Sontag, S.: Reborn: Journals and Notebooks. In: Rieff, D. (ed.), pp. 1947–1963. Farrar, Straus and Giroux, New York (2008)
5. Winnicott, D.W.: Playing and Reality. Tavistock, London (1971). http://web.mit.edu/allanmc/www/winnicott1.pdf

6. Schwab, G.: Reader Response and the Aesthetic Experience of Otherness. Stanford Lit. Rev. 107–136. Spring (1986)

7. Poulet, G.: Criticism and the experience of interiority. In: Tompkins, J.P. (ed.) Reader - Response Criticism. From Formalism to Post-structuralism, pp. 41–49. The Johns Hopkins University Press, Baltimore (1980)

8. Ramada, L., Reyes, L.: Digital Migrations: Exploratory Research on Children's E-Lit Reading Profiles. Peter Lang, New York (2015)

9. Monfort, N.: Twisty Little Passages: An Approach to Interactive Fiction, p. 24. MIT, Cambridge (2005)

10. Goicoechea, M., Sanz, A.: Literary reading rituals and practices on new interfaces. Literary Linguist. Comput. **27**(3), 331–346 (2012). Oxford University Press

11. Dena, C.: "The Dance of Life." Cross-Media Entertainment. 15 March 2006. http://web.archive.org/web/20060524225045/http://www.cross-mediaentertainment.com/index.php/2006/03/15/dance-of-life/

12. The Marino Family. Mrs. Wobbles and the Tangerine House (2013–2015). http://markcmarino.com/mrsw/

13. Pressman, J.: The aesthetics of bookishness in twenty-first century literature. Mich. Q. Rev. **48**, 465–482 (2009). Fall

14. Aarseth, E.J.: Cybertext. Perspectives on Ergodic Literature. Johns Hopkins University Press, Baltimore (1997)

15. Plott. Sean S. A Case Study of Day [9] TV: How Interactive Web Television Parallels Game Design. Masters thesis. USC (2011)

16. Douglass, J.: Command Lines: Aesthetics and Technique in Interactive Fiction and New Media. Dissertation. UC Santa Barbara, p. 66 (2007)

17. Douglass, J.: Personal interview via telephone, 6 June 2016

18. Buckingham, D.: Game literacy in theory and practice. J. Educ. Multimedia Hypermedia **16**(3), 323–349 (2007)

# The Character as Subjective Interface

Jonathan Lessard[1]([✉]) and Dominic Arsenault[2]

[1] LabLabLab, Department of Design and Computation Arts, Concordia University,
Montréal, QC, Canada
`jonathan.lessard@concordia.ca`
[2] LUDOV, Department of Art History and Film Studies, Université de Montréal,
Montréal, QC, Canada
`dominic.arsenault@umontreal.ca`

**Abstract.** This paper re-frames virtual interactive characters as "subjective interfaces" with the purpose of highlighting original affordances for interactive storytelling through conversation. This notion is theoretically unpacked in the perspectives of narratology, interaction design and game design. Existing and imagined scenarios are presented in which subjective interfaces are elevated as core interaction mechanics. Finally, technical challenges posed by this approach are reviewed alongside relevant existing research leads.

**Keywords:** Theoretical foundations · Interface · Narratology · Game design

## 1 Introduction

I have a friend—let's call him Jean—who regularly informs me of events taking place at his workplace. Over time, I have conceived a rough mental model of this office space and become familiar with the people that populate it. For example, I know that in the afternoon Annette likes to drink grenadine in the cramped, brown kitchenette while playing Sudoku, and that her glass always leaves a sticky mark which she never cleans. I know that, but have never been there nor ever met Annette myself. To the extent of my experience, this office could very well be a fiction, a virtual world or an elaborate simulation. Jean is my window to this world, he's the one representing it to me through narrative.

Actually, Jean is more than a window. He's not only a vector going outwards, carrying information from his office-world to mine. He can also act as a proxy for me there. Once, as he was complaining about an obnoxious co-worker (this one is Jacques), I suggested a clever prank to him. I explained to him all the steps he should take to make this work. I must say that I would have done it better myself, but I couldn't as I'm not allowed there. Still, he pulled it off decently and I had a great time when he described to me the events and his colleagues' reactions.

One day, I met a guy at a cocktail party. He was complaining about how toxic his workplace was, that there was this asshole—someone called Jean—that kept pulling these mean pranks on him. You've guessed it, it was Jacques. And he painted me a similar yet different picture of that office and its inhabitants. Apparently, the kitchenette

© Springer International Publishing AG 2016
F. Nack and A.S. Gordon (Eds.): ICIDS 2016, LNCS 10045, pp. 317–324, 2016.
DOI: 10.1007/978-3-319-48279-8_28

318     J. Lessard and D. Arsenault

is *taupe*, not brown. It shouldn't have come as a surprise that Jean had not communicated an objective representation of his office but a biased one—that of a subject *within* this world, limited by his perceptions, motivations and mental schemata.

By now, and especially if you've bothered to read this paper's title, you see clearly where this is headed: Jean can be considered as an interface—a *subjective* interface. This short paper aims to explore this notion as preparatory work for a new game-design oriented research-creation project titled—you've guessed it again—*Subjective Interfaces*. The work here will consist in a theoretical unpacking of the concept in the light of various perspectives, exploring potential design directions, and outlining looming technical challenges.

## 2  Perspectives on a Subjective Interface

### 2.1  Narratology

I have no access to Jean's office. Just like a fictional world, this one cannot present itself to me. I need someone or something to *represent* it. In fiction, that instance is the narrator, acting as threshold between the reader and the *diegesis*, telling a story through the particular form of discourse that is narrative. Considering Jean as narrator allows me to understand a few things on how he delivers his office world to me.

Gérard Genette's classical narratology distinguishes three aspects of the narrative instance (*i.e.* the narrator): narrative voice ("who speaks?"), time ("when does the telling occur relative to the story?"), and perspective ("how is the information restricted?") [1] The first aspect concerns how the narrator is situated *vis à vis* the narrative: outside (heterodiegetic) or inside (homodiegetic)? Jean reports on his office as a witness and participant, and is thus clearly part of his diegesis. We can further specify his homodiegetic position as autodiegetic, meaning that he is in fact telling his own stories. These are usually told after the fact, which situates the time of the narrative as ulterior to the events reported. We could however imagine a situation in which I would be talking to Jean on the phone and he would deliver a simultaneous narrative.

Perspective, the third aspect of Genette's narrative instance, is perhaps the more interesting here. Originally, it allowed Genette to distinguish two different phenomena that were typically bundled together in catchall terms like "first-person narration" or "omniscient narration": the narrator enunciating the narrative, and whether the narrative is espousing a particular character's range of knowledge or not in telling the story. The latter is termed *focalization* by Genette [2], who distinguishes three types: "zero", where the narrative has access to all information, "internal", where it sets its sights on a character and limits itself to that character's perceptions and thoughts, and "external", in which only the physical world is perceived, without getting access to any character's internal states.

The appeal of Genette's framing is that the narrative voice belongs to the narrator, but the extensity and position of knowledge available belongs to the narrative itself. For instance, an omniscient (heterodiegetic) narrator may choose to recount the events from the point of view of a particular character, thus resulting in a narrative organized through an internal focalization on that character. In other words: an omniscient narrator may

craft a narrative with a reduced, more selective focus than what he actually knows. I can now cast Jean as an autodiegetic narrator, and the narrative he produces as being internally focused on himself. This means that he can tell me about what he perceives as well as what he thinks (whether he tells the truth or not is something else entirely[1]). If his narrative is ulterior to the events, he can also throw in details he's learned after the fact, potentially exceeding his own limited scope of information and allowing him to present a zero-focalization narrative that goes over events or thoughts that he couldn't have seen or had himself at the time.

Jean is not the only narrator here. *I* am telling you the story that Jean told *me*. In doing so, I have spun a tale that contains a tale. And here we run into Genette's other key contribution, that of narrative *levels*. In a narrative, any homodiegetic (in-world) character may start another embedded or nested narrative, which temporarily confers the role of narrator to that character until the narrative-in-the-narrative is resolved. Or is it? Adapting Genettian narratology to film, André Gaudreault [4] fleshed out the logic of narrative levels and concluded that things were not so simple: the fundamental narrator or mega-narrator (the "zero-level" entity outside of which there is no framing story) always retains control over narration, even while it cedes the speaking part to a delegate or surrogate narrator. This is easy to see in movies: when a character starts recounting events and opens a story (becoming a homodiegetic surrogate narrator), the film camera doesn't just stand there and show her talking; the images and sounds shift and start illustrating her words. The filmic mega-narrator chooses to use its own voice (speaking in camera framing, motions, shots, montage, and all other filming devices) to accompany the surrogate narrator's oral narration. The mega-narrator always retains control.

For you, Jean's story is still *my* story. This situation will be reproduced in the context of an eventual computational interactive narrative: we cannot do without some form of "conventional" interface that will allow human users access to the virtual character's narration. This will introduce another narrative level (or a mega-narrator). Not interfacing with users directly, the subjective interface can be considered an *intraface,* in Galloway's terms [5], meaning an "interface internal to the interface." (p. 40)

Genette's narratology can only go so far in helping us think of computational "subjective interfaces." It is, after all, a system tailor-made for (and from) *literary* narration. Even considering a system of textual interaction, we must acknowledge specificities of computational interactive storytelling. An important blind spot is the issue of readers talking back to the narrator. As I put it earlier, Jean may do a lot of talking, but I can always reply, question him further, and even instruct him to do things in his office. For this, we need to turn to a discipline that is as concerned with inputs as it is with outputs.

## 2.2 Interaction Design

The concept closest to Jean in the fields of interaction design and human-computer interaction (HCI) is that of the virtual or conversational agent. This has been a deeply

---

[1] For more on this, see Booth's concept of *unreliable narrator* [3].

researched problem since the 1990s with numerous (though somewhat infamous) applications including automated call centers and help lines. This form of interface is now coming of age with such virtual agents as Siri or Cortana becoming ubiquitous and gaining in popularity. New devices such as smart watches or wearable technologies are thought to increase the demand for it [6]. Just like Jean, virtual agents allow users to access remote information, but also to act upon it.

However, Jean is radically different from Siri. To Jean, the office isn't a database to be searched and filtered for pieces of evidence that might satisfy my curiosity. He perceives and makes sense of the world with his peculiar, idiosyncratic senses and cognitive apparatus. Like all functional virtual agents, Siri and Cortana promise to deliver me the world as it is, and are designed to convey a sense of transparency. Jean might have known that the exact color of the kitchenette walls are taupe and still choose to say "brown" to make them sound more shabby and miserable. Understanding Jean as a human subject leaves room for interpretation as to whether he chose to deliberately be imprecise or simply didn't know. If it were Siri I would assume that taupe wasn't part of her color model or else she would have said so.

Virtual agents are generally evaluated in terms of their *usability*—how efficiently they allow users to perform such tasks as finding the right information, redirecting a call to the right person, booking a train ticket at the right time for the right destination. But that's not how I value Jean. I like him because of all the boring, routine events happening in his office, he will choose the interesting anecdote, and spin it in his own inefficient but charming way. He's not great as a proxy either. Even when acting upon my recommendations, he will always end up doing things the way he wants. If he had done exactly as I had said, the prank would have been better. But then, much of the fun is in finding out what he actually made of my suggestions as it gives me further insight into his personality. If some designers dream of transparent and immediate interfaces, I have to admit Jean is rather to be classified with the murky and viscous ones. That mindset is different enough to make interface characters like Jean completely different from humanized interfaces like Cortana or Siri. Their nature, and the context in which we use them, belong to the realm of aesthetics, rather than functionality.

### 2.3  Game Design

As Ian Bogost [7] argued, partial inefficiency of the interface can be a feature, not a bug when dealing with video games, as they "are not tools that provide a specific and solitary end, but experiences that spark ideas and proffer sensations"; indeed, interface restrictions can be meaningful: "We gripe when a game doesn't do what we expect, rather than asking what such an unexpected demand means in the context of the game." Bernard Suits' [8] example of golf is telling: as an "interface" between the player and her pre-lusory goal, the lusory means of golf (its instruments and rules) are ridiculously inefficient, yet they are accepted by the player in order for golf to exist. Let's note that the understanding of game interface is not limited here to menus, heads-up display signs (HUD) or graphical user interface (GUI) elements as opposed to the "actual" game. Kristine Jørgensen [9] rightfully observed that game worlds are not separate from an

interface but are themselves an interface inasmuch as they participate in the bidirectional information flow between players and the underlying mechanical system.

Much in contrast to HCI experts, the bulk of the game designer's work is to actually *complicate* interaction in interesting ways. Game designer Greg Costikyan [10] frames this complication in terms of uncertainty: "games thrive on uncertainty, whereas other interactive entities try to minimize it." (p. 15) In this perspective, subjective interfaces will be relevant as game mechanics if they afford original and interesting ways to make interaction uncertain. Costikyan analyzes a number of sources of uncertainty in games, two of which are particularly relevant to subjective interfaces: "hidden information" and "performative uncertainty."

While some games like Chess are founded on a regime of perfect information, many others would be ruined by a perfectly transparent interface. Imagine Poker with visible hands, real-time strategy without the fog of war, or first-person shooting with transparent walls. The character as subjective interface is a diegetically grounded way to design a game's information flow. Part of the world can only be known through the partial and biased reports of characters, requiring players to obtain and cross-check testimonies.

But knowing is only half of the picture; many games also hinge on the uncertain capacity of doing. Subjective interfaces entail a context in which the player is incapable of acting directly, relying on the proxy actions of non-playing characters (NPCs). This introduces a very particular form of uncertainty, that of delegated performance: can Jean do what I told him to do? Did he understand properly? Is he motivated to act well?

Jean's flaky usability as a conversational interface and situatedness as a narrator have a lot to offer in terms of complicating interaction with a virtual world in interesting ways. Let's see if we can find or imagine ludic interactive scenarios that would put the notion of subjective interface at the center of their design.

# 3 Scenarios (Existing and Imagined)

The game design and interactive fiction worlds did not wait for this paper to develop NPCs that might effectively (though perhaps in a minor way) act as subjective interfaces to their virtual worlds. What we're looking for here is if we can foreground this dual role of informant/delegate, and upgrade it to a core game mechanic.

## 3.1 Leadership

The experience of relying on others for both information and action is very familiar to those who have been in a position of leadership. A boss does not have the time to consult all documents relevant to her business firsthand and generally relies on the reports of assistants dedicated to specific areas of administration. Similarly, she does not undertake all actions herself but instead delegates tasks, hoping others will do things as efficiently as she would have (or better).

Consider the complex empire management game series *Civilization*. It is hard to imagine a larger-scale leadership position to that of being the boss in these games. Although your information is limited when it comes to your adversaries, everything in

your own empire that is knowable is exposed to you. Between two diplomatic negotiations with the world's superpowers, you can home in on a single engineering team and tell them where to build the next strip of road.

In order to help out players that might feel at a loss with the abundance of things to know and do, the games offer advisors that will highlight what they consider to be the most pressing issues. Each is only concerned with its own sector (economy, military, etc.), and so there is interesting ambiguity between the advisors' competing advice—the player has to judge which suggestion to actually implement. This setup is even more developed in the clan management game *King of Dragon Pass* [11]. The main difference being that in the latter, the game state and the exact workings of the simulation are much more obscure to the player, making the advisors' opinion more important. This is complicated further by the fact that the advisors have individual characteristics and proficiencies that orient their judgment. A fully-realized subjective interface take on a leadership scenario could go a step further and remove direct player action in favor of advisors implementing player decision, thus leaving room for their interpretation and individual performance.

Other leadership-related scenarios include managing field agents; for example the hired assassins of *Assassin's Creed: Brotherhood* [12] or James Bond himself in the *British Intelligence Officers Exam* [13]. The *Football Manager* series is also ripe with "subjective interfaces" including football players themselves but also player agents, scouts, trainers, etc. Conversations with these characters are however very limited and mechanistic.

### 3.2 Investigation

The classical mystery fiction investigator often has to retrieve information from a world inaccessible to him first-hand: the past. He wasn't there, but others were. Witnesses are subjective interfaces between him and the events surrounding the crime. Each of them knows only part of the story and some might decide to obfuscate information to protect themselves or others. This approach can be found in LabLabLab's *SimHamlet* game [14] consisting entirely of a natural-language conversation with a witness of the tragic events having taken place at Elsinore. The player needs to interrogate the reluctant and dumb character to piece together the murders' ramifications.

In this type of scenario, the player's input is not so much to delegate actions but rather convince or coerce characters in delivering information. *SimHamlet* is however a set piece, a puzzle that once solved is of little further interest. One could imagine a crime-generating simulation (like the board game *Clue* for example) in which culprits, motives and alibi are shuffled, offering renewed challenges.

### 3.3 Meddling

Grand strategy and murders are not necessary to spark our interest in other people's lives. If Jean were to ask me to help him woo Annette, I'd be happy to play Cyrano de Bergerac and effectively enjoy a second-order "dating sim." In PullString's *Humani: Jessie's Story* [15], I can chat on Facebook with Jessie, my fictional best friend, helping

her out with moving, finding a new job and a boyfriend—all that without moving from my keyboard. Social simulations like *The Sims* series or *Prom Week* [16] provide great foundations for expanded meddling games about matching or breaking up a pair, mending friendships, learning something about someone or transmitting information down a social chain.

## 4  Technical Challenges

There seems to be a number of varied gameplay scenarios that would make interesting use of the notion of subjective interface. Some games like *SimHamlet* or *Humani* even leverage it as core mechanic. For a fuller implementation of the idea, one would however hope to go beyond pre-scripted interactive fiction or chatbots—having computationally modeled characters that could generate representations of dynamic, procedural simulations. This implies a number of technical challenges. Let's walk through them with a simple, minimal example: imagine playing Chess via subjective interfaces, that is: having the pieces tell you about the game state.

First, one needs a simulated world. This does not represent a major difficulty: Chess has been computationally modeled since the early days of computing, and many modern games feature much more complex and deep simulations. The next step is having characters that are also computationally modeled to perceive and make sense of their simulated world in "subjective" ways. Interactive storytelling and agent-based AI research exists on such topics, such as Ryan *et al.* [17] or Carvalho *et al.* [18] for example. In the case of Chess, a pawn could perceive that eating that other pawn would be a good move for the team but also that this would mean being eaten back the next turn, and thus choose to recommend a course of action that would not lead to that effect.

Having the pawn talk is the next problem. Considering the combinatorial explosion of possible Chess states, an author could never write in advance all the possible lines that could be said by a pawn about its current situation. This is where some form of natural-language generation seems to be needed. Fortunately, there is also interesting current research done on similar problems such as Berhooz *et al.* [19] and Ryan *et al.* [20].

The last issue is providing users with an interface to meaningfully interact with the subjective interfaces. Natural-language understanding (NLU) seems an obvious choice but it's neither fully functional as of yet and not suited for all game playing situations (see [21] for a discussion). It is also an issue to script a NLU technology to understand player inputs referring to events and objects that might have been generated at runtime and did not exist at the time of authoring. It's likely that tailored input schemes might be best to suit specific game designs.

## 5  Conclusion

By proposing the notion of "subjective interface", this paper highlights the unique voice of "talkable" NPCs as situated at the intersection of narrative, interface and games (none of those things being able to entirely account for the phenomenon by

itself). Reframing and zooming in on forms of interactions that exist here and there as supporting role to larger gaming or interactive fiction experiences, we identify promising new approaches to emergent storytelling, implicating players in non-trivial interaction through conversation.

# References

1. Genette, G.: Figures III. Seuil, Paris (1972)
2. Genette, G.: Nouveau Discours du Récit. Seuil, Paris (1983)
3. Booth, W.C.: The Rhetoric of Fiction. University of Chicago Press, Chicago (1961)
4. Gaudreault, A.: From Plato to Lumière: Narration and Monstration in Literature and Cinema. University of Toronto Press, Toronto (2009)
5. Galloway, A.R.: The Interface Effect. Polity, Malden, Cambridge (2012)
6. McTear, M., et al.: The Conversational Interface - Talking to Smart Devices. Springer, Heidelberg (2016)
7. Bogost, I.: Persuasive games: windows and mirror's edge. Gamasutra (2008). www.gama sutra.com/view/feature/132283/persuasive_games_windows_and_.php
8. Suits, B., Hurka, T.: The Grasshopper: Games, Life and Utopia. Broadview Press, Peterborough (2005)
9. Jørgensen, K.: Gameworld Interfaces. The MIT Press, Cambridge (2013)
10. Costikyan, G.: Uncertainty in Games. The MIT Press, Cambridge (2013)
11. Sharp, A.: King of Dragon Pass (1999)
12. Ubisoft: Assassin's Creed: Brotherhood (2010)
13. Hide&Seek: British Intelligence Officers Exam (2012)
14. LabLabLab: SimHamlet (2015)
15. PullString: Humani: Jessie's Story (2016)
16. McCoy, J., et al.: Prom Week (2012)
17. Ryan, J.O., et al.: Toward characters who observe, tell, misremember, and lie. In: 2nd Workshop on Experimental AI in Games. AAAI Press (2015a)
18. Carvalho, D.B., et al.: A perception simulation architecture for plot generation of emergent storytelling. In: Proceedings of the International Conference on Computer Games, Multimedia and Allied Technology. pp. 6–11. Citeseer (2012)
19. Behrooz, M., et al.: Remember that time? Telling interesting stories from past interactions. In: Schoenau-Fog, H., et al. (eds.) Interactive Storytelling. LNCS, vol. 9445, pp. 93–104. Springer, Heidelberg (2015)
20. Ryan, J.O., et al.: Toward natural language generation by humans. In: 8th Workshop on Intelligent Narrative Technologies. AAAI Presss (2015b)
21. Lessard, J.: Designing natural-language game conversations. In: 1st International Joint Conference of DiGRA and FDG (2016)

# Right, Left, High, Low Narrative Strategies for Non–linear Storytelling

Sylke Rene Meyer[(✉)]

Department of Screenwriting, Dramaturgy and Serial Storytelling,
International Film School Köln (ifs), Cologne, Germany
post@sylke-rene-meyer.com

**Abstract.** Based on studies of affect, and on theoretical works concerning spatial semantics by Yuri Lotman, Mikhail Bakhtin, Michel Foucault and others, spatial story design provides a seven step algorithm of story development for interactive audio-visual narrative. Following spatial semantics and its application in inter-active storytelling, the author no longer creates the protagonist, his or her want or need, nor controls the story arc. Instead, spatial story design allows the author(s) to make the formative creative decisions by designing a narrative space, and spatial dynamics that then translate into user generated storylines. Spatial story design serves as a framework for interdisciplinary collaborations, and can be used to not only create interactive digital narrative but also screenplays, impro-visational theatre, 360° films, and walk-in story world experiences for a number of users in either live or holographic virtual reality spaces. Spatial story design could inspire creators of interactive narrative, storytellers in time-based media, and possibly also technology developers for authoring tools.

**Keywords:** Non–linear storytelling · Environmental storytelling · Spatial story design · Affect theory · Screenwriting · Digital filmmaking · Improvisational theatre · Mikhail bahktin · Yuri lotman · Michel foucault

## 1 Introduction

Today, interactive user-oriented narrative is overtaking the story structures linked to the linear narrative of time. Unlike time-based media which are often single-authored, and presented to its audience, digital narrative evolves through use. The user, unlike the audience, co-creates the story while playing it. This most recent manifestation of story-telling challenges time-based linear storytellers, as well as spatially oriented narrative designers.

Coming from linear storytelling and filmmaking, my paper offers a narrative solution to narrow the gap between game designers and storytellers, and to overcome some contradictions and tensions that evolve from the different mind sets driving ludologists and narratologists (the problem of interactivity versus plot), in which interactivity is almost the opposite of narrative [1]. Spatial story design privileges space over time and usership over authorship, yet at the same time, it gives the author some creative control

© Springer International Publishing AG 2016
F. Nack and A.S. Gordon (Eds.): ICIDS 2016, LNCS 10045, pp. 325–335, 2016.
DOI: 10.1007/978-3-319-48279-8_29

over the narrative trajectory in space beyond the archetypal story patterns of fight, survival, and conquer that still dominate in narrative games today.

In non-linear storytelling, linear story models are generally not useful. In game design for example, linear story models like the 'hero's journey' have been employed to only create a predictable story arc based on narrative clichés already present at the users narrative vocabulary. On the other hand, story models like the P.I.N.G. model (Passive-Interactive Narrative-Game model) struggle with the lack of narrative control (here with the game Aporia) over the narrative experience that the user makes. "In general too few (20%) participants understood the story in Aporia. The interaction with key objects seemed to steal the focus from the narrative and took most of the participants' focus, also when describing the narrative [2]."

In linear storytelling, especially in filmmaking, spatial story design expands the narrative field, and may also serve as a collaborative tool that allows all departments to contribute in all its capacities. In this context, the cross pollination between today's media may lead to a different kind of storytelling, as film in the beginning of the 20th century influenced storytelling in all other media. Following Marie-Laure Ryan, I contend that "the choice of a certain medium, e.g. computer game vs. film, modifies the way in which the story is shaped, presented and received [3]."

The seven step algorithm which I outline is a space-based tool for linear and non-linear storytelling: user-generated narrative, interactive digital storytelling, screen-writing, 360° film making, or any audience-engaging narrative practice that relates to space. It is a basic narrative tool that allows the author to control–to some extent–the space, the story, and the objects that lead to objectives. Referring to Henry Jenkins [4] and his terminology of "environmental storytelling," the seven step spatial story design strategy may work in every aspect of environmental storytelling: with evoked narratives that have the ability to enhance an already existing one, with enacted narratives that provide narrative elements built up around characters, with embedded narratives where the object and the staging enables the plot, and with emergent narratives where the users construct their own narrative in the story space.

Similarly to the idea of interactive narrative design as defined by Stephen Dinehart, that creates stories via viewer/user/player (VUP) navigated dataspaces [5], spatial story design borrows from structuralist, and literary semiotic narratology. Spatial story design is a narrative strategy that draws from a theory of narrative space, which emerged from the outer frontiers of an empire; marginalized, forbidden, almost secret, it was conceived in provinces of the former Soviet Union. The concepts of Yuri Lotman and Mikhail Bakhtin laid the ground work for an entirely new philosophical approach that became eminent in the late 1980 s under the label of the 'spatial turn,' and include, amongst others, the works of Michel Foucault, Julia Kristeva, Susan Stanford Friedman, Gaston Bachelard, Michel de Certeau, and Henri Lefevbre. At this point, many works on spatiality could not been taken adequately into account, and the following concept only outlines the basic idea of spatial story design.

## 2   Spatial Semantics

### 2.1   Yuri Lotman and the Semiosphere

Yuri Lotman was born in 1922, and graduated at the age of only 17 years, and with excellent grades from the University of Leningrad. Being Jewish however, the high potential youth was not allowed to proceed with his doctorate at the heart of the empire, and instead had to go to Tartu, a small town in Estonia where he stayed for the rest of his life. Therefore his theoretical body of work is referred to as the "Tartu-Moscow Semiotic School."

In Lotman's analysis of narrative texts, the temporal structure of the story is not in the foreground, but the spatial organization, the "semiosphere." According to Lotman, a semiosphere (from the Greek *semio* for sign, and *sphere* for space) can be a concrete space with a real geographical topology, such as St. Petersburg, but it can also be a metaphorical space, whose topology consists of the characters of a "plot space," such as the main characters of a myth, the hero, the opponent, the helper, father, mother, son, daughter, etc. [6].

In Lotman's terminology, cultures, semiotic spaces, and semiospheres share the same topological characteristics. In other words, cultures, semiotic spaces, and semiospheres have centers, peripheries, insides and outsides, and boundaries. A (semantic) room is defined in contrast to another room, by its differences, and the border between these two spatial areas is particularly visible. A semiosphere thus is surrounded by a boundary.

For Lotman, the border is the most important topological feature, that parts the text (or its overall semantic space) into (at least) two disjunct areas, a term he borrowed from set theory where disjunct spaces are defined as 'M' and 'Not-M,' meaning the areas are divided into completely separated parts or pieces.

Lotman contends that these areas differ at various levels: first, they are topologically in opposition - for example, one space is high, the other low. Second, spaces are defined not only by size and location, but also by content, such as characters, states, and functions. For this content, Lotman introduced the term 'semantic properties' of space. Third, to establish a border between two rooms or two areas, each room has to be assigned with a different meaning. For example, one room is good, the other is evil. The semantically loaded topological order then translates into topographical contrasts within the world represented: for example a city vs. mountains (the city being low and evil, and the mountains being high and good).

### 2.2   Mikhail Bakhtin and Chronotope

The second outsider of spatial narratology in the Soviet Union is Mikhail Bakhtin, who was banished to Kazakhstan by Stalin in 1929, and worked as a teacher intermittently until his retirement in 1961. Bakhtin created his main body of work in the 1920s and 1930s, but became more widely known only in the 1960s, mainly through Julia Kristeva and her translation of his works into French. Bakhtin left us an abundance of discourse

material from which I will emphasize only one aspect at this point: his concept of the chronotope, translating from the Greek *chronos* for time and *topos* for space.

According to Bakhtin, the relationship between time and space constitutes the possibility of actions of the characters. Space organizes the chronological order of the narrative events, and time fills the space with meaning. In other words, the chronotope forms the dynamics of the story world.

Often, time becomes more important in a confined space; and if time is less important, the room expands. In a road movie, we expand space and travel long distances, while the duration of the trip often plays only a subordinate role. In prison films, time plays a prominent role in the compressed space of the prison cell.

Game designers are quite aware of this property of the chronotope, as the author of a game has more control over the user in confined spaces, because the possibilities of movement are limited for the player. In contrast, a player can walk endlessly through a vast, or open source narrative game landscape. In narrative games, the author controls time mostly by controlling space. Therefore, temporal markers are rare in narrative games: we mark time often with the question, "where" we are in the game. It is a question that asks for time and space at the same time, and that is often answered only by space. In response, the player may tell us that she is in the water dungeon and this is how we know on what level of the game she is, how temporally advanced, and how spatially located.

Bakhtin assigns a special symbolic message to spaces such as the threshold, the gate (meeting, farewell), the court (determination, accuracy, judgment), the path (life, travel, maturity). Other examples are the exile, the landscape, the river, the island, the ship, the lighthouse, the city, the fortress, the house, the stage, etc. that may carry a variety of symbolic messages depending on their context. Also, for example, the places of childhood–like the attic of the family house where a child has found magical things–is a chronotope. Chronotopes announce through convention, and their symbolic connotation is a narrative planting, a certain course of action that is about to come. The space generates the dramatic or narrative question, like a room with a locked door, which generates the question of whether or not the characters or players will be able to open the door and to find out what's behind it.

## 2.3 Affect-Emotion-Feeling

The player (the subject) that enters the story world responds to his or her environment, and this is how he or she will emotionally respond, make decisions, and consequently act.

Therefore, object-based affect-control is an important aspect of story design. These affective practices are triggered in familiar ways, and with familiar patterns. Affect can also be seen partially as, "any evaluative (positive or negative) orientation towards an object." In this way, the player or user responses with judgment, and object placing in this sense can influence his or her process of decision making. However, every subject, every player, has a unique consciousness and set of personal experiences, therefore no one player will have the same relationship with another entity that exists outside of him or herself.

Although the terms emotion, feeling and affect are routinely used interchangeably, it is important not to confuse them [7]. In the definition of Brian Massumi, feelings are personal and biographical, emotions are social, and affects are pre-personal [8]. Affects in this definition are visceral and not informed by culture. They function as a basic physical response, much like instincts. For example, the object 'fast approaching tiger' will trigger an affect that is most likely related to death and fear of deadly violence.

There are particular affect-laden, social phenomena that can be usefully investigated through storytelling. For example, institutionalized moments of celebration (New Year), grief (funeral services), joy in belonging (sport fans in a stadium) etc. In certain spaces, the subject-object-relationship may be so strongly predefined that the players' decision making corridor is extremely narrow. Here, the author or story designer holds a maximum of narrative control over the affect-informed behavior of the user. These spaces are quite often chronotopical as described by Bakhtin, and have been analyzed in depth by Michel Foucault in his concept of "heterotopias."

## 2.4  Michel Foucault and Heterotopia

In most heterotopian spaces, the subject is forced to submit to the order of things. Foucault introduced the term to mainly reveal power structures but the terminology also serves as an useful narrative tool, and since stories (myth) reflect power relations, literary settings are often–not coincidentally–heterotopias. Additionally, in narrative design, the author may create his or her own order of things, his or her own heteropias, and thereby not only offers an alternative worldview, but also gains some control over the user's affects.

Heterotopias are spaces that reflect social conditions in a special way by representing, negating or reversing social relations. Examples of heterotopias are juvenile, retirement, and nursing homes; psychiatric hospitals; prisons; colleges of the 19th century; barracks; cemeteries; cinemas and theaters; gardens; museums; libraries; fairgrounds; holiday villages; ritual and non-ritual purification sites; guest houses; brothels; and colonies. Heterotopias are places where a behavior deviant from the prevailing norm is ritualized and localized. To understand what deviant behavior, what "the other" means, Foucault returns repeatedly to the subject of travel as the symbol of journey, of exploration, and discovery. Like a story that takes the recipient or user on a journey, Foucault contends that the place of hopes and desires has always been the ship: a "place without a place," a self-contained room on the high seas. Foucault emphasizes that from the Renaissance to present time, the ship not only serves as an important tool for economic development, but also as the greatest arsenal of imagination: "The ship is the heterotopia par excellence. In civilizations without boats, dreams dry up."

Concerning the key role of time in this regard, Foucault describes two forms of heterotopias: those in which time is accumulated endlessly, piled up, and pressed in books or pictures to be showcased and archived in libraries and museums, and those in which time is extremely limited, and dissolves within a few hours or days, as with festivals or fairs.

Furthermore, heterotopias are always bound to a system of openings and closings to prevent easy exit and entrance. Every entry and exit is subjected to a certain incoming and outgoing ritual. These rituals may manifest itself in complex purification rituals such

as a Japanese tea house ceremony, or in a relatively mundane activity like paying your entrance fee at the cinema. The examples show how different these rituals can be, and to what degree the opening or closing to the outside can vary - in cinema everyone buying a ticket is admitted, in the Japanese tea house, however, the visitor must first acquire specific knowledge of the ceremonies before being allowed to enter the place. In addition, not everybody entering a room is participating voluntarily in the heterotopia. For example, entering a prison for prisoners is a highly involuntary form of participation; on the other hand, a visitor walking into the area of the prison remains largely excluded from its heterotopic structures.

## 3    Spatial Story Design

### 3.1    Defining Space

Time-based narratives have a beginning, middle, and end. In contrast, in space-based storytelling, the story unfolds while the user navigates through space, interacting with objects present and possibly with other users. It has no determined beginning, and no specific course. In linear, time-based storytelling, a writer usually starts with a character and an action; in space-based storytelling, a narrative designer creates a space and objects. Following spatial semantics and its application in interactive storytelling, the author no longer creates the protagonist, his or her want or need, and does not control the story arc.

Defining a space is one of the most important creative decisions a narrative designer must make. The starting point is always a specific narrative space that contains per se a prolepsis (a narrative planting), and a number of suggested dynamics.

In a next step, the space will be filled with objects. Objects are far from arbitrary but influence how a player will navigate the space. Objects in this sense can be physical things but also other characters. Here an object is defined as something observed, while a subject is an observer.

### 3.2    Border Crossing

In Yuri Lotman's terminology, simply relocating a hero within the assigned space is not an event, or in other words: it is not a dramatic action.

> "What then is an event as a unit of plot construction? An event in a text is the shifting of a persona across the borders of a semantic field." [9]

Here the term event corresponds with Aristotle's perepeteia (turning point). To Lotman, an event presupposes a couple of binary oppositions: a norm, and a non-norm. Here, the (semiotic) border is a key concept in Lotman's thinking. It doesn't matter if the division falls into friends and enemies, living and dead, rich and poor, or other. What is important is something else: the boundary that divides the space must seem insurmountable.

Based on this this logic, another basic assumption implies. As explained earlier, in set theory, disjunct spaces are defined as 'M' and 'Not-M'. 'M' would be something like: all motorists drive on the right side of the road. All scientists argue rationally. All Germans are diligent. Here, the definition of 'M' formulates a norm. Lotman also draws

from this context in his concept of border control. In his view, an event-creating border crossing also always violates a norm. Romeo and Juliet cross the physical border from one enemy house to the other, but even more so, they violate the fraternization ban of their houses. An event therefore questions the validity of a set order. If this order is represented by a topographic boundary, the event appears as a border crossing; if the given order manifests itself as a norm or rule, the event appears as the violation of that rule, as an incident departing significantly from the norm, or in Foucault's terminology, is deviant. Therefore, in order to create an event, one needs to clarify the standard, the norm, first.

Lotman gives the example of a couple arguing about art. She hates abstract painting, he loves it. In his example, the aggravated couple goes to the police to report the other. The policeman obviously sends them home. No norm–as far as he is concerned–has been violated. Hating or loving abstract art is not a crime. However, at home, the couple decides to get a divorce – the falling out over art has shaken the very foundation of their marriage. Therefore, not every room change is an event, just as in time-based linear storytelling, not every activity is dramatic action, and not every story step is a turning point.

### 3.3   Characters and Action

According to Lotman, rooms can be inhabited by mobile and immobile figures. The immobile figure classifies and defines the space. For the immobile character, a border crossing is prohibited. The mobile character, the hero, is a character with a special predisposition that allows him or her to cross the border between the two disjunct spaces.

As an example, Lotman points to the hero of fairy tale, who penetrates the enchanted forest and frees the princess from the clutches of the dragon. The hero leaves the daytime world of his village and crosses the border into the night world of the forest. The forest and the village are disjunct to one another, they don't share a single property, and no one in the village dares to enter the forest- but the hero.

Space in this sense is not necessarily only seen topologically, but may also be characterized semantically, i.e. rooms with different meanings can be found in one physical space. Lotman calls an event "restitutive" if the hero tries and fails, and "revolutionary" if the hero tries and succeeds, which relates to the dramatic concepts of tragedy (trying and dying) and comedy (trying and succeeding) in the Aristotelian sense.

The mobile character leaves the room, or at least he or she tries. On his or her way to overcome the border, the hero faces obstacles. The obstacles can be so substantial that it is impossible for the hero to cross the border. The hero may die (physically or symbolically) in the attempt to make it from the original field into the anti field.

If the hero manages to cross the border, she or he has to merge with the new room, and will now become an immobile figure. The transition from a mobile to an immobile characters marks the end of the story. If he or she does not merge with the new space, the story has not come to an end yet, and border crossings will have to continue until the mobile character has become an immobile character.

Characters in rooms do not perform aimless movements. Lotman describes rooms, or spaces, as hierarchical, and distinguishes certain elements as the highest-ranking.

High ranking elements can assume the function of a topographical property. Examples of topographical extreme points are main streets, town squares, towers, mountain peaks, canyons, the abyss, but also interior elements like the TV, the fireplace, and the dinner table. All these examples serve as power centers of the room.

Taking its cues from Lotman, narratologist Karl N. Renner suggested that all character movements within the hierarchal space are oriented towards the to "extreme point." Extreme points are high ranking elements that set the rules of that space. All other elements gravitate towards the extreme point.

Non–topographical elements may also structure the space, and serve as extreme points. These are the extreme points of social space, for example, the position of a head of the family.

When designing or analyzing space, the extreme point is based on the question of who or what owns or rules the space. Then, two complementary patterns of movement can be identified: in one case, the direction of the character's movement changes once he or she has reached the extreme point, and the character leaves the space into which he or she has entered. The extreme point here marks a turning point in the story. For example, the character is having an argument with an abusive boss, quits the job, exits, and slams the door. In the second case, the movement of the character comes to a standstill when reaching the extreme point, and the character assumes the status and nature of this space (the hero kills the evil magician, and takes his throne). Here, the extreme point is the end point of the story.

### 3.4   The Seven Step Algorithm of Spatial Story Design

Story design based on spatial semantics takes the following steps:

1. Authorship begins with the design of a specific setting. How does the author characterize the semantic space, topology, semantic properties, meaning, topography – intellectually and aesthetically? What chronotope or heterotopia forms the setting? What are the norms and objects of this story world? What is the order of things?
2. The author or authors place specific objects and subjects at the place, and hereby gain some control over the affects of the user, and the promised narrative, inherent to the symbolic language of the space. In this context, the ideas and insights developed in the field of affect theory will prove to be essential, to help to understand how affect and emotion of the user can be directed by and through object making and object interaction.
3. The author controls and designs entrances and exits. The authors design the rituals performed to allow a character or player to exit, or enter.
4. The authors create immobile characters, and room for mobile characters.
5. The authors create norms, boundaries, and extreme points.
6. The authors design obstacles – topological and social.
7. Based on the properties and characteristics of the foundational space, the authors create disjunct subspaces and anti fields, potentially in indefinite numbers, and potentially in collaboration with the users, like in reality based environments, or massively multiplayer online role-playing games (MMORPGs).

# 4   Usership and Conclusion

The seven step spatial design process privileges co-authorship over single authorship, can be used to create 360° narrative, walk-in story world experiences for a number of users in either live or holographic virtual reality spaces, and may also serve as a framework for interdisciplinary collaborations.

Digital filmmaking today doesn't comply with the traditional linear work flow of story development, preproduction, postproduction, and distribution, but rather follows the iterative design process. Consequently, the former division of labor between the departments, especially the line between writing the screenplay and realizing the screenplay, has blurred [10]. Screenplay development and film development have merged, and involve nearly every department. Spatial story design may close the common gap between writers whose thinking is quite often informed by the linearity and chronology of a written text, and their collaborating creators who think predominately spatially. In film production for example, where production designers design the sets, the DOP assembles the room through different camera angles, the director navigates the characters through space, the editors re-assemble the spatial aspects, and so on, all departments may contribute with their specific areas of spatial competence to the story development. Story development would then include every department from the beginning, and interactive narrative interventions could also include the user, formerly known as the audience member.

In 360° film making, the viewer cannot interact with the subjects and objects of the story world. Most experiments in 360° fiction narrative film that aim to create an immerse experience, fail to overcome the narrative oddities of a forced POV perspective that explains why the viewer is barred from (inter) acting with other characters – such as being chained, in a coma, or hidden in a closet – for the entire film. The misunderstanding I believe lies in the assumption that an immersive 360° narrative visual experience has to be also an experience of dramatic identification of the viewer with and as the protagonist of the story. Instead, 360° narrative visuals work best for an observer, a non-identified viewer which is maybe why 360° films are most successful in non-fiction storytelling like documentaries, concerts, or sports events. Here, the concept of spatial story design can be used as dramaturgy to structure real live events. Instead of arbitrary recording, the seven step algorithm can be used to select and design place and object, and to analyze, emphasize, and utilize its semantic properties. Intelligent film design allows the filmmaker to respond to the way the user navigates and perceives the story world. The viewing devices record and remember what the viewer has already seen, and now redirect the viewer's attention through audio cues, audio volumes, object placing, and moveable character action in relationship to the extreme point.

Spatial story design may also help to design a narrative experience in VR environments, and to create holodeck cyberdrama as described by Janet Murray: "A world we can enter, manipulate, and observe in process. We might therefore expect the virtuosos of cyberdrama to create simulated environments that capture behavioral patterns and patterns of interrelationships with a new clarity [11]." In cyberdrama, the heterotopian laws of everyday life apply. The authors of cyberdrama will create a specific order of things, and have full control over the spatial design, the social order, the exit and entrance

rituals, and the placing of affect-laden objects. The authors may also create anti-fields for other users to enter the cyberdramatic holodeck from the (semantically speaking) opposite direction that are designed to create conflict – the heart of drama. Just as Hamlet makes decisions, the user will make decisions, within the restrictions created for the narrative semantic field, and be able to "enact the contemporary human struggle to both affirm and transcend our own limited point of view" as envisioned by Janet Murray.

Interactive digital narrative may be seen as the medium of the 21th century, and probably mark the end of time, because it is no longer based on time, as time-based audio visual media is, but on space, and therefore correlates with our current world view of "living in the epoch of space" described by Michel Foucault in his essay "Of Other Spaces: Utopias and Heterotopias [12]. Taking its cue also from Adorno and Marshall McLuhan, that every social contradiction returns as a formal problem in art, and that every revolution employs the newest medium, spatial story design may provide the dramaturgy for stories that respond to the social contradictions and collective neuroses of our time, and to the message of a digital medium that is inclusive, democratic, and user-oriented.

# References

1. Adams, E.: Three Problems For Interactive Storytellers, Gamasutra, Greg Costikyan. Where Stories End and Games Begin, Game Developer, September 2000, pp. 44–53, Jesper Juul, A Clash Between Games and Narrative, paper presented at the Digital Arts and Culture Conference, Bergen, November 1998, http://www.jesperjuul.dk/text/DA%20Paper %201998.html, Jesper Juul, Games Telling Stories? Game Studies, http://cmc.uib.no/ gamestudies/0101/juul-gts, Markku Eskelinen, The Gaming Situation, http:// www.gamestudies.org/0101/eskelinen/
2. Bevensee, S.H., Dahlsgaard Boisen, K.A., Olsen, M.P., Schoenau-Fog, H., Bruni, L.E.: Project Aporia – An Exploration of Narrative Understanding of Environmental Storytelling in an Open World Scenario. In: Oyarzun, D., Peinado, F., Young, R.M., Elizalde, A., Méndez, G. (eds.) ICIDS 2012. LNCS, vol. 7648, pp. 96–101. Springer, Heidelberg (2012). doi: 10.1007/978-3-642-34851-8_9
3. Ryan, M.-L.: On Defining Narrative Media. http://www.imageandnarrative.be/inarchive/ mediumtheory/marielaureryan.htm
4. Jenkins, H.: Game design as narrative architecture. In: Wardrip-Fruin, N., Harrigan, P. (eds.) First Person: New Media as Story, Performance, and Game, pp. 118–130. MIT Press, Cambridge (2004)
5. Dinehart, S.: Transmedial Play, USC thesis paper. http://webcache.googleusercontent.com/ search?q=cache:419ShBXQ35QJ:interactive.usc.edu/membersmedia/edinehart/archives/ %2520SED_ThesisPaper_V152.doc+&cd=6&hl=en&ct=clnk&gl=us&client=firefox-b
6. Lotman, Y.: Universe of the Mind: A Semiotic Theory of Culture (Translated by Shukman A.), pp. 121–214. Indiana University Press, Bloomington (1990)
7. In detail, Heise, D.R.: Understanding Social Interaction With Affect Control Theory. In New Directions in Sociological Theory. Joseph Berger and Morris Zelditch (eds.), Chapter 2, Rowman and Littlefield (2002). http://www.indiana.edu/~socpsy/papers/ UnderstandingInteraction.htm. Accessed 11 May 2016
8. Massumi, B.: Introduction to Deleuze and Guattari's A Thousand Plateaus, pp. ix–xv. University of Minnesota Press (1987)

9. Lotman, Y.: The Structure of the Artistic Text, translated from the Russian by Ronald Vroon, pp. 233. University of Michigan (1972). https://www.scribd.com/doc/246258795/Lotman-Juri-The-Structure-of-the-Artistic-Text-pdf. Accessed 3 May 2016

10. Davis, N., Zook, A., O'Neill, B., Headrick, B., Riedl, M., Grosz, A., Nitsche, M.: Creativity support for novice digital filmmaking. In: A Process also Described in the Analysis of Machinima as Digital Filmmaking. http://homes.lmc.gatech.edu/~nitsche/download/Davis_CreativitySupport_13.pdf

11. Murray, J.: Hamlet on the Holodeck: The Future of Narrative in Cyberspace, part II. http://www.altx.com/ebr/ebr7/7murray/7mur2.htm

12. Foucault, M.: Des Espaces Autres (Of Other Spaces: Utopias and Heterotopias). In: Architecture, Mouvement, Continuité, no. 5 (October 1984): 46–49; translated by Jay Miskowiec in Diacritics 16(1), 22. (Spring, 1986)

# Qualifying and Quantifying Interestingness in Dramatic Situations

Nicolas Szilas[(⊠)], Sergio Estupiñán, and Urs Richle

TECFA, FPSE, University of Geneva, 1211 Genève 4, Switzerland
{Nicolas.Szilas,Sergio.Estupinan,Urs.Richle}@unige.ch

**Abstract.** Dramatic situations have long been studied in Drama Studies since they characterize tension and interestingness in a plot. In the field of Interactive Digital Storytelling (IDS), integrating knowledge about dramatic situations is of great relevance in order to design improved systems that dynamically generate more narratively-relevant events. However, current approaches to dramatic situations are descriptive and not directly applicable to the field of IDS. We introduce a computational model that fills that gap by both describing dramatic situations visually and providing a quantitative measure for the interestingness of a plot. Using a corpus of 20 Aesop's fables, we compared the calculations resulting of the model with the assessments provided by 101 participants. Results suggest that our model works appropriately at least for stories characterized by a strong plot structure rather than their semantic content.

**Keywords:** Interactive storytelling · Interactive narrative · Interactive drama · Computational narratology · Computational models of narrative · Dramatic situation · Aesop's fables

## 1 Dramatic Situations and Interactive Storytelling

In theatre and drama, the concept of *situation* is a key dimension in the analysis of a given piece [15, 18]. A situation is understood here as a set of characters and their relationships that makes the drama interesting. Examples of dramatic situations include the 'love triangle'—two characters love a third one—, forbidden love between siblings (who may ignore their family ties), love between different social classes, and others just to mention the romantic domain as example.

The concept of dramatic situation is interesting in the field of Interactive Digital Storytelling (IDS) because it provides a founding principle that may be used to dynamically generate narratively-relevant events. More precisely, a dramatic situation describes a narrative in a static manner[1]. As P. Pavis puts it: "Describing the situation of a play is like taking a picture of all the relationships of the characters at a particular moment, like 'freezing' the development of the events to take stock of the action" [14]. This "atemporality"—the term comes from C. Levi-Strauss' analysis of myths [9]—is particularly relevant in the field of IDS, because it makes possible to provide

---

[1] This makes "situations" radically different from "plots", usually defined as sequences.

© Springer International Publishing AG 2016
F. Nack and A.S. Gordon (Eds.): ICIDS 2016, LNCS 10045, pp. 336–347, 2016.
DOI: 10.1007/978-3-319-48279-8_30

potentialities for interesting developments of the story so far, without explicitly providing a temporal order [23].

Of course, not any set of characters and their relationships is likely to create an interesting drama, and the concept of dramatic situation, as it is found in existing plays or movies, implicitly supposes that the situation is *interesting*. In this paper, we are willing to characterize, formalize and implement, as a computational model, such interestingness of a situation, with the underlying idea that the latter contributes to the interestingness/appreciation of a story as a whole. The concept of dramatic situation is related to the concept of *conflict* in drama, as already formulated by G. Polti: "any dramatic situation arises from a conflict between two main directions of effort" [15]. A fair number of computational models of conflict have been proposed and evaluated [2, 3, 21, 25], that compare human perception of conflict with predictions of a model. Our research problem is slightly different, because our goal is to characterize a whole dramatic situation that may include several conflicts of different types. In addition, with the long-term goal of building a narrative engine for interactive drama, we consider dramatic situations to be part of what the author would need to write. Therefore, our goal is not only to characterize a dramatic situation but also to represent it visually so that an author could write at this very level. Effectively, dramatic situation appears to be an appealing concept for authors, judging by the frequent reference to Polti's 36 dramatic situations in the domain of screenwriting[2].

The goal of this research is therefore to build a computational model of dramatic situations that will enable to both *qualitatively describe* these dramatic situations for non-interactive and interactive narratives and drama, and *quantitatively assess* the interestingness of such situations for a given story. In the next section, the computational model of dramatic situations and their interestingness will be presented, followed by two kinds of validations: First, in Sect. 3, the model will be applied to various existing stories, and compared with other drama representations; Second, the capacity of the model to predict human judgment of interestingness will be assessed.

## 2   A Computational Model of Dramatic Situations

### 2.1   Representing Dramatic Structure

As mentioned in the introduction, a dramatic situation consists of a set of characters and their relationships. Before characterizing a situation, one needs a language to describe these characters, in particular their intentions and goals. Artificial Intelligence formalisms have been widely used in the field for that purpose, in particular in the agent-based approach of AI [16]. With authors in mind, we will, for this research, use a formalism that is based on dramaturgy and screenwriting, already described in detail elsewhere [22] that we summarize here. It consists of the following six fundamental elements:

---

[2] http://writeworld.org/post/44959188412/the-36-dramatic-situations.    http://www.wordplayer.com/columns/wp12.Been.Done.html.    https://gideonsway.wordpress.com/2009/10/31/screenwriting-tip-15-%E2%80%93-the-36-dramatic-situations/. http://www.scenario-buzz.com/2011/01/26/lecons-de-scenario-les-36-situations-dramatiques/

- Goals, that represent a state a character may wish for.
- Tasks, that represent an action a character may undertake.
- Obstacles, that represent the failure to perform a task.
- Side effects, that represent an event that occurs as a consequence of a task although it was not the primary intention of the character.
- Characters, who are impacted, positively or negatively, by what happens.
- Families (in the general sense), representing some ties (not necessarily genetic) between two or more characters.

A dramatic structure—we use here the term *structure* rather than *situation* to indicate that it may be quite uninteresting from a dramatic point of view—is defined as a set of elements of the above-mentioned six types connected to each other via *relations* of various types. For example, a task is related to a goal via a *reaching* relation. All relations in the proposed model are summarized in Table 1.

**Table 1.** Various relations in the model of dramatic structures

| Relation: | Reaching (r) | Hindering (h) | Collateral (c) | Needing (n) | Inhibiting/ exciting (i/x) | Satisfying/ unsatisfying (s/u) | Belonging (b) | Failing (f) | Weak success (w) | Degradation (d) |
|---|---|---|---|---|---|---|---|---|---|---|
| Source: | Task | obstacle | task | side-effect | goal | goal | character | obstacle | task | task |
| Target: | Goal | task | side-effect | goal | obstacle | character | family | goal | obstacle | character |
| Weight: | 1 | $-1$ | 1 | $-1$ | $-1/1$ | $1/-1$ | 1 | $-1$ | 1 | 1 |

A dramatic structure can therefore be represented as a graph, with nodes and edges, which enables a visual representation. We take the example of the famous last scene of "The Caucasian Chalk Circle" from B. Brecht (derived from a Chinese play and the biblical story *The Judgment of Solomon*): A judge must decide who is the real mother of a child. He places the child at the center of a chalk circle and states that the woman who manages to pull the child from the circle will obtain the child and if both pull, the child will be pulled apart. At the end, one mother refuses to pull and, instead of losing the child, she is declared to be the real mother. The corresponding dramatic structure is represented in Fig. 1. The mother and the false mother both wish to get the child (goal), by pulling him from the circle (task), but both may fail (obstacle). Should the mother fail or succeed, the child would be hurt (side effect) which is negative for her (conversely, the false mother does not see things this way). Finally, the graph shows that both goals satisfy them (characters), and that both characters are people (family).

In this example, the judge—a central character in the scene—is not represented, neither his goals or tasks, because he does not intervene in the dramatic situation itself but rather before, by setting it, and after, by making his judgment.

This kind of visual representation shares similarities with other narrative formalisms such as Drammar [10], plot units [8], or DramaBank [5]. The main difference here is that we are not necessarily trying to capture all actions in a scene, as it is the rule when adopting an annotation approach, but instead we are constructing an abstraction of a scene, representing what is considered as the core meaning of the scene. In addition, the next section will show more clearly the specificity of our representation of dramatic situations.

**Fig. 1.** The dramatic structure of "The Caucasian Chalk Circle" story. Triangles, circles and rectangles represent nodes, while arrows represent relations (see this section). Dashed lines represent dramatic cycles (positive and negative paths, see next section).

## 2.2    What Makes a Situation Interesting from a Dramatic Point of View?

A first answer, taken from screenwriting prescriptive theories is: "obstacles" [7, 11, 24]: a structure with an obstacle is already narratively relevant if, for the concerned character, the goal is significant and the consequences are fearful if the obstacle is not overcome [19]. However, it seems that the mere presence of an obstacle in a dramatic structure does not cover all cases of interesting dramatic situations. In that respect, the term 'conflict', also mentioned as the main feature of drama may be more distinctive to define dramatic situations, but given the fuzziness around the term 'conflict', it is difficult to draw some formal properties from it. Finally, we take the observation of B. Nichols as a starting point: "[narratives] tend to share in this quality of stretching out paradox by holding contraries in juxtaposition before resolving them" [12]. This concept of *paradox* is related to the notion of conflict, but its pseudo logical formulation "if A then B, but if B then not-A" provides a hint on the topological configuration needed for a dramatic graph to be an interesting dramatic situation. Let us consider the graph in Fig. 1: We observe that if the mother pulls her child, on the one hand she may be satisfied if the child comes to her but on the other hand, performing the task might hurt or even kill her child. This corresponds to a cycle in the structure. More precisely, a *dramatic cycle* is defined as a subgraph containing two nodes A and B such as one *positive path* goes from A to B and one *negative path* also goes from A to B, as illustrated in Fig. 2. This constitutes the basis of a formal definition of dramatic situations. We have documented elsewhere how this formal definition may be used to generate abstract graphs that may be instantiated into interesting dramatic situations [22]. By analyzing the structure in Fig. 1, one can derive the following dramatic cycles that we express both formally and in plain English as follows:

**Fig. 2.** Different representations of the 'Gift of the Magi' story. Top left: Plot Units, Top Right: Story Intention Graph, Bottom: our proposed model.

- c1: If the mother pulls her son, she can reach her goal of obtaining him, which satisfies her, but at the same time, her child is hurt and she is unhappy: {(mother pulls → mother gets the child → mother),(mother pulls → child hurt→mother)}[3]
- c2 and c3: If the mother reaches her goal of getting her child, she is satisfied but the other mother is not, and reciprocally: {(mother gets the child → mother → people), (mother gets the child→false mother → people)} and {(false mother gets the child → false mother → people),(false mother gets the child→ mother → people)}.

## 2.3    Comparing Different Types of Dramatic Situations

Are all dramatic situations equal in value? In screenwriting for example, it is common to distinguish between external and internal obstacles, with the idea that the latter is more valued than the former. Within our representation formalism, one can distinguish different kinds of dramatic cycles:

---

[3] Simple arrows represent negative weight relations while double arrows represent positive weight relations.

- The two paths converge towards one goal: this is a typical paradox, because an event or action can both support and hinder the same goal.
- The two paths converge towards the same character: this happens when a character has two conflicting goals.
- The two paths converge towards the same family: this represents a conflict between characters.

In order to quantify the interest of these different kinds of cycles, we give non-integer weights to some relations, and use the following formulas:

Let $c$ be a dramatic cycle, $c$ being composed of two paths $p^+$ and $p^-$ from A to B of opposite strengths.

Let $s$, the strength of a path $p$, be:

$$s_p = \prod_{m,n \in p} w_{m \rightarrow n} \tag{1}$$

with $w_{m \rightarrow n}$ being the weight of the relation between node $m$ and node $n$.

Then the interest of a dramatic cycle is calculated as follows:

$$I(c) = \frac{|s_{p^+}| + |s_{p^-}|}{2} \tag{2}$$

Finally, the interest of a dramatic situation $S$ as a whole is estimated as follows:

$$I(SIT) = \sum_{c \in \mathcal{C}_{SIT}} I(c) + \sum_{o \in \mathcal{O}_{SIT}} I(o) \tag{3}$$

with $\mathcal{C}_{SIT}$ being the set of all cycles in the situation $SIT$ and $\mathcal{O}_{SIT}$ being the set of all "free" obstacles, that is, obstacles that are not part of any dramatic cycles. This calculation considers that even without dramatic cycles, obstacles contribute to the interest. For the current version, this contribution is simply estimated by:

$$I(o) = \Omega$$

with $\Omega$ being a constant.

Two important remarks are necessary at this point: First, these calculations are somehow arbitrary, that is, other variants may be proposed in the future. Second, it needs to be reminded that these estimations are structural/syntactical only because they put aside all semantics associated with the nodes.

The interest calculation depends on the relations' weights. With all values being either 1 or −1, the interest of a dramatic cycle will be equal to 1. But if the weight of the satisfaction relation is lowered, then the interest of a situation with conflicting goals will be lower than the interest of a conflict with only one goal, without satisfying relations. Similarly, by lowering the weight of the belonging relation, one lowers the general interest of the enclosing dramatic situation, compared to other kinds of dramatic cycles. In addition, it makes sense to choose variable weights for the belonging relation depending on the situation: a simple interpersonal conflict may occur when two persons are unrelated, but if the two persons are close friends, then it is a betrayal

situation and we may suppose that such a situation is more interesting. Consequently, by setting the weight of the regular belonging relation lower than the weight of the friend belonging relation, the interestingness with a simple interpersonal conflict is effectively lower than the interestingness of a betrayal situation, according to Eqs. (1) – (3) above.

## 3   Application of the Model to Existing Stories

We claim that this model is applicable to a large set of stories, following B. Nichols approach [12]. For example, we have successfully analyzed Disney movies' plots (*the Little Mermaid, Aladdin*). Note however that it is easier to apply the model to simpler stories. For example, we can borrow from W. Lehnert [8] the analysis of the story *The Gift of the Magi*, in which she has already simplified the original short story [6]. In Fig. 2 we compare the visual representation of this story analyzed by three approaches: Plot Units [8], SIG [4] and our model. All three representations show the symmetry in the story. The specific contribution of our model is that it also visualizes the dramatic situation, in terms of dramatic cycles. The structure contains four cycles, two of them being almost identical. The cycle represented on Fig. 2 can be expressed in plain English by: "By selling her hair, Della can buy him a gift which pleases *him* but at the same time she makes Jim's goal of pleasing Della unreached, therefore she displeases *him*". The almost identical cycle consists in replacing the "*him*" in the previous sentence by "*her*". Then the two other cycles are the symmetrical ones, considering Jim's point of view when he sells his watch.

Finally, beyond these illustrations of the model, it is also useful to provide a more comprehensive evaluation, based on a *corpus* of stories. We chose Aesop's fables for that purpose. Very importantly, once the choice of Aesop's fable was made, the detailed composition of this corpus was randomly made. This randomness is critical, because by doing it differently, which could be done by selecting *illustrative* stories, one would tend to select the stories that seem to fit the model and discard the others. This would obviously bias the analysis. In our case, we selected the first twenty fables of the paperback book edition [1]. The underlying research question is: do these stories effectively possess dramatic cycles? The choice of fables to evaluate a model inherited from drama theory may seem questionable. However, without entering a complex narratological discussion that would be out of the scope of this paper, our position is that, as far as we are concerned with the story content (characters, goals, etc.), narrative and drama do not have strong boundaries. In other terms, to quote a current narrative theorist: "it seems high time to give up cherished normative dichotomy between fiction and drama" [13].

For each story, one of the authors manually extracted the dramatic structures, and exhibited the dramatic cycles. Because the application of the model for analyzing an existing story is still difficult to perform, we did not hire a pool of raters to estimate an inter-rater agreement. Such a procedure could be adopted in the future.

In some cases, a story needed two successive situations, which we represented visually by two rectangles containing the two corresponding structures. With more complex stories, one can expect much more successive dramatic situations. Examples

of analyzed fables are shown in Fig. 3, and the complete list has been made available online[4].

17 out of 20 stories have one or more dramatic cycles. In average, the number of dramatic cycles per story is 1.85, with a maximum of 6 (as in "The Ass, the Fox & the Lion"). This shows that the characterization of stories in terms of dramatic cycles makes sense, vis-à-vis real stories.

The fables that do not contain dramatic cycles are: "The Fox & the Grapes", "The Crow & the Pitcher" and "The Moon & Her Mother". These three stories still have at least one obstacle. What characterizes these three stories is that they seem to be fundamentally sequential, meaning that they surprise the reader by an unexpected twist, yet based on simplistic situations. In the Fox and Grapes for example, it is the very fact that the character drops his goal that makes the story interesting, not the plot itself, which is a simple obstacle. In the "The Moon & Her Mother", it is the semantics of the elements that conveys the main meaning of the story. The obstacle met by the mother, the impossibility to make a dress for the ever-changing moon, is interesting because of its content, while in many other fables, obstacles could be easily replaced by other similar obstacles.

## 4 Preliminary Empirical Evaluation

In order to further evaluate the relevance of the proposed model of dramatic situations, we attempted to assess whether the model could predict how humans would rate dramatic situations.

### 4.1 Method

A total of 101 subjects were recruited online, via a microworking website[5]. According to their explicit declaration on the microworking website, they were all native English speakers and in terms of education they were at a college level or higher.

All participants had the same task: after a general explanation of the exercise, they had to read four Aesop's fables in English and answer the following question on a 10-point Likert scale: "How interesting did you find the plot of this story? Give it a score between 1 (not at all) and 10 (extremely)". The four fables were randomly selected from the abovementioned pool of 20 fables, for which a dramatic situation graph was already built. In addition, at the end of the experiment, we asked them the optional question "What do you think makes an interesting plot?", in order to get qualitative information regarding the participants' judgment and involvement.

This experiment enabled to collect a number of judgments regarding the first 20 Aesop's fables. Additionally, for each fable, the above formula (3) applied to the dramatic situation graphs produced a score. The set of weights and parameters of the formula was decided according to our own judgment, before the experiment: weights

---

[4] http://tecfalabs.unige.ch/mediawiki-narrative/index.php/Aesop's_Fables.

[5] http://www.prolific.ac.

**Fig. 3.** Two examples of Aesop's fables represented using the proposed model. In "The Fox & the Crow", three dramatic circles are identified: two cycles correspond to the diverging interest of The Fox and the Crow (if the Fox has the cheese, the Crow has not, and vice versa) while a third one corresponds to the fact that the Crow is tempted to sing although it would lose the cheese if it did. In "The Horse & the Groom", there is one dramatic cycle: stealing the oat provides money to the groom but at the same time it prevents him to have a nice horse.

for the un/satisfying (u/s) relations were set to 0.8, weights for the belonging relation (b) were set to either 0.5 (target is "people" or "animal"), 1.5 (target is "friends"), or 1 for others; weights for weak success relations were set to 0; all other weights were set to 1; and $\Omega$ was set to 0.2. The resulting estimations are represented in Table 2.

**Table 2.** Model's estimation of interestingness for the first 20 Aesop's fables, compared to the human judgment. Fables between parentheses have been later withdrawn, see text.

| Fable | 1 | 2 | (3) | 4 | 5 | 6 | 7 | (8) | (9) | 10 | 11 | 12 | 13 | 14 | (15) | 16 | (17) | 18 | 19 | (20) |
|---|---|---|---|---|---|---|---|---|---|---|---|---|---|---|---|---|---|---|---|---|
| Model | 3.9 | 6.9 | 4.9 | 6.3 | 4.7 | 6.4 | 6.3 | 4.2 | 6.8 | 3.8 | 6.1 | 6.1 | 6.1 | 6.1 | 5.9 | 5 | 7.2 | 7 | 6.2 | 6.9 |
| Human | 0.2 | 1.4 | 1.1 | 2.1 | 1 | 1 | 2.9 | 1.2 | 1.6 | 0.8 | 1.3 | 0.8 | 0.6 | 1.6 | 2.5 | 0.2 | 1.8 | 5 | 1.7 | 0.2 |

## 4.2    Results

All 101 subjects completed the experiment. We put a minimum threshold to the duration of the experiment at 90 s, which discarded one subject, who finished the experiment in only 70 s. The 100 remaining subjects (57 males, 43 females; M = 34 years, SD = 9.7, range 18-59) completed the experiment in slightly less than 4 min in average (M = 3'53"; SD = 2'9"; Min = 1'33"; Max = 15'34").

All subjects but one completed the optional open question. The 99 subjects who answered provided a serious explanation, except for one subject. This provides some hints that the subjects took time and effort to read and assess the four fables. Note also that most subjects came from the UK or USA. Each fable received a number of scores, depending on the random affectation of fable to the participants. If in average, each fable received 20 scores, it varied from 12 to 26. For each fable, the average score was

calculated, providing 20 scores. These scores were compared with the 20 scores provided by the interest evaluated through the above formula (see Sect. 2.3). Raw results are displayed in Table 2. Then, the correlation between these two series of data was computed (Kendall's tau-b coefficient). No significant correlation was found (0.316, sig. = 0.055).

When looking at specific stories, some showed a big contrast between the two scores. An extreme case for example was The Crow and the Pitcher: human subjects evaluated this story very high while our formula gives it a low score, because the situation is basic. At the same time, the observation of the answer to the open questions suggests that subjects did not clearly distinguished between the interest of the story in general and the interest of the plot/structure itself, the latter being what we are assessing. Therefore, we decided to restrict the domain of the experiment by considering only stories for which the dramatic structure is predominant, compared to the semantics of particular actions and events. Taking the above example of The Crow and the Pitcher, the story seems interesting because of the particular task (using pebbles) that the character undertakes to solve his problem (drink in the pitcher) that surprises the reader because it is creative. For that purpose, we asked one expert to read all 20 fables and to select which one were "semantic" and which ones were "structural", with a proper explanation of these two categories. In addition, the expert was asked not to put more than 6 stories into the semantic category, in order to avoid ending up with too little data to find any correlation. As a result, 6 stories were discarded (The Cat & the Mice, The Dog & the Saw, The Fox and the Crow, The Old Woman & the Doctor, Mercury and the Woodman, The Crow and the Pitcher). With the 14 remaining fables, the Kendall's tau-b coefficient was calculated and a significant correlation of 0.506 (sig. = .013) was found.

## 4.3 Interpretation

The absence of correlation between the human judgment of plot interestingness and our estimation based on dramatic situation shows that, in general, stories such as Aesop's fables generates the reader's interest via many different "components" that mask the role of the specific dimension of dramatic situations. However, when focusing on stories for which a plot's structure is predominant, our model of dramatic situation manages to predict the interest of the story's plot fairly well. We can therefore conclude that the concept of dramatic situation matches reader's perception of plot's interest, at least for a certain type of stories.

Beyond the above correlation results, the diversity of answers on a single story combined with the observation that people provided very different criteria for plot's interestingness, suggest that our protocol for evaluation could be improved. One direction could be to manipulate the story itself, in order to neutralize some dimensions, rather than using ecologically valid stories.

# 5  Conclusion and Future Work

The temporal nature of narratives has driven most research in computational models of narrative (e.g. planning, problem solving, Petri nets). In this article, a different approach is taken, by considering situations as a "static picture" of the story at a significant moment of time. The proposed model allows to both represent situations visually and to evaluate their interest quantitatively. Assessing the relevance of such a model is a difficult task, then two approaches were taken. First, at the qualitative level, the model was applied to numerous existing stories in order to estimate to which extent the model covers a variety of narratives. In particular, the systematic analysis of 20 arbitrary Aesop's fables enabled us to concretely assess its abilities and limitations. Second, its estimations were compared to human judgments of plot interestingness. Results showed that the model correctly assess interestingness, but only for stories that are more driven by their structure than by their semantic content.

To use this model for story generation and interactive storytelling, a situation must be derived into a temporal succession of actions. This is not a challenge per se because it is a goal-based representation of events, similar in that respect to several existing IDS systems [2, 17, 20]. Two research directions deserve more attention: First, the story generation could be performed as a series of transitions from one dramatic situation to the other, each successive situation being automatically calculated from one single author-defined situation. Second, when rendering a story, the dramatic situation that a single action is part of, could provide the pragmatic context for surface realization in order to insert appropriate linguistic markers. This may improve current automated story generation systems in which successive events tend to be rendered flatly without logical connectors. On the visual side, dramatic situations could inform the staging of events, regarding the elements that are in conflict.

**Acknowledgment.** This research was made possible thanks to the support of the Swiss National Science Foundation under grant #159605 - Fine-grained Evaluation of the Interactive Narrative Experience.

# References

1. Aesop: Aesop's Fables. Wordsworth Classics (1994)
2. Barber, H., Kudenko, D.: Dynamic generation of dilemma-based interactive narratives. In: Proceedings of Third Conference on Artificial Intelligence and Interactive Digital Entertainment – AIIDE, pp. 2–7. AAAI Press, Menlo Park, CA (2007)
3. Battaglino, C., Damiano, R., Torino, U.: A character model with moral emotions : preliminary evaluation. In: Finlayson, M.A., Meister, J.C., Bruneau, E.G. (eds.) 5th Workshop on Computational Models of Narrative (CMN 2014), pp. 24–41. OASICS (2014)
4. Elson, D.K.: Detecting story analogies from annotations of time, action and agency. In: LREC 2012 Workshop on Computational Models of Narrative, pp. 91–99 (2012)
5. Elson, D.K.: DramaBank: annotating agency in narrative discourse. In: Proceedings of the Eigth International Conference on Language Resources and Evaluation (LREC), pp. 2813–2819 (2012)

6. Henry, O.: The Gift of the Magi. http://www.eastoftheweb.com/short-stories/UBooks/GifMag.shtml
7. Lavandier, Y.: La Dramaturgie. Le clown et l'enfant, Cergy (1997)
8. Lehnert, W.: Plot units and narrative summarization. Cogn. Sci. **5**(4), 293–331 (1981)
9. Levi-Strauss, C.: Anthropologie Structurale. Plon, Paris (1958)
10. Lombardo, V., Battaglino, C., Pizzo, A., Damiano, R., Lieto, A.: Coupling conceptual modeling and rules for the annotation of dramatic media. Semant. Web. **6**(5), 503–534 (2015)
11. McKee, R.: Story: Substance, Structure, Style, and the Principles of Screenwriting. Harper Collins, New York (1997)
12. Nichols, B.: Ideology and the Image. Indiana University Press, Bloomington (1981)
13. Nünning, A., Sommer, R.: Diegetic and mimetic narrativity: some further steps towards a narratology of drama. In: Pier, J., Landa, J.Á.G. (eds.) Theorizing Narrativity, vol. 12, pp. 331–354. Walter de Gruyter, Berlin, New York (2008)
14. Pavis, P.: Dictionary of the Theatre: Terms, Concepts and Analysis, trans. Christine Shantz. University of Toronto Press, Toronto, Buffalo (1998)
15. Polti, G.: Les Trente-six Situations Dramatiques. Mercure de France, Paris (1903)
16. Russel, S.J., Norvig, P.: Artificial Intelligence: A Modern Approach. Prentice Hall, Englewood Cliffs (1995)
17. Sgouros, N.: Dynamic generation, management and resolution of interactive plots. Artif. Intell. **107**(1), 29–62 (1999)
18. Souriau, E.: Les Deux Cent Mille Situations Dramatiques. Flammarion, Paris (1950)
19. Struck, H.-G.: Telling stories knowing nothing: tackling the lack of common sense knowledge in story generation systems. In: Subsol, G. (ed.) ICVS 2005. LNCS, vol. 3805, pp. 189–198. Springer, Heidelberg (2005). doi:10.1007/11590361_22
20. Szilas, N.: A computational model of an intelligent narrator for interactive narratives. Appl. Artif. Intell. **21**(8), 753–801 (2007)
21. Szilas, N.: IDtension: a narrative engine for Interactive Drama. In: Göbel, S., Braun, N., Spierling, U., Dechau, J., Diener, H. (eds.) Proceedings of the Technologies for Interactive Digital Storytelling and Entertainment (TIDSE) Conference, pp. 187–203. Fraunhofer IRB, Darmstadt (2003)
22. Szilas, N.: Modeling and representing dramatic situations as paradoxical structures. In: Digital Scholarship in the Humanities (2016)
23. Szilas, N.: Structural models for Interactive Drama. In: 2nd International Conference on Computational Semiotics for Games and New Media (COSIGN) (2002)
24. Vale, E.: The Technique of Screenplay Writing. Grosset & Dunlap, New York (1973)
25. Ware, S.G., Young, R.M.: CPOCL: a narrative planner supporting conflict. In: Proceedings of the Seventh AAAI Conference on Artificial Intelligence and Interactive Digital Entertainment, pp. 97–102. AAAI Press, Palo Alto, CA (2011)

# Usage Scenarios and Applications

# Transmedia Storytelling for Exposing Natural Capital and Promoting Ecotourism

Mara Dionisio[✉], Valentina Nisi, Nuno Nunes, and Paulo Bala

Madeira-ITI, University of Madeira, Campus da Penteada, 9020-105 Funchal, Portugal
{mara.dionisio,paulo.bala}@m-iti.org, {valentina,njn}@uma.pt

**Abstract.** Humanity benefits from natural ecosystems in a multitude of ways; collectively, these are known as ecosystem services. Our project investigates how storytelling, coupled with mobile interactive technologies, can be used to design interventions that bring awareness and engage people in understanding the benefits of ecosystems and their underlying biodiversity. "Fragments of Laura" a technology mediated transmedia story, reveals to its audience (mostly tourists) information related to the local natural capital and ecosystem services of a UNESCO-protected forest, and embodies many aspects of its history, culture and ecotourism potential. In this paper, we present the overall interaction and story design, together with the results from the "Fragments of Laura" experience prototype. We conclude with a description of the future work and how the results from the experience prototype will affect the final working prototype.

**Keywords:** Analyses and evaluation of systems · Methods for testing story development · Ecosystem services · Interactive digital narrative

## 1 Introduction

With the increasing importance of sustainability and the ubiquity of digital technologies, new opportunities for design are emerging. One particular area is designing interventions that look at informing users and creating awareness regarding the preservation of our ecosystems. This movement goes hand in hand with the recognition of the value of natural capitals and the benefits that ecosystems bring to humans through what is known as ecosystem services. Ecotourism, for example, is emerging as an area where information, awareness and education are aligned with the promotion of responsible travel that will preserve the environment and sustain the wellbeing of these natural areas [1]. Our work, positioned between what Pratten refers to as Transmedia for Change, (T4C) [2] and ecotourism, aims at promoting the local natural capital through a technology enabled transmedia story. More specifically, T4C is an umbrella term that encompasses transmedia activism (change in society or community) and personal growth (change in lifestyle or personal development). According to Pratten, T4C is the belief that stories matter and that these stories need to be told to the right people at the right time. Success in this context involves engaging audiences with positive messages that inspire and motivate better choices and provide solutions that have an impact in the world.

© Springer International Publishing AG 2016
F. Nack and A.S. Gordon (Eds.): ICIDS 2016, LNCS 10045, pp. 351–362, 2016.
DOI: 10.1007/978-3-319-48279-8_31

The project, "Fragments of Laura" and its story was inspired by the natural capital of the local UNESCO World Heritage Laurisilva Forest, a primary forest, with many trees predating human settlement (c. 1420). The forest plays a crucial role in "maintaining the hydrological balance of Madeira Island", and it holds "great importance for its biodiversity conservation" [3]. It is also one of the most important attractions of the island. The fictional story of "Fragments of Laura" embodies many aspects of Laurisilva's history, culture and tourist potential. It is developed around two central themes: the past, present, and future impact of human settlement on the forest ecosystem; and the medicinal uses (as explored in folk remedies) and other benefits of local flora. The transmedia experience invites the audience to embark on a quest to find a lost herbarium – an annotated and illustrated book of medicinal plants. The experience is mediated through a custom-made mobile application that uses location-aware sensing to guide the audience in the discovery of different parts of the story leading to the lost book. The story is presented in the form of audiovisual content, and interactive artifacts placed in significant locations around the village of Ponta do Sol.

In this paper we present the design and experience prototype of "Fragments of Laura". This process led to insights and reflections on how interactive storytelling can be used to drive interventions that require people to ponder on the benefits of the local natural capital and its underlying ecosystem services. The findings and discussion emerging from the study led to the redesign of the story and its first technical implementation. In the longer term, we envisage the participants that experienced "Fragments of Laura" will gain insights into and knowledge of the local natural capital leading to the adoption of eco-friendly behaviors during their stay and beyond.

## 2   Related Work

Due to the continuous technical improvements and rapid uptake of mobile smart devices, public spaces are increasingly augmented with layers of information and multimedia content [4]. Such technologies enable the tailoring of ever complex and specific experiences for the mobile users [5, 6]. In particular, tourists are influenced by continuously evolving and innovating mobile applications and experiences. In the following sections, we will introduce projects and research efforts that have addressed the potential of ubiquitous and mobile technology applied to real locations and tourism experiences. For ease of categorization, we will divide this section into three parts: the first one regarding location-based experiences tailored for tourism, the second related to transmedia storytelling experiences for tourists, and finally ecotourism and digital experiences.

### 2.1   Location-Based Experiences for Tourists

In the past decade, location-based tourism experiences have flourished as a research topic and several projects have explored the association of digital media with physical movement with the intention of providing rich, entertaining and educational tourist experiences as well as connecting audiences and players with the local cultures and

history. The bulk of such experiences has materialized as location-based games, augmented reality games or location-based storytelling tours [7].

Location-based games often rely on pervasive, ubiquitous and mobile technologies to expand the play space into the real world [8]. Among the most influential work in this field are the projects "Uncle Roy all Around You" [9] and "Can you See Me Now" [10] combining the self-reporting of position with location-based gaming and loose storytelling. Other approaches combine history with character driven gaming as in "Death at Berlin Wall" [11], where players meet a virtual policeman in the real streets of Berlin alerting them to the former position of the Berlin Wall. This concept of using virtual characters as guides who recount and give background information about the visited destinations as well as provide visitors with the possibility of scavenger and treasure hunts, through the use of smart phones and location-aware applications, has been explored in several locations. An example of such as project is REXplorer [12], where players encounter historical figures portrayed as spirits that are associated with significant buildings in the urban setting of Regensburg, Germany, with the aim of extending the visitor experience beyond the museum walls. Similarly, Wu and Wang have developed "The Amazing City Game" [13], a pervasive Android game where groups of participants can play a game where their knowledge is evaluated in the city of Trondheim, Norway. McLoughlin's "Reminisce" [14] aims at supporting visitor engagement at a heritage site through the use of auditory digital "memories". The visitors immerse themselves in reconstructions of ways of life, interactions between people and activities from times past while listening to "memories" narrated by fictional characters associated with the sites. In The "Media Portrait of the Liberties" [15], urban settings and neighborhoods are augmented with locally inspired multimedia stories in order to tempt tourists off the beaten track in order to see these neighborhoods in a better light. The aim of this is to counteract the bad reputation of these areas, a reputation which is promoted by mainstream media. More recently, "Seven Stories" [16] has reported on the successful combination of GPS markers and Narrator devices in order to drive tourism to the local folklore of downtown Funchal.

While, most of these projects contribute to the growing trend of supporting tourists with augmented experiences that blend real and virtual with local culture and values, they rely mainly on a single media channel to deliver the experience. Our approach is to couple transmedia storytelling with ecotourism, where the experience develops in multiple media channels.

## 2.2 Transmedia Storytelling in Tourism

One of the most recent trends in location-specific experiences and interactive entertainment is transmedia storytelling, which is defined as 'the technique of telling a single story or providing a story experience across multiple platforms and formats using current digital technologies [17]. In other words, transmedia storytelling is a technique that uses current digital technologies to turn stories into immersive, multilayered experiences that can be delivered to a range of different audiences through different media channels. Transmedia storytelling has recently been used to promote innovative forms of tourism across North America. The Roswell Experience, a location-based story told across 32

locations in Roswell, New Mexico, has, as its main character, an alien who introduces visitors to the area's rich and unusual history [18]. Another project, Bear 71 [19], a fully immersive, interactive, multi-platform social narrative created by the National Film Board of Canada; this narrative traces the intersection of humans, nature and technology. Participants explore and engage with the world of a female grizzly bear through webcams, augmented reality, geolocation tracking, motion sensors, social media, and other platforms and channels [19]. Recently in Portugal, the TravelPlot Porto project put transmedia storytelling successfully to work to publicize local brands and inform and entertain tourists at the same time [20]. Through the eyes of a character named Peter Smith, visitors learned about highlights of the city, including 'secret' or 'hidden' ones. Several platforms and channels were used to communicate the story: a mobile application (iPhone/Android), a website, a print map, live events (gastronomy, wine tasting, a Douro cruise), and social networks (Twitter, Pinterest, YouTube). Despite the emerging trend of transmedia applied to enhance tourism and tourist destinations not much has been developed for the growing area of ecotourism in particular. Even the award-winning Canadian project "Bear 71", while on one hand touching all intersections of nature, humans and technology was not conceived with a tourist audience in mind. Nevertheless some initial documented efforts have been spotted; we report on them in the section below.

### 2.3  Ecotourism and Digital Experiences

Ecotourism is a growing area in the tourism domain, but digitally enabled experiences in this area are still quite scarce. In the project "ME-Learning Experience" [21] for example, mobile and e-learning technologies have been applied to ecotourism in order to support the field training of ecotourism guides, interpreters, managers and developers. In a recent project by Lu and Ho [22] the authors present the design and scenario development of an interactive experience to assist the elderly in engaging in ecotourism in Taiwan. Through a study using the "think-aloud" usability protocol, the authors highlighted four behaviors that would make active aging groups increase their positive feelings during ecotourism experiences, namely: nostalgia, experiencing the use of all five senses, mutual sharing between companions and reward. Similar feeling were reported during location-based pervasive experiences and transmedia storytelling, for example "Seven Stories" [16] and Travel Plot [20]. Such experiences take advantage of the real world where users have all their senses stimulated and make use of treasure hunt elements making them work together in order to achieve something [5, 12, 13].

New technologies and in particular mobile technologies have revolutionized the traditional model for tourism by allowing easy access to a variety of information about tourism destinations. A new type of tourist has emerged, one that uses and relies upon technology to have a more insightful experience in the place that they are visiting [23]. In summary, while location-based applications (games, stories and services) are well-researched and documented as reported above, we have identified a lack of research projects combining the use of mobile digital media and in particular transmedia storytelling applied to ecotourism experiences. With our project we intend to contribute to the effort to fill this void. "Fragments of Laura" is a location-based experience enhanced

with elements distilled from transmedia storytelling such as the adoption of multiple channels to engage the audience and deliver the story. Moreover, it tackles the area of ecotourism and promotion of the local culture and territory. In the following sections we will progress to describe in detail the story and the experience design and prototyping of "Fragments of Laura".

## 3 "Fragments of Laura"

### 3.1 Conceptual Design

The story guiding the "Fragments of Laura" experience draws inspiration from the wealth of the natural capital and rich cultural heritage of the Island. The protagonist, Laura Silva, is a young woman who escapes a difficult childhood in an orphanage to receive medical training from her adoptive father who is the village doctor. Her notes and samples are kept in a vast herbarium but Laura and the book go missing, apparently swept away in the historic flood of 1803. The focus on a fictional character allows for the interweaving of varied facts (cultural, historical and scientific) that would be difficult to incorporate if not for the liberty that fictional writing affords. Through our transmedia experience, visitors to Madeira will embark on a quest to find the ancient book of knowledge and its author, Laura. They must uncover a series of possible story endings, which will translate into different future scenarios. What impact will past knowledge and present action have on our shared future? The story will unfold using a location-aware mobile platform, traditional media such as handwritten journals and letters, and interactive artifacts that will be placed in significant locations as part of the immersive experience. The mobile platform (due to its positioning service) will play a crucial role in the experience in helping tourists to discover the story locations. It will serve to display rich media content that allows the recreation of the 19th century way of life including architectural features, clothing and behavior.

### 3.2 The Experience

In the beginning of "Fragments of Laura", users are first shown a video at an eco-friendly hotel in the village. The video features Horacio, a scientist from the future who travels back in time to ask for help in his search for Laura Silva's lost herbarium. Laurisilva forest is under threat in the future, and the herbarium contains encyclopedic knowledge of the forest's rich biodiversity as well as invaluable samples of the endemic medicinal plants. If the herbarium is brought to the future it can be used to regenerate the forest, as it once existed. In return for this help, the audience will be given a glimpse into the future: how would the future of the Laurisilva natural capital look if the book is found, and what happens if it is not? The audience has two hours to find the book before Horacio disappears. Those who accept the challenge are given a smartphone at the reception desk and directed to the first location, where they will find some clues as to the whereabouts of Laura Silva. The story unfolds as the audience walks through the village, learning how various local plants can be used as remedies but also how the natural capital of the forest has been exploited. The audience ends up behind the old pharmacy, where they

learn how a massive flood, significantly exacerbated by widespread deforestation, destroyed many villages including Ponta do Sol. The old pharmacy was washed away and with it (in our story), Laura and her wealth of knowledge. As a final step in the experience, the audience members discover that Laura Silva had a laboratory up on the hill which was untouched by the flood, where they can look for the herbarium. There they find a digital note, informing them that they can send the herbarium directly to Horacio. Finally, the participants will receive a special glimpse into the future on their mobile device. These endings should prompt participants to reflect on the future of the forest as they learn how important natural capital is and connect with the local heritage of the Island.

Despite the detailed conceptual design and story, we were still left with several important questions regarding the experience of our audience. For example: "How do we attract our audience?", "Will users feel compelled to embark on the experience?", "How well does the experience flow as a whole?", "Is the story engaging enough to keep the audience moving forward?", "Is the scientific information regarding the plants interesting and understandable enough?", "Is the final reward of glimpsing possible futures a sufficiently satisfying end to the experience?".

We realized that before moving onto the refined technical production of the prototype, it was important to answer these questions and find out more about possible audience reactions. Therefore, we decided to design a specific experience prototype and test our story with several experts.

## 4    Experience Prototype

Experience prototyping is a well-known technique used in many different areas of design to understand and test the flow of a user experience through physical space and across different media and means. We made use of experience prototyping to understand some key aspects of the transmedia story, including how to better attract and engage the audience, how to connect the scenes to the physical locations, how to balance the different media elements and finally how to make the scientific and historical information understandable. In the experience prototype, we limit the use of technology so as to elicit feedback and critiques from users without unnecessary distractions caused by media frames.

### 4.1    Methodology

The experience prototype was designed to be tested in the village of Ponta do Sol. We recruited 11 experts (aged between 25 and 50) composed of: artists, designers and storytellers, to get feedback on story flow and immersion; botanists and biologists, to test the credibility of the scientific information distilled through the story. Three researchers conducted the experience prototype as facilitators and observers. As facilitators they helped the users to flow through the experience; enacted all the plot points of the story on site, impersonating Laura and the various characters and explained the

interactive artifacts. As observers, they would take note of participant comments and reactions. To guide the experience, we printed a booklet (Fig. 1) to hand out to each participant. The experience prototype started by introducing the goal of the experience to the users, and showing them how to use the booklet. Users were expected to express their thoughts during each phase of the experience, either to us directly or by writing comments in the space provided for feedback in the booklet. Each page of the 40-page booklet represents a step of the experience in the order that would be presented in the mobile application. Each one of the rectangular shapes in the grid represents a page of the booklet (See Fig. 1 where sample pages 1 to 6 are illustrated).

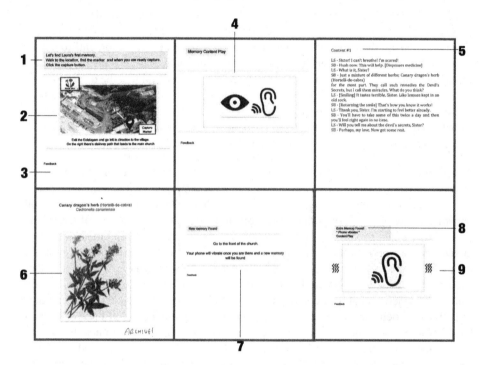

**Fig. 1.** Experience Prototype Booklet: (1) Instructions to the Participants; (2) Map of the location to find; (3) Participant Feedback; (4) Icon illustrating the type of content (video); (5) Transcription of the content re-enacted; (6) Illustration of the plant related to the content; (7) Instructions to discover the next content; (8) Feedback about the interface; (9) Indication of vibration feedback and audio content;

At each stop, before moving on to the next point, we gave participants a few minutes in case they wanted to write down comments about what they had just experienced. In the end, we had feedback collected in three ways: through our own notes taken during the experience; through the feedback that participants wrote in their booklets; and later through a group discussion conducted and recorded indoors after the experience was concluded.

## 4.2  Research Insights

In general, the experience prototype was well received. Participants (most of whom were unfamiliar with the area) saw it as a useful way to get to know the village, to engage with the physical surroundings, and learn about the Madeiran forest as valuable natural capital providing a range of ecosystem services. The feedback gathered will be important for further iterations, and to understand it more clearly we organized the feedback into three main sections: story-related feedback, media-related feedback, and experience design feedback.

*Story Feedback:* Participants enjoyed the story and generally wanted to hear more details. Some participants suggested presenting the story in a more fragmented, less linear way during the experience, and then find a 'post-experience moment' to deliver the complete story. Moreover, it was suggested that some story fragments needed to contain a better 'hook' to the next fragment, so that users would feel the desire to move forward to the next location. Other participants suggested improving the dramatic arc of the story by adding more moments of suspense and by creating moments of empathy with the protagonist. Finally, several participants suggested that the story needed to have clearer and stronger anchors to each physical location.

*Media Feedback:* Participants were excited by the possibility of interacting with real artifacts and they encouraged us to push for more interactions of this kind. One participant suggested that it would be interesting to be able to obtain the recipes of herbal folk remedies to use at home, or perhaps to be given herbal teas as a souvenir of the experience. There was a debate during the group discussion afterwards and there were very mixed opinions on the topic of audio vs. video as a way to deliver the story content. It became clear that some users preferred to have audio only so that they could focus their attention on the actual physical locations rather than looking at a screen, while others wanted the video so that they could connect more strongly with the characters and have something to focus on. Once user said: 'When listening to audio I don't know where to look - video gives me a focus'. More than one participant mentioned the use of augmented reality as a means of seeing how specific village locations looked in the 18th century. Augmented reality (AR) would also strengthen the link to the locations. One user said: 'I would like to be given magic powers to see through the walls and into a doctor's office from back then.'

*Experience Design Feedback:* Participants suggested that the distance between locations sometimes felt too long. In other words, the ratio of time spent walking between points, and time spent with the experience content itself should be more balanced. The ideal solution would be to find secondary activities for the 'in between' time: to give users a task to focus on as they walked, for example, or to feed them more of the background story via audio. Participants enjoyed the 'treasure hunt' aspect of the experience and several wished that it could have been expanded with even more 'treasures' planted. This relates to the fact that many participants indicated that a higher level of individual agency was desirable; they wished to interact and engage more with the locations and the people who live and work in the village. It was generally felt that tasks requiring

users to talk and meet with people while looking for clues and following the story would enrich the overall experience. One suggestion was that it would be interesting for users to have to go into a local shop and ask for something; to gather real clues. Participants also felt that the story would be enriched for them if they had to make more choices that directly affected the experience in some way - if they had to be more actively involved. More autonomy when it came to finding locations and walking around the village would also be welcome, they suggested. Moreover, if one point was visible from another, users would not have to rely so much on a map, screen, or guide to navigate. Finally, comments suggested that a greater sense of urgency was needed in the experience as a whole, and that users had to be reminded from time to time why it was so important to reach the end goal (the herbarium).

## 5    Discussion

Distilling the extensive feedback we received on site and afterwards in the recorded focus group, as well as from our own observations and the results of the future scenarios workshop, we identified a set of reflections, refinements to the concept and future work directions. Briefly, our key reflections centered around the need for a stronger start to the experience, more effectively engaging users on the journey, sustaining interest throughout, and choosing the most effective ending(s) to the experience both in terms of audience satisfaction and feasibility of maintenance. Principal refinements, meanwhile, included: adding scenes to thicken the plot and increase coherence and suspense; using real artifacts such as plant samples to reinforce the illusion of the story world and heighten engagement through sensory stimulation (touch, smell, taste); expanding into AR, for example, allowing users to see action taking place behind closed doors or in a different time or space; offering tangible souvenirs (e.g. herbal remedies) as takeaways; building a physical, interactive artifact of the herbarium itself, that can be consulted by users; creating an online blog to extend especially educational aspects of the experience, with regular contributions by botanists and other experts. The truthfulness of the scientific information provided during the experience was very much appreciated by the audience hence a close collaboration between storytellers and botanists is a sought after characteristic of such a project. Last but not least the experience prototype was successful in giving the authors, as well as the audience, a complete impression of the story flow and its interactive dynamics, collecting feedback for improvements before reaching the development stage. We concluded on the usefulness of experience prototyping for testing and communicating story flow and interaction dynamics among the authoring team in addition to using this method for collecting early feedback from users. The feedback and insights learned were applied to the first working prototype of "Fragments of Laura." We moved the setting to the main city, Funchal, as in the village it was hard to find enough users to appreciate the experience, and we realized that Funchal would be a better trampoline to inspire tourists.

In summary our experience prototype helped us gage the gap between concept and practice in transmedia storytelling for change, refining our ideas, and improving the final prototype and implementation of the story experience. Such improvements and refinements are described below.

## 5.1 Implementation

Informed by the experience prototype findings, the final software platform was developed for the Android platform using the Unity 5 game engine. The story was simplified and divided into 8 different scenes, which correspond to the main touchpoints of the transmedia story. Since the story is location-dependent, the map view acts as the main navigational element of the transmedia experience, where through GPS positioning (for location of the user) and a mobile data connection (for map tile download), the user can understand the path of the transmedia story. Low-power Bluetooth beacons are also used to deliver content at specific locations, in order to combat the errors of GPS device positioning. Once the user arrives at one of the touchpoints, a notification is received, warning the user about new content. These touchpoints are delivered as interactive 3D Virtual Reality scenes or 2D motion comics. In the interactive scenes, users can explore 3D representations of the story world while the story develops. In the motion comics, users can visualize portions of the story animated and edited through digital manipulation of historic photos and paintings alongside 3D renderings. To complement the story, users can find 4 additional locations to the ones where the Beacons are located, where they can hear audio fragments, delivered as "Gossip" from the secondary characters, recounting some back story related to the main characters and adding some historical information to the context. This "gossip", is intended not only to immerse users in the transmedia experience, but also to bridge the gap between touchpoints that are farther apart. This final working prototype is now under preliminary testing (Fig. 2).

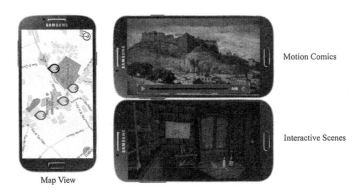

**Fig. 2.** Fragments of Laura mobile application screenshots

# 6    Conclusion

In this paper we describe the design and experience prototype of the "Fragments of Laura" transmedia story, a technologically mediated effort aimed at creating awareness, disseminating knowledge, and engaging its audience in learning about the natural capital and ecosystem services of Madeira Island and its UNESCO-protected nature. Before moving into the technical production and development phase of the story, we decided to test our concept with a group of experts: interactive storytellers, expert botanists and biologists, to test the flow of the story and its experience as well as the credibility of the scientific information distilled through the story. The collected feedback from the experience prototype and the workshop served as a sounding board from which to radically refine our concept and move towards implementation. Work on implementing these major and minor refinements is already under way with a second iteration ready to be tested in terms of story flow, transformational impact on the audience, and mobile delivery platform.

We believe our efforts are moving towards improving the quality of ecotourism on the island by jointly highlighting cultural with natural heritage to a wide range of audiences.

**Acknowledgments.**  We wish to acknowledge our fellow researchers Julian Hanna, Rui Trindade, Sandra Câmara, Dina Dionisio and the support of LARSyS (Projeto Estratégico LA 9 - UID/EEA/50009/2013). The project has been developed as part of the MITIExcell (M1420-01-0145-FEDER-000002). The author Mara Dionisio wishes to acknowledge Fundação para a Ciência e a Tecnologia for supporting her research through the Ph.D. Grant PD/BD/114142/2015.

# References

1. TIES: What is Ecotourism? http://www.ecotourism.org/what-is-ecotourism
2. Pratten, R.: Transmedia for Change. http://www.tstoryteller.com/transmedia-for-change
3. Laurisilva of Madeira World Heritage Centre. In: Periodic Report - Section II (2014)
4. Zheng, Y., Capra, L., Wolfson, O., Yang, H.: Urban computing: concepts, methodologies, and applications. ACM Trans. Intell. Syst. Technol. **5**, 1–55 (2014)
5. Paay, J., Kjeldskov, J., Christensen, A., Ibsen, A., Jensen, D., Nielsen, G., Vutborg, R.: Location-based story telling in the urban environment. In: Proceedings of OzCHI 2008, pp. 122–129. Association for Computing Machinery (2008). http://doi.acm.org/10.1145/1517744.1517786
6. Bell, M., Chalmers, M., Barkhuus, L., Hall, M., Sherwood, S., Tennent, P., Brown, B., Rowland, D., Benford, S., Capra, M., Hampshire, A.: Interweaving mobile games with everyday life. In: Proceedings of the SIGCHI Conference on Human Factors in Computing Systems, pp. 417–426. ACM, New York (2006)
7. Xu, F., Tian, F., Buhalis, D., Weber, J.: Marketing tourism via electronic games: understanding the motivation of tourist players. In: 2013 5th International Conference on Games and Virtual Worlds for Serious Applications (VS-GAMES) (2013)

8. Magerkurth, C., Cheok, A.D., Mandryk, R.L., Nilsen, T.: Pervasive games: bringing computer entertainment back to the real world. Comput. Entertain. CIE **3**, 4 (2005)

9. Benford, S., Flintham, M., Drozd, A., Anastasi, R., Rowland, D., Tandavanitj, N., Adams, M., Row-Farr, J., Oldroyd, A., Sutton, J.: Uncle Roy All Around You: Implicating the City in a Location-Based Performance. http://www.europeana.eu/portal/record/2022113/urn_axmedis_00000_obj_a5e61424_e3f1_46ea_b471_99a9536a5a73.html

10. Benford, S., Crabtree, A., Flintham, M., Drozd, A., Anastasi, R., Paxton, M., Tandavanitj, N., Adams, M., Row-Farr, J.: Can you see me now? ACM Trans. Comput. Hum. Interact. **13**, 100–133 (2006)

11. Brombach, G.: Death at Berlin Wall. https://sprylab.com/en/projekte/mobile-edutainment-app-death-berlin-wall

12. Ballagas, R., Kuntze, A., Walz, S.P.: Gaming tourism: lessons from evaluating REXplorer, a pervasive game for tourists. In: Indulska, J., Patterson, D.J., Rodden, T., Ott, M. (eds.) Pervasive Computing, pp. 244–261. Springer, Heidelberg (2008)

13. Wu, B., Wang, A.I.: A pervasive game to know your city better. Presented at the November (2011)

14. Ciolfi, L., Bannon, L.J.: Designing hybrid places: merging interaction design, ubiquitous technologies and geographies of the museum space. CoDesign **3**, 159–180 (2007)

15. Nisi, V., Oakley, I., Haahr, M.: Inner city locative media: design and experience of a location-aware mobile narrative for the Dublin liberties neighborhood. In: Intelligent Agent (2006)

16. Nisi, V., Costanza, E., Dionisio, M.: Placing location-based narratives in context through a narrator and visual markers. Interact. Comput. (2016)

17. Phillips, A.: A Creator's Guide to Transmedia Storytelling: How to Captivate and Engage Audiences Across Multiple Platforms. McGraw-Hill, New York (2012)

18. Pratten, R.: The Roswell Experience – transmedia storytelling for America's small towns (2012)

19. Makarechi, K.: "Bear 71": interactive film at Sundance tells dark side of human interaction with wildlife (2012). http://www.huffingtonpost.com/2012/01/23/bear-71-interactive-film-sundance_n_1225040.html

20. Ferreira, S., Alves, A., Quico, C.: Location based transmedia storytelling: the travelplot porto experience design. J. Tour. Dev. Rev. Tur. Desenvolv. **17**, 4 (2012)

21. De Crom, E.P., De Jager, A.: The "ME"-learning experience: PDA technology and e-learning in ecotourism at the Tshwane University of Technology (TUT). M-Learn (2005)

22. Lu, L.-S., Ho, Y.-F.: A study on the factors of interactive scenario design on ecotourism for active ageing. Sociol. Anthropol. **3**, 19–23 (2015)

23. Economou, D., Gavalas, D., Kenteris, M., Tsekouras, G.E.: Cultural applications for mobile devices: issues and requirements for authoring tools and development platforms. ACM SIGMOBILE Mob. Comput. Commun. Rev. **12**, 18 (2008)

# Rough Draft: Towards a Framework for Metagaming Mechanics of Rewinding in Interactive Storytelling

Erica Kleinman[1]([✉]), Valerie Fox[2], and Jichen Zhu[1]

[1] Drexel University, Philadelphia, PA 19104, USA
erikleinman@gmail.com, jichen.zhu@drexel.edu
[2] Department of English, Drexel University, Philadelphia, PA 19104, USA
vf25@drexel.edu

**Abstract.** Recently an increasing number of narrative games have incorporated the metagaming elements of rewinding as their core mechanics. Although there has been research on metagaming as a whole, there is little that focuses on interactive storytelling and on the act of rewinding to remake a choice. In this paper, we present two main contributions. First, we propose a theoretical framework on the structure of rewinding. Based on our survey of related games, we categorize common designs into Restricted Rewind, the Unrestricted Rewind and the External Rewind. Second, we created an rewind-based interactive story called *Rough Draft* and we report the design lessons we learned.

## 1 Introduction

Metagaming, the practice of using information from outside of the game to influence the gameplay [2], has been widely used in games. For example, players use real-life information about their opponents to choose their fighting strategies or to inform their character's actions in an RPG. When it comes to narrative games, however, game designers often discourage players from these practices. It is a general belief that doing so may break the immersion of the game world.

Recently there has been an increasing number of games, especially narrative games such as *Stanley Parables* and *Life Is Strange*, that incorporate metagaming elements of rewinding as their core mechanics. In most cases, the player finds out the outcome of certain decisions they have made and is then given the chance to make them again, with the new information they just learned.

Although there has been research on metagaming as a whole, little has focused on the role of metagaming as a core mechanic in interactive storytelling. As a result, there is a lack of understanding in the design space of narrative games with core metagaming mechanics as well as to how different metagaming mechanics impact players' narrative experience.

Our work seeks to bridge this gap of knowledge by studying rewinding, one of the most common metagaming core mechanics in narrative games. In this paper, we present two main contributions. First, we propose a theoretical framework

© Springer International Publishing AG 2016
F. Nack and A.S. Gordon (Eds.): ICIDS 2016, LNCS 10045, pp. 363–374, 2016.
DOI: 10.1007/978-3-319-48279-8_32

on the structure of rewinding mechanics. Based on our survey of related games, we categorize common designs into three types: restricted rewind, unrestricted rewind and external rewind. Second, we created an interactive story called *Rough Draft* that utilizes the design lessons we learned in the survey. More specifically, *Rough Draft* contains three options, restricted rewind, unrestricted rewind, and no rewind. Here we discuss *Rough Draft* as a stand alone interactive storytelling game. In our future work, we plan to conduct a user study of *Rough Draft* to evaluate the effect of different rewind structures on players' narrative engagement.

## 2    Background

### 2.1    Metagaming

Metagaming is a broad term used in many forms and exists within many game genres. Some defined it broadly. "It is how a game interfaces with life" [7] and "letting information from outside of the game world influence the gameplay" [2]. While others more narrowly construe it as "player stepping outside the intended rules of the game and playing with the rules of the game's environment" [12].

Recently, Carter et al. [2] break it down into three most common forms: "as a higher strategy", "a peripheral consideration" and "additional content". A higher strategy refers to the form of metagaming often seen in online multiplayer and e-sport games. Players figure out the best ways to use and counter certain mechanics, typically by taking advantage of designed mechanics in ways that they were not initially intended for and developing these strategies with other players in internet forums. These strategies are often encouraged by the games' designers despite not having been created by them and are typically referred to by players as "the meta". A peripheral consideration is often seen in tabletop RPG games. Here, a player would act based on real-life information that her player character did not possess. For example, when experienced players encounter a new game, they know from previous experience that a stone their character just picked up is probably magical and thus act accordingly, despite the fact that their character has no access to such information. This form of metagaming is often considered cheating and discouraged because it breaks the fourth wall of the game world. The additional content refers to achievements and similar "bonuses" that are awarded to players for performing specific tasks that are not necessarily a part of the game but exist alongside it. For example, crashing a large number of cars in a racing game in order to get an achievement, even though it makes no sense within the game world to do so.

Focusing on narrative-based games, the definition of metagaming we use is gameplay practices where the players use information not accessible to the player characters in the story world. Metagaming traditionally refers to any action taken outside of the world or design of game, however the mechanics that we are discussing are a key part of the games' designs. As such they are not metagaming in the traditional sense, and we instead define them as metagaming mechanics. By metagaming mechanic we refer to a mechanic that is based off of traditional metagaming practices but has been adapted as a core mechanic

within the design of the game. By core mechanic we mean a mechanic that is necessary to use in order to experience or beat the game in its entirety. So while metagaming typically refers to something that is not a part of the design of the game, a metagaming mechanic is a part of the design of the game, but is based on an action that traditionally was not.

Compared to existing work [11,15] where metagaming is usually not core mechanics, we focus on games that are designed to be played through metagaming mechanics, particularly rewinding.

## 2.2   Rewind Mechanics in Storytelling Games

Traditionally, the choices given to a player in interactive storytelling were finite. But when players did not like the outcome of a choice they had made, they would often manually rewind the game by replaying from an old save file and remake a past choice. The action of rewinding — reversing the in-game time and re-making past choices — allows the players to use knowledge unavailable to the player character, such as the consequences of a particular option, and then to remake previous decisions. Traditionally, rewinding to remake a choice was viewed as cheating and frowned upon [4,9]. Imagine a player of *Mass Effect* saves the game before each decision point and reloads the game if she does not like her choices. The player will potentially win the game more easily thanks to knowing all the outcomes. More important, by allowing the players to shift in and out of the diegetic world, this action breaks the narrative immersion and reminds the players that they are playing a game, not reality. As a result, designers have gone to great lengths to implement systems such as auto-saves, in order to prevent this type of lawn mowing practice [9].

However, the worry that rewinding breaks immersion and therefore reduces the quality of the gameplay and narrative experience may be overstated. As a storytelling device, the theme of remaking past decisions has been explored in linear media such as novels and films. In *Groundhog Day*, for example, the main character is stuck in a time loop and remakes his choices based on what he learned in the previous loops.

More recently, game designers have start to experiment with rewinding as an essential part of gameplay [18] and to facilitate accretive player character [16]. For instance, *Braid* is a platformer game that allows the players to rewind time instead of giving them multiple lives. The player must cleverly use rewind in order to solve the puzzles. Similar mechanics can be found in a growing number of storytelling games such as *Life is Strange* [5], *Undertale* [6], *Zero Escape: Virtue's Last Reward* [3], *Save the Date* [13], and *The Stanley Parable* [21]. All of these games feature some mechanic that allows the player to go back and revisit a past choice, but in all these games, the mechanic of rewinding is a core gameplay mechanic, rather than optional.

As a relatively recent development, the metagaming mechanics in interact storytelling games have not been sufficiently studied. Our work attempts to provide a framework to analyze rewinding as a storytelling device in narrative games.

**Fig. 1.** The three rewind structures. Left to right: restricted rewind; unrestricted rewind; external rewind

## 3    Design Patterns in Narrative Games with Rewinding

In addition to the metagaming mechanics above, we recognized certain narrative thematic patterns and constrains common in games that featured metagaming mechanics. We define these stories as metagaming plots. A typical metagaming plot will feature an in-story explanation for the ability to rewind and will be structured in such a way that it cannot be fully experienced or understood without use of the rewind mechanic.

In our work, we reviewed and analyzed popular narrative games that use rewinding as their core mechanics. They include *Life is Strange, Save the Date, The Stanley Parable, Undertale*, and *Zero Escape: Virtue's Last Reward*. Although we are aware that this is not an exhaustive list, these five games provide a representative sample of this type of games. We have played all five games, and read online reviews. The rest of the section describes our framework of understanding the narrative structure and content patterns in these games.

### 3.1    The Structure of Rewinding

In our sample of games, we have identified and defined three distinct types of rewind design: unrestricted rewind, restricted rewind, and external rewind (Fig. 1). In *restricted rewind*, exemplified by *Life is Strange*, the player can only go back to the last choice or two they have made (in the case of Life is Strange they can go back a couple choices but not all the way back to the beginning). This design requires the player to make different choices at *a single choice point* over and over, each time observing the immediate and usually negative outcome of her choice, and then go back to try another one based on what she learns. The player does this until she unlocks the correct answer through mistakes or until she is ready to proceed. Once she moves on, she will be unable to revisit past choices.

The second rewind structure, exemplified by *Zero Escape*, is what we call the *unrestricted rewind*. This design allows players to revisit any choice they have previously made and remake it. In this design, players have a higher *agency scope* [10]. The player will eventually reach a block in the story where the correct answer or choice will only be available after information has been collected from elsewhere in the story tree. This design encourages the player to explore the previous story branches, in search of how to solve the block.

The *external rewind*, exemplified by *The Stanley Parable*, requires the player to replay the game from the beginning to end in multiple iterations in order to explore different choices. Although it is possible to experience the game in a single play-through, to fully understand the game, and story, requires the player to play multiple times. Unlike regular interactive stories where replaying provides additional content, the meaning of an external rewind game *relies on* the meaningful differences between different iterations. The player does not just get *more* story when they restart and make new choices; they get the *rest* of the story. Unlike a game designed for replaying which may only grant minimal additional content, the story acquired through replaying and making different choices is a part of the overall story of the game and is necessary to experience it properly. Another aspect of the "External Rewind" that separates it from simply replaying is the amount of agency the player has. The player has the ability to replay the game, make different choices, and drastically change the events they experience or the ways that they take place. Having high amounts of agency to change things and explore options as well as high amounts of variation to the events is the key to the "External Rewind" design and what separates it from simply replaying.

Whereas restricted rewind focuses on local difference in a single decision point, both external and unrestricted rewind are built on the accumulative differences of multiple decisions. Rogue-like games are related to external rewind, although the rewind is from the middle point where the player character dies and the rewinding in these games focuses on gameplay rather than narrative alternations.

## 3.2   Narrative Constraints

In terms of narrative themes, we discovered patterns in the rewind-based interactive stories we reviewed. The player character is typically on a quest to save a person or people by preventing a horrible disaster that they know is coming because they have already experienced it and have now come back to prevent it. In essence, these stories follow the structure of the epic plot, which lends itself well to game design [14]. Through the use of their "rewind power" the protagonist is able to progress a little further on their quest each time they rewind, and try again each time they fail. The key aspect here is that the character has a distinct goal and that the events they experience threaten their ability to reach that goal.

Notably, there are two main narrative strategies to justify the player's ability to rewind. First, the player's ability to rewind is explained in the narrative setup. In *Life is Strange*, for example, both the player and the player character experience the time-reserving power for the first time together in the story world of the game. By providing a narrative explanation of rewinding, this design attempts to keep the player immersed *inside* the story world. It is perhaps not surprising that many games in this category (e.g., *Zero Escape*) involve time traveling.

The second narrative strategy is not to provide diegetic explanations of the rewind but to purposefully break the fourth wall by calling to attention the nature of the experience as a game. *The Stanley Parable* does this by refusing to provide a definitive narrative explanation for the way the player character experiences the same levels over and over again, instead only providing meta commentary regarding the fact that the player is playing a game. Similarly, the lead NPC in *Save the Date* acknowledges that she is a character in a game and accuses the player of reloading save files to try and find a better answer.

It is also possible to combine strategies, as can be seen in *Undertale*, which features meta acknowledgement of its existence as a game but also within-narrative hints of time travel. Depending on one's interpretation, *The Stanley Parable* can also be seen as combining strategies, based on how one understand the rooms visited within the game.

The concept of a media artifact acknowledging its own nature as a representation of, but not, reality is called *reflexivity* [1,17]. Examples of reflexivity in linear media can be found in metafictions [8,20] (e.g., *Slaughterhouse-Five* [19]) and film (e.g., *Adaptation*). Games like *The Stanley Parable* continue the avant-garde tradition and openly reflect on the core element of the medium — agency.

## 4    Rough Draft

Based on the insights from our analysis of existing games, we created an interactive story titled *Rough Draft*[1]. The story has three modes: restrict rewind, unrestricted rewind, and no rewind. Due to time constraints, we were unable to create a version with external rewind, as it is the most different from the others. In the rest of the paper, we discuss our design rationale for *Rough Draft* as a stand-alone interactive story. We hope our experience of instantiating a story world into three different rewinding structures offers useful lessons to designers interested in using rewinding in narrative games.

### 4.1    Story Design

All of the versions of the game were designed to resemble an author typing a story on a typewriter (Fig. 2). The author's voice was present via text on the bottom of the screen, where she would react to her own writing and voice her opinions or frustration. This was to help remind the player of their position in relation to the story.

In *Rough Draft*, the player plays Denise, a children's book author who faces a fast approaching deadline. The player chooses how the story in the children's book progress. Denise's story is about a young princess, Reina, whose older brother abducted a young dragon and was subsequently cursed by its mother.

---

[1] Three different versions of *Rough Draft* are available at: http://digm.drexel.edu/pxl/rough-draft/.

**Fig. 2.** An example of how text is presented in *Rough Draft*

Reina has taken the young dragon, Lyre, and the pair is traveling across a fantastical land in order to return him to his mother in the hopes that the latter will lift the curse. Along the way they encounter a number of characters and obstacles that either help them or impede their journey. The goal of the player is to help Denise complete the story by guiding Reina and Lyre towards their destination. However, in the two rewind versions, some decisions can get the characters stuck in bad situations and thus stall the writing process. The player has to go back and remake previous choices.

In choosing a writing framed story, we attempt to break away from the common time travel framework discussed above. This framework provides a narrative justification for why the player, who is playing as the author, is able to rewind when things do not go as planned. Additionally, most of the existing stories are about a hero trying to avoid failure, however the other side of that coin is trying to achieve success, which is one of the motivations behind the action of metagaming. As such, Denise's story is about a hero trying to achieve a goal, and avoid failure on the way.

### 4.2   Adapting the Story to Different Rewind Structures

This story world was adapted to all three versions of the game. All four main scenes (i.e., 1. the sea road, 2. the stone road, 3. the wood road, and 4. dragon's den) are accessible to the player in all versions to maximize consistency.

Although the designs of the structures of the three games were different due to the way the rewind mechanic functioned in each version, the same story

**Fig. 3.** The branching structure of the unrestricted version. (Color figure online)

content was applied to all three versions. The exact number of and nature of choices vary from version to version but the story content remains largely the same. The main difference was how much story content was presented to the player between choice points, which varied from version to version depending on the rewind design and resulting story structure. In our case, this was done in preparation for the user study we plan to perform in our future work, to ensure that all participants would experience largely the same story regardless of which version they play.

**Unrestricted Rewind.** The Unrestricted Rewind version of *Rough Draft* allows the player to return to any previously made choice. In order to progress through this version of the game, the player has to seek out key items or information that can unlock previously unavailable choices in other parts of the story. Similar to *Zero Escape*, in the unrestricted rewind version of the game, the player needs to explore every main branch (i.e., scenes) of the story in order to find the key items and information.

More specifically, the first decision point branches into one of the first three scenes. As we want the rewind to be the core game mechanic, the player cannot reach the final scene (Scene 4) until they unlock appropriate elements, scattered through all of the first three scenes. Because the player could return to any pre-

**Fig. 4.** Two interactive maps for the stone road story branch at different stages. (Color figure online)

viously made choice, they could easily explore all of these branches by revisiting and remaking the initial choice. Figure 3 shows the branching structure of this version. A node represents a story segment whereas a link represents a player choice. Green nodes indicate story content that needs to be unlocked by certain items and information. A blue and dashed arrow indicates that a key item or information from a certain node would unlock a particular choice (i.e., that choice will not be visible until it is unlocked). As indicated in the figure, not all nodes need to be visited to complete the game, but at least one option at every choice point has to be made.

Through playtesting, we realized that the unrestricted rewind could not function properly without a visual map, as players would lose track of where they are in the story. Our interactive map was inspired by *Zero Escape* and refined through playtesting. The interactive map (Fig. 4) outlines story events and their narrative structure as the player makes choices. To maintain the narrative theme, the map is designed to visually resemble hand drawn story maps that an author would be creating as they were working on a story.

In the beginning of the game, the map is one node with three branches, the structure of which are not specified. As players make choices, the nodes they have visited will fill in with text indicating the choice made. Players can return to previously made choices by selecting one of these nodes. Dead ends are marked on the map by an "X" over the node to indicate that the player has already experienced that outcome and that it is the wrong one (Fig. 4, left). When a key point is discovered and thus the player unlocks something, it would be marked on the map in red text (Fig. 4, right), in addition to indications in the story. In order not to give away too much information about the story in the beginning, the map has different levels of granularity. The more the player interact, the more detailed the map will be.

**Fig. 5.** The flow chart for the story in the restricted version (Color figure online)

**Restricted Rewind.** The Restricted Rewind version of *Rough Draft* allowed the player to return to only the last choice they had made. *Life is Strange* and *Save the Date* were referenced during the design process for this version. The first game allows the player to only go back one or two choices while the second version allows the player to return to their last save point but can be played like a restricted rewind if the player saves before every choice. The only way to proceed through the restricted version of the game is to try the different options and explore their immediate outcomes until the correct answer is unlocked and the player is allowed to proceed.

The story structure of this version is shown in Fig. 5. Again, the green nodes indicate unlock-able content and the blue lines indicate what information is necessary to unlock choices. As you can see, its structure is more linear compared to that of unrestricted rewind, in order to account for the restriction in the scope of rewind. The order in which the main scenes take place is determined by which route the player chooses to explore at the initial choice. For example,

**Fig. 6.** An unlocked choice in the restricted version

if the player initially chooses the sea road instead of the stone road, they would still experience the events of both scenes, but the events of the stone road will happen after they completed the sea road, and vice versa.

The interface to show the rewind is designed differently, too. When the player arrives at choice points for the first time, the "correct" answer is typically not available. The initial options often lead to dead ends but one of them will provide information to unlock the "correct" option when rewinding. This can be seen in Fig. 6, on the left is the choice before rewinding, here the "correct" choice is not available but after obtaining information through a dead end, the player can rewind and the new correct choice will emerge (right).

**No Rewind.** The No Rewind version of the game is a traditional interactive narrative game with no rewind mechanic. Players of this version of the game traverse the branching narrative through making choices, again, with no option to go back and remake them. In order for the player to experience the same amount of content as the previous two versions, the branch structure of the no rewind version in designed in such a way that the player only influences the sequence of the four main scenes, but will experience all of them regardless.

## 5    Conclusion and Future Work

Metagaming, a practice that has traditionally been frowned upon within certain game genres, has begun to become integrated into game design as a core mechanic. Based on our analysis of five popular games that use the megagaming mechanics of rewinding as their core gameplay, we proposed a theoretical framework to understand three different structures of rewind, unrestricted Rewind, restricted rewind, and external rewind, as well as the narrative constraints they impose. In addition, we developed an interactive story *Rough Draft* that utilizes the insights we learned in our game review and adapt them to three different

rewind structures. Our next step is to conduct a user study based on the different versions of *Rough Draft* and empirically analyze how different rewinding structures affect players' narrative engagement. This knowledge will further help game designers to understand how to use the rewinding mechanic especially in the context of interactive narrative.

# References

1. Bolter, J.D., Gromala, D.: Windows and Mirrors: Interaction Design, Digital Art, and the Myth of Transparency. MIT Press, Cambridge (2003)
2. Carter, M., Gibbs, M., Harrop, M.: Metagames, paragames and orthogames: a new vocabulary. In: Proceedings of the International Conference on the Foundations of Digital Games, pp. 11–17. ACM (2012)
3. Chunsoft: Zero escape: Virtue's last reward [Playstation Vita] (2012)
4. Consalvo, M.: Cheating: Gaining Advantage in Videogames. MIT Press, Cambridge (2007)
5. Dontnod Entertainment: Life is strange [Digital Game] (2015)
6. Fox, T.: Undertale [Digital Game] (2015)
7. Garfield, R.: Metagames. Jolly Roger Games, Charleston (2000)
8. Gass, W.H.: Philosophy and the form of fiction. In: Fiction and the Figures of Life, pp. 3–26 (1970)
9. Gile, C.: Life is strange: embracing metagaming, February 2015. http://tinyurl.com/jfb3nm6
10. Harrell, D.F., Zhu, J.: Agency play: dimensions of agency for interactive narrative design. In: AAAI Spring Symposium: Intelligent Narrative Technologies II, pp. 44–52 (2009)
11. Jordan, W.: From rule-breaking to rom-hacking: theorizing the computer game-as-commodity. In: Situated Play DiGRA 2007 Conference, pp. 708–713 (2007)
12. McCallum, S.: Gamification and serious games for personalized health. Stud. Health Technol. Inform. **177**, 85–96 (2012)
13. Paper Dino Software: Save the date [Digital Game] (2015)
14. Ryan, M.-L.: Interactive narrative, plot types, and interpersonal relations. In: Spierling, U., Szilas, N. (eds.) ICIDS 2008. LNCS, vol. 5334, pp. 6–13. Springer, Heidelberg (2008). doi:10.1007/978-3-540-89454-4_2
15. Shen, S., Iosup, A.: The xfire online meta-gaming network: observation and high-level analysis. In: 2011 IEEE International Workshop on Haptic Audio Visual Environments and Games (HAVE). IEEE (2011)
16. Short, E.: Analysis: the accretive player character. In: Gamasutra: The Art & Business of Making Games (2009)
17. Stam, R.: Reflexivity in Film and Literature: From Don Quixote to Jean-Luc Godard. Columbia University Press, New York (1992)
18. Stamenković, D., Jaćević, M.: Time, space, and motion in braid a cognitive semantic approach to a video game. Games Cult. (2014). doi:10.1177/1555412014557640
19. Vonnegut, K.: Slaughterhouse-Five. Delacorte, New York (1969)
20. Waugh, P.: Metafiction. Routledge, New York (2013)
21. Wreden, D.: The stanley parable [Digital Game] (2013)

# Beyond the Gutter
## Interactivity and Closure in Comics

Tiffany Neo[✉] and Alex Mitchell

Department of Communications and New Media,
National University of Singapore, Singapore, Singapore
neo.yuhan@gmail.com, alexm@nus.edu.sg

**Abstract.** This paper examines the impact of the introduction of simple interactions to comic panels on the reader's process of interpretation and narrative closure, perception of time, and experience of immersion and agency. We conducted two qualitative studies of reader response to interactive comics using semi-structured interviews. Our findings suggest that interactivity creates an additional level of interpretation, which may be seen as a second interpretive gap or 'gutter'. The studies also identified some preliminary design criteria that allow interactivity to have a meaningful impact on the portrayal of time, story immersion and comprehension, and an increased sense of agency. These findings suggest new areas for research in the field of interactive comics and storytelling.

**Keywords:** Usage scenarios and applications · Interactive comics · Reader response · Agency · Immersion · Interpretation · Narrative closure

## 1 Introduction

The role of interactivity in the reader's experience is a key area of interest when discussing interactive storytelling. However, comics is one particular form of storytelling that has seen little academic exploration in the context of interactivity. Much of the work on interactive comics revolves around the incorporation of animation, elastic borders, and the "infinite canvas" [1]. Branching comics have also been explored in more recent studies [2], as well as the generation of dynamic content [3]. However, there is little existing literature specifically exploring how the incorporation of interactivity impacts the reader's experience of comics.

This paper discusses qualitative findings from two exploratory studies, which suggest that interactivity, when perceived as relevant to actions taking place in the story world, has an impact on the reader's experience of interactive comics, particularly in terms of agency, immersion, sense of time, and story comprehension. The latter two points relate to Scott McCloud's [4] notion of closure across the gutter between comic panels, the conceptual gaps that require effort from the reader to interpret. This concept is not exclusively associated with the physical white space between panels, but any gaps that require interpretation in the

© Springer International Publishing AG 2016
F. Nack and A.S. Gordon (Eds.): ICIDS 2016, LNCS 10045, pp. 375–387, 2016.
DOI: 10.1007/978-3-319-48279-8_33

process of reading [5]. Our findings also suggest that interactivity, by creating another level of interpretation required of the reader, may be viewed as a second interpretive gap, in addition to the traditional comic gutter.

## 2    Related Work

While there is very little published literature on interactivity in comics, there exists a substantial body of research on the impact of interactivity on other forms of storytelling, such as hypertext fiction and games. Here, we highlight the research into the impact of interactivity on the reader's experience that we have found most directly relevant to the introduction of interactivity in comics. In particular, we focus on forms of interactive storytelling where interactivity forms part of the process of interpretation: hypertext fiction, works that exhibit agency of various types, and games that make use of "Quick Time Events".

In hypertext fiction, the role and meaning of the links that allow interaction with such works have been examined. Ricardo [6] suggests that these links possess semantic meaning of their own, forming a "paratext" beyond, but not necessarily completely independent of, the main text. Tosca [7] argues that this semantic value also possesses a "suggestive power" that helps to define the relationship between departure and arrival text when a reader follows a link. Applying relevance theory, Tosca [8] also explores how the search for relevance before and after following a link creates a pleasing aesthetic experience. Links may also map the temporal aspects of narrative onto the spatial environment of hypertext [9].

The active, purposive role of the reader in clicking on a link while reading a hypertext story has been emphasized [10], calling to mind the concept of agency, the sense of making a meaningful narrative impact [11]. The performance of purposive actions has been argued to create feelings of agency via "commitment to meaning" [12], in which readers feel responsible for a narrative outcome simply because they have taken an action that led to it, even in the absence of choice.

In video games, one type of interactivity that may also be pertinent to comics is Quick Time Events (QTE), prompts that usually appear during cinematic cutscenes that require the player to press designated buttons in order to successfully progress through the scene, and have been found to create a sense of agency by requiring physical intervention corresponding to the narrative [13]. Indeed, Nixon and Bizzocchi [14] argue that in *Heavy Rain* [15], in which QTEs are a part of core gameplay, the interaction "contributes to the process of identification and serves to make the choices feel more real to the player".

In summary, the impact of interactivity on the reader's experience of narrative has been discussed with relation to forms of storytelling such as hypertext and games. This has inspired the design ideas tested in the following studies, which seek to apply similar forms of interactivity within the context of comics.

## 3    Purpose of Research

Existing research has allowed us to identify interesting aspects of interactivity, such as the creation of additional meaning and impacts on agency and immersion,

in other genres of interactive storytelling besides comics. This raises the question of whether these concepts are transferable to the more visual realm of comics.

This paper explores this question by examining the impact of introducing hypertext- or QTE-inspired interactions (independent of branching or choice) between comic panels on agency, immersion and narrative closure as experienced by readers. Since the aesthetic impact of interactivity on narrative depend on the reader's ability to perceive additional layers of meaning from simple mouse click or keystroke actions, we are also interested in exploring how interactivity changes the nature of the interpretive gap that is the conceptual gutter.

## 4   Methodology

To investigate the research questions described above, two qualitative studies were run. The first study was a controlled comparative study between stand-alone panel pairs, whereas the second was a more holistic study, using a complete short comic as a test case, that built on the findings of the first study.[1] The first study compared three types of links (a "next" button, an embedded, clickable hyperlink, and an externally represented QTE-like action), with participants activating the links or actions to move between two comic frames. Embedded hyperlink interactions were tied to story world objects within the comic panel itself, while externally represented QTE-like interactions had an independent interface in the blank space outside the frame. The second study required the participants to perform embedded QTE-like interactions in order to proceed to the next panel in a short but complete digital comic. The first study was conducted with 12 participants, whereas the second study involved 8 participants. All participants were volunteers from an undergraduate research methods class. None of the researchers were involved in the teaching of the class.

In both studies, participants were asked to read the interactive comic material, followed by a semi-structured interview. The semi-structured interview approach borrows some elements from the Piagetian clinical interview [16], in which the interviewer may present or propose changes to the original task asked of the participants in order to probe for more information.

### 4.1   First Study

The first study was intended to provide focused, comparative insight into the impact of different types of interaction, which are suggestive in terms of narrative meaning, on the reader's experience of specific panel transition types. Scott McCloud identified six different panel transition types [4], five of which are relevant to mainstream narratives: moment-to-moment, action-to-action, subject-to-subject, aspect-to-aspect, and scene-to-scene. According to McCloud, different levels of closure occur in the gutter within different types of panel transitions.

---

[1] Samples of the comic materials used in the studies can be found at http://narrativeandplay.org/publications/beyondthegutter.

Five independent pairs of comic panels were developed for this study, one from each of the five panel transition types mentioned above. The participant began by seeing only the first panel of each pair, and had to perform a brief action in order to reveal the second panel. Each pair was further split into three possible variations on interaction types for comparison purposes:

1. clicking an external "Next" button
2. clicking on a relevant object within the first image
3. a short QTE-like interaction performed with keyboard or mouse, with the interface indicators positioned outside the panels

The first variation served as a control condition with the bare minimum of suggested meaning, as it was external to the comic panel and consisted of a neutral "Next" label unrelated to the narrative. In contrast, the clickable object in the second variation and the QTE-like interaction in the third variation were both designed to relate directly to the narrative, either by highlighting a meaningful object or by mirroring a significant process or action. The second was intended to be similar to the links found in hypertext fiction, which are often embedded on meaningful key words. The third was inspired by the QTEs found in games. The main focus of the study was to examine the effects of the latter two interaction types, which were intended to be more suggestive (in the sense used by Tosca [7]) of the narrative transition taking place between panels.

Each participant viewed five panel pairs, seeing each transition type only once, with each of the three interaction types being applied at least once, in different orders to avoid order effects. Every unique permutation of transition and interaction type was covered a total of four times across all participants. Immediately after viewing each pair, participants were asked questions about their interpretation of the two panels and their thought process in coming to that conclusion, perception of how much time passed between the panels, how much agency they felt, and which panel pairs they felt most immersed in and why. In addition, ad-hoc probing questions were asked about issues that arose as a result of observations or the participants' responses to the initial questions.

## 4.2  Second Study

The second study built on the findings of the first study, serving as a test case for the approaches found most likely to be effective during the first study.

The first study found that embedded clickable links tended to improve immersion, while QTE-like interactions contributed more to feelings of agency, with no clear universal preference between the two. Building on this, the second study combined these two suggestive interaction types into one: embedded QTE-like interactions, in which the interface elements were placed in context right next to relevant areas in the panels (similar to *Heavy Rain*). While the first study compared three different interaction types, the second study focused on exploring the impact of this combined approach.

This study also explored a phenomenon that emerged from the first study: some participants expressed a desire to see a series of intermediate changes in

a single panel while carrying out an interaction. This feature was implemented in one panel of the comic in the second study, which went through intermediate changes as stages of interaction are completed.

Finally, while the findings in the first study indicated that the more suggestive interactions seemed to have some impact on the reader's interpretation and experience of immersion and agency, some aspects of the process of interpretation could not be accurately judged by using isolated panel pairs, due to the lack of any larger narrative context. The second study thus made use of a complete, coherent one-page short comic story, allowing the findings on reader impact to be further refined in a more natural setting. This comic was created for the study, although the storyline was based on the independent short film *Cargo* [17].

Similar questions to the first study were asked, but in relation to the comic story as a whole as well as specific transitions within it. Additionally, participants were asked about how relevant they found each interaction, and why. Further probing questions were asked based on the comments readers made.

## 5  Findings and Discussion

This section presents the main findings of the studies, supported by quotes from the interviews with the participants. Note that as this was an exploratory study with a very small pool of participants, the focus was on surfacing relevant issues in detail to facilitate further study, rather than to produce generalizable results. Hence, there was no quantitative coding of the interviews. Future work will involve quantitative studies to attempt to confirm and generalize our findings.

Our observations suggest that, when the interactivity was seen as both relevant to the progression of the story in the comic, and clearly connected to specific, concrete actions that were taking place between panels, interactivity did indeed impact the reader's interpretations of time and narrative, as well as their experience of immersion and agency. The intermediate-snapshot variation in the second study was positively received by users, who reported that it gave them a sense of smooth flow and acted as an aid to interpretation when the panel transitions involved large gaps in time.

### 5.1  Agency and Perceived Relevance

QTE-like interactions were found to enhance the sense of agency felt by readers, but only when applied to an 'active' transition between panels, and only when perceived as relevant to the progression of the story.

**Effectiveness of QTE-like Interactions in Eliciting Agency.** In the first study, the QTE-like interactions were generally positively received by participants with regard to agency, with many participants reporting the interactions made them feel a high degree of influence over story events. As one participant described:

"There's a girl, she's shooting the bat, and then when I pressed the left arrow key, I saw some build up pressure... and then the arrow sets loose and pins the bat to the statue... I guess I had quite a big influence in the sense that I felt like I was the one helping her to gather the energy for the bow to pull it back and then release it, like if I didn't press the left arrow key she wouldn't have shot the bat." (Study 1, Participant 6)

This approach had an advantage over the embedded clickable link variation, which some participants found ineffective in terms of giving them a sense of agency due to the perceived relative passivity of merely clicking an object:

"For this I didn't feel like I had influence, because the only thing I could to do was find an object, and... that was, like, that was all that I could do to get to the next picture, so there wasn't anything like the pressing of the spacebar to pump the water out." (Study 1, Participant 4)

Based on these findings, the second study retained the use of QTE-like inter-actions in the comic design. As explained below, this was largely effective in creating a sense of agency, provided some specific conditions were fulfilled.

**Conditions for Eliciting Agency.** In both studies, the responses of many participants seemed to indicate that there are two prerequisites in order for them to feel a sense of agency via interactions.

The first prerequisite was the perception that the process being mirrored in the interaction was concrete and attributable to a character's actions, as opposed to abstract and unrelated to character actions. For example, in one transition in the second study, the reader had to repeatedly press the "space" key to break free from a zombie and hit it with a knife. When asked about agency, one participant said that "...I feel very influential because I'm the one like, chopping the person, because it's like the knife action..." (Study 2, Participant 8). In contrast, in a later panel transition where the "T" key was held down to move time forward, the same participant reported that "This one is like, not really in control, because you can't control time, so you're just pressing it."

It is worth noting that this finding has some relevance to the use of different panel transition types in the first study. While the findings seem to suggest that transition type does not matter as much as whether the transition is 'active' and attributed to concrete action by characters, some transition types are inherently more prone to being seen as 'active'. For example, action-to-action transitions, featuring key points in a character's behaviour, were more likely to be seen as active and attributable than aspect-to-aspect or scene-to-scene transitions, which often involved changes in uncontrollable forces such as space and time.

The second prerequisite is the perceived relevance of the interaction to the story. Participants claimed to feel a sense that they were participating in story events when the action is perceived as relevant. As one participant explained:

"I mean the whole point of this interactive comic is to make you feel like you're part of the story, like you're playing that character, so if the action is relevant you feel like you're actually participating in it, so it's kind of fun." (Study 2, Participant 5)

In contrast, interactions with little perceived relevance failed to provide a sense of agency, and were even found to be distracting. As one participant said, "I don't know what I'm doing, so I don't feel influential" (Study 2, Participant 8). Similarly, another participant explained that "I think if it's less relevant it's more distracting" (Study 2, Participant 4).

When these prerequisites are fulfilled, readers often reported feeling a strong sense of influence or participation, contributing to both agency and immersion. For example, in one of the panel transitions in the first study, when the reader needed to use the mouse-wheel to focus a gun on a target, the participant said:

"It feels like I'm really the one shooting, so like, I'm taking the role of the protagonist... it's from the perspective of this guy who's trying to shoot, so it's like you're already in the story itself; you're not just like outside looking at the whole thing happening." (Study 1, Participant 1)

This is seen as both mirroring the character's action, and directly relevant to the story. Similarly, in the second study, one transition involved pressing the "X" key to aim, and then releasing it to fire a gun. The participant reported:

"There was one where I had a lot of influence... because you had to aim and shoot, so in a sense after you release the button then that's where the person shoots the zombie, so that's the part I think I had the most influence." (Study 2, Participant 7)

These observations suggest that interactions indeed have a great deal of potential for fostering agency in comics. Additionally, as certain prerequisites have to be fulfilled in order for this to be done successfully, the findings begin to point towards some design considerations when creating such interactions.

**Factors Contributing to Perceived Relevance.** In addition, we observed that the design of the controls and interface of the interaction had an impact on perceived relevance. In the second study, several participants cited the strong parallel between the design of the interface feedback visuals and the corresponding action in the story as the reason for perceiving relevance.

For example, in one panel transition in the second study the participant needed to press the "up" arrow repeatedly to have the main character pick up a baby. Here, the participant felt that "...it's quite relevant because the idea of picking up, you pick up, and it's an upwards arrow and then it's also pick up so it makes sense" (Study 2, Participant 6). Similarly, in the aim-and-shoot scene described above, another participant felt there was relevance "...because

you're taking aim, and then like I think the action is really good, because it's like focusing in the middle" (Study 2, Participant 8).

Interestingly, some participants performed retroactive determination [18] in order to understand the relevance of the interactions themselves, not just the story panels. In such cases, the relevance of the interaction only became apparent when the outcome had been seen. For example, with reference to the aim-and-shoot transition in the second study, one participant observed that:

> "I didn't get it initially like the first time when I was doing, I was like, okay let go, and then eh? So the girl is dead, then I realised that the letting go was to shoot." (Study 2, Participant 2)

These observations suggest that the process of interpreting the connection between interactivity and the comic visuals could be eased through careful design of the controls and interface. This implies that the gap between interactivity and comic content is another conceptual 'gutter' that requires effort to interpret.

### 5.2    Interpretation and Immersion

The first study found that the 'embedded-ness' of the embedded clickable links was a key factor in the level of immersion. As one participant observed:

> "I would say that I'm actually immersing myself into the story, because I'm interacting with the elements itself rather than clicking a next button which is actually external to the visuals." (Study 1, Participant 3)

Some participants in the first study mentioned that the external placement of the QTE-like interactions disconnected them from the story:

> "It felt just like the next button as well, because what I'm doing on the outside doesn't really have much effect on what was happening in the frame ... it was an alternative way of progressing but it still didn't feel as part of the story." (Study 1, Participant 2)

This informed the design of the comic used in the second study, which utilised embedded rather than external QTE-like interactions. As explained below, the interactions in this case were able to foster a sense of agency in the readers.

In the first study, both QTE-like interactions and embedded clickable links were found to serve as interpretive aids that helped the participants to develop an understanding of what happened between the panels. This supports the idea that the interaction itself, as well as the search for relevance before and after, have an impact on meaning-making, especially when there is ambiguity or lack of information. This parallels Tosca's writings on the suggestive power of links [7] and the application of relevance theory [8]. For example, one transition shows a man reaching down to save a girl who is falling off a cliff. Pressing the spacebar activates the transition, with the second panel showing the man holding the girl's arm. As one participant explains:

"The pressing of the spacebar actually makes me think that the girl is jumping, but it's an ocean below her, so I guess she has some superpower to elevate herself towards the guy, and he's actually trying to reach out to her to pull her towards the cliff." (Study 1, Participant 4)

Here, it wasn't initially clear from the visuals what had happened between panels. Instead, the action that had to be taken helped to clarify the panel transition.

Similarly, in one transition the first panel showed a woman summoning a demon, and the second panel showed her, older, leading the demon into battle. For one participant, the relationship between the panels was not initially clear:

"Not very sure what's going on... I think it's a bit far of a jump ... This is a sundial, right? Er, maybe like, a jump into the future ... She looks older here ... Oh, is this like a time thing? So yeah so it's like ... you click on it so you fast forward the time for them." (Study 1, Participant 9)

Here it was the action that had to be taken, in this case clicking the image of a sundial, that make the transition between panels clear.

In the second study, as the material used was a full story with plenty of visual context, most participants could interpret the story without help of the interactions. Still, some participants felt the interactions emphasized certain aspects of the narrative, and fostered a sense of identification or empathy with the character. For example, in the transition involving picking up a baby, one participant felt "...because you have to hold for a while, so you can feel like it takes a bit of effort to pick up the baby" (Study 2, Participant 5). Here, the effort to execute the interaction was interpreted as time and effort required by the character.

Similarly, a later panel required the participant to hold down the "T" key to move time forward, as the mother walked to a "safe point" carrying the baby. This again was interpreted as the passage of time, and effort by the character:

"It's like the same action, but over a period of time, so you can see like, hmm, how the mom is like trying desperately to get to the safe point, perseverance or something, over a few hours you keep doing the same thing, just to get to the safety point." (Study 2, Participant 7)

Even when there was little difficulty in interpreting the comic from the images alone, interactions can still help to clarify certain events, or create empathy for the feelings or experiences of the characters, which creates greater immersion. Thus, interactions clearly have a role in meaning-making, whether as direct interpretive aids or by adding another layer of empathic information.

## 5.3 Perception of Time

QTE-like interactions, due to their mirroring of the process that is happening in the fictional world of the comic, sometimes had a direct impact on readers'

perceptions of how much time has passed between panels. This was apparent in both studies, with participants saying that the time it took to complete some interactions was directly equivalent to the time that passed in the story. For example, in one panel transition in the first study, the participant had to hold the "left" arrow and then release it to shoot a bow. When asked about the time that had passed between panels, the participant answered:

> "Maybe like, three seconds? About the time that it took for me to hold the left arrow key and then release. Because that's the time it took for her to pull the bow back and release the bow." (Study 1, Participant 6)

Similarly, in the panel transition involving picking up a baby in the second study, one participant felt that "Then you have to hold the up button for a few seconds, the time you take to pick the baby off the ground" (Study 2, Participant 7).

Even when this direct parallel was not applicable (e.g. long time skips, other visual cues used to determine time), the interactions were still able to create an impression of pacing or speed. In the changing panel in the second study where the participant had to hold the "T" key repeatedly to progress through the stages, one participant reported:

> "I did feel it slowing down especially here, because you have to press and release, press and release, so it's like trying to make you feel like you're going through the grind." (Study 2, Participant 5)

Overall, the QTE-like interactions influenced the readers' sense of how much time passed, both as a direct parallel and as an empathic device that allows the reader to feel various aspects of time beyond what is displayed by a static comic.

### 5.4   Intermediate Snapshots

In the first study, when the interaction was seen to consist of parts or stages, several participants reported expecting to see intermediate scenes leading up to the second panel. This was especially so when the time or visual lapse between the two panels was large, requiring more effort for closure, such as in a scene-to-scene transition. For example, in the panel transition involving the use of the "arrow" keys to move time forward, one participant explained that:

> "When I clicked the right arrow I thought the hourglass would turn right away... but the fact that I had to click multiple times, I assumed that there would be gradual changes." (Study 1, Participant 2)

To explore this, one panel in the second study was designed to progress through three states as the reader held down the "T" key. This was well-received:

> "It signifies a different period of time. The starting, the middle and the end within this single panel... I think it's better, because you can see there's some flow going on." (Study 2, Participant 4).

This is in contrast with some of the other transitions that were perceived to have a wide gap between the images. In some of these cases, participants felt the jump was too abrupt and expressed the wish to see intermediate steps between the two panels as well. For example, in the immediately preceding panel transition, the participant had to press the "T" key to move through a static scene where the character was planning her next action. In this case, one participant reported that "I didn't really understand ... because it's very abrupt, like there's no panel showing her planning or anything" (Study 2, Participant 6).

The intermediate snapshots also sometimes aided participants in their understanding of what occurred during the large gap of the scene change:

> "Now that I realise, I think she's making her way towards the place, like she took a couple hours to walk... [if the intermediate stages were not shown] I will be more confused... suddenly at night, and she's standing at this place. It's going to be more abrupt." (Study 2, Participant 5)

All this suggests that readers do desire the relative ease of interpretation and the sense of progression that comes with intermediate changes. This is interesting, as traditional paper comics have worked well even without the possibility of such changes – indeed, most readers indicated that they would have been able to understand the story even if it had been presented only in its traditional comic-like final state. Thus, there may be something inherent in the digital platform or the presence of interactivity that causes such expectations of continuous flow.

## 6 Implications for Design

In terms of actionable design knowledge, the results of both studies suggest several implications for the design of interactivity in comics:

1. When perceived as relevant to the narrative, suggestive interactions may aid readers in understanding ambiguous panels or large temporal jumps.
2. Even when no such aid is needed, QTE-like interactions have the potential to emphasise certain narrative, experiential or emotional aspects of the story.
3. Interactions perceived as relevant, especially those perceived as 'active' or performed from a first-person perspective within the story world, tend to result in a sense of agency via commitment to meaning.
4. QTE-like interactions, especially those which closely parallel the story event they correspond to, may influence readers' perception of time and pacing, suggesting the potential of using such interactions as an alternative way of portraying time in interactive comics.
5. Panels that change within themselves to reflect intermediate stages in a transition with a wide gap tend to improve flow and reduce abruptness, and also serve as an interpretive aid.

These design guidelines can be used to inform the effective design of interactive comics. For example, an author should make sure the choice of controls

and the design of the interface helps readers to see the relevance between their actions and what is happening in the story. These interactions should also only be applied to relevant and active panel transitions in order to elicit greater immersion and agency, and to avoid the reader perceiving them as forced or superfluous.

## 7 Conclusion

The findings from these two studies begin to sketch out some possible considerations when it comes to designing interactive comics, and also suggest that effectively designed suggestive interactions can ease the movement of readers across the gutter by expediting understanding and immersion. The findings regarding panels with intermediate changes also suggest that some QTE-like interactions encourage readers to look for ways of easing large, cognitively challenging jumps across the traditional gutter in favour of a more continuous form of visual storytelling. This is in line with the idea that digital comics are starting to converge with continuous media such as film and games [1].

Interestingly, while interactivity seems to undermine the traditional gutter, it also appears to create a new type of conceptual gutter in interactive comics – the gap between the interaction and the visual storytelling of the comic. The studies described in this paper demonstrate that the ability to bridge this new gutter has an impact on how effective interactions in a comic are in contributing to reader understanding and agency. Participants often seemed to make sense of these connections via some of the same methods used to understand stories in traditional comics, such as retroactive determination. Appropriate labels, interface and feedback design was also important, perhaps similar to the importance of elements such as speech bubbles and motion lines for traditional closure.

Studying the introduction of interactivity to comics is a first step in redefining our understanding of gutters and closure in the digital realm. Further research should expand these initial findings to further develop our design guidelines, and to expand the scope of the reading experience beyond the types of panel transitions, style of interaction, and length of the comic used in this study.

## References

1. Samanci, O.: Embodying Comics: Reinventing Comics and Animation for a Digital Performance. Ph.D. thesis, Georgia Institute of Technology (2009)
2. Andrews, D.E.W.: Employing branching comics to design, visualise and evaluate interactive stories. Ph.D. thesis, University of Birmingham (2015)
3. Soares de Lima, E., Feijó, B., Furtado, A.L., Diniz Junqueira Barbosa, S., Pozzer, C.T., Ciarlini, A.E.M.: Non-branching interactive comics. In: Reidsma, D., Katayose, H., Nijholt, A. (eds.) ACE 2013. LNCS, vol. 8253, pp. 230–245. Springer, Heidelberg (2013). doi:10.1007/978-3-319-03161-3_16
4. McCloud, S.: Understanding Comics: The Invisible Art. Tundra Publishing, Northampton (1993)

5. Duncan, R., Smith, M.J.: The Power of Comics: History, Form, and Culture. Continuum International Publishing Group Inc., New York (2009)
6. Ricardo, F.J.: Stalking the paratext: Speculations on hypertext links as a second order text. In: HyperText 1998, pp. 142–151 (1998)
7. Tosca, S.P.: The lyrical quality of links. In: Hypertext 1999, pp. 217–218 (1999)
8. Tosca, S.P.: A pragmatics of links. In: Hypertext 2000, pp. 77–84 (2000)
9. Luesebrink, M.C.: The moment in hypertext: A brief lexicon of time. In: Hypertext 1998, pp. 106–112 (1998)
10. Harpold, T.: The contingencies of the hypertext link. Writ. Edge **2**(2), 126–138 (1991). The New Media Reader
11. Murray, J.H.: Hamlet on the Holodeck: The Future of Narrative in Cyberspace. The Free Press, New York (1997)
12. Tanenbaum, K., Tanenbaum, T.J.: Commitment to meaning: A reframing of agency in games. In: Digital Arts and Culture (2009)
13. Auerbach, D.: The quick time event, May 2014. http://www.thewhitereview.org/features/the-quick-time-event/
14. Nixon, M., Bizzocchi, J.: Press X for meaning: Interaction leads to identification in heavy rain. In: Proceedings of DiGRA 2013: DeFragging Game Studies (2013)
15. Dream, Q.: Heavy rain. Video game (2010)
16. Ginsburg, H.P.: Entering the Childs Mind: The Clinical Interview in Psychological Research and Practice. Cambridge University Press, Cambridge (1997)
17. Howling, B., Ramke, Y.: Cargo. Motion picture (2013)
18. Groensteen, T.: The System of Comics. University Press of Mississippi, Jackson (2007)

# The Design of *Writing Buddy*: A Mixed-Initiative Approach Towards Computational Story Collaboration

Ben Samuel[✉], Michael Mateas, and Noah Wardrip-Fruin

Expressive Intelligence Studio Center for Games,
Playable Media University of California, Santa Cruz, USA
{bsamuel,michaelm,nwf}@soe.ucsc.edu

**Abstract.** The act of writing is often a difficult process; writing partners can be a way to test ideas, provide critiques, and overcome the difficulty of adding words to a blank page. *Writing Buddy* is an in-development prototype of a mixed-initiative playful tool, intended to serve the role of a digital writing partner by combining the authoring affordances of writing software with the natural curiosity inherent in playable media. In it, players create and arrange dramatic beats to achieve certain story goals. Those dramatic beats are then satisfied through assigning character actions to them. Finally, players pen prose and dialogue to bring those actions to life. *Writing Buddy* aims to ease the authoring process by offering suggestions based on character simulation and story structure.

**Keywords:** Usage scenarios and applications · Ensemble · Playspecs · Collaborative writing · Story recognition · Content authoring · Mixed-initiative · Playful tool

## 1 Introduction

Computational media has proven itself to be a powerful medium for telling stories. However, many of the interactive stories available today achieve that interactivity through devices such as branching narratives. Players engaging in these experiences are often presented choice points, which will alter the course of the narrative. This can be an effective means of allowing the player to tailor a story to their desires, but it is an act of guidance, selection, and uncovering an existing narrative rather than creation.

The act of making a story can be very pleasurable; there is inherent joy in creation, and penning a story can be an excellent way to express one's self. However, it can also be a daunting process; overcoming the oppressiveness of a blank-page is merely the first of many challenges a would-be author must face. Writing partners can help one overcome these challenges, but might be difficult to find. This paper introduces *Writing Buddy*, an in-development prototype of a playful tool that is meant to serve as a digital writing partner. By working and playing with *Writing Buddy*, players create–rather than discover–simple, narratively consistent stories.

© Springer International Publishing AG 2016
F. Nack and A.S. Gordon (Eds.): ICIDS 2016, LNCS 10045, pp. 388–396, 2016.
DOI: 10.1007/978-3-319-48279-8_34

## 2    Related Work

Many efforts have been made to produce computer systems capable of generating stories [4,6,11,13,28]. Though some of those systems allowed for interactivity, they were largely passive experiences for the player, i.e., the player was being told a story rather than creating one themselves. Many of these generators are either author-centric or character-centric; the IPOCL planner [16] recognizes the importance of characters acting believably within a coherent plot. More recently, the NetworkING system [14] generates plan-based stories after users fine-tune character social relationships; the Wide Ruled system [21] enables players to chart similar plans themselves.

Other recent experiments, such as *Creative Help* [17] which builds off of the *Say Anything* [26] system, aids the user in producing full stories with creative control throughout the process. *Creative Help* takes free text written by a user, compares it against a substantial corpus of English-language stories, finds a similar sentence in the corpus, and presents the next sentence from the corpus story as a suggestion for the next sentence in the user's story. This work allows for deep creative freedom on the part of the player, but the system has no semantic understanding of the story being written. This lack of an internal understanding has been recognized as a problem in mixed-initiative computational storytelling [5], and one which has at least been partially addressed in other domains, such as procedural architectures [7], level design [23], and quest generation [25].

In addition to being a tool to help players create stories, interacting with *Writing Buddy* is meant to be playful. As such, it shares design philosophies with casual creators [2], and is an example of AI-based game design [3] in which novel AI technologies enable new forms of gameplay; this notion is related to the ideation-implementation-simulation cycle of co-creating with story generators outlined in [27]. Other examples of such experiences include *Endless Web* [22], *Storyteller* [1], *Prom Week* [8], and *The Ice-Bound Concordance* [15]. *Storyteller* and *Ice-Bound* are particularly relevant as both involve players constructing stories. *Storyteller* asks players to construct stories that satisfy short narrative puzzles, emphasizing puzzle solving over player self-expression. *Ice-Bound*, on the other hand, gives players more freedom of expression, while learning about a pre-existing backstory. *Writing Buddy* attempts to meld the features of these examples by giving the player creative control to shape the length, content, and characters of the narrative, while still providing specific narrative goals.

## 3    System Description

The intended audience of *Writing Buddy* are casual authors interested in tinkering with dramatic beats and character actions. Though players are free to play with different characters and actions in a social physics-guided sandbox (see Sect. 3.2), *Writing Buddy* provides narrative goals for those seeking a more directed experience. Since myriad stories would satisfy these goals, "solving" them is meant to evoke the puzzle-solving pleasure found in games, while assisting players in creating stories they feel creative ownership over. As the player

begins crafting their stories, *Writing Buddy* provides suggestions for narratively consistent character actions, shows hypothetical possible worlds the player might wish to pursue [18] and helps recognize overarching themes and character arcs. As the player solves more goals, they are presented with increasingly challenging writing prompts meant to provide the player opportunities for creative self expression.

In order for *Writing Buddy* to be a collaborative writing partner, it must be able to reason over character desires and actions, as well as have an understanding of overarching storylines or plots. To achieve this, it uses libraries that, though well suited for this purpose, have prior to this work never been used in just this capacity. Namely, it uses the social simulation system *Ensemble* [20] to calculate and determine character behavior (see Sect. 3.2), and it uses the play trace analyzer *Playspecs* [12] to recognize and reason about larger-scale, plot-level moves and moments (see Sect. 3.3). Before we discuss the precise uses of these technologies in this system, we will first give a broad overview of how one engages with *Writing Buddy* to create a story. This section will conclude with a brief example of how one might construct a story using the system (see Sect. 3.4).

We remind the reader that *Writing Buddy* is still under development. The elements described in Sects. 3.1 and 3.2 have been implemented; Sect. 3.3 is in development.

## 3.1   The Authoring Process

*Writing Buddy* has three authoring modes: beat, action, and prose authoring.

**Beat Authoring** is intended to capture the broad strokes of the moves of the narrative. The term *beat* is inspired by Robert McKee's usage of the term [10] (which also informed the seminal interactive narrative *Façade* [24]), though in truth it is closer to his description of a *life value*. A beat, otherwise known as an emotional exchange, is meant to be the smallest unit of dramatic content that can occur between two characters A life value, then, is a character's state of being that changes over scenes through a progression of beats. These values often deal with large themes (e.g., life, hope, elation) and their opposites (e.g., death, despair, sorrow). *Writing Buddy* collapses this structure; whereas McKee would argue for a life value to change after multiple beats, *Writing Buddy* associates a life value change (i.e., a character state change) with every beat. Similarly, the state changes currently present in *Writing Buddy* tend to be less grandiose, to make it more believable that such swings are possible given the shortened time

Due to this one-to-one relationship, beats take the form of a specific state and its opposite. For example, one beat might call for a character that is angry at another character to lose this anger. Another might call for a physically weak character to find the strength to overcome this aspect of their nature. The specific beats present in the system are represented by the Ensemble Engine (see Sect. 3.2). *Writing Buddy* goals request the creation of a story that contains

specific beats. The user can add, remove, and reorder beats to the story with no constraints through a simple graphical user interface. At this level, *Writing Buddy* does not enforce any form of narrative cause and effect or overarching plot structure; the player is free to add or remove beats to tell a story in terms of changing life values that suits their interests. Beat authoring does not in and of itself change the underlying state of any of the characters of the story, or their relationships towards one another; that occurs when the player assigns actions to beats.

**Action Authoring** has players assigning an *action* to each beat. Whereas a beat is an abstract concept of intended state change with no actual impact on the modeled status of the characters or the narrative, actions have actual effects on characters and their relationships to one another. For an action to be assigned to a beat, three criteria must be true. Firstly, the action must have an effect which satisfies the beat being described; for example, if the beat is detailing a character transitioning from being angry at another character to not being angry, then the action must have the effect of removing that anger. The second criteria is that characters must have the volition to perform the action; to continue our peace-making example, just because actions such as *shake hands, tell joke,* or *apologize* might have the impact of making characters form peace with each other, if the characters involved do not have the volition to engage in those activities, they will not be presented as options for consideration. They will, however, be presented as *almost actions* (*AAs*, see below). For more detail on the volition formation process, see Sect. 3.2. Thirdly, actions have preconditions which must be satisfied. To continue our example, a beat calling for two parties to stop being angry at each other only makes sense if the two parties are indeed presently angry; if they are not, then actions which depend on their anger to be true will not be applicable. The system, recognizing that there may have been an authoring error at the beat level, will also include the actions whose preconditions were not satisfied in the list of almost actions.

AAs refer to actions whose effects would satisfy the beat in question, but that are not applicable for any of the aforementioned reasons (the characters do not have the volition to engage in this action, or the preconditions for the action do not hold). Players are presented with the list of AAs for each beat, along with a description of why the action was disqualified from actually being assigned to the beat. Presenting this list is meant to have a twofold effect for the player. One is strictly informative, and explain why certain actions the player might have thought were applicable are not in this context. The other is to provide insight into the underlying state of the system, and spark creativity towards adding story beats that could make the action viable. It is a form of emergent narrative through hypothetical consideration; by seeing the possible worlds which could be true under different circumstances, the player might take inspiration in attempting to make those circumstances come to pass [19]. Once the player has added enough beats to satisfy the goal set out by *Writing Buddy*,

and each of those beats has been assigned an action, the player can move on to the final authoring process.

**Prose Authoring** allows the player to write plain-text prose to accompany each beat. Beyond the underlying state changes encoded in the actions themselves, this stage of authoring represents the performance realization of the actions. The system has no means of reasoning over this text, and thus the player may free write whatever they wish. We acknowledge that the final prose of the piece are incredibly important to the discourse of the narrative, and at present *Writing Buddy* places the responsibility of its creation entirely on its users.

### 3.2    Ensemble

Beats, character volitions, and actions are represented using the Ensemble Engine, a social simulation system that represents characters' individual personalities, their relationships to one another, and the social norms which drive their behavior. A more thorough description of this social physics system and its progenitor may be found here [20] and here [9]. In *Writing Buddy*, Ensemble is responsible for keeping track of characters, their current state, and the actions that they may take towards one another. In addition to maintaining the current state, Ensemble keeps a history of every discrete state the characters of the story have been in. Each of these discrete states is called a *timestep*. Each beat is considered to be a separate timestep.

To determine the actions available for assignation to a beat, Ensemble calculates the volitions of the story's characters. This is done through the evaluation of Ensemble "influence rules." Each rule consists of a precondition and corresponding effects that affect character behavior. For example, characters that are rivals will be more likely to try to one-up each other. Actions, then, are tied to these effects; arm-wrestling, spit-contesting, and drink-quaffing might all be considered actions that characters trying to one-up each other might engage in.

Because each beat represents a separate timestep, and because actions can be assigned to beats in any order, *Writing Buddy* marks the first experience using a social physics engine in which players may edit the past. This is an important feature, as sometimes in the authoring process writers may wish to start in the middle or end of the story and fill in the beginning afterwards. In the spirit of AI-based game design [3], this requirement from the game inspired improvements to the AI, as prior to this point, Ensemble only allowed operation in the present, adding each new action to the end of history. Enabling the functionality to add actions prior to "future" ones has involved validating that changes made to a beat in the past do not obviate the actions already assigned to beats which come after it. For example, if a later beat is currently assigned an action with the precondition of two characters being enemies with each other, that action will no longer make sense if the player resolves the conflict between the two characters prior to that action taking place. When a previously assigned action becomes problematic for reasons such as this, the system highlights the issues for the player to resolve.

### 3.3 Playspecs

Playspecs were designed as a means of analyzing a game via play trace analysis, allowing for regular expression operations to be applied to both player inputs and game states. A more thorough description of Playspecs can be found in [12]. In short, an individual Playspec details a sequence of player inputs or game state that the game designer is interested in, and a play trace is one such sequence generated via gameplay. A trace is said to match the Playspec if the trace contains the specific sequence outlined in the Playspec.

Up to now, Playspecs have been used in post game analysis; after collecting play traces, one uses Playspecs to discover if certain game states are ever encountered, any outliers indicating subversive play, or otherwise extraordinary behavior. *Writing Buddy* plans to integrate Playspecs into the gameplay itself. The integration will take place on multiple levels. First is a simple level of recognition; any given goal is defined as a Playspec. As beats are added and removed, the current list of beats will be run through the Playspec; if the list of beats matches the Playspec then the goal of the level will be met. Besides recognition, Playspecs could also be used to propose new beats to add, to capture the feel of an active writing partner. Casual users may opt to disable this feature, preferring themselves to be the primary arbiter of narrative content. The capability for players to author Playspecs to share with one another is a long-term goal.

### 3.4 Simple Example Interaction

To clarify the authoring process, we present a simple scenario illustrating use of the system. When the player starts using *Writing Buddy* they are presented with a goal; the goal for this example is to write a story in which a man leaves home and returns. The player begins by authoring beats. They see that they can author a beat in which a man goes from the state of "being at home" to "not being at home" and adds that to the list of beats. Similarly, they then add another beat that changes the state of the man from "not being at home" to "being at home." The story now has these two beats, and the Playspec representing the goal lets the player know that the beats they have selected satisfy it.

The player then attempts to assign actions to the beats. However, they are stymied, as there are currently no valid actions for the beats as they stand. There are, however, almost actions that appear. One such almost action is labeled "storm out" but the player is informed that the man does not have the volition to perform this action, but would if he had gotten into a fight recently. The player then goes back to the interface for authoring beats, creates a new one called "man goes from not angry to angry", and adds it to the beginning of the list of beats. This causes the Playspec goal to re-evaluate the list of beats; the man still leaves home and comes back, so it evaluates as a success. The player then attempts to assign an action to their new beat, and finds that there is an action that the man is willing to do: "have an argument." The player assigns this action to the beat, which updates the underlying state of Ensemble. Now when the player attempts to assign an action to the "leave home" beat, Ensemble

recalculates the man's volitions and determines that, yes, because the man had recently gotten into a fight, it makes sense for him to "storm out." The player assigns this action to the beat in question. A similar editing process can be followed for the beat pertaining to returning home.

Once all beats have been assigned actions (or before then, if the player so chooses), the player can begin writing prose for each beat. When doing so, they are reminded of the life value they are attempting to change associated with the beat (e.g., have the man go from not angry to angry), and the specific action that they selected to realize it (e.g., "have an argument"). Here they have the means to write whatever they wish.

## 4    Conclusions and Future Work

In this paper we have described *Writing Buddy*, a mixed-initiative based playful tool to assist in story writing. By combining the character based social simulation system *Ensemble* with a real-time application of the playtrace analyzer *Playspecs*, we have created an experience that combines the puzzle-solving pleasure found in games with an authoring environment that guides and assists players in creating narratively consistent stories.

Though this is a promising start, the system is currently just a prototype, and there remains much exciting work to be done. The system's current structure lends itself best to short, fast stories, since a story is nothing more than a collection of beats, and each beat changes a life value. Future incarnations of this work could incorporate additional structure, introducing the notion that it takes many beats to constitute a single scene, many scenes to compose an act, and multiple acts to tell a story.

Embedding *Writing Buddy* into a fully realized game seems a natural extension of its playful design. One can imagine such an experience framing the player as a struggling writer: the player's reputation would be determined by the nature of stories they pen; their prestige would grow as they solve more challenging authorial goals, earning new characters, beats, actions, and social rules to make richer stories mark their growing skills as a writer.

There is also much to be learned about the nature of mixed-initiative collaborative authoring tools. Players using this system should feel creative ownership over the stories they created using this system, while at the same time recognizing that these stories were made in collaboration with a digital writing partner. Discovering what relationship players have with the system—and with the stories they produce with it—will help inform the future development of this system and the development of other such tools.

## References

1. Benmergui, D.: Storyteller (2012). http://www.ludomancy.com/storyteller.php
2. Compton, K., Mateas, M.: Casual creators. In: Proceedings of ICCC (2015)

3. Eladhari, M., Sullivan, A., Smith, G., Mccoy, J.: AI-based game design: enabling new playable experiences. UCSC-SOE-11 (2011)
4. Klein, S., Aeschlimann, J., Balsiger, D., et al.: Automatic novel writing: a status report. Wisconsin University (1973)
5. Kybartas, B., Bidarra, R.: A semantic foundation for mixed-initiative computational storytelling. In: Schoenau-Fog, H., Bruni, L.E., Louchart, S., Baceviciute, S. (eds.) ICIDS 2015. LNCS, vol. 9445, pp. 162–169. Springer, Heidelberg (2015). doi:10.1007/978-3-319-27036-4_15
6. Lebowitz, M.: Creating characters in a story-telling universe. Poetics (1984). http://academiccommons.columbia.edu/catalog/ac:140682
7. Lipp, M., Wonka, P., Wimmer, M.: Interactive visual editing of grammars for procedural architecture. In: Proceedings of TOG. ACM (2008)
8. McCoy, J., Treanor, M., Samuel, B., Reed, A.A., Mateas, M., Wardrip-fruin, N.: Prom week: designing past the game/story dilemma. In: Proceedings of FDG (2013)
9. McCoy, J., Treanor, M., Samuel, B., Reed, A.A., Mateas, M., Wardrip-Fruin, N.: Social Story Worlds With Comme il Faut. TCIAIG (2014). http://ieeexplore.ieee.org/lpdocs/epic03/wrapper.htm?arnumber=6732913
10. McKee, R.: Story: Substance, Structure, Style and the Principles of Screenwriting. ReganBooks, New York (1997)
11. Meehan, J.: TALE-SPIN, an interactive program that write stories. In: IJCAI, pp. 91–98 (1977)
12. Osborn, J., Samuel, B., Mateas, M., Wardrip-Fruin, N.: Playspecs: regular expressions for game play traces. In: Proceedings of the AIIDE (2015)
13. PÉrez, R.P., Sharples, M.: Mexica a computer model of a cognitive account of creative writing. J. Exp. Theor. AI **13**(2), 119–139 (2001)
14. Porteous, J., Charles, F., Cavazza, M.: Using social relationships to control narrative generation. In: AAAI, pp. 4311–4312 (2015)
15. Reed, A.A., Garbe, J., Wardrip-Fruin, N., Mateas, M.: Ice-bound: combining richly-realized story with expressive gameplay. In: Proceedings of FDG (2014)
16. Riedl, M.O., Young, R.M.: An intent-driven planner for multi-agent story generation. In: Proceedings of Autonomous Agents and Multiagent Systems (2004)
17. Roemmele, M., Gordon, A.S.: Creative help: a story writing assistant. In: Schoenau-Fog, H., Bruni, L.E., Louchart, S., Baceviciute, S. (eds.) ICIDS 2015. LNCS, vol. 9445, pp. 81–92. Springer, Heidelberg (2015). doi:10.1007/978-3-319-27036-4_8
18. Ryan, M.L.: Possible Worlds, Artificial Intelligence, and Narrative Theory. Indiana University Press, Bloomington (1991)
19. Samuel, B., Lederle-Ensign, D., Treanor, M., Wardrip-Fruin, N., McCoy, J., Reed, A., Mateas, M.: Playing the worlds of prom week. In: Narrative Theory, Literature, and New Media: Narrative Minds and Virtual Worlds (2015)
20. Samuel, B., Reed, A.A., Maddaloni, P., Mateas, M., Wardrip-Fruin, N.: The ensemble engine: next-generation social physics. In: Proceedings of FDG
21. Skorupski, J., Jayapalan, L., Marquez, S., Mateas, M.: Wide ruled: a friendly interface to author-goal based story generation. In: Cavazza, M., Donikian, S. (eds.) ICVS 2007. LNCS, vol. 4871, pp. 26–37. Springer, Heidelberg (2007). doi:10.1007/978-3-540-77039-8_3
22. Smith, G., Othenin-Girard, A.: PCG-based game design: creating endless web. In: Proceedings of Foundations of Digital Games (2012)
23. Smith, G., Whitehead, J., Mateas, M.: Tanagra: a mixed-initiative level design tool. In: Proceedings of FDG, pp. 209–216. ACM (2010)

24. Stern, A., Mateas, M.: Façade (2005)
25. Sullivan, A., Mateas, M., Wardrip-Fruin, N.: Questbrowser: making quests playable with computer-assisted design. In: DAC (2009)
26. Swanson, R., Gordon, A.: Say anything: a massively collaborative open domain story writing companion. In: Interactive Storytelling (2008). http://link.springer.com/chapter/10.1007/978-3-540-89454-4_5
27. Swartjes, I., Theune, M.: Iterative authoring using story generation feedback: debugging or co-creation? In: Iurgel, I.A., Zagalo, N., Petta, P. (eds.) ICIDS 2009. LNCS, vol. 5915, pp. 62–73. Springer, Heidelberg (2009). doi:10.1007/978-3-642-10643-9_10
28. Turner, S.R.: Minstrel: a computer model of creativity and storytelling (1993). http://dl.acm.org/citation.cfm?id=166478

# Posters

# Towards Procedural Game Story Creation via Designing Story Cubes

Byung-Chull Bae[1]([✉]), Gapyuel Seo[1], and Yun-Gyung Cheong[2]

[1] School of Games, Hongik University, Sejong, South Korea
{byuc,gapseo}@hongik.ac.kr
[2] College of Software, Sungkyunkwan University, Suwon, South Korea
aimecca@skku.edu

**Abstract.** This paper describes our ongoing effort to create game stories procedurally and collaboratively via designing story cubes. Our current work includes the following four phases. First, creating stories with the help of existing storytelling tools such as Story Cubes. Second, drawing relatable storyboards based on the created stories. Third, designing and making own story cubes based on the storyboards. Finally, re-creating stories based on the story cubes designed by others. Particularly in this paper we describe our team-based storytelling project that we have conducted as a part of college course in the classroom environment.

**Keywords:** Story creation · Story cubes · Storyboards · Story variation

## 1 Introduction

Storytelling is one of the oldest forms of entertainment. We love stories regardless of their representing media. In particular, Oatley [2] claims that stories can appeal to us both cognitively (that is, relating more to the structure of narrative such as suspense, surprise, curiosity) and emotionally (that is, relating more to the content of narrative which can evoke the emotions such as empathy and a sense of identification).

While storytelling is a powerful tool for entertainment and other purposes (such as education or communication), not everyone is a great author or storyteller. For this reason various tools and games in both tabletop board games (e.g., storytelling card games such as *Once Upon a Time* [5], *Dixit* [4]) and digital games [3] have been developed to help the user/player develop creativity, language skill, and collaboration. In the storytelling games, story elements such as characters, actions, emotions, props, and settings are usually represented as images and symbols with the form of either cards [8] or dices [6, 7].

Those images and symbols provided either by a deck of cards or a set of dices are helpful for average users to create simple stories, but they may also act as constraints to limit the user's narrative creativity. In this paper we explore how the story cube images can work for creating story variation and discuss how they can contribute to the procedural story generation for games. Our work was strongly inspired by the StoryCube interactive installation [1] that had been displayed as a part of art exhibition in ICIDS 2015 conference.

© Springer International Publishing AG 2016
F. Nack and A.S. Gordon (Eds.): ICIDS 2016, LNCS 10045, pp. 399–402, 2016.
DOI: 10.1007/978-3-319-48279-8_35

## 2  Our Approach

We have conducted a 4-week game storytelling project with 120 students enrolled in a college course titled 'Introduction to Game Studies'. About two thirds of students were majoring in game graphics and one third of them in game programming. Each week they completed each task in the following phases:

  i. Creating simple stories using a storytelling game (Rory's Story Cubes [6])
 ii. Creating storyboards from the created stories
iii. Designing own story cubes based on the created storyboards
 iv. Creating (or re-constructing) stories by referring to the other's story cubes

In the first phase, the students created stories using Rory's Story Cubes [6] as a team. Each team consisted of 8 students and three types of Rory's Story Cubes - Original, Actions, and Voyage - were employed. Figure 1 shows an example set of 9 images selected from the original Rory's Story Cube. These images were developed to a simple story about a shepherd boy and a possessed sheep, the boy's best friend, taking an adventure to find a cure. In total, after the first phase, 15 different stories were created and each team presented the created story in class.

**Fig. 1.** 9 images selected randomly by rolling original Rory's Story Cube [6]

In the second phase, the created story lines or plots were represented as storyboards, that is, consecutive images over story time, by adding details on characters, settings, actions, happenings, etc. Depending on the length of the story line, 9 to 18 drawings comprised a storyboard. The left picture in Fig. 2 shows a storyboard based on the story derived from the images in Fig. 1.

In the third phase, based on the created storyboard, the students designed story cube templates by selecting 6 to 8 images from the storyboard and made their own story cubes similar to the Rory's Story Cubes as in the right picture of Fig. 2. Each team designed and made 3 to 4 story cubes.

Finally in the last phase, the students installed their story cubes with a string on the ceiling in the classroom (see the left picture in Fig. 3). After completing the installation, each student freely chose one story cube from the installed cubes and re-created a story based on (or inspired by) the images of the selected story cube (see the right picture in Fig. 3).

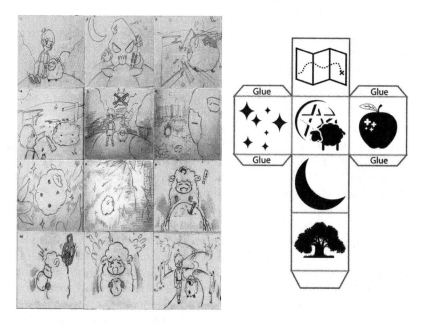

**Fig. 2.** A storyboard portraying a story developed from the 9 images in Fig. 1 (left); a story cube template derived from the storyboard in the left and the relating original Story Cube images in Fig. 1 (right).

**Fig. 3.** Students are installing their own story cubes in the classroom (left); students are selecting story cubes to re-create a story from the images in the selected story cube (right).

## 3  Discussion and Future Work

We did not give any limitations on the students' story cube selection process in the fourth phase. Interestingly, the most popular story cube selected from the installed 60 story cubes was the one illustrated in the right picture of Fig. 2; 12 out of 120 students chose it. The re-created 12 stories from the story cube were completely different from the original one with regard to main characters, settings, and motifs. While in the original one, specifically, main characters were a boy (who is missing in the story cube) and a (possessed) sheep, in the reconstructed stories the main characters were various from stars, a young couple, and a greedy young man to an old woman. The sheep, meanwhile, was a main character in a half of the 12 stories; magic and trip were two major motifs.

Currently we are tackling three issues. First, we are analyzing how stories can be varied through the repeated processes of concretization (from storycubes to stories or storyboards) and abstraction (the reverse of concretization) in terms of narrative elements including characters, settings (time and location), motifs/themes, and perspectives. Second, we are evaluating the quality of the created stories by human evaluators. As evaluation metrics for narrative quality, we consider various narrative-relating factors such as causality, verisimilitude (motivation/details), fun, novelty, cliche, overall satisfaction, as well as various narrative emotions (curiosity, suspense, surprise, empathy, a sense of identification). Finally, we are also working on adding game quests in the created stories in a seamless manner. As future work, ultimately, we plan to apply those results for computer-based procedural story generation and evaluation using case based reasoning.

**Acknowledgments.** This work was in part supported by 2015 Hongik University Research Fund.

## References

1. Anilasophy, H.S.-F.: Aalborg University Medialogy Students: The StoryCube Physical Interactive Installation in ICIDS 2015. http://icids2015.aau.dk/exhibition/screen-shot-2015-11-14-at-06-32-52/
2. Oatley, K.: A taxonomy of the emotions of literary response and a theory of idenification in fictional narrative. Poetics **23**, 53–74 (1994)
3. Yuksel, P., Robin, B.R., McNeil, S.: Educational uses of digital storytelling around the world. In: Koehler, M., Mishra, P. (eds.) Proceedings of the Society for Information Technology and Teacher Education International Conference, pp. 1264–1271 (2010)
4. Dixit by Livellud. http://en.libellud.com/games/dixit
5. Once Upon a Time by Atlas Games. http://www.atlas-games.com/ouat3/
6. Rory's Story Cubes by the Creative Hub. https://www.storycubes.com/
7. Story Dice by Zuid Soft. https://play.google.com/store/apps/details?id=com.zuidsoft.storystones
8. Tell Tale by Blue Orange. http://www.blueorangegames.com/index.php/games/telltale

# Phylactery: An Authoring Platform for Object Stories

Charu Chaudhari and Theresa Jean Tanenbaum(✉)

Department of Informatics, University of California, Irvine, Irvine, CA, USA
jrickman@uci.edu, tess.tanen@gmail.com

**Abstract.** In this work, we describe *Phylactery,* a hybrid physical/digital system for authoring interactive stories across collections of objects. Unlike many Interactive Digital Storytelling (IDS) systems, which are concerned with the representations of formal narrative structures within software, or with the simulation of high-fidelity narrative environments populated by humanlike agents, *Phylactery* is focused on the act of storytelling as it occurs among humans in the physical world. It is designed to connect personal narratives, memories, and rituals of storytelling with material containers by associating spoken stories with physical objects. *Phylactery* can be used to imbue the physical world with stories as both a formal authoring platform, and an informal and playful narrative technology. In this way, our system participates in older traditions of reminiscence, memory transmission, and heritage preservation through the collection of meaningful objects.

**Keywords:** Memories · Heritage · Objects · Hybrid physical/digital systems · Tangibles · Interactive narrative · Oral traditions

## 1 Introduction

In this paper we present *Phylactery,* a hybrid physical/digital system for authoring stories by attaching audio narration to physical objects. Phylactery provides a way to explicitly attach stories and memories to physical objects by recording oral histories associated with objects and "attaching" those stories to their objects via RFID technology.

Humans have long used physical objects as sites of meaning [1] with some artifacts becoming repositories for memories, emotions, and personal stories. Some objects become prized possessions: a gift from a dear friend; a watch worn by one's father; a set of Sabbath candlesticks carried across the ocean by an immigrant grandmother; souvenirs from a long journey. There are many ways that possessions can become imbued with meaning. Autotopography [2] refers to "an arrangement of those objects that people use to construct a sense of themselves by cultivating their physical environment." For many of us, the material objects in our lives become extensions of our identities. Meaningful objects need not have any particular functional or aesthetic value to take on a sentimental value. People associate memories, histories, experiences, dreams, and desires with objects in their environments. Meaningful objects can trigger these memories and can serve as loci for narrative information.

Phylactery provides a way to explicitly attach stories and memories to physical objects by recording oral histories associated with objects and "attaching" those stories

© Springer International Publishing AG 2016
F. Nack and A.S. Gordon (Eds.): ICIDS 2016, LNCS 10045, pp. 403–406, 2016.
DOI: 10.1007/978-3-319-48279-8_36

to their objects via RFID technology. A user places a tagged object upon a wooden "alter", activating a recording system that captures her narratives of the object and stores them in a database associated with it. Phylactery is unique in the Interactive Digital Storytelling world in that it calls attention to *practices* and *rituals* around storytelling in physical and social contexts.

## 2   Background and Prior Work

In his canonical work on comparative mythology, Sir James Fraser describes a "phylactery" as "a magical object that stores a piece of one's soul" [3]. In mythology, Phylacteries are used to secret away a piece of a person's soul in an object, thus ensuring their immortality. In more recent popular culture, this idea has appeared in *Advanced Dungeons and Dragons*, and within JK Rowling's *Harry Potter* stories under the name "horcrux". In selecting the name *Phylactery,* we also hoped to invoke a more recent scholarly tradition around material culture known as *ensoulment*. An object is *ensouled* when we attach memories to it [4, 5] causing it to take on importance in our lives.

Phylactery draws on a rich tradition of tangible narrative technologies; however, it differs from many prior systems in some important ways. Working with Hiroshi Ishii, Ali Mazalek has created several tangible narrative systems including *Genie Bottles* [6] and *Tangible Viewpoints* [7]. In Genie Bottles, a set of glass bottles tells a story through the voices of the "genies" trapped within, who converse and debate when their bottles are unstopped. Tangible Viewpoints allows a user to navigate a multi-viewpoint story by interacting with graspable pawns upon which different narrative information is projected.

Perhaps most relevant to the design of Phylactery is the *Materializing Memories* project led by Elise van den Hoven [8–11]. The various projects within the Materializing Memories project use physical objects as containers and mediators of important moments in their user's lives. The StoryBeads project led by Rietzma et al. [8] aims to preserve the indigenous knowledge of the culture of a South African community. The system is designed so users can associate stories with physical handcrafted beads. The beads hold special meanings in the culture and therefore are crucial in preserving indigenous knowledge. The system consists of a "Storyteller" and several handcrafted "eBeads". The beads activate the Storyteller to record a story, or to play a previously recorded story. A story can also be deleted from a bead by passing a bead through a hole in the Storyteller.

However, Phylactery's primary inspiration is our own *Reading Glove* project, which we developed several years ago [12]. The Reading Glove used collections of evocative objects to communicate a mystery story by playing back audio narration when objects were handled with an RFID enabled glove. While the Reading Glove was successful in many respects, it was difficult to disseminate the material stories we created for the system, and it was difficult for others to create their own object-based stories. We seek to address some of these shortcomings with Phylactery.

# 3   System Design

Phylactery uses RFID (Radio Frequency Identification) technology to simply (and inexpensively) associate digital information with physical objects. This process requires the user to attach an RFID tag to an object, place it on the Phylactery "alter" Fig. 1, and speak into the microphone to record the story or the memory associated with it. To play back the memory, the user simply places the object back top of Phylactery. LED indicators communicate the state of the object: blue when an RFID is detected, green when Phylactery is recording and yellow when it is playing a previously recorded clip.

**Fig. 1.** Phylactery

Phylactery takes the form of a wooden octagonal box, which contains a Raspberry Pi microcomputer; a Ph1dgetRFID reader; and a USB microphone and speakers. When the system detects a tag that isn't in the database, it automatically begins recording audio to a microSD card. When it recognizes a tag it automatically plays back the audio associated with it. This simple and lightweight interaction allows users to easily create stories across collections of objects, transforming their possessions into meaningful *heirlooms* through storytelling. In this way, Phylactery participates in a deep tradition of technologically augmented memory practices, and within the relatively young traditions of tangible computing and interactive digital storytelling. As such, it is capable of supporting deeply personal and private storytelling practices and highly public works of new narrative art. While none of the technology in Phylactery is "new", it combines existing technologies toward a unique new set of hybrid communicative affordances.

# References

1. Hoskins, J.: Biographical Objects: How Things Tell the Stories of People's Lives. Routledge, New York (1998)
2. Petrelli, D., Whittaker, S., Brockmeier, J.: AutoTopography: what can physical mementos tell us about digital memories? In: Proceedings of the SIGCHI Conference on Human Factors in Computing Systems, New York, NY, USA, pp. 53–62. ACM (2008)
3. Frazer, J.G.: The Golden Bough: A Study in Magic and Religion. Simon and Schuster, New York (1995)
4. Nelson, H.G., Stolterman, E.: The Design Way: Intentional Change in an Unpredictable World : Foundations and Fundamentals of Design Competence. Educational Technology, Englewood Cliffs (2003)
5. Odom, W., Pierce, J., Stolterman, E., Blevis, E.: Understanding why we preserve some things and discard others in the context of interaction design. In: Proceedings of the SIGCHI Conference on Human Factors in Computing Systems, New York, NY, USA, pp. 1053–1062. ACM (2009)
6. Mazalek, A., Wood, A., Ishii, H.: genieBottles: an interactive narrative in bottles. ACM Press (2001)
7. Mazalek, A., Davenport, G., Ishii, H.: Tangible viewpoints: a physical approach to multimedia stories. ACM Press (2002)
8. Reitsma, L., Smith, A., van den Hoven, E.: StoryBeads: preserving indigenous knowledge through tangible interaction design. In: 2013 International Conference on Culture and Computing (Culture Computing), pp. 79–85 (2013)
9. van den Hoven, E.: A future-proof past: designing for remembering experiences. Mem. Stud. **7**, 370–384 (2014)
10. van den Hoven, E., Eggen, B.: Tangible computing in everyday life: extending current frameworks for tangible user interfaces with personal objects. In: Markopoulos, P., Eggen, B., Aarts, E., Crowley, J.L. (eds.) EUSAI 2004. LNCS, vol. 3295, pp. 230–242. Springer, Heidelberg (2004)
11. Moncur, W., Julius, M., van den Hoven, E., Kirk, D.: Story shell: the participatory design of a bespoke digital memorial. In: Proceedings of 4th Participatory Innovation Conference, pp. 470–477 (2015)
12. Tanenbaum, T.J., Tanenbaum, K., El-Nasr, M.S., Hatala, M.: Authoring tangible interactive narratives using cognitive hyperlinks. In: Proceedings of the Intelligent Narrative Technologies III Workshop, New York, NY, USA, pp. 6:1–6:8. ACM (2010)

# What is Shared? - A Pedagogical Perspective on Interactive Digital Narrative and Literary Narrative

Colette Daiute[1]([⊠]) and Hartmut Koenitz[2]([⊠])

[1] The Graduate Center, City University of New York, New York, USA
cdaiute@gc.cuny.edu
[2] Professorship Interactive Narrative Design, University of the Arts Utrecht, Utrecht, Netherlands
hartmut.koenitz@hku.nl

**Abstract.** This paper builds on our analysis of interactive digital narrative (IDN) and traditional literary narrative (LN) to address issues relevant to theory and pedagogy of narrative technologies. We discuss pedagogical problems with narrative design and introduce an interdisciplinary experimental course (in computer science and psychology) to increase understanding of complementing and conflicting qualities of IDN and LN. This perspective extends recent debates about protostory [1] elements, processes, and specific micro-structures unique to and possibly shared [2] across these forms. Our practice-based research addresses students' development of narrative design skills and the question, "What is shared across narrative forms?"

**Keywords:** Narrative models · Pedagogy · Creative writing · Interactive digital narrative · Design · Literary narrative

## 1 Introduction

While the printed page might be slowly declining in everyday use, writing today is as important as it ever was [3]. Simultaneously, the advent of computational media enables the creation of interactive digital narrative experiences, which have gained significant roles in education (serious games, interactive news paper articles and interactive documentaries) as well as in entertainment (video games and transmedia franchises). Research into these new forms has identified shared qualities [2, 4] and unique affordances [5]. Therefore, the question of design processes and pedagogies becomes ever more important [6, 7]. Nevertheless, in higher education practice, the specific overlap and distinction of traditional literary writing (LN) and interactive digital narrative (IDN) are rarely addressed.

## 2 LN and IDN Design Processes

From the perspective of students, what IDN and LN design activities share is the intent to create an interesting narrative that engages its audience. According to previous theoretical views [2], categories like World, Objects, Events, and Characters are shared across narrative media. What differs, however, are the ways that IDN designers and LN

© Springer International Publishing AG 2016
F. Nack and A.S. Gordon (Eds.): ICIDS 2016, LNCS 10045, pp. 407–410, 2016.
DOI: 10.1007/978-3-319-48279-8_37

authors think about engaging their users or readers and the attendant strategies for enacting narrative design decisions. IDN designers and LN authors might ask "How can I make this character believable yet also surprising and engaging?" Differences occur especially in the designer/author's control over the specific story or stories that evolve out of the potential protostory [1]. The LN author must engage readers with psychological dynamics that bring characters to life. The IDN designer must construct potential trajectories with numerous interconnected possibilities for player selection. While the LN author might test these cognitive and emotional connections herself, the IDN designer must keep track of how potential players might combine options and compose narrative consequences.

Scholars have argued that interactive media offer novel avenues for narrative expression [5, 8]. Indeed, the model of the linear traditional story appears to inhibit students' use of procedural mechanics involved in creating a successful IDN experience [9, 10]. Nevertheless, research examining the shared and unique qualities relevant to IDN and LN design is scant.

## 3   Problems of Character Development in IDN and LN Design

Many students struggle with both LN writing and IDN design. Although these skills are rarely, if ever, connected in college curricula or departments, the reasons for these problems may be similar: besides the lack of experience with genre expectations, there is a paucity of theoretical knowledge to guide instructional design about cognitive structures required to mediate imagination and production within and across these two forms. In our experience, the majority of students create narratives that either omit character development altogether or they rely on strong binary oppositions (good/evil). In the latter case, the binary extremes are often paired with transparent choices ("Do you want to help the elderly woman cross the street or not?"). Such dualities result in reduced interest and motivation to replay an IDN and failure to connect the LN with intriguing dilemmas or emotional connections.

In the case of IDN design this means that characters might lack dynamic development. Yet, the specific potential of interactive digital media is in its procedural nature, which means that character traits can change over time – from good guy to bad guy. Ideally, though, a character in an IDN experience will transform in much more subtle and interesting ways. A comparable problem in LN writing is the stereotyped character. Characters in students' works often conform to ideological scripts, such as the perpetrator versus victim or person who is lost and then (somehow magically) found [11]. In addition to lack of experience carefully reading high quality literature and an implicit pressure to conform to cultural norms, student writers may gravitate to such a redemption script because they have failed to map out a trajectory of a character's considerations relevant to a moral dilemma. The expressive potential of characters' psychological states in relation to events and other characters might come to life as a process if LN authors are exposed to IDN character mechanics.

## 4    Strategies for IDN-LN Course Design

A course seeking to build on core qualities of narrative could usefully focus on character development. The course topics will include initial characteristics, character progress, use of personified objects, appropriate connection to environments, to other characters, and contingencies to development of the narrative. Categories for the media specific skills of IDN will be based on design principles we have developed earlier [10]. This means the use of procedural elements (trackers reflecting aggregated decisions, timers and inventory), opportunities for interaction and variety in replay on the backdrop of the aesthetic qualities of immersion, agency, and transformation [5]. LN skills will focus on character development, such as with psychological states (motivations, cognitions, affects) and interactions of those character states with cultural and moral values as established in the story settings and events [12].

To explore these options, we have designed a 16-session course with 10 sessions of parallel IDN and LN modules each to foster genre-specific strategies and outcomes. The IDN student should improve in ability to design a playable and re-playable digital narrative, and the LN student should improve in ability to write an engaging linear story. The course will also involve 6 cross-module shared sessions, highlighting media-agnostic objects, such as character development, and media-specific strategies to develop characters with affordances inherent to each medium. For example, one shared class will present Murray's BOG/BOD character analysis [13]; another will present an overview of IDN character mechanics (global options, tracking, etc.). A third shared class will involve a workshop on psychological states development.

Our prototype course is based on the familiar fairy tale of "Little Red Riding Hood." This story has been taken up, recreated, and tested in IDN (e.g. in a series of workshops at the ICIDS conference), game design [14] and traditional LN versions.

Contrasting IDN and LN narrative designs can begin with an initial encounter in the forest between Red and the wolf. In the IDN version, Wolf says "Hello there. What a pretty hat you have", to which there are 3 possible responses by Red, "What pretty eyes you have;" "I'm not supposed to talk to wolves;" and "Thank you, my name is Red. What's yours?" The IDN and LN design students will map out trajectories for each of the possible responses, for psychological as well as action consequences. We believe working with cross-media as well as core strategies might offer students scaffolding to overcome the limits of each single design emphasis. The success of this strategy will be determined with pre- and post-course assessments of IDN or LN designs, analyses of assignments in process, and student reflections [15].

## 5    Discussion and Conclusion

Establishing links across long-standing disciplinary divides such as humanities and computer science is overdue. Narrative design is a theoretically and practically relevant context for doing so. More specifically, as human knowledge technologies become increasingly complex, understanding the shared and unshared categories and processes of narrative, in particular, could contribute to developing vocabularies, instructional

strategies, and increased cross-disciplinary collaboration. Given the importance of narrative for understanding [16], it might even have consequences for decision-making in this technological world.

# References

1. Koenitz, H.: Towards a theoretical framework for interactive digital narrative. In: Aylett, R., Lim, M.Y., Louchart, S., Petta, P., Riedl, M. (eds.) ICIDS 2010. LNCS, vol. 6432, pp. 176–185. Springer, Heidelberg (2010)
2. Aarseth, E.J.: A narrative theory of games. In: Presented at the Foundations of Digital Games 2015 (2012)
3. Relles, S.R., Tierney, W.G.: Understanding the writing habits of tomorrow's students: technology and college readiness. J. High. Educ. **84**, 477–505 (2013)
4. Ryan, M.-L.: Narrative Across Media: The Languages of Storytelling. University of Nebraska Press, Lincoln (2004)
5. Murray, J.H.: Hamlet on the Holodeck: The Future of Narrative in Cyberspace. Free Press, New York (1997)
6. Spierling, U., Szilas, N.: Authoring issues beyond tools. In: Iurgel, I.A., Zagalo, N., Petta, P. (eds.) ICIDS 2009. LNCS, vol. 5915, pp. 50–61. Springer, Heidelberg (2009). doi: 10.1007/978-3-642-10643-9_9
7. Koenitz, H., Louchart, S.: Practicalities and ideologies, (re)-considering the interactive digital narrative authoring paradigm. In: Li, B., Nelson, M. (eds.) Proceedings of the 10th International Conference on the Foundations of Digital Games (2015)
8. Jenkins, H.: Game design as narrative architecture. In: Wardrip-Fruin, N., Harrigan, P. (eds.) First Person: New Media as Story, Performance, and Game. MIT Press, Cambridge (2004)
9. Crawford, C.: Chris Crawford on Interactive Storytelling. Pearson Education, Upper Saddle River (2004)
10. Koenitz, H.: Design approaches for interactive digital narrative. In: Schoenau-Fog, H., Bruni, L.E., Louchart, S., Baceviciute, S. (eds.) ICIDS 2015. LNCS, vol. 9445, pp. 50–57. Springer, Heidelberg (2015). doi:10.1007/978-3-319-27036-4_5
11. Inayatulla, S.: Beyond the dark closet: reconsidering literacy narratives as performative artifacts. J. Basic Writ. **32**, 5 (2013)
12. Daiute, C.: Narrative Inquiry. SAGE Publications, Thousand Oaks (2014)
13. Murray, J.H.: A tale of two boyfriends: a literary abstraction strategy for creating meaningful character variation. In: Koenitz, H., Ferri, G., Haahr, M., Sezen, D., Sezen, T.I. (eds.) Interactive Digital Narrative. Routledge, New York (2015)
14. Tale of Tales: The Path [Video Game]. http://tale-of-tales.com/ThePath/
15. Daiute, C., Koenitz, H.: 21st Century Narrative: Proposal to the Spencer Foundation. Graduate Center CUNY, New York
16. Ricoeur, P.: Narrative identity. Philos. Today **35**, 73–81 (1991)

# A Reflexive Approach in Learning Through Uchronia

Mélody Laurent[1]([✉]), Nicolas Szilas[3], Domitile Lourdeaux[1],
and Serge Bouchardon[2]

[1] Sorbonne Universités, Université de Technologie de Compiègne, CNRS, Heudiasyc,
Centre de Recherche Royallieu CS 60 319 60 203, Compiegne Cedex, France
{melody.laurent,domitile.lourdeaux}@utc.fr
[2] Sorbonne Universités, Université de Technologie de Compiègne, Costech,
Centre de Recherche Royallieu CS 60 319 60 203, Compiegne Cedex, France
serge.bouchardon@utc.fr
[3] TECFA, FPSE, University of Geneva, CH 1211 Geneva 4, Geneva, Switzerland
nicolas.szilas@unige.ch

**Abstract.** This work in progress paper presents a story-based approach
in a simulation-based learning environment in the context of crisis man-
agement. We offer a reflexive approach to learning for adults based on
the uchronia. Our game design UCHRONIE offers two phases of simula-
tion. During the scenario, the learner will explore several possible worlds.
During the debriefing, he may view several possible alternatives to the
scenario as a timeline.

**Keywords:** Intelligent narrative technologies · Virtual training ·
Debriefing · Interactive storytelling · Uchronia · Game design

## 1 Narrative as a Maze

In narrative-based Virtual Environments for training, such as FearNot! [1], Noth-
ing For Dinner [2], IN-TALE [3] and Crystal Island [4], it remains difficult for
computer systems to combine objectives like maintaining control over the story
and user agency without inconsistency. In order to leave a degree of freedom to
the user, and allow the author to retain control on the artwork, Umberto Eco's
works [5,6] are especially interesting on the relation between reader and work.
Deleuze and Guattari in their pluralistic book [7] offer with their definition of
rhizome in terms of maze the possibilities of infinite paths, which leads us to
propose to make this maze/network an explicit part of the story and a kind of
fiction that combines back in time travel and alternatives, as in uchronia.

Learning through a story has many advantages in terms of contextualiza-
tion, memorization and facilitation of emotional engagement in learning. In fact,
according to Bruner [8] our memory is narrative. A narrative has the ability to
isolate and highlight strong points of story, key moments. As part of an appren-
ticeship, these key moments allow the learner to consider possible alternatives
and naturally bring reflexivity. As for the system, those key points are what it
needs to achieve the objectives cited above.

© Springer International Publishing AG 2016
F. Nack and A.S. Gordon (Eds.): ICIDS 2016, LNCS 10045, pp. 411–414, 2016.
DOI: 10.1007/978-3-319-48279-8_38

## 2   Game Design for Adult Learning: UCHRONIE

The application domain is the management of mass casualties in the context of medical emergencies. The VICTEAMS project[1] aims at creating a Virtual Environment for training rescue team leaders during crisis situations. UCHRONIE is a first-person simulation-based learning environment through interactive narrative. The Virtual Environment is populated by semi-autonomous virtual characters, upon which no direct control can be enforced. The learner, the team leader, can interact with them and operates in an open-world.

### 2.1   First Phase of Simulation: Scenario

**The learner** begins as an explorer of possibilities. He explores "forwardly" successive possible states of the world. He interacts on the course of events, the story. At the beginning of the simulation, each event is unique. The learner has to make decisions depending on the event and the choices provided by the system. In Fig. 1: first, the medical team arrives with a patient on a stretcher. W1: the team leader could have asked a briefing but he makes the decision to examine the patient alone. Then he tries to operate alone and the patient ends up crippled but alive! At this point, the learner may wonder: "What would have happened if I had made a different decision?" and our system offers him the chance to answer this question.

The learner becomes a traveller when he decides to "go back" to a past event. This event will be the point of divergence between two universes. The event to which he has just returned marks the beginning of a new world to explore, W2, which past is identical to the last world he has left.

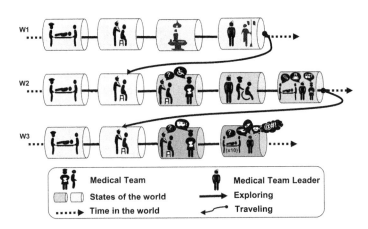

**Fig. 1.** Example of scenario

---

[1] VIrtual Characters for team Training: Emotional, Adaptive, Motivated and Social. https://victeams.hds.utc.fr/.

**The system** records all states of current worlds to be able to let the learner go back to the point of divergence he wants. At the same time, the system records all the risks and errors which serves as a basis to change the course of events between worlds and display events that the learner had not seen.

When the learner becomes a traveler, consistency from one world to the other is kept: the state of the world in which the learner goes is a copy of the state of the world he has left. The decisions that the learner has taken in previous worlds will be integral to the story as a uchronia: same frame, same characters but different events and probabilities. The system will intrinsically bring the reflexivity of the learning by looking at its database and makes sure that the learner has seen all the consequences of his actions/decisions. If not, the system will increase the probability of events to occur. In Fig. 1, while the learner goes back for the second time during examination to try a new option, the system will generate new consequences rather than let him train again to find the "right" diagnosis or to make the "right" decision since, in such complex domains, there is none. This makes UCHRONIE different from a mere saving/backup system.

## 2.2   Second Phase of Simulation: Debriefing

Once the concrete part of scenario is over, the learner may wonder: "Did I make other mistakes?" / "Which were the other ways to proceed?" and our system offers the learner to visualize the different worlds he explored as well as choices that he did not take in the form of a multiple timeline.

**The learner** can freely switch between multiple scenarios with the same duration, the same frame, and same characters but with a different ending. Each timeline represents a world he has finished, or a world he has left, or a world he has not decided to explore but which could be of interest. The learner has the opportunity to become aware of the issues of some of these decisions, and which consequences he had not taken into account during the simulation. In Fig. 2, W1 matches the first scenario in Fig. 1: the learner does not ask for advice from his colleagues, and with this timeline he should becomes aware that

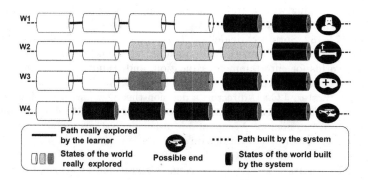

**Fig. 2.** Example of debrief

his team could have ended the day with very low morale. W4: the system offers the learner another plot that ends with a helicopter evacuation.

**The system** reconstructs the states of worlds based on the point of divergence, represented on the timeline as thumbnail images. It will build some additional states of the world for each world to get to a possible end for each scenario based on planning techniques. W4 was built up from all sides by the system.

## 3     Conclusion and Future Work

This paper presented a general overview of the UCHRONIE game design. We have explained how it supports a story-based approach in simulation-based learning environment. We have proposed a reflexive approach of learning for adult in the context of crisis management. Learners can explore multiple worlds that keep the same characters in the same frame, but the plot is changed by the system at each point of divergence by changing the probability of occurrence of an event. As part of our future work we plan to implement this approach within the VICTEAMS project to investigate and evaluate the game design performance to end-users.

**Acknowledgments.** The authors would like to thank the Picardie region and the European Regional Development Fund (ERDF) 2014/2018 for the funding of this work, as well as the French National Research Agency (ANR) and the French Government Defense procurement and technology agency (DGA) which funds the VICTEAMS project.

## References

1. Aylett, R., Vala, M., Sequeira, P., Paiva, A.: FearNot! – An emergent narrative approach to virtual dramas for anti-bullying education. In: Cavazza, M., Donikian, S. (eds.) ICVS 2007. LNCS, vol. 4871, pp. 202–205. Springer, Heidelberg (2007). doi:10.1007/978-3-540-77039-8_19
2. Habonneau, N., Richle, U., Szilas, N., Dumas, J.E.: 3D Simulated interactive drama for teenagers coping with a traumatic brain injury in a parent. In: Oyarzun, D., Peinado, F., Young, R.M., Elizalde, A., Méndez, G. (eds.) ICIDS 2012. LNCS, vol. 7648, pp. 174–182. Springer, Heidelberg (2012). doi:10.1007/978-3-642-34851-8_17
3. Riedl, M.O., Stern, A., Dini, D., Alderman, J.: Dynamic experience management in virtual worlds for entertainment, education, and training. Int. Trans. Syst. Sci. Appl. Spec. Issue Agent Based Syst. Hum. Learn. **4**(2), 23–42 (2008)
4. Mott, B.W., Lester, J.C.: U-director: a decision-theoretic narrative planning architecture for storytelling environments. In: Proceedings of the Fifth International Joint Conference on Autonomous Agents and Multiagent Systems (2006)
5. Eco, U.: L'oeuvre Ouverte. Éditions du seuil, Paris (1965)
6. Eco, U.: Lector in Fabula. Grasset, Paris (1985)
7. Deleuze, G., Guattari, F.: Mille plateaux: Capitalisme et schizophrénie II. Les Éditions de Minuit, Paris (1980)
8. Bruner, J.: Life as narrative. Soc. Res. **54**, 11–32 (1987)

# Interactive Chart of Story Characters' Intentions

Vincenzo Lombardo[1]([✉]), Antonio Pizzo[2], Rossana Damiano[1], Carmi Terzulli[1], and Giacomo Albert[2]

[1] Department of Computer Science and CIRMA, University of Torino, Turin, Italy
{vincenzo.lombardo,rossana.damiano,carmi.terzulli}@unito.it
[2] Department of Humanities and CIRMA, University of Torino, Turin, Italy
antonio.pizzo@unito.it

**Abstract.** This paper presents a visualization of stories that aligns the hierarchy of story units and the hierarchy of characters' intentions, respectively, with the story text, subdivided into chunks. The solution takes inspiration from the design introduced by the movie narrative charts, and presents an interactive tool.

**Keywords:** Intelligent narrative technologies · Interactive visualization · Character intentions · Story structure

## 1 Introduction

The visualization of stories and story-related facts has gained much importance in the recent literature and art. This is particularly true for stories with intricate plots that are not immediate to grasp (see, e.g., the visualization of two Nolan's films *Memento*[1], 2000, and *Inception*[2], 2010). A source of inspiration for a number of approaches have been the Movie Narrative Charts by Munroe[3]), where the layout centers upon the notion of destiny of each character, depicted as a horizontal line, which travels from left to right and becomes adjacent to others when the characters interact in the story. This design layout has been automatized through algorithmic approaches in [5,8] and later by [1], with increasing levels of legibility and performance. [3] introduce the motivations of character into the visualization: characters strive to achieve their goals and often end up conflicting with each other; the visualization aligns the sequence of the story incidents with the characters' intentions through a chart. The box–based design layout succeeds in fleshing out the story units (named "beats", scenes, sequences and acts in the literature, depending on their extension [4,7]) and the interpretation of characters' intentions (derived from AI models of agency, with short–, mid–, and long–term goals organized hierarchically [2,6]), but misses the immediacy of line–based design and thus the representation of the continuity of characters' behavior. Also, interactivity is limited to the retrieval of textual box content.

---

[1] http://visual.ly/memento-scene-timeline.
[2] http://visual.ly/inception-timeline-visualisation.
[3] http://store.xkcd.com/collections/posters/products/movie-narrative-charts-poster.

© Springer International Publishing AG 2016
F. Nack and A.S. Gordon (Eds.): ICIDS 2016, LNCS 10045, pp. 415–418, 2016.
DOI: 10.1007/978-3-319-48279-8_39

In this paper, we build on the character–based story–visualization design by introducing the hierarchical organization of the story incidents and the alignment with the characters' intentions. The result is an interactive tool that takes as input the hierarchical story structure and the hierarchical characters' intentions and visualizes the alignment between such hierarchies and the story text units: in particular, the hierarchies span some portion of the text and hierarchy elements are aligned with text chunk boundaries. The tool provides zoom and pan facilities, hide/show toggles, and text balloons for exploring the visualization and appraising the mapping of the story hierarchies over the portions of text. The design phase of the tool relied on the involvement of experts through qualitative methods of analysis, in particular a focus group conducted with experts.

Now we describe our design solution and the implementation of the visualization interface (Sect. 2). Section 3 proposes a case study on Shakespeare's Hamlet and the discussion about the results as well as some reflections on the lesson learnt. Conclusion ends the paper.

## 2    Visualization Design

The design layout puts the sequence of story incidents, called timeline, in the middle of a chart representation (see Fig. 1).

Above the timeline, we have the hierarchy of the incidents, organized into scenes of increasing large span (scenes, acts, play). Scenes are represented as grey arcs, spanning from their initial to their final incident; another colored arc, doubling the grey arc, marks the characters that are participating within that scene. A rectangle allows for the interactive inspection of the incident description in detail.

Below the timeline, separate tracks represent the individual characters, each in a different color. Each track features a header that allows for the inspection of the character details through a circle with the character's initials. Within the tracks, each intention is again represented as an arc; short–term to long–term intentions are visualized with different heights within the track size; smaller size intentions are included into the span of the larger size intentions. As mentioned above, the colors of the characters who participate into some incident structure are reported onto the arcs of the incident structure hierarchy, displayed above the timeline. When intentions are not accomplished in the timeline of incidents, they are visualized partially and with a barred rectangle.

The visualization is an interactive display that allows zooming into the representation, in order to visualize small portions of the timeline together with their accompanying structures, and pan from left to right and top to bottom, in order to explore the various areas of the visualization. In particular, zoom allows the user to focus on a given incident structure, with the colors on the structure arc to help her/him to figure out what characters participate into the incident; then, panning from top to bottom allows the user to discover what are the intentions of the individual characters in coincidence with the incident; passing the mouse over the rectangles that are associated with the arcs reveals

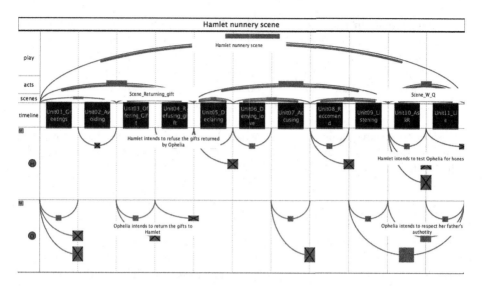

**Fig. 1.** Visualization of Hamlet nunnery scene. Through the tooltip facility of the interface we have highlighted two scenes with the intentions (in conflict) hinging on those scenes. (Color figure online)

the detail of the intentions, while passing over an incident box reveals the details of the incident. Finally, we added a feature, taken from the audio editors, where tracks can be muted or played solo: we introduced a toggle to the track headers that excludes/includes some character track from the display, respectively.

The visualization tool takes as input an annotated table of events that includes the intentions of the characters and their eventual accomplishment. The tool is implemented in Processing[4], after a pre-processing phase that extracts the individuals and relations from the tables provided by annotation.

## 3   Case Study

As a case study, we have applied the visualization technique to a scene from Shakespeare's *Hamlet*, the "nunnery scene" (visualized in Fig. 1). Notice the hierarchical representation of the intentions of the characters, with more complex intentions encompassing shorter, simpler intentions that only span one segment of the timeline. The number of plan failures spanning the same segment signal the high level of conflict that characterizes this part of the play. Failed intentions are represented by incomplete arcs marked by a crossed box. For example, Ophelia fails in returning the gifts to Hamlet at some point.

The succession of intentions displayed by a character's track represents the character's changes through planning and re–planning because of the conflicts with other characters, thus stress the emotional charge of the drama. This is

---

[4] http://processing.org/.

particular evident in the case of Ophelia (Fig. 1): she has two main intentions (bottom of the figure) separated by a gap filled by one of Hamlet's intentions. This shows that Ophelia has to execute some sort of re–planning, given the failure of the first (bottom left), so to regain the lead of the scene with another overarching plan (bottom right). Moreover, all along the scene we see that there is a large number of failed intentions (rectangles barred with a cross); hence, the visualization reveals the inner nature of this scene with failed attempts on both sides to achieve their goals: on the one hand, Ophelia wants to discover the motivation for Hamlet's madness, on the other, Hamlet wants to send the "fair Ophelia" to the nunnery, but discovers that she is not honest at all.

## 4  Conclusion

This paper has presented an approach for the visualization of stories, based on the alignment between the incident sequence and the hierarchies of scenes and characters' intentions, respectively. The major novelty of the visualization is the introduction of the characters' tracks, that represent multiple hierarchies that span the sequence of story incidents.

Our approach is more analytic than existing ones with respect to addressing the basic constituents of a story; for example, some of the visualizations proposed elsewhere could be derived from our visualization. We are going to produce a large dataset of visualized dramas and to introduce the visualization tool systematically within drama analysis classes and to test its usefulness thoroughly.

## References

1. Liu, S., Wu, Y., Wei, E., Liu, M., Liu, Y.: Storyflow: tracking the evolution of stories. IEEE Trans. Vis. Comput. Graph. **19**(12), 2436–2445 (2013). http://dx.doi.org/10.1109/TVCG.2013.196
2. Lombardo, V., Battaglino, C., Pizzo, A., Damiano, R., Lieto, A.: Coupling conceptual modeling and rules for the annotation of dramatic media. Semant. Web J. **6**(5), 503–534 (2015)
3. Lombardo, V., Pizzo, A.: Ontology–based visualization of characters' intentions. In: Mitchell, A., Fernández-Vara, C., Thue, D. (eds.) ICIDS 2014. LNCS, vol. 8832, pp. 176–187. Springer, Heidelberg (2014). doi:10.1007/978-3-319-12337-0_18
4. McKee, R.: Story. Harper Collins, New York (1997)
5. Ogawa, M., Ma, K.L.: Software evolution storylines. In: Proceedings of the International Symposium on Software Visualization, pp. 35–42 (2010)
6. Rao, A., Georgeff, M.: BDI agents: from theory to practice. In: Proceedings of the First International Conference on Multi-Agent Systems (ICMAS 1995) (1995)
7. Spencer, S.: The Playwright's Guidebook: An Insightful Primer on the Art of Dramatic Writing. Faber & Faber (2002). http://books.google.it/books?id=nDrHmckSqi4C
8. Tanahashi, Y., Ma, K.L.: Design considerations for optimizing storyline visualizations. IEEE Trans. Vis. Comput. Graph. **18**(12), 2679–2688 (2012)

# Location Location Location: Experiences of Authoring an Interactive Location-Based Narrative

David E. Millard and Charlie Hargood[✉]

Electronics and Computer Science, University of Southampton,
Southampton SO17 1BJ, UK
{dem,cah07r}@ecs.soton.ac.uk

**Abstract.** Location-based narratives are a form of digital interactive storytelling where a reader's physical movement triggers narrative events. Unlike traditional hypertext the poetics of these narratives is poorly understood, meaning that it is difficult to build effective authoring tools or to train new writers. In this paper we present our experience of authoring an interactive location-based narratives, focused on the creation of a story 'The Isle of Brine' set on the island of Tiree. Our experience highlights the primacy of location in the authoring process, and both pragmatic and aesthetic considerations for the design of the narrative.

**Keywords:** Location-based narratives · Sculptural hypertext

## 1 Introduction

The popularity of smart-devices with location awareness has led to increasing interest in location-based interactive narratives. These are digital stories, read on a smart-device, which react or change to the reader's location [1,5,7]. However, little work has been undertaken to understand the poetics of location-based writing (in contrast to the body of theory on hypertext writing and poetics [6,9]). Without this understanding it is difficult to produce effective tools for creating location-based narratives, or to educate writers about the possibilities.

The StoryPlaces project is a collaboration between Computer Scientists and English Scholars to explore the poetics of location-based narratives in order to inform the creation of authoring tools and support writers.

There are models of hypertext that can be applied. *Sculptural Hypertext* sees all nodes as potentially available, but sculpts away certain nodes based on the user's state, and conditions and rules on the nodes. If one makes user location a variable that can be used for conditions, and changed by rules, then the model becomes sufficient to describe most location-based narratives [4].

In StoryPlaces we are exploring the issues around authoring interactive location-based stories based on sculptural hypertext models. However, as technologists it became clear that our understanding would always be deficient unless

© Springer International Publishing AG 2016
F. Nack and A.S. Gordon (Eds.): ICIDS 2016, LNCS 10045, pp. 419–422, 2016.
DOI: 10.1007/978-3-319-48279-8_40

we attempted to create a story ourselves. The Tiree Tech Wave provided us with the opportunity of a safe space [8] where we could take on the role of authors and the risk of failure was minimal. We attended the April 2016 Tech Wave, and spent five days on the island, using this time to research local history, explore locations, and draft a story structure in the format required for our technology.

## 2  Methodology and Experience

Experiential Inquiry is a qualitative approach where "the agent himself (sic) engages systematically in a self-directed exploration of his own experience and behaviour and attends fully to the experience and behaviour of other agents who are similarly engaged in interaction with him" [3]. For us the creation of a location-based story on the island was the focus of the inquiry, and the Tech Wave the mechanism by which we came together to engage with the task.

We began on day one by discussing key themes, the starting premise, and the narrative and sculptural structures that we might use. We wanted our story to reflect our own experience, and so decided that our protagonist should be a visiting professional in the spirit of Lovecraft's 'The Mountains of Madness'. The conceit being that it is the expert whose view is changed by the experience.

We decided on a basic structure for the story, based around three acts unfolding across three separate areas of the island. This would enable readers to drive between acts, but then walk the nodes of the story itself. It was clear that there were excellent local resources about the history and myths of the island, and our idea was to link these with our protagonist as the reader progressed through the Acts of the story. a website that mapped English, Gaelic and Norse place names to survey data from around the island. This inspired us to make our protagonist a surveyor, and we reasoned we could use this resource to populate a number of nodes about the island and its history. Act 1 would be played straight, with our surveyor exploring the island and using this historical information. Act 2 would begin to hint at some connection to the island, and begin to blur fact and fiction. While Act 3 would disolve into delusion and reveal some connection between the surveyor and the island and its legends.

With the help of local expertise we drafted a list of local stories, identified three key areas of the island, and created a simple written manifest of locations for each area, listing the sorts of location we would need to match our stories. On the following two days we visited the areas, located appropriate starting places (where we could park), and then walked around the area using a GPS tool to record location stamps. Our choice of location stamps was partly practical (was it on an effective path or route), partly logical (could you see things that were referenced in the stories), and partly aesthetic (was the location evocative of the things described in the stories).

## 3  Our Story: The Isle of Brine

As part of our project we had already undertaken some analysis work around patterns of sculptural hypertext [2]), and decided that we would use a version of

the *Phasing* pattern to manage the high level structure of our story. Phasing is where a story progresses through a number of distinct phases, typically nodes are available in any order within a given phase, with particular nodes transitioning the whole system to the next phase. A typical example would be to support a three-act structure, where each act is a separate phase.

Isle of Brine uses two three act structures that develop independently. This is similar to another pattern, *parallel threads*, but with two entire phases progressing in parallel rather than two sequences of nodes. One (the Island phases) moves forward in time from the surveyors arrival on the island, the other (the History phases) moves backwards. The Island phases develop the surveyors experiences on the Island and contain revelations about his past. The History phase develops the story of how he came to travel to the island, and contains revelations about his motivations. Readers experience of the story thus varies according to the juxtaposition of phases, and the order in which the revelations are made.

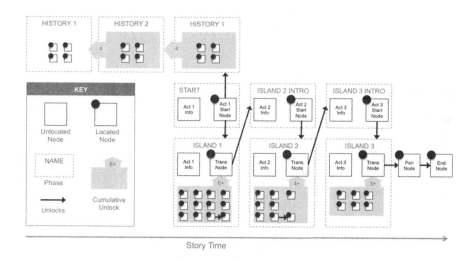

**Fig. 1.** The sculptural structure of 'Isle of Brine'

The main phases are the ones for the Island. In each act there is an intro phase, with a start node at a specific location, once this has been read it moves into the main phase that contains the remaining nodes. In both phases an unlocated node (which is always available regardless of location) gives some context for the current state of the story. Specific transition nodes exist in the main phases that move the acts along, but we use another pattern *Unlocking* to ensure that a certain number of nodes are read in each phase before the transition node becomes available. The secondary phases are the ones for History. In these cases all the nodes in the phase must be read before the phase changes to the next one. Each node in the history phases is mapped to three alternative locations, one for each area used by the Island nodes. Thus as long as the appropriate

History phase is active, they can be read in a location that is near to wherever the current act is playing out. Figure 1 shows a graphical version of the structure.

## 4    Conclusions

In this paper we have described how a journey to the Tiree Tech Wave created a safe space in which we could explore the authoring process ourselves, pushing the technology beyond what was being done in the main project activities, and confronting directly the issues that we had previously only seen second hand. The results is a story 'The Isle of Brine' that goes beyond the typical hypertextual complexity of a location-based story[1]. Despite our focus on the non-linear structure our experience has highlighted the primacy of location in the authoring process, and revealed a number of ways that this has a pragmatic and aesthetic impact on the narrative. Rather than a neatly layered process, where stories can be laid down upon locations, we have discovered a deeply interconnected set of decisions that show that narrative structure, location topology, and the events of the story itself are co-dependent. Our view is that authors must design, select and develop these simultaneously, or at least iteratively, in order to create successful location-based stories.

## References

1. Broadbent, J., Marti, P.: Location aware mobile interactive guides: usability issues. In: Proceedings of the Fourth International Conference on Hypermedia and Interactivity in Museums (ICHIM97), pp. 162–172 (1997)
2. Hargood, C., Hunt, V., Weal, M., Millard, D.E.: Patterns of sculptural hypertext in location based narratives. In: Proceedings of the 27th ACM Conference on Hypertext and Social Media, HT 2016 (2016). ACM, New York
3. Heron, J.: Experience and method: An inquiry into the concept of experiential research. Technical report, University of Surrey, UK, April 1971
4. Millard, D.E., Hargood, C., Jewell, M.O., Weal, M.J.: Canyons, deltas, plains: Towards a unified sculptural model of location-based hypertext. In: Proceedings of ACM Hypertext 2013, pp. 109–118. ACM, New York (2013)
5. Nisi, V., Oakley, I., Haahr, M.: Location-aware multimedia stories: turning spaces into places. Universidade Católica Portuguesa, pp. 72–93 (2008)
6. Pisarski, M.: New plots for hypertext?: Towards poetics of a hypertext node. In: Proceedings of Hypertext 2011, pp. 313–318. ACM, New York (2011)
7. Pittarello, F.: Designing a context-aware architecture for emotionally engaging mobile storytelling. In: Campos, P., Graham, N., Jorge, J., Nunes, N., Palanque, P., Winckler, M. (eds.) INTERACT 2011. LNCS, vol. 6946, pp. 144–151. Springer, Heidelberg (2011). doi:10.1007/978-3-642-23774-4_14
8. Reason, P.: Editorial introduction: the practice of co-operative inquiry. Syst. Pract. Action Res. 15(3), 169–176 (2002)
9. Walker, J.: Piecing together, tearing apart: Finding the story in afternoon. In: Proceedings of ACM Hypertext 1999, pp. 111–117. ACM, New York (1999)

---

[1] We would like to thank Professor Alan Dix for his support during the Tiree Tech Wave, our fellow participants who contributed enormously to our experience, and our colleagues on StoryPlaces - funded by The Leverhulme Trust (RPG-2014-388).

# Using Theme to Author Hypertext Fiction

Alex Mitchell[✉]

Department of Communications and New Media,
National University of Singapore, Singapore, Singapore
`alexm@nus.edu.sg`

**Abstract.** This paper explores the use of a "thematic linking" model to support the authoring of complex, emergent hypertext fiction. Initial observations suggest that while this approach is promising, as it allows authors and readers to discover unexpected connections within a work, it is also potentially overwhelming, due to the second-order nature of the writing process.

**Keywords:** Intelligent narrative technologies · Interactive storytelling · Authoring · Complex storytelling · Hypertext · Theme

## 1 Introduction

Readers and players are increasingly being exposed to, and coming to appreciate, "complex" narratives in which "the organizing principle of causality, the cornerstone of narrative, is subordinated to... emergence" [1]. Examples of this type of work include *The Family Arcana* (Berry, 2015), *The Whale Hunt* (Harris, 2007), and *Her Story* (Barlow, 2015). These works require the reader or player to actively (re)construct the causal connections between narrative fragments, and in the process attempt to determine the (possible) meaning of the story. This does not, however, mean that the author has completely abdicated responsibility for authoring these connections and the overall structure of the story. This approach, something Wingate refers to as *synaptic writing*, instead "involves arranging the component building blocks of narrative to best enable the associative process by which readers create meaning" [2].

This raises an interesting question for designers of interactive story authoring tools: how can a tool empower authors of hypertext fiction to write stories that allow for meaning and structure to emerge through the reading process while still providing some authorial control over the resulting reader experience? I propose that one possible approach to this form of authoring is to use *theme* to automatically generate connections between story fragments. In this paper, I describe the implementation of this approach in the *HypeDyn* hypertext fiction authoring tool [3], and discuss my initial observations of use of the tool.

© Springer International Publishing AG 2016
F. Nack and A.S. Gordon (Eds.): ICIDS 2016, LNCS 10045, pp. 423–427, 2016.
DOI: 10.1007/978-3-319-48279-8_41

## 2   Related Work

Work to support the authoring of exploratory, emergent hypertext stories has introduced a number of ways to more loosely specify the linking of story fragments than in traditional hypertext. For example, the Korsakow non-linear film authoring tool [4] allows the author to specify a set of "in" and "out" tags for each fragment in a story. Korsakow finds all the relevant fragments whose "in" tags match the "out" tags for the current fragment, and presents these to the viewer. Bernstein [5] introduced *sculptural hypertext*, in which all nodes in a hypertext are initially linked to all other nodes, and the author "create[s] structure by removing unwanted connections, much as a sculptor may create objects by removing unwanted material." HypeDyn [3] provides an implementation of sculptural hypertext in which authors specify rules to determine which nodes will be linked from anywhere within a story. Similarly, Literatronica [6] allows authors to specify the "distance" between nodes, and uses this distance to generate links. Another, related approach is taken by StoryNexus [7], where the use of "qualities" determine which "cards" will be available to the player at any time.

## 3   Research Problem

The approaches discussed above have a number of limitations in terms of balancing authorial control and emergent structure. Korsakow requires explicit tagging of every fragment, a tedious process that can degenerate to the creation of a branching structure. Similarly, the creation of sculptural hypertexts or StoryNexus's "quality-based" stories requires the author to specify preconditions for all nodes or cards, which can also lead to over-constraining and the creation of a branching structure. This suggests that it is worth exploring alternative approaches to balancing structure and emergence.

Tomashevsky defines theme as "the idea that summarizes and unifies the verbal material" [8, p. 67] of a story. More concretely, Prince defines theme as "a macrostructural category or frame allowing for the unification of distinct (and discontinuous) textual elements", which "does not *consist* of textual units... rather, theme is *illustrated by* any number of textual units" [9, p. 5]. This suggests that theme can provide a new way to structure the fragments that make up a work of hypertext fiction. This is what I am investigating: how can a thematic approach to authoring help authors balance the reader's desire for emergence against the need for some authorial control over the reader's experience?

## 4   A Thematic Hypertext Authoring Tool

To explore this question, I created a modified version of the *HypeDyn* [3] hypertext authoring tool that incorporates "thematic links" using a model for describing thematic relations within a text as proposed by Hargood [10]. In Hargood's model, stories consist of narrative atoms, or *natoms*, which are the smallest

unit of a narrative. Natoms contain certain visible, computable elements or *features*, such as the fragments of text within a node. These features denote certain *motifs*, which in turn connote *themes* within the story. A specific natom may be considered to have a numerical *thematic quality* with respect to a given theme. Thematic quality is calculated based on the average of the *thematic coverage* (the percentage of the desired themes that are present in the natom), and the *component coverage* (the percentage of motifs and sub-themes that connote the desired themes which are present in the natom). The thematic quality can be used to determine which natoms are more closely related to a given set of themes.

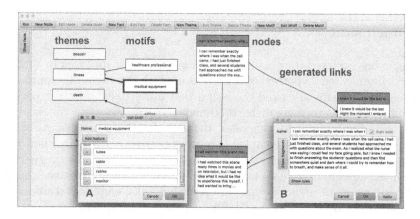

**Fig. 1.** The thematic authoring system: editing a motif (A) and a node (B).

To write a story using thematic links (see Fig. 1), the author first creates a series of nodes containing the text of the story. These nodes correspond to natoms in Hargood's model. She then creates a thematic structure consisting of themes, motifs, and features. The system automatically generates links from a given node to other thematically similar nodes by first identifying the themes present in the node, and then searching for all nodes for which the thematic quality is above an author-specified threshold. Note that the creation of nodes and the thematic structure can be carried out iteratively. Using this method, the author is essentially creating indirect connections between nodes by means of the motifs and themes. The automatically generated links are visualized in the authoring tool as arrows between nodes. For a reader, links are shown at the bottom of the node, and are labelled based on the name of the destination node.

## 5   Reflections on Writing a Thematic Hypertext

To explore whether this approach would support the creation of complex narratives that balance authorial control with emergent structure, I wrote a 50-node hypertext story using the "thematic" version of HypeDyn.

While I found that this approach can initially present the author with a potentially overwhelming web of connections between nodes, it is possible to gradually see patterns emerging within this complex structure. Within these patterns, it became clear that the automatic generation of links based on themes could easily lead to overlapping and sometimes unbreakable cycles. Part of the problem was due to the fact that I started by using an existing thematic structure, suggesting that it is important for an author to create her own, story-specific thematic structure. However, even with a custom set of themes, unexpected links appeared, suggesting the need for a more nuanced system for detecting themes, one that takes the context of features into consideration.

## 6 Conclusion

This paper has explored the possibility of using a thematic approach to authoring complex, fragmented hypertext stories. I described the thematic approach to authoring, and briefly discussed the issues that arose based on my experiences using thematic links to write a short, 50-node hypertext.

The use of automatically generated thematic links is a promising approach to support the authoring of complex hypertext fictions, potentially allowing for a balance between author control and reader exploration and discovery. Future work will explore alternative visualizations of the relationships between the node content and thematic structure and the resulting links, empirical studies of the use of the tool by other authors, and other techniques for generating connections between the nodes in the story. It may also be interesting to explore how to support thematic progression across the story, and ways that the reader's choices could be incorporated into the run-time generation of thematic links.

**Acknowledgements.** This work was funded under the FASS startup grant "Authoring Paradigms and Representation in Interactive Storytelling Tools".

## References

1. Poulaki, M.: Network films and complex causality. Screen **55**(3), 379–395 (2014)
2. Wingate, S.: On the interactive digital lyric. Essay Rev. **1**(2) (2016). http://theessayreview.org/on-the-interactive-digital-lyric/
3. Mitchell, A.: The HypeDyn procedural hypertext fiction authoring tool. In: Intelligent Narrative Technologies 7: Papers from the 2014 Workshop (2014)
4. Soar, M.: Making (with) the Korsakow system. In: Nash, K., Hight, C., Summerhayes, C. (eds.) New Documentary Ecologies, pp. 154–173. Springer, New York (2014)
5. Bernstein, M.: Card shark and thespis: exotic tools for hypertext narrative. In: Proceedings of Hypertext 2001, pp. 41–50. ACM Press (2001)
6. Gutierrez, J.B., Marino, M.C.: Literatronica: adaptive digital narrative. In: Proceedings of Creating 2008, Pittsburgh, PA, USA, pp. 5–8. ACM (2008)
7. Kennedy, A.: Echo bazaar narrative structures, part one, March 2010. http://www.failbettergames.com/echo-bazaar-narrative-structures-part-one/

8. Tomashevsky, B.: Thematics. In: Lemon, L.T., Reis, M.J. (eds.) Russian Formalist Criticism: Four Essays, pp. 61–95. University of Nebraska Press, Lincoln/London (1965)

9. Prince, G.: Narrative as Theme: Studies in French Fiction. University of Nebraska Press, Lincoln (1992)

10. Hargood, C.: Semiotic term expansion as the basis for thematic models in narrative systems. Ph.D. thesis, Faculty of Engineering and Applied Science, Department of Electronics and Computer Science, University of Southampton (2011)

# Towards a Model-Learning Approach to Interactive Narrative Intelligence for Opportunistic Storytelling

Emmett Tomai[(✉)] and Luis Lopez

Department of Computer Science, University of Texas Rio Grande Valley,
Edinburg, TX, USA
{emmett.tomai,luis.a.lopez02}@utrgv.edu

**Abstract.** Opportunistic storytelling is an approach to interactive narrative where game play is the ordinary activity that underlies notable story events, and the AI challenge is to tell a story about what the player is doing, that meets authorial goals. In this preliminary work, we describe a game and AI system that motivates the need for event prediction within the game world, and provides the opportunity for automated machine learning of such a predictive model. We report results showing how different feature models can be learned and compared in this context, towards automating model selection.

**Keywords:** Intelligent narrative technologies · Artificial intelligence · Machine learning · Game design

## 1 Introduction

One vision for interactive narrative seeks to combine the interactivity of video games with the immersion of narrative. However, the strength of game play as a model of interaction includes the freedom to master consistent systems through repetitive exploration [1]. This is at odds with the carefully curated web of meaningful events found in traditional narrative. But this conflict suggests a promising approach: to embrace game play as a stream of ordinary activity – the mundane events that are left out of stories – and recasts the AI challenge as telling a story, that meets authorial goals, about what the player is doing. In this *opportunistic storytelling* approach, the player has a clear role as game player, and the AI is constrained to the rules of the game simulation. We believe this can mitigate the conflict between player freedom and authorial control [2], and enable the AI to understand the domain in which the story is being told. We describe a game and narrative AI to implement this strategy, discuss the importance of event prediction, and report preliminary results in that direction.

## 2 Opportunistic Storytelling: Game and Narrative AI

Prior work in interactive narrative has used consistent simulation of agents [cf. 3], of story-specific behaviors [4] and of social interactions [5] to create interactive experiences with different degrees of emergent vs. directed story. The *Marlinspike* system [6]

© Springer International Publishing AG 2016
F. Nack and A.S. Gordon (Eds.): ICIDS 2016, LNCS 10045, pp. 428–432, 2016.
DOI: 10.1007/978-3-319-48279-8_42

uses *Inform7* [7] game mechanics, and opportunistically selects scenes that make prior player actions significant to the story. Our approach is similar, but we have chosen graphical, open-world game play simulation, to lessen the problem of players feeling limited or led along. We are also combining the simple robustness of low-level believable agents with high-level story direction, as done in *IN-TALE* [8]. In our case, believable refers to meeting player expectations for the game mechanics, and the high-level direction is opportunistic guiding towards desired story states.

We have created a procedurally generated, infinite world survival game, similar to Klei Entertainment's *Don't Starve* [9] and others. The player follows an upward cycle of exploring and collecting resources to craft and build in order to survive the environment and simple *mobs* that wander and attack. This provides everyday goals, actions and experiences. Autonomous agents in the game have the same capabilities as the player, and choose behaviors that are consistent with surviving. The goal is not for agents to act just like players, but to have behaviors that make sense – that players can understand, explore and master. Within this world, stories emerge about friendship, betrayal, providence and so on from simple interactions between the player and agents over gathering resources and avoiding threats. The job of the opportunistic storytelling system is to maximize the probability of those stories being experienced. It can only intervene on unseen entities and internal goals and attributes, similar to the *alibi generation* problem [10]. To do this, it must be able to predict outcome probabilities with and without intervention.

Beyond integrating in a graphical real-time game world, the novel aspect of this work is using agent simulation to build a predictive model. Of course the game itself is already a perfect model, but simulating every possible future to find the narratively interesting ones is not tractable on-line. By running the game off-line, the AI can train models for estimating features and relationships among events. Typical machine learning work in video games [cf. 11] has focused primarily on models for optimal action selection. We believe that narrative intelligence will require learning and composing many heterogeneous models under higher level control abstractions. At this time, we are focused on automated learning of event prediction.

## 3   Learning Models for Event Prediction

The goal of this preliminary experiment is to explore the impact of different models on learning to predict events. The data is a set of game play traces where a single agent is assigned to complete a random set of gathering tasks in a randomly generated environment while surviving enemy mobs. Anywhere from zero to dozens of gathering nodes and mobs could be in sight of the agent at any time. The system applies a feature model to the traces to create standard classification data, then trains and tests its ability to predict the next agent action: Attack, Gather, Flee or Explore.

Three feature models were evaluated. The *individual* model transforms every entity within visual range of the agent into a feature vector including its distance from the agent and game attributes like health, combat power and the resources that can

be gathered from it. Agent attributes such as risk aversion (randomly assigned) are also included. The *paths* model includes a numerical estimate of how clear the path from the agent to the entity is – a higher-level abstraction that should be relevant to predicting what will happen. The *regions* model clusters entities into spatial groups and aggregates their individual attributes. Again, this higher-level abstraction would be relevant to a human evaluation of the agent's next move. For each model, the experiment was run with 25, 50, 75 and 100 traces, randomly selected and split in half for training and testing. Each condition was averaged over 1000 runs. Both Naïve Bayes and Random Forest classifiers were used, with no notable difference. The Random Forest results are reported.

Results for Attack and Flee events were very poor across the board (precision and recall $< 0.1$), and degraded with more training samples. Precision and recall for predicting Explore and Gather events are shown in Figs. 1, 2, 3 and 4. The horizontal axis shows number of game play traces used. The simple individual model generally improved with additional samples, but was erratic in its recall for Explore events. The paths model was the most consistent performer across both tasks, suggesting that it is an appropriate level of abstraction for these tasks. The more complex regions model showed no advantage, and significantly underperformed in recall for Gather events.

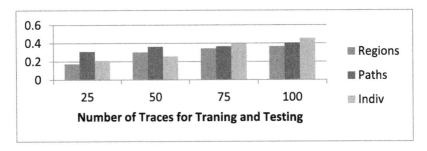

**Fig. 1.** Precision for predicting Explore events with three different feature models

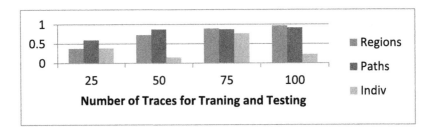

**Fig. 2.** Recall for predicting Explore events with three different feature models

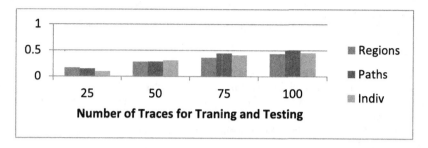

**Fig. 3.** Precision for predicting Gather events with three different feature models

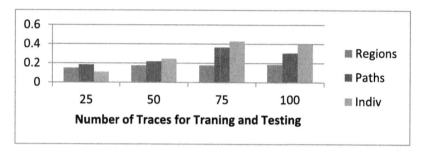

**Fig. 4.** Recall for predicting Gather events with three different feature models

These initial results allowed us to establish the experimental pipeline. We are also encouraged by the ability to get coherent results from simple, fast learning models with under 50 training samples. Even though the learning component of the system is offline, bringing those learned prediction models back into the real-time game environment will be a future necessity. Finally, the easy interchange of features and learning models is promising for the future step of automated model selection and composition.

# References

1. Koster, R.: A Theory of Fun for Game Design. O'Reilly Media Inc., California (2010)
2. Young, R.M.: Creating interactive narrative structures: the potential for AI approaches. In: Proceedings of the AAAI Spring Symposium in Artificial Intelligence and Interactive Entertainment. AAAI Press (2000)
3. Louchart, S., Aylett, R.: Narrative theory and emergent interactive narrative. Int. J. Continuing Eng. Educ. Life Long Learn. **14**(6), 506–518 (2004)
4. Mateas, M., Stern, A.: Façade: an experiment in building a fully-realized interactive drama. In: Game Developers Conference (2003)
5. McCoy, J., Treanor, M., Samuel, B., Reed, A., Mateas, M., Wardrip-Fruin, N.: Prom Week: Designing past the game/story dilemma. In: Proceedings of the 8th International Conference on Foundations of Digital Games, Chania, Crete, Greece, 14–17 May 2013
6. Tomaszewski, Z., Binsted, K.: Demeter: an implementation of the marlinspike interactive drama system. In: AAAI Spring Symposium: Intelligent Narrative Technologies II, p. 133 (2009)

7. http://inform7.com
8. Riedl, M.O., Stern, A.: Believable agents and intelligent story adaptation for interactive storytelling. In: Göbel, S., Malkewitz, R., Iurgel, I. (eds.) TIDSE 2006. LNCS, vol. 4326, pp. 1–12. Springer, Heidelberg (2006)
9. https://www.kleientertainment.com/games/dont-starve
10. Sunshine-Hill, B., Badler, N.I.: Perceptually realistic behavior through alibi generation. In: Proceedings of the Sixth AAAI Conference on Artificial Intelligence and Interactive Digital Entertainment (2010)
11. Galway, L., Charles, D., Black, M.: Machine learning in digital games: a survey. Artif. Intell. Rev. **29**(2), 123–161 (2008)

# Art-Bots: Toward Chat-Based Conversational Experiences in Museums

Stavros Vassos[1]([⊠]), Eirini Malliaraki[2], Federica dal Falco[3], Jessica Di Maggio[3],
Manlio Massimetti[3], Maria Giulia Nocentini[3], and Angela Testa[3]

[1] DIAG, Sapienza University of Rome, Rome, Italy
vassos@dis.uniroma1.it
[2] Filisia Interfaces, London, UK
eirini@filisia-interfaces.com
[3] Architecture, Sapienza University of Rome, Rome, Italy
federica.dalfalco@uniroma1.it, jeppy.dm07@gmail.com, mmanlio@gmail.com,
maria.giulia.nocentini@gmail.com , angelatesta993@gmail.com

**Abstract.** In this work we explore how a widely used conversational interface can be employed to offer engaging experiences in museums. "Art-bots" interact with visitors through chat and convey information about the museum artifacts in the form of short stories. The wide adoption of chat platforms such as Facebook messenger offers new ground to revisit approaches on avatars and virtual guides and build interactive dialogues to engage visitors. We take a practical approach based on a set of responses that are triggered by certain keywords and a curated story that guides visitors to a gamified information hunt.

## 1 Introduction

One of the challenges for museums is to connect to the personal narratives that visitors carry with them. An engaging storytelling approach that is based on direct conversations between the visitors and the characters, places, and items of the exhibition can contribute to building an emotional connection and a deeper understanding of the artifacts and their stories [2,6]. The delivery of the museum narrative is typically verbal and textual. Spoken word is used in audio commentaries, film installations, and live performances, whereas written word is used in collection catalogs, wall panels, visitor guides, and artifact labeling. What happens though when the stories become a *live conversation* with artists and artifacts in an established and ubiquitous chat interface?

As of 2015, 75 % of internet users worldwide had accessed messaging services such as WhatsApp, Facebook Messenger, Viber or WeChat on their mobile devices,[1] with Facebook Messenger being the most popular among them (900 million monthly users).[2] Fueled by this growth, mobile messaging apps have lately spurred the rise and growth of *chatbots*. A chatbot can sit on top of these

---

[1] http://www.statista.com/topics/1523/mobile-messenger-apps/.
[2] http://newsroom.fb.com/news/2016/01/heres-to-2016-with-messenger/.

© Springer International Publishing AG 2016
F. Nack and A.S. Gordon (Eds.): ICIDS 2016, LNCS 10045, pp. 433–437, 2016.
DOI: 10.1007/978-3-319-48279-8_43

platforms and communicate with people in an automated way, to answer questions, perform tasks online as a digital assistant, or just engage in conversation.

As chatting is becoming a familiar and international medium for communication, conversational interfaces are becoming pervasive and offer immediacy, familiarity and versatility. However, museums have not yet capitalized upon these while also missing opportunities to engage with the younger "digital natives". This is a very interesting ground for experimenting with interactive narrative and storytelling at large, making use also of exciting artificial intelligence methodologies that have been developed.

## 2  Chat with Mario Praz: A Museum Art-Bot

*The Mario Praz museum use case.* Our Facebook *art-bot* impersonates the collector Mario Praz[3] and is able to converse with guests and visitors in the Mario Praz museum. The museum features ten rooms with more than 1200 collectibles dating from late 18th century and the first half of the 19th century. Each object is connected to the other by analogy and story, and follows a precise narrative linked to an era, artistic period, and the life of collector Mario Praz himself. With our art-bot we aim at revealing the intricate and "hidden" stories behind the life of Mario Praz, by allowing direct conversation with an automated chatbot persona on Facebook.

*A Facebook persona of Mario Praz.* A visitor of the museum is informed by catchy posters that Mario Praz is available on Facebook and he is happy to talk with people about his collectibles. Our authoring team has studied the artifacts and the stories behind them and has crafted a set of short stories that reveal interesting information. The art-bot prompts visitors to ask questions, challenges them to carefully observe artworks and contemplate about artifacts. These prompt the visitor to wander in the rooms of the museum. While these dialogues are mainly used to convey information about the background story of items, parallel stories, in the guise of "small talk," are used to expand the agents conversational repertoire. Moreover, Mario Praz art-bot has its own first person conversational tone. The immediacy of a first-person narrative gives visitors direct access to the intimate thoughts and feelings of the protagonist, promoting a closer relationship between visitor/guide and subject/character.

*Example scenarios.* For our stories we have picked some of the most important pieces of art from each room of the museum and tied them together with an underlying story, orchestrated by the art-bot. For example, in the first room the art-bot invites the visitors to find and observe a small sofa depicting two Egyptian heads. Then the art-bot asks a question and as the visitors respond correctly, the bot then reveals interesting stories about how he/Mario Praz embroidered the piece together with his beloved wife Vivyen. Continuing the narrative, just above this sofa there is a photo of a lady with a hair bun and

---

[3] https://en.wikipedia.org/wiki/Mario_Praz.

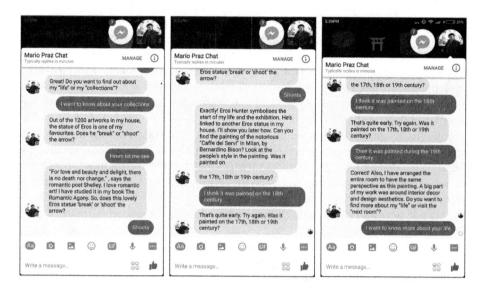

**Fig. 1.** Chatting with the Mario Praz art-bot.

the art-bot invites visitors to guess who this lady is. When visitors confirm that the photo shows the mother of Mario Praz, the art bot then narrates intimate anecdotes about his relationship with her. Another example interaction can be seen in Fig. 1.

*A simple technical methodology for art-bots.* The Mario Praz art-bot follows a set of short stories, each of which consists of a small graph of interactions or plot-points. At each of these plot-points, the art-bot prompts the visitor to respond with some information related to the exhibits of the museum. The visitor can respond in free-form text but in reality it is just a fixed set of keywords that can bring the story forward if mentioned in the chat response. Each plot-point then specifies (i) the text to be used to prompt the user, (ii) a set of keywords and the plot-point which they lead to when mentioned, and (iii) a larger set of witty prompts to be used when the visitor is not able to mention one of the intended keywords. This approach is quite simple and does not require the authors and museum staff to be experts in computer science or artificial intelligence. The keyword-based interaction can be easily build upon widely available chatbot frameworks such as *Api.ai* which was used for this prototype.

## 3   Discussion

There are several approaches in the literature for personalized storytelling museum experiences, e.g., [3], as well as a lot of related work in employing artificial intelligence techniques for generating narrative and interactive story-telling, a survey and categorization of methodologies can be found in [5]. In

this work we decided to take a practical approach that allows non-experts in technologies to focus on the authoring of short stories. The plot-points of each story are connected with real items, characters, locations, and keywords that trigger conversational interactions. As it is often the case also in videogame development, simple (programming) methodologies can go a long way compared to more sophisticated approaches, and one reason for this is that the former are easier to understand and control.

One challenge of this paradigm is to build a conversational agent that can engage a visitor in a longer conversation. Having this prototype as a ground we intend to experiment with integrating more sophisticated techniques for interactive narrative and storytelling from the literature, and see which ones can offer a better experience for visitors in the museum setting. The keyword-based methodology is not new and our approach can be loosely seen as a much simplified case of the *ABL* framework [4].

As part of our current and future work we are experimenting also with *co-creation patterns* that allow us to gather responses from conversations between visitors, and incorporate them into the stories. This is similar to the direction of [1], but while they are concerned with increasing the engagement with add-ons through existing co-creating paradigms, we focus on using the so-called "human computation" paradigm. The idea is to take advantage of some parts of the interaction in order to get the perspective or interpretation of visitors through their response, while they think they actually answer a question about an artifact as a challenge in the gamified treasure hunt on information.

Finally, the recent adoption of virtual reality (VR) offers an opportunity for attracting online guests with more engaging interactions. For example, in our case online visitors can also follow the clues and treasure hunt by looking at the images for each room of the museum on the Facebook wall of the art-bot. A more engaging interaction can be based on 360° images of the museum rooms that can be viewed using VR devices.

## 4    Conclusions

We propose (to the best of our knowledge) the first museum related art-bot that does not operate in the browser or in a native museum application, but in a highly adopted messenger chat interface. We present Mario Praz personified chatbot as a first step toward a modern exhibition method that (i) is not invasive to the museum setting, (ii) allows an engaging communication through the familiar chat interface, (iii) conveys the hidden information about the exhibits in an organic way inside casual conversations, (iv) provides a user friendly way to receive feedback in a gamified manner. Our work can be seen as a baseline approach to this direction, and we intend to develop detailed use cases to be used for benchmarking. Finally, we think that art-bots need not be limited to personified artists but visitors can also talk to artifacts directly, e.g., sculptures or paintings, which will convey their story and artistic elements in a witty chat experience.

# References

1. Battaglino, C., Bickmore, T.: Increasing the engagement of conversational agents through Co-Constructed storytelling. In: Proceedings of AIIDE Conference (2015)
2. Bedford, L.: Storytelling The real work of museums. Curator Mus. J. **44**(1), 27–34 (2001)
3. Katifori, A., Karvounis, M., Kourtis, V., Kyriakidi, M., Roussou, M., Tsangaris, M., Vayanou, M., Ioannidis, Y., Balet, O., Prados, T., Keil, J., Engelke, T., Pujol, L.: CHESS: personalized storytelling experiences in museums. In: Mitchell, A., Fernández-Vara, C., Thue, D. (eds.) ICIDS 2014. LNCS, vol. 8832, pp. 232–235. Springer, Heidelberg (2014). doi:10.1007/978-3-319-12337-0_28
4. Mateas, M., Stern, A.: A behavior language: Joint action and behavioral idioms. In: Life-like Characters: Tools, Affective Functions and Applications (2004)
5. Riedl, M.O., Bulitko, V.: Interactive narrative: An intelligent systems approach. AI Mag. **34**(1), 67–77 (2013)
6. Springer, J., Borst, B.J., Kajder, S.: Digital storytelling at the national gallery of art. In: Proceedings of Museums and the Web. Archives & Museum Informatics (2004)

# Demonstrations

# The Alter Ego Workshop

Josephine Anstey$^{(\boxtimes)}$

Department of Media Study, University at Buffalo (UB), Buffalo, USA
jranstey@buffalo.edu
http://josephineanstey.com

**Abstract.** This paper describes the Alter Ego Workshop, a collaborative and socially mediated work of interactive fiction which allows participants to explore an evolving scenario from multiple points of view. The paper discusses interactive fiction as a vehicle for experiencing alternate "selves."

**Keywords:** Puppet avatars · Alter Egos · Melodrama · Improvisation

## 1  Introduction

In *Hamlet on the Holodeck*, Janet Murray identified the strong potential of interactive fiction to present multiple points of view. The Alter Ego Workshop (AEW) employs puppet avatars, narrative context, and improvisation to encourage participants to construct and inhabit multiple selves. Sections 2 and 3 of this paper briefly describe related work and the AEW project itself. Section 4 considers the construction of self as a function of narrative context. Section 5 considers Murray's contention in the context of AEW.

## 2  Influences and Related Work

In *The Path* the player sequentially chooses one of six red-riding-hood avatars and is invited to walk through the woods to Grandma's house. As each girl journeys she meets her version of the wolf, a personified threat that may be sexual, speak to fears of success, of becoming an adult. The Path is an extended metaphor about female identity and growing up [7]. In *Herstory* the role of the player is to uncover a murder mystery by viewing clips of the main suspect. The suspect spins a complicated story of a secret twin sister and the sharing of one life. The viewer is not able to clearly tell if there are two women or only one pathological liar. The fragmented form of uncovering the story mirrors the fragmented mind or minds that are being explored [4]. Both projects show the power of interactive fiction to delve into the complexities and multiplicities of self and identity. The AEW is operating in the same territory, particularly attempting to draw the participant into a first person experience of multiple identities contingent on narrative context.

F. Nack and A.S. Gordon (Eds.): ICIDS 2016, LNCS 10045, pp. 441–444, 2016.
DOI: 10.1007/978-3-319-48279-8

# 3   The Alter Ego Workshop

The Alter Ego Workshop is a collaborative, interactive drama with two sequential elements: first participants use physical materials to fabricate an alter ego; second participants employ the puppet avatars they have made to improvise a three act melodrama.

**Fig. 1.** Stage and Puppets

The first version of AEW took place at a workshop. A facilitator introduced the alter ego theme, suggesting that we all suppress personality traits and characteristics or indeed whole personalities, and told participants that this was an opportunity to allow hidden selves to emerge. The participants were then given pegs, fabric, crayons & wool and encouraged to build their alter egos. As the participants worked they listened to a soothing audio track. After they had finished, individual participants were introduced to two live actors, each with their own puppet avatar, and invited to use the puppet they had made to take part in a melodrama, Fig. 1.

A revised hybrid print/online online version of AEW has just gone live [9]. The print element introduces the participants to the idea of making an alter ego, leaving the choice of materials and therefore the size of the avatar more freely up to each participant. An URL sends them to a webpage where they can access the audio to listen to while making their puppet avatars - it is now a twelve minute lecture imagining the evolution of a future mind with multiple counscious formations.

Next, participants are invited to sign up for an improvisation partner online. Once they have their partner they are furnished with character descriptions,

preambles and *starter scripts* for the melodrama and asked to use video chat to improvise the ending of the scenes. The melodrama is based on the interrelationships of three characters and comprises three scenes that dip into the lives of the characters at three critical times in their lives. Five or six years pass between each scene. The puppet avatar of each participant sequentially takes the role of each character, so by the end of the process, the participant had played from the point of view of each one. The participants are informed, "Love, compassion, repulsion, depression, and some of their attendant difficulties, are explored as your avatar serially steps into the mind of each character." A final, optional, step is to join a face-book group to share screen captures and posts about the experience.

## 4    Self as Function of Narrative Context

Computer-based media have long been recognized as a place for experimentation with identity and the self [8]. Much of my own interactive drama work has had the explicit goal of scripting the participant so that they engage in very specific emotional and psychological explorations, [1–3]. As I worked on these projects, I first assumed and then observed that the *self* that grows up in the context of a managed, responsive narrative environment is flexible and very contingent on that environment.

In the context of social media, a paradigmatic case study is Roseanne Stone's cross-dressing psychiatrist who developed a full-blown separate identity in the very early days of chat rooms by creating stories about his female alter ego which he told, retold and elaborated in dialog with online friends [6]. Both media theorists and my own media practice led me to the conclusion that our conscious, everyday self may be a function of a narrative context. AEW attempts to make visible the story-telling processes that produce our current sense of self with its attendant emotions, motivations, reactions. It is designed to enable a reflective experience of how our mind works and, by showing the mechanisms, hint at how it could work differently.

## 5    Multiple POV

If *self* is contingent and contextual then of course there can be multiple selves both in social media and interactive fiction. In *Hamlet on the Holodeck* Janet Murray invokes the "kaleidoscopic power" of the computer, arguing that interactive fiction/computer based fiction/theater has immense potential to offer participants multiple viewpoints into a story scenario which reflects a post-modern distrust of master narratives and may deal better with contemporary understanding of the complexities and multiplicities of both societies and people [5] p. 161. AEW is an implementation of this possibility - offering a mechanism for exploring the multiple potential of ourselves, de-stabilizing any sense of a unitary self, and encouraging the unpacking of many selves.

AEW creates a structure within which the participant can serially construct and inhabit four distinct selves: the puppet-avatar and three selves improvised using the puppet in the context of the melodramatic narrative. In the melodrama the participant plays the role of each character in turn: sometimes betrayer, sometimes betrayed; sometimes suicidal, sometimes coping with a would-be suicide. The goal of the piece is that, as the participant co-creates the narrative from the different points of view, s/he will produce three different selves. The proximity of these three instances of building a self, is designed to engineer an additional level of reflexivity - suggesting to the participant that all and any selves are narrative constructs.

The Alter Ego Workshop (AEW) enables an experience of our conscious self that foregrounds its language-based and very malleable construction. If the novel was the paradigmatic form for initiating, investigating and representing the kind of psychological structures identified by Freud, perhaps interactive stories and games are the form of initiating, investigating and experiencing post-human identity.

# References

1. Anstey, J., Pape, D.: Scripting the interactor: an approach to VR drama. In: The Fourth Conference on Creativity and Cognition, ACM SIGCHI, pp. 150–158. ACM Press (2002)
2. Anstey, J., Pape, D.: The trial the trail: building a VR drama. In: Technologies for Interactive Digital Storytelling and Entertainment Conference, pp. 394–402. Fraunhofer IRB Verlag (2003)
3. Anstey, J., Seyed, A.P., Bay-Cheng, S., Pape, D., Shapiro, S., Bona, J., Hibit, S.: The agent takes the stage. Int. J. Arts Technol. **2**(4) (2009)
4. Barlow, S.: Her story. http://tale-of-tales.com. Accessed 5 June 2016
5. Murray, J.: Hamlet on the Holodeck: The Future of Narrative in CyberSpace. Simon and Schuster, New York (1997)
6. Stone, A.R.: The War of Desire and Technology at the Close of the Mechanical Age. MIT Press, Cambridge (1996)
7. Tales, T.: The path. http://tale-of-tales.com. Accessed 5 June 2016
8. Turkle, S.: The Second Self: Computers and the Human Spirit. Simon and Schuster (1984)
9. Wisconsin-Milwaukee, U.: Cream city review: I/O. http://www.creamcityreview.org/io-main/. Accessed 5 June 2016

# DreamScope: Mobile Virtual Reality Interface

Valentina Nisi[1], Nuno Nunes[1], Mara Dionisio[1], Paulo Bala[1(✉)],
and Time's Up[2]

[1] Madeira-ITI, University of Madeira, Campus da Penteada,
9020-105 Funchal, Portugal
{valentina,njn}@uma.pt,
{mara.dionisio,paulo.bala}@m-iti.org
[2] Time's up, Industriezeile 33b, 4020 Linz, Austria
info@timesup.org

**Abstract.** DreamScope is an interactive, bespoke 360° mobile virtual reality (VR) interface designed for immersive interaction of visitors in a post-apocalyptic fictional world called Lucid Peninsula. The goal of the installation is to offer a way for people to experience the future. DreamScope is composed of two assets; on one side, the DreamViewer binoculars, which enable participants to see the Lucid Peninsula fictional world and on the other, the DreamCatchers mobile devices that 'catch' the dreams of the inhabitants of the peninsula. Initial evaluations of the Dreamscope support the positive role of 360° mobile virtual reality in strengthening the narrative and the artists intent.

**Keywords:** Mobile 360 virtual reality interactive storytelling · Physical narrative · Art installation · Interaction design · Experience design

## 1 Introduction

In this paper we describe DreamScope, the digital component of a physical narrative art installation called Lucid Peninsula. Lucid Peninsula is an interactive installation designed to immerse participants in a dreamlike, post-apocalyptic story world where changes to the Earth's atmosphere have led to the emergence of new species, conditions, and ways of life. Fragments of memories and dreams belonging to the inhabitants of the previous era still linger in this new world, hovering over certain locations. The Lucid Peninsula story world emerged from a future scenario planning activity undertaken by artists and designers from the FoAM and Time's Up collectives under the Future Fabulators European Project[1] in June 2014.

In our art installation, the DreamScope interface is composed of a stereoscopic viewer (DreamViewer) and a mobile catcher (DreamCatcher). The Viewer and Catcher work in tandem to augment and deepen the audience experience with the artistic installation. Our focus is to gain knowledge on the general perception of a digitally enhanced narrative based installation. To achieve this we shown the art installation to a wide variety of public, in an exhibition or gallery setting, with the focus of evaluating

---

[1] http://futurefabulators.m-iti.org; http://www.timesup.org/FutureFabulatorsEU.

© Springer International Publishing AG 2016
F. Nack and A.S. Gordon (Eds.): ICIDS 2016, LNCS 10045, pp. 445–448, 2016.
DOI: 10.1007/978-3-319-48279-8

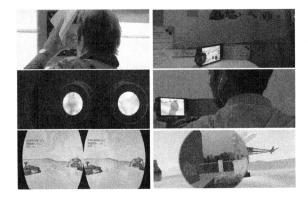

**Fig. 1.** DreamScope Viewer (Left); DreamScope Catcher (Right)

**Fig. 2.** DreamScope deployment in art exhibits

the art installation by applying evaluation procedures, such as questionnaires and observations.

## 2   Related Work

In this section, we define interactive physical narrative installations deriving from interactive art and physical art installations. In the context of Interactive Art, we refer in particular to Installation Art - a contemporary art form in which the viewer is required to physically enter the work in order to experience it [4]. A current trend in interactive artwork in Installation Art is the use of mobile devices as found in the work of Bluff and Johnston [2], where mobile devices are used by the artist himself as well as by the audience, to control and adjust an interactive installation. Another current trend in Installation Art is the use of Virtual Reality. According to Smith's [1], in the last years, artists manifested a strong desire to use Virtual Reality to create expressive 3D experiences. Char Davies artwork for example [5] makes use of VR headsets for the environmental exploration of other worldly shapes and particles. The merging of these trends in the form of the use of mobile devices as VR platforms, has potential to be used in future art installations.

## 3  DreamScope

The DreamScope interface is composed of a stereoscopic viewer (DreamViewer) and a mobile catcher (DreamCatcher). In the context of the art installation, DreamScope will be located in a special room, dedicated to the detoxification and recovery of air force pilots who sweep the peninsula in search of rare green plants and need to undergo a special purification treatment before they can fly the next mission.

### 3.1  DreamViewer

The DreamViewer enables the audience to glimpse life in the Lucid Peninsula. With the DreamViewer, visitors can enjoy a 180-degree panoramic view of the outside world, as if they are looking through a window of the room. The 3D world depicts a desert-like landscape with orange sky and a large red sun, simulating the landscape outside the recovery room, highlighting buildings that the user can explore in the city. Users can zoom in on buildings in the landscape to apprehend more details of the structure. This is possible through the use of a Google Cardboard[2]. The software was built using the Unity game engine and receives input from the accelerometer and gyroscope in order to show the virtual environment of the Lucid Peninsula.

### 3.2  DreamCatcher

With the DreamCatcher visitors will discover the dreams and memories of the Lucid Peninsula inhabitants. The DreamCatcher runs on a mobile device through an Android application built using the Unity game engine. By using image recognition software, virtual environments are triggered by scanning image markers. In these virtual environments, the characters' dreams are narrated as voice overs. By tapping the mobile device screen, users create circular viewing portals, that show what the Lucid Peninsula world looked like at a different time. An audio narration recounts the dream mixed with memories from the dreamers. The dreams themselves focus on the past and how the world once was (which is a reference to our current world) and the nostalgia the present inhabitants feel about such distant times.

## 4  Evaluation

The Lucid Peninsula full installation was successfully exhibited in Austria and Romania, in the context of the exhibition Intime Raume 2014 by IMA[3] and Future Fabulators exhibition by AltArt[4]. Based on these preliminary positive results, we designed a specific survey to be deployed in future exhibitions touching upon a series

---

[2] http://www.google.com/get/cardboard/.

[3] http://ima.or.at/lucid-peninsula/?lang=de.

[4] http://www.altart.org/?p=1322.

of parameters such as: (i) Demographics and background; (ii) Engagement and enjoyment experienced while visiting the exhibition; (iii) The extent to which they felt immersed; (iv) How was their experience and interaction while using the mobile devices; (v) How did the visitors perceive the overall theme of the exhibition and how did the artefacts supported this perception. Finally, we gathered data about: (vi) Provoked emotions by applying Positive and Negative Affect Scales [6]. The methods chosen are conductive to data that is quantitative when compared to more open ended techniques such as interviews, talk-aloud protocols or participant observation, which rely on a subjective understanding of the personality and attitudes of the audience [3].

## 5 Conclusion and Future Work

From the audience feedback where DreamScope was shown, the audience found DreamScope entertaining and thought-provoking. Preliminary results reveal that the experience was enriched by using the digital and and physical artefacts to create a thought-provoking environment. In future work, we will detail these results and discuss how the design evaluation method can benefit art installations and how mobile and VR technology should be further explored to expand the artistic experience.

**Acknowledgments.** We wish to acknowledge Future Fabulators, EU Culture and Media Project Funds (2013-1659/001-001 CU7 COOP7) for sponsoring our investigation, our fellow researchers at all partner institutions, Time's Up, and FoAM for their help and contributions, and the LARSyS (PEst-OE/EEI/LA0009/2013) research group for support.

## References

1. Abbasi, M. et al.: Use of creative tools, technologies, processes and practices in the sectors of Art, Media, and Architecture: State-of the-Art and desired future scenarios (2015)
2. Bluff, A., Johnston, A.: Remote Control of Complex Interactive Art Installations. Presented at the (2015)
3. Höök, K. et al.: Sense and sensibility. In: Proceedings of the Conference on Human Factors in Computing Systems. CHI 2003, pp. 241–241. ACM Press (2003)
4. Jacucci, G., Spagnolli, A., Chalambalakis, A., Morrison, A., Liikkanen, L., Roveda, S., Bertoncini, M.: Bodily explorations in space: social experience of a multimodal art installation. In: Gross, T., Gulliksen, J., Kotzé, P., Oestreicher, L., Palanque, P., Prates, R.O., Winckler, M. (eds.) INTERACT 2009. LNCS, vol. 5727, pp. 62–75. Springer, Heidelberg (2009). doi:10.1007/978-3-642-03658-3_11
5. Popper, F.: From Technological to Virtual Art. MIT Press, Cambridge, Mass (2007)
6. Watson, D. et al.: Development and validation of brief measures of positive and negative affect: the PANAS scales. J. Pers. Soc. Psychol. **54**(6), 1063 (1988)

# Quasi-experimental Evaluation
# of an Interactive Voice Response Game
# in Rural Uganda

Paul L. Sparks(✉)

Media Innovation Laboratory, Peripheral Vision International, Kampala, Uganda
Sparks@pvinternational.org

**Abstract.** This paper reports findings from the empirical evaluation of the Wanji Games project in rural Uganda. Wanji is a choice-based interactive narrative platform that utilizes interactive voice response (IVR) technology to present educational entertainment content through basic mobile phones. Players engaged with one of two games, using the keypad of their mobile phone to direct the plot of the narrative through a series of decision points. Players in the treatment condition (the Saving Game) reported an increased orientation toward long-term economic benefits and high-value crops, as well as increased awareness of a fictional mobile banking service relative to players in the control condition (a fantasy-based game). Findings suggest support for the application of a combination of Social Cognitive Theory (from educational entertainment) and Transportation Theory (from interactive narratives) to voice-based interactive narrative for education entertainment.

**Keywords:** Entertainment education · Africa · Interactive narrative · Mobile phones · Transportation theory

## 1 Introduction

Sub-Saharan Africa has the fastest growing number of unique mobile phone subscribers in the world, amounting to 18 % per annum from 2008–2013 with enormous growth potential [8]. The proliferation of mobile phones means that even in remote areas, people of all levels of education have at least some access to a basic device. While Short Message Service (SMS)-based interventions have been common in communication for development for sometime [1] audio-based systems are relatively underutilized despite the fact that they overcome the barrier of low literacy and allow for messaging to be adapted to appropriate vernacular. Some research has suggested positive results for a la cart audio-information services [9]; however, the effectiveness of phone-based audio messaging for entertainment education (E-E) in a developing country has not previously been empirically evaluated.

Wanji Games is an E-E platform targeting rural, low-literacy adults who otherwise have limited access to media and educational resources. In Wanji, interactive voice response (IVR) technology is utilized to create second-person narratives intended to influence knowledge, attitudes and/or behavior. For the present study, two interactive

© Springer International Publishing AG 2016
F. Nack and A.S. Gordon (Eds.): ICIDS 2016, LNCS 10045, pp. 449–454, 2016.
DOI: 10.1007/978-3-319-48279-8

audio narrative games were developed for, and deployed in, the Teso region of Uganda. The treatment condition, called the "Saving Game," aimed to educate smallholder farmers on locally appropriate agricultural and financial management practices. The control condition, a fantasy adventure story, had the non-explicit goal of influencing attitudes toward family planning.

The two games differ considerably in degree of verisimilitude. The design of the Saving Game is underpinned theoretically by Social Cognitive Theory (SCT) [2] and Transportation Theory [7]. Applying SCT, E-E interventions have scripted characters as social models who either engage in targeted behaviors and are rewarded or eschew them and suffer adverse consequences [3]. The effectiveness of this approach has been demonstrated repeatedly, notably through radio and television dramas [e.g. 10, 11]. Importantly, the situations and characters in E-E interventions are designed to be familiar and identifiable to the target audience [12]. Identification with characters and situations is likewise a key component of Transportation Theory, which emphasizes that engagement with the narrative increases persuasive impact [5]. Green and Brock have conceptualized transportation as an "integrative melding of attention, imagery, and feelings" wherein "all mental systems and capacities become focused on the events occurring in the narrative" [7]. Interactive narratives explicitly ask readers to step into the mind of a character and are thus more likely to facilitate transportation [6]. With this in mind, the Saving Game was designed to mirror reality as closely as possible for the target audience and thereby facilitate identification, transportation, and narrative impact. The control condition largely disregarded verisimilitude. Although both games were intended to promote specific (and different) social and psychological outcomes, theory suggests that differences in key indicators would be much weaker for the control condition (if they existed at all).

## 2   Stimuli

*"Welcome to Wanji Games, where you are part of the story! You have four free plays. Please listen carefully. As you play you will be asked to make choices. Each choice leads to a different outcome."*

This message welcomed players of Wanji Games and was identical in both conditions. As indicated, the IVR phone tree allowed listeners to alter the narrative at key decision points. The control game, with its more fanciful plot, was similar to a traditional "Choose Your Own Adventure" story. It required that players think of themselves as the hero protagonist, an individual with social connections to powerful people, unique knowledge, access to magical items and a companion in the form of a talking bird.

The Saving Game opened with the central character, a smallholder famer, harvesting a large crop of maize—a situation designed to be identifiable to the target audience. Players then encountered a series of economic decisions prompted by questions such as "What will you do with the harvest, sell it or store it? Press 1 to sell it, press 3 to store it." Making the choice to invest in the future (e.g. store the bulk of the harvest) was rewarded with positive narrative outcomes and extended game play. Careless or shortsighted

decisions, such as choosing to gamble earnings or store grain in an unprotected area of the house, lead to unfavorable outcomes and truncated play. The treatment story thus asked players to simply put themselves—as they are—into a fictional yet realistic story requiring a series of decisions that directly resonated with their lives.

Aside from these differences, the two games were similar in structure. There were 20 branch points and 19 possible endings to the Saving Game, and 19 branch points and 14 possible endings to the control game. At every branch point players were prompted to choose one of two options. Though the total number of branches was greater for the Saving Game, the average call duration for the control was slightly longer—218 s versus 227 s. The average play through the Saving Game included 5.7 narrative passages, while control players encountered 4.7 passages on average (not counting welcome and goodbye messages). Both games were available in English and the local language Ateso.

The scope of these games is broad, covering a variety of educational and behavioral topics. The control game aimed to subtly influence attitudes toward family planning, while the Saving Game targeted agriculture and financial management practices that are appropriate and available to smallholder farmers in the region. Additionally, the Saving Game included a test for the effectiveness of product placement on the platform. During the game, players could encounter up to 11 modules in which "Bankiphone," a fictional mobile banking brand, was utilized or recommended by characters in the story.

# 3  Study Design

This study is an empirical evaluation utilizing a quasi-experimental design in which the primary sampling units are sub-counties of the Katakwi, Amuria, Kumi and Bukedea districts of Uganda. For each sub-county assigned to one game, a comparable sub-county was assigned to the other. Though formal statistical matching was not performed, specific consideration was given to the size and density of the population (provided by the Uganda National Bureau of Statistics), accessibility of products and services (e.g. distance to local markets and health facilities), connectivity (electric and telecom), and access to media (e.g. number of public television screens). The assignment of eligibility across sub-counties was performed blindly and although non-random, should be considered independent of treatment. Following assignment, a team of promoters visited each sub-country, hung posters, passed out flyers and demonstrated the game selected for that area to small groups of individuals.

The estimate of effects was drawn from the comparison of average responses between Saving Game and control game players to a survey conducted approximately three days after completing four rounds (the maximum) of play. The survey instrument included key outcome indicators related to saving, family planning and product placement as well as a battery of questions meant to capture potential confounders. Additionally, the survey utilized a task method to elicit respondents' psychological disposition toward subjective time discounting, a characteristic related to saving and investment behavior that has been shown to positively correlate with education [4]. The key indicator of discounting was a score derived from two sets of three questions

wherein the respondent was asked to choose between receiving hypothetical payments in the near-term or in the long-term.

Ultimately, 653 players (384 treatment, 269 control) were interviewed via phone. A subset of respondents (n = 357) were asked more detailed questions about their experience with the game they played and a smaller sub-set (n = 70) were asked to describe in an open-response format what they did and did not like about the game.

# 4  Results

## 4.1  Player Characteristics

Although respondents presented similar characteristics across the two groups on the majority of 33 independent variables compared through bivariate regression analysis, respondents in the treatment condition were more likely to be female and had slightly more children. They tended to save money less frequently, were more likely to have a cash income and to have engaged in agriculture in the last season. Importantly, they were also more likely to state having previously planted beans or sweet potatoes, crops specifically promoted as good options for diversification in the game. Both games succeeded in reaching the target audience. Eight-six percent of players were subsistence farmers, 41 % of whom had no secondary-level education. Ninety percent of players chose to play in Ateso (the local language).

Of the respondents asked to describe their experience (n = 357), 69 % of control game players and 79 % of Saving Game players said that they enjoyed it "very much." From the open-ended responses the difference observed in favorability between the two games appears to be mainly due to genre and verisimilitude.

## 4.2  Main Results

Most family planning indicators showed no significant difference between the two groups. However, antithetical to the intended result, playing the Saving Game—not the control—was associated with a desire for fewer additional children in bivariate analysis. This difference is driven by the fact that Saving Game players tended to have slightly more children on average and was no longer significant once demographic factors were controlled for through multivariate regression.

Playing the Saving Game was associated with positive responses on key agricultural indicators. Being exposed to the Saving Game increased the stated intention to plant beans and sweet potatoes in the upcoming season, even after controlling for previously reported planting behavior. Playing the Saving Game was also associated with a positive result in product placement test. Respondents in the treatment group were significantly ($p < 0.01$) more likely to recognize the Bankiphone brand.

Turning to the clearest findings from this evaluation, playing the Saving Game was strongly associated with more patient responses to the subjective time discounting measure and preferences for long-term monetary benefits over reduced benefits in the near-term. Likewise, stated intention to safely store a portion of the next season's harvest (in a granary or another storage facility located outside of the respondent's

primary dwelling) was significantly and positively associated with playing the Saving Game. After controlling for potential confounders[1] through multivariate regression analysis, the discounting and safe storage outcomes remained positive and significant at the 95 % confidence level. Treatment was associated with a 0.35 unit increase in the number of times the respondent chose the long-term payment option and a 12 percent increase in the intention to safely store the next season's harvest. These findings demonstrate that the treatment positively influenced psychological dispositions and specific intentions toward saving.

## 5   Conclusion

The present research demonstrates the viability of the Wanji Games platform as an entertainment education initiative for rural, low literacy adults. More broadly, it confirms the feasibility of voice-based interactive narrative for education entertainment delivered through basic mobile phones. Not only did the Saving Game have a positive impact on participants in terms of learning and potential behavioral changes, it was also well received and highly enjoyable.

The results of this study provide support for the combined application of Social Cognitive Theory and Transportation Theory to interactive narrative for education entertainment. Though transportation was not directly measured through the survey instrument, the stark differences between the two games, as well as the considerably greater desirability of the Saving Game, suggest that factors associated with transportation played an important role in the observed outcomes. The verisimilitude of the Saving Game appears to be a key facilitator of both enjoyment and psychological changes experienced by players in the treatment condition.

Although this report provides strong evidence for the potential positive impact of Wanji Games, the research is still in a pilot phase. Stating that one intends to do something, such as plant beans or sweet potatoes, does not necessarily signal a change in behavior. However, these responses do argue for the effectiveness of in-game knowledge transfer and potential attitude change, an essential component of many development initiatives. The window of time for measuring change (3 days between completing play and the interview) was likely too narrow to observe several practically important behavior changes. A program in which baseline data on participants could be collected prior to exposure and in which random assignment of participants could be conducted would provide a far more rigorous assessment of causality. Both for

---

[1] Multiple regression analysis was performed to model outcomes where a significant difference between the two groups was in evidence in bivariate analysis. Controls for potentially confounding variables include differences exposed in balance checks, age, gender, level of education completed, occupation dummies (e.g. whether or not the respondent is a teacher), cash income (dummy), saving frequency, amount of money currently lent out, planted beans last season (dummy), planted sweet potato last season (dummy), number of agricultural extension visits in the past year, poverty likelihood according to a proxy means test, parent headed household (dummy) and marital status.

programmatic and research interests, the application of Wanji in a setting where the population is more clearly defined in advance would be beneficial.

The effect of interactivity generally was not tested in this study. Future research should test the interactive narrative format against an a la cart presentation of the same information. At present though, it is clear from the findings of this study that Wanji is a viable product with considerable potential for both research and media campaigns.

# References

1. Aker, J.C., Mbiti, I.M.: Mobile phones and economic development in Africa. J. Econ. Perspect. **24**(3), 207–232 (2010)
2. Bandura, A.: Social Foundations of Thought and Action: A Social Cognitive Theory. Prentice-Hall, Englewood Cliffs (1986)
3. Bandura, A.: Social cognitive theory for personal and social change by enabling media. In: Singhal, A., Co-dy, M.J., Rogers, E.M., Sabido, M. (eds.) Entertainment-Education and Social Change: History, Research, and Practice. Routledge, New York (2003)
4. Bauer, M., Chytilová, J.: The impact of education on subjective discount rate in Ugandan villages. Econ. Devel. Cult. Change. **58**(4), 643–669 (2016)
5. Dahlstrom, M.F.: The persuasive influence of narrative causality: psychological mechanism, strength in overcoming resistance, and persistence over time. Media Psychol. **15**, 303–326 (2012). doi:10.1080/15213269.2012.70260
6. Green, M.C., Jenkins, K.M.: Interactive narratives: processes and outcomes in user-directed stories. J. Commun. **64**, 479–500 (2014). doi:10.1111/jcom.12093
7. Green, M.C., Brock, T.C.: The role of transportation in the persuasiveness of public narratives. J. Pers. Soc. Psychol. **79**(5), 701–721 (2000). doi:10.1037//0022-3514.79.5.701
8. GSMA: Sub-Saharan Africa Mobile Economy 2013. Technical report, GSMA Association (2013)
9. Minischetti, E., Karim, S.F.: Connected Women Case Study HNI Madagascar: Information Via Mobile to Tackle Gender-Based Violence. Case Study, GSMA Association (2015)
10. Paluck, E.L.: Reducing intergroup prejudice and conflict using the media: a field experiment in Rwanda. J. Pers. Soc. Psychol. **96**(3), 574–587 (2009). doi:10.1037/a0011989
11. Rogers, E.M., Vaughan, P.W., Swalehe, R.M., Rao, N., Svenkerud, P., Sood, S.: Effects of an entertainment-education radio soap opera on family planning behavior in Tanzania. Stud. Family Plann. **30**(3), 193–211 (1999)
12. Slater, M.: Entertainment education and the persuasive impact of narrative. In: Green, M.C., Strange, J., Brock, T. (eds.) Narrative Impact: Social and Cognitive Foundations, pp. 157–181. Taylor and Francis, New York (2002)

# Workshops

# Tutorials in Intelligent Narrative Technologies

Chris Martens(✉) and Rogelio E. Cardona-Rivera

Department of Computer Science, North Carolina State University, Raleigh, USA
{crmarten,recardon}@ncsu.edu

**Abstract.** This workshop aims to afford its participants an opportunity to explore advances in the field of artificial intelligence for interactive digital storytelling. We will present a diverse program that includes core research areas of intelligent narrative technologies, as well as techniques from allied disciplines that can inform research in this field.

**Keywords:** Intelligent narrative technologies · Systems · Tutorials

## 1 Introduction

The Tutorials in Intelligent Narrative Technologies (TINT) workshop aims to provide an opportunity for researchers and practitioners to get hands-on experience with artificial intelligence (AI) techniques relevant to interactive digital storytelling (IDS). TINT will serve as a forum for sharing tools and resources, providing a foundation to build upon each other's work. Our emphasis is on systems that people can access and use to create IDS experiences.

## 2 Program

**Interactive Narrative Planning using Sabre** – This tutorial will introduce narrative planning in general, and present *Sabre*, an interactive narrative planning system. Sabre is a successor to the Glaive narrative planner [4], which has been used to generate and adapt stories within interactive virtual environments. Narrative planning systems are a variant of classical AI planning systems that seek to solve a problem commonly faced by storytellers: the problem of coordinating many agents with their own goals, and who may cooperate or compete in pursuit of those goals, while reasoning about the constraints and desired outcomes of a story. The audience will walk away with knowledge of current techniques used to solve narrative planning problems, and experience using a narrative planner.

**Modeling Story Worlds in Ceptre** – This tutorial will present *Ceptre*, a rule specification language that enables rapid prototyping of interactive storytelling games, with unique affordances for domains involving procedural content

© Springer International Publishing AG 2016
F. Nack and A.S. Gordon (Eds.): ICIDS 2016, LNCS 10045, pp. 457–458, 2016.
DOI: 10.1007/978-3-319-48279-8

generation and multi-agent interactions [2]. Ceptre is based on a formal logic concerned with resource usage, and it enables practitioners and researchers to design, analyze, and debug generative, multi-agent gameplay systems. Ceptre includes programming idioms similar to parser interactive fiction authoring environments like Inform, but with fewer assumptions about the world (e.g. movement through space with an inventory) and the ability to express mechanics commonly found in non-text-based games. The audience will walk away with the ability to rapidly develop and tinker with ideas in interactive storytelling and games.

**Tracery: generating text, art, twitterbots and more** – This tutorial will present *Tracery*, an author-focused open source tool for writing generative grammars [1]. Grammars are composed as JSON objects in a simple and readable syntax, and then recursively expanded by Tracery into a finished artifact. Tracery has been intentionally designed to be lightweight and syntactically simple to encourage its use, and works as a modular system with several independently usable components, including a parseable language and visualization tool. Tracery has been presented previously at ICIDS and has been used by many members of the ICIDS community. The audience will walk away with a twitterbot, and the ability to make an assortment of other things (poetry, text, music) with Tracery.

**The Talk of the Town Simulation framework** – This tutorial will present *Talk of the Town*, an asymmetric multiplayer simulation game environment in the style of Dwarf Fortress that features character knowledge propagation as a core mechanic [3]. Talk of the Town is an AI framework that supports gameplay with non-player characters (NPCs) who observe and form knowledge about the world, propagate knowledge to other characters, misremember and forget knowledge, and lie. Talk of the Town will be used in this tutorial to generate (small, American) towns as settings/material for other works of interactive storytelling and story generators. The audience will walk away with knowledge of how to generate their own towns, and a guided walk-through of their generated content.

# References

1. Compton, K., Kybartas, B., Mateas, M.: Tracery: an author-focused generative text tool. In: Proceedings of the 8th International Conference on Interactive Digital Storytelling, pp. 154–161 (2015)
2. Martens, C.: Ceptre: a language for modeling generative interactive systems. In: Proceedings of the 11th AAAI Conference on Artificial Intelligence and Interactive Digital Entertainment, pp. 51–57 (2015)
3. Ryan, J.O., Summerville, A., Mateas, M., Wardrip-Fruin, N.: Toward characters who observe, tell, misremember, and lie. In: Proceedings of the 2nd Experimental AI in Games Workshop at the 11th AAAI Conference on Artificial Intelligence and Interactive Digital Entertainment, pp. 56–62 (2015)
4. Ware, S.G., Young, R.M.: Glaive: A state-space narrative planner supporting intentionality and conflict. In: Proceedings of the 10th AAAI Conference on Artificial Intelligence and Interactive Digital Entertainment, pp. 80–86 (2014)

# How to Rapid Prototype Your Very Own VR Journalism Experience

Marcus Bösch[1](✉), Linda Rath-Wiggins[1], and Trey Bundy[2]

[1] VRagments VR Studio, Berlin, Germany
{marcus,linda}@vragments.com
[2] Center for Investigative Reporting, San Francisco, USA
tbundy@cironline.org

**Abstract.** Introducing a rapid prototyping approach we want to scribble, sketch and play around with VR paper prototypes. The concept – broadly used in the context of game design – aims for fast results and iterative development circles. That enables us to come up with first results after a very short amount of time at almost no cost.

**Keywords:** Virtual reality · Protoyping · Digital storytelling · Interactive digital storytelling

## 1 Introduction

Utilizing Virtual Reality (VR) in the context of digital journalism is a fairly new and evolving field. Besides 360 degree video, VR gives you the chance to truly immerse your audience by offering individual interactive experiences. It is not yet clear what kind of stories, levels of interactivity or what kind of multimedia usage will suit the new genre VR journalism best. A fast, fruitful and promising way to gain knowledge here is a structured hands-on approach that utilizes prototyping techniques.

## 2 Description

Introducing a rapid prototyping approach we want to scribble, sketch and play around with VR paper prototypes in the workshop. The concept – broadly used in the context of game design – aims for fast results and iterative development circles. That enables us to come up with first results after a very short amount of time at almost no cost. We want to explore what kind of topics are suited and how we can start thinking, planning and designing an interactive VR Journalism experience best. Besides a hands-on demonstration of rapid paper prototyping for VR we introduce a user centric design methodology.

© Springer International Publishing AG 2016
F. Nack and A.S. Gordon (Eds.): ICIDS 2016, LNCS 10045, pp. 459–460, 2016.
DOI: 10.1007/978-3-319-48279-8

## 3  Goals

With this workshop we want to contribute to a deeper understanding of VR journalism and the means of methodologies that help to shape future products in that emerging field. At the end of the workshop, each participant has designed and presented an idea for an interactive VR journalism product. These prototypes are perfectly suited for further usage and presentation in the newsroom.

## 4  Expected Outcome

We expect participants to learn and experiment with a variety of new approaches and methods. As a result, participants will

- Be familiar with the concepts of rapid prototyping,
- Learn about applied user centric design methodologies,
- Have enhanced knowledge of the needs and constraints of a VR experience,
- Attain hands-on experience in sketching and presenting a VR storyboard.

## References

1. How to design for VR. https://backchannel.com/immersive-design-76499204d5f6#.1d2esxl2e
2. Storyboarding in Virtual Reality. https://medium.com/@vmccurley/storyboarding-in-virtual-reality-67d3438a2fb1#.kglj328k8
3. The Secret of Rapid 3D Prototyping for AR/VR & IoT. http://blog.leapmotion.com/break-scissors-secret-rapid-3d-prototyping-arvr-iot/

# In-depth Analysis of Interactive Digital Narrative

Hartmut Koenitz[1]([⊠]), Mads Haahr[2], Gabriele Ferri[3],
Tonguc Ibrahim Sezen[4], and Digdem Sezen[5]

[1] HKU University of the Arts Utrecht, Professorship Interactive Narrative
Design, Lange Viestraat 2b, 3500 BM Utrecht, Netherlands
Hartmut.koenitz@hku.nl
[2] School of Computer Science and Statistics, Trinity College, Dublin 2, Ireland
Mads.Haahr@cs.tcd.ie
[3] Amsterdam University of Applied Sciences, Lectoraat in Play & Civic Media,
Wibautstraat 2-4, 1091GM Amsterdam, Netherlands
g.ferri@hva.nl
[4] Faculty of Communications, Istanbul Bilgi University, SantralIstanbul,
Kazim Karabekir Cad. No: 2/13, 34060 Eyup – Istanbul, Turkey
tonguc.sezen@bilgi.edu.tr
[5] Faculty of Communications, Istanbul University,
Kaptani Derya Ibrahim Pasa Sk., 34452 Beyazit - Istanbul, Turkey
dsezen@istanbul.edu.tr

**Abstract.** Critical analysis of narrative artifacts is long established academic
practice in literature, film, and theater studies. However, the same is not yet true
for Interactive Digital Narrative (IDN). In this field, the maker's own perspec-
tive on their work is still dominant, a situation that is unusual in comparison to
earlier narrative forms. Important reasons for this state of affairs are the per-
ceived lack of critical vocabulary and dedicated venues for IDN criticism, as
well as the need to apply specific theories of IDN to properly tease out the
differences between them and unilinear media. In a series of prior workshops,
we have developed an analytical toolset that we now want to put to use for the
detailed analysis of *Firewatch*, a prominent IDN artifact.

**Keywords:** Interactive digital narrative · Interactive digital storytelling ·
Narrative analysis · Narrative categories

## 1 Introduction

Critical analysis of narrative artifacts by third parties is long established academic
practice in literature, film, and theater studies. However, the same is not yet true for
Interactive Digital Narrative (IDN). In this field, the maker's own perspective on his
own work and the terminology he chooses to use is rarely challenged, a situation that is
unusual in comparison to earlier art forms. There might be several explanations for this
state of affairs. One is the perceived lack of critical vocabulary. Also, few venues and

© Springer International Publishing AG 2016
F. Nack and A.S. Gordon (Eds.): ICIDS 2016, LNCS 10045, pp. 461–463, 2016.
DOI: 10.1007/978-3-319-48279-8

opportunities for critical analyses of IDN artifacts exist. Finally, the complexity of IDNs makes specific knowledge a prerequisite for IDN criticism. In a series of prior workshops, we have developed an analytical toolset we now want to put to use for the detailed analysis of a prominent IDN artifact, Campo Santo's *Firewatch* [3]. We engage in this discussion through an ongoing multidisciplinary research effort to develop categories and vocabulary for achieving an improved analytical understanding of IDN [1, 2]. We argue that turning to concrete exemplars is a highly effective way to further develop new analytical terminology and critical perspectives.

## 2  Detailed Analysis of *Firewatch*

*Firewatch* is a critically acclaimed interactive digital narrative by San Francisco-based Campo Santo. In *Firewatch*, the interactor is in the role of a desperate man, who has taken on a job in a remote location – specifically as a firewatcher in an American national park – in order to get away from the sorrows in his life. At the firewatch tower, his only direct human contact is via a walkie-talkie, which connects him to his supervisor in the next tower. During his stay, strange happenings help the two characters to connect and form a bond. In the end, both characters have to be evacuated while a large wildfire consumes the forests around them. *Firewatch* is an exemplar of a masterfully designed narrative experience that invites deeper analysis. How does the interactor get 'drawn into the action?' How does the relationship develop between player character and the NPC of the supervisor? What narrative design principles have the creators applied? Some tentative answers to these questions might include "scripting the interactor" in the multimodal and multi-temporal introduction sequence and the frequent use of dramatic compression.

## 3  Workshop Format

The half-day workshop kicks off with a short overview of the work and existing specific vocabulary and analytical tools. A Research-through-Workshop (RtW) approach (thematic introductions, brief directed discussions, collaborative sketching and reasoned comparisons), developed in the organizers' previous workshops, will be employed to produce insights through collective brainstorming at the conference. The process places emphasis on informal discussion, is programmatically open-ended, and will produce raw data, which will be accessible to the research community on the *Games & Narrative* website [4].

## References

1. Koenitz, H., Ferri, G., Haahr, M., Sezen, D., Sezen, T.I.: Interactive Digital Narrative: History, Theory, and Practice. Routledge, New York (2015)

2. Koenitz, H., Haahr, M., Ferri, G., Sezen, T.I., Sezen, D.: Mapping the evolving space of interactive digital narrative - from artifacts to categorizations. In: Koenitz, H., Sezen, T.I., Ferri, G., Haahr, M., Sezen, D., Catak, G. (eds.) ICIDS 2013. LNCS, vol. 8230, pp. 55–60. Springer, Heidelberg (2013). doi:10.1007/978-3-319-02756-2_6
3. Campo Santo: Firewatch [video game] (2016). http://www.firewatchgame.com/
4. http://gamesandnarrative.net

# Exploring New Approaches to Narrative Modeling and Authoring

Fanfan Chen[1], Antonia Kampa[2], Alex Mitchell[3(✉)], Ulrike Spierling[2], Nicolas Szilas[4], and Steven Wingate[5]

[1] Department of English, Research Centre for Digital Games and Narrative, Design, National Dong Hwa University, Shoufeng Township, Taiwan
ffchen@mail.ndhu.edu.tw
[2] Hochschule RheinMain, University of Applied Sciences, Munich, Germany
{antonia.kampa, ulrike.spierling}@hs-rm.de
[3] Department of Communications and New Media,
National University of Singapore, Singapore, Singapore
alexm@nus.edu.sg
[4] TECFA, FPSE, University of Geneva, Geneva, Switzerland
Nicolas.Szilas@unige.ch
[5] Department of English, South Dakota State University, Brookings, USA
steven.wingate@sdstate.edu

**Abstract.** Despite a long tradition of interactive storytelling (IS) researchers drawing inspiration from narratology, and recent interest by narratologists in interactive storytelling, there is still a gap between the two fields. Even when IS researchers make use of narrative models, it is not clear how authors use these models. This workshop brings together narratologists, developers of IS authoring systems, and creative practitioners to share their experiences, and prototype new approaches to authoring, grounded both in the needs of authors, and in recent approaches to narratology and narrative modeling.

**Keywords:** Interactive storytelling · Narrative models · Narratology · Authoring

## 1 The Gap Between Narrative Models and Authoring

There has long been a tradition of interactive storytelling researchers drawing inspiration from narratology for approaches to modeling interactive stories. Despite this tendency for interactive storytelling researchers to make reference to narratological models, there has historically been a lack of interaction between the disciplines of AI/interactive storytelling and narratology. Although this is slowly starting to change, there is a need for more discussion and interaction between AI/interactive storytelling and narratology. This includes a need for a broader exposure to and use of narrative models, beyond the specific models often used in interactive storytelling. There is also a need for awareness of more recent, innovative approaches to narratology, such as possible worlds theory and unnatural narratology.

© Springer International Publishing AG 2016
F. Nack and A.S. Gordon (Eds.): ICIDS 2016, LNCS 10045, pp. 464–465, 2016.
DOI: 10.1007/978-3-319-48279-8

In addition, there is a need for more consideration of the impact of the design of authoring tools and the representation of these underlying models on the authoring process, and more involvement of authors in the process of designing these tools and representations. Unlike an author of a non-interactive story, the author of an interactive story often needs to be conscious of the underlying narrative model, due to the technical demands that result from the authoring process. This requires some way of representing the underlying model to the author, in a way that makes sense from a storytelling perspective, in the form of an authoring tool. Such an explicit representation of the model can both afford and constrain particular approaches to storytelling with a given model as represented in a particular tool. Both tool designers and narrative theorists would benefit from taking this into consideration.

These issues are particularly important now that areas such as location-based and transmedia storytelling, augmented reality, and virtual reality are growing in popularity and are being picked up by the mainstream entertainment industry, often with little consideration for the ways that these new forms of storytelling impact both the stories that can be told, and the ways that these approaches to storytelling can inform and impact our theoretical understanding of narrative.

There has also been an increase in the development of interactive stories within the hobbyist community, often using tools such as Twine that have little or no incorporation of more complex models. This in itself raises interesting questions, such as whether using simple, accessible tools that do not embody any particular model (the equivalent of pen and paper for interactive storytelling) could enable more authors to create interactive stories, or whether the use of complex computational models is more appropriate? If the answer is the latter, then how to empower authors to write the stories they want using these complex models? Or should authors be empowered to create their own approaches to modeling interactive stories, and if so, how can these models be implemented in authoring tools? A key concern with this last approach is how to enable this type of authoring, given the technical demands involved in both conceptualizing and implementing underlying models in an authoring tool.

## 2 Structure of the Workshop

This full-day workshop involves two parts. The first part involves informal sharing of experiences by authors, tool designers, and technologists regarding narrative models, approaches to authoring interactive stories, and the design and use of interactive storytelling authoring tools. The second part of the workshop consists of small groups brainstorming and prototyping new approaches to authoring based on narrative models and approaches to representation and authoring discussed during the first half of the workshop. Participants are encouraged to submit position papers and/or examples of authoring tools or creative works for distribution to other participants proper to the workshop. These form the basis for the presentations during the first part of the workshop. Outcomes of the workshop include new insights and inspirations for narratologically-grounded approaches to authoring and interactive storytelling, and (ideally) ideas for new collaborative projects between participants.

# Author Index

Printed in the United States
by Baker & Taylor Publisher Services